LEONARDO DA VINCI

—

PAINTER AT THE COURT OF MILAN

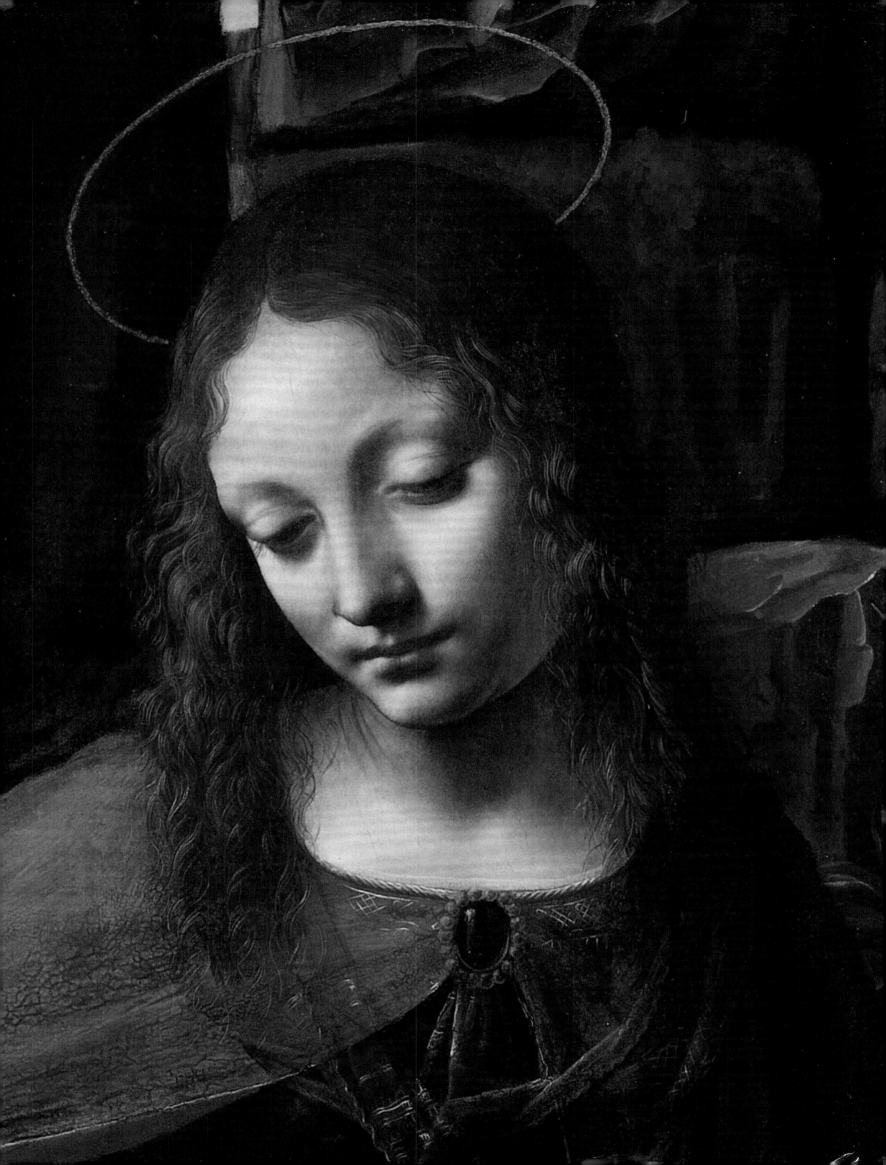

LEONARDO DA VINCI

— PAINTER AT THE COURT OF MILAN

LUKE SYSON

WITH

LARRY KEITH

ARTURO GALANSINO, ANTONIO MAZZOTTA,
MINNA MOORE EDE, SCOTT NETHERSOLE
AND PER RUMBERG

National Gallery Company, London

DISTRIBUTED BY YALE UNIVERSITY PRESS

Published to accompany the exhibition

LEONARDO DA VINCI
PAINTER AT THE COURT OF MILAN

The National Gallery, London
9 November 2011 – 5 February 2012

Sponsored by Credit Suisse

First published in Great Britain in 2011 by
National Gallery Company Limited
St Vincent House
30 Orange Street
London WC2H 7HH
www.nationalgallery.org.uk

ISBN 978 1 85709 491 6 HB
ISBN 978 1 85709 490 9 PB

British Library Cataloguing in Publication Data
A catalogue record is available from the British Library

Library of Congress Control Number 2011933356

PROJECT MANAGER Jan Green
EDITOR Johanna Stephenson
EDITORIAL ASSISTANT Sophie Wright
DESIGNER Philip Lewis
PICTURE RESEARCHER Maria Ranauro
PRODUCTION Jane Hyne and Penny Le Tissier

Printed and bound in Great Britain by
Butler Tanner & Dennis Ltd, Frome, Somerset

All measurements give height before width
All the works illustrated are from the
National Gallery, London, unless otherwise indicated

COVER *Portrait of Cecilia Gallerani ('The Lady with
an Ermine')*, about 1489–90 (cat. 10, detail)

FRONTISPIECE AND PAGES 78–9 the London
Virgin of the Rocks, about 1491/2–9 and 1506–8
(cat. 32, details)

PAGES 7 and 160 the Paris *Virgin of the Rocks*, 1483–
about 1485 (cat. 31, details)

PAGES 8 and 280 *The Virgin and Child with Saint Anne and
the infant Saint John the Baptist ('The Burlington House Cartoon')*,
about 1499–1500 (cat. 86, details)

PAGES 11, 80 and 102 *Portrait of Cecilia Gallerani
('The Lady with an Ermine')*, about 1489–90
(cat. 10, details)

PAGES 12 and 84 *Portrait of a Young Man ('The Musician')*,
about 1486–7 (cat. 5)

PAGE 54 *Portrait of a Woman ('The Belle Ferronnière')*,
about 1493–4 (cat. 17, detail)

PAGE 134 *Saint Jerome*, about 1488–90 (cat. 20, detail)

PAGE 212 *Head of a woman*, about 1488–90
(cat. 59, detail)

PAGE 246 *The Last Supper*, 1492–7/8 (fig. 100, detail)

CATALOGUE
CONTRIBUTORS

AG Arturo Galansino
AM Antonio Mazzotta
LAK Leah Kharibian
LK Larry Keith
LS Luke Syson
MME Minna Moore Ede
PR Per Rumberg
SN Scott Nethersole
TK Tatiana Kustodieva

Contents

Catalogue

Sponsor's Foreword

WE ARE PARTICULARLY proud to be associated with this landmark exhibition – the first to be dedicated to Leonardo da Vinci's aims and ambitions as an artist during his time as court painter in Milan, where he worked for the city's ruler, Ludovico Maria Sforza, il Moro ('the Moor'), in the 1480s and 1490s. One of the greatest and most talented Renaissance artists, Leonardo da Vinci is admired all over the world; something which Credit Suisse aims to emulate as one of the world's leading and trusted banks.

As with all our sponsorships, we aim to partner with institutions that share the same core values as Credit Suisse and thus strive to achieve outstanding and long-term success. This exhibition at the National Gallery in London offers visitors a rare opportunity to view around half of the 15 or so paintings by Leonardo which are known to be in existence, as well as 50 of his original drawings, including 33 sketches and studies from the Royal Collection loaned by Her Majesty The Queen.

We are pleased to be able to play our part in helping to bring this once-in-a-lifetime exhibition to London, and hope you enjoy your visit and the opportunity to see significant paintings such as the *Musician* (Pinacoteca, Milan), the *Belle Ferronnière* and the *Virgin of the Rocks* (both Musée du Louvre, Paris) and the highly prized *Portrait of Cecilia Gallerani*, popularly known as the *Lady with an Ermine* (Czartoryski Foundation, Cracow), arguably Leonardo's greatest masterpiece of this period.

FAWZI KYRIAKOS-SAAD
CEO, Europe, Middle East and Africa
Credit Suisse

Partner of the National Gallery

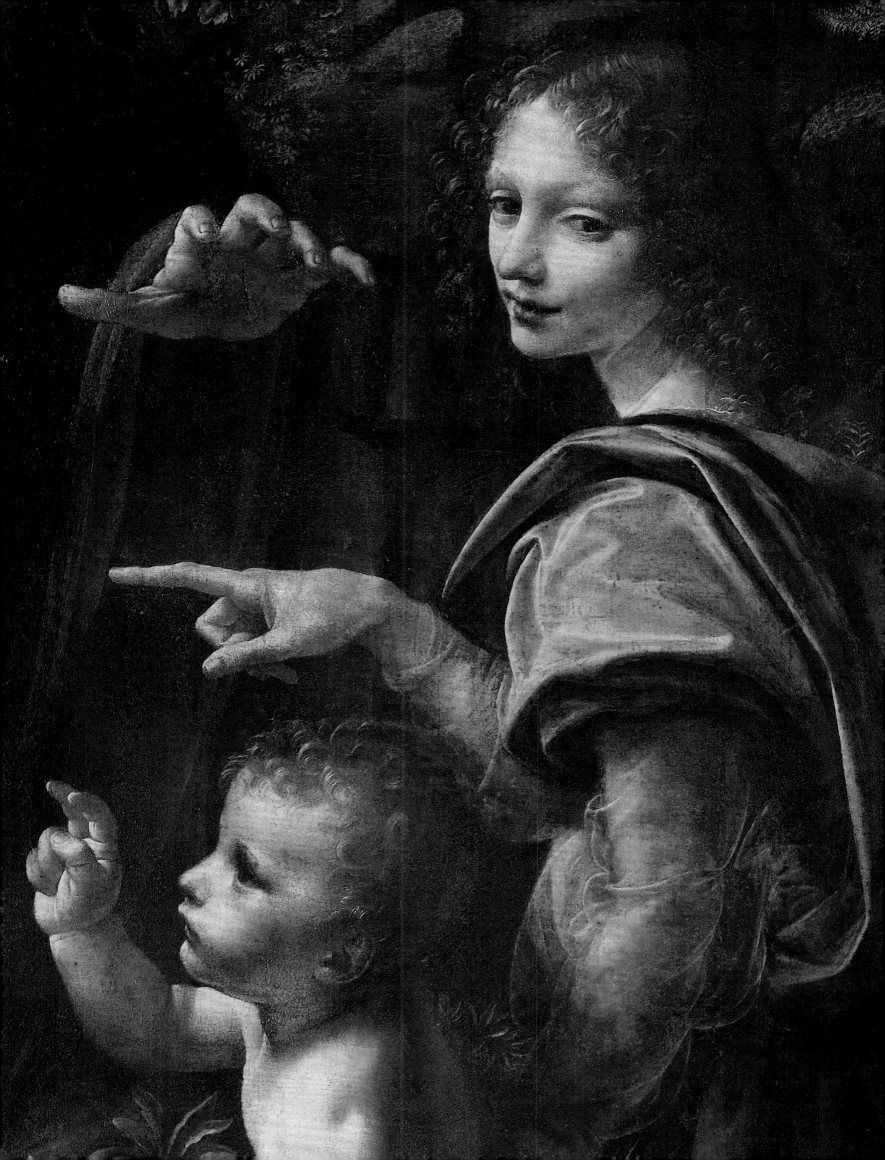

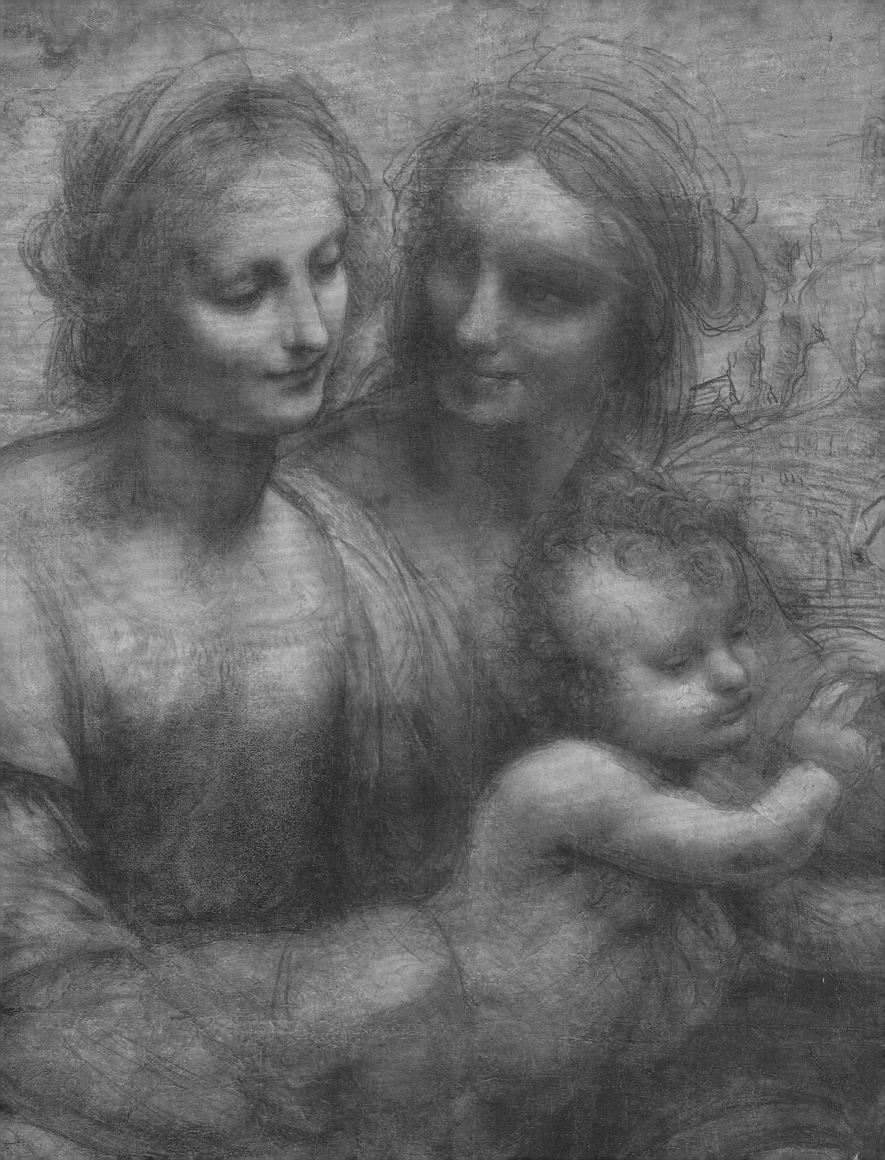

Director's Foreword

THIS EXHIBITION EXAMINES Leonardo's career as a painter working in Milan and attached to the ducal court. In this period he painted the two pictures both now called the *Virgin of the Rocks*. The first version, which he seems uncharacteristically to have completed rather quickly, is in the Louvre. The second, which he perhaps never did complete, has since 1880 hung in the National Gallery. Thanks to an extraordinary agreement reached with our colleagues in Paris, the first version will hang, for this brief period, side by side with ours: a juxtaposition that was almost certainly not seen even in Leonardo's own lifetime, nor at any time since, and one that is unlikely ever to be repeated. This comparison will be exciting and revealing for more than the scholars who have long debated the degree of Leonardo's involvement in painting the second version. And the exhibition provides other unprecedented opportunities to understand exactly how much the paintings and drawings that bear Leonardo's name owe to him and how much to his collaborators.

Our exhibition concentrates on his painting and, thanks above all to the exceptional generosity of Her Majesty The Queen, on the drawings that relate to his paintings. The sacrifice made by all the lending institutions – especially the Princes Czartoryski Foundation, Cracow; the State Hermitage, St Petersburg; the Vatican Museum, Vatican City; the Pinacoteca Ambrosiana, Milan; and the Louvre, Paris – is a huge one, for their paintings by Leonardo are among the greatest popular attractions on display in any collection of Old Master paintings anywhere. From the works assembled, and from the catalogue accompanying the exhibition, the visitor will be powerfully impressed by the artist's ideals of beauty, his understanding of how mind influences body, his theories of character and expression. Leonardo was certainly an 'intellectual' and the catalogue touches on how his ideas were affected by other great thinkers. However, visitors to this exhibition are invited to suspend much of their curiosity concerning Leonardo as a 'scientist'. His work as a geologist, and as a designer of irrigation systems and lethal armaments, is only peripherally present.

We are indebted to Credit Suisse for its continued support, which has enabled us to bring these works together for the first, and perhaps only time. Among the many individuals who should be thanked for their special help and advice I must mention in particular two: Rt Hon. Ed Vaizey, Minister for the Arts, and Prince Adam Karol Czartoryski. The exhibition has been immeasurably enriched by the help of all those with whom we have worked at the Czartoryski Foundation and the National Museum in Cracow.

NICHOLAS PENNY
Director, The National Gallery

Acknowledgements

ALL EXHIBITIONS ARE collaborative enterprises. So too are the publications that accompany them. However I could never have anticipated how very important my companions on this long and complex journey would become. The contributions of these many individuals has been of different kinds.

I must start by thanking Stefano Pessina, who has supported my post during the three years of most concentrated work on the exhibition and catalogue.

Many colleagues at the National Gallery have helped in many ways. Working with Larry Keith on the restoration of the London *Virgin of the Rocks* has been one of the most extraordinary privileges of my career. The commitment of all my co-authors has been hugely important: Arturo Galansino (Harry M. Weinrebe Curatorial Assistant), Antonio Mazzotta, Minna Moore Ede, Scott Nethersole and Per Rumberg (Pidem Curatorial Assistant); Per, Arturo and Antonio, in particular, did much more for the exhibition and catalogue than is evident just from the admirable catalogue entries that bear their name. The book would be less eloquent and less beautiful had it not been edited by Johanna Stephenson and designed by Philip Lewis.

For the assistance of those who have studied Leonardo and his pupils over many years and with an intensity I could not hope to match, I would like to thank: Carmen Bambach, Juliana Barone, David Alan Brown, Maria Teresa Fiorio, Martin Kemp, Pietro C. Marani, Frank Zöllner. Juliana and Martin in particular I thank for giving me advance sight of their monumental catalogue of drawings by Leonardo and the Leonardeschi in British collections.

I am hugely grateful to all the generous lenders and to all who have facilitated loans or have read different parts and versions of the text, and in particular to Giovanni Agosti, Sandrina Bandera, Beverly Brown, Stephanie Buck, Lorne Campbell, Stephen Campbell, Hugo Chapman, Pierre Curie, Janusz Czop, Andrea Di Lorenzo, Jill Dunkerton, David Ekserdjian, Marzia Faietti, Michael Gallagher, Olga Jaros, Leah Kharibian, Jill Kraye, Tatiana Kustodieva, Fabrizio Moretti, Arnold Nesselrath, Vincent Pomarède, Cristina Quattrini, Jane Roberts, Charles Robertson, Ashok Roy, Francis Russell, Xavier Salomon, Nicola Shulman, Robert Simon, Martin Sonnabend, Francesca Tasso, Carel van Tuyll, Stefan Weppelmann, Aidan Weston-Lewis, Linda Wolk-Simon and Annalisa Zanni. Caroline Elam deserves special mention for having done so much to improve the introductory essays. Most of the research for this project was undertaken at the Warburg Institute, that precious resource for scholars from all over the world – that must be protected and nurtured at all costs.

Diplomatic support was given by Hillary Bauer and her colleagues at DCMS who provided timely and essential support with loan negotiations.

Friends have provided love and hospitality over many months, in some cases giving over their kitchen tables for the writing of the catalogue. Once again it is invidious to name names, but I could not have achieved this without Philip Attwood, Sophie Dickens, Louise Ferdinando, Gail Getty, Esther Godfrey, Dillian Gordon, Jeannie Hobhouse, Anna Keay, Jean Ramsay, Simon Thurley, Martin Wyld and, not least, Lucy Gaster, Nicholas Deakin and the rest of my lovely family.

And finally there are four people whose support has been heroic, their friendship unstinting – Martin Clayton, Vincent Delieuvin, Alberto Rocca and Adam Zamoyski – without whom this exhibition certainly could not have taken place.

LUKE SYSON

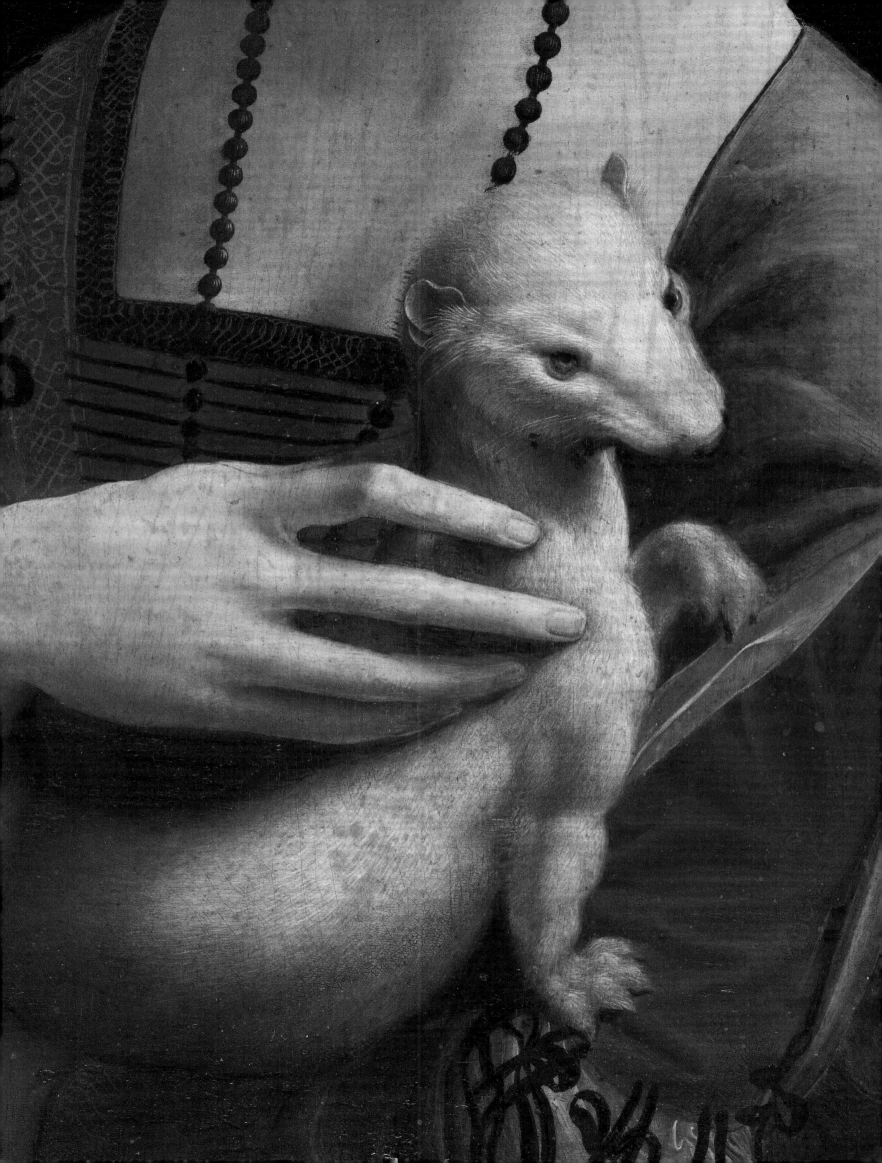

THE REWARDS OF SERVICE

LEONARDO DA VINCI AND THE DUKE OF MILAN

LUKE SYSON

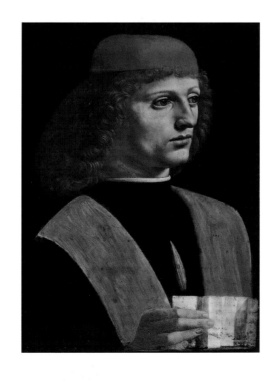

LEONARDO DA VINCI'S 18 YEARS IN MILAN were the making of him.[1] It was probably in 1482 that he journeyed from the mercantile republic of Florence to this, the wealthiest and most populous of Italy's dynastic city states, and he soon entered the orbit of its magnificent ruler, Ludovico Maria Sforza (1452–1508; nicknamed il Moro – 'the Moor' – probably because of his swarthy features: see cat. 2). And when, in about 1489–90, Ludovico began paying Leonardo a salary, the prince was granting the painter the time and space to effect a quite extraordinary metamorphosis of the art of painting. Leonardo's three surviving Milanese portraits (cats 5, 10, 17), not least his likeness of il Moro's mistress, Cecilia Gallerani, chronicle a stylistic journey that was to revolutionise the genre.[2] His two versions of the *Virgin of the Rocks* (cats 31, 32) were both painted for an elite Milanese confraternity, packed with Ludovico's courtiers. Superficially they look alike – their compositions are more or less the same – but in their details and hence their overall ambition they are revealed as profoundly different from one another. These are disparities that reflect Leonardo's significant change of direction in the years after 1490.

In 1550 Giorgio Vasari, the first great historian of art, placed Leonardo in the vanguard of what he dubbed the modern manner, notable for his 'force and boldness of design, the subtlest counterfeiting of all the minutiae of Nature exactly as they are, with good rule, better order, correct proportion, perfect design and divine grace'.[3] Leonardo was being credited with the stylistic leap that resulted in what many art historians call the High Renaissance. This changed sense not just of what pictures might look like, but of their whole purpose and scope, is usually located in Florence during the years Leonardo spent there immediately after 1500. But of all Leonardo's works Vasari devotes most attention to the *Last Supper* (fig. 105), a work of almost uncanny perfection (despite its rapid decay), executed in Milan in about 1492–7/8. Quite properly, Vasari gives Ludovico Sforza a leading role in the narrative of its execution. For it was actually with this picture, and as Ludovico's court painter, that Leonardo had first attained that pioneering combination of detailed naturalism, a feature already familiar from the work of Netherlandish painters and their Italian imitators, with something that is deemed new: the

'divine grace' that – with the artist seeking to surpass the beauties of nature – could take painting into the realm of the otherworldly.

In return for Ludovico's protection, this marvellous, modern painter would be celebrated as 'his', the human emblem of the Sforza court. The rhetoric surrounding his employment ensured that Leonardo's highly visible gifts were taken as the mirror of his patron's more abstract talents as a ruler. And, particularly in the 1490s, Leonardo's painting of a world made perfect by analysis, discipline and imagination could be understood as corresponding to the much promoted notion of the prince as the perfected ruler of an ideal state. Onlookers may have been aware of the ways in which the life stories of Ludovico and Leonardo chimed, making it clear that their achievements were due to their outstanding talents, but also the responsible ways in which they had honed these gifts. Patron and painter were exactly of an age and their roads to glory had been unconventional. Ludovico became Duke of Milan only in 1494, but (with the title Duke of Bari) had ruled the city as regent for his young nephew, Gian Galeazzo, from 1481. However, as the fourth son of Duke Francesco Sforza, he had been brought up with no real expectations of power. Leonardo was born with even fewer prospects, the illegitimate child of a peasant girl and a middle-class notary, tucked away in the Florentine countryside until his late teens, but becoming a painter whose gifts were so manifest and manifold as to guarantee his success. A publicly emblazoned partnership between patron and painter could make their contemporaries contemplate the question – of immense rhetorical importance to both men – of where talent comes to reside, of the difference between a great man and the rest.

The connections that can be traced between Leonardo's artistic trajectory and Ludovico's rhetoric of rule should emphatically not, however, be seen as matters of mere cause and effect. Unlike many of his courtier contemporaries, Leonardo was too creative and too independent to turn himself into a servile panegyrist. And Ludovico was wise enough not to attempt the complete annexation of his painter's immense creativity. Leonardo is often treated as peerless, unconnected with the world around him, locked away in the tower of his own genius. But his artistic philosophy evolved against a background of collectively

held beliefs about what a prince and his state should be. What Leonardo produced as a court painter was a body of work that might subtly reinforce the more strident messages put out by the Sforza propaganda machine, nuanced, perceptible to those looking, but never blatant. This is an instance in which the artist travelled down certain stylistic and – strictly connected – philosophical paths that suited both him and his employer, precisely that journey which would be celebrated by Vasari.

It is crucial to recognise from the outset that Leonardo thought of himself as a painter-philosopher. He read very widely and he wrote; indeed he never stopped writing. Famously, he used his left hand and a backwards script that needs to be read with a mirror.[4] His writings are of a particular character. Unlike so many of his contemporaries, he was almost entirely uninterested in diaries, memoirs or autobiography, and he was, it seems, no letter writer. Instead – and intimately linked to his aspirations as a painter and for painting itself – his writings chart the conversion of a set of initially disjointed 'scientific' interests into one of the most profound and extensive investigations of Nature and her laws ever undertaken. The earliest of his several intact notebooks belong to this first period in Milan; others from the same time are now dismembered, their pages scattered; still more, of the early 1490s, are lost, known only from the transcriptions of his devoted pupil, Francesco Melzi, intent on constructing the so-called *Treatise on Painting*. In these notebooks Leonardo explored an unprecedentedly wide terrain, moving fluidly, if untidily, from optics, engineering and hydraulics to the analysis of the flight of birds, from the anatomy and ideal proportions of man (and, as we shall see, horse) to discussions of the relative virtues of painting and music, sculpture and poetry. In these efforts he remained indebted to earlier thinkers, ancient, medieval and modern; for his writing on art in particular he relied upon Pliny the Elder's *Natural History* and the treatises on painting by two Florentines, the painter Cennino Cennini (about 1370 – about 1440), for whom colours should be 'blended like smoke',[5] and especially the great humanist Leon Battista Alberti (1404–1472). But he was careful to maintain that he was no man of letters (not *literato*; certainly he had poor Latin and no Greek),[6] and he believed in building his theories upon proofs rather than earlier opinion. This insistence on experience,

upon detailed observation, ensured that his flights of the mind were never entirely headlong.

Leonardo planned and re-planned a whole series of treatises, including several on painting, but if any of them was fully finished, not one survives. Easily distracted, regularly assailed by the prickles of boredom and the keener thorns of self-doubt, he never succeeded in training and pruning the body of his thought into coherent shape; his notes can appear unresolved and philosophically incoherent – and this not just because they were written over a considerable period of time. As the first Renaissance writer who was also, and primarily, a great artist, it was in his paintings, he discovered, that these philosophical fault-lines could be effectively bridged. The pictures themselves would constitute proofs both for his philosophies of the cosmos and for the ways it should be painted. And if at the beginning his painting – a form of knowledge – has an empiricist character, by the early 1490s Leonardo's goal was not just to discover but to create an otherworldly beauty that was absolute and essential, simultaneously unauthored (always unsigned) and brilliantly invented. His was a style that should appear both real and inspired.

Though it had its triumphant finales, Leonardo's was also a career of overtures, of false starts, frustration and failure. Finding – making – the pictorial proofs for his theories was bound to be painful and, though he repeatedly espoused self-discipline, he seldom met his own high standards. Dissatisfaction was built in to his method: 'When a work stands equal to one's judgment, it is a bad sign for the judgment. When the work surpasses one's judgment that is worse … and when the judgment disdains the work this is a perfect sign.'[7] Like his many projected but unrealised treatises, some of his paintings (similarly instructive) collapsed under the weight of their own ambition. Notoriously, Leonardo might worry away at a picture for decades, thinking, rethinking and refining. He started probably no more than 20 pictures in a career that lasted nearly half a century, and only 15 surviving pictures are currently agreed to be entirely his, of which at least four are to some degree incomplete.

Leonardo's life and career are pieced together from a jumble of documentary sources – contracts, account books, legal disputes, letters between competing patrons and their agents, and – least reliable – early biographies. They are all precious, given his own fierce reticence, but

there remain many gaps in our knowledge. Frustrated, scholars have sometimes been tempted to pick over the detritus of his private life, attempting interpretations of his psyche that might be applied to his art. Whether or not his shifting visual ideologies were in fact expressive of his temper and biography, his illegitimacy or his probable homosexuality, we can only be certain that Leonardo's decisions as a painter were informed by his theories of art (as these theories were by his paintings). We therefore need to trace the ways in which his aesthetic beliefs evolved from his beginnings in Florence, during his 18 years in Milan, and again after he left the city. We have to work out when and in what order his pictures – the testing grounds and proofs for his hypotheses – were painted. And we should think about what was going on around him, what were the political and religious events and discussions of the day that might have had an impact. His career cannot be discussed as if his aims for painting were consistent throughout; they were in constant flux. These changes are felt in his writings but particularly in his pictures. Thus the documented facts of his life become valuable chiefly because they provide the foundations for a chronological sequence of his artistic achievements. Tracking Leonardo's stylistic development in this way also

provides an indispensable armature for dating and, by so doing, better understanding those works for which firm documentary evidence is lacking.

Beginning in Florence

To all intents and purposes Leonardo was a Florentine and, before his move to Sforza Milan, he attempted a different sort of career in Florence. He was born on 15 April 1452 in or near the small town of Vinci, a Florentine possession about a day's ride from the city, to the well-born (and already betrothed) notary Ser Piero and his peasant mistress, Caterina. It was probably in about 1469, with father and son both recorded in the city for the first time, that Piero apprenticed Leonardo to the conspicuously successful sculptor-painter Andrea del Verrocchio. Leonardo's training was complete by June 1472 when his name was inscribed in the membership ledger of the newly revived artists' confraternity of Florence, the Compagnia di San Luca.[8] The bond between master and pupil was nonetheless enduring and it is likely that Leonardo went on operating under Verrocchio's commercial umbrella for some time, not yet ready to set up a workshop of his own. As late as 1476 Leonardo was described as

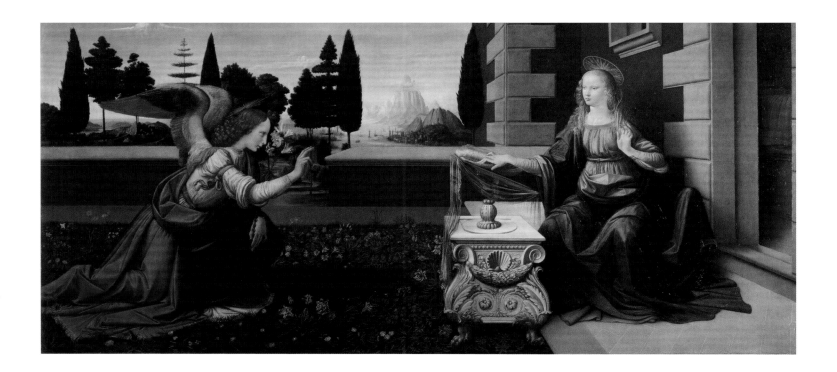

FIG. 2
LEONARDO DA VINCI
The Madonna of the Carnation, about 1477–8
Oil on poplar, 62 × 48.5 cm
Alte Pinakothek, Bayerische
Staatsgemäldesammlungen, Munich

being 'with Andrea del Verrocchio' when he was accused – but, proof lacking, absolved – of sodomy.[9]

Three early pictures, now correctly ascribed to Leonardo, depend so closely upon Verrocchio's prototypes that they must have been executed in the mid-1470s, with the young painter still under his master's wing. The earliest is probably the measured and monumental Uffizi *Annunciation* (fig. 1), a long horizontal panel, full of delicate incident. It was almost certainly in the middle of the decade that Leonardo painted his superbly remote *Portrait of Ginevra de' Benci* (fig. 31), acclaimed for her beauty and poetry, a picture which brings him within the rarefied circle of Florentine poets and scholars. In all likelihood these included one of Ginevra's admirers, Cristoforo Landino, the translator of Pliny's *Natural History* and the editor of Dante's *Inferno*. The *Madonna of the Carnation* (fig. 2), with its complex flutter of flowers and drapery folds, is a work in which, though the palette has darkened, Leonardo's ongoing stylistic dialogue with his former master is unmistakable. At about this time, in 1476–7, Leonardo completed the *Baptism of Christ* altarpiece (fig. 85), left to languish some years earlier by Verrocchio.[10] The young painter flooded its rocky landscape with water but did less to his master's figures than is usually supposed.

These pictures of the 1470s reveal the extent to which Leonardo was trained within a tradition of painting where 'every feature, the principals and the extras alike, the birds in the sky, the green forest and every single leaf of it, are all granted an equal and undiminished right to exist'.[11] This is the fifteenth-century world of Leonardo's Uffizi *Annunciation*, exquisite, meticulous, even slightly finicky. But there are parts of that early work, its ambitious perspective and its grey-blue mountains dissolving on the horizon, that make it evident Leonardo already wanted to paint pictures that could approximate more closely to the ways we see. It was in the late 1470s that he began to teach himself the science of optics. His paintings were to contain objects, natural and man-made, that resembled their prototypes seen in life as closely as possible. This was hardly a new aspiration for a painter. But more than any of his painter predecessors, Netherlandish or Italian, Leonardo wanted to understand and reproduce the ways in which external factors – distance, light and so on – can distort or cause some things to be more visible than others. The *Madonna of the Carnation* shows that he had

become as fascinated by the shadowed as by the fully illuminated. And he was also beginning to understand how these simulacra of the way we see could be allied to our emotional and intellectual priorities as viewers, to appreciate that the eye skims over things it finds unimportant, coming to rest on what is brightest, on what most precisely described. This is really the point of his unifying landscape in Verrocchio's *Baptism*, a first move away from the 'everything matters' approach of the previous generation. Leonardo realised, as the sculptor Donatello had before him, that an artist could be more than merely a recorder – he must act as an editor.

By 10 January 1478 Leonardo had at long last set up on his own, obtaining what was almost certainly his first public commission – to 'make and paint' a framed altarpiece for the Chapel of San Bernardo in the Palazzo della Signoria, the seat of Florentine government.[12] Its proposed content was not, as far as we know, spelled out but a small group of compositional drawings (cats 35, 36), datable stylistically to the later 1470s, shows that he was planning to paint an Adoration of the Shepherds. Indeed, these are the *only* drawings from this period that can plausibly be related to an altarpiece subject. The composition was to centre around the Virgin adoring the Child, with a host of angels whirling above, and the infant John the Baptist, the patron saint of Florence, prominent in the foreground (see cat. 36). It was a scheme that would bear slightly different fruit in Leonardo's two versions of the *Virgin of the Rocks*, but this first commission was also destined to become his earliest unfinished work.[13] It was also in 1478 that Leonardo himself declared that he had begun two images of the Madonna, presumably devotional panel paintings, though neither necessarily finished. On a torn sheet with quickly drawn heads, machinery and unrelated jottings, Leonardo wrote in his most graceful hand: '…mbre 1478 inchomincai le 2 vergini Marie [I began the two Virgin Marys]'.[14] One of these Marys can possibly be related to the series of gloriously lively drawings for a Virgin and a cat, dating from around this time (see cat. 56). It is generally thought that these gradually evolved into the equally vivacious Virgin and Child painting known as the *Madonna Benois* (fig. 3) – with no cat.[15]

Leonardo was getting work but already his lack of sympathy with the commercial cut and thrust of Florence was becoming plain. In July 1481 the Augustinian monks

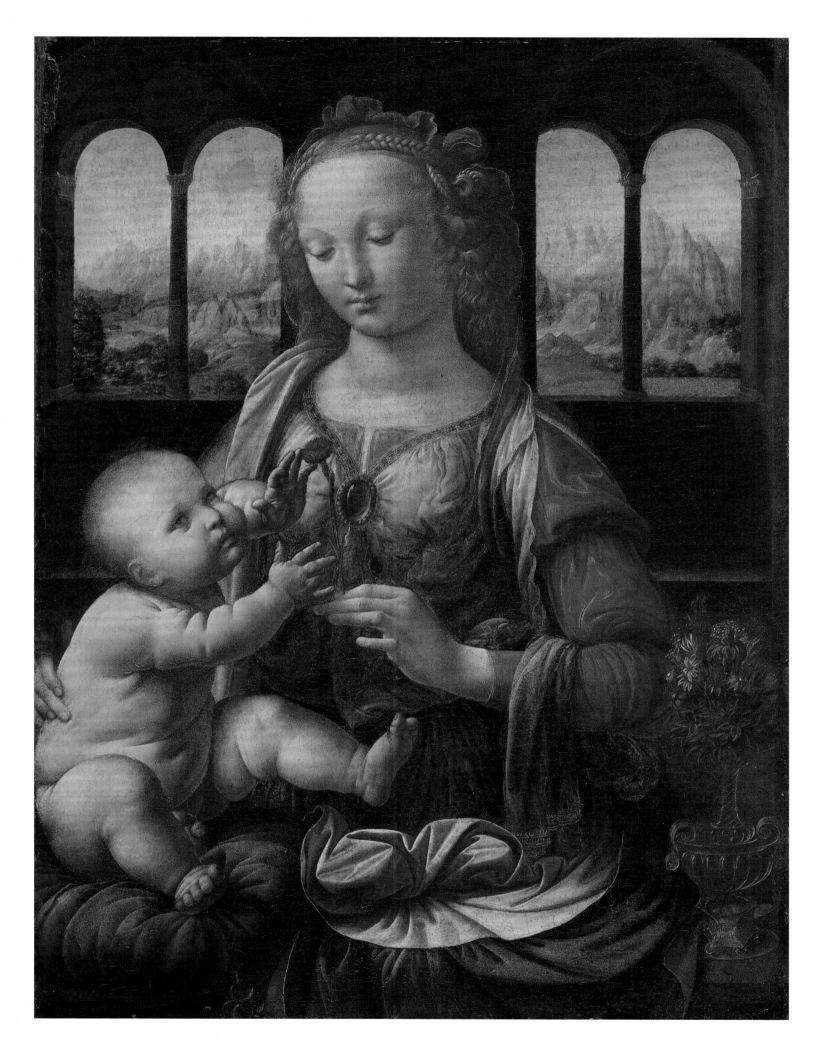

FIG. 3
LEONARDO DA VINCI
Madonna with a Flower ('*The Madonna Benois*'),
about 1481 onwards
Oil on wood, transferred to canvas,
48 × 31 cm
The State Hermitage Museum,
St Petersburg

of San Donato a Scopeto, just outside Florence's Porta Romana, were worried that he would default on the picture they had ordered some time before. They drafted a document which, most unusually, sets out what would happen if he lived up to their pessimistic expectation, and which reveals that they had asked Leonardo to execute an *Adoration of the Magi* for the high altar of their church in 'March 1480'.[16] This date is usually interpreted as – modern style – 1481, because the Florentine year began on 25 March. Conceivably, however, Leonardo received this commission in the last days of the month of March, in which case the date would fall in (modern) 1480; a longer time lag would explain the monks' anxiety. Despite their precautions, the *Adoration of the Magi* never got further than its monochrome undermodelling (fig. 34). Its composition is strenuously intricate, revised more than once, and it was left as something of a palimpsest. Leonardo was attempting something very new indeed. His picture was to be a seething cauldron of emotions, to be understood, as Alberti had suggested many years before and Donatello had demonstrated in his relief sculpture, primarily from the gestures of the protagonists, the throng surrounding Mary. Leonardo had arrived at a remarkably complicated conception of space and relative scale, combining a medieval hierarchy in which the most important figure – the Virgin – is the biggest, with a rigorously calculated perspective for the architecture. In its unfinished state, these contradictory impulses coalesce in way that is truly exciting. Painted, they might have become jarring and peculiar, and it is quite possible that Leonardo came to realise that his *Adoration* was unfinishable. At any rate, after he received in September 1481 the last of a short series of payments, his connection with the monks was seemingly severed. He had jumped ship, thought to have quit Florence shortly afterwards.

Arriving in Milan

Leonardo is first mentioned as present in Milan in April 1483, though very probably he had travelled north a year or more earlier. He had arrived therefore just a few short months after Ludovico Sforza had unexpectedly attained power. Though a member of the ruling family, Ludovico had been reared with no dynastic expectations. In 1450 his father, Francesco Sforza, had been chosen as Duke by

a Milan in crisis. Married to Bianca Maria, the illegitimate daughter of his one-time master Duke Filippo Maria Visconti, whose death had caused the temporary suspension of dynastic rule, Francesco was thus able to assert a kind of continuity and his children could declare a legitimising Visconti ancestry. In 1466 he was succeeded by his unashamedly despotic oldest son, Galeazzo Maria, now avid to stress his maternal links with the old Visconti regime, not least by the art he commissioned.

Growing up, Ludovico had been all too aware that he was not the heir, not even the spare. He was taught to ride and hunt and bear arms. But he was also an avowed lover of books, tutored by the leading humanist scholar Francesco Filelfo (1398–1481).[17] Filelfo himself was diligent (though not uniquely so) in his efforts to construct a philosophy that would synthesise those two great philosophical systems inherited from ancient Greece, Aristotelianism and Platonism, now often viewed as antipathetic. We can assume that these attempts were appreciated by his extremely clever pupil. Filelfo was also a regular correspondent of Lorenzo de' Medici, *de facto* ruler of the Florentine Republic.

The assassination of Galeazzo Maria Sforza on Saint Stephen's Day 1476 changed everything.[18] His murder – or tyrannicide – was the start of a period of considerable political unrest in Lombardy and the Italian peninsula as a whole.[19] He left two daughters and a 7-year-old son, Gian Galeazzo (1469–1494), immediately declared the new Duke of Milan, but not the bastion the state required. His French mother, Bona of Savoy, was appointed regent; unfitted for the job, she found herself dependent on Francesco's former secretary, Cicco Simonetta. Here were the glimmerings of a chance for Ludovico il Moro.

Their success in quelling a rebellion in Genoa – then a Milanese possession – in 1477 caused Ludovico and his surviving brothers to overreach themselves, attempting to seize power from their ineffectual sister-in-law. They were punished with exile, Ludovico sent to drum his heels in Pisa (and to reinforce his friendship with Lorenzo de' Medici, whom he visited in 1478). But Bona's regency was unravelling. Ludovico and his older brother, Sforza Maria, were presented with a second window of opportunity and with the tacit support of Naples and Florence they began their march on Milan. In June 1479, on the eve of a decisive battle, their ambitions suffered a dreadful blow with the

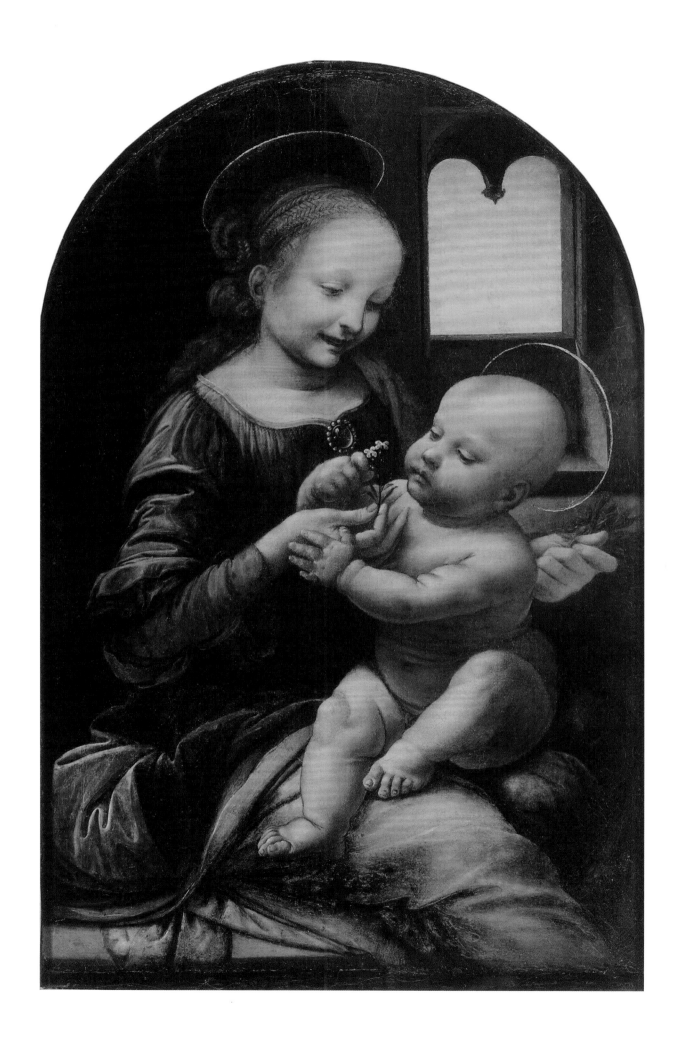

sudden death of Sforza Maria. Ludovico inherited his brother's title, Duke of Bari, but he suffered, we are told, a few hours of horrid hesitation, only calmed by the counsel of a more experienced military ally. This was Ludovico's moment of symbolic transition – the moment he conquered fate and used all his skills and native talents to master himself, to become a prince. He duly took Bona's place as regent and swiftly dispensed not just with Simonetta (hastily beheaded), but also with the old Milanese nobility whose support had been crucial in bringing him to power, an early example of his political adeptness.[20] Ruthless to just the right degree, Ludovico was quite ready to eliminate those who stood in his way. By early 1481 his name appears with that of his nephew (now aged 12) on all state documents, and in about 1482 he added his portrait head to the Milanese coinage (see fig. 50).

In all likelihood, Ludovico's first contact with Leonardo had been brokered by Lorenzo de' Medici. So, certainly, thought one of Leonardo's earliest biographers writing in about 1530–40:

> An eloquent speaker, [Leonardo] was an exquisite musician on the lyre and taught the singer Atalante Migliorotti.... When he was thirty years of age, it is said that the Magnificent sent him to the Duke of Milan to present, with Atalante Migliorotti, the gift of a lyre which the latter could play with rare execution ...[21]

Ludovico was not yet in fact the Duke of Milan and this anonymous author's account of Leonardo's subsequent movements is truncated and garbled; but it is unwise to dismiss his version of events simply as fanciful tittle-tattle. Leonardo had been lodged and salaried by Lorenzo, we are told, and had studied in the Medici sculpture garden on Piazza San Marco; long dismissed as propagandist myth, it is now established that this garden existed from the mid-1470s, used from 1480 for the restoration and display of ancient statuary.[22] That Leonardo left for Milan at the age of about thirty, as this source claims, is also correct. Vasari's account (based on different sources) is, if anything, more muddled, but has come to be considered the more reliable.[23] Vasari entirely fails to give a part to Lorenzo, normally one of his heroes; in his narrative the painter travelled to Milan at the express invitation of Ludovico Sforza himself. Vasari does confirm, however,

that Leonardo arrived there equipped with a lyre: 'his own instrument, made by himself in silver, and shaped like a horse's skull'. Although such an artefact would have advertised several of Leonardo's skills, it would certainly have been too expensive a present for a young artist to make out of his own resources. Costly, novel and ingenious, it sounds instead like a typical diplomatic gift, plausibly funded by Lorenzo de' Medici. The narrative therefore accords rather well with what might be termed Lorenzo de' Medici's policy of 'meta-patronage': his promotion of the careers of Florentine artists, and their city, by putting them in the way of Italy's other potentates.[24] Both sixteenth-century versions of events may be substantially correct: Ludovico was on the hunt for a talented artist, Lorenzo supplied one, and Leonardo was only too glad to go.

Once in Milan, Leonardo decided to stay put, and this was almost certainly his intention from the first. A letter addressed to 'my most illustrious lord', Ludovico il Moro (now in the Biblioteca Ambrosiana, Milan), was undoubtedly authored by Leonardo, though it is unsigned, undated and in someone else's hand.[25] He may have travelled to Milan already armed with this letter and, perhaps coached by Lorenzo de' Medici, he had come to understand the priorities of Ludovico rather well. Despite his lack of experience in this field, the artist offered to share his 'secrets' as the specialist designer of 'instruments of war'. Ludovico was far from politically safe and he could hardly neglect the arts of war. A canny artist on the lookout for a court salary might therefore claim an expertise in the design of weaponry and fortifications: many of Leonardo's drawings of siege machines, primitive tanks, pontoons, trebuchets and so on, are dated by their style and handwriting to the mid-1480s (though there is no evidence that any of these designs were used). After listing various bellicose possibilities, Leonardo went on to declare: 'In time of peace I believe I can satisfy as well as any other in architecture and the design of buildings, both public and private, and in conducting water from one place to another.' And, in a notably immodest afterword, he asserted: '... I can execute sculpture in marble, bronze and clay; likewise in painting, one could compare me to anyone else, whoever he may be', ending shrewdly with this suggestion: 'one could undertake work on the horse of bronze that will be to the immortal glory and eternal

honour of the auspicious memory of the father of Your Lordship and of the illustrious house of Sforza.' This was a reference to the equestrian monument to be erected in memory of Duke Francesco. Leonardo offers to substantiate any of these large claims by *experimento* – an early use of one of his key terms, containing the notions of experience, demonstration and experiment.

Leonardo was attempting to tap into a tradition that was already well understood by Tuscan artists, appreciative for many years of the very real benefits of court service.[26] A key precursor for Leonardo, the Sienese Francesco di Giorgio Martini, painter, sculptor, engineer and architect, had entered the service of the Duke of Urbino in 1477 and was later in considerable demand in the Kingdom of Naples. Francesco di Giorgio's visit to Lombardy in 1490 stirred Leonardo to think more deeply than before about the connections between architecture and the human form.[27] There was moreover a tradition of allowing the court artist considerable latitude, a concept summed up in a letter from Sigismondo Malatesta, lord of Rimini, who in 1449 had just found a painter in – predictably – Florence:

> About the master painter . . . since you write that he needs money, my intention is to commit to him, and give him a certain amount per year, to make him secure, wherever he wishes to be . . . my intention is to treat him well, so he will come to live and die in my lands . . . And therefore you should know I intend to keep him salaried, so that whether or not working for his own pleasure [*per suo piacere*] he will never go without a stipend.[28]

Leonardo would thus have been well aware of the advantages court employment held for an artist who was both multi-talented and temperamentally unsuited to the rigours of a commercially minded Florence. By entering court service, he would be relieved of contractual deadlines and penalties, though he knew, of course, that a court artist had to deliver tangible proofs of his talent: portraits, exquisite 'treasures' and large-scale wall-paintings which could be widely admired.

It was by no means obvious, however, that when Leonardo arrived there this concept of the court artist, so shrewdly exploited elsewhere in North Italy, was fully appreciated in Milan. Though high-spending clients of Milan's many celebrated goldsmiths and armourers, the Sforza rulers had, up to this point, been less than assiduous in obtaining artistic talents of any real magnitude. Instead they wanted painters who would deliver by the square yard. Galeazzo Maria Sforza is known to have favoured group efforts, lavish decorative schemes for his palaces executed by painters who formed themselves into temporary companies to bid for these commissions, the lowest tender securing the prize.[29] This was the Lombard practice, a system that inevitably suppressed individual voices. The sumptuous 'no-style' that resulted, shrill with bright colour, gilding everywhere, is exemplified by the ducal chapel at the Castello Sforzesco, decked out in the 1470s, a rare survival. Many of their decorative schemes involved the painting of copious portraits; the Sforza always wanted portraitists.

If his letter was to have its desired effect, Leonardo therefore had to persuade his potential patron to take on a court painter of a kind that was basically unfamiliar, and he needed to see off – or at least neutralise – a rival. No surprise then that he was not immediately salaried by Ludovico or that his first major work was undertaken for patrons connected with, but outside, the Sforza court. And it can be no coincidence that Leonardo chose Ambrogio de Predis (about 1455–1510), a portrait specialist already associated with Ludovico (see cats 2, 8, 33), as his business associate.[30] When Leonardo is first documented in Milan on 25 April 1483, he was about to start work on a very Lombard altarpiece. In partnership with Ambrogio and his brother Evangelista, he was commissioned to gild and colour the massive sculpted polyptych that had just been carved for the chapel of the newly constituted Confraternity of the Immaculate Conception, at the church of San Francesco Grande. The Confraternity boasted many of Milan's leading courtiers among its members, providing a potentially invaluable network of clients for Leonardo, new in town. The decoration of its altarpiece was, however, in all probability, intended as just another example of Lombard collaboration. The team was also to supply five pictures for the altarpiece including, most importantly, a Virgin and Child with Angels (see p. 168). This was to become the *Virgin of the Rocks* now in the Louvre (cat. 31), almost certainly finished by December 1484.[31] But it quickly emerged that the partners considered themselves underpaid, not least because they realised that Leonardo had produced something remarkable. The long

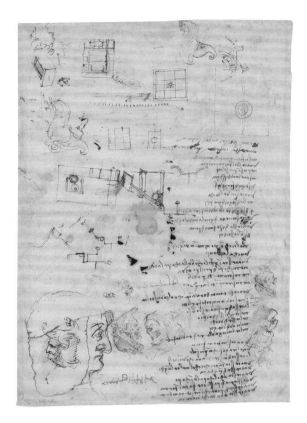

FIG. 4
LEONARDO DA VINCI and ASSISTANT
List of items in Leonardo's Milanese studio
and doodled images, about 1485–7
Pen and ink on paper, 40.6 × 28 cm
Biblioteca Ambrosiana, Milan
(CA fol. 888r, ex 324r)

and tortured history of this commission (of exactly the kind Leonardo must have hoped to escape) had only just begun. It would result in a second version of the composition, painted mainly in the early 1490s and now in the National Gallery (cat. 32). But it was this first *Virgin of the Rocks* that would stand as proof for Milan's ruler of Leonardo's extraordinary abilities, a demonstration – cleverly by direct comparison – that he had more to offer than his partner.

In the Louvre painting, Leonardo the scientist-painter is much to the fore. Botanists and geologists have vied to commend the accuracy with which he has rendered the mysterious landscape setting.[32] This is a picture that seems designed to validate a much-quoted passage from Leonardo's planned treatise.

> If you would scorn painting, which is the sole imitator of all the manifest works of Nature, you certainly disparage a subtle invention which with philosophical and subtle speculation considers all the qualities of the forms – the sea, places on land, plants, animals, grasses, flowers, all of which are enveloped in shadow and light. Truly this is science and the legitimate daughter of Nature, because painting is born of that Nature; but to speak more accurately, we would say it is the granddaughter of Nature, for all perceptible things are born of Nature and from *those* things painting is born. So, rightly we call it the granddaughter of Nature and the kin of God.[33]

In many ways, the Louvre *Virgin of the Rocks* remains a picture made up of its parts, of what Vasari was to call 'minutiae', all lovingly but individually observed. This picture pre-dates Leonardo's first serious consideration of human anatomy, but it is loaded with everything he had taught himself about aerial perspective, so critical for the establishment of distance and space. And it broadcasts his unmatched understanding of the transitions of light and shade – crucial for the description of volume, for achieving what he and others called *rilievo*, the 'soul of painting'. As in all his works, there can be no doubt that here he was painting as a natural philosopher, and the Louvre *Virgin of the Rocks* posits Leonardo as a supreme 'imitator of Nature'. When Leonardo first began to formulate his recipes for good painting in the late 1480s, he regularly declared that painting, Nature's faithful servant, should mirror the world precisely as it was experienced. Such avowals have coloured the interpretation and even

affected the attribution of his pictures, with some commentators wrongly assuming that *all* his pictures were intended, like this one, as exercises in naturalism. By so carefully observing the external forms of all the plants and rocks that he included, Leonardo was casting himself as a follower of Aristotle, whose investigation and analysis of the natural world was so much the bedrock of his philosophy. Leonardo was looking for a system of thought founded on proofs, drawn at this stage of his career to the proposition that the essential nature of everything that exists is internal and intrinsic – the factor that generates its specific external appearance with which it is unified – all entirely worthy of study.

Here then Leonardo was setting out to be the pious painter, whose work embraces 'only the works of God' (while the rival poet 'embraces the lying fictions' of man).[34] Leonardo the scientist hoped to arrive at final and fixed conclusions and in this period his laws for painting were to be just as naturally derived, rather than invented or imposed. His thinking on the art of painting was still, perhaps deliberately, the sum of its parts, rather than a unified, overarching aesthetic philosophy (one reason why his instructions do not always join up very easily) – and in this too his thinking might be termed Aristotelian. But his belief that looking and analysis – reason – were indivisible but separate gave him the emotional distance he required to take this work onto a higher plane: 'The senses are of the earth; Reason in contemplating them stands apart'[35] – and so too does the rational painter, especially when he is tackling, as here, Christian subject matter of the most arcane variety. The *Virgin of the Rocks*,

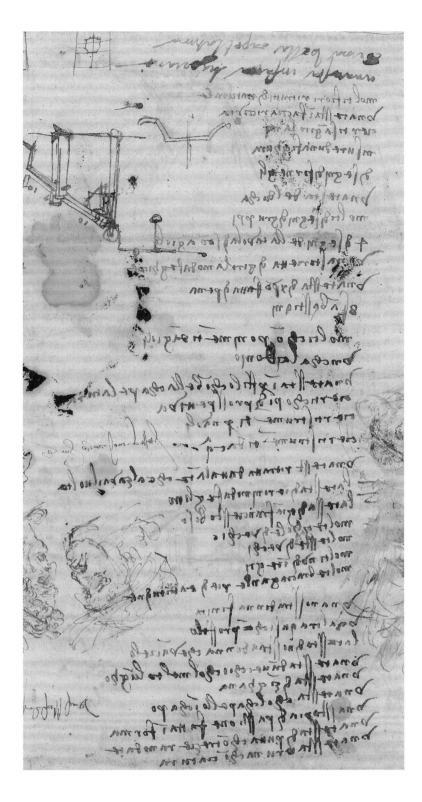

FIG. 5
*List of items in Leonardo's Milanese studio
and doodled images* (detail of fig. 4)

came in useful for achieving naturalistic effects, but one in which his unique understanding of the characteristics of light, for example, became a fundamental element of painting's capacity to ignite the beholder's religious emotions.

A list of works

For Leonardo drawing was always his principal route to understanding, his main instrument of reason and one that he elevated to the level of 'deity'. Sight was the most important of the senses that fed the *senso comune*, the seat of the soul and the place in the brain for analysis and imagination – *fantasia* (see cat. 1). Drawings provided the cues for analytical writing and mathematical calculation, fixing images in the memory of a kind that could inform artistic decision-making. And his paintings in this period not only included evidence but also provided conclusions. These, not his treatises, were to contain his most complete arguments as a philosopher.

Clues to his principal artistic preoccupations in the mid-1480s – the kinds of drawing he was making at this time and the pictures they served – are found in a rather uneven and untidy autograph list, datable by the hand-writing (figs 4, 5). Once assumed to be a catalogue of the works Leonardo brought with him from Florence,[37] it seems instead to be a scrappy catalogue of the contents of his Milanese studio made in about 1485–7, a time which remains otherwise rather shadowy.[38] His notebooks show that he was intermittently seized by the compulsion to make lists. At different times[39] we read reminders to borrow potentially useful books, to measure Milan or its buildings, buy clothes, or learn a recipe for coloured drawings; he might identify particularly fine models, equine or human; and he made two fascinating inventories of his own working library.[40] These lists have their visual equivalents in his sheets covered with haphazardly assembled designs and doodles (see cats 30, 37) and in his so-called pentiment drawings, in which figures and poses are at times so speedily rethought as to become unreadable (see cat. 85). Many sheets of course combine images and text.[41]

Even by Leonardo's standards this is a strangely chaotic example, mostly listing drawings, and scrawled over by another clumsy (right) hand, suggesting that he had a young pupil or assistant by his side. The North Italian

after all, is a religious work by a painter who wrote (in defence of those who drew on feast days) that

> a true understanding of all the forms found in the works of Nature ... is the way to understand the maker of so many wonderful things and the way to love so great an inventor, for in truth great love is born of thorough knowledge of the beloved.[36]

This is the first major – and finished – work by a painter-philosopher attempting to show others how to love God by penetrating the mysteries of his universe. It is not therefore just a work in which his scientific observations

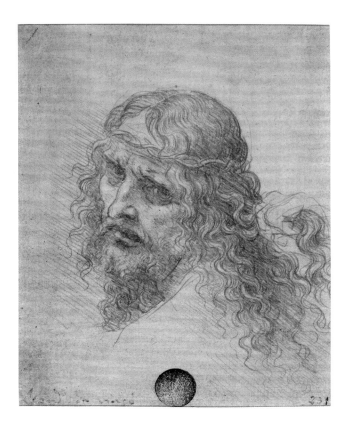

FIG. 6
LEONARDO DA VINCI
Head of Christ, about 1485–8
Metalpoint on prepared paper,
11.6 × 9.1 cm
Gallerie dell'Accademia, Venice (231)

FIG. 7
LEONARDO DA VINCI
Saint John the Baptist, about 1486–9
Metalpoint heightened with white on
pale blue prepared paper, 17.8 × 12.2 cm
The Royal Collection (RL 12572)

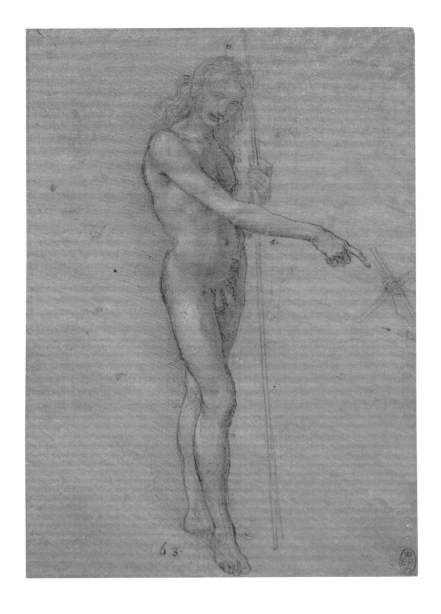

spelling of the knotted '*trezie*' – braids – said to adorn the
head of a young girl in one of the drawings, suggests that
the list was written only *after* Leonardo's arrival in Milan.
This view is reinforced by the inclusion of two 'heads'
of sitters whose surnames are almost certainly Milanese
(see cat. 3). Interestingly, fifth down, we find 'a head of
the Duke'. It is often argued – implausibly – that this was
a portrait of the late Duke Francesco, made in preparation
for the Sforza equestrian monument.[42] Much more likely
this was a portrait of Ludovico or Gian Galeazzo. Also
included is 'a head portrayed from Attalante who was
lifting his face' – surely a depiction of the Atalante
Migliorotti (active around 1482–1535) who accompanied
Leonardo to Milan, probably used here as a life model for
a foreshortened pose rather than sitting for his portrait.[43]
Leonardo was beginning to use his portraits to make
larger statements and there are good stylistic grounds
for dating the Ambrosiana *Musician* (cat. 5), probably
a likeness of Atalante himself, to about this time.

But the list shows that Leonardo's subject matter was
chiefly religious in this period – that he was painting
pictures for domestic devotion. He was working on two
Madonnas, one described as finished, the other, with Mary
in profile, nearly done; Virgin and Child panels provided
a bread-and-butter income for many painters in this period.
The first of these may have been the *Madonna Benois*, taken
with him to Milan, a picture that shows that even when
undertaking such standard productions Leonardo would
turn the image into something extraordinary. More
unusually, he was making designs for images of Christ

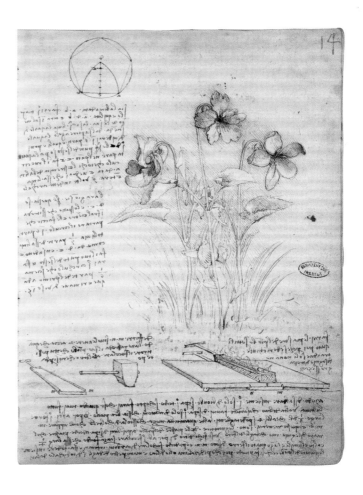

and of the Saints. He had executed drawings for a Saint Jerome and eight images of Saint Sebastian.[44] A head of Christ is specified as 'made with a pen', suggesting that most of the other drawings on the list were executed in metalpoint. Its technique must have been close to Leonardo's Courtauld sheet with two quick sketches of Mary Magdalene (cat. 9), and it may have been a design for a picture of the adolescent Christ (see cat. 66). But it could also have been the starting point for his intensely analysed study of Christ's pain and despair on the road to Calvary (fig. 6), the drawing that best stands for his metalpoint technique of the late-1480s.[45] Equally intriguing are the '4 drawings for the panel of the Holy Angel', a subject Leonardo is known to have tackled later. At this date his angel Gabriel (if this was indeed his subject) might have resembled the willowy John the Baptist in his exquisite metalpoint study (fig. 7), another drawing that should certainly be dated to the mid-1480s. The histories of his images of the Angel of the Annunciation and of his adolescent Saint John are entwined, and may have been so from the beginning.[46] We cannot know if Leonardo began – let alone completed – any of the pictures that were to be based on these designs. More often they are reflected in the works of pupils.

Other drawings listed are of the kind that would have ensured the profound naturalism of works like the Louvre *Virgin of the Rocks*, the *Musician* and the *Saint Jerome* (cat. 20). Leonardo was certainly drawing from nature (cat. 28), and his botanical studies, the 'many flowers copied from life', must have lain behind the accurately depicted plants in the Louvre *Virgin of the Rocks*, probably rather resembling his study of violets in one of the earliest of his surviving notebooks (fig. 8). The *Jerome* was decisively informed by his early studies of human anatomy and like the projected picture of Saint Sebastian was planned to show these off. The 'many heads of old men' and 'throats of old women' may well have been his first efforts at understanding the anatomy of the head, bones and sinews made prominent by the dwindling of the flesh (see cat. 22). Such drawings marked the beginning of the first phase of his anatomical investigations which culminated in his series of skull studies of 1489 (fig. 69; see cat. 25). His heads 'of a gypsy woman' and 'of an old man with a long chin', which should be classified with the profiles of aged men – sagging, gnarled, awful – that survive in some quantity alongside

the smaller group depicting old crones (see cat. 74), are conventionally (rather frivolously) categorised as caricatures; in fact they seem to have served a more serious physiognomical purpose.[47] As investigations of facial expression and the ways in which a person's soul or history might show in his features they are strictly connected with Leonardo's other investigations of the human body, its anatomy and ideal proportion (see cats 23, 24, 27).[48]

'Maestro Leonardo Fiorentino, in Milano'[49]

This then was the artistic persona Leonardo offered up to Ludovico il Moro. The degree to which Leonardo's pictures were different from anything that could be seen in Lombardy cannot be over-stressed; they must have been very startling indeed. And the Duke did quite quickly take note of his gifts as a painter, though in such a way as to shift the emphasis to his own ability to attract

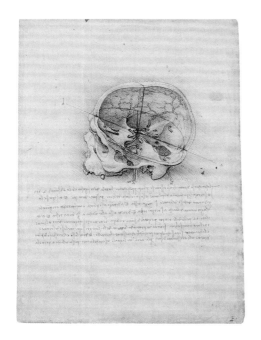
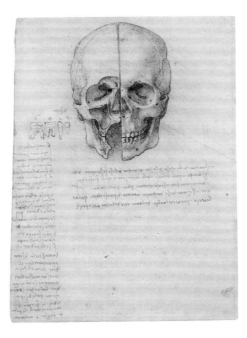

FIGS 9, 10
LEONARDO DA VINCI
Anatomical studies of the human skull, 1489
Pen and ink over traces of black chalk
on paper, 19.0 × 13.7 cm
The Royal Collection (RL 19058 r/v)

the best of the best to his court. On 13 April 1485 Ludovico offered a diplomatic gift to King Matthias Corvinus of Hungary, a political ally then being wooed as possible father-in-law for one of his nieces:

> … and because we have heard that His Majesty delights much in beautiful pictures, especially those that contain some [religious] devotion, and finding that there is at present an excellent painter here, to whom, having seen proof of his talent, we know no equal, we have given orders to this painter to make a figure of Our Lady, as beautiful, excellent and devout [*divoto*] as he knows how, without sparing any expense. And he is set to begin this work now and will not undertake anything else until he has finished, the which we will then send to his Majesty as a gift.[50]

This 'excellent painter', from out of town, must surely have been Leonardo da Vinci, though there is no record that Matthias Corvinus ever received a finished picture. The proof seen by Ludovico of this painter's unequalled talent was plausibly the first *Virgin of the Rocks*. Leonardo's pictures would be described as *divoto* again, a word whose precise meaning is always hard to pin down. Here it may denote a kind of simplicity, a picture in which the religious message and function were not obscured by excessive striving after artistic effect.[51] Leonardo was attempting, according to this analysis, to let Nature (the child of God) speak directly to the viewer without the distortions caused by artistic invention, and Ludovico's choice of term becomes analogous to the praise (and later opprobrium) heaped on Perugino and Netherlandish painters for just the same ambition.

If this is right, Ludovico had understood the point of Leonardo's scientific naturalism. He may even have thought of it as a stylistic feature that was particularly Florentine in a period when his choice of artists and writers from Florence was politically significant. Milan and Florence mattered particularly to each other at this time and there are many clues to the cultural diplomacy between their two not-quite-rulers. In the first phase of his rule Ludovico looked to Lorenzo de' Medici, an ally of long standing who was powerful not just on account of his parentage but because of his genius for government. Politically, Lorenzo was therefore an astutely chosen model, and, as a consequence, his cultural example was also potent. Tuscan was now promoted as the language of the Milanese court – seeking to rid itself of what was perceived as the inelegant Lombard dialect.[52] The Petrarchan poet Bernardo Bellincioni (1452–1492), another of Lorenzo's circle, travelled north from Florence at much the same time as Leonardo.[53] And in 1485–6 Ludovico organised the translation by Cristoforo Landino of the Latin biography of his father, a commission obtained through the good offices of Lorenzo: Francesco Sforza's deeds were to be 'celebrated in the Florentine language'.[54] The advent of Leonardo da Vinci, especially as finessed by Lorenzo, was in line with these other cultural initiatives; all the painter had to do during his first years in Milan was to be himself, to be recognisably Florentine, manifestly un-Lombard.

This may be one reason for his inclusion of the infant Saint John in the *Virgin of the Rocks*, not mentioned in the contract but familiar from devotional paintings in Florence, a city dedicated to the Baptist. Leonardo appears to have been adapting his compositional ideas for the Palazzo della Signoria altarpiece – and Ludovico might have remembered what for Leonardo was an obvious model, Fra Filippo Lippi's altarpiece, with its mysterious woodland setting, made for the chapel of the

THE REWARDS OF SERVICE

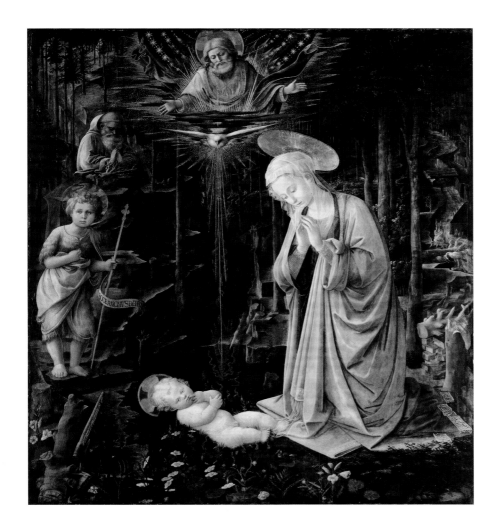

Medici Palace (fig. 11). The cross-legged Christ Child in the *Virgin of the Rocks* is based on an antique marble statue of a boy with a goose (fig. 12), also owned by Lorenzo the Magnificent.[55] Even without these references to works of art in Florence, the naturalism of Leonardo's picture would have been enough to make it Florentine for viewers elsewhere in Italy. It was, for a start, deeply and self-consciously heedful of Leon Battista Alberti's precepts for naturalistic painting. Anyone who had read Alberti's treatise (and it was read in Milan) would recognise that his instructions on how to use colour, how to achieve volume and depth, had been obeyed and extended.

But Alberti was not of course a practising artist and Leonardo's pictures of the 1480s also look back to the only two modern painters he ever named in his writings: 'Giotto Fiorentino' and 'Tommaso Fiorentino, nicknamed [*cognominato*] Masaccio' (fig. 13; he never once gives credit to his master Verrocchio). Thanks to passages in

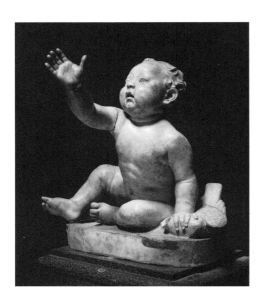

FIG. 13
MASACCIO (1401–1428)
The Baptism of the Neophytes, 1426–7
Fresco, 255 × 162 cm
Cappella Brancacci, Santa Maria
del Carmine, Florence

Landino's renowned commentary on Dante, the styles of these two artists were already regarded as canonical, applauded above all for their *rilievo* – achieved by graduations of light and shade and the consideration of tonal unity – and their truth to Nature.[56] This is Leonardo on Masaccio: '. . . the decline continued until Tommaso the Florentine . . . showed to perfection in his work how those who take as their authority any other than Nature, mistress of the masters, labour in vain.'[57] Leonardo had discovered that a visual language he had learned as an apprentice was prized and could be profitably cultivated. It was as 'Maestro Leonardo Fiorentino in Milano' that he would achieve his first fame there.

And it was as a Florentine that Leonardo painted his portraits of the 1480s. The *Musician* is often said to be indebted to Antonello da Messina (whose works were seemingly known in Milan; fig. 53) but Leonardo looked as much or more to Florentine precedents, to portraits by Verrocchio and above all to Piero del Pollaiuolo's portrait of Galeazzo Maria Sforza, which he could have seen hanging in the Medici Palace in Florence (fig. 52). His portrait of Cecilia Gallerani (cat. 10) is known to have been painted some time before 1492; it had been taken as the subject of a poem by Bellincioni, who died in that year. Cecilia had become Ludovico's mistress by early 1489, and this was probably when her lover commissioned the portrait. It is perhaps Leonardo's most consummate proof that beautiful pictures could be achieved by precisely recording – commemorating – great natural beauty. No exercise in scrupulous naturalism could have been more flattering to the Duke.

The court artist

At the start of the next decade Ludovico il Moro still treated Medici Florence as his stable for artists. In about 1490 he received a letter from his ambassador there detailing the diverse styles of the painters Botticelli and Filippino Lippi, Ghirlandaio and Perugino, all of whom had worked at Lorenzo de' Medici's villa at Spedaletto.[58] But Ludovico was beginning to feel politically safe – and it was apparently the individual qualities of these artists rather than their generic Florentine-ness that had begun to count more. Power attained, some cultural and artistic priorities remained constant, such as the making of

portraits, though no longer merely as propaganda tools or markers of marriage. Magnificence was a *sine qua non* and il Moro owned tapestries of the kind that signalled that virtue so clearly.[59] Ludovico was still keen to emphasise his Visconti ancestry and to promote his Sforza paternity, but his unconventional rise to power had already ensured different priorities from those of his predecessors (or Gian Galeazzo). In the years around 1490, in tandem with his political priorities, his cultural concerns were changing.

Ludovico could now concentrate on how to present himself to the world, to his dominions – and to posterity

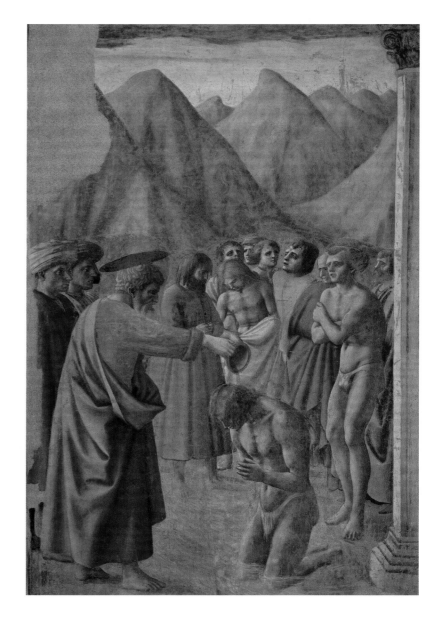

– as a proper, out-and-out ruler. He had, at last, achieved the 'time of peace' mentioned in Leonardo's letter, and thus the opportunity had arrived for him to shore up his claim to the Duchy by showing himself wise, just and popular – and by promoting an ostentatious flourishing of the city. He took an interest in spiritual matters, particularly favouring the reformed religious orders.[60] He reviewed the judicial system.[61] Above all, he began the process of turning the court into what Baldassare Castiglione, grateful and rosy-spectacled, lauded as 'the receptacle of the flower of the men of the world'.[62]

It was only now that Ludovico really started to think about how much a fully fledged court artist could do for him. He had replaced his mistress Cecilia Gallerani with a consort who could not have been more established: Beatrice d'Este, second daughter of Ercole I d'Este, Duke of Ferrara, and Eleonora of Aragon (herself the child of the King of Naples), became his wife in January 1491. Like her more famous and deeply competitive older sister Isabella, the Marchioness of Mantua, Beatrice was a cultural leader in her own right, lauded especially for her protection and encouragement of a new class of poet in Milan who wrote in a courtly style, rather than in Tuscan mode.[63] Ludovico now had personal (as well as political) connections by marriage with the courts of Naples, Ferrara and – impoverished but culturally rich – Mantua, the states which had pioneered the employment first of court architect-engineers and then court artists. His own cultural aspirations for the court of Milan went up a notch or two as a result and he took careful note of what was expected of artists elsewhere. The chief of his chosen aesthetic 'instruments' were an illustrious pair: Leonardo and the superbly gifted painter-architect Donato Bramante of Urbino (1444–1514). Bramante had arrived in Lombardy by 1481–2, at much the same time as the Florentine painter, but like Leonardo he was regularly employed by il Moro only from the early 1490s.[64]

An appreciation of the qualities of painting was seen as the visible sign of nobility and intellect. It was therefore in both Ludovico's and Leonardo's interests to promote an art for the elite, for Leonardo to make stylistic choices that the common herd could not comprehend. This was a distinction made long ago by Petrarch, describing the response to a Virgin and Child by Giotto, 'the beauty of which was not understood by the ignorant, but it

stupefied the masters of art'.[65] This theme was now reiterated by Leonardo:

> Therefore whoever fights shy of shadow fights shy of the glory of art as recognised by noble talents [*ingegni*], but acquires glory according to the ignorant masses, who desire nothing of painting other than beauty of colours, completely forgetting the beauty and marvel [*maraviglia*] of a flat surface displaying relief.[66]

By advocating the avoidance of bright colours, Leonardo was echoing the ancient Roman architectural theorist Vitruvius. And this flagrantly muted good taste also had a courtly dimension, of which both artist and patron were fully aware. Leonardo's denunciation of garish colour (and, elsewhere, of the immoderate use of gilding) recalls the anecdote, told by the Florentine scholar Vespasiano da Bisticci, of the flashy Sienese ambassador who had the gold rubbed off his costume when he was deliberately jostled by the sober courtiers of the kingdom of Naples, where rich black velvets were preferred.[67] Noble intellects would – naturally – value natural beauty:

> … as you adorn your figures with costly gold and other expensive decorations, do you not see the resplendent beauties of youth are diminished through excessive devotion to ornament? Have you not seen the women of the mountains wrapped in their poor plain draperies acquiring greater beauty than women who are adorned?[68]

Leonardo believed he could teach his audience how to look, how to interpret these elusive stylistic messages. As for other 'how-to-do-it' manuals of the period, he would have presumed the audience for his writings would be made up primarily of the consumers of art, more than his fellow painters. Indeed the sixteenth-century art theorist Giovanni Paolo Lomazzo tells us that Leonardo's treatise on the *paragone* – the comparative merits of painting, on the one hand, and music, sculpture, poetry, on the other – was written at Ludovico's behest.[69] By 1498 Leonardo was said to have written a treatise on 'painting and human movements', a text that could have provided footnotes for the *Last Supper*. His writings had emerged from the intellectual debates known to have been staged at court – argument enjoyed as a form of elite entertainment.

The Sforza monument

The choice of Leonardo to model and cast the Sforza equestrian statue indicates that this project was initially conceived as another exercise in the Florentine (visual) dialect. The design and manufacture of such monuments had become a speciality of Florentine sculptors. Ludovico was reviving an idea that had been first mooted in 1472–3 by his oldest brother, Galeazzo Maria, a scheme for which another Florentine, Antonio del Pollaiuolo (about 1432–1498), had made a drawing depicting Francesco mounted on a rearing horse.[70] Nothing had come of this but Leonardo's letter to Ludovico suggests the plan was known about in Florence. From almost as soon as he had arrived, Leonardo hoped, as Pollaiuolo had done, to represent Francesco controlling his spectacularly rearing steed (fig. 15). On 22 July 1489 a letter written by the Florentine ambassador reveals that Leonardo had been asked to make the model for the Sforza monument.[71] This is the first unambiguous mention of Leonardo in Ludovico's employ, and now Ludovico wanted nothing less than a colossus ('the like of which has never been seen'). He worried, however, that Leonardo was not up to the task of translating his design into the biggest bronze statue in Europe, and he asked Lorenzo de' Medici to look out someone more expert in Florence. No alternative was produced, but Ludovico's qualms were perhaps justifiable. Leonardo lacked any real experience in this arena and though his plan was glorious, feasible if the statue had remained life-size as first planned, it was quite impractical on the scale desired by Leonardo and his patron.

Leonardo thought again, and one of the sources he used in reconsidering the sculpture is suggestive of a small change of emphasis in his art. On 23 April 1490 he had started a new notebook where he announced that he had begun again on the Horse – the *Cavallo*. It was probably around then that he reverted to the solution proposed by the *Regisole*, an ancient Roman equestrian statue at Pavia, little more than 30 km from Milan. This set the rider astride a trotting horse.[72] Leonardo examined the equestrian monument in June 1490 and his resulting notes were typically both scattergun and measured, disorderly and considered. He immediately converted his personal responses into a staccato series of generalising maxims (some, it must be admitted, a little opaque):

The one in Pavia is to be praised most of all for its movement.
The imitation of antiquities is more praiseworthy than [the imitation] of modern things.
One can combine beauty and utility, as it appears in castles and in men.
The trot has almost the quality of a free horse.
Where natural vitality is lacking, we must supply it artificially.[73]

On 19 May 1491 he decided to record 'everything relating to the bronze horse now under construction'; in December 1493 he worked out that it would be better to cast the statue on its side, rather than upside down. The tail and – still to be modelled – the figure of Duke Francesco would be cast separately. He can only have reached this judgement if his enormous clay model, about 24 ft high (12 *braccia* from hoof to head), were basically complete. What appears to have been the finished horse had in fact been displayed less than a month earlier, during the celebrations for the marriage of Ludovico's niece Bianca Maria Sforza to the Holy Roman Emperor Maximilian I.[74] But in November 1494 the 100 *meira* (about 75 tons) of metal intended for the horse were sequestered for the use of a beleaguered Ercole d'Este to be cast into cannon, and the material was never replaced.[75] Sforza money was running out, the ducal treasury bled dry by the vast dowry Ludovico had paid out to ensure his niece's Habsburg marriage. Once again, a project with Leonardo at the helm was becalmed. Vasari reports that the great clay horse, standing in the courtyard of the Corte Vecchia (the old Visconti palace near the Duomo), was used for target practice after French troops invaded Milan in 1499.[76] Since the French could hardly have missed their mark, we should understand this as a political assault, a kind of damnation.

An ancient capital

The horse they had destroyed was patently of a kind that could only have been ridden by the greatest of warriors, fully the heir of Alexander the Great and the Roman emperors. This in fact was a sculpture to outdo anything achieved in ancient Greece or Rome. 'Come, I say', proclaimed Bellincioni in about 1490, 'to today's Athens in Milan! For here is the Ludovican Parnassus ... every worthy comes here as bees to honey; from Florence he has brought an Apelles.'[77] Ludovico's brilliant painter is still

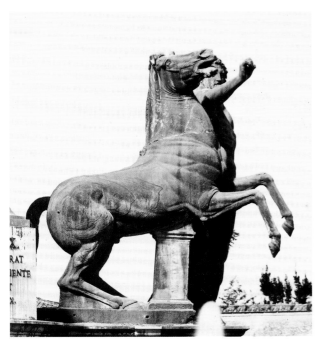

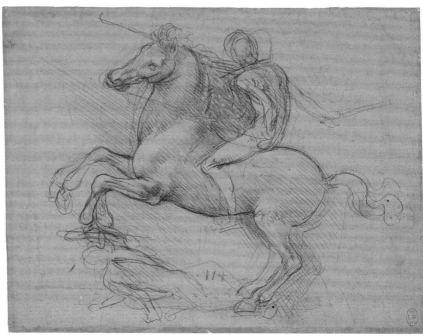

FIG. 14
Roman, second-century AD copy of Greek
fifth-century BC original
Detail of a horse from the *Dioscuri*
Piazza del Quirinale, Rome

FIG. 15
LEONARDO DA VINCI
Study for the Sforza Monument, about 1489–90
Metalpoint on blue prepared paper, 14.8 × 18.5 cm
The Royal Collection (RL 12358r)

kept anonymous in this poem, hidden behind the mask of that most celebrated of all ancient painters, Apelles, famed for his exclusive working relationship with Alexander. Ludovico – presented as the new Alexander – is given the credit for attracting this great modern equivalent to Milan. Only when the poem was posthumously published in 1493, acquiring a wider readership, was it deemed necessary to spell out that Ludovico's Apelles was Leonardo.

Ludovico was certainly concerned that his city should be understood as having ancient origins and values – and that he was the ruler who had revived them. His city therefore had to be properly antique and several of his favoured scholars searched industriously for evidence of Milan's ancient foundation.[78] Roman pedigrees were given to buildings in the Sforza capital,[79] and even the Early Christian basilica of San Lorenzo, centrally planned, was proclaimed a second Pantheon.[80] Ludovico was an active patron of humanist scholars, doing much to build up the reputation of the University of Milan (previously eclipsed by its older rival at Pavia).[81] For Leonardo to perform as Ludovico's Apelles his works similarly needed to exhibit a meaningful debt to the art of ancient Greece and Rome. Apelles was supposed to have written a treatise on painting and for Leonardo to do the same would have been recognised as an act of emulation.[82] Significantly it was Apelles who was chosen by Leonardo as the painter to say – as Leonardo himself might have done – 'I will make a fiction which signifies great things'.[83] Most importantly it would appear that aspects of Leonardo's style and technique were formulated to remind viewers of Pliny's

description of his pictures. Apelles was said to have limited his palette to just a few colours, Leonardo's deliberately muted palette, so striking in the London *Virgin of the Rocks*, has been connected with Pliny's account of Apelles covering pictures with a glaze or varnish (*atramentum*), one of whose functions was to moderate or darken florid colours.[84]

But Apelles' paintings were all of course lost, and Leonardo needed to find other, more obvious ways of making his works look *all'antica*. Both artist and patron are now usually said to have had only a limited interest in the artistic remains of ancient Greece and Rome, but we should remember that Leonardo was more than once identified as a student of antiquities by his Milanese contemporaries. He had a pre-existing interest in the Antique, drawing Medici sculptures while still in Florence, and we cannot doubt that he noted Alberti's advice that the painter should study ancient marbles for the creation of pictorial relief.[85] Ludovico, we know, particularly coveted ancient gems and coins, and Leonardo too looked hard, for example, at the coin portraits of the Roman emperors (see cat. 80). There is also good evidence that he found inspiration in a marble Leda which arrived in Milan in 1495 (see cat. 86, fig. 109). In his letter of thanks, Ludovico (or a humanist adviser) wrote: '… it is not reputed alien to the desires of talented minds to have some testament of the virtue of the ancients in this art of carving and founding', a platitude perhaps, but one which shows that he subscribed to a theory of elite, educated viewing, in which a proper understanding of the Antique played a part.[86]

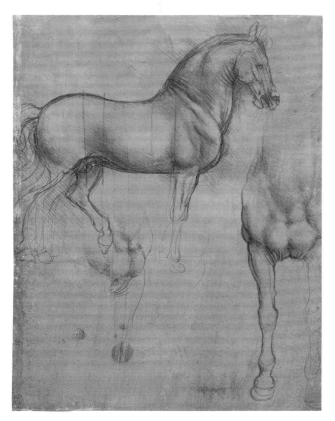

FIG. 16
LEONARDO DA VINCI
Horse studies, about 1490
Metalpoint on pale blue prepared paper,
21.2 × 16.0 cm
The Royal Collection (RL 12321r)

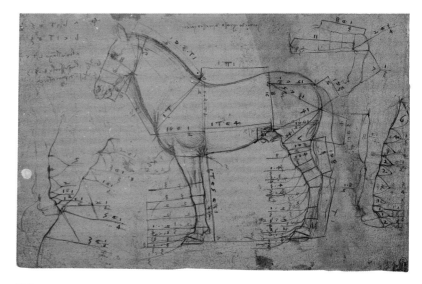

FIG. 17
LEONARDO DA VINCI
Horse studies with measurements, about 1490
Metalpoint and pen and ink on blue prepared paper
with some water damage, 32.8 × 23.8 cm
The Royal Collection (RL 12319)

The perfect horse

So for Leonardo to imitate the *Regisole* in designing the
Sforza equestrian monument represents a subtle and
meaningful change of direction. And the Leda was not
the only ancient statue he studied. Leonardo's *Cavallo* is
a good place to begin our discussion of the ways in which
his figurative style might have been recognised as marrying
with the notion of Ludovico's princely perfection. When
the horse was to be shown rearing, the pose would
immediately have evoked the enormous and enormously
famous paired marble statues of the Horse-tamers – the
Dioscuri – on the Piazza del Quirinale in Rome (fig. 14).
These were the most celebrated and frequently repro-
duced of all ancient marbles until the end of the fifteenth
century, and were believed to have been carved by the
Greek sculptors Praxiteles and Phidias. Though there is
no evidence that Leonardo had yet been to Rome, he
knew all about them. In the mid-1490s he mused, not
for the first time, on time's destructive capacity:[87]

> If you do not wish to have them [sculptures] made of
> bronze to prevent that they should be taken away,
> remember that all the good things of Rome were
> plundered from cities and lands conquered by the Romans, and it
> was of no avail if such things were of extraordinary weight,
> like the obelisk and the two horses.

The connection between the Sforza monument and the
Dioscuri seems quickly to have become part of Milanese
thinking. The well-connected Milanese tourist Giovanni
da Tolentino, racing round Rome in 1490, admired the
Dioscuri unreservedly: 'I hurried along to see the works of
Praxiteles and Phidias ...'.[88] And in a careless but reveal-
ing slip of the pen, he described them as being cast in
bronze, suggesting that he had Leonardo's planned eques-
trian monument in Milan at the back of his mind.

The *Dioscuri* were also mentioned by Francesco
Filelfo.[89] In one of his last works, the court philosopher
tried to explain Plato's argument concerning the difference
between the supreme maker's perfect Idea of everything
and the imperfect derivations we know in our world.
The gap, he said, is exactly like the difference between the
horses and men seen every day and the faultless *Dioscuri*.
Filelfo was wrestling with a philosophy laid out by Plato
in the *Republic*, but in a way that inverted Plato's own
arguments. When Plato elucidated his objections to
artistic mimesis – the faithful imitation of what is seen
– his discussion pertains to poetry, but he employed
a parallel between painting and poetry to deplore the
deficiencies of both. Fundamental to Plato's view of the
universe was his belief that the perfect form or Idea of
everything exists only in the mind of an all-powerful

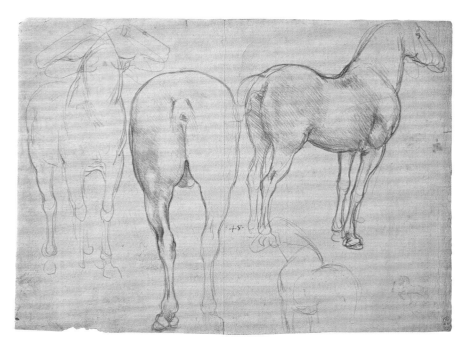

creator. We on earth experience through our senses merely the distorted reflections of these unattainable ideals, the shadows on the wall of Plato's famous cave (*Republic* 532). An art in which the primary goal is accurately to reproduce what can be seen is thus twice removed from God's perfection and can only be condemned. Plato gives the instance of the difference between the Idea of a bed or couch, the item of furniture as it is encountered on earth (already a poor imitation), and the copy of *that* made by the painter.[90] Filelfo, on the other hand, in line with Neo-Platonic thinking and referring to an idea found in the writings of Cicero, was suggesting that a great artist could get closer than Nature to God's perfect Idea.

The parallel between the Sforza monument and the *Dioscuri* was not abandoned with the change of pose. In 1498, in his treatise *On Divine Proportion* dedicated to the Duke, the Platonist mathematician Luca Pacioli directly compared the ancient and modern works – claiming that the makers of the former could only be envious of the latter.[91] And Leonardo seems to have been very much aware of the implications of such a comparison. That he had access to Plato's *Republic* we cannot doubt: early in his writing he inverted Plato's image of the cave, choosing to penetrate its mysterious darkness from the world outside, to investigate rather than desiring to move out of the

shadows into God's pure light.[92] This passage is regularly associated with the craggy *mise-en-scène* of the Louvre *Virgin of the Rocks*, and is rightly interpreted as a rejection of Plato by an artist whose practice, at this stage, was almost wholly Aristotelian. He did the same with Plato's condemnation of the artist who sets out primarily to mirror the world around him. By the early 1490s he had come to realise that the division was less clear-cut and (as Filelfo had done) that Aristotelianism and Platonism could both be accommodated within a single philosophy. He could never become a Platonist – no figurative artist ever could – but perhaps through reading Filelfo and others he had come to know more about Neo-Platonic thought.[93] Certainly he was beginning to believe that a great artist could physically encapsulate God's Idea of a horse (for example). And in part this was possible by the imitation of idealising ancient sculpture – the *Dioscuri* or the *Regisole*.

But perfection was also to be reached by a method that has been usefully termed 'synthetic naturalism'.[94] Leonardo was by no means repudiating his Aristotelian rigour, but it was now overlaid with a new purpose. In the years around 1490 he drew a string of remarkable horse studies, noting the particular beauties of a number of different horses (figs 16–19) and at the same time investigating the horse's

FIG. 20
PIERO DEL MASSAIO
(about 1420–1478)
Map of Milan, about 1472
From Ptolemy, *Cosmographia*
Pen and ink and wash on parchment,
59.7 × 42.7 cm
Biblioteca Vaticana, Vatican City
(Cod. Urb. Lat. 227, fol. 129v)

FIG. 21
Ground plan of Sforzinda, about 1465
From Filarete, *Trattato d'architettura*
40 × 29 cm
Biblioteca Nazionale, Florence
(Codex Magliabecchianus II.I.140,
fol. 43r, detail)

ideal proportions (as Verrocchio had done). Leonardo
was attempting to weld the most beautiful parts of real
horses into a perfect whole: he had realised that in order
to make visible the invisible he had to create fictions
that did not lie, inventions that could be judged more
truthful than things actually seen.

This change of direction tellingly coincides with
Leonardo's new position as a court employee. As we have
seen, il Moro lacked faith in Leonardo's ability to carry
out this commission; needing a boost, Leonardo turned
to a friend of Filelfo, the humanist Piattino Piatti, to write
a set of poems on his behalf. One of these draws a direct
parallel between the 'supernatural' horse and the aston-
ishing powers of Francesco Sforza, so that Leonardo's art
in making the horse becomes a metaphor for the Duke's
own extraordinary abilities: 'Art, imitating the immortal
actions of the duke, made the horse under the duke a
supernatural one.'[95] Here then was the Platonic ideal –
of horse and prince – brought into physical existence
and at least one commentator, presumably instructed by
Leonardo himself, understood that this idealistic turn
in Leonardo's art might exalt the house of Sforza.

Urban improvement

Such rhetoric was in line with other initiatives – the
improvement, the perfecting of the real world under the
protection of the perfect Sforza ruler. It is in these years
of the Horse, about 1489–94, that we arrive at the peak
of Leonardo da Vinci's involvement with Ludovico Sforza.
By 1490 Leonardo was on the Sforza payroll and for the
next decade he lived and worked in the old Visconti
palace in Milan, the Corte Vecchia. Tasks like the design
of scenery and costumes for theatrical entertainments and
other festivities were of a kind well understood at the
courts of Ferrara and Naples, and such activities should be
directly connected with the Sforza marriages into the
houses of Aragon and Este.

The other jobs he took on fell more within the tradi-
tional remit of the court architect-engineer: designs for
urban planning, ecclesiastical and palace architecture in
Milan, Pavia and Vigevano (where Ludovico had been
born), hydraulics – drainage and canal-building – and
even agriculture. These urban and agricultural improve-
ments were not unprecedented but now they could be
interpreted as further material metaphors of Ludovico

FIG. 22
Diagram of the Cosmos
From Isidore of Seville, *De responsione mundi et astrorum ordinatione*, Augsburg, 1472, fol. 7v

FIG. 23
LEONARDO DA VINCI
The Vitruvian Man (detail), about 1490–2
Pen and ink over metalpoint on paper,
34.3 × 25.5 cm
Gallerie dell'Accademia, Venice (228)

Sforza's rule. Analogies between the prince's person, the fabric of his city and his way of ruling the state were widely understood. Ludovico and Leonardo both appreciated that 'eternal fame' was to be had by the actual and metaphorical 'enlargement' of the city.[96] And Leonardo was chosen as Ludovico's main 'instrument' for these urban improvements.[97] He started in about 1490 by taking measurements of the city and its key buildings, including the centrally planned church of San Lorenzo and the Castello (fig. 88). The area round the Castello was to be the Duke's main focus and Leonardo was involved in the creation of a new piazza in front of the castle, the intended setting for the *Cavallo*.

As much as possible, Leonardo was to assist Ludovico with turning Milan into a perfect city as imagined, for example, by the architect and theorist Filarete when he invented the city of Sforzinda (fig. 21).[98] This physical improvement was understood as a means by which the prince made the process of his own self-improvement manifest, a way of demonstrating externally the continual perfecting of his inner self. Already, as Filarete knew very well when he wrote his treatise, the walls of Milan were

more or less circular (fig. 20), its ground plan temptingly close to that ideal Platonic shape. This is a circle that could be imagined as both the shape of God's cosmos (fig. 22; see cat. 91) and as the circumference inscribing an ideally proportioned human being at its centre, as in Leonardo's celebrated image of Vitruvian Man (fig. 23). Certainly he had read enough of Filarete's architectural treatise, and latterly the writings of Francesco di Giorgio, to think of the city in human shape. In Milan, the Castello Sforzesco is where a man's head would be; the Cathedral is at its centre. The city itself might be read as the Vitruvian circumference for the ideal ruler.

Painting perfection

The idealised horse and the perfected city were complemented by the altered style of Leonardo's paintings of the 1490s. These were the years of the second version of the *Virgin of the Rocks* (cat. 32), the portrait of a lady, known as the *Belle Ferronnière* (cat. 17) and, above all, of the *Last Supper*. These are pictures with aspirations very different from those in Leonardo's paintings of the 1480s.

Several scholars have argued that the palpable differences between the first and second versions of the *Virgin of the Rocks* should be explained by the delegation of the later picture, now in the National Gallery, to pupils, working individually or in concert; until its recent restoration this theory seemed quite credible, not least because it was in the early 1490s that his first Milanese pupils are documented. Now we can see that it was Leonardo himself who had begun again, probably in 1491–2 (see pp. 172, 174). The theory that this picture was painted in collaboration with pupils was, however, bolstered by the opinions of those experts so struck by the verisimilitude of the Louvre picture. They have condemned the National Gallery painting for its deviations from the real: the rocks straightened, generalised, regularised; the flowers lovely but not seemingly precisely identifiable.[99] This picture cannot, they claim, be by the same hand.

But their denigration is profoundly misjudged. They have not appreciated that in the early 1490s Leonardo began to pursue this new direction. Changes to the landscape in the London *Virgin of the Rocks* were accompanied by numerous other alterations. The picture is now more unified – by light and by subtle changes to the composition (especially the elimination of the angel's pointing hand). The proportions of heads and bodies are different and closer to the proportional canon Leonardo had worked out in 1489–90 (see cats 25, 30). The draperies are considerably simplified and more volumetric. The space the figures inhabit is less logically described. This is no longer a picture just about devout naturalism. It still depends on the recording and comprehension of natural phenomena, but now Leonardo combined those ingredients he regarded as essential (sometimes simply the most beautiful) to generate things – plants, landscapes, people – which are even more perfect, more completely themselves, than Nature had made; closer, it could be said, to their Platonic ideal. It is now that the ingredient identified by Vasari as 'divine grace' is introduced. Ever perceptive, Kenneth Clark was right to insist that Leonardo (with an inscrutable smile, a pointing finger) sought to preserve the greatest mysteries of God's creation.[100] Since, Leonardo had declared, the human mind is finite, it cannot 'extend to infinity'.[101] But by the time he started the London *Virgin of the Rocks* he had begun to think that, rather than set these mysteries aside, painting might actually encapsulate the

other-worldly, the supernatural in its literal sense. The internal inconsistencies in his writings become especially marked in this period as he sought to demonstrate that painting should not only encompass the depiction of the natural – a hard enough task if undertaken with the proper scientific rigour – but also the metaphysical. The painter should depict 'whatever there is in the universe through essence, presence or imagination'.[102]

There has always been a tendency to over-secularise Leonardo; we should remember that over half of his paintings represent the prime protagonists of the Christian story: Christ, his Mother, and the saints. Leonardo, whose Christian beliefs were basically orthodox, would not have quarrelled with the view that these holy men and women were the most miraculous of all the creations of his 'prime mover'. These were figures who had to be imagined as both real and divine. And it is worth stressing that the *Virgin of the Rocks* treats the mystery of the Immaculate Conception of the Virgin that, as the Franciscans had long argued, was planned by God even before the beginning of time. Leonardo may even, like many of his peers, have been troubled by the downplaying of an overarching and omnipotent controlling mind, equivalent to a Christian God, in Aristotle's philosophy of the natural world. Of the two great philosophical approaches, many fifteenth-century theologians argued that it was Platonism rather than Aristotelianism that was the more compatible with a Christianity that incorporated vast and celebrated mysteries: Platonism admitted a grand scheme, an infinite, timeless creator, a single deity. Despite Plato's own objections, Christian painting might therefore attempt to depict God's ideal universe – infinite and eternal – the universe carried in his mind.

How then could the painter see this other, better world? Leonardo thought that there was a method that could be learnt, one that he had practised in modelling his Horse. This passage starts familiarly, with the painter proposed as the mirror of Nature, but it changes tack midway through:

> What should the mind of a painter be like? The painter's mind should be like a mirror, which transforms itself into the colour of the thing it has as its object, and is filled with as many likenesses as there are things placed before it [this appears to be a conscious rejection of Plato's condemnation of mimetic art as mirror-like in his

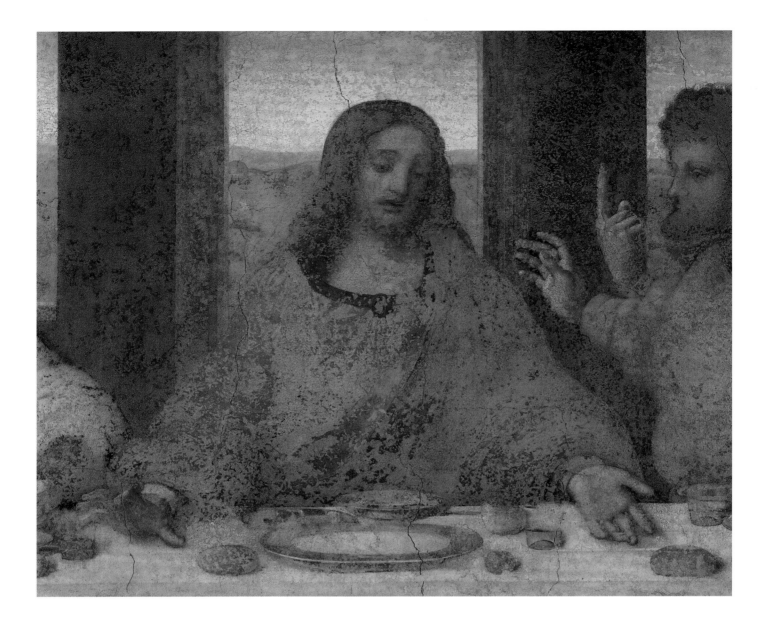

Republic]. Therefore, painter, knowing that you cannot be good if you are not a versatile master in reproducing through your art all the kinds of forms that Nature produces – which you will not know how to do if you do not see and represent them in your mind – as you go through fields, exercise your judgement of various objects, noting first this thing and then that, making a composite of various objects, selected and harvested from among those less good.[103]

This is his own explanation of the technique of 'synthetic naturalism', still insisting on close observation but incorporating the exercise of imaginative judgement. It was a method lent authority by ancient precedent. Leonardo knew the story of the ancient Greek painter Zeuxis, who had invented a face for Helen of Troy by combining the features of five beautiful maidens from the city of Croton. The tale appears in Cicero's treatise *On Invention* and Pliny's *Natural History*, and it had been re-told by Alberti.[104] These texts provided a shared frame of reference for Leonardo's audience of educated connoisseurs –

guaranteeing that they would understand what he was up to. And, in case they did not, he spelled it out:

> It seems to me that no little grace [is manifest in] the kind of painter who gives his figures a pleasing air. He who does not naturally have that grace can acquire it by additional study [*or*: artificially] in this way: look out for the good parts of many beautiful faces, those features confirmed beautiful by public fame rather than by your own judgement; for you might deceive yourself, choosing faces that have some similarity to your own, for often, it seems, such conformities please us; and if you were ugly, you would select faces that are not beautiful and you would then make ugly faces, as many painters do, so that often [their] figures resemble their masters. So pick beautiful features, as I tell you, and fix them in your mind.[105]

What then did Leonardo think made a head especially fine, if his judgement was to be impersonal? Leonardo's mathematics were about more than just measuring what he could see. Recording the measurements of a number of the same category of object allowed him to identify

universal patterns – and in turn these would inform his canon of ideal, harmonious proportion. This was another field of study he had inherited from Alberti but, as so often before, Leonardo had made his unique contribution, even before the arrival in Milan of that great champion of mathematical and geometric harmony, Fra Luca Pacioli. The title of Pacioli's treatise, *On Divine Proportion*, written in 1496–8 with Leonardo standing at his shoulder, immediately suggests its Platonic content, as well as giving a clue that his theories could be applied to religious art.[106]

It was a method that could also pertain to portraiture.[107] Leonardo's *Belle Ferronnière* (cat. 17) is sometimes dubiously identified as the portrait of another of il Moro's mistresses, Lucrezia Crivelli. An image of Lucrezia made by Leonardo was celebrated in a pair of poems by Antonio Tebaldeo.[108] But to judge from its style, particularly its palette, and from the speedy responses of his pupils, this picture was painted rather earlier, in about 1492–4, just when he was beginning the painting of the *Last Supper*. The *Belle Ferronnière* may in fact be a depiction of Beatrice d'Este, but if so she has been idealised to the point, one suspects, of making her unrecognisable even to her contemporaries. Unlike the portrait of Cecilia Gallerani, this is not really a likeness: his sitter, with her perfect oval head, her features positioned to accord with theories of divine proportion, has become Leonardo's Helen. Leonardo now insists upon twinned roles – disinterested observer but also elevated creator – and by these means he universalises his individuality.

The artificiality that is the consequence of this method is at its apex in the *Last Supper*, a picture much admired by Pacioli, and this stylistic choice was therefore vital to the desired result. Leonardo painted the *Last Supper* in the mid-1490s at one end of the refectory of the reformed Dominican convent of Santa Maria delle Grazie. Ludovico il Moro dined there twice a week – and church and convent should therefore be thought of as an extension of Sforza court space into a spiritual domain. In the *Last Supper* the human protagonists no longer look quite human, their grand gestures strangely careful and the composition relentlessly harmonious. The spaces are both mathematically calculated and unreadable using only the logic of one's eyes. These are all features that were intended precisely to distance what can be painted from what can be seen. Some twentieth-century critics have found this flawlessness excessive, even slightly repellent,

still more so when it is heightened in the works of Leonardo's pupils (see e.g. cats 19, 50).[109] But to his contemporaries these would have been signs that Leonardo was getting closer to God. Here was a picture that demonstrated unequivocally that Painting could be placed higher than Nature in the hierarchy.

The painter as lord

So when Leonardo defines the painter as the 'lord of … all things', this is a very different concept from that of the painter as mirror – and the terms he uses in this explanation of a new direction link his patron's powers to his own, connecting both to God's omnipotence. This is rhetoric again, but we need to understand that, even if this was never Leonardo's primary motivation, his artistic products would have been considered rhetorically as speaking for his employment by Ludovico.

'Lord' [*signore*] is a word found rather frequently in Leonardo's notes as he entered the period of his closest working relationship with Ludovico. Lordship had become a useful – and telling – metaphor. Trying, for example, to explain the soul and its physical seat in the brain, the *senso comune* (for which see cat. 1), Leonardo twice employs the word as part of a metaphor of the body politic.[110] These passages are found in fragments of his anatomical studies datable to about 1489. The soul, he suggested, was like the lord of a state: 'The tendons, with their muscles, serve the nerves as soldiers do *condottieri*, and the nerves serve the *senso comune* as *condottieri* their captain, and the *senso comune* serves the soul as the captain serves his lord.'[111] At much the same date he wrote 'of the muscles':

> Nature has ordained that in man the muscles are the official pullers of the tendons, which can move the limbs according to the wish and desire of the *senso comune* in much the same way as the officials sent out by a lord to his various provinces and cities, who represent and obey the will of the lord in those places.[112]

From these examples we understand that when Leonardo makes the parallel between painter and lord (the painter called the '*signore* of every level of person and of all things') he is in part talking about the capacity of both prince and artist to exert control over their subjects; this pun is entirely deliberate.[113]

But Leonardo adds another dimension to the analogy, fully cognisant as he was of the concept of 'lord' as creator. He may have found this idea, of God as architect and craftsman and consequently of the painter as his human equivalent, expressed by Cicero, and it would therefore have been familiar to most of his educated audience, certainly to Ludovico. It was a concept Leonardo had grown up with; Alberti several times calls the painter a sort of god.[114] Leonardo wrote:

> The divinity which is the science of painting transmutes the painter's mind into a resemblance of the divine mind. With free power it reasons concerning the generation of the diverse natures of the various animals, plants, fruits, landscapes, fields, landslides in the mountains, places fearful and frightful, which bring terror to those who view them; and also pleasant places, soft and delightful with flowery meadows in various colours, swayed by the soft waves of breezes, looking beyond the wind that escapes from them, rivers that descend from the high mountains with the impetus of great deluges, dragging along uprooted plants mixed with stones, roots, earth and foam, carrying away everything that opposes its own ruin . . .[115]

This passage, as applied to the London *Virgin of the Rocks*, suggests that Leonardo was developing a new mode of pious painting – making pictures in which his creativity was seen to emulate God's. But he combines these concepts in his statement that continues to refer to the temporal ruler: 'If the painter wishes to see beauties that charm him, it lies in his power to create them; and if he wishes to see monstrosities that are frightful, buffoonish or ridiculous, or pitiable, he can be lord and god thereof.'[116] For Leonardo therefore, the painter could be analogous to both earthly lord and the Lord of Creation. The word '*signore*' itself creates just such a blurring between the human and the metaphysical. And the connection between the ruler of a state (like Milan) and the Lord God was also already conventional – it had long been argued that the creative powers of God were to be emulated by the prince. To quote Thomas Aquinas, 'These are then briefly the duties of a king in founding a city or kingdom as derived from a comparison with the creation of the world.'[117] We have seen this played out in Milan in Ludovico's urbanism – and now perhaps we can discern analogies with his court painter's new style.

Leonardo's writings and pictures of the 1490s all therefore propose that painters should pursue a style purged of every individual quirk. His paintings in this period are beautiful but aloof, utterly impersonal, notably lacking in ordinary human affection – as opposed to a pure love – for his subject matter. Leonardo believed that the fame and honour of a painter were to be achieved through a combination of talent and self-discipline. 'One can have no smaller or greater mastery [*signoria*] than the mastery of oneself.'[118] The painter, he believed should control, conceal or eradicate his 'self'. In the late 1480s the court poet Gaspare Visconti directed a poem to an unnamed artist accused of replicating himself in every picture he made, providing endless proofs for that old proverb, 'every painter paints himself'.[119] His target was probably his friend Bramante who had just finished a series of heroic figures that rather resemble his later self-portrait medal.[120] Leonardo, however, explicitly denounced this practice. A good painter could arrive at the perfect, the essential, only by eliminating personal responses.

And this thinking can be related to what was expected of a lord. Leonardo's sense of how a good painter should be trained – and how he should perform – has something in common with the education and expectations of the prince. In a letter that was included in a 1481 volume dedicated to Ludovico il Moro, his former tutor Filelfo began by describing princely talent and the right to rule as divinely bestowed: 'Above anything else, you must always have in mind omnipotent God, from who proceeds lordships and kingdoms and empires and every human good.'[121] Other necessary virtues – justice and piety, fortitude and temperance – should be acquired and polished. Filelfo's letter falls at the tail end of a long tradition of 'mirror-of-princes' manuals or treatises in which all commentators agreed that the prince himself should be in some measure superhuman – an idealised human who embodied this defined set of abstract virtues. Like Leonardo's painter, similarly perfected, he was to be innately talented, self-disciplined and above all disinterested yet all-seeing.

So can we in fact detect this kind of thinking in Leonardo's supremely perfect *Last Supper*? The notion might seem almost blasphemous, but such a connection between almighty God and earthly ruler had, as we have seen, been proposed by Thomas Aquinas, no less. Sforza panegyrists pushed this analogy to its limits. 'There is one

FIG. 25
LEONARDO DA VINCI
Central lunette above the *Last Supper*:
*Coat of arms of Ludovico Maria Sforza and
Beatrice d'Este*, 1495/6
Tempera and oil on plaster,
width 335 cm
Santa Maria delle Grazie, Milan

God in heaven and one Moro upon Earth', fawned the poet known as 'il Pistoia'.[122] Another writer even claimed a correspondence between the Sforza dukes and Jesus Christ himself, the perfect ruler of men, declaring Ludovico's father, Francesco Sforza, 'King of Kings'.[123] On one level at least, the unblemished beauty of Leonardo's style in the *Last Supper*, Christ at its centre, could therefore be understood as a metaphor of Ludovico's perfect rule of a perfected state. And so that the analogy could not be missed the narrative of Christ's betrayal is played out under a set of Sforza coats of arms, surrounded by wreaths that are in themselves brilliantly considered exercises in synthetic naturalism (fig. 25).

Ludovico's last years

Ludovico Maria Sforza finally became Duke of Milan on the death of his nephew on 21 October 1494. Even before Gian Galeazzo's demise, Ludovico had been preparing the way by negotiating the marriage alliance of his niece Bianca Maria Sforza with Maximilian I, the first step to his investiture as Duke of Milan, the gift of the Holy Roman Emperor. That the ceremony took place on Saint Theodore's day was interpreted as a signal that Ludovico's attainment of power had been always destined by God. On that very day, Gaspare Visconti wrote a poem which he glossed as a

> sonnet made on the day of the enthronement of our most illustrious Lord, to show that the bad weather there has been in the past days was not a matter of chance, but of divine intervention, so that the enthronement of our most illustrious Lord would be delayed until the feast of Saint Theodore, whose name translates as 'gift of God', and so the state understands that it has such a Lord not through its merits, but only because of the liberality and clemency of almighty God.[124]

And that Ludovico was indeed God's choice was increasingly emphasised. One can detect a high note of spiritual uncertainty in the avalanche of printed religious texts dedicated to the Duke in this period: greater emphasis was placed on Ludovico's piety than ever before, particularly following his wife's early death. Though a *post hoc* rationalisation, this became another way of understanding the *Last Supper*.[125]

For all his efforts to improve the city and its amenities, Ludovico was finding himself ever more unpopular. Even as his political rise reached its climax, the seeds of his destruction were already sown. The balance of power in Italy had started to shift with the death in 1492 of Lorenzo de' Medici and the election in the same year of Rodrigo Borgia as Pope (preferred to Ludovico's own brother, Cardinal Ascanio Sforza, who had been considered a front-runner). The new Pope Alexander VI was not an ally Ludovico could count on. Worse, he had lost the friendship of the King of Naples, who deplored what he perceived as the shabby treatment of his granddaughter, Isabella of Aragon. Ludovico, struggling to adapt to this breaking up of the old order, looked outside Italy for support, and was roundly condemned for involving both the French and the Holy Roman Emperor in the political affairs of the Italian peninsula. The first French invasion by Charles VIII in 1494 initially shored up the Duke's position. But his successor, Louis XII, staked a claim to the Duchy of Milan via one of his ancestors, Valentina Visconti. Ludovico's luck had turned. Having already provided her consort with two sons, Beatrice d'Este died in childbirth on 2 January 1497, aged only 21. Though Ludovico had acquired a new mistress the previous year (perhaps during his wife's pregnancy), he wrote with apparent sincerity, 'I would rather have died myself than lose the dearest thing that I had in the world'.[126] Beatrice was buried at Santa Maria delle Grazie; her husband's last hours in Milan were spent by her tomb as he awaited the

arrival of the French army. In September 1499 the French troops of Louis XII took the city. 'The Duke has lost his state, his possessions and his liberty and none of his works was finished', lamented Leonardo.[127] Ludovico il Moro made a temporary escape; the artist outlasted his *signore* in Milan by no more than three or four months.

None of the tensions that led to the Duke's fall should, of course, be visible to the outside world. In the second half of the decade the function of Ludovico's court artists was changing again – moving from mirror to mask – and Leonardo and his peers were now called upon to demonstrate that all was right in Ludovico's magnificent world. However, he was close enough to his master to read the political runes. It was perhaps in 1498 that Leonardo thought of sending one of his rare letters to Ludovico Maria Sforza. Provokingly – somehow typically – his draft is torn in half top to bottom, tantalising us with the few anxious, hiccupping phrases that remain. They are nonetheless enlightening:

... of the reward of my service [*premio del mio servizio*]. Because I am not able to be ... My Lord, knowing Your Excellency's mind to be occupied ... to remind Your Lordship of my small matters and I should have maintained silence ... that my silence should have been the cause of making Your Lordship angry ... my life in your service. I hold myself ever in readiness to obey ... of the horse I say nothing because I know the times ... to Your Lordship how I was still two years salary in arrears from ...[128]

This break in the payment of Leonardo's salary was not the first; he had already explained to Ludovico that, waiting for his wages, he had been forced to take on work elsewhere.[129] By the end of the 1490s he was scouting for work. In around 1495 he offered to cast bronze doors for the cathedral in Piacenza – the draft of his letter explaining that it was a ruler's or government's duty to beautify their city.[130] Slightly later he began to plan a large altarpiece, thought to be for a church in Brescia, of the Madonna and Child with Franciscan saints, whose utterly familiar attributes Leonardo characteristically took the trouble to list.[131] And before he left Milan he made commitments to the invaders: the French king and one of his principal courtiers.

In April 1498, a few months after he had at last finished the *Last Supper*, Leonardo moved on to another scheme for Ludovico, of a very different order: the decoration of two rooms in Ludovico's principal residence in Milan, the Castello Sforzesco, to be finished by September. The rooms' redecoration – one of the principal elements in the post-investiture remodelling of the Castello interiors – has been interpreted as a means whereby Ludovico converted the castle from a place where he had ruled indirectly to one where 'his authority was public and unambiguous'.[132] Leonardo used the opportunity to render allegorical or emblematic his method as an artist, now linking it (not least by its physical context) absolutely explicitly with Ludovico's style of rule. A painter's creativity, as we have seen, lay for Leonardo in his ability to transform the natural, as experienced by the senses, into something new, by the disciplined exercise of reason (*scienza*) and imagination (*fantasia*). And this is precisely what Leonardo shows in the enormous Sala delle Asse, Ludovico's principal reception room (fig. 27). At the bottom of the walls is rude Nature

FIG. 27
LEONARDO DA VINCI
The Sala delle Asse (detail), about 1498
Tempera on plaster
Castello Sforzesco, Milan

– a mass of boulders heaved and cracked by force of the roots growing through them. Here Leonardo is observing but not choosing to improve. Growing out of this chaos, however, is his grove of regularly spaced tree trunks, their lower branches lopped off to turn them into columns. Though these trees – probably mulberries in a standard play on il Moro's nickname – are still growing, we are being reminded of the origins of architecture as they were described by Vitruvius: primitive man had turned trees into buildings, man's first exploitation – and transformation – of nature. Alberti too had described marble columns carved to resemble tree trunks – and Bramante included them in one of his Sforza-sponsored building projects.[133] Human ingenuity is taken to a much higher level in the vault, where Leonardo invents his largest and most

complicated knot pattern – literally elevated – training the branches into a 'muscular intertwining' of foliage.[134] Such knot patterns were termed at the time *fantasie* (see cat. 54). *Fantasia* was Leonardo's word for the imagination, and here the painter's imagination stands for the Duke's, seen as lying behind his success; the scrupulously tangled branches surround and support four plaques inscribed with the details of Ludovico's principal political and diplomatic feats (fig. 25).

Though so innovative and serious in its message, seen with all the other decorative schemes in the Castello, and compared with those that could be seen in the Visconti castle at Pavia (all now lost), this project asserted Ludovico's role as the heir of a long visual tradition. Ludovico had, it would appear, instituted a return to a strident, extravagant, Visconti-style magnificence. Gold – so despised by Leonardo – was now reintroduced as a signal of (a somewhat imaginary) wealth but also continuity. The gilding of the rope running through the branches of the Sala delle Asse is distinctly un-Leonardesque, reminiscent instead of the earlier lavishness of Visconti and Sforza palace decor. Political circumstances were beginning to make Leonardo effectively redundant; whereas previously Ludovico had needed a man of extraordinary talent, now he required little more than a glorified interior decorator.

The so-called *Pala Sforzesca* is a product of this new climate (fig. 26; see cat. 49). This altarpiece had been commissioned by January 1494 for the church of Sant'Ambrogio ad Nemus.[135] To judge from the inclusion of the swaddled Francesco II Sforza, born in February 1495, the picture was not, however, started until early that year, delivered (since this is an ambitious work) some time after that – by which time it could be linked to Ludovico's long-awaited investiture as Duke of Milan. The *Pala Sforzesca* is an overblown hotchpotch of a picture, strongly indebted to Leonardo for the figure style – and quite possibly produced under his aegis since the votive portraits of the ducal family were painted from the same cartoons as those used for the portraits added to the fresco opposite the *Last Supper* (a task assigned to Leonardo). In this instance, Leonardo's assistant, still anonymous, may have emerged from the more traditional workshop of the Milanese painter Ambrogio Bergognone, who used gilding rather similarly, painting over gold leaf with black

FIG. 28
LEONARDO DA VINCI
Portrait of Isabella d'Este, about 1499–1500
Black, red and ochre chalk heightened
with white on paper, 61 × 46.5 cm
Musée du Louvre, Paris (M 1753)

paint and coloured glazes to provide details of architecture and costume. If this was considered a work 'by' Leonardo, it represents a sad decline.

After the fall

The stylistic developments that occurred in Florence in the early 1500s constitute further indication of Leonardo's sensitivity to place – and to the politics of place. He had returned to a Florence where republican values had never been more important, and soon he could be found painting once again 'in the Florentine language'. Leonardo's long stint in Milan was to have a coda: he spent another eight years there from 1506. But in the meantime he found himself hugely in demand, his reputation utterly transformed by his work as Sforza court artist. If Florence was to be his new base, he was less than settled there and now began three years of frenetic travel. He was pulled in all directions, physically and intellectually. In March 1500 he was in Venice, where he seems to have reverted to his role as expert in military defences. While there he showed a portrait of Ludovico's sister-in-law Isabella d'Este, Marchioness of Mantua – 'so well done it could not be better' – to Lorenzo da Pavia, Isabella's agent.[136] This, it seems, was one of two drawings he had made from a sitting granted by the Marchioness – not her favourite activity; he had left the other, a 'sketch' in black chalk or charcoal, in Mantua where (one can imagine the fury) it was given away by her husband. Only one of these drawings survives (fig. 28), probably the more finished version that travelled with the artist, a cartoon that has been pricked for the transfer of the design to another surface.

The Marchioness went on trying to extract a picture from Leonardo for some time, while he stonewalled her with empty promises. Isabella was sensitive and well-informed, and her descriptive terms for Leonardo's painting style are crucial evidence for how his pictures were appreciated at about the time he left Milan, in the first years of the new century. In March 1501 she was angling for a little panel of the Madonna, 'devout [*divoto*] and sweet [in style] as is naturally his'. Isabella may have been using the word rather differently from the way her brother-in-law had some 16 years earlier. When Vasari discussed what made a picture stylistically devout, he used terms that a post-1500 Leonardo would have recognised,

praising 'good judgement of the painter, who holds that the male and female saints, who are celestial, are as much more beautiful than mortal man as are the heavens over earthly beauty and our works'.[137] It is possible that Isabella appreciated that the idealism achieved by Leonardo's syntheses of nature could also be 'devout'.

Leonardo was paying a flying visit to Rome when Isabella wrote to the Carmelite friar Pietro da Novellara, her eyes and ears in Florence. In April 1501 Fra Pietro reported: 'The life of Leonardo is very various and indeterminate, so much so that he seems to live from day to day.'[138] He described a small but monumental cartoon in which Leonardo had represented the Virgin and Child with Saint Anne and a lamb (see cat. 86). In it, he says, the Virgin tries to restrain the Child who is embracing an animal which Fra Pietro associated with sacrifice. Saint Anne, on the other hand – perhaps representing the Church – wants no impediment to this symbolic Passion of Christ. Fra Pietro's is one of the earliest iconographic readings of its kind – an appealing blend of symbolism and the reading of human emotion – evidence that Leonardo's pictures were subjected to such theological analysis. In another letter sent to Isabella later that month he explained that Leonardo was distracted from painting by his 'mathematical experiments', and that he was hoping to bow out of his prior commitments to Louis XII of France. He was, however, painting a 'little painting' (*quadretino*) of the Madonna and Child for Florimond Robertet, Louis's secretary, a work that had almost certainly been commissioned and perhaps started while Leonardo was still in French-occupied Milan. His account makes it clear that Leonardo was painting the prime version of the *Madonna of the Yarnwinder* (cat. 88).

In the summer of 1502 he was back on the road, working for the ferocious Cesare Borgia and moving with him through the Marche, occupied mainly with military matters. But he was not away for long, back in Florence by April 1503. These two years saw a truly amazing burst of activity. Leonardo began all four of his late works, three pictures on panel and another great mural; the three easel paintings were finished but only two survive (his image of a standing Leda was lost in France in the eighteenth century and is now known only from copies). Leonardo had recovered his nerve and concentration as a painter. That we now know much more about these pictures is due to Armin

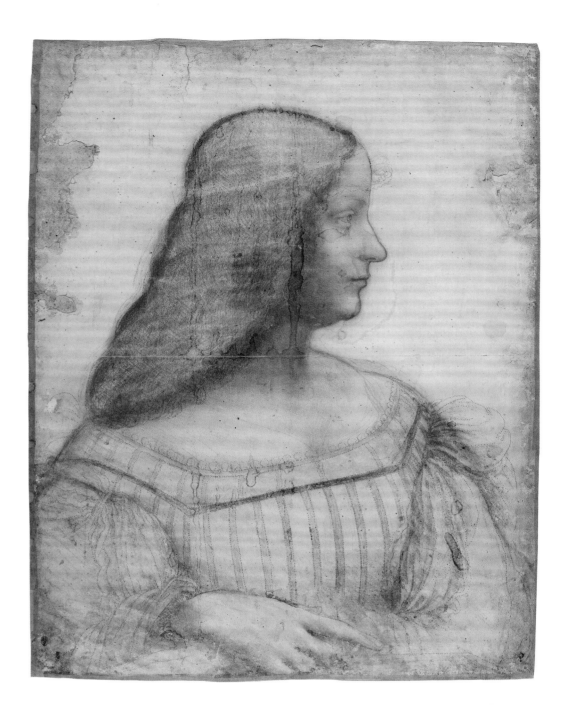

Schlecter, who recently re-examined a 1477 edition of Cicero's letters – the *Epistulae ad familiare* in Heidelberg University Library, which once belonged to the Florentine Agostino Vespucci. The text is annotated in Vespucci's careful humanist hand; he was particularly struck by a fascinating passage in which Cicero describes the painterly technique of Apelles (once again), who 'perfected the head and bust of his Venus with the most elaborate art, but left the rest of her body roughed out [*literally*: inchoate]'. He commented:

> ... So Leonardo da Vinci does in all his paintings, such as the Head of Lisa del Giocondo, and Anne, Mother of the Virgin; we shall see what he will do concerning the Hall of the Great Council, regarding which matter he has already made an agreement [*or*: he is now making an agreement] with the Gonfalonier. October 1503.[139]

Vespucci was satisfied that Leonardo had finished two pictures, a portrait and what must have been a Virgin and Child with Saint Anne, and, even if their bodies were still loosely painted, Vespucci had realised that this lack of finish had the best of ancient precedents. Leonardo was about to begin a third work, the huge mural in the Sala del Gran Consiglio in the Palazzo della Signoria (where both his independent career and his history of non-completion had begun quarter of a century before). Working at the heart of the Florentine government, Vespucci was in a position to know what was going on. His marginal annotation clarifies what has long been an unnecessarily thorny issue – the identity of the sitter of the *Mona Lisa* (fig. 32). This is, exactly as Vasari said so long ago, a portrait of Lisa Gherardini, the wife of the Florentine silk merchant Francesco del Giocondo. Vespucci's date can be

independently confirmed; Leonardo was indeed about to begin the decoration of one wall of the Sala – by a long way the most significant of his Florentine commissions – with a painting of the Battle of Anghiari, Florence's military victory of 1440. Leonardo received a first payment in February 1504, though the official contract was signed only in May that year. Work continued throughout 1505, but things were already going terribly wrong. According to an eyewitness, Leonardo had experimented disastrously with the medium of his picture and, no matter what he tried, the paint simply slid off the wall.[140]

Thus far Vespucci's annotation has proved completely accurate. His mention of a *Saint Anne*, finished enough by autumn 1503 for him to make his analogy, therefore provides crucial new evidence for the chronology of Leonardo's picture and drawings of the Virgin Mary with her mother. Since Vespucci refers to Leonardo's 'pictures' (*picturis*), comparing their different levels of finish to Apelles' technique as a painter, he must surely have seen Leonardo's picture of the *Virgin and Child with Saint Anne* in the Louvre (fig. 30). This picture tallies precisely with Fra Pietro da Novellara's description of April 1501 of a cartoon, save for the fact that the painting reverses the design of the cartoon in which the action was, it seems, directed 'to the left hand' ('*verso la man sinistra*'). Leonardo would not, however, have had any difficulty flipping his composition, perhaps because he had decided the figures should be lit – unusually – from the right. Infrared examination of the picture, revealing the preliminary underdrawing, shows that a cartoon was indeed used for the Louvre *Saint Anne*.[141] We can therefore assume that Leonardo started painting his picture, using the cartoon described by Fra Pietro, later in 1501 or in early 1502. And, as a result, we need to revise the dating of his first preparatory drawings for this picture – and of others close to them in style and technique.

Scholars have been unable to decide whether Leonardo's large drawing (usually and erroneously called a cartoon) depicting the same subject (cat. 86), once in Burlington House, now in the National Gallery, London, was drawn before or after the Louvre painting, or to agree its chronological relationship with Fra Pietro's missing cartoon. There are some obvious differences: the *Burlington House Cartoon* has an infant John the Baptist; its composition is more complicated, more frieze-like and less pyramidal.

It is argued here that this bold, exquisite masterpiece was executed before the lost cartoon and hence before the Louvre painting (see pp. 290–1). There are good circumstantial reasons for so believing but most importantly the two works are very different in spirit. In the past some critics explained this difference by dating the London cartoon *after* the Louvre picture, regarding its more complex composition as more 'formally advanced'.[142] On the contrary: the complicated twists and turns of the figures have all the artifice we have discerned in the *Last Supper*, almost reaching the level of the interlaced foliage in the vault of the Sala delle Asse. The natural vivacity of his early Virgin and Child drawings has here become somewhat mannered. It seems likely therefore that Leonardo began the *Burlington House Cartoon* while he was still in Milan. His patron may well have been the French king Louis XII, whose wife was Anne of Brittany. Is this one of the commissions Leonardo was ostensibly hoping to drop so that he could start working for Isabella d'Este? Its style makes a date of about 1499–1500 entirely plausible.

The *Burlington House Cartoon* in its turn is particularly close in style to the Louvre *Saint John the Baptist* (fig. 41). Saint John and Saint Anne could be brother and sister and the Baptist's slightly contorted pose, focused on his pointing gesture, has much in common with all the figures in the London drawing. The *Baptist* is usually considered Leonardo's last painting, mainly on the basis of its technique but – more dangerously – on iconographic grounds. In recent years scholars have realised, however, that it belongs to an earlier moment. The picture was known in Florence by at least 1505–6, when the Baptist provided the inspiration for the figure of Saint John the Evangelist in an altarpiece by Piero di Cosimo.[143] Its painting technique is indeed similar to that of the *Mona Lisa* and the *Virgin and Child with Saint Anne*, but unlike those indisputably Florentine pictures, the *Baptist* is painted on a panel cut from walnut wood – Leonardo's preferred support while in Lombardy, where we can assume the picture was begun. And, like the cartoon, it belongs to the period of Leonardo's period of most delicate artifice. Thus it seems reasonable to think that it too was started in Milan in about 1499–1500. This early dating would explain aspects that art historians have found anomalous – the combination of very soft and notably crisp contours,

for example. John's tightly painted hand and forearm are neatly paralleled by the brisk outlines of Saint Anne's hand, just as his smoky shadowing, Leonardo's celebrated *sfumato*, has its equivalent in the charcoal and white chalk transitions in the cartoon. This reconsideration of its dating has become all the more urgent with the recent re-emergence of the prime version of Leonardo's *Salvator Mundi* (cat. 91), previously thought lost, with which it has several features in common. Also painted on a walnut panel, it is likely that this picture too was begun in Milan in about 1499–1500.

The deliberate artifice of these works is worth emphasising because when Leonardo came to paint the *Mona Lisa* and the Louvre *Saint Anne* he chose to take yet another turn. The steadily increasing monumentality of his figures, their self-conscious classicism, was already a characteristic of his Milanese works of the 1490s. This is now enhanced by their backgrounds – the vast panoramic landscapes against which they are set. And it is accompanied by something new – an injection of Florentine naturalism, a tenderness; there is a return to a kind of simplicity. Compositionally, the *Mona Lisa* has more in common with the *Ginevra de' Benci* (fig. 31) than with the

portraits he had produced in Milan in the interim. But Lisa del Giocondo has a humanity that is lacking in the 1470s portrait of Ginevra. This whisper becomes louder in the Louvre *Virgin and Child with Saint Anne*, in which Leonardo returns to the humane, sometimes startling realism of Donatello (fig. 29), whom he particularly admired at this time.[144] While he maintains the symbolic conjunction of the figures, with the Virgin sitting (as she must) on her mother's commodious lap, he has disentangled his earlier composition. Mary is now fully supported, her head tucked into her mother's strong shoulder, and Leonardo has imagined a charming emotional connection between the Virgin and her son and a touchingly truthful awkwardness about the little boy struggling with the lamb. Leonardo's facial expressions have become more understated – his smiles reduced in intensity but now reaching the eyes. Never was the human form so central to his vision of God's universe and never, it would seem, did he like his fellow human beings more.

These first years of the sixteenth century took Leonardo to the peak of his fame as a painter. His skills as a portraitist were now so much admired as to be proverbial.[145] But the time he needed to achieve this perfection was just as

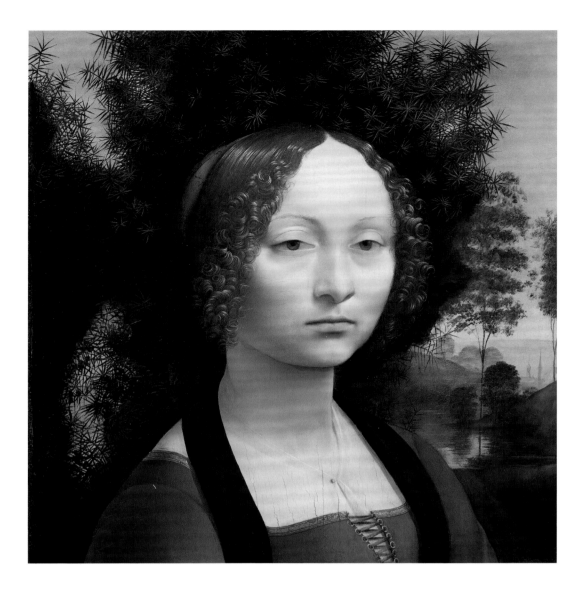

FIG. 31
LEONARDO DA VINCI
Portrait of Ginevra de' Benci, about 1474/8
Oil on wood, 38.1 × 37 cm (original panel),
42.7 × 37 cm (with addition at bottom edge)
National Gallery of Art, Washington, DC,
Ailsa Mellon Bruce Fund

FIG. 32
LEONARDO DA VINCI
Portrait of Lisa Gherardini ('The Mona Lisa'),
about 1502 onwards
Oil on wood, 77 × 53 cm
Musée du Louvre, Paris

famous. 'Leonardo possibly surpasses everyone, but he is incapable of removing his hand from the panel and so, like Protogenes, takes many years to finish one', wrote the humanist poet Ugolino Verino in about 1501–2.[146]

The end of painting

And indeed the second *Virgin of the Rocks* was still waiting to be finished in Milan. In a document of April 1506 the main panel of the altarpiece was judged unfinished with only Leonardo trusted to apply the finishing touches; Leonardo in his absence was committed to completing the picture within two years; in May he obtained permission from the Florentine government to go to Milan for three months – after which he was to resume work on the *Battle of Anghiari*. Though he did make a couple of brief trips back to Florence, with a deft wriggle he managed to escape another unfinishable painting. Backed up by Louis XII, he again based himself in Milan (the Florentines grumbling in the background) and he remained there until September 1513. In all that time only this one picture is mentioned. In August 1508, 25 years after it was first

commissioned, Leonardo at last received satisfactory payment for the *Virgin of the Rocks*. However perfunctorily, he had finished the picture.

He almost certainly went on refining the *Saint John the Baptist*, the *Salvator Mundi*, the *Virgin and Child with Saint Anne*, the standing *Leda* and the *Mona Lisa* in these years. But there is no evidence that he started a single new picture after his flight from the catastrophic failure of the *Battle of Anghiari*. From December 1513 to 1516 he was in Papal – at that time Medici – service. And still no new pictures are mentioned. Indeed, it seems that he had concluded that conventional image-making had become too restricted a vehicle for his thinking. Baldassare Castiglione, quintessential courtier, knew Leonardo in Rome and, writing in about 1513–16, he described him as one 'of the world's finest painters, [who] despises the art for which he has so rare a talent and has set himself to learn philosophy; and in this he has such strange ideas and novel fancies that, for all his skill in painting he could not depict them'.[147] This is plausibly the moment when Leonardo begun his series of apocalyptic deluge drawings (fig. 33). Though he still believed in a grand design, he had apparently relinquished

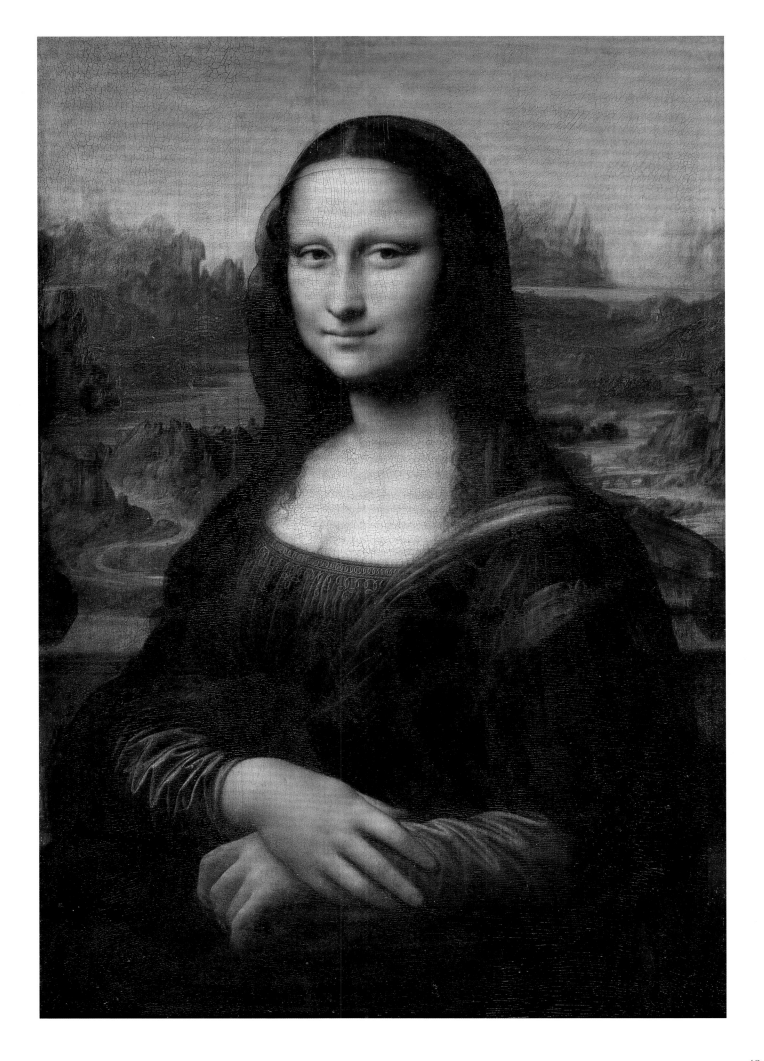

FIG. 33
LEONARDO DA VINCI
A deluge, about 1517–18
Black chalk on paper, 15.8 × 21.0 cm
The Royal Collection (RL 12383r)

his efforts to find a governing order and logic for the universe; he had surrendered to the mysteries, to the ungovernable, unknowable power of Nature.

Leonardo had met the new king of France, François I, in Bologna in 1515 and by May 1517 he had entered royal service, a court artist to the end. Some of his pictures travelled with him to France – and he went on working on them there: the last studies for the *Virgin and Child with Saint Anne* have French watermarks.[148] There is a description of an encounter with Leonardo in the travel diary of Antonio de Beatis, chaplain-secretary to Cardinal Luis of Aragon, who saw three pictures at Cloux in October 1517: the *Saint Anne*, a half-length *Saint John the Baptist* (fig. 41) and the portrait of 'a certain Florentine woman', painted, Antonio thought, for Giuliano di Lorenzo de' Medici, Duke of Nemours, the recently deceased younger brother of Pope Leo X.[149] This statement has caused much confusion, but the picture he admired was almost certainly the *Mona Lisa*, which Giuliano had probably hoped to own. Leonardo was no longer active as a painter because of a paralysed *right* hand, we are (rather oddly) told. Nonetheless, he was receiving an enormous court salary: 2,000 *écus* a year.[150] He was paid, it appears, simply for being Leonardo. His few pictures now fetched vast sums. In the year before Leonardo's death on 2 May 1519 his apprentice Salaì received a quite incredible 6,250 *lire imperiali* for procuring for the French king a group of paintings, inconceivable if Leonardo's three late masterpieces, now in the Louvre, were not the principal part of the package.[151] This was monetary recognition of the cultural value of Leonardo's achievements.

Vasari started his life of Leonardo with these words:

The heavens often rain down the richest gifts on human beings, naturally, but sometimes with lavish abundance they bestow upon a single individual beauty, grace and ability, so that, whatever he does, every action is so divine that he distances all other men and clearly displays how his genius is the gift of God and not an acquirement of human art. Men saw this in Leonardo da Vinci . . .[152]

Contemporaries did indeed perceive his talent as God-given – and Leonardo made sure they should (see pp. 281–3). As we have seen, his was a carefully constructed persona, novel in many of its ingredients, and artfully idealised: Leonardo da Vinci, the courtier-musician, urbane, charming and beautiful, but above all the supremely gifted philosopher-painter whose style was designed to suggest his closeness to God. He had been chosen like a prince and, like a prince, he needed to polish his talent by effort and education. The unhappy ending of the association between Leonardo da Vinci and his Milanese patron should not diminish the scale of their mutually reinforcing achievement in the first half of the 1490s. Arguably Leonardo's colossal talent would have ensured that his transformation of painting would have happened anywhere. But if he had stayed in Florence, the perfection he so ardently pursued might have been of a different order; going to Milan meant that he had to understand a prince's needs, to appreciate a court philosophy. Just as il Moro might have hoped, his own fame is now assured by the triumphs of his court painter. And perhaps we can agree that the Duke deserves a little of the credit.

1 I am indebted to Stephen Campbell, Martin Clayton, Nicholas Penny, Charles Robertson, Xavier Salomon and, above all, Caroline Elam for their critical readings of drafts of this essay. I am grateful too for the stimulating conversations I have had with Leonard Barkan, Paul Hills, Jill Kraye, Maria Loh and Alison Wright.

2 In a survey of this kind it is not possible to represent all the differing views of my predecessors. I have therefore tried where possible to indicate recent and straightforward routes to key information, but neither the notes here nor the Bibliography at the end of this volume aim to be complete. My chief debts in writing this essay are as follows. For analysis of his paintings, his writings and his works in other media that take properly holistic account of one other, I have been most inspired by Blunt 1940, pp. 23–38; Shearman 1962; Dionisotti 1962; Gombrich 1966; Ackerman 1969 and 1978; Garin 1972 and 1978, pp. 21–74; Kemp 1981, 1985, 2003, 2004b; Arasse 1997 and 2006; Fehrenbach 1997; Pardo 2008. For the attribution, detailed analysis and sometimes competing chronologies of Leonardo's paintings, I have consulted especially Suida 1929, Clark 1939, Brown 1983, 1998a and 2003; Marani 1989 and 1999. For Leonardo's drawings I have always begun with Popham 1946; Clark and Pedretti 1968–9; Martin Clayton (especially in Edinburgh and London 2002–3); Carmen Bambach (especially in New York 2003). The chronology and content of Leonardo's notebooks, extant and missing, have been rendered much less mysterious by the extraordinary efforts of Richter (see Leonardo's writings and their abbreviations, p. 305 of the present volume); Calvi 1925; Pedretti 1964 and 1977; Farago 1992. For other documents I have relied on the compilation edited by Villata 1999. Select bibliography for individual works included in the exhibition will be found under the catalogue entries.

3 Vasari (1966–87), vol. 4, p. 8.

4 Bambach 2003b.

5 Described as 'sfummanti con delicatezza', Cennini (1971), p. 149.

6 CA fol. 327v (ex 119r.a); R 10. Pedretti 1977, vol. 1, pp. 109–10, dates this passage to about 1490. Leonardo later taught himself Latin.

7 Urb. fol. 131v; MCM 439; K/W 507.

8 Villata 1999, pp. 7–8, no. 5.

9 Villata 1999, pp. 8–9, nos 7–8.

10 For which see most recently Dunkerton 2011.

11 Sebald 2000, p. 73. Sebald (or his narrator) is analysing Pisanello's Sant' Anastasia fresco of *Saint George and the Princess* in Verona, but what he says might apply equally to the works of, say, Fra Filippo Lippi or Benozzo Gozzoli in Florence.

12 Villata 1999, p. 10, no. 9.

13 It is regularly asserted that this commission was taken over, as was the *Adoration of the Magi*, by Filippino Lippi, whose *Sala degli Otto* (Uffizi) was actually finished in 1486 for a different setting. See Zambrano and Nelson 2004, pp. 351–2.

14 Uffizi 446 Er; R 663; Villata 1999, p. 11, no. 11. The bottom right corner of the sheet is torn away and we cannot know if this first word was 'September', 'November' or 'December'.

15 Heydenreich 1954 (pp. 30, 55, pl. 26) believed that Leonardo continued to work on this picture even into the sixteenth century, a view that deserves serious consideration, Certainly it has the appearance of remaining unfinished. Moreover, while it was regularly cited during Leonardo's Milanese years, its impact in Florence is marked only from the date of Leonardo's return there in 1500.

16 Villata 1999, pp. 12–13, no. 14.

17 Firpo 1967. For an overview of Filelfo's life and writings, see Robin 1991, esp. pp. 3–10, 141–59 (for his work *On Moral Doctrine*).

18 Casanova 1899.

19 The most complete narrative survey of Lombard politics in this period is still to be found in Catalano 1956. This necessarily much abbreviated account depends substantially on this essay, supplemented by information in Dina 1886; Ady 1907, pp. 112–71; Nulli 1929; Arcangeli 2000. For the cultural history of Ludovico's Milan see e.g. Garin 1983; Giordano 1995a and 1995b; Pyle 1997, pp. 8–25, 63–90.

20 Ludovico preferred to trust 'new men' – major figures at court like Marchesino Stanga and Gualtiero Bascapè, who turn up in documents directing commissions undertaken by Leonardo. See Bueno de Mesquita 1960 and 1976. In April 1489 it was Stanga, by then ducal secretary, who made Leonardo his first recorded payment – 103 *lire*, 12 *soldi* – as a Sforza employee. He also oversaw Leonardo's works at Santa Maria delle Grazie. Bascapè was responsible, among other projects, for the post-investiture redecoration of the Castello Sforzesco; in the dedication of Bellincioni's poems and in the context of il Moro's plans for the urban improvement of Milan, Francesco Tanzio called him: 'Gualtiero, the human, faithful, prudent and solicitous executor of your orders, instrument of your innate talent'. The terms are revealing, and Leonardo might easily have been characterised rather similarly.

21 The author is now often called the Anonimo Gaddiano. Biblioteca Nazionale, Florence, Cod. Magliabechiano, cl. XVII, 17. See Magliabechiano (1968), p. 119; Farago 1999a, vol. 1, p. 73.

22 Elam 1992.

23 In the 1568 edition Vasari has Leonardo arriving in Milan in 1494, for example. See Vasari (1966–87), vol. 4, p. 24. In the 1550 edition Leonardo is summoned by 'Duke Francesco'.

24 Elam 1988.

25 Villata 1999, pp. 16–17, no. 20.

26 As early as 1428, the Sienese sculptor and architect Jacopo della Quercia, for example, explained to the uncomprehending cathedral authorities in his home town the desirability of an architect obtaining employment at court: 'In Ferrara, he receives 300 ducats a year and board for eight persons … He is not a master craftsman wielding a trowel, but a talented "inventor" and "engineer" …'. See Warnke 1993, p. 33.

27 Marani 1982b, 1991b, 2004.

28 See Gaye 1839–40, vol. 1, pp. 159–60; cited, rather inaccurately, by Warnke 1993, p. 44. I am grateful to Xavier Salomon for his assistance with this translation.

29 Ffoulkes and Maiocchi 1909, pp. 92–103; Welch 1989 and 1990.

30 Motta 1893, p. 973.

31 See Shell and Sironi 2000.

32 Emboldon 1987, pp. 125–32; Pizzorusso 1996.

33 BN 2038 fol. 20v; Urb. fols 4v–5r; R 13/652; MCM 6; K/W 9. See also Farago 1992, pp. 194–5, 314–15. Leonardo takes this image from Dante, *Inferno*, Canto 11, vv. 100–5.

34 Urb. fol. 15r; MCM 28; K/W 51.

35 Triv. fol. 33r; R 1145. Pedretti 1977, vol. 2, p. 236 dates the passage to about 1487–90.

36 Urb. fols 38v–39r; MCM 80; K/W 503.

37 CA fol. 888r (ex 324r); R 680; K/W 640. See also Villata 1999, p. 15, no. 19.

38 The only items in the inventory which have no connection with his painting are the 'disegni di fornegli' (presumably for crucibles or small ovens), the 'certi strumenti per nav[i]li' (machinery for galleons or other large boats), and the 'certi strumenti d'acqua' (designs for hydraulic machinery).

39 See e.g. R 667, 1379 (the Ligny memorandum), 1384, 1387, 1391, 1402–4, 1416, 1420–1, 1434–6; K/W 643–4, 646–8; Villata 1999, pp. 69–70, no. 60.

40 In about 1493 he wrote down around 40 titles and authors' names in CA fol. 559r (ex 207r.a), R 1469; he left 116 books in Florence in 1504 (Madrid 11 fols 2v–3). For Leonardo's collection of books and its impact on his thought see, among many others, Dionisotti 1962; Garin 1962; Reti 1972; Reti 1974, vol. 3; Solmi 1976. We should not forget that Leonardo frequently borrowed books from others and had access to the magnificent Visconti library in Pavia.

41 For a stimulating discussion of this phenomenon, see Holly 1996.

42 It is true, however, that a portrait of Francesco Sforza is recorded in the Medici Palace in Florence in 1492. See Spallanzani and Gaeta Bertelà 1992, p. 33.

43 The head seen from this angle was also a Verrocchio trope. See his *Virgin and Child with Angels* (NG 296). Leonardo's drawing may therefore have somewhat resembled the sheet by his fellow Verrocchio student Lorenzo di Credi (Louvre 1781r). See Sénéchal in Florence 2010–11, pp. 310–11, cat. 22.

44 See the dashingly economical pen and ink (over metalpoint) sketch in Hamburg (Kunsthalle 21489r) which was probably made a little before this inventory was taken – perhaps the starting point for more finished drawings. These lost

drawings are perhaps reflected in the Saint Sebastian in Francesco Napoletano's signed altarpiece in the Kunsthaus, Zurich. Francesco seems to have spent time in Leonardo's workshop in the later 1480s. The Saint John the Baptist standing on the left of the same work by Francesco rather resembles Leonardo's drawing of the head of Christ mocked (Accademia, Venice 231) as well as the *Saint Jerome*.

45 Accademia, Venice 231. This is usually dated later, sometimes well into the 1490s. Christ, however, has a head close in both viewpoint and proportion to the angel in the Louvre *Virgin of the Rocks* (cat. 31), to whom he is a kind of anguished first cousin.

46 An *Angel of the Annunciation* by Leonardo is mentioned in 1568 by Vasari (1966–87), vol. 4, p. 23, as belonging to Duke Cosimo I de' Medici in the mid-sixteenth century; one of Leonardo's pupils made a drawing of this subject, corrected by his master, who may well have provided him with an original to copy. What may be a damaged replica of this lost picture survives in St Petersburg, from which it appears that Leonardo conceived a Gabriel looking straight out at the viewer, who is given the place of the Virgin Annunciate. Leonardo's invention of this subject and his solution were intertwined with his thinking about how to paint the image of the youthful Saint John the Baptist, another of God's messengers. A young Baptist in the same pose as Gabriel is known from a painting in Basel (recently restored) by another copyist. This type lies behind the slightly differently composed painting of the adolescent John the Baptist in the Louvre. It appears that Leonardo painted, or at least designed, two paintings that emerged from the same stream of thought: a Holy Angel and a young Baptist. Because Leonardo's pupil made his drawing of the angel on the same sheet as autograph sketches for Leonardo's *Battle of Anghiari* fresco, commissioned in 1503, and because of the style of the Louvre *Saint John*, it is always thought that these interconnected images had their beginnings sometime in the first decade of the sixteenth century. This occurrence of '4 drawings for the panel of the Holy Angel' in a list of the mid-1480s suggests, however, that their genesis may have been considerably earlier. Leonardo's designs for an angel may *always* have been entangled with his ideas for the Baptist. In the Basel and St Petersburg pictures, the youth's semi-draped torso – with its nipped-in waist, exaggeratedly large lower back muscles and high, soft pectorals – resembles the upper body of the Windsor drawing of Saint John. See Delieuvin in Florence 2010–11, pp. 250–5, cat. 5.

47 These include Windsor RL 12490r – in which the profile on the left has a notably jutting chin, rather like the 'long chin' of the list – as well as Ambrosiana F 263 inf. 53, 78, 93, and 94.

48 Laurenza 2001. esp. pp. 45, 153–5.

49 R 1368. This is the title given to a chapter in Arasse 1997, pp. 147–53.

50 Villata 1999, p. 35, no. 24.

51 Landino called Fra Angelico's style 'divoto', among other things. His use of the word is associated by Baxandall with one of Saint Thomas Aquinas's stylistic possibilities for preaching: 'like the sermons of the saints which are read in church … the most easily understood'. By report, Michelangelo was later to associate the word with Netherlandish painting of the fifteenth-century, fit only for women, monks, nuns and clumsy peasants, a pejorative twist on the same stylistic reading. See Baxandall 1972, pp. 148–50; Dempsey 1987.

52 Tissoni Benvenuti 1989.

53 Scrivano 1965, p. 687.

54 To be 'celebrate nella fiorentina lingua'. See Bongrani 1986a; Comanducci 1992, pp. 309–16.

55 Bober and Rubinstein 1986, p. 234, no. 201; Fusco and Corti 2006, p. 253 n. 53. The piece is documented in the Medici collections from 1455.

56 Baxandall 1972, p. 118.

57 CA fol. 387r (ex 141r.b); R 660; K/W 500. In this same passage he refers to Giotto, not content to follow his master Cimabue.

58 Baxandall 1972, p. 26.

59 These were weavings of the celebrated series depicting the History of Troy. See McKendrick 1991, pp. 52–3, 58. I am grateful to Paula Nuttall for this reference.

60 Gazzini 2006, pp. 266, 298–302.

61 Black 2009.

62 Castiglione (1964), p. 613 (letter to Giacomo de' Boschetti).

63 Bongrani 1986b.

64 For Bramante in Milan see Bruschi 1969, 1977 and 2002; Schofield 1989 and 2001; Schofield and Sironi 1997 and 2000.

65 In his 1370 will. Petrarch (1957), pp. 78, 80.

66 Urb. fol. 133r, v; MCM 434; K/W 16.

67 Vespasiano (1951), pp. 60–1.

68 Urb. fol. 131r; MCM 442; K/W 504.

69 See Pedretti 1977, vol., pp. 65, 77.

70 Staatliche Graphische Sammlung, Munich 1908.168.

71 Villata 1999, pp. 44–5, no. 44. For the full history of the horse and its documentation see Bernardoni 2010.

72 This was destroyed in 1797. Leonardo made a little drawing of it (Windsor RL 12345r) now cut from a larger sheet (CA fol. 399r; see note 73 below).

73 CA fol. 399r (ex 147r.b); R 1445.

74 As demonstrated by the poem celebrating the event by Baldassare Taccone. Villata 1999, pp. 78–9, no. 73.

75 Villata 1999, p. 85, no. 90.

76 Vasari (1966–87), vol. 4, p. 27.

77 Villata 1999, pp. 75–6, no. 72B.

78 Colombo 1956; Agosti 1987; Clarke 2003, pp. 9, 24, 235–6.

79 Mompellio Mondini 1943.

80 Kleinbauer 1967.

81 Pesavento 1996, pp. 48–50.

82 Cited by Pliny, *Natural History*, XXXV, xxxvi, 79. Apelles is also said to have invited scrutiny and criticism from the public.

83 BN 2038 fol. 19; Urb. fol. 9r; R 654; MCM 30; K/W 52.

84 Shearman 1962, p. 41; Weil Garris Posner 1974. For Leonardo and the Antique see most recently Marani 2003e.

85 Magliabechiano (1968), p. 119; Farago 1999a, vol. I, p. 73. For Alberti's advice, see Alberti (1950), p. 119; Alberti (1972), pp. 100–1 (III.58).

86 Malaguzzi Valeri 1902a, p. 61.

87 See flyleaf of Madrid I, about 1495. Pedretti 1977, vol. 2, p. 240, under 1163.

88 Schofield 1980, p. 249. Admittedly he does not seem to have been looking very hard, since he also turns the bronze statue of the *Spinario* into a marble.

89 Kraye 1979, p. 240: 'Intueri licet vel hac tempestate Romae et equos duos marmoreos et item iuvenes iuxta duos factos e marmore utrosque mirae pulchritudinis magnitudinisque eximiae, quos Praxiteles et Phidias nobili opificio elaborarunt. Non enim aut in equis Cillarum atque Arium, aut in iuvenibus figurendis Herculem aliquem et Iasona ante oculos habuerunt, ad quorum similitudinem tam praeclara opera posteritati admiranda relinquerunt; sed ingenii acrimonia et cogitatione sua pro exemplari sunt usi. Idem existimandum est de Scopa et Polycleto. Idem quoque de nobilissimis illis pictoribus Euphranore, Asclepiodoro, Plisteneto Phidiae fratre, et Apelle, cum pingerunt, alii deas, alii heroas, alii pugnas, alii victorias. Quanta vero in cogitatione fuisse Niciam putemus, qui servos persaepe inter pingendum interrogaret si lotus esset et pransus. Huiusmodi autem, de qua loqui coeperam, notio atque cogitatio, quanquam per sese non existit, utpote quae et oriatur et occidat, materias tamen informis insignit forma effigieque figurat atque efficit ut videantur exterius.'

90 *Republic*, X, 599d 2; Keuls 1989, pp. 13, 25, 33–4; Janaway 1995, pp. 110–13. For the challenge to artists and for texts which provided possible solutions, see Panofsky 1968, esp. pp. 11–12; Gombrich 1968, pp. 83–4. Marsilio Ficino's translation of the *Republic* into Latin was published in Venice in 1491, making it much more accessible – and, interestingly, this does seem to coincide with a turn in Leonardo's thinking. Milan was certainly not the purely Aristotelian city it is sometimes said to be (see Hankins 1990, vol. I, p. 95, vol. 2, pp. 402–3, 417–20). Neo-Platonic theories seem to have influenced Gaspare Visconti, for example (see Pyle 1987). The *Timaeus* was also readily available in the Visconti Library (Hankins 2004, p. 94) and it has been argued that, perhaps via an intermediary, Leonardo knew this text reasonably well. He may well have taken note of the passage (55c) in which the Demiurge (Creator) is described as creating the Cosmos by painting or 'delineating' it.

91 Villata 1999, p. 108, no. 124.

92 BL fol. 155r; R 1339.

93 Leonardo certainly owned texts by Filelfo. See Reti 1974, vol. 3, p. 98, no. 41 ('Pistole del Filelfo').

94 Kemp 2004b. See also Kemp 1995, p. 74.

95 Welch 1995, pp. 200–1; Villata 1999, p. 46, no. 47.

96 See CA fol. 184v (ex 65v.b); R 1203: 'There will also be eternal fame for the inhabitants of the city built or enlarged by him.' This text with its pronoun 'him' ('lui') seems to continue a lost passage that must also have concerned urbanism. At the bottom of the sheet Leonardo wrote down his only surviving political opinion in which, among other things, he equates political loyalty with the building of palaces within a lord's city. He finishes 'And the city will gain beauty worthy of its name, and it will be useful to you [seemingly Ludovico] by its revenues and the eternal fame of its aggrandisement.' Leonardo seems to have been planning a letter to his patron.

97 Maltese 1954; Firpo 1963; Garin 1972; Garin 1978, pp. 21–48; Pedretti 1978, pp. 57–60.

98 Firpo 1956; Lang 1972. See also Francesco di Giorgio (1967), pp. 3–4; Onians 1988, pp. 158, 160, 171–3. For microcosmic metaphors of the body politic see e.g. Barkan 1975; Najemy 1995.

99 Embolden 1987, p. 132; Pizzorusso 1996.

100 Clark 1939, p. 174.

101 H fol. 67[19]r; McCurdy 1938, p. 69 (dated to mid-1490s).

102 Urb. fol. 5r; R 19; McM 35; K/W 49. Dated about 1492.

103 BN 2038 fol. 2r; Urb. fol. 32r–v; R 506; McM 71; K/W 524.

104 Alberti (1950), pp. 107–8; Alberti (1972), pp. 98–9 (III.56); Cicero, *De inventione*, II, i, 1–3; Pliny, *Natural History* XXXV, xxxvi, 64.

105 BN 2038 fol. 27r; Urb. fols 50v–51r; R 587; McM 276; K/W 530. Pedretti 1964, p. 183 dates this passage to about 1492.

106 Onians 1988, pp. 216–19. See pp. 222–33 for divine harmonies as they were expressed in Milan in music and architecture.

107 Brown 1983.

108 Villata 1999, pp. 106–7, no. 122.

109 See e.g. Clark 1939, p. 98, on the 'cold and academic' *Last Supper*; Pedretti 1991a, p. 39 on the 'repulsive' Louvre *Saint John the Baptist*, which Clark (p. 176) judges 'dogmatic' and 'a failure'.

110 See the series of recent articles by Versiero (2004, 2005, 2007a, 2007b), which treat this theme exhaustively.

111 Windsor RL 19019r; R 838.

112 CA fol. 327v (ex 119v.a). See Marinoni 2000, vol. I, p. 564.

113 Urb. fol. 5r: 'signore di ogni sorta di gente e di tutte le cose'. This phrase introduces the passages cited in notes 102 and 116.

114 See e.g. Alberti (1972), pp. 60–1 (II.26).

115 Urb. fol. 36r–v; McM 280. Dated to about 1490–2.

116 Urb. fol. 5a; R 19; McM 35. See also Farago 1992, pp. 194–7, 332–4.

117 Aquinas (1935), p. 97.

118 H³ fol. 119 (70r); R 1191.

119 Visconti 1979, pp. 117–18, no. CLXVIII (171): 'There is one nowadays who has so fixed/ in his conception the image of himself/ that when he wishes to paint someone else/ he often paints not the subject but himself.' The painter in this poem is quite regularly identified as Leonardo himself, odd given the artist's own strictures on the subject. For Leonardo and the problem of what has been termed 'automimesis' see Kemp 1976; Zöllner 1992.

120 See Bramante's men-at-arms frescoes (now detached; Brera, Milan) executed for Visconti himself, many of which resemble Bramante's self-portrait medal. See Bora in Brera 1988, pp. 121–30, nos 94 A–H, as compared with Syson in Washington and New York 1994, pp. 112–15, cats 33, 33 A.

121 Firpo 1967, p. 140. For Pre-Machiavellian concepts of the perfect prince, see Born 1928; Gilbert 1939, pp. 453–76. See also Hörnquist 2004, p. 20: 'Since the ideal prince and the values he represents are considered to exist on a universal, if not transcendental, level, which the individual prince is expected to strive for, and to arrive at, by modelling himself after his example, originality and diversity did not become hallmarks of the genre. The success of the mirror-for-princes genre was guaranteed as long as the princely reader accepted its premises and identified with the idealized image presented to him.'

122 Cartwright 1903, p. 137; Nulli 1929, p. 293 ('... un sol Dio/ Si trovi in cielo ed un sol Moro in terra.').

123 Ianziti 1988, p. 233. Similarly Ludovico was compared to Saint Ambrose by canon Stefano Dolcino della Scala in his dedication to Ludovico of the saint's *Epistolae*, printed in 1491. See Soldi Rondanini 1983, p. 49.

124 Visconti 1979, p. 128, no. CLXXIX (134); cited by Welch 1995, p. 326 n. 80.

125 By Luca Pacioli. Villata 1999, p. 109, no. 124C.

126 Luzio and Renier 1890a, p. 639; Cartwright 1903, pp. 307–8.

127 Flyleaf of Ms L; R 1414. See also Villata 1999, pp. 126–7, no. 139.

128 CA fol. 914r (ex 335v.a); R 1345; K/W 614.

129 CA fol. 867r (ex 315v.b); R 1344; K/W 615.

130 CA fol. 887r (ex 323r.b); R 1346; K/W 617.

131 Ms I fol. 107r; R 679. See also Villata 1999, p. 104, no. 120.

132 Kemp 1981, pp. 182–9; Kiang 1989; Welch 1995, pp. 230–6; Fiorio and Lucchini 2007.

133 Bruschi 1969, pp. 810–15; Marani 1982a. See also Schofield 1995, pp. 298–9, 312–13.

134 Manca 2001, p. 59. Manca continues: 'Leonardo found here a perfect balance of Nature and abstraction, of science and artistic patterning, of past and present.'

135 It may well be that this is the 'tavola del Duca' mentioned on Ms H², fol. 94r; R 1391.

136 Villata 1999, pp. 130–1, 133–4, nos 144, 149 (March 1501).

137 Vasari (1966–87), vol. 3, p. 274 (in the *Life* of Fra Angelico).

138 Villata 1999, pp. 134–5, no. 150.

139 Schlechter 2008. Vespucci's annotation is written against a passage of Cicero's text: 'Nunc ut Appelles Veneris caput & summa pectoris politissima arte perfecit: reliquam artem corporis incohatam reliquit.' He adds: '[Apelles] pictor. Ita leonar/dus uincius facit in omnibus suis / picturis. ut est Caput lise del giocondo. et anne matris uirginis / videbimus quid faciet de aula / magni consilii. de qua re conuenit / iam cum vexillario. 1503. 8bris.' I am grateful to Caroline Elam for her translation.

140 Magliabechiano (1968), p. 122; Farago 1999a, vol. I, p. 75. Information from Giovanni da Gavina. For the documented beginnings of the project, see Villata 1999, pp. 165–9, nos 188–9.

141 That the Louvre picture was indeed made from a cartoon was confirmed by Martin et al. 2005, esp. figs 7–10.

142 Franklin 2001, p. 13.

143 Villata 1997, pp. 225–7.

144 Vasari (1966–87), vol. 5, p. 240.

145 Villata 1999, p. 162, no. 184.

146 Villata 1999, p. 147, no. 170.

147 Villata 1999, pp. 249–50, no. 297B.

148 See Clayton in London 1996–7, p. 134.

149 Villata 1999, pp. 262–5, no. 314.

150 Villata 1999, p. 265 and n.p., nos 316, 316 *bis*.

151 Jestaz 1999.

152 Vasari (1966–87), vol. 4, p. 15.

IN PURSUIT OF PERFECTION

LEONARDO'S PAINTING TECHNIQUE

LARRY KEITH

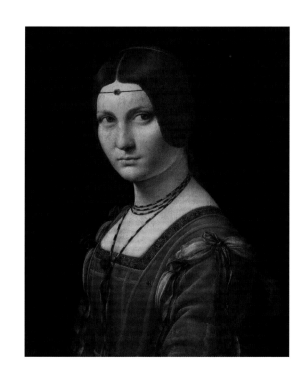

THERE IS AN INTANGIBLE QUALITY TO Leonardo as personality and painter that is resistant to our understanding. The very concept of his painting technique as a discrete and self-contained entity is also hard to justify – perhaps unsurprisingly, since Leonardo was the master of the infinitely subtle gradation. His trail of unfinished or abandoned activity, whether in paint, bronze or prose, suggests an artist for whom the process of enquiry, the potential of the idea, was more engaging than the final result. Yet the few paintings that he produced are rightly held as great works in their own right, whatever their condition or state of completion. Careful study of the paintings themselves, their materials and techniques, provides important information about the nature of his enquiry – evidence which it is fascinating to consider within the context of the extensive corpus of drawings and writings that has survived.

What we discover is a painter firmly grounded in traditional practice who was able to stretch his methods and materials to express unprecedented intellectual and artistic concerns. However, these painterly interests were only part of a larger pursuit; he believed that careful observation of all manner of natural phenomena was essential for both new knowledge and deeper understanding. With Leonardo, the whole relationship between study and painting has shifted, and there is a new sense in which his paintings illustrate his way of thinking as much as they depict any specific subject matter.

The most immediate and comprehensive record of Leonardo's artistic activity is found in his drawings, which are important not just in the narrow sense of charting the evolution of a given pose or composition, but also in showing how he developed more fundamental aspects of representation – especially those concerning the action of light and the creation of atmospheric tonal effects. Leonardo employed a wide range of drawing technique, including lead- and silverpoint, hatched pen and ink, red and black chalks and ink washes. Every type of drawing can be seen to inform some aspect of his painting: the precision of metalpoint allowed the detailed exploration of the fall of light across flesh, hair or drapery (see cat. 59), while by contrast the deep shadows, blurred contours and implied movement of inky washes (see for example cat. 56) more immediately suggest his approach to painting, especially the tonal undermodelling of

famously unfinished works such as the *Adoration of the Magi* (fig. 34).

The National Gallery *Virgin of the Rocks* (cat. 32) is a painting that is at once unique and highly representative of how Leonardo worked. Produced in fits and starts over the last 15 or so years of a commission that took 25 years to complete, it is a composition of the most artful complexity and an image where local colour was sublimated to the newer demands of tonal unity. Leonardo left behind very few finished pictures, and in the period covered by this exhibition perhaps only his *Portrait of Cecilia Gallerani* (cat. 10), the *Belle Ferronnière* (cat. 17) and the *Last Supper* (fig. 100) can really be considered as fully completed works, while others such as the *Saint Jerome* barely moved beyond the drawing stage. The National Gallery *Virgin of the Rocks* falls somewhere between the two categories; it is manifestly uneven in finish and execution but, perhaps paradoxically, this quality allows us to explore key issues of his painterly practice – methods, materials, collaboration, delegation and finish – and thereby understand better the larger question of the relationship between his painting techniques and his artistic intent.

Approaches to painting

Leonardo's move to Milan in 1483 marks the beginning of the first sustained period in which he was responsible for the running of a studio. Both Milan's court-based patronage networks and the circumstances of his arrival as an outsider must have had a strong influence on key aspects of the studio's initial organisation; at least initially he was reliant on collaboration with locally established artists the de Predis brothers to a degree that would have been unusual in Florence. But if Milan was the place where Leonardo was first firmly established as an independent master, his habits were deeply Florentine and their roots lie in the experience of his training in the workshop of Andrea del Verrocchio. Like Verrocchio, he retained the practice of a sustained activity in both painting and sculpture; even his engineering works have antecedents in those of his master (that were themselves a kind of continuation of Filippo Brunelleschi's famous expertise in both engineering and architecture). Leonardo also absorbed much of his master's evolving conception of the role and function of preparatory drawing; on a superficial

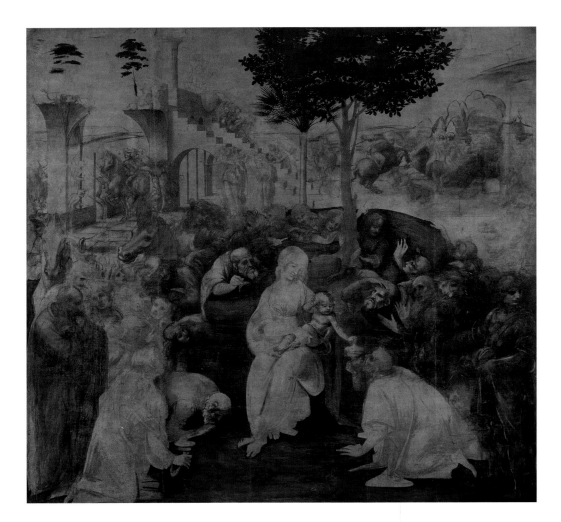

FIG. 34
LEONARDO DA VINCI
The Adoration of the Magi,
about 1480–2
Preparatory layer of paint in yellow
and bistre on wood, 243 × 246 cm
Galleria degli Uffizi, Florence

level this is indicated by the persistence of certain idealised types within his work that are ultimately derived from Verrocchio's imagery, but in a deeper sense his notion of the uses of drawing for the repeated testing of ideas, or as a vital pedagogical tool within the studio, owes much to Verrocchio's practice.[1]

Yet if many of Leonardo's interests and practices can be seen as traditionally Tuscan, from the earliest period he was expanding his conception of the approaches and techniques of his predecessors. The range and integration of his interests was arguably wider and deeper than had been seen before – so much so that it is more inaccurate to categorise him simply as a painter than almost any other of his artistic contemporaries, however widely they too may have ranged beyond painting. For Leonardo the creation of works of art has a different sense – not a profession as such, but an aspect or expression of a wider enquiry into the nature of things.

Leonardo's typical erosion of normal categories is (literally) illustrated by his production of drawings. Of course many served as preparatory material of varying degrees of finish in the traditional artistic sense. But his drawing also served to illustrate his other interests – such as engineering, anatomy, optics – many of which were to some extent intellectually autonomous to the production of artworks, and some of which feel like an almost spontaneous expression of thinking itself.

As a result of such intellectual breadth, the task of describing Leonardo's painting technique is problematic in that narrowing the focus to a study of his painting materials or layer structures feels especially arbitrary and distorting. His own view of painting reinforces the difficulties of concentrating on simple notions of methods and materials; he saw it as a kind of *scientia media*, a medieval term originating with Thomas Aquinas (1225–1274) that was applied to activity that combined theoretical and practical knowledge.[2] However interesting it is to us, however skilful it appeared to his peers, the craft element of his art was perhaps more subordinated to the service of his intellect than with any of his contemporaries. Of course we are extremely fortunate to have an exhaustive record of the scope of his intellectual and artistic ambition within his writings – thousands of pages of them, on all subjects. Not surprisingly, they too fall into the pattern of works which ultimately promise more than they contain, for his stated ambition to systematise and streamline his researches into more formal modes of presentation, in particular a systematic treatise on painting, was never carried out.[3] As in most of his paintings, we are left to imagine the potential of his achievement

through the many flashes of brilliance within the unfinished work.

Thus the study of how Leonardo's paintings were produced can open a window on his mind – even if the view must remain somewhat restricted – and a better understanding of the details of their production raises themes of great importance for his intellectual pursuits. His pictures were constructed on a bedrock of penetrating, original empirical observation, informed by an increasing theoretical awareness, while their execution displayed an innovative development of previously unexplored possibilities within largely traditional painting materials. In terms of techniques of painting two aspects stand out – the role of drawing and his particular use of the oil medium. Just as his wider conception of drawing often extends beyond traditional artistic concerns, when it is deployed in the service of painting it has a new and

expanded practical function as well – both in the types and range of purely preparatory work and in the way drawing techniques are employed on the panel itself. This is perhaps the most distinctive technical feature behind the distinctive 'look' of a Leonardo painting.

The other key element of Leonardo's painterly interest is to be found in the way he used drying oils (that is, oils that harden after a period of exposure), his exploitation of their potential for both subtle transitions and distinctions within the deepest tones, all of which were carefully orchestrated within a system of unified lighting. Of course not even a character as exceptional as Leonardo should be seen as entirely *sui generis*, and he was part of an increasing Italian interest in the techniques of Netherlandish oil painting.[4] In Florence oil paint seems to have been increasingly widely adopted in the late 1460s and 1470s,[5] and some Florentine artists shared an interest in its use to recreate the appearance of things based on empirical observation. Compared to the traditional egg tempera techniques, the oil medium offered a new range of optical effects, the most important of which was the even greater transparency it gave to the glazing pigments, which could be applied to modify the colour of opaque underlayers. Its longer drying time also allowed softer transitions between colours and a greater variety of application, both more broad and more detailed, than had been possible before, even the virtual elimination of all traces of the brush-stroke if so desired. It was also easier to make changes. But the differences from Netherlandish approaches are also revealing. Technical influences from the North were relatively indirect; Florentine painters were increasingly able to see imported Netherlandish pictures, but the production of such works lay largely outside their experience and they were probably unable to absorb the lessons of oil technique through direct instruction. Sadly for us, this is amply demonstrated in Leonardo's case by the disfiguring cracking of paint layers and other paint drying defects that are for the most part absent from the northern works themselves. More important, however, is that Leonardo's painterly interests went beyond an exploration of how things look, but also questioned what principles lie behind the specifics of any given empirical observation, however minute or precise.

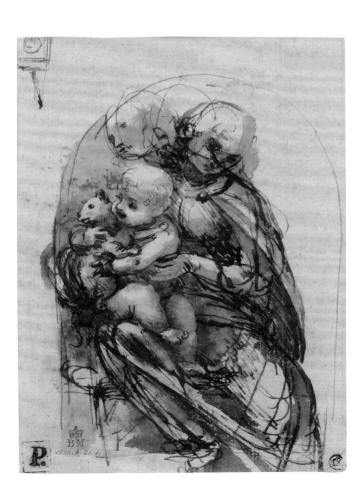

FIG. 36
Infrared reflectography detail of *Saint Jerome* (cat. 20)

Beginnings

Leonardo always found it difficult to finish pictures; however frustrating this must have been for his patrons, it now allows us to see better how he worked. Two of the least completed paintings are the *Adoration of the Magi* (fig. 34) and the *Saint Jerome* (cat. 20). The former just pre-dates his departure from Florence, the last of his works begun there, while the latter is more plausibly placed in the earlier years of his activity in Milan. Taken together, they provide invaluable evidence of his methods of planning and developing his compositions. The *Adoration* was commissioned in Florence in 1480 or 1481 and abandoned when he left for Milan in 1482–3.[6] The picture is notable for the great complexity of its multi-figural composition, combining landscape, architectural elements, horses and figures, and as such it required a great number of drawn preparatory studies, many of which survive. The drawings encompass both sketches of individual elements and larger compositional essays, including a meticulous perspective study (Uffizi 436 E), now a famous image in its own right.

The development of Leonardo's compositional ideas in his preparatory drawings is a fascinating process worthy of its own study. His conception of the purpose of such drawing is entirely new; it has become a vehicle for testing the potential of compositional ideas, inherently provisional, where the traditional goal of fixing upon a composition has become at best secondary. He instructed:

> You who compose pictures, do not articulate the individ-ual parts of those pictures with determinate outlines, or else there will happen to you what usually happens to many and different painters who want every, even the slightest trace of charcoal to remain valid; this sort of person may well earn a fortune but no praise with his art, for it frequently happens that the creature represented fails to move its limbs in accordance with the movements of the mind; and once such a painter has given a beautiful and graceful finish to the articulated limbs he will think it damaging to shift those limbs higher or lower or forward or back. And these people do not deserve the slightest praise in their art.[7]

One of the more interesting aspects of these instructions and the so-called pentiment drawings that resulted (see cats 9, 37 and especially 85) is the way this evolutionary

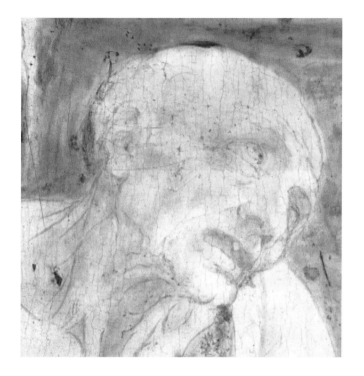

process continued once the work had begun on the panel. The poplar panel was first prepared with coatings of gesso, on top of which Leonardo laid in his initial brushed drawing with lamp black.[8] While no traces of the direct transfer of preparatory drawings, whether through tracing or pouncing (*spolvero*), have been identified in the *Adoration*, both his earlier Uffizi *Annunciation* (fig. 1) and the later *Saint Jerome* show evidence of a brushed elaboration of what must have been more schematic indications trans-ferred to the panel surface (fig. 36), suggesting the use of cartoons for particular parts.[9] Once the composition had been established with the freely brushed black drawing, the whole of the support was covered in a thin layer of lead-white paint, presumably in oil,[10] which veiled but did not obscure the drawing below. This first drawing, which now appears as a cool blue-grey as the result of the covering *imprimitura* – a semi-transparent priming layer – was itself the departure point for further brushed drawing, in line and wash in dark browns and blacks. These included significant changes to the composition and established the basis for the tonal modelling to follow in the subsequent paint layers. Much of that first brushed drawing was incorporated into the developing work without modifica-tion; one example can be seen in the bluish colour of the

front of Christ's proper right foot in the *Adoration*, which is distinctly cooler in tone than his other foot, the drawing of which was strengthened and elaborated over the white priming. These differences between the initial drawing and its subsequent elaboration over the priming are clearly visible throughout the image; most of the Virgin's torso and right arm appear to be under the *imprimitura*, while Christ's upper body and head have been further developed over it (detail of fig. 34). The development of the initial drawing into a more or less monochromatic tonal underpainting is quite remarkable; it shows a degree of interest in the effects of light and shadow that was already greater than in pictures by any of his contemporaries, even if it must have been in some way informed by the practice in Verrocchio's workshop of drawing tonal drapery studies.[11] Leonardo was to develop whole systems for conveying the effects of light falling on surfaces; here one suspects the striking effects are more empirically based, but their artistic implications are already clear. The traditional mathematically derived perspective, though present in the background architecture,[12] is already somewhat bested by a greater interest in light and shade. The modelling is achieved in a technically efficient way, exploiting the cool optical 'blue shift' of scumbled light tones applied over the warmer dark colours, skills first developed in the drawings made in the Verrocchio workshop.[13]

This initial underpainting is taken slightly further, if only in parts, in the *Saint Jerome*. Recent research has convincingly placed its execution in Milan.[14] The choice of walnut for the panel's support offers further strong circumstantial evidence for this;[15] walnut was frequently used for smaller format pictures in Milan by Leonardo's pupils and associates, as well as for three indisputably Milanese portraits by the master himself: the *Portrait of Cecília Gallerani* (cat. 10) the so-called *Belle Ferronnière* (cat. 17) and the *Musician* (cat. 5).[16] By contrast, no work by Leonardo or his circle known to have been begun outside Milan is painted on a walnut panel.[17] Like the *Adoration*, the *Saint Jerome* also started with some sort of mechanical transfer of an initial design onto the gessoed panel, probably using some combination of one or more partial cartoons, before being more comprehensively sketched with the brush directly onto the gesso.[18] As in the *Adoration*, the first brushed drawing – itself a development and

'first edit' of the design transferred from the cartoons – was then covered with a thin, semi-transparent *imprimitura* layer of white paint. A passage written around 1490–2 describes a similar process of design transfer, albeit in the context of a longer technical passage about the preparation of panels which remains difficult to interpret.[19]

After it was covered by the priming, the initial drawing of the *Saint Jerome* was again developed with lines and washes of brushed translucent dark brown paint, placed over the *imprimitura*, with the same readily discernible differences between the cooler shades of the partially veiled initial drawing and the darker, lustrous tones of the later applications as are found in the *Adoration*. The covered earlier drawing is apparent in the saint's feet and the lion's mane, while the subsequent working is clear in the lion's front leg and the distant church – a wholly improvised feature added only at the later stage.[20] Also apparent, however, is the increasingly sophisticated way in which the differences between the colours and tonal values of the veiled and unveiled paint used for drawing are exploited as the work progresses. The cooler grey of the covered drawing provides an instant mid-tone in the flesh modelling; the darker brown washes are added to deepen and intensify the shadows. Parts of the saint's flesh are further developed than anything seen in the *Adoration* by the addition of white highlights of varying intensity, carefully placed and blended to increase the depth and degree of relief of the highly convincing anatomical description. The saint's face shows the use of the cooler veiled drawing as a mid-tone, with darker shadows selectively laid in around the eyes, nose, mouth and neck; as the eye moves down to the tendons of the neck and collarbone region the modelling includes some of these added highlights to extraordinary effect.[21] The more fully modelled anatomy of the exposed shoulder is perhaps the most highly worked passage of the picture, and contrasts tellingly with the bare contours of the extended arm and hand.

Leonardo had begun to apply other areas of colour, the first laying-in of the blue paint of the distant landscape – including sky, water, and mountains, which have been subsequently modelled with dark brown colour. The blue paint is loosely and freely worked, in part using the fingers to spread the colour, a particularity of handling which also has been identified in Leonardo's part of Verrocchio's

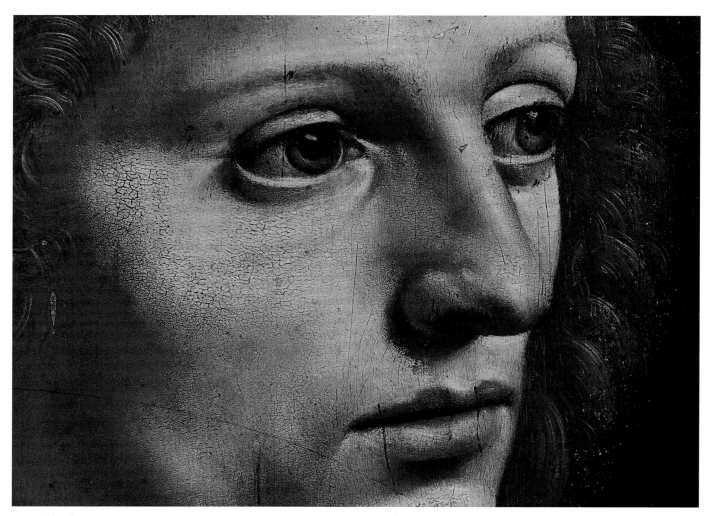

CAT. 5 (detail)

Uffizi *Baptism*, in his *Portrait of Ginevra de' Benci* (fig. 31), both belonging to his first Florentine period, and in the *Portrait of Cecilia Gallerani*, among other works.[22]

The Milanese portraits

The *Musician* (fig. 5) is also unfinished, but it has been taken much closer to completion. The fine underdrawing visible for the head again suggests the use of a detailed preparatory drawing, while the more loosely drawn elaboration of the rest of the composition is in keeping with the method used for the *Saint Jerome*; the tawny, brushy underpaint of the unfinished tabard also has its counterpart in the initial blocking-in of the shadows of the saint's draperies.[23] The face itself is much more fully realised in paint than any part of the *Saint Jerome*, however, even if the principles of its modelling are the same. The lighter colours are built up to create an extraordinary sculptural quality, and the subtle tonal distinctions between the various curving planes and surfaces of the face are meticulously described. The boldness of some of the transitions, for example around the sitter's left eyelid or the edge of shadow cast by the nose (which is created within the

undermodelling), suggests that even in this most finished part of the picture there was still more refining to be done. The X-radiograph shows very low density in the darker tones of the face, suggesting that they were for the most part created in the first tonal underpainting rather than by glazing over an applied flesh colour. This constitutes a striking difference from Leonardo's other Milanese portraits, which are more built up and blended in their flesh painting. This may be largely due to the differing palettes used for male and female flesh, but it may also be a measure of the degree of incompletion of the musician's face. The sharp shifts in contrast are somewhat at odds with Leonardo's written preference for avoiding strong light, which renders works 'crude and ungraceful'.[24] Nonetheless, the darker undermodelling of the type seen in the more unfinished works is now deployed within the full range of light and dark values, and the head has all the convincing mass and volume of a completed work. The fine highlights of the curls, which betray their origins in Leonardo's metalpoint drawings of the 1480s (see e.g. fig. 6), provide teasing evidence of the level of overall finish and care the picture might have received if fully completed. The hand and sheet of music – which appear

IN PURSUIT OF PERFECTION

to be painted over an initial laying-in of the costume – were covered by an old restoration until the early twentieth century and have suffered somewhat from that experience.[25]

The *Portrait of Cecília Gallerani* (cat. 10) was executed at about the same time – probably in 1489 – as the *Saint Jerome*,[26] and shows Leonardo's system of flesh modelling carried to completion. The potential of the techniques so readily seen in the unfinished works is now fully realised. The picture has again been developed from a cartoon transferred to the gessoed walnut panel, this time probably by the traditional pouncing technique: rubbing charcoal dust through tiny holes pricked through the preparatory drawn cartoon, leaving a pattern of small dots, or *spolvero*, on the panel surface.[27] The dots were then joined by the now familiar brushed drawing, on top of which would have been applied the *imprimitura* which in turn provided the non-absorbent base for the paint layers that followed. It is not certain whether the image was first made as a single completed cartoon or assembled from separately drawn elements, as often done in the Verrocchio work-shop.[28] Cecilia's right hand, which has some affinity to the (reversed) pose of Saint Jerome's proper left hand, is very distinctive and finely resolved, although slightly large in scale relative to the head. Its pose is one which would recur in many later works, thereby suggesting some system of reuse of preparatory cartoons or drawings, sometimes in markedly differing scales.[29]

This portrait is highly finished, with a striking plasticity and an impressive variety of convincingly rendered textures. The smooth and translucent half-tones of the sitter's face are produced by the careful applications of lighter colours, rich in lead-white, pulled over the under-lying darker modelling – which itself may lie above or below the *imprimitura*. The picture's X-radiograph reveals the extent of these covering scumbles (lighter colours applied over darker tones) and highlights, which leave the underlayers to show through in varying degrees to achieve the desired effects of modelling (fig. 37). The density of the X-radiograph suggests that within the face this coverage of the undermodelling is quite extensive, if not so opaque as to eliminate its optical influence. The deepest shadows of the flesh are for the most part achieved by applying a final dark glaze to the scumbled half-tones, which is shown by the relatively high X-ray opacity of

darker areas such as the shadow of the inside edge of the sitter's right eye socket. By comparison, the small shadow below the lower lip appears darker in the X-radiograph, indicating that its darker tone is created in larger part by the thinly covered undermodelling. The relative thickness of build-up of the lighter areas is indicated by the difference of X-ray opacity between the lit and shadowed hands; the latter is barely visible in the X-radiograph, not because it is unfinished, but because the artist has skilfully manipulated the undermodelling to achieve the desired distribution of light and shade within the image.[30]

As the result of subsequent restorations, the overall impact of that careful modelling now appears even more emphatic than was perhaps intended. The present black background was added much later, probably in the early nineteenth century. Leonardo appears to have given the background a blue-grey colour, also seemingly modelled from light to dark in keeping with the fall of light on the figure from right to left.[31] While the modelling of the figure would have been no less impressive, the cooler palette must have given the picture a quite different over-all impact – perhaps more graceful and decorative. The repainting of the background seems to have followed the repair of some damage to the panel.[32] It is interesting to speculate on the degree to which it was influenced by other Milanese portraits by Leonardo and his studio which were indeed painted with black backgrounds; in these works the resulting higher tonal contrasts focused the viewer's attention on the accentuated fall of light and the creation of relief (*rilievo*). In the *Portrait of Cecília Gallerani* this plastic modelling of the figure is remarkable, even with the now solid black background, but the equivalent graduated modelling of Leonardo's lighter background must have played a significant role in the original effect. It was at about this time that he wrote that the painter must 'always contrive also to arrange the figures against the background in such a way that the parts in shadow are against a light background and the illuminated portions against a dark background'.[33] Though difficult to determine from the available evidence, it is quite possible that this lighting device was used for *Cecília Gallerani*. Certainly the painter followed his own advice in lighting the torso behind the fingers of the sitter's projecting hand. His description of how to increase the

projection of arms crossed before a sitter's torso applies equally well to Cecilia's fingers:

> ... show, between the shadow cast by the arms on the breast and the shadow on the arms themselves, a little light seeming to fall through a space between the breast and arms; and the more you wish the arm to look detached from the breast the broader you must make the light.[34]

By contrast, in the *Belle Ferronnière* (cat. 17) the sitter's arms are held close to her sides, her hands concealed by the foreground parapet, and the background is solid and unmodulated. Such formal differences between it and the *Cecilia* may be in part explained by the differing demands of decorum appropriate to the respective sitters.[35] The slight twist of the *Belle Ferronnière*, with her barely tilting head, is no less sophisticated, however, despite the painting's greater formality. The basic technique of the flesh painting is very similar to that of *Cecilia Gallerani*; the initial tonal undermodelling provides the essential foundation for carefully applied scumbles of lighter colours, which are in turn selectively glazed down. The resulting highlights, half-tones, reflected lights and shadows (and the transitions between them) are orchestrated to create an utterly convincing illusion of the play of light across the sitter's face. The basic method is perhaps more boldly applied than in *Cecilia*: the X-radiograph shows more contrast within the flesh painting, the more extensive areas of thinly applied paint suggesting greater use of more relatively exposed underlayers as part of the final effect (fig. 38). Also noteworthy is the network of drying cracks within the flesh paint, a feature which is absent from *Cecilia*. While a specific cause for this may never be known,

the most likely explanations – poorly drying, medium-rich, darker undermodelling or overly thick applications of upper paint layers – are consistent with the idea of a more confident, if technically problematic, application of the methods more carefully deployed in *Cecilia*. The resultant modelling, especially the play of reflected light and shadow on the jawline, has almost become a subject to rival the depiction of the sitter herself – a feeling enhanced by the portrait's static pose and dark background.

The study of light and its behaviour was of particular concern to Leonardo in the early 1490s, both as a matter of independent enquiry and as a method of producing that *rilievo* which he described as 'the summit and soul of painting'.[36] The *Belle Ferronnière* is a virtual demonstration of the fruits of that study, closely following the painter's written instructions for giving 'most grace to faces', through the use of 'a broad light, high up and not too strong' to 'render the details of objects very agreeable'. She is even placed in a setting reminiscent of his 'court arranged with the walls tinted black' within which, he wrote: 'Note in the streets, as the evening falls, the faces of the men and women, and when the weather is dull, what softness and delicacy you may perceive in them'.[37] And if the picture's primary impact lies in the treatment of the subtle gradations of tone made by the fall of light across the gently curving surfaces of the sitter's flesh, this broad, almost abstract modelling is enlivened by the meticulous rendition of the fine details within the costume – the exquisite golden embroidery of the border of her neckline, or the light that plays within the translucent folds of the chemise appearing through the juncture of sleeve and bodice. The interest in depicting such fabrics may have

IN PURSUIT OF PERFECTION

FIG. 37
X-radiograph of the *Portrait of Cecilia Gallerani* (cat. 10)

FIG. 38
X-radiograph of the *Belle Ferronnière* (cat. 17)

FIG. 39
X-radiograph detail of the *Virgin of the Rocks* (cat. 32)

FIG. 40
X-radiograph of *Saint John the Baptist* (fig. 41)
The reversed 'CR' is the collector's mark of King Charles I, a former owner, on the back of the panel

FIG. 41
LEONARDO DA VINCI
Saint John the Baptist, about 1500 onwards
Oil on wood, 69 × 57 cm
Musée du Louvre, Paris

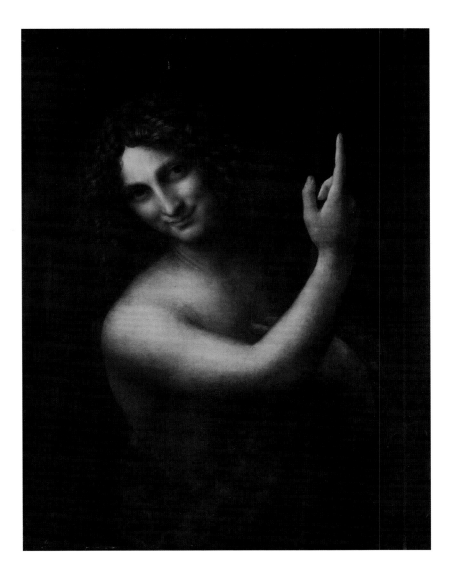

had its origin in the drapery studies of the Verrocchio workshop, but Leonardo painted them with a particular fluency and skill, perhaps most famously in the sleeve of the angel in both versions of the *Virgin of the Rocks*.

The Virgin of the Rocks

A composition of several figures like that of the *Virgin of the Rocks* allows much greater possibilities than a single portrait for the expressive manipulation of closely observed lighting effects, for in addition to the intrinsic beauty of their depiction they can also be used to enhance the narration of the subject. The two versions of the picture show Leonardo using the whole range of techniques and artistic goals found in the portraits to much more ambitious ends, while the extraordinarily complex and lengthy tale of its commission allows us to follow the better part of nearly 25 years of Leonardo's growth and development within a single composition.

The details of that commission are discussed at length elsewhere within this volume.[38] Most scholars now believe that the version of the picture now in the Louvre (cat. 31) was begun in 1483 for the Confraternity of the Immaculate Conception of San Francesco Grande, Milan, as part of a group of pictures designed to go within a large wooden altarpiece containing sculpted figures and reliefs which had just been completed by Giacomo del Maino.[39] Contractual disputes in the early 1490s about the value of the completed work probably resulted in it eventually being sold to a third party. A replacement version of the picture – the panel that is now in the National Gallery (cat. 32) – was most likely begun at about this time,

though not completed to the satisfaction of the Confraternity until 1508, when the final payment was made.

Unfortunately the present condition of the Louvre painting somewhat compromises our appreciation of its qualities. The picture was transferred from panel to canvas in 1806, perhaps because it had already suffered; alternatively, the transfer process itself resulted in considerable paint loss.[40] The transfer also involved the application of a new lead-white ground behind the original paint layers, which both disrupts the optical relationships within the original material and distorts the information available from conventional X-radiography. Nonetheless, recent technical examinations have provided important information concerning the picture's technique. Infrared reflectography shows that the composition was laid out with a comprehensive underdrawing, which is probably again the result of the combination of traced elements from partial cartoons with more freely drawn elaboration.[41] The one surviving design element is also to be found at the Louvre: a partial cartoon, first drawn in metalpoint and then itself worked up with ink and brush, for the head of Saint John the Baptist (cat. 41). This drawing has been pricked for transfer and also shows signs of tracing incisions, and its contours align perfectly with those of the painted head in the Louvre picture; its survival as a working tool for a completed painting by Leonardo is unique in his oeuvre.[42] The Louvre version's underdrawing is now in some ways a clearer record of the composition than the painting itself, obscured as that now is by losses, overpaint and degraded varnishes. It shows important features which are not otherwise readily apparent, such as the rippling of water in front of the rocks of the foreground. It also reveals evidence of compositional changes, one of which is of fundamental iconographic significance: the famous pointing right hand of the angel was added by Leonardo quite late in the day; he first drew the hand supporting the infant Christ in a manner similar to the later London version, the pose of which had previously been interpreted as a refinement of the seemingly old-fashioned narrative device now evident in the Louvre painting.[43] The changed positioning, which has important implications for the picture's intended degree of emphasis on the Baptist, was carefully studied some distance into the project. A black chalk drawing now in the Royal Library at Windsor (RL 12520) almost certainly copies

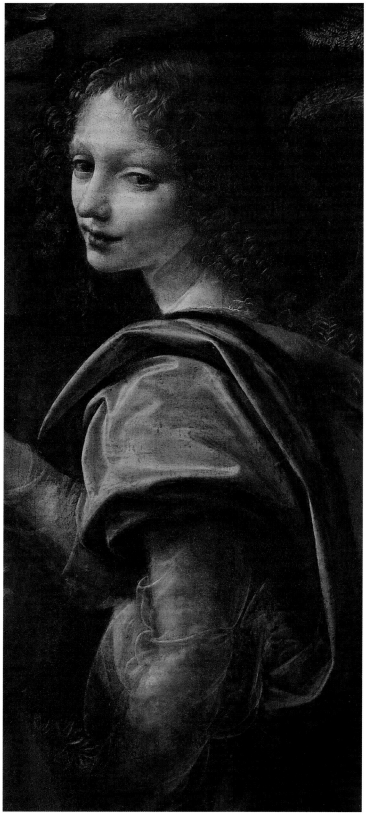

CAT. 31 (detail)

IN PURSUIT OF PERFECTION

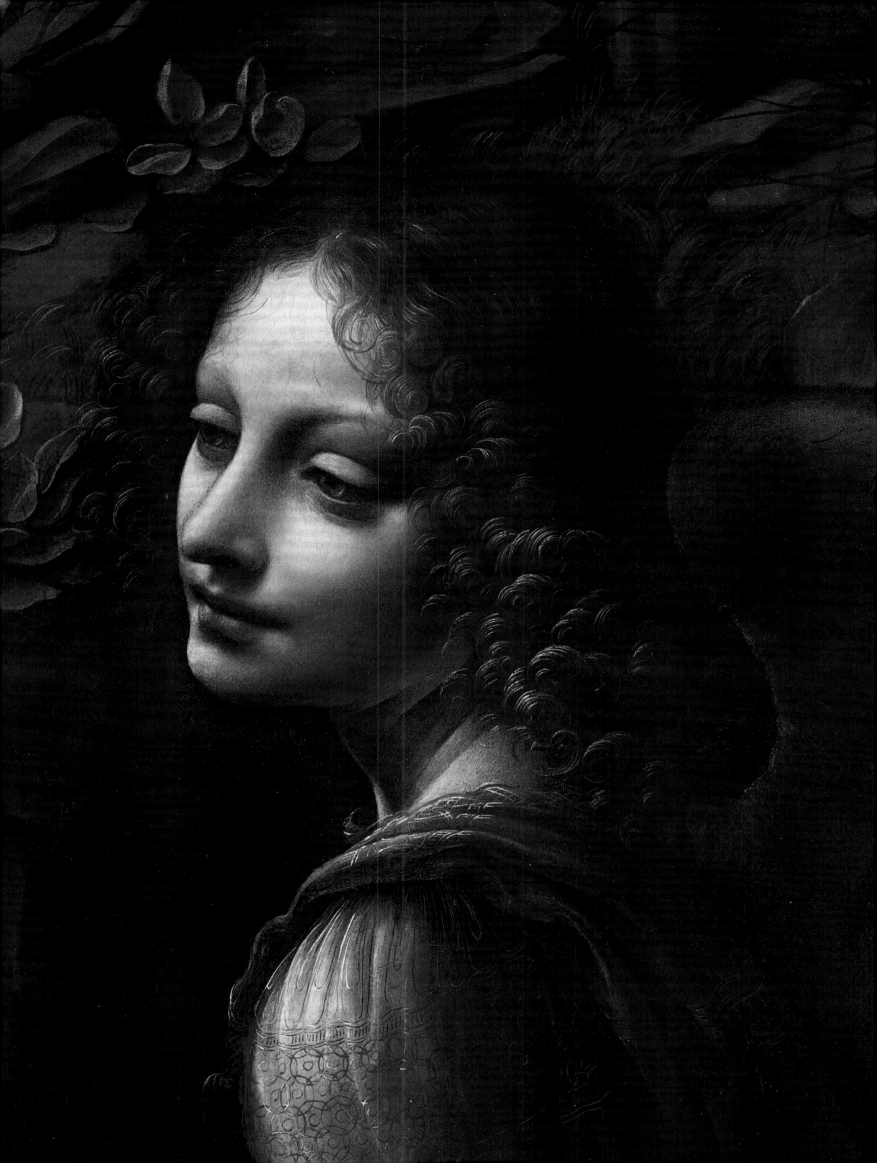

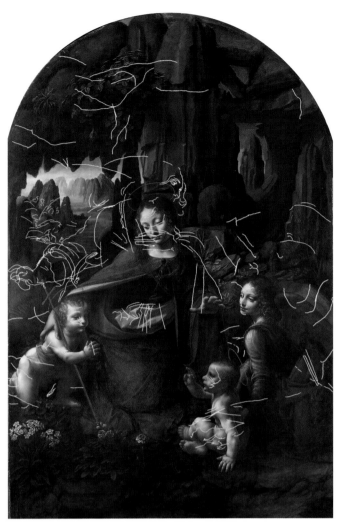

FIG. 42
Diagram of hidden composition in
the London *Virgin of the Rocks* (cat. 32)

a lost original by Leonardo.[44] Before the composition was
laid out on the panel Leonardo probably made similar
drawings for the heads of all the protagonists, as he did
for Saint John. Both provide early examples of Leonardo's
lifelong habit of working out detailed elements within
larger compositions through the targeted use of highly
finished drawings, studies that may even have been
made after painting had begun, a practice which is most
famously evident in the next decade during the execution
of the *Last Supper*.[45]

The Louvre *Virgin of the Rocks* (cat. 31) is a significant
advance on Leonardo's previous work (coming just after
the *Adoration*). For the first time we have a multi-figure
composition that is fully completed, set within a remarkably
complex landscape. Even in its compromised condition
the picture demonstrates a remarkable level of execution:
surviving details of hair, draperies and foliage display a
sustained degree of finish, equal to any of his portraits.
More important, each detail is carefully calibrated within
a larger scheme of relationships of colour, tone and illumi-
nation, which are coordinated across the whole of the

composition – an interest of increasing importance to
Leonardo, and one even more evident in the better-preserved
version of the painting now in the National Gallery.

The National Gallery *Virgin of the Rocks* (cat. 32) might
seem to be a simple reprise or variation of the Louvre
painting, but research undertaken in 2005 has made it
clear that its production was a more convoluted process
than its appearance suggests. Surprisingly, the panel was
begun with a wholly unrelated composition which appears
to be closely connected to compositional sketches for the
Adoration of the Christ Child at Windsor and in New York
(fig. 42, cats 30 and 40). The principal elements of the
kneeling Virgin of that initial composition are revealed
by infrared reflectography. Drawn with the brush in a
liquid medium, her head and left hand are based on some
sort of mechanical transfer from partial cartoons, while
the drawing of her drapery and right hand is much more
free and improvised, the latter in particular still sketchy
and unresolved (fig. 44).[46]

The relationship of this now hidden composition to
other works by Leonardo is of fundamental importance
for our understanding of the working practices of his
studio. The designs of the Virgin's head and left hand
appear in other works, a clear indication of the existence
of partial cartoons, sometimes rescaled, for these features,
as well of as the reuse and recycling of such elements

FIG. 43
GIOVANNI ANTONIO BOLTRAFFIO
and MARCO D'OGGIONO
The *Grifi Altarpiece* (detail of fig. 98), about 1497

IN PURSUIT OF PERFECTION

FIGS 44, 45
Infrared reflectography details
of the London *Virgin of the Rocks*
(cat. 32)

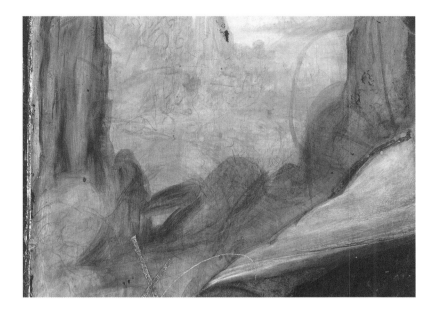

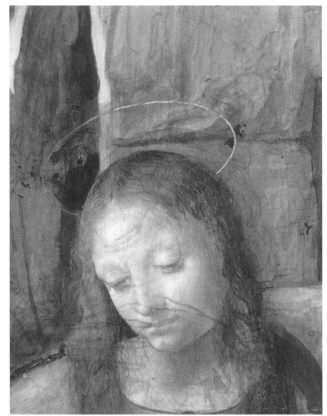

for a variety of purposes. The pose of the hand (fig. 44) appears in the *Last Supper* (fig. 46), as well as in *Portrait of Cecilia Gallerani* (cat. 10) and the *Grifi Altarpiece* (fig. 43) – a documented work by Boltraffio and Marco d'Oggiono – both of which can be dated to the mid-1490s.[47] The underdrawn Virgin's head (fig. 45) is extremely similar to a reversed image of the head of a youth (cat. 76) used for Saint Philip in the *Last Supper*, probably planned at about the same time as the London *Virgin of the Rocks*.[48] The dating of these various works, from about 1489 to 1493, is also consistent with the documents of the initial contract

dispute concerning the *Virgin of the Rocks*, shortly post-dating December 1490, providing further confirmation of the starting date of the London work – and thereby clarifying its relationship to the painting in the Louvre. Interestingly, the preliminary sketch in the Royal Collection, which is closest to the initial composition of the National Gallery picture, also contains architectural elements that are closely related to features that appear within the unfinished *Saint Jerome*; this reinforces the evidence provided by its walnut support for dating this picture to Leonardo's Milan years, started most probably in the very late 1480s.[49]

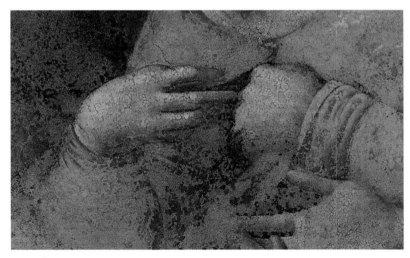

FIG. 46
LEONARDO DA VINCI
The Last Supper (detail of fig. 100 showing
Saint Philip's hands), 1492–7/8

CAT. 10 (detail)

The reasons for the abandonment of the composition underneath the National Gallery's *Virgin of the Rocks* in favour of one based on the Paris picture remain unclear, although it is not the only example of such an occurrence within Leonardo's studio.[50] The first composition, which was initially applied directly on the gesso, was subsequently covered with a thin off-white *imprimitura* layer consisting of predominantly lead-white and black in a medium of linseed oil.[51] It may have been elaborated to some degree over the *imprimitura*, as we have seen in the *Adoration of the Magi* and the *Saint Jerome*. In any event another *imprimitura* layer was applied to panel, this time also containing a little lead-tin yellow; this ingredient probably had some function in reducing the subsequent visual confusion resulting from the superimposition of the second (present) design – closely based on the picture in the Louvre.[52] However, the final design was not just a simple repetition of the Paris painting: for example, the rocky grotto now extends to the top of the image, covering most of the sky that appears across the top of the Louvre picture. This gives a greater sense of the figures being placed within the confines of the rocks.

The second composition also appears to have been developed in Leonardo's customary manner from a combination of the mechanical transfer of partial cartoons and freehand drawing. Indeed, while parts of the two versions of the *Virgin of the Rocks* appear to match nearly perfectly, the relative positioning of individual elements varies significantly, as would be expected to result from this practice.[53] Further evidence for Leonardo's sustained use of partial cartoons in the early 1490s can be seen in the development of the design and placement of Christ's head. The pure profile of the finished figure is a departure from the slight twist and tilt of the Paris picture, and was achieved through the use of a red chalk drawn study (cat. 45) (the use of red chalk suggests a dating after the commencement of the London painting).[54] However, Christ's head was first drawn and painted in a pose taken directly from the same cartoon, simply reversed, that had been used for the head of the Baptist in the Louvre painting (fig. 41).[55] Other drawings associated with the picture suggest the perseverance of the habit of assembling larger compositions from partial cartoons, or at least the focused exploration of specific elements through drawings executed well into the project,

such as the black chalk study for the kneeling angel's drapery in the Royal Collection (cat. 47).[56] Indeed, slight anomalies in the placement and spatial relationships within the image reinforce the impression of an assembled composition; for example, we gaze down on the heads of the Baptist and the angel slightly more than we do on that of Christ, who is placed significantly lower – and whose feet hover somewhat unconvincingly over what appears to be a slight void in the rocky foreground shelf.[57] And even after his figures were substantially painted Leonardo might go on revising their poses, adding new contour lines or reshaping the Virgin's mantle as it falls across her shoulders. A composition might remain provisional until very late in the day.

Nonetheless, in spite of these inconsistencies the painting has a new and remarkable unified coherence created by a carefully considered manipulation of lighting, colour and tonal values. This has been achieved using the same basic array of methods and materials, but the resultant effects show how these skills have been put to the service of a new enquiry into the nature of vision, the behaviour of light and the potentialities of painting itself. The closing off of the sky has allowed Leonardo to manipulate the light to fall more selectively within the darkened grotto, with a resultant spotlit effect that gives expressive contrasts between strong highlights and less well-defined shadows. The sense of volume and space is also enhanced by the way the light falls within and among the spaces between the forms, as in the *Portrait of Cecilia Gallerani* – here picking out the front of the Baptist's left foot or the angel's right arm, and in so doing emphasising the volumes of the shadowed spaces around them.[58] The shadowed areas are themselves relatively blurred and indistinct in colour, and thereby essential to the creation of Leonardo's principal goal of creating *rilievo*.[59] There is a greater concern with the accurate depiction of the softened transitions between light and dark, and an informed awareness of our limited ability to perceive forms which are subsumed in darkness. The early 1490s were a period of intense research into optics and the physiology of vision for Leonardo, and the London *Virgin of the Rocks* clearly shows their artistic consequences. His writings describe the painterly goals of such a work: 'When you transfer to your work shadows, which you discern with difficulty and whose edges you cannot distinguish, so that you perceive

them confusedly, you must not make them definite or clear lest your work look wooden as a result.'[60] This is the basis of the concept of *sfumato* – a term defined many years later by Galileo Galilei (1564–1642) as a way of 'passing without crudeness from one tone to the next, by which paintings emerge soft and round, with force and relief'.[61]

Sfumato has come to describe both an aesthetic effect and a technique for achieving it; its technical underpinning is found in Leonardo's development of his systematic monochrome undermodelling, for the National Gallery *Virgin of the Rocks* had a comprehensive underpainting at least as developed as that of the *Adoration* or *Saint Jerome*.[62] This underpainting lies at the heart of his control of modelling transitions, as we have seen in the portraits; we can now see in X-radiography (fig. 39) how the use of the underlayers has become even more prevalent in the flesh painting, with the application of predominantly lead-white containing flesh tones becoming ever more targeted and selective.[63] Furthermore, the level of completion and state of preservation of the picture allow us to see how the underpainting was also used in the depiction of fabric and landscape. The basic method of selectively heightening and glazing down the underpainted tones can easily be seen in the painting of foreground rocks, while the relatively unfinished state of parts of the picture such as the hand of the angel, the right foot of the Baptist or the middle-distance landscape above him shows more of how this stage of painting was to be subtly incorporated within the look of the final image. While many of the less completed-looking areas owe their appearance more perhaps to the vagaries of Leonardo's working habits than to deliberate artistic intent, the looser handling of the underpainting also has had an important influence on much of the intended finish.[64] For example, the sleeve and tunic of the angel show a remarkable combination of this looser tonal undermodelling punctuated with the most precise and meticulous rendering of the fabric's embroidered details, selectively applied to mimic the effect of the fall of light across the diaphanous folds of the fabric.

Less immediately apparent to the viewer, however, is the way that this systematic tonal underpaint has also become an essential component of Leonardo's handling of colour. He was perhaps the first artist to understand that we lose much of our ability to perceive colour at lower light levels – in other words, that all colours are more or less black in the dark.[65] Therefore the shadows of the yellow lining of the Virgin's mantle below her outstretched hand tend toward the same browny-black colour as the darks within the blue mantle itself, the angel's draperies or indeed much of the landscape. From a tonal point of view, the London *Virgin of the Rocks* is much like the unfinished *Adoration of the Magi*; however richly coloured parts of the London picture may be, that colour sits within a consistent, unified range of values – particularly within the darks – that are first established in the brownish, virtual monochrome underpainting of the sort so clearly visible in Leonardo's unfinished works. This was a key insight into how vision functions and one with fundamental artistic consequences: the softened contours and eroded chroma of the darks in Leonardo's Milanese paintings show a radically different artistic intent from that found in the work of most of his contemporaries, who usually depicted colours which kept a relatively high degree of colour saturation as they grew darker – particularly in drapery. Colours are still balanced and co-ordinated with one another; in fact, the angel's mantle was changed from a more intense red to the present more subdued version of the Virgin's blue and yellow drapery as part of that process of considering colour relationships across the whole of the composition.[66] Nonetheless, colour is now used within a larger conception of how light works and vision functions, resulting in an understated pictorial unity that is an important departure from the more traditional fifteenth-century balancing act of setting intense localised colours against one another – a development that can be seen in the comparison of the two versions of the *Virgin of the Rocks* themselves.[67] Thus the technique of using the brownish underpainting, a method which can be traced back through Leonardo's early works to Verrocchio himself,[68] is now the principal means of expressing newer artistic aims.

It is interesting to consider this phase of the painting, which would have looked essentially like a large-scale washed drawing, in the context of the new appreciation of cartoons as finished works of art in their own right. So-called *cartoni finiti*,[69] such as the National Gallery *Virgin and Child with Saint Anne and the infant Saint John the Baptist* (cat. 86), allowed Leonardo an even greater concentration on the use of light and shadow to provide relief and tonal unity. The resultant work deliberately rivals his paintings

FIG. 47
MICHELANGELO BUONARROTI
(1475–1564)
The Holy Family ('Doni Tondo'),
about 1504–6
Tempera on wood, diameter 120 cm
Galleria degli Uffizi, Florence

FIG. 48
LEONARDO DA VINCI
Virgin and Child with Saint Anne,
about 1501 onwards
Oil on wood, 168 × 130 cm
Musée du Louvre, Paris

in its monumentality and plasticity, and also demonstrates the growing importance of his need to consider orchestrated lighting and tonal effects across the whole of a composition from its inception.

The colour within a work such as the *Virgin of the Rocks* is not entirely subsumed within a system of tonal values; the yellow lining of the Virgin's mantle at her waist is nearly as hard and sculptural as anything within the *Doni Tondo* (fig. 47), but unlike Michelangelo's painting, its handling is an accent within the whole of the work which results from Leonardo's careful orchestration of directed lighting to serve the needs of his narrative. The ultramarine of Mary's mantle has deteriorated and lost much of its original intensity,[70] but it would have been nearly as strongly coloured as the yellow lining, further emphasising the Virgin's importance. The picture therefore shows a new balance between this more traditional narrative-based manipulation of colour and Leonardo's newly informed optical realism, and the question of the relationship between the more abstract notions of ideal beauty and the hard-won truths of empirically observed nature has now become a fascinating aspect of how it was created. In works like the *Last Supper* or the Louvre *Virgin and Child with Saint Anne* (fig. 48) this will lead to a greater interest in depicting optical phenomena within a higher-keyed, lighter palette, but in the National Gallery *Virgin of the Rocks* Leonardo is more resolutely interested in the visual consequences of selectively lighting a darkened setting.

Writing some fifty years later, the architectural patron and theorist Daniele Barbaro (1514–1570) described how a 'painting made with soft contours and *sfumati* brings one

to understand what one does not see',[71] and it is certainly true that most of the paintings Leonardo made in his first period in Milan are primarily concerned with the effects created by strong lighting contrasts and deep shadows. Leonardo wrote that 'painting originates in the shadows and the light, or if you wish, brightness and darkness. Therefore he who avoids shadows avoids what is the glory of the art.'[72] Of course it was the oil medium that allowed him this exploration; its long drying time and improved pigment saturating qualities enabled him to make subtle and important distinctions in colour and tone, especially within the darker passages of his paintings.[73]

Unfortunately the umber and black pigments generally used in such darker areas are inherently less well-suited to the creation of a physically tough, chemically robust paint layer upon drying, and so the majority of his paintings show significant physical defects in such areas. Ultramarine was another poorly drying pigment, particularly when used in a relatively pure application with very little added lead-white – as Leonardo was inclined to do for his draperies.[74] As a result, many of his pictures show extensive regions of broad, irregular cracks which relate to shrinkage during the initial drying of the paint film, while other areas display disturbingly wrinkled surfaces which appear to result from differential drying times between superimposed paint layers. The prevalence of these phenomena, combined with the famous technical failures of the *Last Supper* or *Battle of Anghiari* murals, could lead to the conclusion that Leonardo was a somewhat reckless technical experimenter. However, the recent restoration of the London *Virgin of the Rocks* has allowed the opportunity for a new study of its painting materials, a range that

IN PURSUIT OF PERFECTION

is quite conventional for his time: walnut and linseed oils, both raw and heat-bodied, and a selection of pigments that are wholly in keeping with those of his contemporaries.[75] The technical problems largely result from the new artistic demands Leonardo made of these materials. It was an unfortunate coincidence that his new emphasis on modelling within the darker tonal values aligned almost perfectly with the range of pigments least well suited to the oil media he employed. These areas were therefore more vulnerable to anything less than perfect technique, such as overly thick paint applications, excessive medium-to-pigment ratios or inadequate drying times between layers. Furthermore, using these materials was still relatively new, so there was probably less of an embedded craft tradition within the artist's workshop, especially for the depiction of new effects. Leonardo was not the only artist whose works suffer from such technical defects,[76] although his extensive use of darker underpainting and associated emphasis on darker tonal values has increased their prevalence. Interestingly, among his Milanese pupils and associates such defects seem more strongly associated with painters who themselves had intellectual ambitions, such as Boltraffio, who appears to have thought more about the purposes of his technique than about the simple appearance of his paintings.[77]

The studio and the problem of collaboration

The question of the nature and degree of collaboration between Leonardo and the members of his studio during his years in Milan is one of the more interesting problems surrounding his activity. Of course, the delegation and sharing of the work of making pictures was common practice, but the particular circumstances of Leonardo's need to quickly create a studio capable of producing paintings, sculpture, courtly entertainments and other activities meant that he worked closely with established Milanese painters as well as training his own apprentices.[78] We have seen how drawings and cartoons such as those of the hand of *Cecilia Gallerani* or the head of the Baptist from the *Virgin of the Rocks* were shared and recycled within the studio, whether by Leonardo himself or by his pupils,[79] but this pattern of cooperation often also seems to have been extended to the process of painting. Vasari mentions that 'there are certain works in Milan that are said to be by

Salaì, but retouched by Leonardo'[80] – a remark that may be taken as a shorthand reference for a much larger group of paintings made within the studio, many of which are smaller format, half-length Madonnas with the infant Christ. These range from wholly derivative workshop productions to paintings of very high quality, including works where the degree of participation between Leonardo and his studio is still a matter of ongoing debate (such as cat. 48 and particularly cat. 57).[81] Such a practice, well-established in Leonardo's Milanese workshop during the 1490s, was maintained during his stay in Florence at the beginning of the sixteenth century. Fra Pietro da Novellara, who was acting as an agent for Isabella d'Este in her attempts to secure a painting by Leonardo, describes how 'two of Leonardo's pupils are doing some portraits and he from time to time put a touch on them'.[82] He also mentions 'a little picture that he [Leonardo] is doing for one Robertet, a favourite of the King of France', clearly a reference to the *Madonna of the Yarnwinder*, a composition that survives in two principal versions. Neither is fully faithful to Novellara's description, perhaps suggesting that a finished cartoon has been lost, but both have accomplished underdrawings with freehand components and the Buccleuch version in particular is widely thought to be attributable to a considerable degree to Leonardo himself (see cat. 88).[83]

The exercise of specifically attributing the various parts of the many such paintings that emerged from the Leonardo workshop to individual members of the studio is fascinating but perilous, and probably anachronistic. It particularly needs to be stressed that the most effective imitations of his style needed to display some measure of understanding of his techniques. This is a difficult enough matter in the context of the production of multiple versions of compositions such as the *Madonna of the Yarnwinder*, which were repeated for their commercial potential. But the question is much more complicated for a painting like the National Gallery version of the *Virgin of the Rocks*. Its particular history, with its abandoned underlying composition and discontinuous execution, has resulted in unintended variations in finish and inconsistencies in materials which might suggest different hands at work. Here, however, any perceived lack of consistency in its materials and handling can also be seen as a measure of Leonardo's changing methods over the 15 years or so of

its execution. Its technical infelicities have more to do with his new painterly ambitions than with a lack of competence, and as a result they have a ring of authenticity about them that would not necessarily apply in another context.

The late style and technique

To judge from his writings, Leonardo did not seem to be deeply interested in exploring the inherent visual or handling properties of the various painting materials *per se*. As a result, the technical failure of a mural like the *Last Supper* could be said to result as much from a kind of technical conservatism as from failed experimentation. There is no written evidence of Leonardo thinking about how to translate his interests and discoveries about the action of light or the creation of *rilievo* into traditional fresco technique, perhaps because it seemed self-evident that the medium was inherently incapable of creating saturated dark tones. His solution was to recreate the essence of panel painting technique for the execution of a large-scale mural. Writing in 1544, Matteo Bandello (about 1480–1562) famously describes seeing Leonardo at work on the *Last Supper* in the varied, improvisatory and often more contemplative manner of the easel painter using oils: he might work for long stretches, or simply stand and stare.[84] At any rate, he designed a method that could be slow.

Leonardo built up the work from a calcium carbonate ground onto which was applied a thin lead-white *imprimitura*, after which the colours were applied over a systematic tonal undermodelling.[85] The technique was poorly adapted for mural painting, especially on a damp wall, and the results were very short-lived.[86] Enough of the work survives, however, to suggest something of the new directions and interest his painting was to take after he left Milan.

Although this is perhaps dictated in some degree by its unusual technique, the *Last Supper* nonetheless shows a distinct shift away from the use of strong lighting, with a resultant compression of the tonal range, at least within the figures.[87] Its *imprimitura* is brighter and the tonal undermodelling less telling in the final result. There seems to be less interest in the creation of emphatic modelling through the use of strong shadows, and instead an increasing concern with the more subtle distinctions between half-tones. One of the first expressions of these

interests in a more traditional easel painting format is to be found in the *Mona Lisa* (fig. 32). Even with its present discoloured varnishes the picture is notable for its luminous qualities, achieved through thin build-ups of medium-rich colours applied over a pure white *imprimitura*.[88] Unity and modelling are now achieved primarily through the variation of colour intensity, not by the domination of colour by strong tonal modelling. The placing of the figure before the light colours of the receding landscape is quite revealing of a different approach; perspective is achieved by making the colours increasingly pale as the landscape recedes, a studied manipulation of colour mimicking the effect of atmosphere on our perception of distant objects. A similar luminosity is achieved in the flesh painting by the use of increasingly thin paint layers and the application of thin translucent shadows over the pale ground – with considerably less use of strong undermodelling.[89] These stylistic and technical changes are the consequence of very different choices about lighting, which in turn reflect different intellectual interests about the behaviour of colour in the absence of strong shading.

The Louvre *Virgin and Child with Saint Anne* (fig. 30) is conceived in a very similar way. Its poplar panel has also been coated with the more coarse *gesso grosso* preparation, followed by the finer *gesso sottile*, on top of which has been applied a pure lead-white *imprimitura*. The design has been transferred from a cartoon – presumably a single comprehensive cartoon of the type now in the National Gallery[90] – and shows signs that this mechanical transferred drawing was again elaborated with freely brushed drawing. There are minor adjustments to the leg, foot, and left hand of Christ, while a more major pentimento is to be found in the covering of Saint Anne's right hand, which was originally placed on the Virgin's left hip, with an extension of her red draperies.[91] The pure white priming is essential to the build-up of the paint layers, particularly in the flesh tones, which are extraordinarily thin and medium-rich. If the Milanese works were unified by the consistent application of uniformly dark shadows, here the pictorial harmony is enhanced by the luminosity of the ground and the progressive lightening of the colours within the receding landscape.[92]

The prominence of the distant landscape is a reflection of Leonardo's theoretical explorations of the effect of

atmosphere on the appearance of distant objects, which is discussed at considerable length in his writings.[93] He had previously depicted convincing aerial perspective within darker works such as the *Virgin of the Rocks*, but in the *Virgin and Child with Saint Anne* it dominates the whole of the background and is a key element in the painting's construction; it provides a different sort of contrasting *rilievo* for the foreground figures, one based on differing degrees of colour saturation rather than on their illuminated projection from a gloomy matrix. The paint application has the same washy quality as the earlier handling of his underpainting, but this is now used for the final colours themselves; essentially placed directly on the priming without any intermediary modelling, the colours preserve the desired high-keyed luminosity – particularly in the flesh. The modelling of that flesh is now achieved through extremely sparing use of lead-white in the highlights, and great care has been taken with the soft and gradual blending of the medium-rich application of darker tones in the shadows – colours which nonetheless preserve something of the luminosity of the underlying *imprimitura*.[94]

The delicacy of this manner of flesh modelling is also present – albeit now somewhat obscured by discoloured varnish – in the *Saint John the Baptist* (fig. 41).[95] It is painted on walnut, and the combination of dry and wet under-drawing – the former from the cartoon transfer and the latter from its brushed development – is characteristic. However, the solidity of the black background makes the differences between its flesh painting and that of the earlier Milanese portraits all the more apparent; its low pigment densities barely register in X-radiographs (fig. 40), and such tonal modelling as may exist appears to be translucent and reddish, not dark, and therefore more in the service of establishing distinctions of colour intensity and saturation than tonal value.[96] The modelling within that flesh painting is so infinitesimally gradual as almost to

defy our ability to distinguish any transition at all, and the final suggestive and ephemeral effect it produces belies the extraordinary effort that must have gone into its creation.

This higher-keyed, translucent late style was to have the greatest impact on subsequent painters, although the influence of such works on Leonardo's contemporaries was not as great as might be expected. The three great late, finished works – the *Saint John the Baptist*, the *Virgin and Child with Saint Anne* and of course the *Mona Lisa* – went with him to France and so were not much seen by Italian painters, while many of the works which remained in Italy were hidden, unfinished or quickly damaged. Milan's cultural importance declined in the sixteenth century, so that those works which remained there were less likely to stimulate a significant artistic response.[97] The exception to this was Florence; the years Leonardo spent there in the first decade of the sixteenth century, and the brief visibility of the cartoons and of the *Mona Lisa* (whatever its state of completion), were to have a decisive influence on the work of artists such as Raphael, Fra Bartolommeo and Andrea del Sarto. Nonetheless, in spite of some outward technical similarities, it would seem that these artists responded more to the challenges posed by his compositional devices and formal structures than to his actual painting technique.[98] The essential quality of Leonardo's artistic endeavour, that near-total identification between abstract intellectual enquiry and the making of pictures, is largely absent, and so the level of engagement with the thinking behind his pictures is somehow diminished. It is in a sense a repetition of the dynamic that existed between the master and his pupils in Milan, albeit at a much higher level of quality; however much the outward appearance of the works exerted a significant influence, the heart of the matter of their production, informed as it was by such a singular intellect, remained by its nature elusive.

1 Brown 1998a, pp. 23–73; Brown 1998b; Dunkerton 2011.

2 Farago 1991, p. 67.

3 While Leonardo clearly intended to compile a formal treatise on painting, the so-called *Trattato della Pittura* was compiled in the sixteenth century from his notebooks after his death (mostly from C, A, E and BN 2038). See Clark 1939, pp. 125–9.

4 See Hills 1980.

5 See Dunkerton and Roy 1996, pp. 30 and 31 n. 20, and Serra 2000, p. 97, on the use of oil in late fourteenth-century Florentine painting. Verrocchio seems to have been consistent in his adherence to egg tempera: Dunkerton (Dunkerton and Syson 2010, p. 19) shows Verrocchio's *Madonna and Child with Two Angels* (NG 296) to have been painted entirely in egg. See Dunkerton 2011, pp. 18–19, on the importance of the Pollaiuolo brothers for the introduction of oil painting in Florence, and a full study of Leonardo's training and early work within the Verrocchio workshop, also described in detail in Dunkerton 2011, pp. 6–16. See also Brachert 1969, pp. 88, 94, 101.

6 It has been plausibly suggested that Leonardo may have worked on the picture again during his return to Florence, although this has not been corroborated by any technical means. His habit of reworking his underpainting above and below the *imprimitura* would make it very difficult to establish this categorically.

7 Urb. fols 61v–62r; MCM 261; K/W 571. See Gombrich 1966, pp. 58–63 on the implications of this new use of drawing, and Kemp 2003, p. 144, on Leonardo's 'brainstorming' methods of evolving compositions in his drawings.

8 The gesso was applied with the finer *gesso sottile* laid over the coarser *gesso grosso* undercoat; see Seracini 2009b, p. 98.

9 See Syson and Billinge 2005, p. 460; Serra 2000, p. 95; and Bellucci et al. 2000, p. 116, for examples of use of partial cartoons.

10 The use of oil for the *imprimitura* has not been analytically confirmed here but has been found elsewhere: see Keith et al. 2010, pp. 75 and 79 n. 15, and Keith et al. 2011, p. 43. The underdrawing for the *Adoration* has been identified as lamp black drawing pigment in a gum medium (Seracini 2009b, p. 98).

11 The attribution of the various drawings among the members of the Verrocchio workshop is a matter of lengthy debate, though less important in this context than the thinking – an exploration of the fall of light upon drapery folds – which lay behind the setting of such exercises. See e.g. Cadogan 1983; Viatte in Paris 2003, pp. 60–70, cats 5–11; Viatte 2003.

12 See Camerota et al. 2006; Seracini 2006a.

13 This blue shift is particularly visible in the highlighting applied to the hair in a drawing attributed to Leonardo from about 1468–75, the *Head of a Woman looking down* (Uffizi 428E), where the effect seems to have been deliberately exploited. See London and Florence 2010–11, pp. 200–1.

14 Identified as Milanese by Strzygowski as early as 1895. See Colalucci 1993, p. 107. The figure type has sometimes however been related to anatomical studies of 1488–90; see Bambach in New York 2003, p. 372, cat. 46, and pp. 135–49 in the present volume. An inventory of pictures and other possessions in the Codex Atlanticus includes drawings for a Saint Jerome, for which see pp. 23–5 in the present volume.

15 Colalucci 1993, p. 109; Bambach in New York 2003, p. 373, cat. 46.

16 See Keith and Roy 1996 on the use of walnut wood by Milanese Leonardeschi. Walnut has been identified on the *Portrait of Cecilia Gallerani*, the *Portrait of a Musician* and the *Belle Ferronnière*; see Marani 1998d, p. 76, who cites Kwiatowski's claim that X-radiographs show that *Cecilia Gallerani* and the *Belle Ferronnière* are from the same plank of wood (Kwiatowski 1955, figs 6, 7, 8, 10). The *Saint John the Baptist* from the Louvre is similarly on walnut, which also has clear implications for its dating – recently suggested as about 1510, after Leonardo's return to Milan from Florence, although it could equally well have been begun before his departure for Florence around 1500. See Ravaud et al. 2009, p. 89; Marani 2009b, p. 56, for the later dating; pp. 46–7 in the present volume for an earlier dating. The use of walnut is typically – but not exclusively – Lombard; see Keith et al. 2004, pp. 41, 47 n. 20, p. 47 for the use of walnut in southern Italy by Polidoro da Caravaggio, whose origins were of course North Italian.

17 The *Ginevra de' Benci*, the *Adoration of the Magi*, and the *Mona Lisa* – none of which were begun in Milan – are painted on poplar. The National Gallery *Virgin of the Rocks* is also on poplar, although it is a Milanese work, presumably because of the difficulty in producing a walnut panel of such a large size. See Seracini 2009b, p. 96; Brown 1998a, pp. 101–21; Mohen et al. 2006, pp. 30–7; Keith et al. 2010, p. 73; Keith et al. 2011, p. 43.

18 Bambach in New York 2003, p. 374, cat. 46, has erroneously identified *spolveri*; Syson and Billinge believe it to be based on a tracing with freehand elaboration drawn with a brush (Syson and Billinge 2005, pp. 458–60).

19 Urb. fols 61v–62r; MCM 261; K/W 571. English translation by Bisacca in Bambach in New York 2003, p. 375, cat. 46: 'The panel should be cypress or pear or service tree or walnut. You must seal it over with mastic or twice-distilled turpentine and lead white, or if you like, lime, and put it in a frame so that it may expand and shrink according to its moisture and dryness. Then give it [a coat] of aqua vitae in which you have dissolved arsenic of [corrosive] sublimate, two or three times. Then apply boiled linseed oil in such a way that it may penetrate every part, and, before it is cold, rub it well with a cloth to dry it. Over this apply spirit varnish and lead white with a stick [brush?], then wash it with urine when it is dry. Then pounce and outline your drawing finely and over it lay a priming of thirty parts of copper resinate and one more of copper resinate with two of yellow.' See also Marani 1998d, pp. 76–7.

20 See Syson and Billinge 2005, pp. 454–5, on the implications of the design of the church for the new dating.

21 The bluish colour resulting from the optical effect of the application of white over brown is seemingly misunderstood as blue pigment by Colalucci (1993, p. 109), who also identifies mixed media in an analytically unsubstantiated manner.

22 Brachert (1969, p. 94) suggests Leonardo as the innovator of the finger technique as he 'got to grips' with the new oil medium in the Verrocchio workshop. If so, it is just one element of paint handling, seemingly used for first laying-in, and one the practice of which seems to fade away as he grows in experience. It is not to be confused with palm and fingerprints associated with the spreading of the *imprimitura* on later, larger works such as the London *Virgin of the Rocks* in a manner described by Vasari some sixty years later.

23 The underdrawing also shows a different initial design for the costume: Marani in Milan 2010, pp. 80–1, 83.

24 BN 2038, fol. 33v; R 516.

25 Marani in Milan 2010, pp. 73–7, and detailed illustration pp. 66–7.

26 Syson and Billinge 2005, p. 457; Marani 1998d, pp. 80–1.

27 This may have been done through another intermediary sheet of paper, which would have protected the original drawing. Bambach 1999a, p. 23; Bull 1998, pp. 84–5, 88 fig.10.

28 Bambach 1999a, pp. 239, 259; Syson and Billinge 2005, p. 460.

29 Leonardo's portrait of *Isabella d'Este* could be seen as an example of a full-scale comprehensive cartoon-like portrait drawing, though slightly later than the date in question (see Viatte in Paris 2003, pp. 185–9, cat. 61). On the other hand, a study of drawn hands (cat. 11) here linked to his *Portrait of Cecilia Gallerani* suggests Leonardo's use of Verrocchio-like single-element study drawings and/or cartoons; see Brown 1998a, pp. 106–7.

30 The X-radiograph is reproduced in Bull 1998, p. 86. While the build-up of the flesh tones is quite opaque in the X-radiograph, they are considerably less thick in application than in the earlier *Ginevra de' Benci*, where the modelling appears to be substantially applied over a thicker application of flesh tones. A reproduction of the *Ginevra* X-radiograph is usefully juxtaposed with that of the *Belle Ferronnière* and *Saint John the Baptist* in Mohen et al. 2006, p. 84.

31 Bull (1992, p. 87) dates the repainting of the background between about 1830 and 1870. The judgement of the shift in the modelling of the background is based on his examination of small areas along the contour of the figure where the

repaint has not completely covered the original background. Although its background is more strongly blue in colour than the traces of paint visible on *Cecília Gallerani*, Giovanni Bellini's *Doge Loredan* (NG 189, about 1501–2) is one roughly contemporary example of the visual effect of *Cecília's* missing lighter background.

32 Bull 1992, p. 87.

33 BN 2038 fol. 21v; R 552.

34 Ibid.

35 See Shell 1998a, p. 86, on the possibility of her higher social status. Both are from the same plank of wood – although there is no reason to insist that the two panels need to have been used at the same time. See also cats 10 and 17.

36 Urb. fol. 48v; MCM 107; 'la importantia e l'anima della pittura'. See Clark 1939, p. 129.

37 A fol. 23r; R 514. And BN 2038 fol. 20v; R 520. See also Zaremba Filipczak 1977, p. 518.

38 See cats 31 and 32.

39 The Del Maino commission dates from 1480. See Marani 2003a, pp.128–37 and Syson and Billinge 2005, p. 450. See also cats 31–4.

40 A payment is recorded in 1806 to 'Sr. Hacquin rentoiler' for the picture's transfer from panel to canvas: 'de enlevé de dessus bois, mis sur toile'. Another payment was made for its restoration in the same year to Jean-Marie Hooghstoel for its restoration. Hooghstoel worked on many Louvre pictures for Denon – including the *Belle Ferronnière*, which he restored in 1813. See Emile-Mâle 2008, pp. 276–7, 279 n. 23.

41 The underdrawing was discussed in detail by Bruno Mottin of the Centre de recherche et de restauration des musées de France (C2RMF) in a conference on Leonardo's technique held at the Louvre, 'Autour de la *Sainte Anne* de Léonard de Vinci', 16–17 June 2009.

42 Louvre 2347. The cartoon has been cut closely around the contours of the head; it is not possible to know when this was done or whether it originally included more of the composition. The head is also appears within a drawing attributed to Boltraffio now in the Chatsworth Collection (fig. 65) – with the same compositional crop as the cartoon element. See Viatte in Paris 2003, pp. 134–7, cat. 37.

43 See note 41. A technical report on the picture made in 2002 by the C2RMF is summarised in Franck 2011, pp. 12–13, which was kindly provided by its author before publication.

44 Windsor RL 12520r.

45 Some of these drawings must have provided the basis for partial cartoons, but the practice seems to have continued beyond the time by which Leonardo had begun making such full-size cartoons as the National Gallery's *Virgin and Child with Saint Anne and the infant Saint John the Baptist*, which dates from about 1499–1500. There are several detailed drapery studies for the Louvre's *Virgin and Child with Saint Anne*, for example, a painting the date of which suggests that it was based on a highly finished cartoon. See Bambach (1999b, p. 127) on *finiti cartoni*.

46 Large parts of the first composition are not visible under infrared reflectography (IRR). While the drawing may be in part unfinished, it seems much more likely that the design was worked up using a combination of carbonaceous materials (which show well in IRR) for the cartoon transfer and its initial elaboration, and later development of the drawing in other materials (such as red chalk) which are not discernible with infrared. This has been demonstrated to be true with the underdrawing of the *Saint Jerome*, the unfinished state of which allows us to see initial drawing with the naked eye that is less visible using infrared. See Syson and Billinge 2005, p. 460.

47 See cat. 65.

48 Building works associated with the *Last Supper* began in 1492; see Syson and Billinge 2005, p. 457; Brambilla Barcilon and Marani 2001, pp. 6–20, 408–12.

49 Syson and Billinge 2005, p. 454. Bambach in New York 2003, pp. 375–6, cat. 46, however, dates the picture to the early 1480s.

50 See Zöllner 2003 (2007), pp. 6, 246, on the presence of an abandoned cartoon transfer of a composition based on Leonardo's *Virgin and Child with Saint Anne* from the Louvre, found beneath the Giampietrino's Kassel *Leda and her Children*. On the Leonardo source of the *Leda* composition see Hochstetler Meyer 1990; on a possible relationship between the two compositions, see Nathan 1992, p. 89.

51 The ground layer contains calcium sulphate dihydrate, identified by FTIR microscopy. SEM–EDX analysis of the cross-section from the yellow lining of the Virgin's mantle indicated that the brown drawing layer below the *imprimitura* included particles containing iron (Keith et al. 2010, p. 75). Analyses carried out by Ashok Roy, Marika Spring and Rachel Morrison of the National Gallery Scientific Department.

52 FTIR microscopy identified agglomerates containing lead palmitate and lead stearate within samples of the *imprimitura*. Some lead azelate was also detected, which appeared to be more dispersed. The identification of the lead tin yellow and the presence of silicates in the second *imprimitura* layer were confirmed by energy-dispersive X-ray analysis in the scanning electron microscope (SEM–EDX). Analyses carried out by Ashok Roy, Marika Spring, and Rachel Morrison of the National Gallery Scientific Department. See Keith et al. 2010, pp. 74–7, 79 nn. 8–19. See Gould 1984 on a possible history of the Paris version of the picture.

53 This was shown with tracings on acetate made from the London picture which were tested against the Louvre painting in 2001; see also Syson and Billinge 2005, p. 462.

54 Red chalk was most commonly used by Leonardo from about the mid-1490s; see Bambach 2003, p. 24; Syson and Billinge 2005, p. 461. See Brambilla Barcilon and Marani

2001, pp. 13–21, for the various red chalk preparatory drawings for the *Last Supper* (cats 79–80) and the suggestion of the possibility of red chalk underdrawing for the mural.

55 Paris 2003, pp. 139–43.

56 Windsor RL 12521; see Clark and Pedretti 1968–9, vol. 1, pp. 92–3. The authors contend that the use of black chalk medium suggests that the study post-dates the Paris painting.

57 BN 2038 fol. 10r; R 537, in which Leonardo describes the importance of taking the height of the viewpoint into account when planning moral narratives, which seems relevant to his positioning of the outstretched hand of the Virgin.

58 See K/W 545; Nagel 1993, p. 9.

59 Nagel 1993, p. 8.

60 BN 2038 fol. 14v; R 236 (about 1492), discussed in Nagel 1993, pp. 9–10. Leonardo also describes what he believed to be the physiological cause of this phenomenon: 'The true outlines of opaque bodies are never seen with sharp precision. This happens because the visual faculty does not occur in a point … [it] is diffused through the pupil of the eye … and so it is proven the cause of the blurring of the outlines of shadowed bodies' (Nagel 1993, p. 9).

61 Quoted in Nagel 1993, p. 7.

62 Each cross-section shows something of this brownish underlayer, varying in thickness and tone as would be expected. See Keith et al. 2010, p. 75; Keith et al. 2011, p. 43; Nagel 1993.

63 The painting technique appears to be loosely linked to the style of the surviving drawings associated with the various heads; the general shift in drawing materials from metalpoint to red chalk to charcoal over the lengthy period of the commission follows the increasing selectivity of lead-white application in the flesh painting.

64 The painting shows many signs of having been worked on in separate campaigns, and to have been left less finished in parts in a way that is consistent with the documented disputes from about 1506–8. The sky at the upper right in particular shows signs of having been finished while the picture was in its frame, and in a different medium to that of the distant landscape at the left of the picture. First noticed by Brachert (1969, p. 99), this observation was given further support by the recent analytical discovery of the use of different paint media (walnut and linseed oil) in the two respective areas; see cat. 32 in this volume; Keith et al. 2010, pp. 77–8; Keith et al. 2011, pp. 36–9.

65 'All colours, when placed in the shade, appear of an equal degree of darkness, among themselves. But all colours when placed in a full light never vary from their true and essential hue' (E fol. 17v; R 24). John Shearman's pioneering study of Leonardo's handling of colour, light and tone (Shearman 1962) remains fundamental to any consideration of this subject.

66 For the identification by Rachel Morrison of the National Gallery Scientific Department of an unusual starch-containing lake pigment

within the red drapery of the London *Virgin of the Rocks*, see Keith et al. 2010, p. 76, and Keith et al. 2011, p. 46.

67 Shearman 1962, p. 26.

68 Dunkerton 2011, p. 13.

69 See Bambach 1999a, p. 127, on the increasing artistic importance of such cartoons.

70 Keith, Roy and Morrison 2010, p. 76; Keith et al. 2011, p. 45.

71 Quoted in Nagel 1993, p. 17, from a 1556 Italian translation with extended commentary of Vitruvius's *Ten Books of Architecture*, published as *Dieci libri dell'architettura di M. Vitruvio*. The work was dedicated to Cardinal Ippolito II d'Este, patron of the Villa d'Este at Tivoli.

72 Urb. fol. 133r–v; MCM 434. See Ackerman 1980, p. 26.

73 Most of these defects appeared very early in the pictures' histories, probably during the initial drying process: 'He made at this time, for Messer Baldassare Turini da Pescia, who was Datary to Pope Leo, a little picture of the *Madonna with the Child* in her arms, with infinite diligence and art; but whether through the fault of whoever primed the panel with gesso, or because of his innumerable and capricious mixtures of grounds and colours, it is now much spoilt' Vasari (1996), vol. 1, p. 638; Vasari (1966–87), vol. 4, p. 35.

74 The National Gallery *Virgin of the Rocks* shows a distinction between well-preserved ultramarine within the lead-white rich sky, and very cracked and wrinkly desaturated pure applications within draperies. See Keith et al. 2010, p. 76; Keith et al. 2011, pp. 45–6.

75 See Keith et al. 2010, pp. 75–6; Keith et al. 2011, p. 48. The process of pre-heating (pre-polymerising) drying oils allowed thicker paint layers to be applied with greater transparency and faster drying times. For recent medium analyses of the *Madonna of the Carnation* in the Alte Pinakothek, Munich, see Koller 2006 and Stege 2006.

76 Brachert 1969, p. 101; Serra 2000, p. 97.

77 See Bora et al. 1998; Brown 2003; Spring et al. 2011; Keith and Roy 1996.

78 This is shown by the initial contract for the *Virgin of the Rocks*, which was jointly awarded to the de Predis brothers and Leonardo – although it may have been designed to some extent to circumvent local guild restrictions in the rewarding of commissions to foreign, that is, non-Milanese, painters. See cats 31, 32.

79 Spring et al. 2011, pp. 78–111; Keith and Roy 1996.

80 Clark 1939, p. 171; Vasari (1996), vol. 1, p. 635; Vasari (1966–87), vol. 4, pp. 28–9.

81 Cats 48, 57 in this volume. See Brown 2003 for a comprehensive and thoughtful study of these paintings as a group; Kustodieva in Rome and Venice 2003–4 for a vigorous rebuttal of Brown's views on the *Madonna Litta*.

82 Clark 1939, p. 121; Villata 1999, p. 135, no. 150.

83 See cat. 88 in this volume; Edinburgh 1992; Penny 1992; Kemp 1994; Zöllner 2003 (2007),

pp. 149, 238–9. Kemp 1994, p. 273 says both versions 'could have been described in contemporary terms as "from the hand of Leonardo", even if in modern parlance we would describe them as not wholly autograph'.

84 Bandello (1952), quoted on p. 251 in this volume.

85 Matteini and Moles 1979; Kühn 1985; Matteini and Moles 1986; Brambilla Barcilon and Marani 2001, p. 411. For a recent overview of the restoration, ten years after its completion see Marani 2011, pp. 124–8.

86 Vasari describes a similar adaptation of oil on panel technique for the *Battle of Anghiari*, which he states was the reason for its abandonment: 'And conceiving the wish to colour on the wall in oils, he made a composition of so gross an admixture, to act as a binder on the wall, that, going on to paint in the said hall, it began to peel off in such a manner that in a short time he abandoned it, seeing it spoiling' Vasari (1996), vol. 1, p. 637; Vasari (1966–87), vol. 4, p. 33. Against this argument is the claim made in the supplement to the biography usually attributed to the Anonimo Gaddiano (from the *Codice Magliabecchiano*), about 1540, by Giovanni di Gavina, Florentine painter and friend of Leonardo (referring to the Palazzo Signoria commission): 'Leonardo da Vinci was a contemporary of Michelangelo, and from Pliny he took the recipe for the pigments with which he painted, but without fully understanding it' (quoted in McCurdy 1928, p. 98).

87 It is interesting to consider the timing of this development during part of the execution of the London *Virgin of the Rocks*, where the different mode of strong shadows was still being explored, albeit in the context of a composition the origins of which dated back to the mid-1480s. The *Last Supper* was also the last work in which mathematically derived linear perspective was to play an important function, probably the result of Leonardo's increasing inability to reconcile his understanding of how we see with the more rigorous and artificial contraints of Albertian perspective. See Kemp 1977, p. 148.

88 The ground is *gesso grosso* and *gesso sottile*, with an *imprimitura* of probably pure lead-white (although admixtures of chalk or gesso could not be excluded with the analytical methods used). See Ravaud in Mohen et al. 2006, p. 56.

89 Mohen et al. 2006, pp. 62–4.

90 This is possibly derived from the cartoon which was famously displayed at Santissima Annunziata in 1501, and described by Fra Pietro da Novellara. See Syson and Billinge 2005, p. 458; Martin et al. 2005, pp. 28–9.

91 This change was described by Vincent Delieuvin and Bruno Mottin at a conference held at the Louvre, 'Autour de la *Sainte Anne* de Léonard de Vinci', 16–17 June 2009; see note 41 above. See also Mottin 2010, pp. 65–71.

92 Shearman 1962, p. 34.

93 R 222–6.

94 See Martin et al. 2005; Franck 2009, where he expounds a theory of 'micro-divisionism', a highly precise and systematic build-up of multiple layers for the flesh painting within these late works. See Viguerie et al. 2010 for an attempt to quantify pigment/medium ratios within such glazed passages. Although slightly different in their interpretation of the precise method of paint application, all maintain the essential truth of the importance of the priming 'veiled' by thin translucent applications of flesh paint as a calculated part of the final effect.

95 See Zöllner 2003 (2007), p. 248, on its autograph status. Additionally, recent technical study shows changes from the transferred drawing and adjustments of the forearms and fingers during the painting phase which support this view; see Ravaud et al. 2009.

96 '… ebauche en lavis de couleur rougeâtre …' (Ravaud et al. 2009, p. 92). The picture has usually been thought to be among the last works painted by Leonardo; however, its materials, technique and artistic aims are also consistent with a date just before Leonardo's departure to Florence in 1500. See Syson in this volume, pp. 46–7.

97 Vasari (1966–87), vol. 4, p. 26, on the French king's frustrated wish to transport the *Last Supper* to his native land.

98 There are echoes of a Leonardesque type of underpainting in early sixteenth-century Florentine painters like Andrea del Sarto and Fra Bartolommeo (readily visible in Fra Bartolommeo's unfinished *Saint Anne Altarpiece* now in the Museo di San Marco, Florence; see Bertani et al. 1986, p. 348, on a kind of tonal undermodelling by Andrea del Sarto), albeit in a much more restricted tonal range in keeping with the higher keyed palette of Leonardo's later works – though this could as easily be explained as a persistence of Verrocchio-like methods. Raphael's knowledge of the *Mona Lisa* is clearly demonstrated in portraits from the first decade of the sixteenth century such as his *Portrait of a Lady with a Unicorn* (Galleria Borghese, Rome) or *Maddalena Doni* (Palazzo Pitti, Florence), while his interest in Leonardo is most obvious in the relationship of his *Madonna of the Pinks* to Leonardo's *Madonna Benois*. See Henry and Plazzotta 2004, pp. 44–5; Henry in London 2004–5, pp. 174–7, cat. 51; Plazzotta in London 2004–5, pp. 190–3, cat. 53; Zöllner 2003 (2007), p. 217.

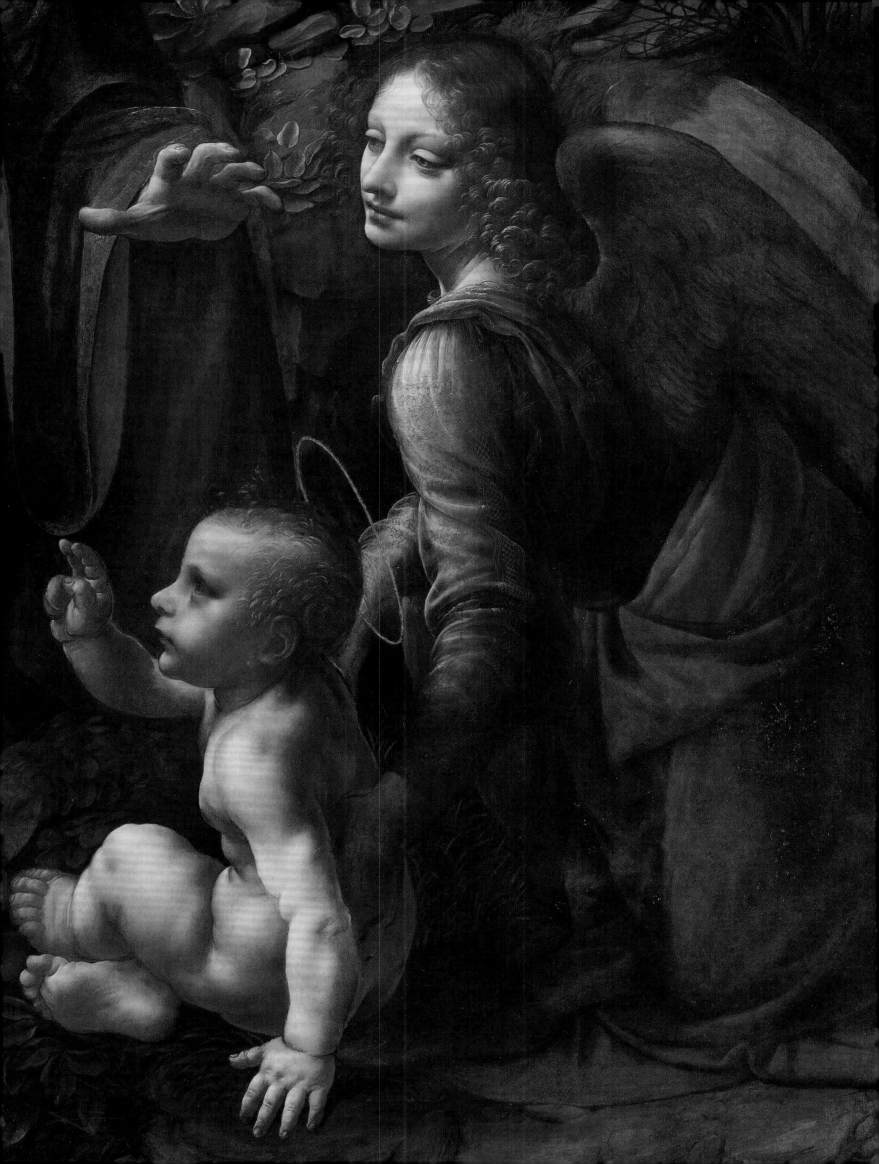

THE EYE AND THE MIND

SEEING AND BELIEVING

*The eye, which is said to be the window
of the soul, is the principal means by
which* senso comune *may so copiously and
magnificently consider the infinite works
of nature, and the second way is the ear,
made noble by being told about things
that the eye has seen.* [1]

IN THE NOTES FOR HIS PLANNED *Treatise on Painting*, Leonardo explained the importance of the senses and their order of priority. These ideas were hardly objective. In the early 1490s he was determined to prove the superiority of painting as the medium that allowed the most complete relationship between art and nature.

The present drawing, one of his early attempts to understand human anatomy, makes much the same point, tellingly, in a series of images. This sheet is devoted to the primacy of vision or, more specifically, the link between the eye and the *senso comune*, an Aristotelian term denoting the power of bringing together and judging external sensations. At the centre of the sheet the profile of a man is seen in partial section. While his strong profile ensures that his physiognomy remains dignified, even heroic, the rest of the head is depicted in sagittal section, showing the structure of the eye linked to the brain, here envisaged as three continuous chambers or ventricles. The diagram also illustrates the various layers of the scalp, identified by leaders and labels; this detail and the eye are repeated below. The head is also repeated in the lower part of the page, this time from above, in traverse section with the top half still hinged to the bottom, as if the head has been flipped open. A small sketch to the left indicates that it is dissected at eye level. The verso features further views of the same head, some with the top partly hinged backwards; these are juxtaposed with a comparative, *en face* view of the man characterised as a sage.[2]

The sheet represents a fascinating synthesis of the real and the ideal. The inclusion of the frontal sinus, for example, correctly placed above the eye, is striking. But although this detail seems to suggest that Leonardo had actually dissected a human head, many details are no more than a visual summary of the contemporary understanding of human anatomy. Even the poignant analogy between the scalp and the layers of an onion, elaborated in the note and accompanying red chalk drawing next to the profile, is not original but based on such authorities as Avicenna (about 980–1037), Mondino de' Luzzi (about 1270–1326) and Guy de Chauliac (about 1300–1368).[3] Another adaptation of ancient theories was the belief that the brain consisted of three ventricles. The anterior ventricle supposedly contained the *senso comune* and

imaginative facilities (*fantasia, imaginatio*), the middle chamber the intellectual facilities (*cogitatio, estimatio*), and the last ventricle the memory (*memoria*). The drawing locates these – entirely fictive – ventricles, showing them from different angles. Leonardo later reconsidered the function of the first two: he eventually described the anterior ventricle as the seat of sensory impression (*imprensiva*), the central ventrical as that of imaginative and intellectual faculties (including the *senso comune*), but he never fundamentally challenged the underlying model of the brain's structure.

In the traverse section the optic and the auditory nerves are directly linked to the first ventricle, but it is unclear whether this is the seat of the *senso comune* or of Leonardo's *imprensiva*, with the *senso comune* behind it. That the location of the *senso comune* should remain non-specific is both odd and revealing. For Leonardo, the *senso comune* was the seat of the soul: 'The soul apparently resides in the region of judgement, and the region of judgement is to be located where all the senses run together, which is called the *senso comune*, and not all throughout the body as many have believed.'[4] His drawing therefore makes the invisible soul – or at least its location – visible, and shows the direct connection between the soul and its window, the eye.[5] Although he assigned a letter to each ventricle, Leonardo could not quite commit himself to labelling them. Strangely, when drawing the top of the head at the bottom of the sheet, he changed the size of the chambers, a detail that contributes to the curiously evasive quality of a drawing that appears at first to be strictly analytical.

The technical character of the drawing, with its different views, parallel projections, leaders and labels, implies scientific objectivity, Leonardo seeming to assert the painter's ability of observation. But he must have been aware that he was presenting theory as fact, attempting to depict what could not in fact be seen. He went so far as to lend the image extra authority by giving his subject the facial features he usually associated with a warrior. While the drawing may be taken as a statement of the superiority of sight, it also acknowledges the limitations of the purely observed, a conundrum, with which Leonardo would wrestle throughout his career. PR/LS

CAT. I (verso)

LITERATURE

O'Malley and Saunders 1952, pp. 330–3, no. 142; Clark and Pedretti 1968–9, vol. I, p. 123; Keele and Pedretti 1979, vol. I, pp. 70–3, vol. 2, pp. 816–18, no. 32; Kemp 1981, pp. 125–7; Kemp in London 1989, p. 171, cat. 94; Clayton in Houston, Philadelphia and Boston 1992–3, pp. 26–32, cat. IA/B; Pedretti 1979 (2007), pp. 63–4, cat. 5A/B.

NOTES

1 BN 2038 fol. 19r; Urb. fol 8r; R 653; MCM 30; K/W 26, transcribed and translated in Farago 1992, pp. 208–9, no. 19.

2 Before Leonardo started working on the verso he obliterated an earlier profile with lead white (now discoloured and visible as a black outline) and turned the sheet sideways, working right to left. See Clayton in Houston, Philadelphia and Boston 1992–3, pp. 30–2.

3 The analogy also appears in one of Leonardo's notebooks (Forster III, fols 27v–28r). A list of books in Leonardo's possession, written shortly after his return from Milan to Florence, includes a reference to Guy de Chauliac ('Guidone in cerusia'). See Madrid II, fol. 2v.

4 Windsor RL 19019r1; R 838.

5 See also n. 1 above. Leonardo called the eye: 'Oh excellent above all other things created by God!' Urb. fol. 16r; MCM 34; K/W 29.

I

LEONARDO DA VINCI (1452–1519)

The ventricles of the brain and the layers of the scalp (recto)

Studies of the head (verso)

about 1490–4

Pen and ink and red chalk on paper
20.3 × 15.2 cm
Lent by Her Majesty The Queen
(RL 12603)

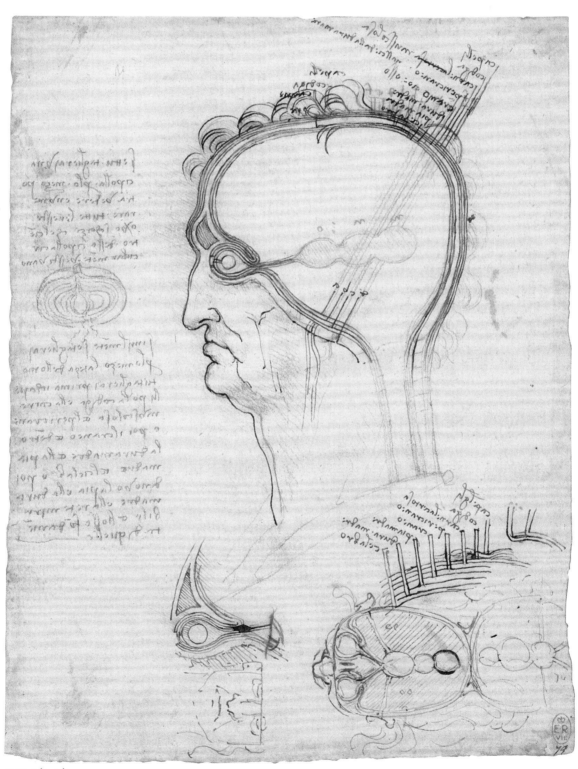

CAT. I (recto)

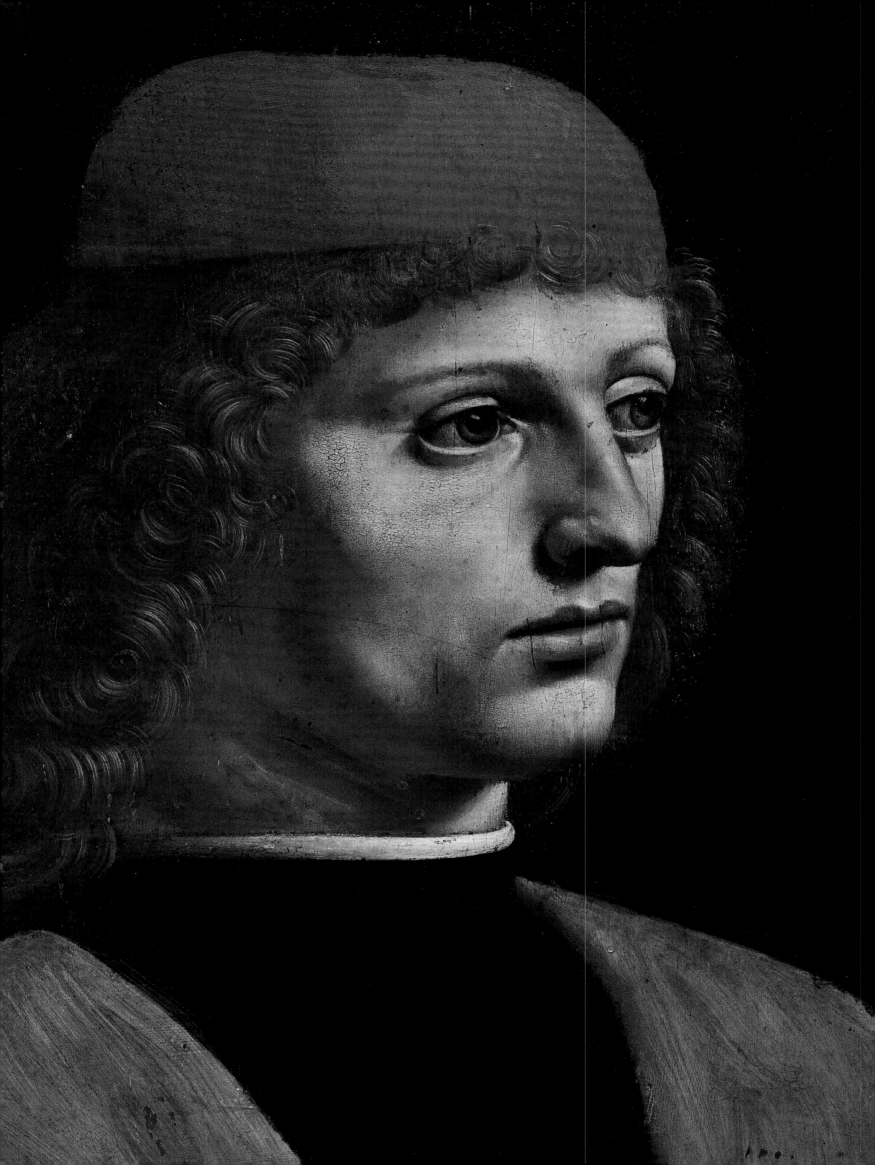

THE
MUSICIAN
IN MILAN
A QUIET
REVOLUTION

I N THE MID-1480S, WHEN LEONARDO DA VINCI HAD BEEN IN
Milan just three or four years, he began to paint a portrait that,
though at first sight modest in its ambition, must have startled
his Milanese audience quite considerably. Though not without
precedent elsewhere in Italy (or, of course, beyond; ultimately its
style depends on Netherlandish portraits), nothing quite like this
three-quarter view of a young man had been made there before.
Leonardo's radical stylistic choices, the obvious difference between
this portrait and what had been traditionally preferred in Milan,
and the impact of his picture upon a younger generation of Lombard
painters are themes that will be encountered in this book more
than once. Indeed, the style, context and authority of the *Musician*
are usefully microcosmic of Leonardo's whole career in Milan.

He had arrived in a city that was artistically conservative
for reasons that had made good political sense. Ludovico Maria
Sforza's desire to temper that conservatism could only go so far.
His sense, for example, of what was proper for the portrait of a
ruler was not a jot different from that of his older brother, father
or indeed Visconti grandfather. The head of state should be
portrayed in profile and, once the likeness was established, there
would be little reason to keep it up to date. That the ruler's image
should remain consistent over the years was more important
than that this reiterated portrait would much resemble its subject.

The profile view of the head was most easily remembered and repeated, and it preserved a seemly emotional distance from the viewer. It could also be the subject of straightforward physiognomical interpretation: the hooked nose that made a duke into the king of birds, the leonine mane, the bull neck, and so on.

Thus the profile was the format adopted by the first Sforza court portraitist, Zanetto Bugatto (died 1476), although he had been trained by the Netherlandish painter Rogier van der Weyden.[1] (We can only wonder what Antonello da Messina's portraits might have looked like had he accepted Galeazzo Maria Sforza's invitation to become Zanetto's successor.) Like his predecessors, Ludovico ensured that his portrait could be seen everywhere; and it was in profile that he chose to have himself represented. His portrait changes very little, the starting point for most remaining portraits a likeness made probably in the early 1480s by Ambrogio de Predis (see cat. 2, fig. 50).[2] Their placement throughout his dominions was a statement of his power, deliberately timeless, permanent and eternal. Leonardo may initially have thought to obey the rules. Three portraits, one of 'the duke', are listed in his famous inventory made in about 1484–7 (see p. 24 and cat. 3). And his earliest surviving portrait drawing, from much the same time, is an exercise in pure profile.

The Sforza were as keen to give and receive portraits as any of the ruling families of Italy. These exchanges were often propagandist and ritualised. But with the capacity of these great men and women to travel strictly limited, having a portrait made might also be a way of satisfying curiosity – about a bride-to-be or a newborn grandson. And since portraits were also a means of ensuring the continual presence of the ruler when he was not actually there, it might become important that they were judged vivid. Many, though probably not all, of these portraits sent from court to court were profiles (for example cat. 8), but even so it was recognised that given within the family, a portrait's capacity to capture and preserve a moment that would pass could come to the fore. In April 1493, for example, Beatrice d'Este wrote to her mother, the Duchess of Ferrara:

I have been hoping for hours now that the painter would bring me the portrait of Ercole [her first son, then three months old, later renamed Massimiliano] that his Lordship and I now send to you. And, we assure you, he is much bigger than the portrait [makes him appear], for it is already more than eight days since he was portrayed.[3]

Thus when Leonardo came to paint the *Musician*, he had every reason to associate the art of portraiture with the several ways in which painting could make time stand still. He introduced new ingredients: the fact of this young man's great natural beauty and the competitive comparison (*paragone*) with music. Above all, by turning the youth's head into three-quarter view and allowing us to read his expression, he invited the viewer to ponder this young man's emotions at a particular moment. Quite unlike most profile portraits, this is clearly the likeness of a sentient being, someone with an observable interior life. The picture speaks even as it remains mute. And Leonardo also succeeded in making the portrait temporally non-specific by placing the head against a neutral black ground. The *Musician* was once identified as the image of a Duke of Milan, and it is just possible that Leonardo painted a somewhat informal image of the adolescent Gian Galeazzo Sforza, a portrait of a kind that might be sent to a close relation. But, as has long been realised, the constraints upon a portraitist were fewer when a portrait was not 'official'. This is more likely therefore to represent an intimate, probably the musician Atalante Migliorotti. Atalante had accompanied Leonardo to Milan, where the painter was presented, at least to begin with, as a fellow musician. He would go on to become one of the most famous performers of his day, but perhaps (rather as, much later, Leonardo chose to paint the portrait of Lisa Gherardini del Giocondo) he had been selected by Leonardo himself as exactly the right person to prompt the meditation of painting, beauty and time.

Perhaps not all of the picture's complex argument was fully grasped. Certainly Leonardo's Lombard contemporaries – artists like Vincenzo Foppa[4] and Ambrogio de Predis – stuck religiously to the profile formula. But a

younger generation of Milanese painters was impressed. The attribution of the portrait of a young man with a head of resplendent red hair (cat. 7) has proved problematic; it is given here to Giovanni Antonio Boltraffio. This is a portrait which evidently responds to the main theme of the *Musician* – the passing and freezing of time – but in a way that takes account of Milanese tradition. To judge by his rich costume, the sitter was probably of courtier status; this was not therefore going to be a commission that permitted any worrying degree of experimentation. A well-spent life is a long one, states the inscription, worthy by implication to be extended still further by the making of a commemorative portrait. The longevity of the painted portrait here becomes associated with the virtue of the sitter (rather than the painter), and now the young man's handsome features, his strong aquiline nose for example, have reverted to becoming physiognomical reminders of his standardised masculine virtues.

The drawing of a young man in profile (cat. 6), here attributed to another of Leonardo's pupils, Francesco Napoletano, shows that the lessons of Leonardo's portrait might well be applied to the old format. Both these works show that, with the *Musician*, Leonardo had indeed played his part in establishing a new language for portrait painting in Milan, of a kind that Ludovico could fully approve: simultaneously innovative and old-fashioned, a language that remained essentially courtly. It was only when Boltraffio came to paint his highly idealised portrait of the Bolognese poet Girolamo Casio (fig. 65) that he finally grasped all the implications of Leonardo's *Musician*.[5] Casio was of much the same status as Migliorotti, and Boltraffio may well therefore have been seeking to compare painting to poetry (as Leonardo had painting to music). Boltraffio's formal solutions depend in part on pictures by Leonardo that we will encounter in the next section. His sense of his young sitter's inner life, however, comes directly from the *Musician*.
LS

NOTES

1 For documents concerning Zanetto Bugatto (and Antonello da Messina's reputation in Milan), see Motta 1884; Malaguzzi Valeri 1902, pp. 125–36; Cavalieri 1989. For his two surviving portraits see Syson 1996. Initially greeted with some enthusiasm, the attributions of two portraits of Galeazzo Maria Sforza and Bona of Savoy (the latter a fragment from a larger altarpiece) at the Castello Sforzesco, Milan, has been treated with increasing caution. Nonetheless, it still seems to me that these two damaged works are by the same hand and that the votive portrait of Bona with a female saint is indicative of Zanetto's training by Rogier.

2 By May 1482 the Duchess of Ferrara (mother of il Moro's future bride) could already call him 'dipintore de lo Ill[ustrissimo] sig[nor] Ludovico Sforza'. Ambrogio seemingly carried a portrait drawing of Ludovico around with him. Seidlitz 1906, p. 17; Campbell 1990, pp. 62, 252 n. 86.

3 See Venturi 1885, pp. 227–8. This document would provide a context for such Sforza child portraits as the Bristol *Duchetto* (fig. 94).

4 For Foppa's portraiture, see Natale in Brescia 2002–3, pp. 258–9, cats 79–80.

5 See Fiorio 2000, pp. 91–3, 107–9, nos A7, A14.

AMBROGIO DE PREDIS (about 1455–1510)

Portrait of Ludovico Maria Sforza
about 1496–9

Tempera on vellum
27.3 × 17.9 cm
Aelius Donatus, *Grammatica*
Archivio Storico Civico and Biblioteca Trivulziana, Milan
(Codex Triv. 2167, fol. 54r)

This coin-like profile portrait of Ludovico Sforza sits perfectly within the oeuvre of Ambrogio de Predis. A painter, miniaturist, embroiderer and goldsmith, Ambrogio maintained a flourishing workshop in Milan with his brothers, Evangelista and Cristoforo.[1] With the exclusion of the *Archinto Portrait* (cat. 19), often wrongly attributed to him, his considerably more 'conservative' style is shown to be more impervious to Leonardesque innovation than once supposed.

This illumination, a homage to Ludovico il Moro, concludes the *Grammatica*, the manuscript which, together with the contemporary *Liber Jesus* (Biblioteca Trivulziana, cod. 2163), is among the most important created for the Sforza court. The *Liber Jesus* is a book of prayers, the *Grammatica* a text intended to provide the first rudiments of humanist teaching with a medieval compendium of the *Ars Minor* by the Latin grammarian Aelius Donatus (sixth century AD) and two anonymous works, the so-called *Disticha Catonis* and the *Institutiones grammaticae*. The book opens and concludes with two sonnets by an unknown author. Both books were commissioned by Ludovico for the education of his first legitimate son, Massimiliano (1493–1530), whose image appears throughout the work.

These ducal commissions are characterised by predominantly full-page illuminations, and both occupy an important position within the history of the Lombard miniature. However, despite the ambition of the commission, the images are variable and not always particularly high-quality examples of manuscript illumination of the time.

The two beautiful full-page portraits by the court artist Ambrogio de Predis are the exceptions. Honorific portraits of this type are rare in Italian books of this period. At the beginning of the manuscript is the portrait of Massimiliano (fig. 49), while at the end the profile of Ludovico is placed opposite a sonnet extolling his glory and his image, which inspires 'giusticia, amor, clemenza' (justice, love, clemency).[2]

The diplomatic visit of Maximilian I, husband of Bianca Maria Sforza (cat. 8), to Milan in 1496 remains the point of reference for dating both these manuscripts, since the event is represented in the *Liber Jesus* (fol. 6r). The portrait in the *Grammatica* of the Duke's son, who appears to be about five years old, confirms that it should be dated to around the end of the decade. The attribution of the two portraits to Ambrogio,

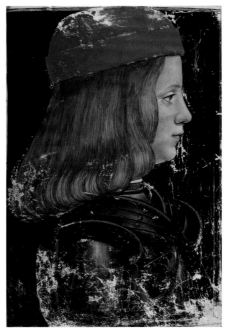

FIG. 49
AMBROGIO DE PREDIS
Portrait of Massimiliano Sforza, about 1496–9
From Aelius Donatus, *Grammatica*
Tempera on vellum, 27.3 × 17.9 cm
Archivio Storico Civico and Biblioteca Trivulziana,
Milan (Codex Triv. 2167 fol. 1v)

proposed by Francesco Malaguzzi Valeri in 1913, has never been questioned, although the authorship of the other painted pages is still subject to debate.

These two profiles typify the traditional Sforza approach to the production of propagandist portraiture. Father and son proudly face each other (albeit at either end of the book), both wearing the armour of a military leader, giving the images their political message and emphasising the legitimisation of the ducal dynasty so recently established by Ludovico il Moro. Ludovico's portrait closely resembles the unchanging coin portrait (fig. 50) struck from the beginning of his regency, following standard Sforza practice. It was more important that a ruler image of this kind was consistent than that it remained an accurate likeness. And one way of ensuring consistency was to employ the same artist. Ambrogio de Predis began his career at the Milanese Mint and he may well have designed the gold ducat coin. AG

LITERATURE

Porro 1884, pp. 139–43; Malaguzzi Valeri 1913–23, vol. I, pp. 450–5; Pellegrin 1955, p. 382; Milan 1958, p. 143 cat. 454; Santoro 1965, pp. 318–19; Bologna 1980; Bologna in Milan 1983, pp. 71–3; Mulas 1995, pp. 58–61

NOTES

1 See Romano in Milan 1983, pp. 57, cat. 3 and pp. 72–80 cats 20–2. On the varied activities of the de Predis workshop see also Shell 1995, pp. 243–4; Venturelli 2005, pp. 396–402; Passoni 2009, pp. 141–6. On Leonardo's influence on Lombard goldsmiths' work see Piglione 1998, pp. 19–21.
2 Symmetrically, at the beginning of the book, a dedicatory sonnet also appears opposite the portrait of Massimiliano.

FIG. 50
Ducat coin of Ludovico Maria Sforza, about 1494–9
Struck gold, diameter 2.2 cm
The British Museum, London
(1847,1108.694)

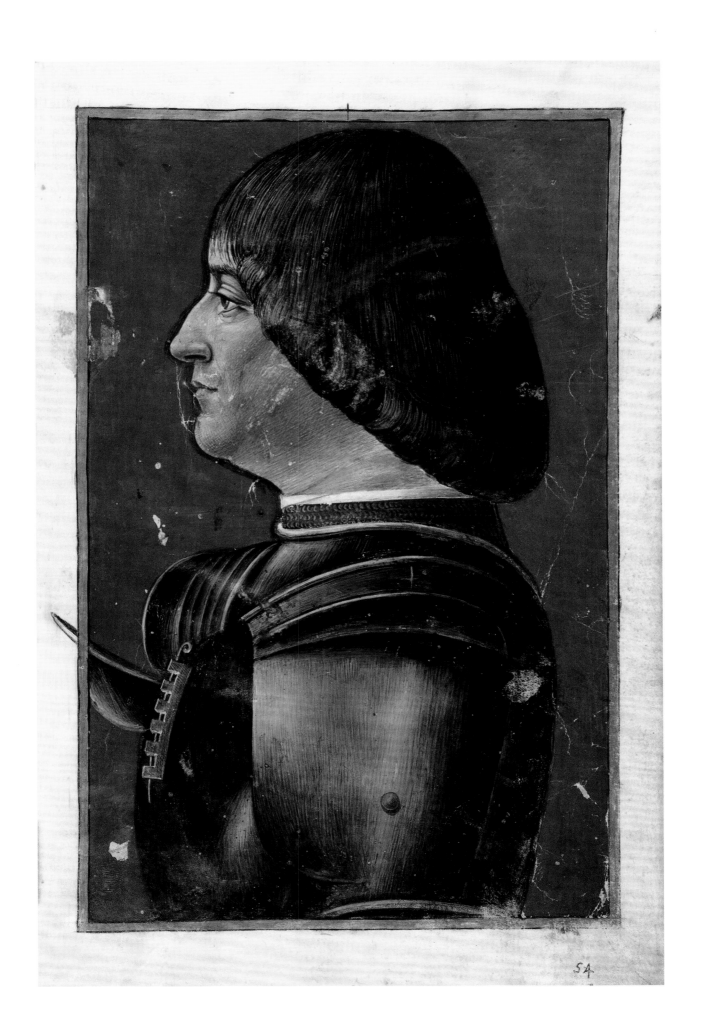

54

3

LEONARDO DA VINCI (1452–1519)
Portrait of a man in profile
about 1484–6

Metalpoint on prepared paper
12.7 × 10.6 cm
Lent by Her Majesty The Queen
(RL 12498)

Leonardo's profile of a man wearing a soft, rounded hat is the most orthodox portrait he ever produced. It is also perhaps his most sensitively particularised likeness – a small miracle of observation. His sitter has a large, markedly aquiline nose, an eye set rather low in his head, a full lower lip and a distinctly unimpressive chin and jawline. His age is difficult to determine, but he is probably in his 30s or 40s; his flesh is just beginning to sag, slacking into a dewlap below the jaw.

Leonardo has focused above all on the man's face and employs particularly fine parallel hatching to map its complex variations of light and shade. The metalpoint is now a little faded and the delicacy of Leonardo's technique is somewhat contradicted by the unusually rough texture of the paper. The hatching gets broader at the back of the neck and as it crosses the sitter's rather straggly hair. Leonardo concentrates his attention on the hair only where it meets the face; elsewhere it is generalised, the detail implied so that its description does not distract from the main focal point (this was a tactic only rarely understood by Leonardo's pupils). Thus the man's hat and shoulder are little more than sketched in. The line of the profile, on the other hand, has been gone over to ensure that its contour cannot be confused with Leonardo's earlier efforts to trace an exact likeness (metalpoint cannot of course be erased). Indeed, it has been reinforced to such an extent that the volumes of the head have become rather flattened out, as in a coin portrait or sculptural relief.

This, then, is a portrait drawn from life with great concentration. Though the page was later trimmed to make it seem a complete work in its own right, it was in fact a working drawing. It is possible that Leonardo intended to use it as the basis of a painted portrait, but he could, as ever, be distracted or might reuse a sheet of paper at random. Here he added a young man's thigh in what is now the bottom right corner. A tiny fragment with the rest of the leg is also preserved in the Royal Library at Windsor (RL 12621).

This sheet is almost always dated early in Leonardo's career, and is thought to have been made just before or more likely immediately after his journey to Milan. The combination of dominant contour and subtly realised internal shading recalls one of his earliest graphic masterpieces, the British Museum silverpoint *Bust of a warrior* in *all'antica* armour, executed probably in the second half of the 1470s – a drawing intended to evoke sculptural relief.[1] The balance becomes more delicate in Leonardo's horse drawings made around 1482–5, probably as he began to think about the Sforza equestrian monument.[2] Comparison with his animal drawings of the mid-1480s (such as cats 14, 15) is also instructive. A date for the portrait drawing in the early to mid-1480s seems most plausible.

Leonardo's use of metalpoint here may be helpful in considering the type of drawings that lay behind the light effects in his portrait of the *Musician* (cat. 5) Especially similar are the ways he achieves varying intensities of shadow on the cheek, around the eye and down the nose. He valued the precision of silverpoint and the deliberation it required, and it seems that Milanese artists were immediately impressed by his example.[3]

The suggestions that the portrait depicts Antonio del Pollaiuolo or the philosopher Pico della Mirandola are completely fanciful. The tentative proposal that it represents Ludovico il Moro is also quickly discounted by comparison with his certain portraits (see figs 26, 50 and cat. 2). On the other hand, Martin Clayton has noted that the subject does rather resemble Galeazzo Maria Sforza (fig. 52): although Galeazzo Maria had been murdered several years before Leonardo's arrival in Milan, the sitter's distinctive nose suggests that he may have been a member of the Sforza family. Alternatively, there may be a connection with the list of his works that Leonardo scribbled down at more or less exactly the moment this portrait was drawn, which includes 'a head of the duke', 'una testa col cappello in capo' ('a head of someone wearing a hat') and two drawings of named sitters.[4] This is a useful reminder that Leonardo had clients in Milan around this time who were not members of the Sforza family. LS

LITERATURE

Bodmer 1931, p. 390, pl. 170; Clark 1935, vol. 1, p. 73; Valentiner 1937, p. 18; Popham 1946, p. 141, no. 130B; Clark and Pedretti 1968–9, vol. 1, pp. 86–7; Pedretti 1979 (2007), pp. 174–7 nn. 8–10.

NOTES

1 British Museum 1895,0915.474. See Chapman in London and Florence 2010–11, pp. 204–5, cat. 50.
2 E.g. Windsor RL 12315r.
3 An unfinished drawing in metalpoint of a young man in profile in the British Museum (1895,0915.614) clearly depends on prototypes by Leonardo. Probably dating to the later 1480s, it has been attributed to Ambrogio de Predis (Popham and Pouncey 1950, p. 140). It has been suggested that the geometrical patterns on this sheet 'may well' be by Leonardo.
4 CA fol. 888r (ex 324r), see pp. 22–5. Two names appear. 'Ieronimo da Feglino' or 'Girolamo da Fegline', was apparently a fellow painter who had executed a small narrative (*storietta*) that appears elsewhere in the list. It is sometimes thought that the man represented came from Figline Valdarno in Tuscany. However, he is likely to have been a member of a successful Milanese painting dynasty active from the beginning of the fifteenth century, which would produce a namesake, Girolamo Figino, in the middle of the sixteenth. 'Feglino' or 'Fegline' are perfectly plausible spellings by Leonardo of Figino. For members of this dynasty, see Shell 1995, pp. 21, 203, 205. For Girolamo Figino, see Bora 2003. 'Gian Francesco Boso' may well be the Giovanni Francesco de Bossi whose tapestries are mentioned as a benchmark of quality in a document of 13 May 1486. See Calvi 1925, p. 59 n. 4, citing Motta 1903, p. 485.

4

LEONARDO DA VINCI (1452–1519)

Bust of a youth in profile
about 1485–7

Pen and ink on paper
13.7 × 8.2 cm
Lent by Her Majesty The Queen
(RL 12432)

Leonardo's dazzlingly rapid sketch of a young man in
profile is viewed as one of his 'ideal types', a particu-
larly fine but still characteristic example of a category
of drawing that survives in large numbers. Many of
these heads were, like this one, cut out of larger sheets
to give them a greater significance than Leonardo
himself intended, turning them into a repertoire of
images deemed useful for other painters. Several such
cut-up sheets, now divided between the Royal Library,
Windsor, and the Codex Atlanticus in the Biblioteca
Ambrosiana, Milan, have been reconstructed by Carlo
Pedretti, often helped by what is drawn on the other
side of the page. The verso of the present sheet has
studies of machinery demonstrating the action of
cog-wheels, on a blue prepared ground. What may
be the 'parent sheet' of this fragment (CA fol. 1001r,
ex 359vb) has similar mechanical drawings, on a blue-
green preparation, with handwriting of about 1485.[1]
A dating in the mid-1480s for the present drawing is
indicated by the utter conviction of the pen-and-ink
technique, full of confident abbreviations (like the
quick meander at bottom left that stands for his
rumpled sleeve) and notable for the masterly control
of the hatching that gives the head its volume.

This cutting up of sheets happened early. The
inscription – 'A / · i ·' – indicates that this was the
first of a consecutive sequence of 52 heads arranged
by Francesco Melzi from the many drawings he had
inherited. Leonardo, however, seemingly drew the
heads without any overarching purpose; throughout his
life he drew images of youthful male beauty and aged
ugliness, also mostly male. There is no question but

that he equated beauty with youth and perceived time as the great destroyer, a theme that became a constant undercurrent. Thus the charming young man here is matched – and significantly outnumbered – by the 'grotesque heads' that are stylistically and technically so similar, also cut out of larger sheets from the mid-1480s.[2]

This fine-boned sitter's nose is rather larger and sharper than those of the heads Leonardo drew when simply relying on his imagination (such as in cat. 37): perhaps he was a real person. But the short upper lip, his overbite and slightly receding chin all became familiar features of his young men. What we are witnessing here is the constant interplay in his corpus of drawings between the imagined and the real in achieving his ideal. This head, though probably not drawn from life, was perhaps made from memory rather than entirely invented. Leonardo may even have been recalling earlier life drawings: the youth's eye recalls a more refined and finished drawing of an eye – another fragment – suggesting that he had a model in front of him when he drew it.[3] He would later suggest a mnemonic technique whereby a painter might draw – in profile – someone seen only briefly.[4]

The youth's abundant curly mane is energetically stylised, his chrysanthemum-like locks seeming almost to spin, like the cogs on the other side of the sheet. Curly hair was another constant element in Leonardo's ideal of human beauty – and was said by Vasari to be one reason for his devotion to the wicked apprentice he nicknamed Salaì. Quite soon Leonardo would render more regular the features of the boys he drew: for example, he straightened the nose of the young man in a celebrated drawing of the early 1490s, one of his first efforts in red chalk, the youth's profile juxtaposed with that of a clamp-faced old man.[5] By the end of the decade he was drawing a fleshier type, with shorter, even curlier hair – closer to an *all'antica* ideal.[6] The idea that these are perhaps slightly idealised images of Salaì is not a foolish one.

Certainly, for Leonardo to have used a living model at the very least as his starting point would accord with his practice (we need only think of the *Mona Lisa*). It is therefore legitimate to speculate as to who the model might have been for the present drawing. Every detail of his face, including the long nose and longish but still slightly undershot chin, precisely matches the *Musician* (cat. 5). If that is indeed a picture of Leonardo's friend and sometime model Atalante Migliorotti, then this drawing might also be based on his features. On the other hand, Leonardo had every reason to explore an ideal of youthful masculine beauty. Milan's legitimate ruler in the mid-1480s was an adolescent boy, Gian Galeazzo Sforza. The details of his physiognomy are not exactly the same, but an exquisitely carved onyx cameo in the British Museum, somewhat uncertainly attributed to the Milanese gem-engraver Domenico de' Cammei (fig. 51), shows the way in which the young duke's features could be idealised – his hair curled for example – to take account of Leonardo's new vision of perfect male beauty.[7] LS

LITERATURE

Clark 1935, vol. 1, p. 60; Popham 1946, p. 142, no. 131A; Clark and Pedretti 1968–9, vol. 1, p. 69; Clayton in Edinburgh and London 2002–3, p. 56, cat. 16.

NOTES

1 See also the large fragment in the Biblioteca Ambrosiana, Milan, with a drawing of a horse, one of the first studies for the Sforza monument. In identical style, its verso is prepared with blue ground.
2 See e.g. the three fragments surviving in the Biblioteca Ambrosiana (F 263 inf. 78, 93, 94).
3 Windsor, RL 12436.
4 Urb. fol. 108v; MCM 416; K/W 535.
5 Uffizi 423E. See Chapman in London and Florence 2010–11, pp. 214–15, cat. 55.
6 See e.g. Windsor, RL 12557, RL 12554 – of the same type or model, both perhaps, by comparison to drawings for the *Last Supper* and *Saint Anne*, a little earlier in date than is often supposed, around 1500.
7 See Dalton 1915, p. xxxiv (when the cameo was still in the distinguished collection of Maurice Rosenheim).

FIG. 51
DOMENICO DE' CAMMEI
(active 1490s)
Portrait gem of Gian Galeazzo Sforza,
about 1490
Onyx and gold, height 3.6 cm
The British Museum, London
(1922,0705.1)

Reproduced actual size
and enlarged

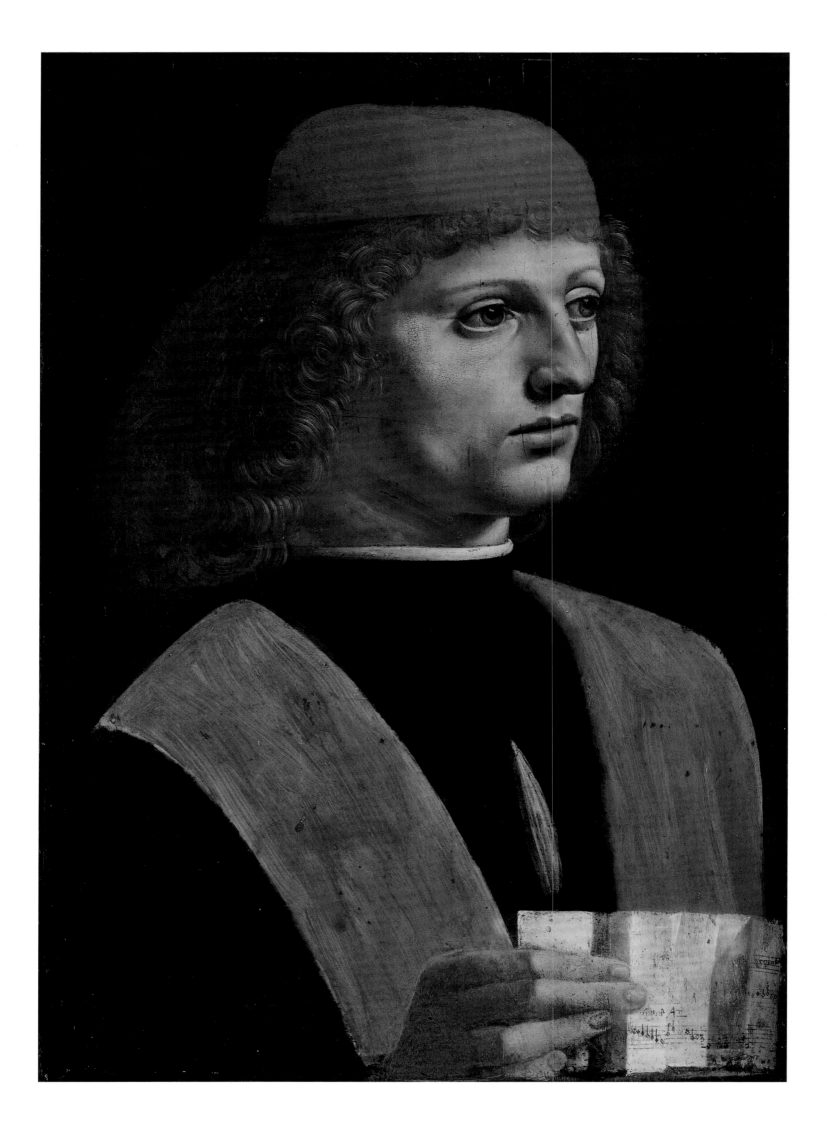

5

LEONARDO DA VINCI (1452–1519)
Portrait of a Young Man ('The Musician')
about 1486–7

Oil on walnut
44.7 × 32 cm
Pinacoteca Ambrosiana, Milan
(99)

Leonardo's portrait of a young man holding a sheet of music is his only surviving painting of a male sitter. Many scholars have found this image compelling, struck by the physical and emotional presence of the sitter, established by a combination of subtle characterisation and dramatically contrasting light and shade. But critics' responses have always been mixed. Some find the pose uncomfortably wooden; others have complained that the *chiaroscuro* is over-emphatic; a substantial minority has always preferred to attribute the picture to one or other of Leonardo's pupils, sometimes in collaboration with the master.

Such negative responses can be largely explained by the work's extremely uneven finish. As Larry Keith explains in his introductory chapter (pp. 60–1), only the youth's face and hair were brought anywhere close to completion, and even they may lack the final touches that would have rendered the transitions of light and shade smoother. The broad brown lapels of the man's coat, on the other hand, seem never to have got beyond brushy underpaint. The exact status of his black jerkin, open on his chest to reveal a flash of white shirt, is dubious; recent technical examination has revealed that at one point it was dark red. Leonardo may have darkened it himself, but equally it may have been painted over later, when much of the black background was reinforced.

The debate regarding its authorship can be documented for nearly as long as the picture itself. It is not known how it arrived at the Ambrosiana – it was not part of the founding gift of Cardinal Federico Borromeo in 1618. It seems to be the picture described in 1672 by Pietro Paolo Bosca (1632–1699), Prefect of the Biblioteca, which he attributed to Leonardo and believed a portrait of a duke of Milan, 'with all the elegance that might be expected of a ducal commission'.[1] This suggests that the hand and music, concealed by overpaint until 1905, were already painted out. It was still called 'a half-length portrait of a Duke of Milan with a red cap' in the 1685 inventory of the works of art owned by the Ambrosiana, but now listed as 'by the hand of Luini'. This judgement was almost immediately corrected with the words 'or rather by Leonardo' added above the line,[2] but the amendment did not catch on. The picture was left in Milan when the Codex Atlanticus, deemed much more valuable, was carried off to Napoleon's Paris, and by 1798 it had been demoted still further to the 'school of Luini'.

Quite soon afterwards, however, the portrait was attributed to Leonardo again, and during most of the nineteenth century it was viewed as the pair to the celebrated Ambrosiana *Profile of a Lady* (which is not by Leonardo), the two mistakenly regarded as portraits of Ludovico il Moro and his consort, Beatrice d'Este. By the end of the century scholars were beginning to have their doubts about both pictures. Morelli noted the similarity of the *Musician* to the London *Virgin of the Rocks* (cat. 32), then believed to be largely the product of Leonardo's workshop. The bold shadowing in both works can in fact be explained by their very similar levels of finish, but taking this resemblance for a stylistic congruity, Morelli's attribution of the *Musician* to Ambrogio de Predis had the force of logic. As a result, Ambrogio's reputation became unduly inflated and neither the restoration of 1905 nor Beltrami's stout defence of the picture in 1906 convinced the sceptics. It was ascribed to Boltraffio by Oswald Sirén in 1916. The names of Boltraffio and de Predis have reverberated in the literature ever since.[3]

Most scholars now believe that the *Musician* was painted by Leonardo. Carlo Pedretti and Pietro Marani in particular have pointed to features which could be by no-one else: the cascade of glorious curls, with their rippling highlights; the hint that he has just closed or is about to open his mouth; the faint but pervasive whisper of melancholy; the moist and properly spherical eyes;[4] the almost obsessive regard for the fall of light. This is a picture in which Leonardo's naturalism is still entirely on the surface, not yet informed by his 1489 skull studies (see cat. 25) or any other serious investigations of human anatomy. It has long been realised that the lighting and the youth's delicate features give the portrait a particular stylistic kinship to the Louvre *Virgin of the Rocks*, begun in April 1483 and largely complete within a couple of years. But there is an additional boldness perhaps derived from Leonardo's admiration of pictures by Antonello da Messina, who had worked in Venice in 1474–6 and who had been wooed by Galeazzo Maria seeking a replacement for the recently deceased Zanetto Bugatto. Leonardo must have had the chance, perhaps visiting his former master Andrea del Verrocchio in Venice around 1486, to study portraits like the so-called *Condottiere* (possibly the portrait of Sforza Maria Sforza, thought to have been painted in Venice in January 1475; fig. 53), which inspired a method for lighting the face – note for example the light that

LITERATURE

Morelli 1890, pp. 236–8; Beltrami 1906; Suida 1929, pp. 89–90; Ottino della Chiesa 1969, p. 100, no. 25; Precerutti and Mucchi in Milan 1972, pp. 1–3; Bora 1987a, pp. 7–22; Pedretti 1998, pp. 22–6; Marani 1999, pp. 160–6; Zöllner 2003 (2007), pp. 99, 225, no. 12; Marani 2004; Rossi and Rovetta 2005, pp. 148–54; Rome 2010–11.

FIG. 52
PIERO DEL POLLAIUOLO
(1441–about 1496)
Galeazzo Maria Sforza, about 1471
Tempera on wood, 65 × 42 cm
Galleria degli Uffizi, Florence

FIG. 53
ANTONELLO DA MESSINA
(active 1456; died 1479)
Il Condottiere, 1475
Oil on wood, 36 × 30 cm
Musée du Louvre, Paris

animates the lower cheek just above the jawline and defines the cleft in the chin.[5] A date in the mid-1480s for the *Musician* thus seems most plausible.

Certainly it cannot be much later than 1487: there are still strongly Florentine elements. Two works by Florentine artists of the previous generation were particularly important for Leonardo. It has recently been confirmed that a powerful head study in the Uffizi (fig. 54) is a self-portrait by Verrocchio of the late 1460s.[6] There are several striking similarities between this drawing and Leonardo's painting, not just (once again) in the whole system of strongly contrasted light and shade, but in the morphology of particular features: the eyes treated so as to emphasise the crease in upper eyelid, the light catching the edge of the lower lid; the mouth with a dark upper lip and the highlight on the lower lip giving it mobility; the light running down the nose and the pool of shadow below the nostril. Some of the muscular contouring has also found its way into Leonardo's picture. Perhaps the closest compositional precedent is Piero del Pollaiuolo's 1471 *Portrait of Galeazzo Maria Sforza* (fig. 52), depicting the duke's head in a rather unconvincing three-quarter view and showing one of his hands holding a glove, just as Leonardo's youth holds the sheet of music. This is a picture that, since it hung in the Medici palace, was surely well-known to Leonardo. There may even have been a second version in Milan.

This iconographic precedent is intriguing given that Leonardo's sitter was first called 'a duke of Milan'. This identification is vague, but it is just possible that it may have referred to some older tradition. And though it was later assumed to depict Ludovico Maria Sforza, it might have been identified as his nephew (and Galeazzo Maria's son) Gian Galeazzo, rightful Duke of Milan when the picture was painted. If this has any basis in fact, Leonardo's citation of the Pollaiuolo portrait would have been especially meaningful. Certainly successive coin portraits of the young

duke show that his image was refashioned as he grew up, and especially after his uncle became regent. His long nose remains a constant, but his rather lank long hair becomes shorter and curlier (see fig. 51). That Leonardo's *Musician* may be a portrait of Gian Galeazzo cannot be entirely ruled out.

The rediscovery of the sheet of music in 1905, however, naturally turned the thoughts of scholars towards the various musicians known to have been active in Milan, especially those with court connections. Leonardo's attributes do not elsewhere have this literal quality, but two factors make this portrait less likely to have been an official commission. That it remained unfinished is unparalleled in the history of fifteenth-century Italian portraiture: Leonardo's dilatory working habits make it possible that he abandoned a portrait even of the young duke but, since its primary importance would have lain in who it depicted, it is likely that someone else would in that case have finished it. Its preservation in its still unfinished state therefore implies that its significance may have been more personal. The piece of music has been unfolded like a letter received by the young man, implying the participation of someone other than sitter and viewer. Might the music have been composed by Leonardo himself?

For these reasons we can probably dismiss the idea that Leonardo portrayed one of the several talented musicians in Milan. Luca Beltrami, for example, suggested Franchino Gaffurio (1451–1522), priest, music theorist and chapel master at the Duomo. Reading the more prominent (but not actually completely legible) of the two inscriptions on the sheet of music as 'Cant. Ang.', he divined a reference to Gaffurio's work *Angelicum ac divinum opus* published in 1508. But Gaffurio was certainly too old in the mid-1480s to be the young man here. In recent years the choice of musicologists has fallen upon the great Josquin des Prez (died 1521), known to have been

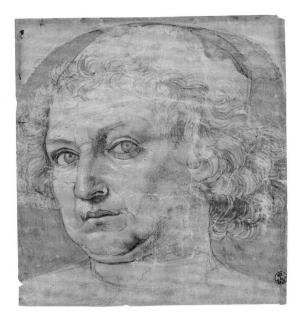

FIG. 54
ANDREA DEL VERROCCHIO
(about 1435–1488)
Self-portrait, about 1468–70
Pen and ink over metalpoint and
wash heightened with white on
prepared paper, 19.2 × 17.5 cm
Galleria degli Uffizi, Florence
(250E)

active in Milan in about 1483–4 and 1489.[7] But he too was born in the early 1450s and this proposal is contradicted by other portraits believed to depict him. Other similar suggestions are also to be rejected.[8]

There is one name that fits the bill rather well: the Florentine musician Atalante Migliorotti (active around 1482–1535),[9] said to have been taught music by Leonardo himself and believed to have been his companion when he journeyed to Milan in 1482/3. The fact that he was the object of praise by the poet Naldo Naldi, one of the circle of Lorenzo de' Medici, suggests his connection with the Medici family.[10] His first name is sufficiently unusual to suggest that he was the model for a drawing Leonardo included in a list of works he made in the mid-1480s: 'Una testa ritratta d'Attalante che alzava il volto' ('a head portrayed from Attalante who was lifting his face').[11] We hear nothing more of Atalante until 1490, when unsuccessful efforts were made by the Gonzaga to get him to perform the part of Orpheus at their country seat of Marmirolo, by which time he had entered the service of the 18-year-old Piero di Lorenzo de' Medici back in Florence. It is therefore entirely possible that he had remained with Leonardo in Milan for some years, a friend who might have prized just this kind of unfinished portrait. Atalante was much sought after as a performer and maker of musical instruments by Isabella d'Este and Cardinal Giovanni de' Medici (the future Pope Leo X), among others. He was a leading member of the Sacred Academy of the Medici, which in April 1515 elected him 'lutenist in perpetuity' and ambassador to the Pope for one year. It appears that he was dividing his time between Florence and Rome and that he had become sufficiently knowledgeable about architecture and building to be paid between 1513 to 1516 as superintendent of building works of St Peter's and the Vatican Palace.[12] Luca Beltrami suggested the picture may have had an early Roman provenance which, if correct, might support this identification. The age of the sitter, about 20, is also right.

If this is indeed a portrait of Atalante Migliorotti, the sheet of music was included to indicate his profession;

but more importantly, it conveys the main theme of the portrait. The beauty of this young man and the harmonious proportions of his face cannot be overstated. The mobility of his mouth and the sheet of music suggest that he has just finished singing. In the picture, however, there can only be silence, and Leonardo has turned what might be considered a demerit into a virtue. The music, he implies, has just faded away and the touch of sadness in the young man's expression implies his sense that his own physical beauty will be equally fleeting. The sequence of notes on the page suggests the march of time. These ideas are contained in Leonardo's writings. In about 1490–2 he compared painting to music:

> … painting excels and lords it over music because it does not perish as soon as it is created, as unfortunate music does. Rather, it endures and shows you something that is only surface as if in life. Oh marvellous science which can keep alive the transient beauties of mortals and give them a permanence greater than the works of nature, always subject to the changes of time, and led to inevitable old age…[13]

Thus Leonardo transforms what might be understood as a conventional portrait into an allegory of beauty and time. Only painting can conquer time, acknowledging its passing but holding a moment for ever. Leonardo has even included a detail to demonstrate the capacity of painting to show the passing of time in a single image: the musician's pupils are slightly different sizes, making the connection with a passage in Leonardo's writings:

> our pupil grows or diminishes according to the brightness or darkness of what it is looking at and because it takes some time to dilate and contract, it does not see immediately on leaving the light and going into darkness, or similarly moving from darkness to light, and this is a thing that has already deceived me when painting an eye, and from that experience I learnt this.[14]

Not only is this a wonderful indication of the absolute interdependence of Leonardo's art and his investigation of natural phenomena, it appears that he has realised that this change – connected with time as well as light – could become an ingredient in his allegory. The eyes are perhaps the most striking feature of the *Musician*, sight given primacy as the noblest sense and the most important tool of the painter. LS

NOTES

1 Bosca 1672, p. 117.
2 The inventory was drawn up by Biagio Guenzati and Francesco Buttinoni. The picture appears on fol. 46r.
3 Sirén 1916, pp. 146–7, citing Sir Charles Holroyd. He also attributes the *Lady with an Ermine* to Boltraffio. See e.g. Wasserman 1984, p. 138; Cogliati Arano in Milan 1982a, pp. 88–90; Bora 1987a, pp. 13–20; Zöllner 2003 (2007), p. 225, no. 12.
4 CA fol. 232r (ex. 85v.a); R51; K/W 103.
5 Many scholars have proposed this connection. See e.g. Schiaparelli 1921, p. 98; Fiorio 2010–11.
6 For which see most recently Syson and Dunkerton 2011.
7 Clercx-Lejeune 1972; Testolin 2007.
8 See especially De Rinaldis 1926, pp. 7–8.
9 For the most complete account to date of Migliorotti's career, see Cummings 2004, pp. 79, 84, 86, 88–9, 240 nn. 31–2. See also Ottino della Chiesa 1969, p. 100.
10 Naldus (1943), pp. 44, 52–3.
11 He may also have posed for the drawing of a left hand positioned on the fingerboard of a lute that Carlo Pedretti discovered examining CA fol. 46v (ex 13vb) under ultraviolet light. The sheet, mostly consisting of metalpoint drawings of the mechanisms for cannons, is dated about 1485–90, much the same time as this portrait (Slim 1988, p. 32, figs 1, 2).
12 See de Zahn 1867, p. 183. I am grateful to Georgia Clarke for her advice on this matter.
13 Urb. fol. 16v; MCM 39; R 32; K/W 61.
14 Forster III, fol. 158v; R 36. This is one of a number of passages regarding the dilation and contraction of the pupils according to what they are looking at. See R 37–9.

6

FRANCESCO GALLI, called FRANCESCO NAPOLETANO

(died 1501)

Portrait of a youth in profile
about 1488–90

Pen and ink and wash on paper
14.4 × 11.3 cm
Musée du Louvre, Paris
(2558)

Though it entered the French royal collection in 1671, this drawing was seemingly ignored for the succeeding four centuries or more and published for the first time as recently as 2003. This neglect is explained by the fact that for all that time it was considered a copy of another sheet in the Louvre with the same provenance (fig. 55), which was acclaimed a masterpiece by Leonardo throughout the eighteenth and nineteenth centuries. Apparently (and seductively) more complete-looking, it was engraved by the Comte de Caylus in his 1752 *Recueil* and subsequently received considerable critical attention. Françoise Viatte, however, realised that the better-known drawing is actually a copy after the present sheet, probably made in the seventeenth century before the original was cut down on all four sides. The present sheet also once contained at the left a loosely drawn three-quarter view of a grotesque old man, a second profile of just

nose, mouth and chin, and another, smaller male profile quickly sketched below.

The first doubts about Leonardo's authorship were expressed at the end of the nineteenth century,[1] but some scholars continued to give the drawing to him well into the next – despite its obviously right-handed hatching.[2] In the early twentieth century it began to be associated with Leonardo's portrait of the *Musician* (cat. 5), and was sometimes called a preparatory work for that painting.[3] Its attributional history was thus closely tied to the fluctuations of scholarly opinion concerning the *Musician* itself.[4] For those critics who believed that the *Musician* was painted by Ambrogio de Predis, the drawing was also judged to be his. Once it was realised that neither copy nor original could possibly be by Leonardo, the *Portrait of a youth in profile* was recognised as crucial evidence of the almost immediate impact made in Milan by the *Musician*, and it may even

LITERATURE
Viatte in Paris 2003, pp. 344–6, cats 116–17 (as Boltraffio); Marani 2008, pp. 96–7, no. 48 (as Boltraffio).

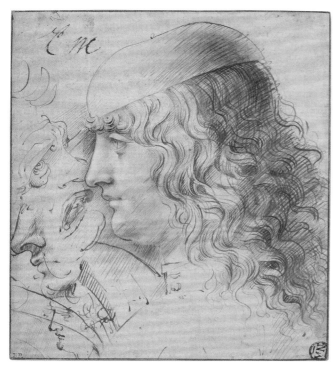

FIG. 55
After FRANCESCO NAPOLETANO
Profile of a young man with long hair, and other head studies,
date unknown
Pen and ink and wash on paper, 18 × 15.5 cm
Musée du Louvre, Paris (2248r)

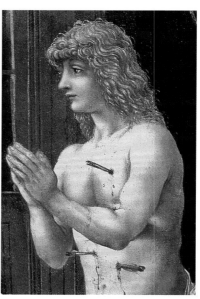

FIG. 56
FRANCESCO NAPOLETANO
Virgin and Child with Saints Sebastian and
John the Baptist (detail), about 1488–90
Oil on wood, 73 × 43 cm
Kunsthaus Zurich, on loan from
the Gottfried Keller Foundation

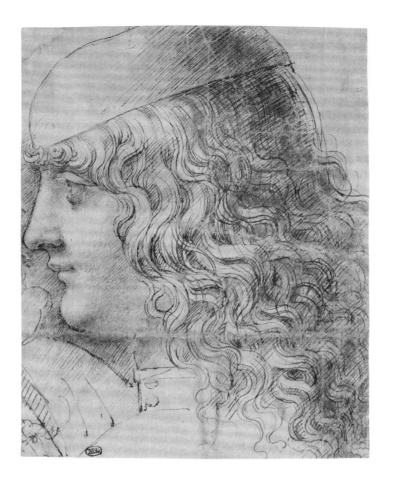

derive from one of Leonardo's preparatory studies
for that portrait.

It is clear that the facial types in Leonardo's painting
and this drawing are indeed very alike. True, the
profile view allows for a more obviously elegant shape
for the eye, the youth's cheeks are slightly chubbier,
his cap tipped lower on his brow and the mass of
snaking curls is more pedantically drawn; the whole
image is a little tidier. But certain details are faithfully
transcribed: the downy curls on his forehead dancing
around the edge of his cap, the short upper lip and
more substantial chin. Interestingly the buttons on
his jerkin at the neck appear both in Boltraffio's
Portrait of a Young Man (cat. 7) and the underdrawing
of the *Musician* itself; this may have been the fashion,
but this coincidence also lends support to the theory
that this drawing by an assistant or pupil depends
quite directly on a preparatory drawing by Leonardo.
If this is not the same young man, it may be a case of
a pupil inheriting his master's physiognomic ideal.

We need then to ask which pupil of Leonardo made
this drawing. In 1987 Alessandro Ballarin ascribed it
on the drawing's mount to Boltraffio, but Boltraffio is
not known for pen and ink drawings.[5] Moreover, if the
Brera *Portrait of a Young Man* (cat. 7) is Boltraffio's, his
response to Leonardo's prototype was rather different
in character. A better candidate might be Francesco
Napoletano (see cat. 48), who died in Venice a little
before 21 August 1501.[6] The discovery of his signature
on a panel of Saint Sebastian from the Saint Nicholas

of Tolentino altarpiece (Pinacoteca, Brescia) other-
wise painted in 1495 by Vincenzo Civerchio (about
1470–1544), defines his mature style. Previously the
only certain touchstone was his twice signed altarpiece
now in Zurich (fig. 56), which must have been painted
in the late 1480s. We can therefore deduce that
Francesco was one of Leonardo's first pupils in Milan;
certainly all his artistic models are to be found in
Leonardo's works from the 1480s. For example,
his Saint John the Baptist in the Zurich altarpiece
adapts Leonardo's *Saint Jerome* (cat. 20), and his Saint
Sebastian looks to Leonardo's proportional drawings
executed about 1487–90 in pen and ink, especially
of the leg,[7] and to the drawing of the youthful Saint
John the Baptist (fig. 7) of a similar date. Napoletano's
Brera *Virgin and Child* (fig. 82) reveals him as a artist
who was also much impressed by the *Madonna Benois*,
which Leonardo had with him in Milan. And, on the
evidence of his own *Portrait of a Youth* (Nelson-Atkins
Museum of Art, Kansas City) of the early 1490s, he
made real efforts to understand Leonardo's innova-
tions in the *Musician*. All Leonardo's own stylistic traits
become a touch exaggerated in Francesco Napoletano's
hands – particularly his strong and lively line and
sharply contrasted light and shade. He particularly
enjoys the calligraphic qualities of corkscrew curls.
This drawing is most usefully compared both to
the Kansas City portrait and particularly to the
profile of Saint Sebastian in the Zurich altarpiece
(fig. 56). LS

NOTES

1 Morelli (1890, p. 227, no. 3) percep-
 tively judged the copy a fake.
2 See e.g. Schiaparelli 1921, p. 97
 and n. 1.
3 Ricci 1913, p. 202.
4 From Seidlitz 1906, p. 31, and
 Malaguzzi Valeri 1913–23, vol. 3,
 pp. 23–5, to Castelfranco Vegas 1983,
 p. 70, n. 6.
5 In the only exception – the drawing
 of the heads of a woman and child
 at Chatsworth usually attributed to
 Boltraffio (fig. 91) – the ink is
 delicate and selectively applied,
 seemingly with a brush, over metal-
 point. This is a technique much more
 akin to Leonardo's Louvre cartoon
 for the head of the infant Saint John
 the Baptist in the Paris *Virgin of the
 Rocks* (cat. 41) from which the child's
 head is copied.
6 Frangi 1991; Fiorio in Bora et al.
 1998, pp. 199–210.
7 See Windsor, RL 19130v,
 RL 19136r–9v.

7

GIOVANNI ANTONIO BOLTRAFFIO (about 1467–1516)

Portrait of a Young Man
about 1490–1

Oil on wood
48.9 × 37.4 cm
Inscribed: 'VITA · SI · SCIAS / VTI / LONGA / EST'
Pinacoteca di Brera, Milan
(Reg. Cron. 2123)

The painter of this fascinating portrait was strongly inspired by Leonardo's *Musician* (cat. 5).[1] Leonardo's composition is simply reversed, the angle of the three-quarter view slightly altered. Infrared reflectography has revealed several *pentimenti* in the underdrawing.[2] The most significant concerns the shape of the far cheekbone, initially underdrawn as in Leonardo's portrait, the tip of the nose meeting the line of the cheek, the whole head in a more foreshortened three-quarter view. Here the painter evidently decided afterwards to set the face more frontally. There is another *pentimento* in the positioning of the right eye and the nostril, both originally drawn lower down and further to the right.[3] Francesco Napoletano's *Portrait of a Youth* (Nelson-Atkins Museum of Art, Kansas City) is another original and individual response to the master's model, of about the same time as the Brera *Portrait*.

The subject of this work is a red-haired, blue-eyed man, richly dressed in a coat with soft fur lapels: an almost identical costume is worn by the sitter in the small *Portrait of a Man* by a Flemish artist of the late fifteenth century (Castello Sforzesco, Milan).[4] His composure and strongly masculine features belie the overall impression of his youth. He looks towards the left, from where a pale, lunar light emanates from above, washing the surface of his skin and draining it of colour. The elegant Latin inscription at top left, 'framed' by a *hedera distinguens* (foliate decorative motif), is from Seneca's *De brevitate vitae* and can be translated as 'Life, if you know how to use it, is long'. A similar motto now in Italian appears in Leonardo's Codex Trivulzianus, datable to the late 1480s: 'la vita bene spesa lunga è' ('Life that is spent well is long').[5] This connection is intriguing in light of the portrait's stylistic debt to Leonardo, and says something about the cultural ambience from which it emerged: since the motto here is in refined Latin, its painter's direct source may not necessarily be Leonardo himself, who probably often found his mottoes from fifteenth-century *zibaldoni* (anthologies). Its inclusion may well have been requested by an educated patron with cultural ambitions, presumably the sitter. Seneca's ancient text had probably just been printed; the motto appears in exactly this form in an edition published in Venice in 1490 (elsewhere the word order varies slightly).[6]

The portrait's attribution is still debated. It was exhibited as 'Lombard School' at the Brera in 1872, when it was lent from the collection of Pietro Giuseppe Maggi (1817–1873), and Gustavo Frizzoni recorded it as such in his manuscripts.[7] But from the end of the nineteenth century it was ascribed to Ambrogio de Predis on the basis of its superficial resemblance to the National Gallery *Portrait of a Man aged 20*, itself wrongly given to de Predis (see cat. 19, where it is attributed to Marco d'Oggiono). The picture has most often been catalogued in this way, even after the connection between the National Gallery portrait and de Predis was challenged. Close comparison shows that the two are not in fact by the same hand: the quality of the National Gallery painting is lower, the underdrawing very different.[8] The similarities between the two should instead be seen as the result of one painter influencing the other.

Since the National Gallery portrait is not by de Predis, could he have painted this work? Despite his reputation as a successful portraitist, comparison with his signed and certainly attributed pictures rules him out (see cats 2 and 8). De Predis never really became a Leonardesque painter: his portraits are less subtle in their use of soft light and *sfumato* and, crucially, all his surviving portraits adopt the old-fashioned profile format, like his only signed and dated (1502) work, *Portrait of the Emperor Maximilian I* (fig. 57).

On the other hand, this portrait can certainly be related to Boltraffio's early activity as a painter. In this phase of his career his sitters, quiet and focused, have a remarkable self-containment. His metalpoint *Study for the portrait of a child* in the Ambrosiana (fig. 93), for example, is lit with the same cool light as the present subject and has strikingly similar, cat-like eyes.[9] Although this seriousness becomes more extreme in his later *Man crowned with thorns and ivy* in Turin (fig. 92), his physiognomy is actually rather similar. The painting stylistically and emotionally closest to the present portrait is the *Madonna Litta* (cat. 57): the light effects and pewter skin tones are comparable, and the Christ Child has the same soft, fine reddish hair as the young man. The two pictures must surely be by the same hand – Boltraffio's – and exemplify his most complete immersion – almost an 'impersonation' – in Leonardo's art in the years around 1490, when he is recorded in Leonardo's workshop.[10] AM

LITERATURE

Milan 1872, p. 17, cat. 87 (as Lombard School, end of fifteenth century); Morelli 1892, p. 187 (as by Ambrogio de Predis); Suida 1929, pp. 90–1, 175, 281, fig. 108 (as started by Leonardo and finished by the Master of the Archinto Portrait); Ballarin 1985 (2005), pp. 24–5 (as by Boltraffio); Marani 1987b, pp. 72–4, no. 2 (as attributed to de Predis); Bora in Milan 1987–8, p. 63, cat. 12 (as by the Master of the Archinto Portrait); Brera 1988, pp. 158–60, no. 107 (as attributed to de Predis); Marani 1998b, pp. 24–30, 36–7 (as attributed to de Predis); Shell 1998, pp. 128–9, fig. 5 (as attributed to de Predis); Fiorio 2000, pp. 34–5 (as by de Predis); Farrow 2001, pp. 82–102 (as by de Predis); Brera 2010, p. 93, no. 157 (as by Boltraffio).

NOTES

1 The identity of the sitter is unknown. According to Malaguzzi Valeri (1913–23, vol. 3, p. 15) Vittadini believed the sitter was Francesco II Sforza, but he was not born until 1495.

2 See Marani 1998b, pp. 24–9; Farrow 2001, pp. 95–6, fig. 9a.

3 Such changes in the positioning of the eyes and nostrils are character-istic of Boltraffio's underdrawings, e.g. the *Madonna of the Rose* (cat. 63) and the *Pala Casio* in the Louvre.

4 The detail of the flap of white collar covering half the top button is also found in cat. 6.

5 Triv. fol. 34v; R 1174. See Calvi and Marinoni 1982, pp. 76–111; Brizio 1980, p. 87; Piazza in Milan 2006, p. 143.

6 *Seneca Moralis*, Venice 1490, fol. lxxviiir. In other editions of the *De brevitate vitae* the order of the words is 'Vita, si uti scias, longa est'.

7 Rovetta 2006, pp. 224, 226 n. 55.

8 Farrow 2001, pp. 88–102; Spring et al. 2011, p. 90.

9 For the Ambrosiana drawing (Cod. F 263 inf. 100), see Bora in Vigevano 2009–10, pp. 194–5, cat. 50.

10 The concept of 'impersonation' has been pointed out (using the word *immedesimazione*, 'identification with', while discussing the authorship of the *Madonna Litta*, cat. 57) by Paolucci 2003.

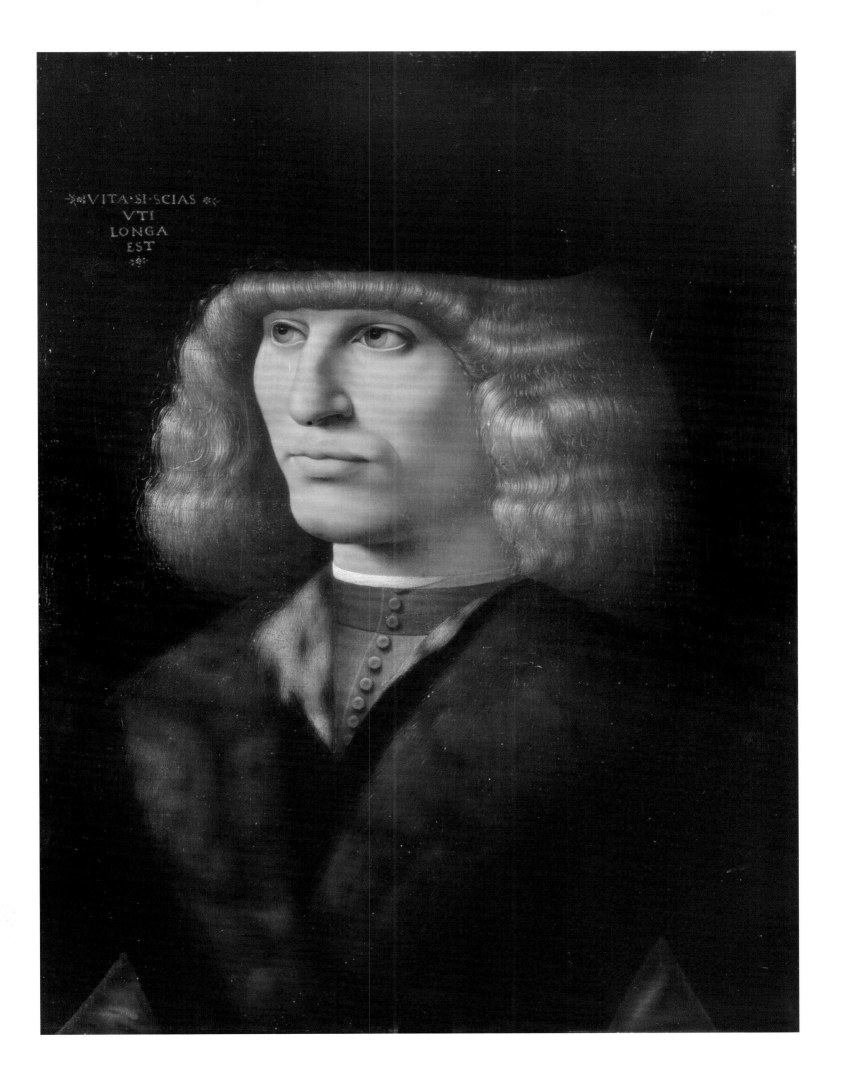

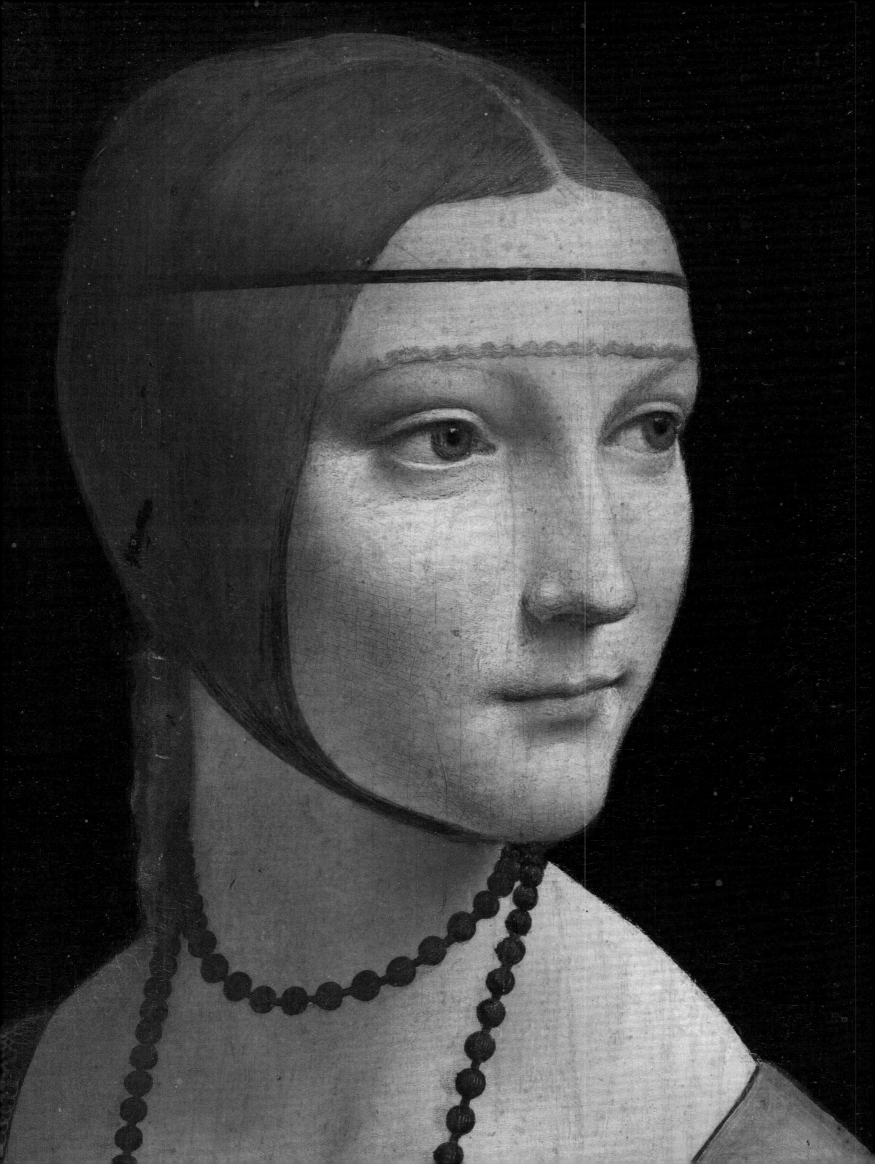

BEAUTY AND LOVE
LEONARDO'S PORTRAITS OF WOMEN

THE CONTEXT FOR PORTRAITS OF WOMEN IN Renaissance Italy was always one of love. The Sforza were not alone in sending and receiving betrothal portraits, sometimes to satisfy the curiosity of the husband-to-be, who may never have seen his bride in the flesh, always as part of an elaborately ritualised courtship. In 1468 Zanetto Bugatto's portrait of Bona of Savoy, who had travelled from France to marry Galeazzo Maria Sforza, received extravagant and – given her apparently Wagnerian build – implausible praise.[1] Cosmè Tura's portrait of Beatrice d'Este (now lost) was sent to Ludovico il Moro in 1485,[2] and he himself arranged for the likeness of his niece Bianca Maria Sforza (cat. 8) to be dispatched to her future husband, Emperor Maximilian I. Poets from Petrarch onwards wrote sonnets at least notionally about portraits of their beloveds – the images, usually judged inadequate, of their chaste mistresses. And though likeness might sometimes be important, it had long been accepted that female portraits in particular could legitimately be idealised. Commentators agreed that men fell in love with outward beauty as the sign of inner virtue. On the basis that this might be a truer image of a woman's soul, her face could be idealised to a point where almost all physical resemblance was lost.[3] Leonardo understood all these conventions and sought to combine them, at the same time observing his own priorities as a painter.

By the time he arrived in Milan Leonardo had begun to understand that the art of portraiture could be placed at the very centre of his philosophy of painting. More than any other category of picture, the 'truthful' portrait of a living sitter could become a key test of the naturalistic painter's mimetic skills. Not only could his version of the sitter's outward appearance be compared directly with the model, but the viewer was also invited to judge how well the painter had captured the whole of the person. Since people (unlike plants or animals) reveal more of their inner selves through behaviour, speech and expression, we form impressions of their essential character; here, then, was Leonardo's subject. He believed that portraiture could encapsulate all his many aims as the painter of a world around him. This was his intention when he painted his portrait of a *Lady with an Ermine* (cat. 10), the embodiment of his philosophy. As his ambitions changed in the early 1490s, he realised that portraiture might still have a part to play, that his capacity to enhance, actually to invent female beauty, might come to stand for all his creative powers as an artist.[4] This is one of the messages of the idealised *Belle Ferronnière* (cat. 17), a picture which points the way forward to Leonardo's own portrait of Lisa Gherardini – the *Mona Lisa* – and to Raphael's and Titian's pictures of women whose specific identities sometimes matter less than the beauty with which they were painted.

But in the late 1480s this was not yet the right solution for Leonardo. On the contrary, his definitions of the purpose of painting demanded that he find a sitter of such outstanding beauty that she would stand for all 'the beauty of all created things, most especially those that arouse love',[5] those things that could only be appreciated through sight. He found this perfect creature in Cecilia Gallerani. It was not entirely chance that she was the beloved mistress of his patron.

Leonardo's story of the response of the King of Hungary to a painting of his mistress may be connected with his execution of this picture. In arguing for painting's superiority to poetry, Matthias Corvinus, cast as alter ego to both Leonardo and Ludovico il Moro, justifies his decision to examine the portrait rather than read a eulogistic poem written as a birthday tribute. He admonishes the disgruntled poet:

> Do you not know that our soul is composed of harmony, and that harmony cannot be generated other than when the proportions of the form are seen and heard instantaneously? Can you not see that in your science [poetry], proportionality is not created in an instant, but each part is born successively after the other, and the succeeding one is not born if the previous one has not died? From this I judge that your invention is markedly inferior to that of the painter, solely because it cannot compose a proportional harmony. It does not satisfy the mind of the listener or viewer in the same way as the proportionality of the very beautiful parts composing the divine beauty of this face before me, and which by contrast are conjoined instantaneously, giving me such delight with their divine proportions. I judge therefore that there is nothing on earth made by man which can rank higher.[6]

Leonardo was explaining how a harmonious arrangement of things that are seen can speak directly to the soul itself, 'composed of harmony'. His inner woman was not a set of carefully labelled abstract virtues – modesty, chastity and so on. Leonardo was seeking a more complex explanation of the connection between body and soul. (It is no coincidence that his portrait of Cecilia Gallerani is exactly contemporary with his *Saint Jerome*, dealing with very much the same concerns and almost a companion piece: see pp. 135–41.) His picture of Cecilia inspires love of her soul by its innate and simultaneous harmonies. As he explains elsewhere, unlike poetry or music, which can never unify their separate parts, painting shows beauty complete: 'Only when taken together do the features compose that divine harmony which often captivates the viewer.'[7] What is more, Leonardo argued,

> Time will destroy the harmony of human beauty in a few years, but this does not occur with such beauty imitated by the painter, because time will long preserve it. And the eye, in keeping with its function, will derive as much true pleasure from depicted beauty as from the living beauty denied to it…[8]

Cecilia was judged to be already perfect, not least in the harmonious proportions of her head and body. At any rate, Leonardo took considerable pains to make us believe this from the evidence of the portrait itself; it is completely convincing as a likeness. But early the following decade he started using two additional tactics that would transform both female and male portraiture, allowing him and others to make images of young men and women that blur the boundaries of what constitutes a portrait.

This tendency in Milan towards idealisation was noted by David Alan Brown,[9] oddly omitting the picture that most significantly contributed to that trend: the *Belle Ferronnière*. If the portrait depicts the lovely Lucrezia Crivelli, another of Ludovico's mistresses, then Leonardo has painted another celebrated beauty with a Sforza connection, but there would arguably have been less need to idealise her features – as he very clearly has done. It has often been stated that he was able to break the rules of portrait-making when painting Ludovico's mistresses, since he was unconstrained by the conventions that went with making images of the ruler, generally portraits showing the head in profile, a type that survived longer in Milan than, for example, in republican Florence. And both Leonardo's portraits of Milanese women are as unlike the traditional profile portrait as it was possible to be. This is broadly correct but requires qualifying. First, we should realise that the profile was actually one of Leonardo's favoured formulae for representing great beauty; he drew innumerable profiles of beautiful young men, but also the profile of a young woman whose

simplicity of dress frames the exquisite beauty of her face (cat. 12). Second, and perhaps more important here, we might ask if he was not also trying to find ways of portraying men and women (with a social and moral standing higher than that of il Moro's mistresses) in images that could convey some of the messages conveyed by the old-fashioned profile – temporally non-specific, emotionally remote, and with all their references to the ancient world and the panoply of imperial power. It is not impossible that the *Belle Ferronnière* is a representation (in the most literal sense of the word; Leonardo has re-presented her) of Beatrice d'Este – not as lovely in real life as her rivals. And if so, it is a picture that can be seen to contain all these ingredients.

This was a method that might be applied to the features of others – including perhaps Beatrice's rival, Isabella of Aragon (see cat. 18). It was also one that would come to collapse the distinctions between religious images, depictions of ancient gods or heroines, and the portraits of contemporaries. A new category emerged: portraits of young women and men dressed in versions of fashionable late-fifteenth-century costume, but with features that appear highly idealised and attributes that evoke figures from history or myth. Indeed, Leonardo's drawing of Mary Magdalene (cat. 9) may well have been an ingredient in the evolution of such paintings. In the same way, the various young men holding arrows painted by Marco d'Oggiono may be adopting the persona of Saint Sebastian (fig. 67),[10] or equally, the subject is perhaps presented as a Cupid – or one of Cupid's victims. This kind of ambiguity seems to be entirely deliberate. LS

NOTES

1 Syson 1996.
2 Manca 2000, p. 119, doc. 115. Tura was paid 4 gold florins 'per sua mercede de depinzere et retrare dal naturale la faza et peto de la Illustrissima Domina Biatrixe da Este ...', which sounds as if it might conceivably have been a full-face or three-quarter view rather than a profile portrait.
3 There is now a vast literature on the portraiture of women. See Brown 2001, especially pp. 20–1, 23 nn. 43, 45.
4 The fundamental discussions of this subject remain Cropper 1976 and 1987.
5 Urb. fol 7r; MCM 13; K/W 34
6 Urb. fols 14v–15r; MCM 28; K/W 42.
7 Urb. fol. 18v; MCM 41; K/W 68.
8 Urb. fols 11v–12r; MCM 42; K/W 40.
9 Brown 1983.
10 See also his *Young Man with an Arrow* (Cleveland Museum of Art).

8

AMBROGIO DE PREDIS (about 1455–1510)
Portrait of Bianca Maria Sforza
about 1493

Oil on poplar
51 × 32.5 cm
National Gallery of Art, Washington, DC,
Widener Collection
(1942.9.53)

An imposing profile portrait, evocative of ancient and Renaissance coins and medals, this work typifies the official portraiture of the court of Ludovico il Moro. Although Leonardo's revolutionary portrait style (cats 5, 10, 17) was taken up by younger artists (cats 7, 18, 19), portraits of the Sforza family continued to employ more traditional formulae, to which Ambrogio de Predis remained faithful. Leonardo's partner in the 1483 contract for the *Virgin of the Rocks* (cat. 31), Ambrogio remained almost impervious to his innovations.

The cornerstone of Ambrogio's painted oeuvre is his *Portrait of Emperor Maximilian I* (fig. 57), signed and dated 1502, and probably painted during a visit by the painter to the court of Innsbruck.[1] Wilhelm von Bode attributed the present portrait of a young lady to de Predis using the Maximilian portrait as his starting point.[2] He identified the sitter as Bianca Maria Sforza (1472–1510), daughter of Duke Galeazzo Maria (1444–1476), who came under the care of her uncle Ludovico il Moro after the death of her father. She married Emperor Maximilian in 1493.[3]

Related to these portraits of the imperial couple is a small drawing of their profiles in the Gallerie dell' Accademia, Venice, perhaps a design for a coin or medal. Bianca Maria has also been identified as the subject of a more finished preparatory study of a woman's forehead, nose and mouth (Kunsthalle, Hamburg, 21478).[4] Despite their stylistic similarities, the portraits of Bianca Maria and Maximilian are not contemporary: in her belt she wears a carnation, a symbol of betrothal, suggesting that the portrait pre-dates her marriage, celebrated in Milan on 20 November 1493 in the absence of the groom.[5]

There is, however, no evidence specifically connecting this picture with Bianca Maria's betrothal to the Emperor, the union that would guarantee the legitimisation of Ludovico's power. Several documents suggest that the painting may be associated with negotiations with Albert III, Duke of Saxony (1443–1500). In 1492 an emissary of the Duke requested 'uno retracto colorito' (a coloured portrait) of Bianca Maria from Ludovico's secretary Marchesino Stanga, who suggested that the emissary engage de Predis. The messenger was already familiar with the artist, having previously commissioned from him a 'dissegno de carbone' (drawing in black chalk) of Bianca Maria.[6]

With his portrait of Anna Sforza (1473–1497)[7] of 1493 (now lost), Ambrogio emerged as the undisputed

FIG. 57
AMBROGIO DE PREDIS
Portrait of Emperor Maximilian I, 1502
Oil on wood, 44 × 30.3 cm
Kunsthistorisches Museum, Vienna

portrait specialist of the court of Milan. Scholars agree upon his authorship of these more conservative portraits. The reattribution elsewhere in this volume of two other works often ascribed to him, the *Portrait of a Young Man* (cat. 7) and the *Archinto Portrait* (cat. 19), further clarifies his corpus and corrects late nineteenth-century attributional errors sometimes perpetuated to this day.[8] The only portrait by Ambrogio that demonstrates an interest in the work of Leonardo, particularly in its light effects, is his *Portrait of a Woman in Profile* in the National Gallery (fig. 83); this can be compared with the *Angel in Red with a Lute* (cat. 33), suggesting that it may be of much the same date (see p. 174).

This portrait shows the artist focusing on the sumptuous clothes rather than the psychology of the sitter. The luxury of the most opulent court in Italy is evident in the rich brocade, sumptuous jewels and elaborate headdress. In her hair, adorned with pearls and precious stones, is a head-brooch bearing emblems of the Sforza dynasty and the motto 'MERITO ET TEMPORE' ('with merit and time'). On her dress is an evergreen,[9] another of Ludovico's emblems. Such symbolic elements, combined in an official portrait, reduce Bianca Maria to a tool of dynasty and diplomacy. AG

LITERATURE

Bode 1889, pp. 71–9; Morelli, 1892–3, vol. I, p. 189 n. 7; Frizzoni 1898, p. 392; Berenson 1907, p. 161; Malaguzzi Valeri 1914, p. 303; Malaguzzi Valeri 1913–23, vol. 3, pp. 13–14; Suida 1929, pp. 168–9, 280; Berenson 1932, vol. I, p. 472; Suida 1933, p. 369; Valentiner 1937, p. 4; Shapley 1945, pp. 25–6, 37–8; Berenson 1968, vol. I, p. 109; Fiorio 1984, p. 42; Amman in Innsbruck 1992, p. 250, cat. 78; Syson 1994, pp. 13–14, 25; Venturelli 1996a, pp. 81, 83, 111, 179, 181, 187; Boskovits and Brown 2003, pp. 597–601.

NOTES

1 Boskovits and Brown 2003, p. 598. There are documented visits by Ambrogio to the Imperial court in 1493, 1498 and 1506; Malaguzzi Valeri 1913–23, pp. 7–8; Shell 1998b, pp. 124–6, 128–30.
2 Bode 1889, pp. 71–9.
3 On the iconography of Bianca Maria see Amman in Innsbruck 1992, p. 250, cat. 78.
4 Boskovits and Brown 2003, p. 598; on Ambrogio's role in the production of coins and medals see Syson 1994, pp. 13, 14, 25; for the study identified as Bianca Maria, see Bambach in Paris 2003, p. 335.
5 Beltrami 1896, pp. 83–95.
6 Malaguzzi Valeri 1917, p. 6; Shell 1998b, pp. 123–4; Boskovits and, Brown 2003, p. 599.
7 Shell 1998b, pp. 123–4; Malaguzzi Valeri 1913–23, vol. 3, p. 6.
8 On this question of attribution see the entries for cats 7 and 19.
9 We know that Bianca Maria owned a similar object. On this and other aspects of her dress and its symbolism see Venturelli 1996a, pp. 81, 83, 111, 179, 181, 187; Venturelli 1996b.

9

LEONARDO DA VINCI (1452–1519)

Designs for a Saint Mary Magdalene
about 1486–8

Pen and ink on paper
13.7 × 7.9 cm
The Courtauld Gallery, London
(D.1978.PG.80)

Once I happened to be making a painting that represented a sacred figure that was bought by someone who fell in love with it. He wanted to remove the attributes of the saint [*deità*] so he would be able to kiss it without misgivings. But in the end his conscience rose above his sighs and his lust, and he was forced to remove it from his house.[1]

Leonardo told this tale to demonstrate that the special power of painting might extend to causing the viewer to fall in love. It is also a story that signals his awareness of a number of blurred boundaries, between pure love and base lust, the sacred and a still elevated profane. It has been suggested that Leonardo's picture, presumably depicting a female saint, may actually have been Mary Magdalene,[2] whose biography appropriately tells of the opposite conversion – from sinner to holy penitent. Finally, he hints at two new categories of image: the portrait-like pictures of saints (of a kind he began to paint in the mid-1480s; see p. 25) and the images, not necessarily portraits, of ideally beautiful women. After all, the picture of a female saint with her halo and identifying attribute expunged would fall into the class of image now defined as *belle*: more or less eroticised, always poetically charged pictures of created and anonymous female beauty. Leonardo's own awareness of the close connections between the religious and the secular meant, in addition, that his sacred subjects became a factor in his invention of the animated portrait.

He seems certainly to have had a painting in mind when he drew these two framed figures of Mary Magdalene.[3] But he may not have been acting on commission; we may here be looking at the germ of an idea. Like other artists of his generation, Leonardo was exploring ways of introducing narrative ingredients into the devotional icon.[4] His Mary Magdalene performs two separate actions. Leonardo has decided that her traditional attribute, the little jar of ointment with which she anointed Christ's feet (Luke 7: 36–50), could do more than identify her: it could be built into an implicit narrative. She holds the pot in her left hand and with her right reaches across her body to lift the lid.[5] We infer that she is offering its contents, in the upper vignette, to whoever is the object of her gaze to the left – someone invisible to us and standing somewhere near the light source (as the shadowing on her forearm tells us). In the lower scene Leonardo drew her first looking down at her pot, and then straight out

of the picture, directly at the viewer. We now become the potential recipients of her balm. Leonardo had seemingly realised that the biblical account of Mary Magdalene at Christ's tomb justified this radical experiment in *contrapposto*. Her twisting pose comes from John the Evangelist's text, the moment when she recognised Christ, whose body she had found missing and whom she mistook for a gardener: 'Jesus saith to her: *Mary*. She turning to him, *Rabboni* (which is to say, *Master*).'[6] In the upper scene she is literally enlightened – by a light that we now understand emanates from her saviour. In the lower, we take Christ's place, encouraged to identify ourselves with the risen Christ, according to the devotional practices of the day.

The energy of the Magdalen's pose is fully matched by the quick, fine lines, the nervous flicker of its hatching, the bold abbreviations and calligraphic flourishes of the two sketches. Some lines are descriptive. In the upper scene, in another reference to the standard iconography of Mary Magdalene, but with startling economy, Leonardo draws her hair coming loose around her face and shoulders (it was with her hair that she wiped the feet of Christ). But what are the curved lines dashed in between her proper right shoulder and the left border supposed to be? Distant hills? A fluttering veil? They seem to be there primarily to increase the dynamism of the pose and to balance the raised hand on the other side of her body; it does not terribly matter what they signify. There is in fact a slight incoherence to this upper sketch. The Magdalen's cloak is wrapped round her hips, its end thrown over her left arm and its folds repeating – somewhat confusingly – the contours of her right arm. As a result, we cannot see exactly how she holds her ointment jar and her pose becomes a little arbitrary. The second, lower sketch is the more purposeful and resolved. Leonardo has clarified the pose, leaving the contour of her shoulders unbroken, her right arm free of draperies and placed lower down the body so that her turning movement now becomes continuous. Her cloak crosses her body in elegant counterpoint to the arm. The curlicue on the left now makes more sense, clearly indicating her cloak falling down her back, but still there to energise and balance.

When Popham first published this sheet he dated it around 1490, comparing it especially to four allegorical drawings made early on in Leonardo's association with Ludovico Sforza.[7] Though it has since been dated both

LITERATURE

Popham 1935, p. 10, no. 1; Popham 1946, pp. 42, 118, no. 29A; Seilern 1959, vol. 2, p. 23, no. 80; Shapley 1968, pp. 136, 138, under nos K1021, K1230; Pedretti 1973, pp. 104, 134; London 1983, p. 11, cat. 5; Trutty-Coohill 1988, pp. 28, 30; Pardo 1989, pp. 80–1, especially n. 52; Jones 1990, pp. 69–72 nn. 18, 25; Kemp 2003, p. 142; Kemp and Barone 2010, pp. 73–4, no. 27.

NOTES

1 Urb. fol. 31r/v; McM 33; K/W 44. This passage is most recently discussed by Nagel 2010, pp. 17–23.
2 See Trutty-Coohill 1988, p. 30.
3 These sketches are cut out of a larger sheet, probably from the bottom of the page. The lower sketch shows that Leonardo was here drawing close to the original bottom edge of the paper.
4 See Ringbom 1965.
5 Leonardo first explored a similar action in his *Adoration of the Magi* (fig. 34).
6 John 20:16. See Pardo 1989, especially pp. 73, 75.
7 Christ Church, Oxford, JBS 18 r/v and JBS 17 r/v.
8 Gould 1975, pp. 122–4.
9 In the 1614 sale of drawings belonging to the sculptor Pompeo Leoni, attributed, not always correctly, to Leonardo, is recorded a cartoon, now lost: 'a little over a braccio [about 2 ft] in which is reproduced from a living model a female Saint shown from below the waist, in black chalk, with a perspective of buildings'. See Pedretti 1973 p. 134. Jones 1990 suggests that the variants by artists more or less close to Leonardo indicates that they were following a model by Leonardo more finished than this drawing.
10 See for example the *Magdalen* by Perugino, of around 1500 (Palazzo Pitti, Florence; see Navarro in Perugia 2004, pp. 240–1, cat. 1.35), and the panel by Piero di Cosimo of about 1501 (Palazzo Barberini, Rome), always correctly described as Leonardesque.
11 The two paintings by Giampietrino are now in the Portland Art Museum, Oregon and the Howard University Study Collection, Washington, DC. Luini's Magdalen is in the National Gallery of Art, Washington, DC. See Shapley 1968, pp. 136, 138, 142–3.

earlier and later, this comparison remains the most compelling. The reiterated contours, the shorthand (the single line for the angled eyebrow ridge, for example) and above all the lightness of touch are all alike, and since these allegories are now thought to be among Leonardo's first works for Ludovico, probably of about 1487–8, his Magdalen drawings should be similarly dated.

This would fit rather well with what is known of his activities in the mid- to late 1480s. Inspired seemingly by Antonello da Messina,[8] and in particular by a picture that must closely have resembled his Palermo *Virgin Annunciate*, it was then that Leonardo began to experiment with religious pictures (like the Holy Angel of the Annunciation that was to evolve into the Louvre *Saint John the Baptist*, fig. 41) that insisted on the presence of the figure depicted partly by acknowledging the viewer. It is not known if his treatment of Mary Magdalene progressed any further, though it has been proposed he may at some point have worked up a cartoon.[9] However, it seems that the success of this formula in Milan in the 1490s and subsequently in Florence from about 1500 can be put down in large part to Leonardo's example.[10] The turning pose and three-quarter length of the figure received its most sophisticated High Renaissance response in Raphael's *Saint Catherine of Alexandria* (National Gallery), painted in Florence in about 1507. Leonardo's followers

Bernardino Luini and Giampietrino both painted pictures of the animated Magdalen in the early fifteenth century; Luini's beautiful rendition even contains the motif of the saint opening her ointment jar.[11]

But, like Leonardo's client, we only need to think away Mary Magdalene's attribute to realise that in the shorter term the greatest impact of these sketches was on his portraits of contemporary women. After all, they could be treated as pioneering studies in rotational *contrapposto* quite independent of the rationale for her movement. Leonardo had found a way of depicting the human figure in emotionally revealing action and within the strictly limited space of a small-scale panel painting. He also realised that the viewer's own emotional response would be profoundly different depending on the direction of the depicted gaze.

The upper figure is asymmetrically framed to increase the vitality of the pose. It is not hard to see how Leonardo applied these lessons in his *Portrait of Cecilia Gallerani* (cat. 10). And we realise quite quickly that this drawing remained a point of reference when he came to paint the *Belle Ferronnière* (cat. 17). Those are pictures in which Leonardo invites us to become lovers and, more specifically, to think ourselves into the role of these women's own lover, Ludovico il Moro, just as in this drawing we are asked to take the place of Christ. LS

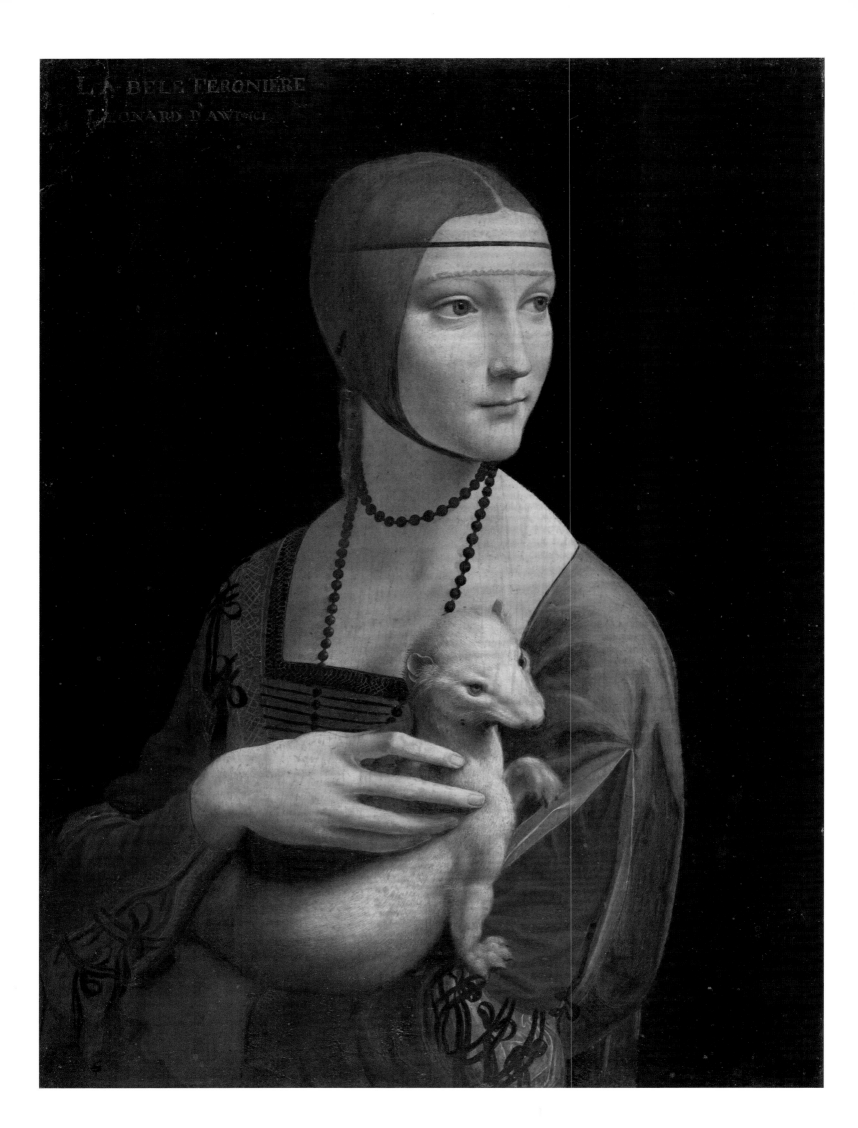

LA BELE FERONIÉRE
LEONARD D AVINCI

10

LEONARDO DA VINCI (1452–1519)

Portrait of Cecilia Gallerani ('The Lady with an Ermine')
about 1489–90

Oil on walnut
54.8 × 40.3 cm
Czartoryski Foundation on deposit at
the National Museum, Cracow
(134)

LITERATURE

Müller-Walde 1889, p. 52; Bołoz
Antoniewicz 1900a and b; Möller 1916;
Ochenkowski 1919; Marani 1989,
pp. 62–3, no. 12; Kemp in Washington
1991, pp. 271–2, cat. 170; Barolsky 1992;
Garrard 1992, pp. 164–5; Rome, Milan
and Florence 1998–9, *passim*; Marani
1999, pp. 166–77; Zöllner 2003 (2007),
p. 226, no. 13; Brown in Budapest
2009–10, pp. 240–3, cat. 54.

It has always been known that Leonardo painted a portrait of Cecilia Gallerani, Ludovico Maria Sforza's lovely mistress. The 1493 Florentine edition of Bernardo Bellincioni's posthumously published poems includes a sonnet celebrating this permanent record of her beauty.[1]

> Who stirs your wrath? Of whom are you envious,
> Nature?
> Of Vinci, who has portrayed one of your stars;
> Cecilia, today so very beautiful, is she
> Whose lovely eyes make the sun seem dark shadow.
>
> The honour is yours, even if with his painting
> It is he who makes her appear to listen and not speak.
> Think only that the more alive and beautiful she
> remains –
> The greater will be your glory – in every future age.
>
> Give thanks therefore to Ludovico
> And to the talent and the hand of Leonardo,
> Who want to share her with those to come.
>
> Everyone who sees her thus, though too late
> To see her living, will say: this suffices for us
> Now to understand what is nature and what art.[2]

Bellincioni was one of Ludovico's leading court poets, close to both Leonardo and Cecilia.[3] We may therefore imagine that this view of Leonardo's painting was approved by all the poem's protagonists. The sonnet indicates that the picture was commissioned by Ludovico, but it is known that it came later into Cecilia's possession – perhaps intended as a gift for his beloved or tucked under her arm when she was bundled out of the ducal household.

That it was intended to demonstrate Leonardo's skill in capturing the rare beauty of this young woman is borne out by Cecilia's correspondence with Isabella d'Este, Marchioness of Mantua. Isabella wrote to her on 26 April 1498:[4] she had seen some fine portraits by Giovanni Bellini and wanted to compare them with one by Leonardo, whom she recalled had portrayed Cecilia 'from life'. Three days later Cecilia replied, happy to lend Isabella the portrait but with this caveat:

> ...I would send it more willingly if it resembled me more, and Your Ladyship must not think that this is due to any defect in the master himself, for in truth I believe that one could not find his equal, but only because this portrait was done at an age so far from

fully formed [*imperfecta*] that I have since completely changed, so much so that if you saw it and me together there is no-one who would judge it meant for me...[5]

This was a likeness she had grown out of.

Thereafter the picture was lost to view,[6] and it was only in 1900 that it was suggested that Cecilia's portrait might well be identified as *The Lady with an Ermine*, which had entered the possession of the Czartoryski family about a century before. The portrait had been little seen in the nineteenth century, first mentioned in print as late as 1889. Like the portrait in the Louvre (cat. 17), the sitter had been erroneously labelled as 'la belle Ferronnière', mistress of François I of France.[7] The identification of Cecilia Gallerani was sometimes challenged thereafter, but her identity was confirmed when it was realised that the first two syllables of her surname match the Greek word for the weasel – and ermine: γαλέη (*galée*).[8] Furthermore, the ermine establishes a close connection with Ludovico il Moro himself. King Ferrante of Naples bestowed the Order of the Ermine upon him in 1486, after which Bellincioni characterised him as 'Italico Morel, bianco eremellino' (Italian Moor, white Ermine) – a neat play on the theme of black and white, dark and light, which Leonardo might have appreciated.[9] The *Lady with an Ermine* has therefore been termed a kind of double portrait, its iconography judged to have a political dimension.[10]

By the mid-twentieth century the portrait was always dated to the early 1480s, judged stylistically most compatible with the Paris *Virgin of the Rocks* and the Turin silverpoint study of a woman's head (fig. 61; this latter in fact belonging to later in the decade). It was thought Ludovico took Cecilia to his bed in 1481. A few scholars still adhere to an early date for the portrait,[11] but most now take proper account of the sitter's biography.[12] Cecilia came from a solid, somewhat impoverished, bourgeois background. In December 1483, at the age of 10, she was betrothed to 24-year-old Giovanni Stefano Visconti. But her brothers failed to keep up the payments of her dowry and in June 1487 the vows of the betrothed couple were dissolved. Cecilia was careful to stipulate that the marriage had never been consummated: her virginity might be a valuable asset if she had already caught the eye of Ludovico. And she became his mistress probably in early 1489, aged 'about 15 years'. Slightly later, Giacomo Trotti, Ferrarese ambassador at the Milanese

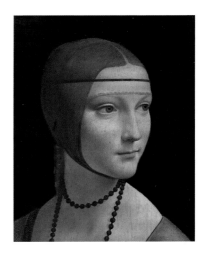

FIG. 58
LEONARDO DA VINCI
Designs; measurements,
about 1490–2
Pen and ink on paper,
21.2 × 14.3 cm
Bibliothèque de l'Institut de
France, Paris (A fol. 2v)

FIG. 59
Profile head in a circle
(detail of fig. 58)

CAT. 10 (detail)

court, reported that Ludovico's extravagant adoration of Cecilia had become an impediment to his long-planned marriage to Beatrice d'Este. Cecilia was pregnant and 'beautiful as a flower', while il Moro regarded his wife-to-be merely as 'a pleasing little thing'.[13]

Nonetheless, Ludovico knew where his diplomatic duty lay. He married Beatrice on 16 January 1491 but continued to visit Cecilia in her rooms at the Castello Sforzesco. Beatrice begged her husband to desist; but Cecilia remained ensconced, calmly accumulating properties in Pavia and Saronno.[14] Her baby, Cesare Sforza Visconti, was born on 3 May 1491. Beatrice's jealousy raged on unabated, fuelled not least by Ludovico's gift to each woman of a very similar dress. Realising that he had a genuine problem on his hands, he decided to see to it either that Cecilia was married off or that she entered a convent. On 27 July 1492, with great ceremony, she married Count Lodovico Carminati de Brambilla, known as Bergamino. She lived as Contessa Bergamina in the Palazzo Carmagnola, given to their son by Ludovico. Praised as the hostess and muse of writers and poets, her somewhat ambiguous reputation – former mistress, attractive wife, elevated lover – may have made it easier for her than for most women to mix freely with men. She lived well into middle age, and by the mid-sixteenth century was reputed an accomplished poet in her own right. She may even have maintained a friendship with Leonardo.

Bellincioni's premature death on 12 September 1492 provides a *terminus ante quem* for Leonardo's portrait but the precise date and circumstances of its making are still debated. Since weasels were well-known talismanic animals for pregnancy and childbirth, it has been suggested that Leonardo painted her portrait while she was expecting.[15] Others have proposed that it was part of her wedding preparations in 1492, but the multiple meanings of the ermine, the content of Bellincioni's poem and, above all, the style of Leonardo's painting all rule out a date after 1490. Moreover, the portrait's elegant linearism and delicate naturalism put it closer to the first version of the *Virgin of the Rocks* than to the second, though it is more sophisticated and credible in the treatment of human anatomy. On stylistic grounds alone, a date of 1489 seems likely, and Leonardo quite plausibly depicts Cecilia aged about 15.

Leonardo was not, according to Bellincioni, seeking to improve upon her outstanding natural beauty; his competition with Nature was based on art's capacity to preserve beauty, to halt the march of time. And of course the comparison of a living sitter with her representation was a familiar test of a painter's naturalistic accuracy: we can guess that Cecilia looked much like this. Leonardo profited from his studies of the human skull, under way at exactly this moment (see cat. 23), to give her head its convincing shape and volume. The bony structure of her hand is also persuasive, though a little large, suggesting that it had been separately studied (see cat. 11). Head and hand are described with what remains Leonardo's most precise and nuanced treatment of the fall of light on soft but solid forms.

His depiction of her modish costume gives a clue as to his overall approach. Cecilia wears a 'Spanish' style of dress that became fashionable after the marriage in 1489 of the granddaughter of the King of Naples, Isabella of Aragon, to Gian Galeazzo Sforza – another good reason for dating this picture to that year.[16] Her left shoulder is covered by an asymmetric silk *sbernia*, a mantle with an opening for one arm; this type of cloak would be draped over one shoulder, falling down the back with the train looped back over the other arm. Leonardo has omitted this detail since it would over-complicate the composition in a crucial part of the picture. As he must have realised, however, this kind of mantle would in itself imply or create a *contrapposto* to complement Cecilia's pose. The *sbernia* also covers one of the gold-embroidered bands on the square-necked bodice of her velvet gown, ornamented with a pattern of knots of a kind frequently mentioned in Milanese dowry inventories, and which so appealed to Leonardo (see cat. 54). But here he would not have wanted to reiterate this design since it would have interfered with the already complex contour of the ermine's head. Cecilia's string of ostentatiously modest black beads is probably costly jet, worn to set off her pale skin.

Her sleek, dark, *alla spagnola* hairstyle does the same. This fashion dictated that the hair was divided by a

centre parting, arranged into two heavy swathes falling over the cheeks, and brought together in a long braid tightly bound in a cloth casing. The head was further adorned with a small, expensive cap, a thin black fillet running across the forehead and holding in place a transparent veil whose scalloped edge is at the level of Cecilia's eyebrows. Her hair is covered by a second veil, the black silk net closely wrapped around the head and bound under the chin, wonderfully revealing the shape of her skull. But Leonardo edited out the little knot under her chin that infrared reflectography reveals in the underdrawing: the unity and harmony of the composition were not to be compromised for the sake of documentary precision.

Bellincioni's evocative description of the Cecilia in the picture, mute but listening, is a witty rethinking of the well-worn cliché of a painted portrait lacking only a voice. But Leonardo planned to do more: to show that a painting can actually communicate without words, that it can represent what is otherwise impossible to see or hear: the mind and soul. He set about proving this in several complementary ways, one building on another. As well as referring to both Cecilia and Ludovico, the ermine was a well-known symbol of purity and moderation (see cat. 16). Scholars have rightly divined a physiognomical resemblance between Cecilia and her attribute.[17] Leonardo's ermine – the stoat in winter fur – is larger than in nature, but its size and its emphatic musculature should surely be taken as indications that this animal is primarily symbolic. Naturalism is not the point here; Leonardo has created a mythical beast, the composite of several animals he drew at this time (cats 14, 15).

In some ways the physiognomical parallel is rather old-fashioned, familiar from Italian court portraiture of the 1430s and 1440s. But what has caused critics to acclaim this 'the first modern portrait' is the way in which the movement of the body, Cecilia's *contrapposto* pose and her gently vivid facial expression convey the motions of her mind and her soul. These ingredients were indeed completely novel, especially in combination. Leonardo tried out a number of energetic poses before settling on this one (cat. 13), and evidently thought hard about where to situate the figure in rela-

tion to the frame (as in cat. 9). The empty space to the right of the sitter is crucial in helping the viewer understand her figure as turning. She turns to the light and begins to smile. The catchlights in her eyes give them liquidity and intelligence, suggesting that she is looking at something, as well as reminding us that the eyes were considered the windows to the soul. We can only guess what she is looking at, this element of mystery providing Leonardo's finishing touch.

For Leonardo it was above all by his demonstration of the inherent harmonies within Cecilia's head and figure, and by his creation of an appropriately harmonious composition to show them off, that he sought to prove the beauty of both sitter and picture. The lines of her costume – the necklace, fillet and gold border of her veil – divide her head and body into its parts, helping the viewer to appreciate their relative proportions just as the carefully spaced and measured lines do in his investigations of ideal human proportion (see cat. 27).[18] Indeed, it was at much this time that he drew a head in profile, with similar proportions, placing it within that perfect shape, a circle (fig. 58), to demonstrate its own perfection. Could this also be an image of Cecilia, more diagrammatic, but further proof of her unassailable beauty?

Leonardo's portrait of Cecilia Gallerani is thus his most complete statement to date about the purpose and scope of painting. She was to be understood as a perfect creation of Nature, 'the unique exemplar of everything beautiful'.[19] By showing so much all at once, he makes the claim that a painter's representation of this great beauty could inspire an elevated love, soul speaking to soul. Though some have detected an erotic undercurrent – Cecilia stroking the neck of ermine as his Leda was later to caress the swan – such an ingredient would run counter to the emphasis on her purity. This was a message that suited Leonardo's purpose – and was moreover to convert Cecilia from Ludovico's physical lover to the idealised chaste mistress of knights, poets and painters. The picture itself proposes Cecilia as a muse. And for Cecilia to be the vehicle of such a large claim for the art of painting raised not just her status, but also that of her ducal lover and of their painter. LS

NOTES

1 Tellingly, the poem was omitted from the contemporary Milanese edition.
2 Villata 1999, pp. 76–7, no. 72C.
3 See Ghinzoni 1889.
4 Villata 1999, pp. 112–13, no. 129.
5 Villata 1999, pp. 113–14, no. 130.
6 See Marani 1999, pp. 202–3 n. 42.
7 An inscription was added upper left, probably during a Polish restoration. See Kwiatkowski 1991, p. 39.
8 First remarked by C.J. Holmes, see Hewett 1907, p. 310 n. 7.
9 Bellincioni (1876), pp. 178–9, no. 128.
10 Pedretti 1990.
11 See e.g. Villata 2005.
12 Shell and Sironi 1992, pp. 47–66; Bucci 1998.
13 Malaguzzi Valeri 1913–23, vol. I, pp. 503–4.
14 Pini 1999.
15 Moczulska 1995.
16 The importance of the sitter's dress for dating was underlined by Schiaparelli 1921, pp. 120–44; Żygulski 1969; Żygulski 1991.
17 Barolsky 1992; Simons 1995, p. 279.
18 Laurenza 2001, p. 43.
19 See the Latin poem by Julius Caesar Scaliger published in Uzielli 1890, p. 13. I am grateful to Caroline Elam for her translation.

II

LEONARDO DA VINCI (1452–1519)
Studies of hands
about 1489–90

Metalpoint over charcoal heightened with white
on pale buff prepared paper
21.5 × 15 cm
Lent by Her Majesty The Queen
(RL 12558)

12

LEONARDO DA VINCI
Portrait of a woman in profile
about 1489–90

Metalpoint on pale buff prepared paper
32 × 20 cm
Lent by Her Majesty The Queen
(RL 12505)

13

LEONARDO DA VINCI
Sketches of the head and shoulders of a woman
about 1489–90

Metalpoint on pale buff prepared paper
23.2 × 19 cm
Lent by Her Majesty The Queen
(RL 12513)

These three drawings show Leonardo's metalpoint technique at its most accomplished and sophisticated. Both rapid and considered, they are studies that truly investigate. And they reveal Leonardo using his experience as sculptor, especially his training under Verrocchio, in his approach to the reinvention of the painted portrait.

His celebrated hand studies (cat. 11), marvellously combining tension and repose, were until quite recently connected with his portrait of Ginevra de' Benci painted in Florence around 1475 (fig. 31). This panel is cut at the bottom, and it was ingeniously hypothesised that the missing lower portion once included the sitter's hands, for which this would be the preparatory study. This theory was forcefully argued when painting and drawing were shown together in Washington with Verrocchio's bust of a *Lady with Flowers* (fig. 60), revolutionary in its decorous animation and always cited as evidence that Leonardo's *Ginevra* also included hands.[1] But the style and technique of the

drawing make it chronologically incompatible with the portrait of Ginevra: indeed, its style, technique and the buff paper on which it is drawn resemble several of Leonardo's horse drawings connected with his work on the Sforza equestrian monument around 1490 (see e.g. fig. 19).[2] The studies of hands from Leonardo's first Florentine period (Windsor RL 12616; for the *Adoration of the Magi*) have more etiolated fingers and an emphasis on grace rather than internal structure. A consensus is now emerging that cat. 11 is better dated at the end of the 1480s. It is usually agreed that it should be linked stylistically with Leonardo's 'learned, unhesitating and masterly' drawing of a young woman with her head in profile (cat. 12); there is little doubt that the two sheets were drawn at much the same moment.

With the hand studies dated in the late 1480s, scholars have realised they are better associated with the *Portrait of Cecilia Gallerani* (cat. 10). It is now possible to construct a coherent group of metalpoint drawings, all from 1490 or a little before, which includes not just

LITERATURE

Cat. 11: Müller-Walde 1889, p. 52, pl. 17; Bode 1921, p. 40; Clark 1935, vol. 1, p. 89; Popham 1946, pp. 41, 117, no. 18; Clark and Pedretti 1968–9, vol. 1, pp. 104–5; Wasserman 1974, p. 113; Roberts in London 1989, p. 51, cat. 4; Colenbrander 1992; Clayton in London 1996–7, pp. 14–15, cat. 1; Brown in Washington 2001, pp. 148–9, cat. 17; Clayton in Edinburgh and London 2002–3, p. 108, fig. 31; Marani 2003b, pp. 164, 187 n. 36.

Cat. 12: Bodmer 1931, p. 399; Clark 1935, vol. 1, p. 74; Popham 1946, p. 141, no. 128; Clark and Pedretti 1968–9, vol. 1, pp. 88–9; Pedretti 1973, p. 66; Wasserman 1974, p. 113; Colenbrander 1992; Clayton in London 1996–7, p. 20, fig. 2; Clayton in Edinburgh and London 2002–3, pp. 104–5, cat. 43; Syson 2004, p. 123.

Cat. 13: Bodmer 1931, p. 387; Clark 1935, vol.1, p. 76; Popham 1946, pp. 40, 47, no. 22; Clark and Pedretti 1968–9, vol. 1, p. 90; Kemp 1981, p. 65; Kemp in Edinburgh 1992, p. 57, cat. 10; Clayton in London 1996–7, pp. 17–18, cat. 3; Clayton in Edinburgh and London 2002–3, pp. 106–8, cat. 44.

FIG. 60
ANDREA DEL VERROCCHIO
(about 1435–1488)
Lady with Flowers, about 1475
Marble, height 61 cm
Museo del Bargello, Florence

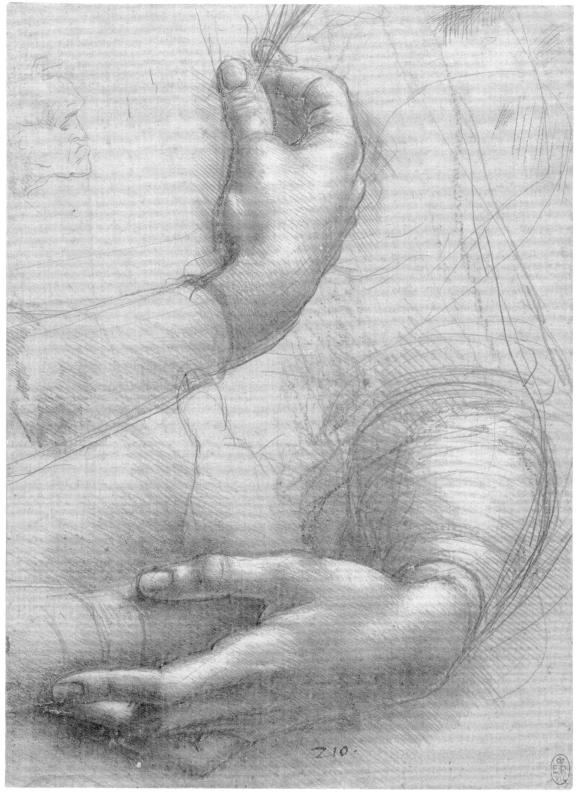

CAT. II

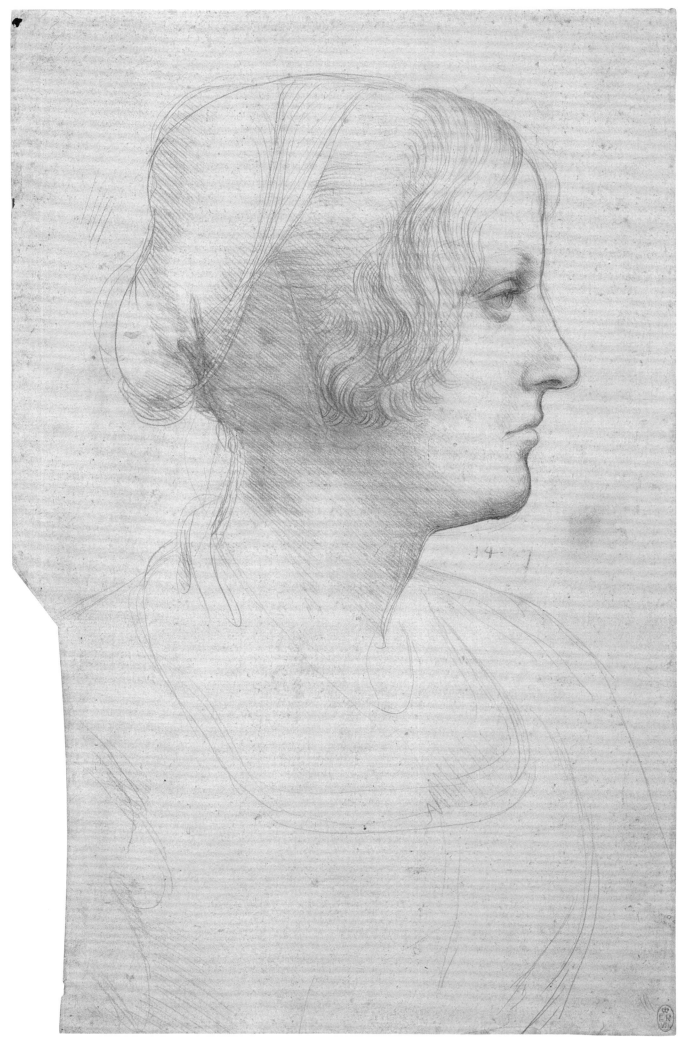

CAT. 12

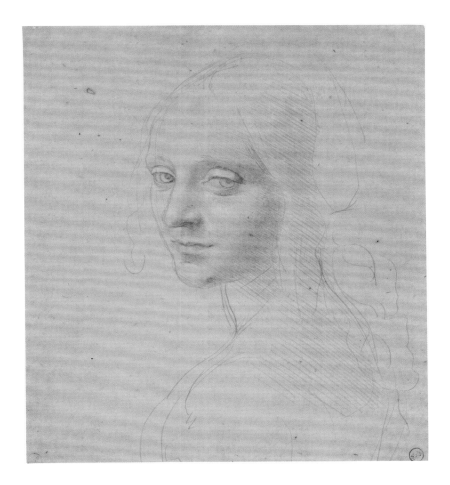

FIG. 61
LEONARDO DA VINCI
Study of the head of a young woman,
about 1488–90
Metalpoint heightened with
white on prepared paper,
18.1 × 15.9 cm
Biblioteca Reale, Turin (15572)

these two works and the horse studies, but also studies of an infant (fig. 96) and two superb drawings of women's heads in Paris (cat. 59) and Turin (fig. 61).

Despite the gap of time, all three drawings catalogued here are in their different ways responses to Verrocchio's marble bust, which evidently lurked in Leonardo's memory. It may well have been a memory of the bust that prompted Leonardo to make his study of rather similarly arranged hands, but he was also recalling Verrocchio's paintings. Leonardo had learned from Verrocchio long before that the elegance of the hand would be accentuated if the fingers are slightly elongated; now he wanted to take proper account of the skeleton underneath.

He began with the lower left hand, drawn from life and worked up to high finish. Though the media are so different, the method by which he built up the relief is not unlike his painting technique (see pp. 59–62). The mid-tone provided by the buff sheet of paper has something in common with his use of off-white *imprimitura*. His first fine guidelines, probably silverpoint, are deliberately slightly sprawling.[3] Even before he determined the final contours he established the areas of shadow, softly hatched in what may be leadpoint. The most strongly lit areas were then added in liquid lead-white heightening. With this hand finished, or nearly so, what he drew next is less certain. It is most likely, however, that he went on to sketch the right hand loosely clasped in the hand he had already completed and curled into the crook of the left elbow.

But this part of the drawing must have been invented: it is not actually possible to hold both hands in this position with the forearms at the angles shown here. As a result the shading has become a little confused and Leonardo went over some of the outlines of the left hand in ink. Since it is partly concealed and largely unresolved, he then re-drew the right hand above, this time from life, the better to understand its lighting, foreshortening and anatomy.

To help him, Leonardo's life model took up this supremely elegant but rather uncomfortable pose; the difficulty of holding it may explain some of Leonardo's problems (in the line of the wrist for example). He again lost the contours of the left side of the thumb and in the shadowed area between thumb and forefinger, this time choosing to score into the dark hatching to re-establish them.[4] In the end, the right and left hands in their most fully drawn states appear as if separated, the right higher up the body, rather as they would be in the *Portrait of Cecilia Gallerani*.

Though her head is in pure profile, it appears that Leonardo still had Verrocchio's bust in mind when he drew the head and shoulders of a young woman (cat. 12): details of costume, hairstyle and the proportions of their heads are rather alike. He sought to mitigate the profile's severity and give the figure a greater three-dimensionality by turning the shoulders and bust into a three-quarter view. Again, this study was largely drawn from life. Leonardo revised most of the contours more than once, especially of the neck and

to a lesser extent the chin, jaw, bridge of the nose and forehead. The face is modelled with extreme economy, the cheek left mostly blank, with isolated zones of hatching in the eye socket and around the nostril and jawline that combine to articulate the whole head. This drawing also reveals Leonardo's new consciousness of skull shape. The dip in the cranium and the bulge of the forehead above the eyebrow are seen in his 1489 skull studies (fig. 9), from where also come the verticality of the profile and the head's overall squareness.[5]

If her head was clearly drawn from life, her torso was surely invented when Leonardo decided to complicate the profile by turning her body into a three-quarter view, extending his drawing in a series of sweeping strokes. There is no sign of strain in the neck that would naturally come with this twisting pose; this was something he chose to study elsewhere.

Thus the remarkable sheet (cat. 13) with a woman's head, neck and upper torso studied from multiple angles and in many different poses belongs to the same distinguished group of metalpoint drawings of around 1490. It is sometimes suggested that Leonardo was exploring options for a Virgin in a Madonna and Child painting, but its subject matter is not clearly defined.

Certainly the sheet contains so many exciting possibilities that it would remain useful for years to come (see cat. 87). Leonardo had recognised that the energy of a turning pose derives chiefly from the relationship between neck, jaw and shoulders, his focus throughout this sheet. He drew his model from two main angles as she moved into a series of graceful poses, making sketches from the front, the back of her neck, the line of her jaw and the top of her spine, and then repositioning her head to squeeze in more sketches where he could.

He was still thinking like a sculptor: Martin Kemp describes this sheet as 'probably the most comprehensive instance of Verrocchio's sense of spatial fluidity re-emerging in his pupil's drawings'. Leonardo was again thinking, but more abstractly here, about how painted portraiture might be informed by the example of the three-dimensional bust, around which a viewer could move. Its connection with the superbly three-dimensional portrait of Cecilia Gallerani is quite specific: the turn of the head in one of the last of these sketches, about half-way down the page on the far left, is exactly that of the *Lady with an Ermine*. LS

NOTES

1 The bust was sometimes even attributed to Leonardo himself. It has been objected that there would not have been enough room for hands even before the dimensions of the panel were altered. Counter-evidence would be the damaged portrait of a woman at the Metropolitan Museum of Art, New York, which apparently reverses the composition of Leonardo's Ginevra de' Benci, and seemingly depicts another woman called Ginevra. This is somewhat uncertainly attributed to Lorenzo di Credi, who was particularly close to Leonardo in the late 1470s. See Zeri and Gardner 1971, pp. 154–7. The left hand of the sitter, holding a ring, in the New York portrait somewhat resembles the upper right hand in cat. 11 but is closer to the similar hand in Windsor RL 12616. We should not forget that Verrocchio himself had painted a portrait of Lorenzo de' Medici's chaste mistress, lost long ago, which should be kept in mind as a possible missing piece in this puzzle – and another potential source for Leonardo.
2 Windsor RL 12317, RL 12321 and RL 12513 are considered the closest.
3 That the sheet is probably slightly trimmed is indicated by the lines that fall off the page.
4 These inked and incised reinforcements bear some resemblance to the British Museum sketch for the *Burlington House Cartoon* (cat. 85).
5 See especially Windsor RL 19057r/v.

CAT. 13 (detail)

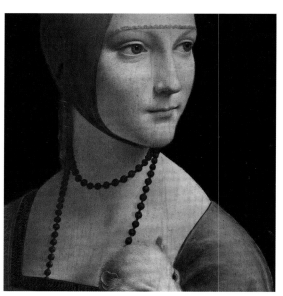

CAT. 10 (detail)

CAT. 13

14

LEONARDO DA VINCI (1452–1519)

Study of a bear's head

about 1485

Metalpoint on prepared paper
7 × 7 cm
Private collection, New York

15

LEONARDO DA VINCI

Studies of a dog's paw

about 1485

Metalpoint on prepared paper
14.1 × 10.7 cm
The National Galleries of Scotland, Edinburgh.
Purchased by the Private Treaty Sale with
the aid of The Art Fund 1991
(D 5189r)

Within the oeuvre of an artist as keenly interested in nature as Leonardo, his studies of animals assume a particular value. In addition to his well-known interest in horses, he made numerous drawings of other animals, both real and fantastical.

These two sheets contain studies made from life and share a common provenance from the collections of Sir Thomas Lawrence (1769–1830) and Captain Norman R. Colville (1893–1974).[1] Both are executed in the same fine metalpoint technique on light pink or buff prepared paper and date from a period in which Leonardo was focusing intensely on the animal world.

An analogous work to the Edinburgh study, dated a few years earlier, is that of the short-haired dog in the *Studies of a dog and cat* (British Museum, London, 1895,0915.477). The two dogs probably belong to a different breed, as seen from the ruffled and individual curled locks of fur on the legs and between the toes and claws in the Scottish drawing.

Leonardo evinces a similar naturalistic accuracy in his two drawings of bears – a beautiful head (private collection) and the *Studies for a walking bear and his paw* (Metropolitan Museum of Art, New York, 1975.1.369), which share similar technique and preparation. Here the artist demonstrates his profound interest in the beast, probably an animal in captivity, with a superb economy of means in the fine, animated metalpoint hatching.[2]

These drawings have been variously dated between the end of the 1470s and the mid-1490s.[3] Though some scholars prefer to situate these studies in Florence, they are better understood stylistically – and hence chronologically – alongside the revolutionary *Portrait of Cecilia Gallerani* (cat. 10). Leonardo's acute observation of animal anatomy and physiognomy as expressed here looks ahead to the pictorial invention of the ermine in that portrait – though with its exaggerated dimensions

CAT. 10 (detail)

and partially fantastical morphology Gallerani's ermine should be seen not as a representation of a real animal but as a symbolic presence or allegorical figure.[4] The combination of fantasy and reality revealed in the invention of the ermine does not contradict Leonardo's conception of the natural, which, as stated in the *Treatise on Painting*, can include constructing imaginary or unknown creatures by assembling their parts from different animals.[5]

Thus both sheets can be seen as important precedents rather than true preparatory studies for the fascinating creature in the *Portrait of Cecilia Gallerani*. The dog's paws, minutely observed from different angles, anticipate those of the wriggling ermine. Similarly, the ermine's powerful head may be associated with the studies of the bear's, in the structure of the cranium and shape of its features: small round eyes, cylindrical muzzle and pointed nose. Furthermore, the present studies are characterised by their energised luminosity, with touches of metalpoint evoking the play of light and shade reminiscent of that on the dense fur of the animal cradled in Cecilia Gallerani's arms. AG

LITERATURE

Cat. 14: Popham 1937, p. 87; Berenson 1938, vol. 2, p. 115, no. 1044C; Popham 1946, pp. 55, no. 78A, 125; Ames-Lewis and Wright in Nottingham and London 1983, p. 74, cat. 8; Kemp in London 1989, p. 96, cat. 37; Pedretti 1992, p. 188; Bambach in New York 2003, pp. 359–61. cat. 43; Wolk-Simon in Cremona and New York 2004, p. 89; Kemp and Barone 2010, p. 106, no. 72.

Cat. 15: Popham 1937, p. 87; Berenson 1938, vol. 2, p. 115 n. 1044B; Popham 1946, pp. 55, 125–6, no. 79A/B; Kemp in London 1989, p. 98, cat. 39; Weston Lewis in Edinburgh, New York and Houston 1999, pp. 14–15, cat. 1; Kemp and Barone 2010, p. 46, no. 4.

NOTES

1 A common French provenance has also been suggested: see Weston-Lewis in Edinburgh, New York and Houston 1999–2000, p. 14.

2 The *Studies of a dog's paw* were made from life from a domesticated dog – and not a wolf or bear, as has been argued (Weston-Lewis in Edinburgh, New York and Houston 1999–2000, p. 14; Barone and Kemp 2010, p. 46). They have also been associated with other studies of dissected bear paws (Windsor RL 12372–5) usually dated to the early

1490s (Clark and Pedretti 1968–9, vol. 1, p. 52; Clayton in London 1996–7, p. 48; Clayton 2001, pp. 50–1) but probably from the mid-1480s (I thank Martin Clayton for this observation).

3 Though frequently dated in the early 1490s, these drawings were correctly retro-dated to the previous decade (Popham 1946, p. 55; Weston Lewis in Edinburgh, New York and Houston 1999–2000, pp. 14–15; Bambach in New York 2003, p. 357–61; Barone and Kemp 2011, p. 46), although too rigidly linked to the end of the Florentine

period. The fact that they are on the same paper as preparatory studies for the *Adoration of the Magi* (fig. 34) and that this pink prepared paper was not as widespread in Milan as blue prepared paper, does not appear to be sufficient grounds for excluding them from the Milanese period. Milanese sheets such as cats 3, 13 and the *Studies of a horse* (fig. 19) are similarly coloured and prepared.

4 On the allegorical and symbolic associations of the ermine see cat. 10.

5 BN 2038 fol. 29r; Urb. fol. 135r; R 585, MCM 554; K/W 573.

CAT. 14

CAT. 15 (recto)

CAT. 15 (verso)

16

LEONARDO DA VINCI (1452–1519)

The ermine as a symbol of purity and moderation
about 1489–94

Pen and ink over traces of black chalk on paper
Diameter 9.1 cm
The Fitzwilliam Museum, Cambridge.
Bequeathed by Louis Colville Gray Clarke, 1961
(PD.120–1961)

Set within an open landscape, this is an unusual hunting scene. Having spread loose earth in front of an ermine's den, the huntsman, his tools visible behind him, blocks access to the den with one hand and prepares to strike his prey with the branch in his other. In this scene of imminent violence Leonardo invokes the virtues of purity and moderation associated with the ermine, an animal featuring within the personal iconography of Ludovico Sforza and prominent in the *Portrait of Cecilia Gallerani* (cat. 10).

This little circular drawing, once owned by Everhard Jabach (1618–1695),[1] was executed in pen with rapid, fine parallel strokes drawn with great precision. The technique is comparable to Leonardo's other allegorical drawings: this work has been particularly associated with the *Fidelity of the lizard* (Metropolitan Museum of Art, New York), the *Unmasking of envy* (Musée Bonnat, Bayonne) and the *Allegory of the solar mirror* (Musée du Louvre, Paris).[2] Among this group of drawings, the present work – probably once part of a larger sheet and perhaps, like the *Unmasking of envy* and the *Fidelity of the lizard* inscribed with text – is characterised by a high level of finish, which it shares with the *Allegory of the solar mirror*. By contrast, the New York and Bayonne drawings are more sketchy.

The allegorical and enigmatic character of the present drawing associates it with decorative arts objects produced at court, especially medals. The image of the ermine appears, for example, as a symbol of purity and moderation in the medals of the earlier fifteenth century, generally associated with mottoes such as 'Prius mori quam turpari' ('Death is preferable to being defiled') and 'Malo mori quam foedari' ('I would rather die than be sullied'); the uninscribed scroll above the animal's head was probably intended to contain such a motto.[3]

The symbolic associations of the *Portrait of Cecilia Gallerani* and this sheet draw upon the same heritage. The pose of the imperilled creature – here, as in the painting, larger than life-size – is similar to that of the ermine cradled in Cecilia's arms. Despite this, we cannot assume a direct association between the two works, particularly if they were made at different moments. But the precise date of this sheet is difficult to determine. Like the drawings listed above, it reflects

Leonardo's interest in allegory that developed during the late 1480s and early 1490s. These images were sometimes inspired by moral and allegorical stories about animals from the classical tradition, such as *Physiologus* and Pliny the Elder's *Natural History*, as well as bestiaries and popular allegorical tales such as the *Fiore della Virtù* (*Flower of Virtue*).[4] It may be more closely associated, however, with Leonardo's notes on the virtue of moderation in Paris Manuscript H (Bibliothèque de l'Institut de France).[5] Dated between 1492 and 1494, these are taken from the chapter dedicated to the ermine in the *Fiore della Virtù* (republished in Venice between 1488 and 1491). The *Fiore* describes how, in order to capture these creatures, hunters spread mud round their dens knowing that they preferred to allow themselves to be caught rather than dirty their pure white fur.[6]

Leonardo's notes and the style of this drawing both suggest a dating around 1490. Stylistically, the sheet appears to precede the *Fidelity of the lizard* and the *Unmasking of envy*, and to post-date the *Allegory of the solar mirror*, which recalls Leonardo's highly finished drawings of the 1480s (such as fig. 6). Further support for this dating is found on the verso of the New York sheet, which includes several notes and sketches for stage sets for *Danae*, a musical comedy written by Ludovico Sforza's chancellor, Baldassarre Taccone. As we know that the play was staged in Milan in the house of Gianfrancesco Sanseverino, captain of the ducal army, on 31 January 1496, this might provide a *terminus ante quem* for the entire group of drawings. AG

LITERATURE

Colvin 1904–15, vol. 9, no. 3; Bodmer 1931, pp. 232, 399; Venturi 1934–42, vol. 3, pp. 20, 24; Berenson 1938, vol. 2, p. 121, no. 1082D; McCurdy 1938, p. 474; Popham 1946, pp. 59, 134 no. 109A; Heydenreich 1943, p. 101; Heydenreich 1954, vol. 1, p. 59; Venturelli 1994, p. 117 n. 16; Fabjan 1998, pp. 73–5; Py 2001, p. 184, no. 762; Viatte in Paris 2003, p. 163, cat. 48; Kemp and Barone 2010, p. 45, no. 3.

NOTES

1 Py 2001, p. 184 n. 762.
2 Popham 1946, p. 59; Viatte in Paris 2003, pp. 156–63, cats 46–8; Bambach in New York 2003, pp. 443–50, cats 67–8.
3 Fabjan 1998, p. 73.
4 Solmi 1908, pp. 155–70, 235–48, 312; Marani 1986.
5 H¹ fol. 12r; R 1234: 'Moderation. The ermine, in its moderation, eats only once a day and, in order to avoid sullying its purity, prefers to be caught by hunters rather than escape into a muddy den'; H¹ fol. 48v; R 1263: 'Moderation restrains all vices. The ermine prefers to die rather than be dirtied'; H¹ fol. 98r; R 670: 'The ermine and mud. Galeazzo between a tranquil time and the figure of fortune'. See also Marani 1986; Fabjan 1998, pp. 73–5.
6 Leonardo's drawing is a close rendition of the text of the *Fiore della Virtù*, see Solmi 1908, p. 167.
7 See Viatte in Paris 2003, p. 162, cat. 47; Bambach in New York 2003, pp. 447–50, cat. 68.

17

LEONARDO DA VINCI (1452–1519)
Portrait of a Woman ('The Belle Ferronnière')
about 1493–4

Oil on walnut
63 × 45 cm
Musée du Louvre, Paris
(778)

LITERATURE

Waagen 1839, pp. 423–4 (as by
Leonardo); Loeser 1901 (as by
Boltraffio) ; Suida 1929, pp. 93–5 (as by
Leonardo and Boltraffio?); Valentiner
1937 (as by Leonardo); Goldscheider
1959, p. 198 (as by Ambrogio de Predis);
Béguin 1983, p. 81 (as by Boltraffio);
Wasserman 1984, p. 166 (as not by
Leonardo); Marani 1989, p. 64, cat. 13
(as by Leonardo); Scailliérez 1992,
pp. 92–3, no. 31 (as by Leonardo);
Marani 1999, pp. 178–87 (as by
Leonardo); Zöllner 2003 (2007),
p. 183, cat. 15 (as by Leonardo); Foucart-
Walter 2007, p. 81 (as by Leonardo).

The impact of the portrait known as the *Belle Ferronnière* is so carefully understated that several leading art historians have been lulled into overlooking its many innovations. As a result, the picture has been regularly removed from Leonardo's corpus of fully autograph pictures, assigned wholly or in part to a pupil or follower, most frequently Boltraffio.

It may be that these critics have been confounded by one of Leonardo's primary aims here, to demonstrate that 'motions of the mind' can be communicated by only the smallest movement of the body, the tiniest idiosyncrasy of facial expression. They have been worried by the concealment of the woman's hands behind the parapet and by the picture's calm. They are also perhaps more disconcerted than they allow by the intensity of her gaze: whereas Cecilia Gallerani's eyes and face are averted, allowing the viewer to look on her without embarrassment (see cat. 10), here the sitter looks steadily back at the viewer. Leonardo places her body at an angle to the picture surface and calculatedly off-centre; her head, slightly inclined, turns towards us, and because her eyes veer to her left this movement is extended. Her appearance is wonderfully sober.

This woman occupies her own space, defined by the parapet that is both barrier and the window-sill that connects our space to hers. But Leonardo chooses not to describe her setting any further, instead allowing her figure to dissolve into the infinite blackness of the ground. The light that falls so strongly on to her face and upper chest comes, however, from behind us, another device linking sitter and viewer. And this directional light causes a sharp diagonal shadow to fall across her neck, with a sufficiently crisp edge to make its own contribution to that crucial meeting of lines where the chin is bisected by the brightly illuminated left contour of the neck.[1] This is the key point in a composition carefully constructed around ovals and triangles. Her head in particular, its form defined by the glossy swathes of her hair and the little cap, has a striking geometric regularity. The black fillet and jewel on her forehead, the necklace of black and white beads tied together over her bosom with a ribbon, and especially the raised gold stripes on her dress all help us to read the volumes of her head, shoulder and torso. Here is a human being described like the perfect geometric bodies illustrated in Luca Pacioli's 1498

manuscript treatise *On Divine Proportion* preserved at the Biblioteca Ambrosiana, Milan.[2]

Leonardo' colour scheme is as deliberately restricted as in the London *Virgin of the Rocks* (cat. 32), with a concentration on rich red and dull gold. Only the ribbons with their trickling highlights and the little puffs of her chemise seen through the gap between bodice and sleeve give this picture the energy needed to prevent it becoming a diagram. Leonardo has here reinvented the idealised portrait, every bit as remote and aloof, as timeless as the traditional profile portrait, but now endowing the sitter with a specificity and presence derived from the convincing way she is lit and, above all, from her compelling gaze.[3]

It is not yet decided whom this portrait represents – and her features, so carefully regularised, impede easy recognition. Its provenance does not help. Could it have been one of pictures in the extensive gallery of Italian portraits owned in 1500 by Anne of Brittany at Amboise? Appearing fifth in the inventory is 'Ung autre tableau paint sur bois d'une femme de fasson ytalienne' ('another panel painting of a woman wearing Italian dress') and it has been suggested that this constitutes our first documented sighting of the *Belle Ferronnière* in France.[4] It may also have been the portrait seen in October 1517 by Antonio de Beatis when he travelled to Blois, 'a portrait in oils of a certain lady of Lombardy, done from life; she is rather beautiful but in my opinion not as beautiful as Signora Gualanda' (Isabella Gualanda was a noted Neapolitan beauty of the age).[5] The first unequivocal mention of this picture comes only in 1642 when Père Dan in his *Trésor des merveilles de la maison royale de Fontainebleau* identified the subject as 'une duchesse de Mantoue'. But when in 1709 Nicholas Bailly listed the contents of the royal collection, he muddled this portrait with another (also in the Louvre), thought to depict the celebrated mistress of François I known as 'la belle Ferronnière'. Repeated later in the eighteenth century, this misleading designation has stuck.

It was first suggested in 1803 that the picture in fact depicts Lucrezia Crivelli,[6] Ludovico Sforza's mistress from about 1495. On the verso of an autograph sheet of geometrical studies in the Codex Atlanticus (fol. 456v) are transcribed – in an unknown hand – three Latin epigrams by Antonio Tebaldeo, inspired by Leonardo's portrait of Lucrezia.[7] The first reads:

How well learned art responds to nature.
Vinci might have shown her soul here, as he has
 portrayed everything else.
He did not, so that the image might have greater
 truth,
For it is thus: her soul belongs to Moro, her lover.[8]

The second epigram posits a neat connection between Leonardo, 'first among painters', and Ludovico, 'first among princes'. The third runs:

Surely, with this image, the painter has angered
 Nature and the goddesses above.
Who were distressed that the hand of man can do
 so much,
And that such beauty which should so quickly
 perish
Has been granted immortality.
He offended them for Moro's sake. Moro will
 defend him.
Both gods and men fear to anger Moro.

There is a new hint here that Nature is dismayed in part by Leonardo's own capacity to create beauty.

That such a portrait once existed seems likely. But the epigrams provide no clue that would allow us to firmly identify Lucrezia Crivelli as the sitter for the *Belle Ferronnière*. Apart from her great beauty, the facts of her life are sketchy.[9] She was a lady-in-waiting to Ludovico's consort, Beatrice d'Este, and in 1494 she was respectably married to a former courtier of Bona of Savoy, bearing him a daughter. In August 1495 Isabella d'Este was informed that her brother-in-law was conducting a dalliance with Lucrezia. The Duke comported himself watching 'with great reticence, extremely cautious of the world'. But a year later a Ferrarese diarist was exercised by 'the latest news from Milan': all the Duke's pleasure was to be had in the company of a maid-of-honour to his wife, now a stranger to Ludovico's bed.[10] Beatrice died on 3 January 1497 and, though Ludovico was publicly broken-hearted, he continued this liaison. Lucrezia gave birth to Ludovico's son Gian Paolo on 10 March that year; her power had reached its zenith and the 'Magnifica et generosa domina Lucretia de Cribellis' set about acquiring ecclesiastical benefices for her brother and lands for herself. When she fled Milan in 1500 Lucrezia was pregnant again with a second son. It is sometimes said that the Duke's ostentatious mourning for his wife makes it unlikely he commis-

sioned Lucrezia's portrait after his consort's death. However, his futile attempt at discretion while Beatrice was alive and Lucrezia's acknowledged role as *maîtresse-en-titre* afterwards might suggest the contrary. If the *Belle Ferronnière* does depict Lucrezia, her biography suggests it could have been painted any time between about 1495 and 1499.

The precise dating of the picture on stylistic grounds has, however, been hard to determine. The supremely smooth transitions of light and shade, in which some outlines disappear almost completely, are best paralleled by the heads of the Apostles in Leonardo's *Last Supper*, finished probably by the end of 1497. The sitter's oval head and the disposition of the features within it recall in particular the Saint John the Evangelist, as well as the Madonna in the London *Virgin of the Rocks* (cat. 32), on which Leonardo was still working at the end of this decade. Both, however, were started much earlier, in the first half of the 1490s, and the impact of the *Belle Ferronnière* is felt in the work of his pupils by about 1494 (see cats 18, 19). The painter of the *Madonna Litta* (cat. 57) was seemingly copying the discreetly shining highlights in the *Belle Ferronnière*'s hair even earlier. There are good reasons therefore to think that this picture was executed in about 1493–4; one expert in the history of fashion has dated this woman's 'Spanish' costume to exactly that moment.[11]

Since Lucrezia was already Ludovico's lover in 1495, there remains a chance that the *Belle Ferronnière* is indeed the portrait celebrated by Tebaldeo. This would be by far the tidiest solution. But if this is a portrait of Lucrezia Crivelli, Leonardo has converted her, even more thoroughly than he did Cecilia Gallerani, into an elevated ideal. This coolly watchful portrait might be judged an odd testament to Ludovico's passion, and it is worth considering the alternative candidates.[12] In particular, we might ask, if this is not a portrait of the mistress, could it be an image of the wife? Though every other certain painted portrait of Beatrice is in profile, this identification has long had a measure of support.[13] Giovanni Romano, for example, dating the picture to 1495–1500, implies that it is a portrait of Beatrice that may have been painted posthumously, from memory.[14] It has been noted that the seventeenth-century identification of the sitter as a 'duchess' of Mantua might reflect a tradition whereby she was thought to be a member of the Este family.[15] And

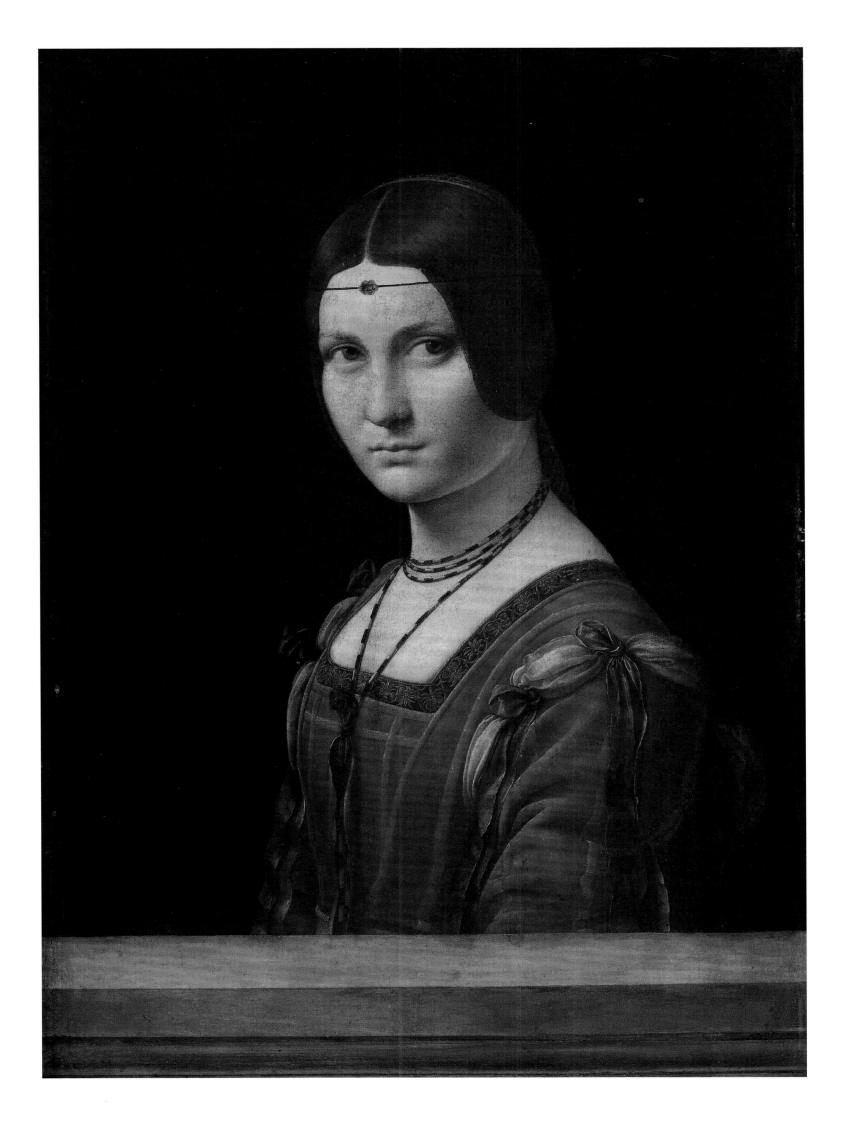

FIGS 62, 63
GIAN CRISTOFORO ROMANO
(about 1465–1512)
Bust of Beatrice d'Este, about 1491
Marble, height 59 cm
Musée du Louvre, Paris

there is also the evidence of a rather feeble drawing, datable to around 1500 by its materials, which clearly depends on the *Belle Ferronnière* (fig. 64).[16] In the early seventeenth century, when it belonged to the collector Sebastiano Resta, he annotated the sheet identifying the subject as Beatrice d'Este and the draughtsman as Leonardo. Though the latter suggestion is absurdly optimistic, this inscription may not be complete nonsense.[17] Finally it should be pointed out that when the Piedmontese painter Macrino d'Alba took the picture as a source for his own portrait of a consort, Anna d'Alençon, Marchioness of Monferrato (Santuario dell'Assunta, Crea), he may have been making a formal decision, but one that would be better justified if he was imitating another ruler portrait.[18]

Beatrice was famed as a pioneer of fashion, who wore just this kind of ribbon-strewn dress in her other portraits (see fig. 26).[19] All her portraitists agree that she had brown eyes and dark brown hair worn in this Spanish fashion. True, she usually has a tendril of hair escaping down her cheek, although not, for example, in an anonymous portrait at Christ Church, Oxford. And it is clear that her features were probably less marvellously regular than here: she had a narrow top to her cranium, a lumpy forehead and a slightly concave profile. But seen from this angle these flaws could be made less visible; Leonardo has chosen his viewpoint carefully. Valentiner compared Leonardo's portrait with the marble bust portrait of Beatrice by Gian Cristoforo Romano, made a little before June 1491 to mark her marriage (figs 62, 63).[20] Gian Cristoforo was chiefly occupied at that time in carving the tomb of Gian Galeazzo Visconti at the Certosa just outside Pavia – but as an accomplished musician and skilled courtier, he was also a rival for Leonardo.

The comparison between the two works remains valid even if the identification of the sitter as Beatrice is rejected. Arguing for the supremacy of painting, Leonardo made several polemical comparisons (*paragoni*) with the other arts and, as we have seen, in the earlier portraits of Cecilia Gallerani and of the Musician, he had sought to contrast 'the simultaneity of visual harmonics with the disjointed beauties of literature and the transitory harmonies of musical performance'.[21] As Pietro Marani has pointed out, in the *Belle Ferronnière* Leonardo deliberately provokes a comparison with sculpture – the parapet becomes a kind of plinth and the pose has all the containment

FIG. 64
NORTH ITALIAN ARTIST
Portrait of a woman inscribed 'Beatrice d'Este',
about 1500–10
Metalpoint, pen and ink and wash
on prepared paper, 41.5 × 26.7 cm
Galleria degli Uffizi, Florence (209Fr)

of a marble bust.[22] Moreover, the subtle twist given to the woman's body invites the eye to move notionally around the figure. Even the apparently raised embroidery on her square neckline recalls the way in which a sculptor would represent such a feature. In the notes towards his treatise on painting Leonardo adumbrates the reasons for painting's superiority to carved sculpture. He cannot deny that sculpture had its own reality, since – obviously – it has three dimensions, a body and shape, but this is a strictly limited reality when compared to the many varied optical effects at the disposal of a painter.[23] Since a sculpture has volume, it cannot *convey* volume, let alone space and distance, light and shade or, not least, colour. These are the things that can make a painting more real than simply being there: 'sculpture has fewer matters to consider and consequently is less demanding of talent [*ingegno*] than painting.'[24] Gian Cristoforo Romano's bust of Beatrice is a tour de force of virtuoso carving. It is also seemingly a rather accurate likeness of the young bride. But, though clearly more idealised, it is Leonardo's *Belle Ferronnière* that is the more fully alive. LS

NOTES

1 What might appear to be a pinkish reflected light along her jaw-line, much discussed in Marani 1999, pp. 183, 187, to support his attribution of the picture to Leonardo, is a passage of later retouching.

2 Veltman and Keele 1986, pp. 170–85.

3 Several scholars (e.g. Joannides 1989, pp. 26–7) have emphasised how deeply indebted Leonardo is here to Antonello da Messina.

4 Adhémar 1975, p. 102. Anne's pictures were reportedly looted from a conquered Milan, probably confiscated from Ludovico Sforza himself. They included a male portrait apparently signed 'Johannes Ambrosius', almost certainly by Ambrogio de Predis, a portrait of 'Sr Ludovic' and two of Filippo

Maria Visconti. Unless they were inscribed, it appears that their identities were already lost. A portrait of Beatrice may have been sent back to France in 1494. See Cartwright 1903, pp. 235–6.

5 Villata 1999, p. 263, no. 314.

6 By Gault de Saint-Germain 1803, p. lvii, no. 14; followed by Amoretti 1804, p. 39.

7 The author was identified by Agosti 1993, pp. 71–81, especially p. 81 n. 59. He found these same epigrams with the author's name in the Vatican Library (Codex Ottobonianus Latinus 2860, fol. 160).

8 Villata 1999, pp. 106–7, no. 122; A fol. 457v (ex 167 v.c); R 1560.

9 For documents pertaining to Lucrezia's life see Luzio 1901, pp. 149, 154; Biscaro 1909; Novata

1910; Malaguzzi Valeri 1913–23, vol. 1, pp. 338 n. 1, 512–13, 517.

10 For the Duke, 'tutto il suo piacere era con una fante che era donzella de la moglie, fiola del Duca di Ferrara, con la quale el non dormiva già; sicchè era mal voluto'.

11 Binaghi Olivari 1983, p. 650.

12 Garrard (1992, pp. 65–6) notes a discrepancy between the sitter's 'self-possessed' demeanour and Tebaldeo's first epigram.

13 See Hewett 1907; Valentiner 1937; Béguin in Paris 1952, pp. 14–19.

14 Romano 1981, p. 44, pl. 61.

15 Scailliérez 1992, pp. 92–3.

16 Dalli Regoli in Pedretti and Dalli Regoli 1985, pp. 76–7, no. 26.

17 This drawing has some relationship to a large-scale, uninscribed portrait print (Hind 15). The image is

reversed, with some variation in costume details. It is unlikely that the drawing, probably later, would reverse the print, but the print might reverse a common source, conceivably the Louvre painting.

18 Villata 1996; Villata in Alba 2001, pp. 30–1, cats 5–6.

19 For Beatrice and her cultural pursuits, see Cartwright 1903; Sizeranne 1924; and the essays in Giordano 2008.

20 See Bormand in Paris 2008–9, pp. 328–9, cat. 135.

21 Kemp 1981, p. 210.

22 Marani was inspired by a remark in Kemp 1988, p. 17.

23 Kemp 2009, pp. 69–70.

24 Urb. fol. 21v; MCM 51; BN 2038 fol. 24v. See Urb. fol. 28r–v; R 656; MCM 53.

GIOVANNI ANTONIO BOLTRAFFIO (about 1467–1516)

Portrait of a Young Woman as Artemisia
about 1494

Oil on wood
49 × 37 cm
Mattioli Collection, Milan

This mesmerising portrait represents a highly personal reworking by Leonardo's most gifted Milanese pupil of his innovations in the art of portraiture, as expressed in his *Portrait of Cecilia Gallerani* (cat. 10) and *Belle Ferronnière* (cat. 17). A young, veiled woman is depicted against a dark background. A strong, even light from top right washes across her face, defining the classically regular shape of her nose. She gazes at the viewer with tear-filled eyes, her expression languid, almost exhausted, as if containing herself after days of weeping. Her slightly swollen upper lip suggests her youth. Her beautifully shaped right hand holds a golden bowl that seems to contain a transparent liquid.

The attribution to Boltraffio has not been disputed since the painting reappeared in Italy in the late 1940s.[1] When Wilhelm Valentiner unsuccessfully requested it for the 1949 Los Angeles Leonardo exhibition, he suggested to its owner that it might be connected with a passage in Enea Irpino's 1520 *Canzoniere*, describing a portrait of the noblewoman Costanza d'Avalos by Leonardo.[2] Irpino's words refer to her as 'under the beautiful black veil', therefore somewhat resembling the dark blue veil worn by the sitter here.[3] However, the rhetorical tone of the *Canzoniere* precludes its use as documentary evidence for the existence of such a portrait.

The sitter represents an ideal of sexless human beauty which recurs, for example, in the contemporary *Head of a youth with an ivy wreath* (cat. 50) and *Portrait of a Youth* (fig. 65), both by Boltraffio.[4] In the past the latter has been thought – erroneously – to represent Girolamo Casio himself; however, it does not record any specific features, but rather employs the ideal used for both female and male allegorical portraits. With its symbolic content, the purpose here is to convey the psychological state of a patron rather than to record his or her particular features. Suida interpreted the subject as Tuccia holding a sieve, the symbol of her chastity.[5] In 1968 it was exhibited at the Poldi Pezzoli Museum, Milan, as depicting Mary Magdalene. She was most convincingly identified, however, by Andrea G. De Marchi as the widow Artemisia.[6] In the fourth century BC, according to Aulus Gellius's *Attic Nights*, Artemisia II of Caria 'is said to have loved her husband Mausolus with a love surpassing all the tales of passion and beyond one's conception of human affection'. When Mausolus died, Artemisia, as proof of her love, 'mingled his bones and ashes with spices, ground them

FIG. 65
GIOVANNI ANTONIO BOLTRAFFIO
Portrait of a Youth, about 1493–4
Oil on wood, 40.5 × 23 cm
Devonshire Collection, Chatsworth

into the form of a powder, put them in water, and drank them'.[7] This is the story evoked here by the presence of Artemisia's liquid-filled bowl and her melancholic appearance.[8]

The woman wears the traditional dress of a Neapolitan widow of the late fifteenth century, which was dark green or, more commonly, dark blue – both colours are present here.[9] In 1494 Isabella of Aragon, daughter of the King of Naples, was widowed after the death of Gian Galeazzo Sforza, legitimate Duke of Milan. It is possible, therefore, that the portrait commemorates the widowhood of a Neapolitan lady, and, by extension, that of Isabella; a patron of Boltraffio, in 1498 she requested that he copy a portrait of her dead brother, Ferrandino.[10] The painting fits perfectly with Boltraffio's style of about 1494 (contemporary with Marco d'Oggiono's *Archinto Portrait*, cat. 19), at the peak of his 'idealising' and 'classicising' period. But its pathos reveals the early impact of Leonardo's researches on the *moti dell'animo* (stirrings of the spirit), which emerged in its fullest form in the *Last Supper*.[11] AM

LITERATURE

Florence 1948, p. 45; Suida in Los Angeles 1949, p. 92, cat. 43; Fiorio in Milan 1987–8, pp. 128–9, cat. 62; De Marchi in Angelelli and De Marchi 1991, pp. 107–8, no. 190; Fiorio 2000, pp. 87–8, no. A5; Macola 2007, p. 49 n. 112.

NOTES

1 It was first exhibited as by Boltraffio in 1948 (Florence 1948, p. 45), and was bought probably the previous year by Gianni Mattioli from Bruno Lorenzelli, a Bergamasque dealer.
2 Letter to Gianni Mattioli, 2 September 1949 (private archive of Mattioli heirs, Milan). The manuscript *Canzoniere* in the Biblioteca Palatina, Parma (MS Parmense 700) was published in Croce 1921, pp. 22–9. Leonardo's portrait of Costanza d'Avalos is described by Irpino on fols 40v and 41r. It was connected with the *Mona Lisa* (fig. 32) by Venturi 1941, pp. xxiv–xxv.
3 This was interpreted as the dress of a widow. Costanza, born about 1460, was married to Federico del Balzo until his death in 1483. There is no evidence that Irpino wanted to allude to Costanza as a widow.
4 On the typology of the idealised portrait, see Brown 1983.
5 Suida's opinion is reported in Valentiner's letter (mentioned in note 2).
6 See also Macola 2007, p. 49 n. 112, apparently unaware of De Marchi's proposal.
7 Aulus Gellius (1927), vol. 2, pp. 260–5. The story of Artemisia is told also by other ancient writers (listed in Macola 2007, p. 48 n. 112).
8 See Sframeli 2008. Marsilio Ficino, in his commentary on Plato's *Symposium* on Love, cited the story of Artemisia to exemplify lovers who desire to take the whole beloved into themselves. See Ficino (1985), p. 164. An *Artemisia* believed to be by Leonardo was sold by 'Strode' in London, Christie's, 27 March 1797 (lot 65).
9 See Levi Pisetzky 1964, vol. 2, p. 467.
10 See Fiorio 2000, p. 221 nn. 4–5; Agosti 2005, p. 246 n. 61.
11 Another example of Boltraffio's combination of idealisation and pathos of about 1495 is the *Head of a young man with a crown of thorns and ivy* (fig. 92).

19

MARCO D'OGGIONO (documented from 1487; died 1524)

Portrait of a Man aged 20 ('The Archinto Portrait')

1494

Oil on walnut
54.4 × 38.4 cm (panel)
Inscribed on scroll: '· 1494 · / · MAR F [in monogram] · /
[A]ETA[TIS] S[VAE] · AN[N]O · 20 ·'
The National Gallery, London
(NG 1665)

The *Portrait of a Man aged 20* of 1494 is extremely important for our reconstruction of Leonardo's Milanese career as a painter, since it is one of the few dated (or indeed firmly datable) works produced under his direct influence. Behind it lies Leonardo's *Belle Ferronnière* (cat. 17), which thus pre-dates this work.

As in Leonardo's portrait, the sitter is seen behind a parapet, his opaque grey eyes turned towards the viewer but focusing elusively on something beyond. But whereas the *Belle Ferronnière* is skilfully set *di spalla* (looking over her shoulder), suggesting that she has spontaneously turned her head, the pose of this young man at first appears entirely frontal. On closer inspection it is clear that the artist has attempted to place one shoulder a little further back, while the head turns slightly in the opposite direction. His expression is curiously sad, the nose flattened and the lips swollen. The reddish '*zazzera*' hairstyle and robe with fur lapels were fashionable in the 1490s.[1] The sitter's right hand, apparently detached from the body, rests bonelessly on the brightly streaked marble parapet,[2] a curling scroll between thumb and forefinger. This bears the date as well as other elements that have caused the attribution of the painting (and of several related works) to be misunderstood.

Thanks to the inscription, it is now known that the *Portrait of a Man aged 20* is the picture described in Gaetano Giordani's 1832 *Zibaldone* as 'believed by most to be painted by Zenale from Treviglio'.[3] A few years later Pompeo Litta ascribed it to Leonardo in his *Famiglie Celebri d'Italia*, and identified the sitter as Francesco di Bartolomeo Archinto, probably drawing upon Archinto family tradition;[4] there is, unfortunately, no further evidence for this identification.[5] The influential art historian Giovanni Morelli saw the painting for the first time in 1847 and believed it to be by Leonardo;[6] it was sold as such at the Archinto sale in Paris in 1863. However, in 1880 Morelli inadvertently caused a major confusion regarding the picture's attribution. Writing about the work of Ambrogio de Predis, he reported that a 'competent source' (Gustavo Frizzoni)[7] had informed him that there was a picture in London (then in the Fuller Maitland collection) with a monogram interpreted as 'Ambrosius Predis Mediolanensis' ('Ambrogio de Predis from Milan'). Morelli almost certainly did not immediately connect this with the *Portrait of a Man aged 20*, which he had seen in 1847, because a few pages later he attributed it to

another follower of Leonardo, Bernardino dei Conti, comparing it with the *Pala Sforzesca* (fig. 26; see also cat. 49), also attributed to Bernardino.[8] From this point the interpretation of the monogram as communicated to Morelli (but not his judgement of the style of the picture, which he associated with another artist) became standard, only rarely challenged, and the portrait effectively became a 'signed' Ambrogio de Predis, an attribution that still persists in some quarters today. The monogram was subsequently read as: 'AMPRF' ('AM[BROSIVS] PR[EDA] F[ECIT]' – 'Ambrogio de Predis made this').[9] As a result, the several paintings and drawings stylistically connected to the *Portrait of a Man aged 20* are also commonly attributed to de Predis.[10]

On stylistic grounds the main objection to the attribution to de Predis is the lack of any real resemblance to his only unequivocally signed and dated painting, the *Portrait of the Emperor Maximilian I* of 1502 (fig. 57). Though subsequently widely ignored, this objection was first raised in 1929 by Wilhelm Suida, who pointed out that Ambrogio de Predis never really became a Leonardesque painter. Suida created a stylistic group around the painting (as by the 'Master of the Archinto Portrait', a formula still used today) to distinguish it from de Predis's own work. In fact, the monogram probably contains no letter 'P' (cat. 19, detail), the first letter of de Predis's surname.

LITERATURE

Morelli 1880, p. 457 n. 1 (inadvertently as by Ambrogio de Predis) and p. 466 (as by Bernardino dei Conti); Morelli 1886, p. 435 (as by dei Conti); Frizzoni 1898, p. 390 (as by de Predis); Venturi 1915, p. 1020, fig. 695 (as by de Predis); Malaguzzi Valeri 1913–23, vol. 3, pp. 15–16, fig. 5 (as by de Predis); Suida 1929, pp. 90, 174–5, 280, fig. 195 (as by a 'Milanese painter of 1494': the Master of the Archinto Portrait); Davies 1961, pp. 448–9 (as by de Predis); Ballarin 1985 (2005), pp. 22–34 (as by Boltraffio); Bora in Milan 1987–8, p. 63, cat. 12 (as by the Master of the Archinto Portrait); Marani 1987a, pp. 35–6, fig. 2 (as attributed to de Predis); Baudequin in Modena and Rennes 1990, pp. 30–1, under cat. 9 (as by Marco d'Oggiono); Brown 1991, p. 33 n. 28 (as by de Predis); Shell 1998, pp. 127–8, fig. 3 (as by de Predis); Fiorio 1999, pp. 152–4 (as by de Predis); Farrow 2001 (as by the Master of the Archinto Portrait); Syson 2004, pp. 120–1, fig. 7.10 (as attributed to the Master of the Pala Sforzesca).

FIG. 66
GIOVANNI ANTONIO BOLTRAFFIO
and MARCO D'OGGIONO
The *Grifi Altarpiece* (detail of fig. 98), about 1497

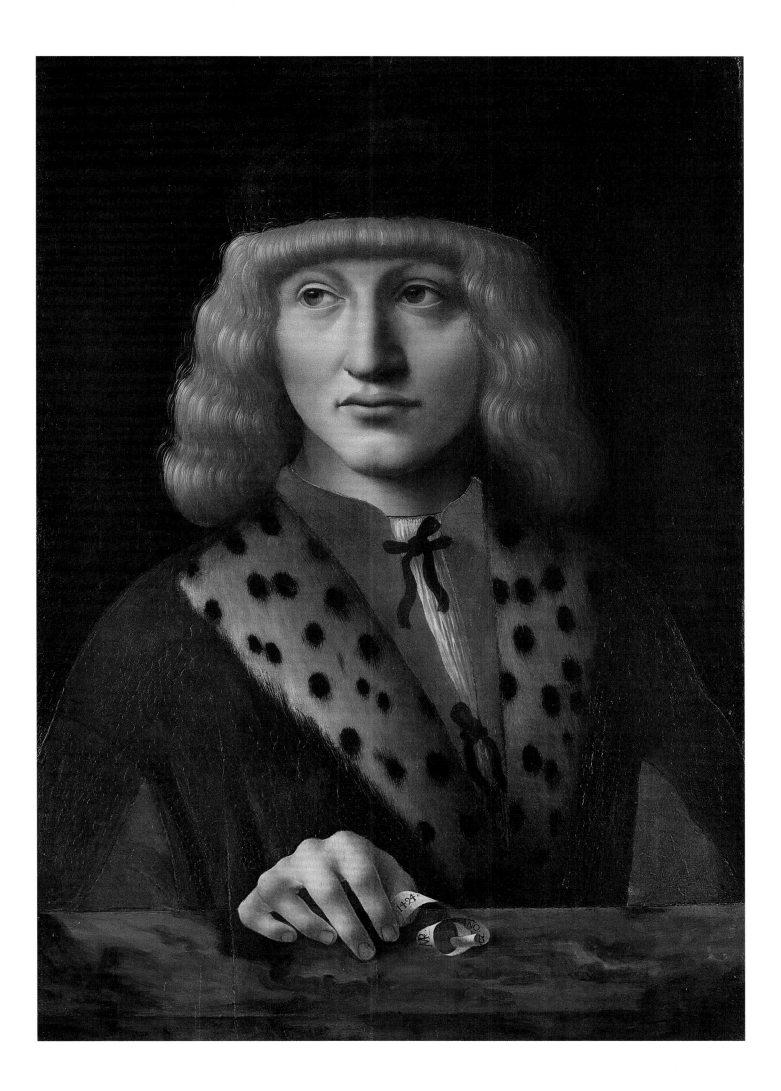

FIG. 67
MARCO D'OGGIONO
Man with an Arrow (Saint Sebastian?), about 1498–1500
Oil on wood, diameter 46 cm
Formerly at the Galerie Tarica, Paris
(current location unknown)

FIG. 68
ANSELMO DE FORNARI (documented
about 1496–1516) or ELIA RONCHI
(documented about 1497–1509),
after a design by Marco d'Oggiono
Saint Julian (detail), about 1501–15
Inlaid wood, 65 × 47 cm
Savona Cathedral

There are many stylistic connections, however, between the *Portrait of a Man aged 20* and the work of Marco d'Oggiono, another of Leonardo's key collaborators.[11] We know that he was in Leonardo's studio by 1490, when the apprentice Salaì stole a silverpoint from him.[12] Art historians have defined Marco's artistic personality based on his later, documented works, mostly made after 1500 and characterised by a monotonously reiterated style, making them easily recognisable.[13] The starting point of his early career remains his only documented work of the 1490s, the *Grifi Altarpiece* (fig. 43), commissioned in 1491 (and again in 1494) for the Grifi family chapel (see cat. 65). Painted in partnership with Boltraffio, this shows the Resurrection of Christ with Saint Leonard and Saint Lucy, and is stylistically so dependent on Leonardo's *Last Supper* that it was probably executed a few years later, around 1497.[14] It is rightly believed that Marco was responsible for the figure of Christ, and Boltraffio for the two saints. Christ's head (fig. 66) does indeed contain, in embryo, Marco's faults that are so clearly demonstrated in his later work: unnecessary emphasis, *sfumato* applied like make-up, rubbery flesh. These also characterise the *Portrait of a Man aged 20*, with his ashen skin tone and waxy, lifeless lips. Indeed, his hand looks almost as dead as Christ's foot in the *Grifi Altarpiece*.[15]

This link establishes a first bridge between this hypothetical early Marco d'Oggiono and his later career. A painting of a *Man with an Arrow (Saint Sebastian?)* (fig. 67), similar in character but currently lost to view, is commonly considered as an early work by Marco.[16] It is strikingly close in style to the *Portrait of a Man aged 20* (although painted slightly later, around the time of the *Madonna of the Violets*, cat. 67), particularly in the shape and orientation of the eyes and nose and the use

of light and shade. Even the spotted fur lapels are rendered in much the same way. However, the *Man with an Arrow* evinces a perceptible falling-off in quality compared with the present portrait. Marco's artistic ability seems to have decreased after he left Leonardo's workshop, probably in the mid-1490s – and still further once he ceased to collaborate with Boltraffio, whose works remained a key point of reference in 1494. The *Portrait of a Man aged 20* is strongly dependent, for example, on the Brera *Portrait of a Young Man* (cat. 7), here attributed to Boltraffio. The stylistic and compositional similarities are such that they have (wrongly) persuaded some critics that the two portraits are by the same hand.[17]

Marco is documented as active in Savona around 1501–4, where he also worked in the cathedral for Cardinal Giuliano della Rovere, later Pope Julius II.[18] Scholars have argued that Marco provided designs for some of the figures executed in wood inlay (*tarsie*) set into the choir stalls of Savona Cathedral;[19] one of these, representing *Saint Julian* (fig. 68), has the appearance of a wooden *Archinto Portrait*.[20]

To return to the monogram, which is partially retouched, it has been suggested that it pertains to the sitter but it is more likely to identify the artist.[21] The only legible letters are 'AMRF', interchangeable in their order; if read as 'MARF' they could stand for 'MAR[CVS] F[ECIT]' ('Marco made this'). Marco d'Oggiono signed himself as 'MARCVS' in the altarpiece with the *Three Archangels* of around 1516 (Brera, Milan). Read in this way, the monogram may be taken as additional evidence for an attribution, made primarily on stylistic grounds, to Marco d'Oggiono. AM

CAT. 19 (detail)

NOTES

1 See e.g. the page-boy in *Portrait of Luca Pacioli with an Assistant*, 1495, usually attributed to Jacopo de Barbari (Galleria Nazionale di Capodimonte, Naples).

2 See the hand of Leonardo's *Musician* (cat. 5).

3 Giordani saw it in 1832 in the Archinto collection. The *Zibaldone* manuscript is in the Archiginnasio, Bologna. I am grateful to Giovanni Agosti for drawing my attention to Jucker 2009–10, p. 51, no. 161.

4 Litta 1842–3 (under Archinto); the Litta miniaturised version was copied in the early twentieth century by Augusto Gerosa (Pini 2004, p. 133, cat. 1). See Ffoulkes 1894, pp. 250–1, fig. 10a, on a possible misreading of the monogram in relation to the identification.

5 Francesco di Bartolomeo Archinto died in 1551; his date of birth is unknown, but if he is the subject of the present portrait this would be 1474. No portraits survive in which he is firmly identified.

6 Morelli's letter is mentioned by Ffoulkes 1894, p. 250.

7 This is clarified by Ffoulkes in her translation. See Morelli 1892–3.

8 In the Italian edition of his book on the Munich, Dresden and Berlin galleries (1886) Morelli deleted the interpretation of the monogram as 'Ambrogio de Predis', realising that it appeared on the picture he believed to be by Bernardino dei Conti. The posthumous English edition of his writings retains the 'mistake' of the first edition, contributing to the myth that he had attributed the *Portrait of a Man aged 20* to de Predis (Morelli 1892, p. 186).

9 See Davies 1961, pp. 448–9. The portrait became internationally known after it was exhibited in England (as by de Predis) at the end of the nineteenth century (listed by Davies).

10 Commonly discussed together, these are: Brera *Portrait of a Young Man* (cat. 7, by another – and better – hand); Lázaro Galdiano *Young Christ* (cat. 66); Bristol *Portrait of a Child* ('*Il Duchetto*') (see cat. 65 and fig. 94); Metropolitan *Girl with Cherries* (fig. 90); Cleveland *Boy with an Arrow*;

and Ambrosiana *Study of a hand* (Cod. F 263 inf. 80). The Getty *Christ carrying the Cross* was recently added to this group: acquired by the Getty in 1985 as by de Predis, now displayed as by Marco d'Oggiono (since Brown 1991, pp. 28, 33 n. 25, 34, fig. 14). To this stylistic group may be added two metalpoint studies of heads at the Pushkin State Museum, Moscow, formerly Franz Koenigs collection (Maiskaya in Moscow 1995–6, pp. 176–7, cats 107–8).

11 Proposed by Baudequin in 1990, but based on mistaken premises (see cat. 66).

12 Villata 1999, pp. 63–4, no. 53.

13 See e.g. his *Virgin and Child* in the National Gallery, London.

14 Ballarin 1985 (2005), pp. 49–55.

15 There are many stylistic connections between Marco's Christ in the Berlin altarpiece and other works of the Archinto group (see note 10). For example, the head of Christ seems extremely close to that of the Metropolitan *Girl with Cherries* (fig. 90). In the early 1980s Romano considered the

Metropolitan picture an early work by Marco (see Trutty-Coohill 1982, p. 178).

16 Previously in the collection of Frizzoni's father, and first attributed to Marco d'Oggiono in Seidlitz 1906, p. 46. See also Fiorio 2000, p. 195, no. D29.

17 Infrared reflectography has revealed a very different underdrawing between cat. 19 and cat. 7. On these matters, see Spring et al. 2011, pp. 78–112. For other examples of Boltraffio providing models to Marco d'Oggiono, see cats 65, 66 and 67.

18 He was commissioned by della Rovere to paint a cycle of frescoes in the cathedral at Savona, demolished 1543 (Sedini 1989, pp. 16–17).

19 See Sedini 1989, pp. 52–3, no. 18.

20 This *tarsia* has been cut in the lower part (Zanelli 2008, p. 149).

21 For different views on the function of the monogram, see Farrow 2001; Syson 2004, pp. 120–1. For a detailed account of the state of the monogram, see Spring et al. 2011, pp. 78–112.

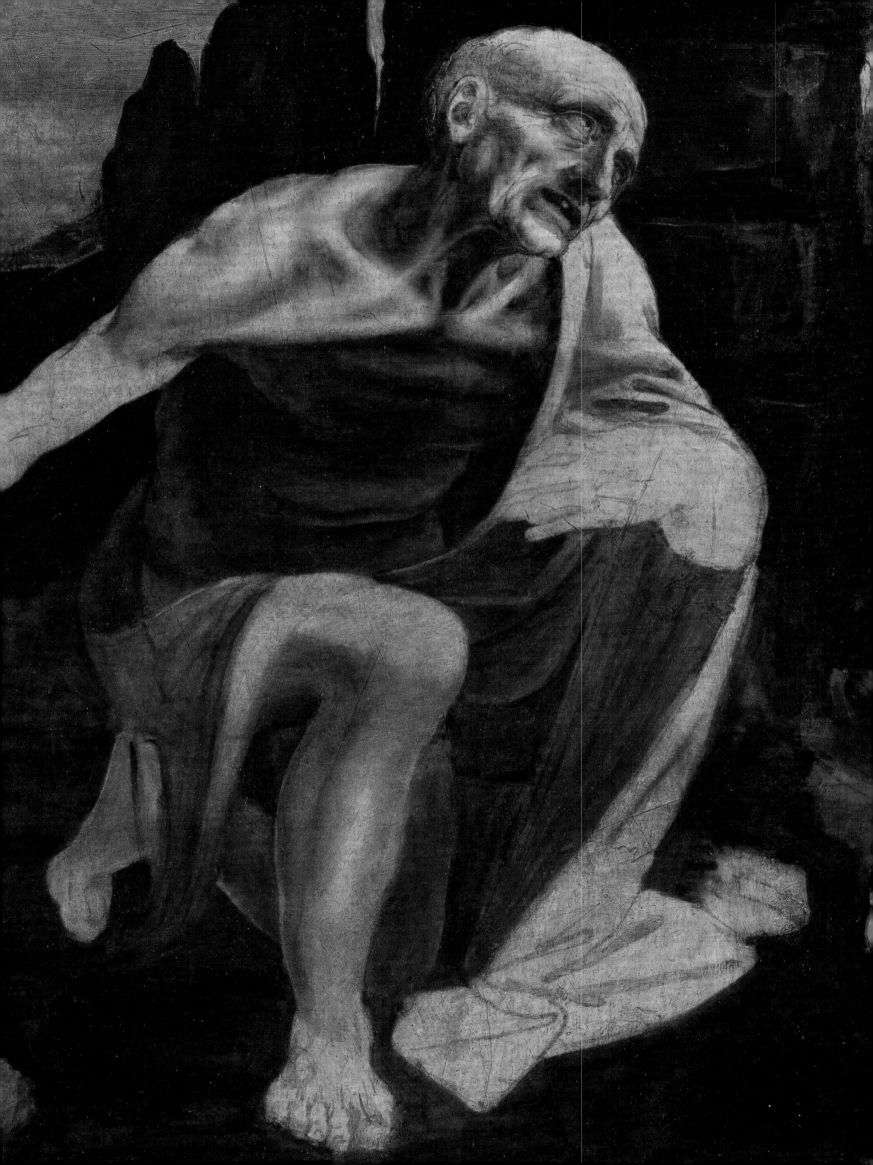

BODY AND SOUL
SAINT JEROME IN PENITENCE

LEONARDO'S UNFINISHED *Saint Jerome* IS A PICTURE THAT SETS out to explore the relationship between the human body and soul, but using a very different frame of reference from that which explains his portraits. The saint's racked expression and his dramatic, almost tortured pose immediately convey his spiritual turmoil and his corporeal agony. Jerome's account of his years in the wilderness was translated into many emotive images of his suffering made in later fifteenth-century Italy. Leonardo's treatment of the subject is among the most remarkable, and comes into a category of its own within his oeuvre. Never before or afterwards was he to show the human body, nude or semi-nude, with such drama. These pictures of Jerome, including Leonardo's, propose that penitential punishment of the body can vouchsafe the soul a direct connection with God. This is not just about the imitation of Christ, important though that was. Leonardo's painting examines a narrative that deals with the banishment of fleeting emotions – Jerome's carnal desires – for the sake of permanent improvement of the soul. The body can be dangerous, prompting thoughts that are distinctly unholy, or it can be the tool of spiritual redemption. This is therefore a picture that is also about ways of seeing and experiencing the real – and seeing beyond it.

FIG. 69
LEONARDO DA VINCI
Anatomical study of the human skull in sagittal section,
1489
Pen and ink over traces of black chalk on paper,
19.0 × 13.7 cm
The Royal Collection (RL 19058v)

The saint arrives at his vision of Christ on the Cross through the painful beating of his chest. It has been observed that a straight line can be drawn from Jerome's fist clenched round the rock, his weapon, through his eye to Christ's outstretched arm and pierced hand.[1] And we, the viewers of this picture (like the lion), are also witnesses – to the scene of an old man whose head and neck are depicted with unprecedented anatomical accuracy and whose whole body, incomplete though it is, seems entirely convincing. We are first invited to believe in the physical truth of this narrative before we notice the implausibilities that render our own viewing visionary.

Best dated to the late 1480s, this is a picture that should be connected with Leonardo's first attempts to understand the human body – which were not at this stage as fully empirical as they would later become. He believed that the proper and detailed observation of human anatomy served the naturalistic intent of good painter. '*Figura*' is the word Leonardo used both for actual and represented bodies, and studying the body (never just the anatomy) has been characterised as a 'side lane' forking off the 'main road' of his painting.[2] There can be no question that this was the case at this date, and it might be added that Leonardo was always thinking as a painter of religious subjects. Quite conceivably such activities always had a spiritual dimension. Leonardo knew the words of Saint Augustine (and by the early sixteenth century he owned the text – the *City of God* – from which they come):

> There is in a man's body such a rhythm, poise, symmetry, and beauty that it is hard to decide whether it was the uses or the beauty of the body that the Creator had most in mind. It is clear that every organ whose function we know adds to the body's beauty, and this beauty would still be more obvious if only we knew the precise proportions by which the parts were fashioned and interrelated. I do not mean merely the surface parts which, no doubt, could be accurately measured by anyone with proper skill. I mean the parts hidden below our skin, the intricate complex of veins and nerves, the innermost elements of the human viscera and vital parts, whose rhythmic relationships have not yet been revealed … The beauty of this music no one has yet discovered, because no one has dared look for it …

If, then, we argue from the facts, first, that as everyone admits, not a single visible organ of the body serving a definite function is lacking in beauty, and, second, that there are some parts which have beauty and no apparent function, it follows, I think, that in the creation of the human body God put form before function.[3]

Augustine was making an argument for natural human beauty as one of God's gift to mankind; its investigation could therefore become an act of piety, all the more so if the results found their way into a devotional painting.

Moreover, Leonardo's researches of the human body were strictly linked to his effort to understand the soul. He was even seeking physically to locate it at this period in the skull (see fig. 69). In a way that makes an interesting parallel with the idea of spiritual enhancement through physical suffering, Leonardo gave some, slightly garbled credence to the Aristotelian notion (in a sense its corollary) that outward appearance is generated from within. Less mysteriously, he believed that all gestures and movements

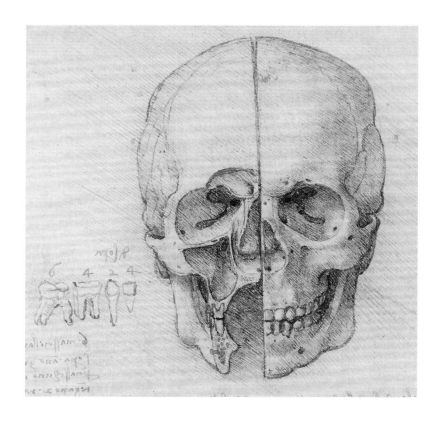

FIG. 70
LEONARDO DA VINCI
Proportional study of the eye and the face, about 1489
Pen and ink over metalpoint on prepared paper,
14.0 and 19.7 × 27.7 cm
Biblioteca Reale, Turin (15576 D.C., 15574 D.C.)

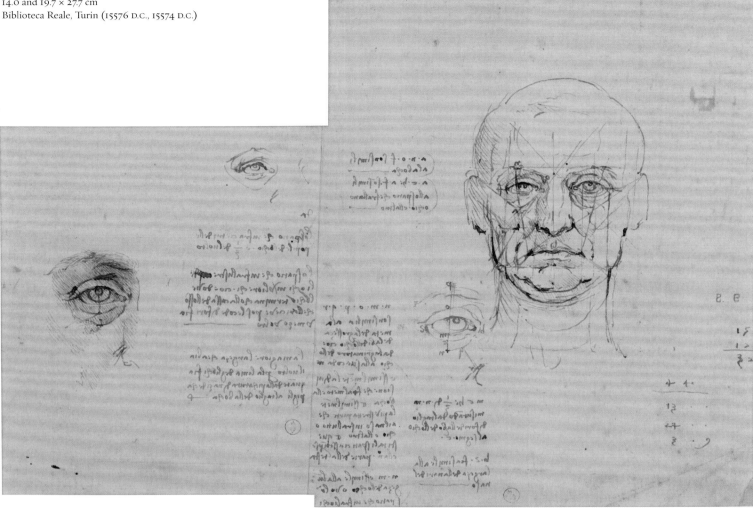

of the body are the external expressions of motions of the mind and soul. And these, too, could be depicted. Indeed, he proposed to explain the four main human emotional conditions in his planned treatise on the human figure by illustrating them in drawn '*storie*'.

Jerome's body therefore needed to be both suffering and beautiful, and here he is both. His head and neck are so brilliantly observed as to make one critic comment that Leonardo himself appears to have stretched his skin over the skull, and they closely resemble his (not always accurate) diagrams of the anatomy of old men (e.g. cat. 22). He also uses an old man's head, closely resembling Jerome, to work out the ideal proportions of the face and eye (fig. 70). But Jerome's body is youthful – truly that of an 'athlete of Christ'[4] – and indeed an expression of his inner beauty. Leonardo's saint is appropriately both real and ideal, reminding us that his earliest investigations of the body were as much about determining its ideal beauty – its perfect mathematical proportions – as about

anatomical accuracy. Parts of the body, like the foot (cat. 73) or the extended arm (cat. 26) were actually units of measurement.

Leonardo was therefore doing both the things Saint Augustine had advocated. And he was also casting himself, and us the viewers, as Jerome. We experience the actuality of Jerome's body while also perceiving the invisible. Leonardo has created a vision that is still entirely based on what can be empirically observed, an utterly credible glimpse of Jerome's moment of spiritual redemption that requires an almost scientific precision to dissect its several mystical layers. LS

NOTES

1 Fehrenbach 1997, pp. 148–52, fig. 23.
2 Playfair McMurrich 1930, p. 53.
3 *De civitate Dei*, XXII.24. Reti 1974, vol. 3, p. 93, no. 11. The relevance to Leonardo's activities was first argued by Pedretti 1988b, p. 81, cited by Kemp 1995, p. 70.
4 Campbell 1998, pp. 80–90 for images of Saint Jerome in North Italy.

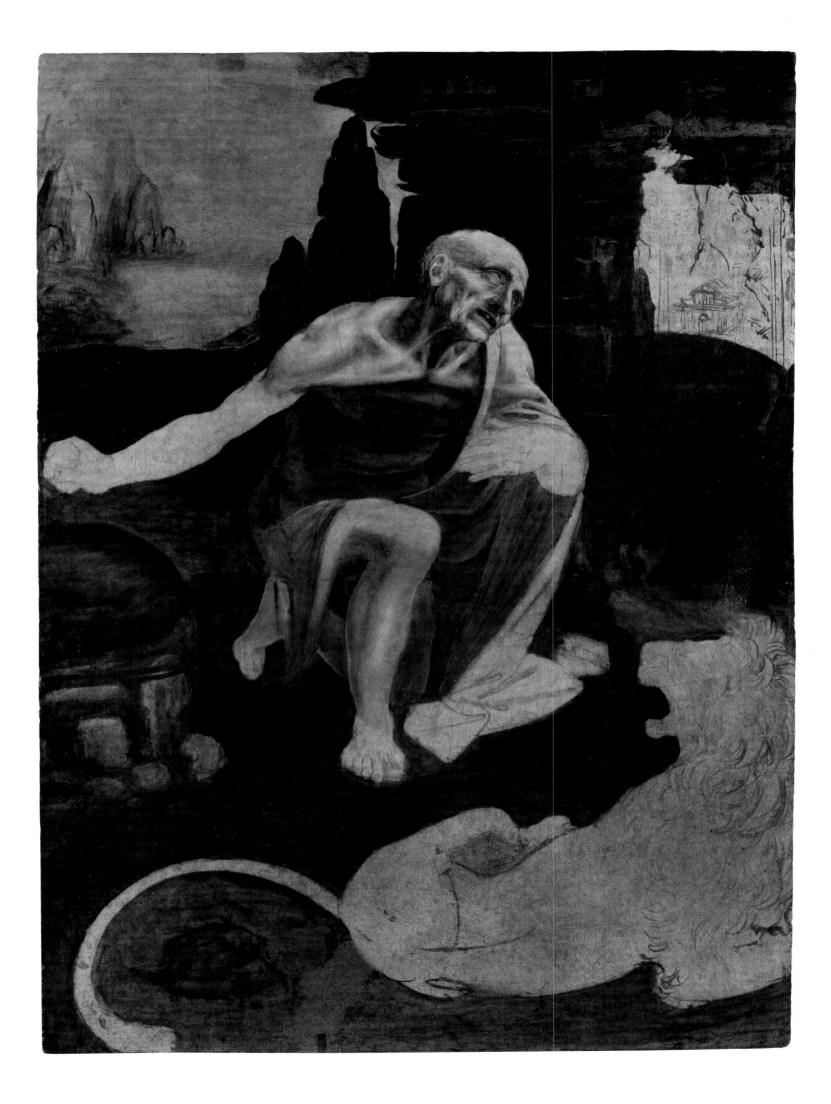

20

LEONARDO DA VINCI (1452–1519)

Saint Jerome
about 1488–90

Oil on walnut
103 × 75 cm
Musei Vaticani, Vatican City
(40337)

LITERATURE

Ost 1975; Marani 1999, pp. 95–101;
Laurenza 2001, p. 41; Bambach in New
York 2003, pp. 370–9, cat. 46; Zöllner
2003 (2007), p. 221, no. 9; Syson and
Billinge 2005, pp. 457–61; Bora 2007.

Saint Jerome is situated at the intersection of two pervasive views of Leonardo's art. At one extreme he is understood to have portrayed the saint's body as an 'embodiment of passion', rendering the transient absolute and permanent.[1] At the other the figure has been considered as an 'anatomical model' observed and copied precisely onto the panel.[2] Sited between naturalism and idealism, observation and imagination, inherited wisdom and self-taught truths, Leonardo's *Saint Jerome* embodies the tensions inherent as different systems of knowledge and belief are adduced.

Relatively little is known for certain about the painting. Its commission is not documented, nor is it mentioned by any of Leonardo's early biographers. Its provenance is also unknown before it was recorded in Rome in the collection of the painter Angelica Kauffmann in the early nineteenth century.[3] While its attribution to Leonardo has never been doubted, its dating, on which there was once general consensus, has recently been challenged and it can no longer be fitted comfortably into the concluding years of his first Florentine period (about 1480–2).[4]

Despite this dearth of evidence, much can still be established visually. The painting is unfinished, which has often led to superficial comparisons with the *Adoration of the Magi*. But the fact that the two paintings were left in a similar state should not blind us to their stylistic disparities. At an unknown date, probably in the early nineteenth century, Jerome's head was cut out, although it has since been reattached. Last restored in the early 1990s, the picture is in fairly good condition.[5] The panel is walnut, rare in Florence but frequently used by Leonardo and his followers in Milan. Indeed, in the early 1490s Leonardo wrote that a panel prepared for painting 'should be cypress or pear or service tree or walnut'.[6] The fact that he does not mention poplar, the support used for all his Florentine pictures (including those he made before he left Florence in around 1482–3), makes a dating earlier than his arrival in Milan unlikely.

The penitential Jerome is shown kneeling in the desert. The lion, his traditional attribute, lies poignantly isolated in the foreground. A standard and fairly unchanging type in Leonardo's oeuvre,[7] here the curve of the lion's tail and the great sweep of its body lead the eye into the composition and define the extremities of the saint's body. Jerome prepares to beat his breast with a stone while contemplating a crucifix summarily sketched on the upper right of the picture. Christ's body on the cross is aligned with a church in the background, of a similar type to Leonardo's own church designs (cat. 29). Its inclusion may be a reference to the monastery near Bethlehem where Jerome stayed, or to his role as Father and Doctor of the Church. The church is glimpsed through the entrance to a cave, in front of which Jerome would later be buried.[8] Its natural architecture calls to mind the rock formations in both versions of the *Virgin of the Rocks* (cats 31, 32), conceived and executed after Leonardo had arrived in Milan. The foreground prominence of the lion forces the saint backwards, against the forward thrust of his body, creating a spatial tension also reminiscent of the London *Virgin of the Rocks*.[9]

Representations of Saint Jerome as a hermit in the wilderness rather than as a scholar were not unusual at this date, especially in northern Italy, and are often associated with altarpieces made for the orders of the Gesuati and the Hieronymites. Leonardo was probably working to commission, at least at the outset – although why he did not finish the picture is difficult to say.[10] Its dimensions suggest that it was probably destined for an altar.[11] However, it was almost certainly never delivered, and might therefore have been used for private devotion.

While the iconography is not itself unusual, several representational choices are startling. The saint is beardless and his arm dramatically outstretched – in Florentine paintings of Jerome the stone is more commonly held to the saint's chest and his age usually emphasised by a long white beard. His clean-shaven face gives an unimpeded view of his cranium and neck, whose anatomical accuracy recalls Leonardo's study of the skull and the musculature of this part of the body, especially on elderly subjects (see for example cats 22, 23, 25 and 27).[12] His extended arm, like his leg, has the musculature of a much younger man than his neck and face. Jerome is depicted as both old and youthful, ingredients that are empirically based but with spiritual connotatons. The arm provides a unit of measurement against which the proportions of the whole body can be gauged. The *braccio* (arm) was a standard measure in Florence and Milan (see cat. 26).[13] The distance from his navel to the end of his proper right arm – or of his right foot – indicates the radius of a circle whose circumference charts the extremities of his body, somewhat like the Vitruvian *homo ad circulum* (fig. 23).[14]

FIG. 71
ANDREA DEL VERROCCHIO (about 1435–1488)
or WORKSHOP
Saint Jerome, 1475–80
Tempera on paper, mounted on wood, 40.5 × 27 cm
Galleria Palatina, Palazzo Pitti, Florence

The concentric form is emphasised by the curvilinear sweep of the lion's body and tail, leading to (unnecessary) speculation that Leonardo originally intended to paint a circular *tondo*.[15]

The *Saint Jerome*, then, demonstrates Leonardo's interest in the anatomy of the face and neck, the relationship between muscles and movement, and in systems of measurement and proportion for the body. These preoccupations are all evident in his many investigative drawings of the late 1480s, including the famous *Vitruvian Man* (fig. 23). There is good reason to interpret the *Saint Jerome* as another kind of distillation of these anatomical and proportional investigations. Bambach has observed that Leonardo's quest to find the seat of the soul in his skull studies of 1489 (cat. 25) has its pictorial equivalent in Jerome's yearning expression.[16] The *Saint Jerome* is equally concerned with the theme of the immortal soul, and can be regarded as the artistic summation of – perhaps in part the inspiration for – several years of scientific research.

A dating of around 1488–90 also helps explain the similarity of the church façade to several of Leonardo's Milanese architectural drawings, as well as the closeness of its composition to the *Virgin of the Rocks* paintings (cats 31, 32).[17] It accounts for its echoes in Lombard compositions, such as the woodcut frontispiece to the *Antiquarie prospetiche romane*, published around 1498 with a dedication to Leonardo.[18] It might even offer an explanation for the close proximity of Saint Jerome's head to that of Saint Lucy, reversed and re-proportioned, in Boltraffio and Marco d'Oggiono's *Grifi Altarpiece* (fig. 43).

Leonardo had ample opportunity to ponder this subject during his early career in Florence. Vasari records that Verrocchio made a head of Saint Jerome in clay, now lost but sometimes thought to be reflected in three busts now in the Victoria and Albert Museum and in a painting by Verrocchio (or a close follower) in the Palazzo Pitti (fig. 71).[19] These show Jerome

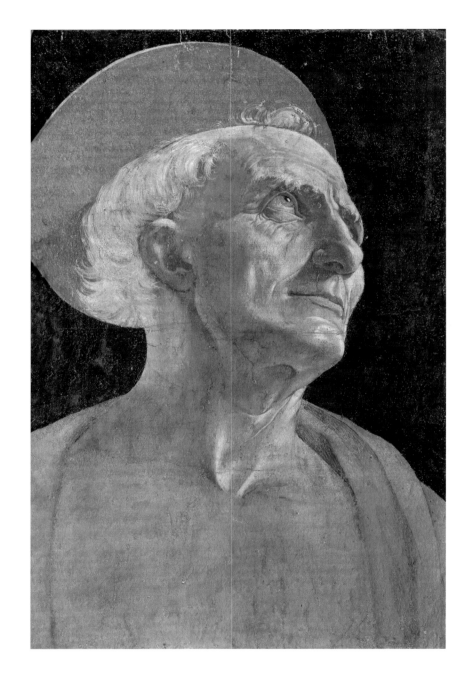

beardless, gazing upwards, a cloak thrown over his left shoulder. It is quite conceivable that Leonardo knew these works and others imitating Verrocchio's proto-type.[20] Indeed, 'cierti San Girolami' [certain Saint Jeromes] appear in the famous list of works often believed to document the possessions he took to Milan from Florence (CA fol. 888r, ex 324r). It is tempting to speculate that these were copies of Verrocchiesque precedents. Yet it is equally possible that the list records the contents of his workshop rather later in the 1480s, in which case they may be preparatory drawings for cat. 20 itself or perhaps copies by his pupils.[21]

Two metalpoint drawings by Leonardo's Milanese followers show Saint Jerome in a related pose, depicting the saint from the back (fig. 79 and Ambrosiana, Cod. F.263 inf. 63).[22] These were surely based on a common source, doubtless a drawing by the master himself. But their existence suggests that Leonardo may have studied a small sculpted *modello*, or at least sketched a live model from several angles, before producing his cartoon.[23] The powerful plasticity and three-dimensionality of the *Saint Jerome* imply that sculpture, as much as the live model, was an important source for Leonardo.[24] Given that his other main preoccupation manifest here is similarly present in the *Vitruvian Man*, it is no surprise that this famous drawing has also recently been related to sculpture, as a potential illustra-tion for Leonardo's projected treatise on sculpture.[25]

Leonardo's picture therefore seems to have been assembled from a variety of studies: of sculpture and the living model, of old and young men, of proportion and anatomy, all directly observed and now imagina-tively reconstituted. The saint is caught between the youthful, ideal proportions of his limbs and the agonised, searching expression of his face. Simply put, Leonardo's Jerome struggles to reconcile the physical presence of his body with the spiritual yearning of his soul. SN

NOTES

1 Clark 1939, p. 42.
2 Pedretti 1973, p. 53.
3 Bambach in New York 2003, pp. 377–8, repudiates Ost 1975, pp. 8–9. The two paintings of Saint Jerome mentioned as part of Salaì's estate in 1525 cannot be related to the Vatican painting; see Shell and Sironi 1991. See Sewell 1957 for the possibility that it was in Spain in the seventeenth century.
4 Syson and Billinge 2005, pp. 457–61.
5 Colalucci 1993; Pedretti 1996.
6 A fol. 1r; R 628.
7 See Windsor RL 1227r (cat. 37), RL 12326r; Turin BR 15630.
8 Jerome's remains were relocated to Santa Maria Maggiore, Rome, in the seventh century. Around 1463 Mino da Fiesole was commissioned to produce an elaborate freestanding reliquary monument for them (Rice 1985, p. 56).
9 The relationship with the *Virgin of the Rocks* (cat. 32) is even more complex: there are similarities of pose between the *Saint Jerome* and preparatory studies for the first underdrawing (Composition A) on the London panel; see Syson and Billinge 2005, p. 455.
10 Bass has speculated that it was commissioned by a Florentine confra-ternity devoted to Saint Jerome, and Cecchi that it was intended for the Badia Fiorentina, to be replaced by Filippino Lippi's painting of the same subject (Cecchi 1984, p. 70 n. 10; Pedretti 1995b; Pedretti 1996). Marani has linked it with the Hieronymite foundation at San Martino in Pavia (Marani 2003b, pp. 167–8, 186 nn. 19–25).
11 The paint surface continues to the edge of the panel, suggesting that it has been slightly cut down.
12 I thank Professor Harold Ellis of King's College, London, for this and other anatomical observations.

13 The size of the *braccio* was, however, different in the two cities (see Keele and Pedretti 1979, vol. 1, p. 46).
14 Ost was the first to suggest that Vitruvius's system of proportion lay behind *Saint Jerome* (Ost 1975, pp. 18–23).
15 Parronchi 1992.
16 Bambach in New York 2003, p. 372.
17 Suida had previously also dated *Saint Jerome* to around 1490 (Suida 1929, pp. 80–2). On the architectural drawings see, e.g., cat. 29 and Pedretti 1978, p. 93.
18 See Agosti and Isella 2004. For a complete list of Lombard works indebted to *Saint Jerome*, see Bambach in New York 2003, pp. 376–7, cat. 46.
19 Vasari (1966–87), vol. 3, p. 545. The busts are V&A 65–1882, 4600–1858 and 8383–1863.
20 There are other Tuscan precedents, such as the Florentine print showing the penitent saint (Hind A.I.58, known only through later impressions). For a discussion of these, including the *Crucifixion* formerly at Santa Maria e Angelo, Argiano, and the fresco frag-ment in the Museo di San Domenico, Pistoia, see Marani 1999, p. 96 and Bambach in New York 2003, p. 376.
21 CA fol. 888r (ex fol. 324r). Calvi and Pedretti (in his commentary on Richter) both place it around 1482, the former through comparison with another sheet in which there are Tuscan solecisms (Calvi 1869, pp. 53–9; Pedretti 1977, vol. 1, p. 388). Zöllner dates the 'inventory' to 1495, but with-out explanation; see Zöllner 2003 (2007), p. 221.
22 Marani 1999, pp. 95–6.
23 On Leonardo's preparatory process and technique in the *Saint Jerome*, see Syson and Billinge 2005, pp. 457–61, and p. 59 in the present volume.
24 On Seneca and the *Saint Jerome* see Ost 1975, pp. 58–61, figs 55–61.
25 Marani 2009a.

21

LEONARDO DA VINCI (1452–1519)

A kneeling angel

about 1480–4

Pen and ink over metalpoint on prepared paper
12.4 × 6.1 cm
The British Museum, London
(1913,0617.1)

The pose of the angel on this sheet, in three-quarter view with raised knee and outstretched arm, clearly prefigures that of *Saint Jerome* (cat. 20). The viewer's attention is directed, through the angel's gaze, to its upward gesture. The intended meaning of gaze and gesture is uncertain, complicated by our inability to establish what the angel is carrying: some have suggested that it is pouring water amid rushes, others that it holds a swathe of drapery.[1] Like the later saint, the angel is angled at 45 degrees to the plane of the sheet, with shoulders, upper body and knee all facing in the same direction. The figure is not twisted in the way of the (much later) *Leda* at Chatsworth, so is not actually in *contrapposto*, as sometimes described.[2]

Characteristically, Leonardo seems to have changed his mind and the arm is drawn in two positions, giving the figure a sense of movement. This vibrancy is greatly aided by the rapidly drawn contours and hatching, which on occasion, as in the wings, is reduced to a single, serpentine line. The uppermost of the two right arms, presumably the first to be executed, is under-drawn in leadpoint. The lower arm shows no sign of any preparatory underdrawing, and was presumably Leonardo's second solution. He experimented – albeit briefly – with a third idea in a lower sketch, in which the figure's left arm is brought across the body to join the right. The relationship between these two poses parallels that of the Courtauld sheet (cat. 9) in which the Magdalen is first shown in three-quarter view, turning away from the viewer, and then frontally with her arms folded below her bust.

The angel is placed at an angle to the sheet. Such compositions are characteristic of Leonardo in the late 1470s and early 1480s, as is evident, for example, in his pen-and-ink drawings showing the Virgin holding a cat, or even the *Madonna Benois* (fig. 3). In these works, as in the present drawing, movement is created not only through narrative action, but also through the relationship of pose to picture surface. Here only the head of the angel is in motion, as it turns to the right.

The dating of this drawing has fluctuated between around 1476 and the 1480s – Leonardo's pen-and-ink drawings of this period are particularly hard to date precisely. Those arguing for an early date have observed that it could be a first study for one of the angels in Verrocchio's *Baptism* (fig. 85); others have countered by suggesting that it was a preliminary

drawing for the angel in the first version of the *Virgin of the Rocks* (cat. 31; commissioned in April 1483). Although neither possibility can be completely discounted, the former is perhaps less likely, as the San Salvi angel would surely have been designed by Verrocchio, even if finished by Leonardo. Perhaps the best comparison for the rapid use of the pen, and consummate short-hand abbreviations of the face, are in the studies for the *Adoration of the Magi* of around 1481 in the British Museum (1895,0915.478). A dating around 1480 or 1481 would also allow it to be related to the studies for the *Virgin and Child with a cat* (see cat. 56). But this does not mean that the angel and the *Saint Jerome* should be dated to the same moment. Leonardo evidently continued to ponder this pose right through the 1480s. SN

LITERATURE

Popham 1946, pp. 42, 118, no. 29B; Popham and Pouncey 1950, no. 102, p. 61; Kemp in London 1989, p. 149, cat. 76; Kemp and Barone 2010, p. 56, no. 13.

NOTES

1 Dodgson 1913, p. 264; Valentiner 1941, p. 14.
2 Chatsworth 717, see e.g. Berenson 1938, vol. 2, p. 110, no. 1013A.

22

LEONARDO DA VINCI (1452–1519)

Ecorché study of the neck and shoulders

about 1487

Pen and ink over metalpoint on pale blue prepared paper
8.3 × 7.9 cm
Lent by Her Majesty The Queen
(RL 12610)

LITERATURE

Clark and Pedretti 1968–9, vol. 1,
p. 125; Keele and Pedretti 1979, vol 1,
pp. 28–9, no. 18; vol. 2, p. 810.

NOTES

1 See Keele and Pedretti 1979, vol 1,
p. 28, no. 18.
2 Clark and Pedretti 1968–9, vol. 1,
pp. 124–5.
3 Keele and Pedretti 1979, vol. 2,
p. 808. This drawing is however
likely to date from a little before
1490.
4 Keele and Pedretti 1979, vol. 1,
p. 28, no. 18.

In the later 1480s Leonardo began to explore ideas of ideal proportion and at the same time started to make anatomical studies, observing the particularities of bodies, both animal and human. These were, however, not the fruits of human dissection, but were based instead on received opinion and extrapolation from other animals.

This fragment was probably once part of a sheet that included another study of the head and neck of an elderly man in profile, also in the Royal Library at Windsor (RL 12611). As with his other early anatomical studies, Leonardo has worked on blue-prepared paper, first in metalpoint (which has faded considerably) and then pen and ink. Under ultraviolet light the shoulder and neck are seen to be rendered in dramatic *chiaroscuro*, emphasising the tense muscles of the neck.

The ink hatching throws the superficial muscles of the neck into high relief.[1] It would not have been necessary to dissect the neck to produce this drawing, which might explain Leonardo's choice of an elderly subject, where the muscles are more pronounced. The drawing is mainly concerned with the pattern created on the surface of the neck, quite unlike cat. 23, to which it otherwise bears a cursory resemblance.

The sheet is usually dated to the period 1487–90. Kenneth Clark grouped together several of these anatomical drawings on blue-prepared paper (including cats 23, 24) and argued that the skull was less well understood here than in the famous studies from Anatomical Manuscript B (cat. 25) dated 1489. He thus proposed placing them around 1487 on stylistic grounds. This dating seems to be confirmed by the architectural studies that appear on some of the sheets.[2] Carlo Pedretti, however, placed it closer to 1490, thus notionally later than the dated skull study, comparing it with a small sketch of the head of an old man in cat. 30, as indeed had Clark.[3]

The relationship of the current sheet to the *Saint Jerome* (cat. 20) is important. The treatment of the muscles of the neck is extremely similar and, although the current sheet is not a study for the *Jerome*, it demonstrates how a single interest – in this case the superficial muscles of the neck – could prompt different visual and intellectual responses in Leonardo.[4] Some scholars have seen this interest as first manifest in the early 1480s (the traditional date for *Saint Jerome*), which was then revived in this and other studies at the end of the decade, before receiving its most advanced expression in the red chalk study for Judas in the *Last Supper* of around 1495 (cat. 79). A simpler and arguably more logical argument is that the *Jerome* and the current sheet are contemporaneous, both dating to the concluding years of the 1480s. SN

23

LEONARDO DA VINCI (1452–1519)

Anatomical studies of the neck and skull; profile of an old man
about 1485–8

Pen and ink over metalpoint heightened with white on pale blue prepared paper
20.2 × 28.7 cm
Lent by Her Majesty The Queen
(RL 12609r)

As is the case with many of his early anatomical studies, the metalpoint parts of this drawing are today faded. The pattern of pen lines to the right of centre is only comprehensible as a diagram of the external jugular veins passing over the sternomastoid muscle (one of the two muscles in the front of the neck) when the skull and facial bones are 'restored' under ultraviolet light (fig. 72).[1] This sketch, the rapid outline to the head beside it and the more detailed drawing on the left side of the sheet appear to be preparatory to the prominent drawing of the skull and neck just left of centre. Leonardo seems to have begun by delineating the contour in metalpoint (now vanished but once again visible under ultraviolet light around the chin and back of the head), then reinforced these lines in pen and ink. On other drawings it is clear that these reinforcements were made at a slightly later date, once the metalpoint had began to fade, but here the pen drawing is probably contemporaneous with the metalpoint: he did not go over every line, implying that he expected

those that are now faded to remain visible. Nor did he correct the errors of anatomy that, judging by his later drawings, would have been apparent to him by the early sixteenth century. Touches of white heightening, such as that along the sternomastoid muscle, might have been added at this point, and the areas shaded in metalpoint are also seemingly drawn after the pen-and-ink lines. This hatching takes on the role of a wash of the kind he used elsewhere in drawings on paper prepared with coloured grounds; since it has not faded, it was probably drawn in a different type of metalpoint from the underdrawing, perhaps softer leadpoint rather than silverpoint.[2]

Kenneth Keele observed that the hyoid bone (the U-shaped bone at the base of the tongue) is not human; it compares well with a similar drawing on another of these sheets, which seems to have been studied from a dog.[3] The larynx is also too high and the external jugular vein is incorrect, particularly surprising since this can easily be observed on living humans.[4]

LITERATURE

Clark and Pedretti 1968–9, vol. 1, p. 125; Roberts and Pedretti 1977, p. 402; Keele and Pedretti 1979, vol. 1, pp. 8–9, no. 3r; vol. 2, p. 802.

FIG. 72
Cat. 23 viewed under ultraviolet light

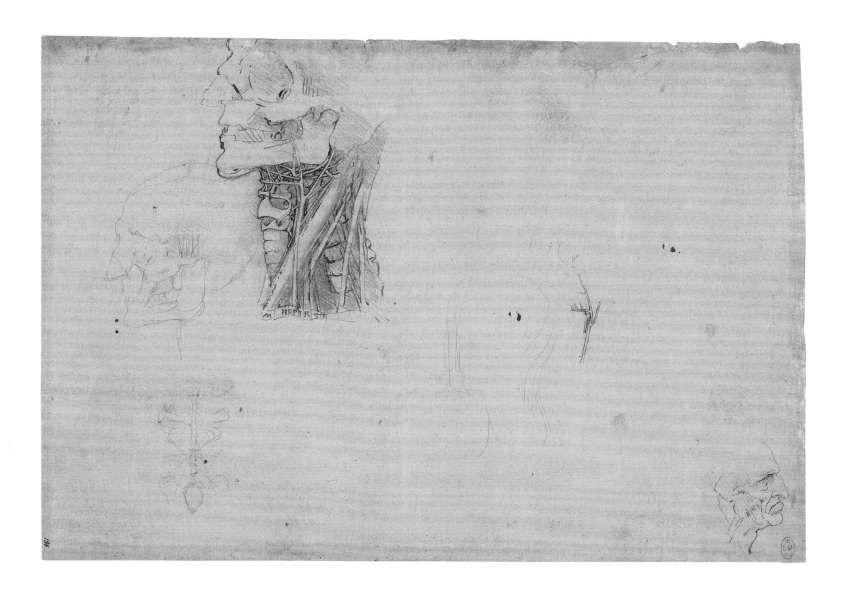

The orbital bone on the skull is also too large. Leonardo is unlikely to have made this mistake after having studied the human skull, indicating that this drawing was executed before 1489 (see cat. 25). By the mid- to late 1480s he seems not yet to have dissected humans, but had probably cut into a monkey and a bear's foot. In other words, this drawing shows him applying to the human neck his knowledge gained from dissecting other animals. But he was not solely reliant on experience. The sketch at lower left shows the abdominal muscles 'crossed', as described by Paduan anatomists Mondino and Pietro d'Abano in the early

fourteenth century.[5] These drawings, then, illustrate Leonardo's ability to extrapolate received wisdom and direct observation of animals into a study of the human.

The dating of this sheet is based on the designs for a church on the verso (after 1487) and the 'grotesque' faces on the recto (some visible only under ultraviolet light) compared to others of about 1487–90.[6] Yet more importantly for the discussion of the *Saint Jerome*, it demonstrates Leonardo's preoccupation in the late 1480s with the anatomy of the skull and neck, and with an architecture partly based on these anatomical forms. SN

NOTES

1 Keele and Pedretti 1979, vol. 1, p. 8, no. 3r.
2 I thank Martin Clayton for these observations.
3 Windsor RL 12608r; Keele and Pedretti 1979, vol. 1, pp. 6–7, no. 2.
4 For this and other observations I thank Prof. Harold Ellis of the Department of Anatomy and Human Sciences, King's College, London.
5 See Laurenza 2001, esp. pp. xix, 32–3.
6 See Keele and Pedretti 1979, vol. 2, p. 802.

24

LEONARDO DA VINCI (1452–1519)

Studies of the nervous system
about 1485–8

Pen and ink over metalpoint on pale blue prepared paper
30.4 × 22.2 cm
Inscribed in Italian
Lent by Her Majesty The Queen
(RL 12613v)

Across the bottom of this page are studies of the leg and arm, each drawn twice, to show first the superficial muscles and then the nerves over the skeleton. These illustrate how his knowledge as an anatomist affected Leonardo's work as a painter: having understood their underlying structure, he was able to clothe limbs in skin, giving the movement of his figures a semblance of naturalism born of genuine anatomical knowledge.

Above these sketches is a drawing of the cervical vertebrae labelled 'virtu gienjtiua' ('generative power'), reflecting the traditional belief that semen was generated in the spinal cord and then flowed to the penis. Typical of Leonardo's early anatomical studies, this sheet combines new observation with received wisdom. The accompanying note shows that he practised vivisection: 'The frog retains life for some hours when deprived of its head and heart and all its bowels. And if you puncture the said nerve it immediately twitches and dies.'

Only the pen-and-ink drawings are now visible (see also cat. 22): the ghostly traces of extensive metalpoint drawing are evident in what now appear as blind incisions, but are revealed by ultraviolet light (fig. 73). Some of these correspond with the pen-and-ink studies, others are entirely independent, but all show that these sketches were originally richly modelled.

The relation of the arm study to the arm of the Madonna in the Paris version of the *Virgin of the Rocks* (cat. 31) suggests a date of the second half of the 1480s.[1] Alternatively, his choice of pose for the arm in the sketch may have been informed by the painting that chiefly occupied him during this period. The letters 'BB' on the verso were probably added by his devoted pupil and literary executor Francesco Melzi in the sixteenth century, and place the sheet in a series with the other early anatomical drawings on blue prepared paper marked 'CC' (RL 12608r) and 'DD' (RL 12627v). These annotations confirm what is evident stylistically – that they should all be dated to much the same moment.

Leonardo appears to have returned to this sheet at a later date. Several lines of notes on the recto, some discussing the spinal medulla of a frog, are in his handwriting of about twenty years later; some of the pen and ink reinforcements are also likely to have been made at this time.[2] Albrecht Dürer's *Dresden Sketchbook* (fol. 130r), dated 1517, contains reversed copies of these and other anatomical drawings by Leonardo, probably

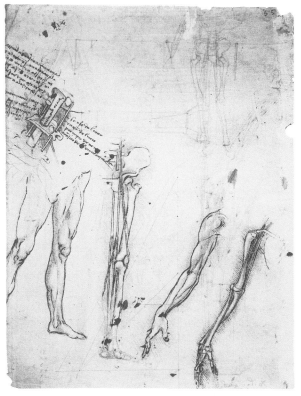

FIG. 73
Cat. 24 viewed under ultraviolet light

made from prints. They do not contain much more information than can be seen in Leonardo's original today, suggesting that his 1480s drawings had already faded by this date and might explain why Leonardo needed to rework the sheet.[3]

Few, if any, of the studies on either side of this page result from the study of humans; some even seem to be composites of several different animals.[4] The humerus at lower right, more curved than it would be in a human, was probably studied from a dog or a monkey.[5] In the late 1480s Leonardo is unlikely to have performed human dissections, relying instead on studying animals, much as the second-century Greek physician Galen had. Such an amassing of different elements into single figures reflects fifteenth-century processes of idealisation, as described by Leon Battista Alberti, among others.[6]

As with other of his early anatomical studies, the recto of this sheet also has architectural studies in the left margin, now only visible in ultraviolet light. SN

LITERATURE

Clark and Pedretti 1968–9, vol. 1, pp. 126–7; Roberts and Pedretti 1977, pp. 402–6; Keele and Pedretti 1979, vol. 1, pp. 2–3, no. 1r; vol. 2, pp. 797–9; Clayton in London 1996–7, pp. 39–41, cat. 17.

NOTES

1 Clark and Pedretti 1968–9, vol. 1, pp. 126–7.
2 Keele and Pedretti 1979, vol. 2, pp. 797–9.
3 Roberts and Pedretti 1977, p. 398.
4 Keele and Pedretti 1979, vol. 1, pp. 4–5, no. IV.
5 Clark and Pedretti 1968–9, vol. 1, p. 126.
6 For the much-cited example of the Croton women, see Alberti (1972), pp. 98–9; see also Panofsky 1968, p. 57.

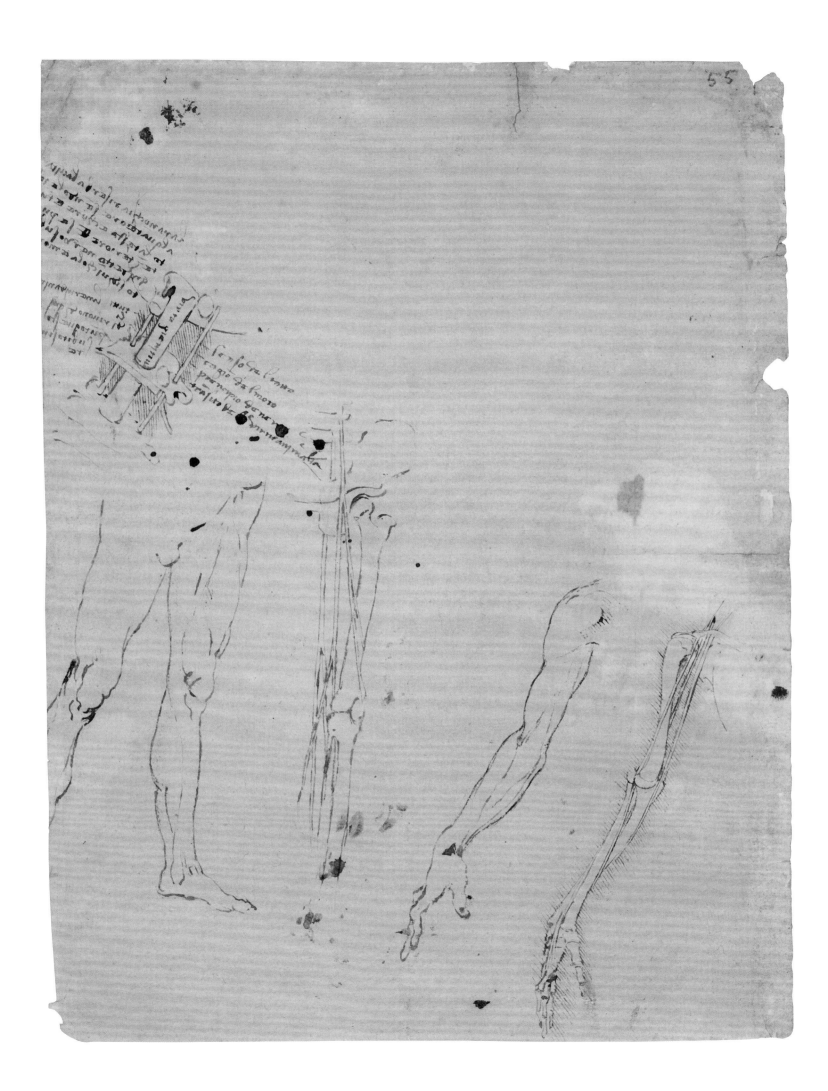

25

LEONARDO DA VINCI (1452–1519)

Studies of the human skull

1489

Pen and ink on paper
18.8 × 13.9 cm
Inscribed in Italian
Lent by Her Majesty The Queen
(RL 19059r)

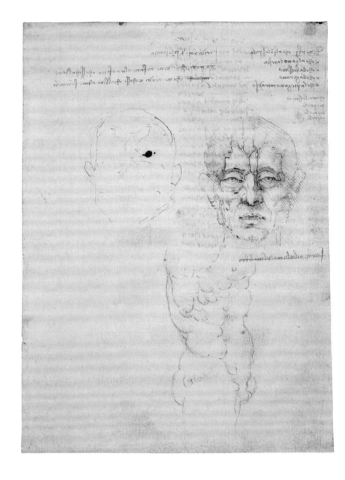

FIG. 74
LEONARDO DA VINCI
The veins of the face; a torso,
1489
Pen and ink on paper,
19.0 × 13.3 cm
The Royal Collection
(RL 19018r)

This sheet was originally part of a now unbound note-book known as Anatomical Manuscript B, made up of 44 folios in signatures (sheets folded to form groups of pages) and probably compiled by Leonardo himself. The skull studies illustrate the refinement and precision with which Leonardo used pen and ink by the late 1480s: he used a quill with the sharpest possible nib. The upper drawing is studied along its primary contours. A subtle suggestion of shadow is rendered by parallel strokes in the lower cranium and right eye socket, while the left eye is densely hatched. The curve of the crown is lifted from the page by a similar series of lines trailing into the background. The lower skull is more richly modelled. Here, instead of employing one system of parallel hatching Leonardo has introduced a second layer in the deepest shadows, angled fractionally off the first set of lines. This technique produced the desired tonal depth while ensuring that the two systems do not blur together. He also added a nose in outline with a broader (perhaps later) line.

The sheet is annotated across the top: 'On the 2nd day of April 1489'. The small 'C' at bottom right, in what would appear to be in the hand of Leonardo's associate and intellectual heir Francesco Melzi, indicates that it was probably the third sheet in the original notebook. This inscription was once thought to date the entire Anatomical Manuscript B but in fact only relates to the initial pages, which are stylistically consistent with one another and largely annotated in Leonardo's early handwriting. These are all given over to the study of a skull which seems to have come into Leonardo's possession around this date. The skull here is that of an elderly man, with jawbone and many teeth missing;[1] in other drawings the teeth and jawbone are reinstated (see fig. 10), suggesting either that Leonardo acquired another skull or, more likely, that he completed – idealised – the one he had. Direct observation was here, as so often for Leonardo, only the beginning of his thought process.

These pages, including the verso of this sheet, also contain notes on the structure of a projected anatomical treatise; this page is inscribed 'Book entitled On the Human Figure' beside the date. Unlike the date, the title is in Leonardo's mature hand, a somewhat greyer ink and a thicker quill (similar to the soft tissue of the nose on the lower skull). This probably dates from about twenty years later, when Leonardo – then in Florence – returned to his study of anatomy having

dissected the body of a 100-year-old man, drawings of whom fill much of the remainder of the notebook. He never again produced such detailed studies of the skull, however.

The text accompanying several of the skull studies demonstrates that his real interest in the internal spaces of the cranium was in locating the *senso comune*, the seat of the soul (see cat. 1) and understanding its relationship to the optic nerve. And the relationship of the current sheet to those which followed also demonstrates an interest in anatomy of use to a painter. The subsequent page (fig. 74), which like the present sheet formed the right-hand side of an opening spread, shows the eyes and nose reconstituted in a study of the superficial arteries, obviously of interest to the artist.[2] However, these are not the arteries of the old man whose skull Leonardo was apparently studying, which would have become tortuous in old age. Moreover, the artery crossing the bridge of the nose is a surprising error, given that he could have felt his own face to establish what was (or was not) there. In this case, the invention would seem to be artistically motivated, functioning to create a balanced composition. And indeed this celebrated sequence of drawings informed not just Leonardo's image of Saint Jerome, but also his *Portrait of Cecilia Gallerani* (cat. 10), whose brilliantly described head is seen from the same angle as the uppermost skull here. SN

LITERATURE

Clark and Pedretti 1968–9, vol. 3, p. 24; Kemp 1971; Keele and Pedretti 1979, vol. 1, pp. 94–5, no. 40r; vol. 2, pp. 820–37; Clayton in London 1996–7, pp. 44–6, cat. 20; Laurenza 2001, pp. 11–48.

NOTE

1 I thank Prof. Harold Ellis of the Department of Anatomy and Human Sciences, King's College, London, for this and subsequent observations.
2 Keele and Pedretti 1979, vol. 1, pp. 98–9, no. 41r.

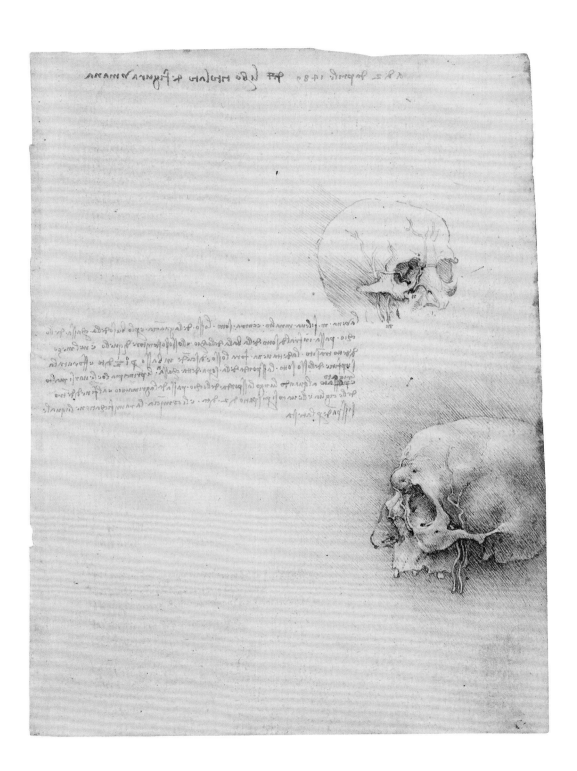

26

LEONARDO DA VINCI (1452–1519)

The proportions of the arm
about 1487–90

Pen and ink on paper
12.8 × 21 cm
Inscribed in Italian
Lent by Her Majesty The Queen
(RL 19131r)

Although not a study for the *Saint Jerome*, this pen-and-ink drawing of three arms invite comparison with Leonardo's depiction of the saint's extended arm. It is tempting to speculate that it resembles the now unidentifiable drawings of 'molte gambe, braccia, piedi e attitudine' listed in the inventory of Leonardo's possessions in the Codex Atlanticus (see pp. 23–5).[1]

Here Leonardo examines questions of ideal human proportion in three diagrammatic sketches of an arm. All are described with consummate economy: he has drawn only their most basic contours and in one case has not even distinguished the fingers (a typical abbreviation for Leonardo). Each drawing is divided by annotated lines to mark the relation of one element to another. Leonardo's aim is to illustrate the relative proportions of the human body: where naturalistic depiction seems unnecessary, such as in the index finger of the bent arm, he makes a rapid adjustment, revealing a constant tension between empirical observation and mathematical calculation.[2]

The study is cut from a larger sheet, the remaining fragments of which are also in the Royal Library at Windsor (figs 75, 76). They are convincingly linked by a line running up the right margin on the verso of each, which would have been ruled before the page was cut up. When reassembled, the sheet has the same measurements as another, also in the Royal Collection (RL 19134–5), confirming that no further fragments are missing.

The annotation of the upper drawing here indicates that the distance from wrist to elbow and elbow to armpit is equal to the length of a foot or the distance between the nipples. Thus two feet equal one arm or *braccio*, the Tuscan system of measurement (the Milanese *braccio* was slightly longer). The length marked d–e on the upper drawing – wrist to top of shoulder – is equal to a third of a man's height. This calculation is derived from the work of Leon Battista Alberti, who argued that a man's ideal height was six feet (or three *braccia*).[3]

The lower annotation records that the distance from the centre of a man's torso to his elbow (f–g) is the same as that from the elbow to the end of the fingers (g–h), and each of these is equal to a quarter of

a man's height (a cubit). While the upper sketch uses Tuscan measurements, this system is Roman. For the Roman architectural theorist Vitruvius a man's ideal height was four times the length of his forearm (four cubits).[4] So while this sheet is concerned with the relation of one part of the arm to another, it also shows Leonardo correlating different proportional systems to calculate a man's ideal height.

His interest in the years before 1490 in Vitruvian theories of ideal human proportion is manifest in his study of a man with his arms outstretched, once part of this same sheet.[5] Thus the present sketch relates to the more finished drawing of the *Vitruvian Man* in Venice (fig. 23). If it is preparatory, then all the studies that once formed part of this sheet, should be seen in relation to that drawing. The challenge that Leonardo set himself was how to fit a man into the two ideal forms described by Vitruvius, the square and circle, for which a precise relationship needed to exist between the man's height and his arm span; and it is this relationship that he calculates here. SN

LITERATURE

Clark and Pedretti 1968–9, vol. 3, pp. 52–3; Keele and Pedretti 1979, vol. 1, pp. 46–7, no. 26r; vol. 2, p. 815; Berra 1993; Zöllner 2003 (2007), p. 384.

NOTES

1 CA fol. 888r (ex fol. 324r).
2 Zöllner 2003 (2007), p. 384.
3 Keele and Pedretti 1979, vol. 1, p. 46. See also Zoubov 1960.
4 Vitruvius (1999), p. 47.
5 See Clarke 2003, pp. 92, 286, 288.

FIG. 75
LEONARDO DA VINCI
The proportions of a standing, kneeling and sitting man,
about 1490
Pen and ink on paper, 16.0 × 21.8 cm
The Royal Collection (RL 19132r)

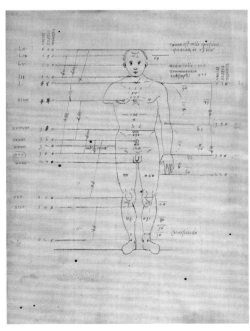

LEONARDO DA VINCI (1452–1519)

The proportions of the male head; a standing male nude
about 1490

Pen and ink over metalpoint on blue prepared paper
21.3 × 15.3 cm
Inscribed in Italian
Lent by Her Majesty The Queen
(RL 12601)

Here Leonardo sketched the profiles of two figures and then, returning to the larger of the two, reinforced the metalpoint outlines of the head in pen and ink, giving him the features of an older man, close to the 'warrior' type that recurs so often in his drawings (see e.g. cat. 80).[1] Over this he inked a grid, which boxes in the head and extends to a key on the left. So as to make the width of the head equal to its height (or at least the distance from chin to hairline), he has had to rework the back of the cranium, exemplifying the frequent marriage of actual and ideal in Leonardo's studies of proportion.

The key is labelled, from top to bottom, 'a b f m c d s'. The note below explains that the distance b–f, f–c and c–s are equal; the face (from hairline to below the chin) can be divided into three equal parts. He also observes that the distance a–b (from the top of the head to the hairline) is equal to c–d, the length of the philtrum (nose to upper lip). Finally, he concludes that point m – the tearduct – marks the middle of the head (a–s). The division of the face into three parts is derived from Vitruvius,[2] while the division of the head into two parts (point m) seems to result from Leonardo's own observations.

Hans Ost related this sheet to a proportional study in the *Trattato di architettura* by the architect Francesco di Giorgio, an acquaintance of Leonardo. Francesco assimilated the profile of a man into a capital, illustrating the extent to which the studies of proportion and of architecture were regarded as inseparable.[3]

Indeed, most commentators are agreed in dating the sheet to around 1490, when these two men met, and relating it to similar studies of facial proportion (e.g. fig. 78).[4] The handwriting is slightly later than the anatomical drawings on blue prepared paper, such as cats 23 and 24, which date to around 1485–8.[5] So in executing this drawing, and others like it, Leonardo supplements his anatomical studies of the skull made perhaps only a year earlier (see cat. 25) by trying to understand its ideal proportions. Yet he still opts for a mature face rather than a youthful (idealised) one.

The full-length sketch on the left shows Leonardo establishing the centre of gravity for a standing figure. Similar concerns are evident in his study of mechanics at around this date, and underlie the drawings on the recto of cat. 29. This figure is often related to a drawing by Leonardo's workshop in the Louvre, itself long

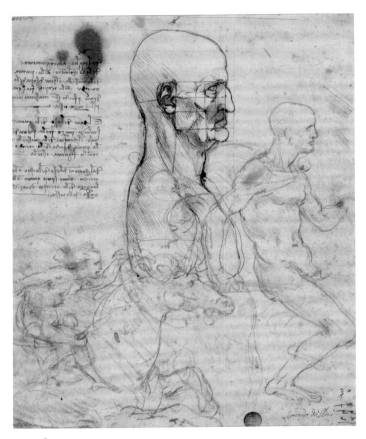

FIG. 78
LEONARDO DA VINCI
Proportional study of a man in profile; horsemen, about 1490 and later
Pen and ink and red chalk on paper, 28 × 22.2 cm
Gallerie dell'Accademia, Venice (236r)

ago connected to Leon Battista Alberti's six-part proportional system for the human body.[6] Alberti had measured various parts of the body with two instruments, one of which was a ruler he called the 'exempeda': 'Whatever the size of the chosen figure, we divide it into six equal parts which we call feet; and this is why we give this rule its name, *exempeda*, from the number of feet' (see fig. 77).[7] Thus Leonardo overlays a system derived from the ancient theorist Vitruvius with more recent theories of proportion, such as Alberti's, and, again, with his own direct observation (see also cat. 26).

In the lower left corner is drawn a seated child, now almost invisible. This has been related to cat. 30, the drawing of a Nativity now understood to be connected with the London *Virgin of the Rocks* (cat. 32). SN

LITERATURE

Clark and Pedretti 1968–9, vol. 1, pp. 121–2; Ost 1975, pp. 55–6; Keele and Pedretti 1979, vol. 1, pp. 30–1, no. 19; vol. 2, p. 812; Clayton in Venice 1992, pp. 222–3, cat. 14; Clayton in London 1996–7, pp. 41–2, cat. 18; Clayton in Edinburgh and London 2002–3, pp. 30–1, cat. 4.

NOTES

1 Clayton in Edinburgh and London 2002–3, p. 31, cat. 4.
2 Vitruvius (1999), p. 47.
3 Ost 1975, pp. 55–6.
4 E.g. Biblioteca Reale, Turin, 15574/6; A fol. 63r.
5 Keele and Pedretti 1979, vol. 2, p. 812.
6 Panofsky 1940, p. 117, fig. 108.
7 Alberti (1972), p. 125.

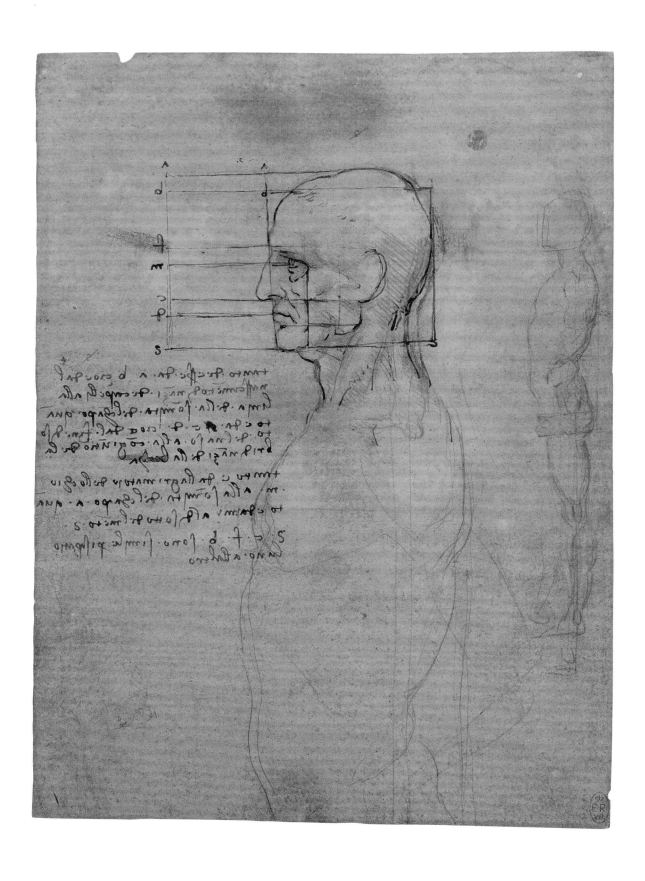

28

LEONARDO DA VINCI (1452–1519)
Studies of a male nude
about 1489

Metalpoint heightened with white on blue prepared paper
17.7 × 14 cm
Lent by Her Majesty The Queen
(RL 12637)

This remarkable page contains two studies of a well-muscled male nude. To judge from the 'inventory' of Leonardo's possessions preserved in the Codex Atlanticus, nude studies ('molti nudi integri', presumably drawings) were part of his workshop equipment (see pp. 23–5).[1] Here he rapidly sketched in the entire body, allowing the metalpoint a certain freedom to follow an occasional intuitive curve – as in the line above the buttocks of the figure in profile – rather than copying the precise forms of the model standing before him. He then concentrated on the musculature of the upper back and shoulder, the upper arm and the trunk in profile, sometimes developing a new outline, ignoring one already sketched (such as along the small of the back in the figure on the right). Only after adding the interior modelling of the figure in light and shade did he return to reinforce the final contour with a line of variable width. His dense hatching and careful use of white heightening to describe the passage of light are so fine as to evoke the smoothness of skin. This is especially clear in the shoulder and upper arm of the left-hand figure, where the brushstrokes are disguised to a greater degree than in the lower arm, and where the heightening has a warmer tonality, perhaps as a consequence of drawing over the metalpoint.

We may assume that both were drawn from a live model but with an eye on the body's overall pose. Leonardo did not, for example, simply seek the most practical position to show the muscles of the back. Instead, the figure on the left is positioned in a graceful *contrapposto*, his left arm outstretched and his hand forming a fist. This pose both tensed the muscles and created an elegant shape redolent of antique sculpture.

This sheet belongs to a different category from Leonardo's anatomical studies of the late 1480s, which were either drawn solely in pen and ink or had essential contours delineated in ink before being shaded with metalpoint, with the blue prepared paper constituting the highlight. Here the highlights are rendered with lead-white heightening and the coloured paper creates the mid-tone.[2] Furthermore, while still concerned with the observation of human musculature – with demonstrable accuracy[3] – Leonardo's chief interest here is in the effect of the underlying structure of the body on the surface.

Although this drawing cannot be directly related to any surviving painting, its function is clear. The expert use of white heightening indicates that Leonardo's immediate objective was to observe the fall of light across different parts of the body. In this sense the role of his anatomical researches here is analogous to that in *Saint Jerome* (cat. 20): both works required a serious attempt to understand what lies beneath the skin, but his knowledge of anatomy is not the primary purpose of either – as it is in, for example, the skull study of 1489 (cat. 23). It is not insignificant that muscle groups, the focus of this study, were also the concern of a follower of Leonardo whose drawing of *Saint Jerome* (fig. 79) is close to his master's style and is similarly executed in metalpoint with white heightening.

The present sheet can be dated to around 1489 by comparison of style, technique and finish with one of Leonardo's celebrated studies of a horse (fig. 16), executed in the period of his most intense work on the Sforza equestrian monument.[4] His nude study of Saint John the Baptist (fig. 7) is also closely related and is surely of much the same period. SN

FIG. 79
Follower of LEONARDO DA VINCI
Saint Jerome, about 1490
Metalpoint heightened with white on prepared paper, 16.5 × 14.7 cm
The Royal Collection (RL 12571)

LITERATURE
Clark and Pedretti 1968–9, vol. I, pp. 133–4; Keele and Pedretti 1979, vol. I, pp. 20–1, no. 9r; Clayton in London 1996–7, p. 48, cat. 19; vol. 2, p. 809.

NOTES
1 CA fol. 888r (ex fol. 324r).
2 Cat. 23 does includes some white heightening, as do the studies of the foot of a bear (Windsor RL 12372, 12373, 12374, 12375).
3 Keele and Pedretti 1979, vol. I, p. 20.
4 Clark and Pedretti 1968–9, vol. I, pp. 133–4; Keele and Pedretti 1979, vol. 2, p. 809.

29

LEONARDO DA VINCI (1452–1519)

A church viewed in perspective
about 1488–90

Pen and ink on paper
21.3 × 15.2 cm
Gallerie dell'Accademia, Venice
(238v)

This drawing of a church corresponds closely with the rapid sketch of a similar building in the background of *Saint Jerome* (cat. 20). The pedimented upper storey is divided into three compartments framed by large scrolled volutes, all above a wider lower storey with three doors divided by niches and pilasters. The design represents a solution to the problem faced by fifteenth-century architects of how to attach a classicising temple façade to a pre-existing church with high nave and lower side aisles. A similar solution had been found by Leon Battista Alberti for the church of Santa Maria Novella in Florence.

This sketch has been associated with a number of projects, some known to have involved Leonardo, from the cathedral at Pavia to the Certosa nearby; from the church of Santa Maria della Grazie in Milan to that of San Lorenzo in Florence.[1] The proposed dating has therefore fluctuated widely, from around 1490 when Ludovico Sforza invited Leonardo and Francesco di Giorgio Martini to inspect the works on Pavia Cathedral to (less likely) 1495–7, or (still more implausibly) 1513–16, based on a possible connection with an unrealised project for the façade of San Lorenzo, Florence.

The recto of the sheet is covered with drawings of mechanics and accompanying annotations. The rest of the verso is largely blank, but may once have had another sheet attached to it; this would explain the 'shadow' across the central section, and also Leonardo's decision to contain his study of a church in what must have been the upper right margin. Ludwig Heydenreich argued that the sheet was once part of a notebook (explaining the number '132' on the recto), from which other fragments survive in the Codex Atlanticus. He convincingly suggested that the notebook was dismembered for a planned treatise on mechanics, and that this page can therefore be dated to around 1490, a few years before Paris Manuscript A (of about 1492), which treats similar subjects related to weights.[2] Marani compared the drawings of pivots and weights on the recto to one of Leonardo's notebooks in the Biblioteca Nacional de Madrid (MS 8937), dated around 1493–5.[3] This may be a little late. The sheet certainly dates from after 1487, when his work on the *tiburio* of Milan Cathedral greatly increased his interest in architecture. A similar design was used for

CAT. 20 (detail)

the façade of Pavia Cathedral, so the drawing may have been made in connection with Leonardo's visit there in 1490.

There is, however, no indication that this drawing was made for any particular project. It has the quality of an elaborate doodle: the perspective is somewhat clumsy and in this sense the drawing can be considered paradigmatic. In fact it is not unlike the many centralised and Latin-cross church designs that fill the pages of Paris Manuscript B (dated to around 1488–90), probably also unconnected to any architectural commission. It is most likely that this represents a quickly drawn version of one of Leonardo's ideal buildings, based on ancient texts, Florentine precedent and pure invention, the architectural equivalent of his proportional studies from the late 1480s. Indeed, his organic view of architecture, his mechanical view of the human body and his search to find an ideal human proportion all came together around 1490, when he seems to have been engaging with Vitruvius' text.[4] Vitruvius's passages on proportion not only proposed a correspondence between human proportion and architecture, but did so within a chapter on temples.[5] Nor is it surprising that such a church appears in his painting of Saint Jerome, where such concerns are given a spiritual context. SN

LITERATURE

Heydenreich 1949, vol. 2, pl. 19;
Cogliati Arano in Venice 1966–7,
pp. 24–5, cat. 11; Pedretti 1978, p. 93;
Marani in Venice 1992, pp. 238–9,
cat. 21A; Zöllner 2003 (2007), p. 564,
fig. 497.

NOTES

1 Marani in Venice 1992, p. 239;
 Pedretti 1978, pp. 254–5.
2 Heydenreich 1949, pl. 19.
3 Marani in Venice 1992, p. 238.
4 Bruschi 1977, pp. 43–4, 158.
5 Vitruvius (1999), p. 47.

238

LEONARDO DA VINCI (1452–1519)

*Architectural studies; designs for an Adoration of the Christ Child;
profile of an old man; designs for a screw-press*
about 1486–9

Metalpoint, much faded, and pen and ink on pale blue prepared paper
18.3 × 13.7 cm
Lent by Her Majesty The Queen
(RL 12560)

Leonardo preserved many drawings which disclose the extraordinary rapidity of his thinking. In these brainstorming sheets he leaps from one of his many areas of activity or investigation to another with seeming randomness. Actually such assemblages were one means by which he could establish links, discerning connective principles of form and essence. This example is fairly typical, concentrating on architectural studies that are plausibly related to his design work for Milan Cathedral, under way from 1487. Kenneth Clark rightly pointed out that the technique, the preparation of the paper and the style of the old man's head at top left are 'identical with those of the early blue anatomies' (see cats 23, 24), making this part of a group that connects an early phase of his architectural thinking with his first sustained efforts to understand the human body – real and ideal. Most of these drawings were executed in metalpoint on blue prepared paper, with parts reinforced then or slightly later in pen and ink. The majority of the metalpoint studies have faded to the point of invisibility – and the architectural and engineering studies in the lower part of this sheet can only be seen properly in ultraviolet light. His correlated thinking had a spiritual dimension – and made an immediate impact on his designs for devotional images. Paul Müller-Walde was apparently the first to connect the pose of the Virgin Mary at the top of this sheet with Leonardo's Vatican *Saint Jerome* (cat. 20).

Leonardo is here considering the composition of what was a standard subject for an altarpiece. The Virgin kneels before the Christ Child, her left hand hovering over him, in a gesture that is both reverent and protective. In Florentine tradition, Christ lies on a cushion. They are given a woodland setting, a distant landscape seen through trees. Leonardo, as was his wont, explored individual motifs separately: an alternative, more excitingly contorted Christ Child and, below and to the right, barely visible even in ultraviolet light, a very lightly sketched figure of the Virgin Mary. As in the principal compositional sketch – and as always for his depictions of the kneeling Virgin – her knees are tight together on the ground. But Leonardo makes one significant change: in a gesture that was well rehearsed in Florentine painting, her left hand is now held to her breast, as Jerome's would be.

Martin Kemp has described the different stages of the main compositional design. Even before Leonardo added ink, he changed the shape of the panel from a

CAT. 30 (detail)

rectangular into an arch-topped picture (a clue that he may not have had a specific commission in mind): his figures had already burst their confines, and he also widened the composition on the left and lowered its base, thus moving the figure group up. The characteristically tiny size of the sketch allowed him to gauge the effectiveness of the overall composition. Key to the desired impact is its most innovative and resolved feature: the Virgin's dramatically extended right arm, the gesture around which the composition revolves.

Even on this diminutive scale we can see that – most unusually – the Virgin's arm and shoulder are bare. We can reasonably surmise therefore that Leonardo's return to this already much explored subject was sparked by his growing knowledge of the structure of the human body and its expressive potential. In particular, this compositional sketch appears directly inspired by his work on the proportions and anatomy of the arm (see cat. 26 and the arm in cat. 24). He would divert this train of thought to his image of Saint Jerome – in which the extended arm remains such an important element. Indeed, it is possible that it was while working on this sheet that

LITERATURE

Müller-Walde 1889, pp. 105–6; Clark 1935, p. 90; Clark and Pedretti 1968–9, vol. I, pp. 105–6; Roberts and Pedretti 1977, p. 401, fig. 14; Clayton in Venice 1992, pp. 204–5, cat. 8; Marani 1999, pp. 83, 117 nn. 7, 124; Kemp 2003, pp. 146–7; Syson and Billinge 2005, pp. 454–5.

NOTES

1 Besides the basic pose, another ingredient of the Adoration design made its way into the *Saint Jerome*. Leonardo drew a palm in a similar position to the tree growing to the left of the Virgin, though he soon painted it out. Fascinatingly, even the architectural studies on this page – mostly relating to a project for a church – have their echo in the Vatican painting. The main focus of the sheet is the relationship between a bell tower and an elaborate apse or transept. There may therefore be a link with the verso of cat. 23, a design for a crossing, which has been dated to 1489–90, though perhaps executed a little earlier. See Schofield 1991, p. 135, fig. 16. The quickly sketched church in the right background of the *Saint Jerome* also has a bell tower. Moreover, the sheet includes a design, very lightly drawn, for the façade of a church close in type to the doodled design in Venice (cat. 29), though with an emphasis on curves rather than triangles; both are slightly more elaborate versions of the church façade in the background of the *Saint Jerome*.

2 This sheet is usually connected with another giving various possibilities for the *Adoration of the Christ Child* (cat. 39). Both seem to have informed a composition, known from 'copies' in the Uffizi and the collection of the Duchessa Melzi d'Eril, Milan. See Suida 1920, p. 284; Möller 1929, p. 217; Clark 1935, vol. I, p. 90. The 'lost original' was identified by Borenius 1930, p. 142 – a picture in the Ashmolean Museum, Oxford. Actually these picture all depend on a design with elements that are clearly closer to Leonardo in about 1500–5.

he realised that his composition might be so adapted. Leonardo often doodled the profile of an old man, but in this case the head is very close to Jerome's, both informed by his *ecorché* depiction of the neck and jaw (cat. 22).[1]

Some have seen this sheet as belonging to the early history of the *Virgin of the Rocks* (cat. 31). Others have connected it (like cat. 39) to a 'lost' work known from early sixteenth-century 'copies'.[2] Most recently it has been discovered that this drawing – and indeed the unfinished *Saint Jerome* – were Leonardo's sources when he came to redesign (albeit temporarily) the main panel of the altarpiece of the Immaculate Conception (see p. 66, fig. 42). LS

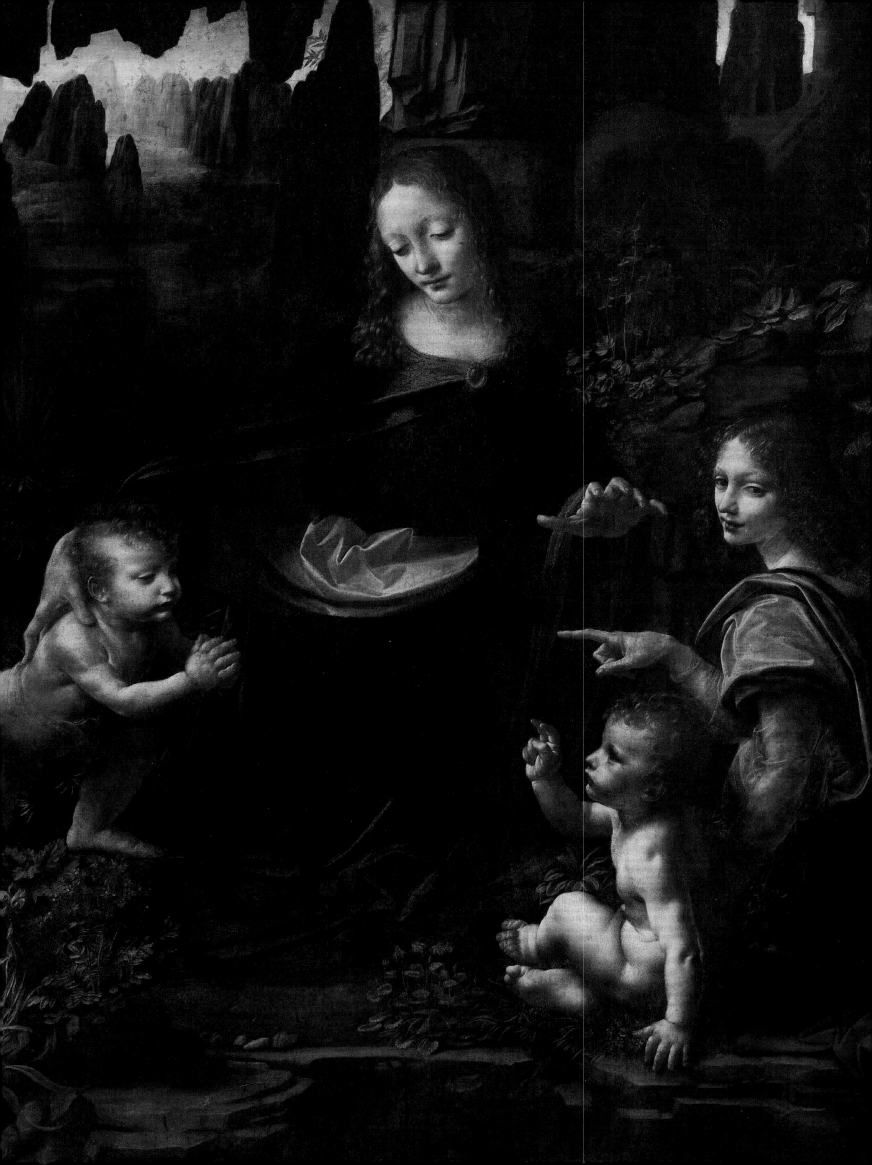

REPRESENTING THE DIVINE
THE VIRGIN OF THE ROCKS

THE DOCTRINE OF THE IMMACULATE CONCEPTION of the Virgin Mary was one of the most contested of the late Middle Ages, and even for believers it was far from easily understood. Indeed, it is an argument that depends on a logic of faith, since it states that, though the daughter of human parents, it was by God's special privilege that Mary was preserved from the first moment of her conception from all 'stain' of original sin. In its detail this argument was chiefly dependent upon the thinking of the Franciscan theologian John Duns Scotus (about 1265–1308), who argued that God had conceived the Virgin Mary as the pure vessel for the incarnation of his son, the saviour of humankind, even before the creation of the world and the beginning of time. Her immaculacy was therefore understood as part of God's infinite and unchanging plan – and was the necessary concomitant of Christ's own purity. And when the contradiction of a woman conceived through sexual congress being without sin was pointed out by Dominican opponents (who believed that Mary was purified in Saint Anne's womb after conception), Duns and his followers responded straightforwardly: because God could do this, he did.

This apparently simple mode of embracing a mystery might at first be supposed to have run counter to Leonardo's way of thinking and reasoning.[1] After all, Leonardo explicitly condemned

those friars who exchanged promises of salvation for gifts of money (he may have favoured the reform movement within the church) and would go on to sneer at those of the religious orders who sought to repress properly devout investigation of the natural world. It was probably for this reason that by the mid-sixteenth century, when Vasari published the first (1550) edition of his *Lives*, Leonardo had gained a reputation as tending to the heretical. By the time, however, that Vasari came to revise Leonardo's biography for the second (1568) edition, he was careful to make the painter's faith more orthodox. In fact, though Leonardo wrote very little about his spiritual beliefs, it is clear that he saw no contradiction between his investigation of the natural world and his trust in a prime mover. He wrote two slightly quirky avowals of his faith: 'I obey thee, Lord, first because of the love which with reason I ought to bear thee; secondly because thou knowest how to shorten or prolong the lives of men.'[2] And, unsurprisingly, he believed in the rewards of hard work, with God characterised rather like a flinty Florentine merchant: 'Thou, O God, dost sell us all good things at the price of labour.'[3] Martin Kemp has explained that while Leonardo had no truck with religious quacks,

> that is not to say that he saw the universe as operating independently of divine guidance. To be sure, all effects and their immediate causes in nature could be rigorously explained in physical terms without recourse to divine powers, but it was the very perfection with which causes and effects fitted together that proclaimed the supreme creator. This creative power, the ultimate 'cause of the causes' lay beyond rational comprehension . . .[4]

Leonardo was in fact careful not to step over the line.

In one of the anatomical sheets in the Royal Library at Windsor, he attempts a definition of the natural origin of the soul of man, first lying dormant and under the tutelage of the soul of the mother. This, incidentally, would make the utter purity of the soul of the Virgin Mary absolutely essential, if Leonardo believed that this construct in any way pertained to the soul of Christ. But he left the rest of the soul's definition to the minds of friars, 'fathers of the people who by inspiration know

all the secrets'. There is no reason to suspect irony here since he adds, 'I let the sacred scriptures stand, because they are the supreme truth'.[5]

It is clear, moreover, that Leonardo read this 'supreme truth'. Much to the surprise of its first editor of 1974 – at the peak of a period when Leonardo was treated as a kind of proto-atheist – one of the recently rediscovered Madrid Codices was found to contain a list of books belonging to Leonardo (datable to June–July 1503) which includes a good number of texts: not merely the Bible, but a Passion of Christ, and what appear to be a number of sermons and religious treatises by Saint Augustine, Saint Isidore of Seville (see fig. 22), Saint Ambrose (patron of Milan) and Saint Bernardino of Siena (the fifteenth-century Franciscan preacher in the vanguard of the Franciscan reform movement).[7] And if they seem not to have affected his written philosophy, these theological deliberations were surely the necessary tools of his painting. The degree to which Renaissance painters used their pictures to confirm or express their own Christian faith must remain debatable (though it would be perverse to exclude the possibility). However, even if this personal element is set aside, we cannot doubt that Leonardo was completely aware of the specific devotional functions of his religious paintings. Indeed, his fundamental belief in the power of paintings to inspire love was perhaps even more important in a religious context than it was in a secular one. Leon Battista Alberti, in his treatise *On Painting*, had stated:

> Some think that painting shaped the gods who were adored by the nations. It certainly was their greatest gift to mortals, for painting is most useful to that piety which joins us to the gods and keeps our souls full of religion. They say that Phidias made in Aulis a god Jove so beautiful that it considerably strengthened the religion then current.[7]

Couched in these terms, ancient practice could, if somewhat uneasily and by implication, be related to the making of modern Christian imagery.

And we can follow this transition from the pagan to the Christian in a passage in Leonardo's writings that,

though long and often cited before, merits quotation almost in full, since in it Leonardo makes a case for devotional painting with a conviction that verges on the passionate:

> Do we not now see pictures representing the divine gods constantly concealed under covers of the greatest price? And whenever they are uncovered there is first great ecclesiastical solemnity with various songs sung to different tunes, and then at the moment of uncovering the great multitude of people who have gathered there immediately throw themselves to the ground, worshipping and praying to her who is figured in the picture, for the recovery of their lost health and for their eternal salvation, exactly as if this goddess were present in life. This does not occur with any other science or other work of man, and if you claim that this is not due to the merit [*virtù*] of the painter but to that of the thing that is imitated, one might reply that if that were the case the mind of men could be satisfied if they were to remain in their beds rather than going to wearisome and dangerous places on pilgrimages . . . But since such pilgrimages continue to take place, what moves these people needlessly? Certainly you will concede that it is such a simulacrum which all the writings could not equal in representing the goddess in both form and spirit. Accordingly it would seem that the goddess loves such a painting and loves those who love and revere it, and delights in being adored in this way rather than in any other form of imitation, and this bestows grace and the gifts of salvation in accordance with the belief of those who gather in that location.[8]

Somewhere in the middle of this passage it becomes evident that Leonardo's 'goddess' is to be understood as the Virgin Mary – and more, that around her Leonardo has developed a complicated theology of the painted image. A picture of the kind he describes can function as a conduit of love from the viewer to the Virgin if, that is, the form and spirit of the 'goddess' are represented with sufficient power. Leonardo's words therefore read like a manifesto for the two versions of the *Virgin of the Rocks*, pictures in which, in slightly different ways, he established the 'living presence' of Mary and conveyed her spirit. Though Leonardo's method changes, these are both paintings in which the reasoned co-exists with the mystical in such a way as to make the ineffable almost, but not quite, concrete. LS

NOTES

1 For Leonardo and religion see especially McCurdy 1928, pp. 213, 218–29.
2 Forster III fol. 29r; R 1132.
3 Windsor RL 12642v; R 1133.
4 Kemp 2006, pp. 338–9.
5 Windsor RL 19115r; R 837.
6 Madrid II fols 2v–3r; Reti 1974, vol. 3, pp. 56–8, 92.
7 Alberti (1972), p. 63.
8 Urb. fol. 3r–v; MCM 18. K/W 25.

CAT. 31 (detail)

CAT. 32 (detail)

31

LEONARDO DA VINCI (1452–1519)

The Virgin of the Rocks

1483– about 1485

Oil on wood, transferred to canvas
199 × 122 cm
Musée du Louvre, Paris
(777)

32

LEONARDO DA VINCI

The Virgin of the Rocks

about 1491/2–9 and 1506–8

Oil on poplar, thinned and cradled
189.5 × 120 cm
Inscribed in Latin: 'ECCE A/GNIUS' ['Behold the Lamb']
The National Gallery, London
(NG 1093)

33

AMBROGIO DE PREDIS (about 1455–1510)

An Angel in Red with a Lute

about 1495–9

Oil on poplar
118.6 × 61 cm (panel)
The National Gallery, London
(NG 1662)

34

Associate of LEONARDO DA VINCI
(FRANCESCO NAPOLETANO?)

An Angel in Green with a Vielle

1490–9

Oil on poplar
117.2 × 60.8 cm (panel)
The National Gallery, London
(NG 1661)

This is the story of a single, relatively straightforward commission that became one of the most tortuous and testing in the history of Renaissance painting. On 25 April 1483 Leonardo da Vinci, new in Milan, and two local painters, half-brothers Evangelista and Ambrogio de Predis, were contracted to gild and colour a large, mainly sculpted altarpiece. It had just been made for the chapel of the newly formed Confraternity of the Immaculate Conception, a small building attached to the church of San Francesco Grande, the main church in Milan for the Franciscan order. The painters were also to provide three pictures, including a Virgin and Child with angels. It was only after 25 years of almost incessant legal and financial wrangling, however, that a picture approximately matching this description was paid for by the Confraternity. In the meantime Leonardo had painted two versions of the same unorthodox composition, a Virgin and Child with the infant Saint John the Baptist and a single angel, both known as the *Virgin of the Rocks*; one is now in Paris (cat. 31), the other in London (cat. 32).

Though there are some who doubt that Leonardo was solely responsible for the National Gallery picture, there is no question that these are the primary versions, to be distinguished from the many others of different dimensions and usually indifferent quality that copy each of them.[1] The London picture is certainly the one that came from San Francesco. The topic of why Leonardo executed two paintings that are so alike has been fiercely debated for more than a century, the problem getting no simpler as more and more documentary material has emerged from the archives. That first the chapel, then the church itself

were demolished, and that, with the exception of two panels of Musician Angels (cats 33, 34), the rest of the altarpiece has disappeared hardly helps.

The precise chronology of documentary discovery – of what was known about the painters' battle for proper remuneration – needs to be taken into account as we assess the changing critical fortunes of the two pictures. Some art historians have also questioned where in the altarpiece the *Virgin of the Rocks* was positioned, and the relationship of Leonardo's picture to the two panels of Musician Angels by his associates. This first chance to see these two extraordinary pictures together will reopen all of these questions and encourage further exploration of the surprisingly neglected topic of what they actually mean.

The Paris Virgin of the Rocks

The thrilling delicacy of the Louvre painting is somewhat compromised by its condition. The picture may already have suffered before it was transferred in 1806, when the wood was planed away and the paint surface and at least some of the preparatory layers reattached to the new canvas support, perhaps explaining this drastic course of action.[2] The transfer process itself may have resulted in further damage, though the picture has been stable since. There is considerable abrasion throughout, with some parts better preserved than others. There are also what seem to be quite large paint losses, such as in the back of the Virgin's head and her dress, though X-radiography indicates that some of these lacunae may have been over-generously retouched, perhaps concealing original paint.[3] The

LITERATURE

Malaguzzi Valeri 1913–23, vol. 2, pp. 382–402; Poggi 1919, pp. vi–xii, pls xiv–xix (with earlier bibliography); Clark 1939, pp. 43–8, 141–3; Beenken 1951; Ottino della Chiesa 1969, pp. 93–6, nos 15–16; Kemp 1981, pp. 93–9, 279–81; Marani 1989, pp. 55–8, 66–8, nos 10, 14; Marani 1999, pp. 124–55; Marani 2003d; Zöllner 2003 (2007), pp. 64–79, 223–4, 229, nos 11, 16 (with earlier references).

For documents, early sources and their interpretation: Verga 1905–6; Davies 1961, pp. 261–81; Melzi d'Eril 1973, pp. 121–3; Glasser 1977, pp. 163–75, 209–23, 328–43, 391–2; Sironi 1981; Villata 1999, pp. 17–34, 72–3, 149–56, 187–94, 214–19, 224–6, 228–31, nos 21–22c, 67, 175, 224–6, 248–51, 258, 263–4; Passoni 2004–5; O'Malley 2005, pp. 56–7, 158, 222.

For iconography and meaning: Holland 1952; Aronberg Lavin 1955; Snow-Smith 1987; Maiorino 1992, pp. 73–92; Ferri Piccaluga 1994a; Stefaniak 1997; Fehrenbach 1997, especially pp. 153–7; Levi della Torre 1998; Ferri Piccaluga 2005.

decayed and yellowed varnish makes reading the dark areas particularly difficult, blunting the impact of the quite astonishingly nuanced shadowing. But the highlighting of the feathers in the angel's wing, the curls of its auburn hair, and the leaves of fern and ivy scintillating above, remains nothing short of miraculous.

And the essential magic of the picture as a whole is undimmed, the exquisite boldness of Leonardo's invention still clear for all to see. Four figures are arranged at the edge of a pool, set back within the picture so as to occupy a defined stage. Some way behind them is an architecture of rocks, towering above them like a rood screen and pierced to reveal views of the single monolith on the right and a lake or sea, with more crags and mountains around it, on the left. The enormous grandeur of this setting is tempered by the damply lush vegetation that grows through the rocks, many of these myriad plants with long-established Marian connotations (signalling the Virgin's sorrows, her humility, her faith and so on) just like the sea behind her and the sacred spring in front. Nothing quite like this had ever been painted before. The poses of the protagonists are complex and graceful, and the draperies seem almost to have independent life. Leonardo gives a complicated turn to the Virgin's body as she looks down at the little boy whom she tenderly enfolds in her cloak – like the traditional Madonna of Mercy. Though her left elbow is tucked into her body and her shoulder pulled back, she leans out to extend her left hand to hover over the sweetly curly head of a second, slightly younger little boy. The drama of her twisting movement, simultaneously active and frozen, is explained and enhanced by the sharp diagonal made by the edge of her mantle and the vigorously crumpled folds of its golden lining. This second child is identified as her son by his gesture of blessing, familiar from so many images of the Madonna and Child and from scenes of the Last Judgement with Christ represented as adult. He sits cross-legged on the ground in a pose derived from ancient sculpture (fig. 12), here perhaps intended to remind the viewer of his crossed feet, pierced by a single nail, at his Crucifixion.

The object of Christ's favour is the other child kneeling opposite and slightly above him in an attitude of reverential prayer, both blessed and protected. It is always assumed that this is the infant John the Baptist. Once again, John is identified primarily by his pose; there is no reed cross or inscribed banderole of the type he usually carries, no accompanying lamb, and Leonardo even replaces his traditional camel-skin tunic with a scrap of something more diaphanous. The Baptist's identity seems deliberately to have been obscured so that he can stand for the human soul in all its nakedness. He actually comes higher in the composition than Christ, reversing the normal hierarchy, but making it evident that his protection by the Virgin is a key theme here. His importance is further emphasised by the pointing index finger of the angel at the other side of the picture. This hand is sometimes seen as the lynchpin of the composition, but it has recently been discovered that it was added quite late in the day,[4] interrupting the carefully calculated connection between Mary and her Child in a way that is actually rather disconcerting. Looking out to the viewer, the angel becomes our guide and instructor: by honouring Christ as this un-Baptist-like Baptist does, we too will receive the Virgin's protection; and she will intercede for us with Christ as she does for John. As pictorial convention dictates, the angel is about half the Virgin's size; this is not therefore an archangel, as is often claimed,[5] but a messenger sent by God to reveal this great mystery to the viewer. Kneeling behind Christ, in a pose that mirrors John's, the angel gives this solemn but appealing little boy his special status: despite his tender years, Christ is presented as Heavenly Judge.[6]

Nothing is known of the early history of the Louvre *Virgin of the Rocks*. It is first recorded in the French royal collection by Cassiano del Pozzo only in 1625 and it is not known how or when it arrived in France, or where it had been before that. It was regularly proposed that, though later taken perhaps to Milan, it was started before Leonardo's departure from Florence, possibly in connection with a civic commission to paint an altarpiece for the Chapel of San Bernardo in Palazzo della Signoria (see cat. 35). For reasons that will become clear, this argument is untenable and most scholars now agree that it was begun in connection with the Confraternity's commission. Many nonetheless continue – contradictorily – to state that its imagery contains no specific references to the theme of the Immaculate Conception, not least because it departs from what was specified in the contract.

It would be most peculiar for such a prominent element within the altarpiece complex to disregard the mystery to which the altar was dedicated. The doctrine of the Immaculate Conception of the Virgin Mary

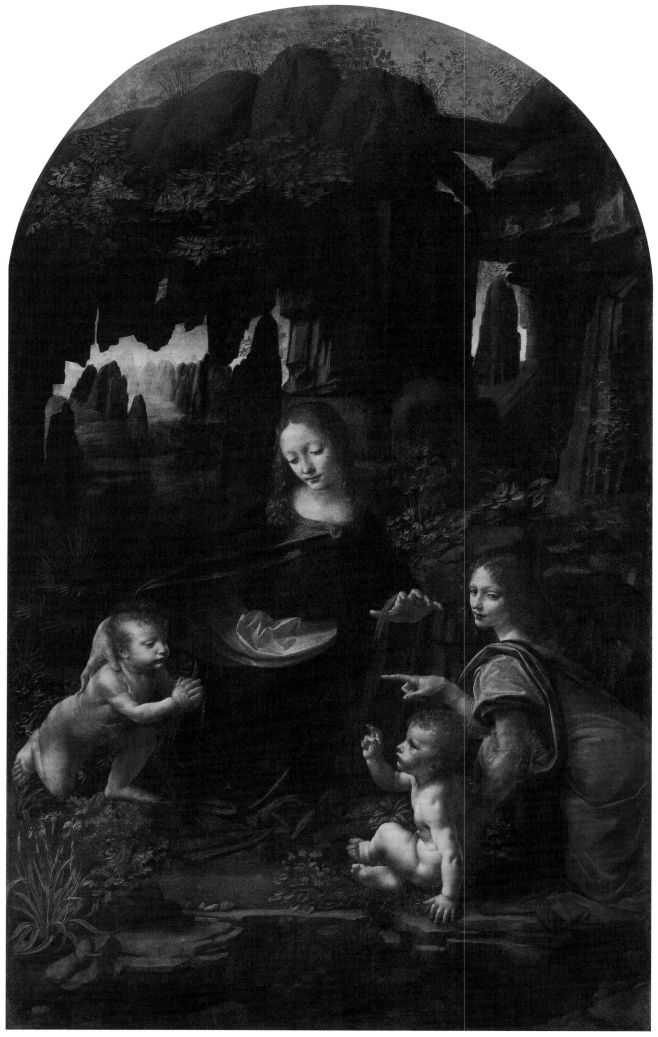

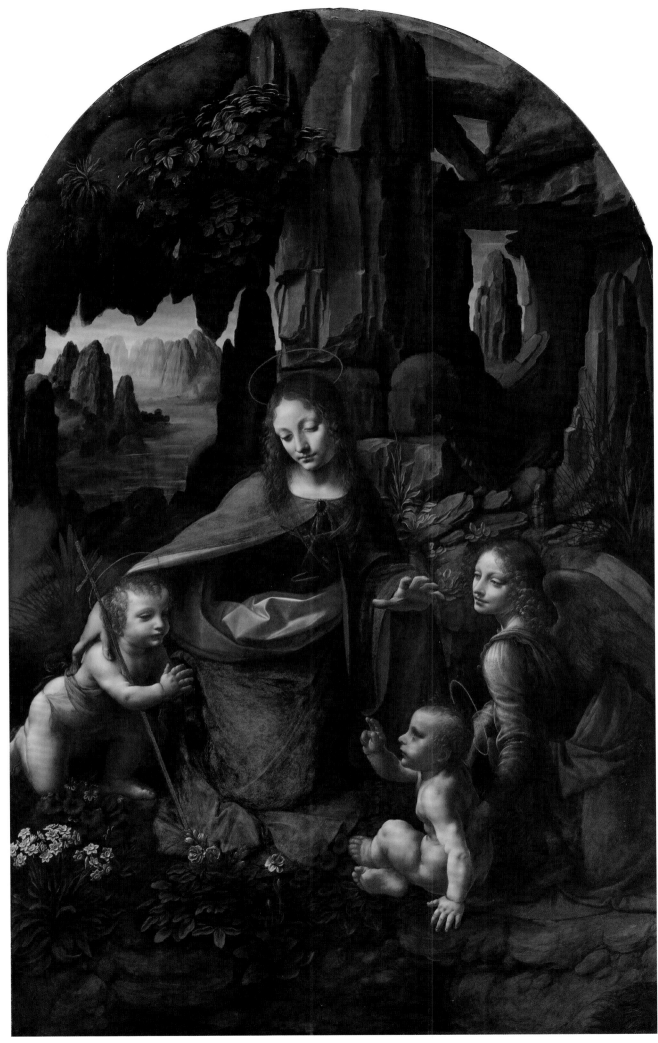

CAT. 32

states that, though the daughter of human parents, by God's special privilege Mary was from the moment of her conception preserved from all 'stain' of original sin. This was a tenet of belief that became particularly important for the Franciscans. In 1475 Fra Stefano da Oleggio delivered a series of sermons in San Francesco during which he proposed building a chapel dedicated to the Immaculate Conception and suggested that a confraternity, similarly dedicated, should be formed. His proposals fell on fertile ground. On 8 May 1479 the newly formed Confraternity commissioned two local painters to decorate the vault of their new chapel; the building must therefore have been complete. On 8 April 1480 the Confraternity commissioned the Milanese sculptor Giacomo del Maino to carve and construct a wooden altarpiece according to designs given him by the prior and two other interested parties. The altarpiece was to be complete by the Feast of Saint Michael, 29 September 1480, though it took rather longer: it was not until 25 April 1483 that Leonardo and the de Predis brothers signed their contract.

The arrangement of the altarpiece

By 1483 there was not yet a set iconography for the depiction of the Immaculate Conception of the Virgin. Sculptor, painters and their advisers had no choice but to make it up. If it is to be argued that Leonardo's two versions of the *Virgin of the Rocks* treat this theme, it becomes especially important to visualise the altarpiece as a whole. Discovering more about the placement of the *Virgin of the Rocks* will assist our analysis of its function and meaning, as well as of Leonardo's artistic decision-making.

Although the terms of the contract have left considerable scope for debate about the exact positioning of its component parts, the attached *lista* – an inventory detailing all the painters' tasks – provides the most complete description of the construction of the lost altarpiece. from top to bottom. It starts with an 'Our Lady in the middle', capable we discover from an earlier document, of wearing a specially donated gold, pearl and enamelled necklace, therefore almost certainly sculpted fully in the round.[7] This is the sculpture thought by some scholars to have been the main devotional focus of the altarpiece. Listed next are

seraphim and a God the Father with angels, again carved. Then, rather surprisingly, are mentioned mountains and stones that should be appropriately coloured with various oil paints, and then, in two blank spaces, were to be painted two pairs of musician angels, one pair singing, the other playing musical instruments. Next comes some form of domed canopy, which seems to have images of the Sibyls standing upon it. Prophecy was evidently an important theme. Then are mentioned 'chapters' (*capitoli*) – the Milanese word indicating narratives – of our Lady, reliefs that required gilding and polychromy. And only now do we come to the picture that was to become the *Virgin of the Rocks*: 'the panel of the middle, made, painted flat: Our Lady with her son and the angels, made in oils as perfectly as possible, with those two prophets to be painted flat.' Assuming the frame around it was arched, it is likely that two roundels of prophets were to be painted in the spandrels.[8] It is worth noting that Old Testament prophets bearing appropriate inscriptions appear in contemporary (Tuscan) Immaculate Conception paintings.[9] No mention is made of the infant Saint John, and the word 'angels' is in the plural. Thus neither version of the *Virgin of the Rocks* precisely matches the scene stipulated. Nor do the surviving panels of Musician Angels – painted singly rather than in pairs. Finally we arrive at a predella – the base of the altarpiece – which contained more carved Marian narratives, and what may have been another carved figure of the Infant Christ in a crib.

Read in this way, it becomes clear that the altarpiece would have looked rather like a cross between the carved altarpieces also made by members of the del Maino family for small towns in the mountains north of Milan (see figs 80, 81). On this basis the statue of the Immacolata would have been right at the top and the *Virgin of the Rocks* placed in the centre of the main tier, flanked by the carved scenes from the life of the Virgin, certainly more legible if placed reasonably low down. Since the Musician Angels are mentioned *before* the painted panel of the Virgin and Child and angels, they probably went on either side of the canopy above. This would explain their disappointing quality.

The predominant colours of the whole altarpiece would have been blue and gold, something Leonardo considered very carefully in making the second (London) version of the composition.

FIG. 80
GIACOMO DEL MAINO (active 1469–1503)
and WORKSHOP
Altar of the Immaculate Conception, after 1495
Polychrome and gilded wood
San Maurizio, Ponte in Valtellina

FIG. 81
GIOVANNI ANGELO DEL MAINO (active 1469–1540),
GAUDENZIO FERRARI (1477/8–1546) and
FERMO STELLA (about 1490–1562)
High Altarpiece, 1516–26
Polychrome and gilded wood surrounding fresco
Church of the Assumption of the Virgin, Morbegno

Iconography

If the *Virgin of the Rocks* occupied the most important space within the altarpiece, it would be odd indeed if it were not intended to prompt contemplation of the mystery of the Immaculate Conception. Certainly, when described *in situ* in the sixteenth and seventeenth centuries it is called a 'Conception' or a 'Madonna' quite indiscriminately.[10] The references to the stories of Saint John in the desert may also have had Immaculist connotations, yet to be rediscovered.

It has been proposed that Leonardo thought carefully about the texts that were used to create the offices for the new feast day, those by Leonardo Nogarolo, published in Rome in 1477, and those by the Milanese friar Bernardino de' Busti, who was based just outside Milan.[11] Bernardino's subsequent sermons on Marian themes must also have been useful. Many of the texts from the Old and New Testaments that they now knitted together and explained were familiar from the offices for other feast days of the Virgin – her Birth, Annunciation or her Assumption into Heaven. By combining ingredients from established Marian iconographies (the Madonna of Mercy, the Rest on the Flight and so on), and by including in the Louvre picture a number of easily recognised symbols of the Virgin, Leonardo was therefore emulating these theologians who had raided these other offices to create their own. One of the most important came

from the Song of Songs (4:7), believed to be written by the prophet Solomon, a candidate therefore for one of the altarpiece's roundels: 'Thou art all fair, my love; there is no spot in thee'. Thus the perfect beauty of the Virgin was not just aesthetically desirable; it was theologically essential. Several other passages from the Old Testament were adduced as evidence of the stainless Virgin as God's first 'creation'. From Psalms (110:3), by the prophet David, perhaps painted in the other roundel: 'From my womb, and before Lucifer, I generated thee'. In Ecclesiasticus (24:9), Wisdom speaks: 'From the beginning, and before the world, was I created, and unto the world to come I shall not cease to be . . .'. The rest of this remarkable chapter provides many vivid metaphors of nature, especially of flowing water, which must have been meat and drink to Leonardo. Above all, he found inspiration in this phrase from Proverbs 8:22–5, in which Wisdom again describes herself:

> The Lord possessed me in the beginning of his ways, before he made anything from the beginning. I was set up from eternity, and of old before the earth was made. The depths were not as yet, and I was already conceived, neither had the fountains of water yet sprung out: The mountains with their huge bulk had not as yet been established; before the hills I was brought forth.

These well-known phrases, already associated with Mary, took on a new importance as proofs for the doctrine of the Immaculate Conception, and they would all have been utterly familiar to the members of the Confraternity. Taken together they add up to an appropriately layered but nonetheless relatively simple explanation of the imagery of both *Virgin of the Rocks* paintings. Leonardo avoids several already familiar Marian symbols that were constructed by man (the tower, enclosed garden and so on), all of which would later become standard ingredients of the iconography of the Immacolata. His is a landscape whose parts can still be read metaphorically, as convention dictated, but which as a whole is strikingly primeval, untouched by human hand. It is immediately evident that this is a holy place, and Leonardo has been able to dispense with the more familiar trappings of sacred status, like haloes – absent in the Paris picture, added later to the London version. And he has also explained why the Virgin needed to be Immaculate: that God had made her to be the worthy mother of the Saviour is explained by the presence and actions of the other figures. Christ's coming – like creation itself – is presented as planned and inevitable, predictable by God's grace by the prophets (including John) and the Sibyls above. The Virgin's role as mediator for mankind is now tied precisely to her status as Immaculate Mother.

Two pictures, 25 years in the making

Regular payments of 40 lire a month to the three painters began almost immediately the contract was signed; a bonus was to be paid at the end of the job. On 28 December 1484 they had received 730 lire, almost the total sum agreed in advance (800 lire), suggesting that their work was nearly done.[12] But then there is a gap of years and, in about 1491–4, a petition for more money follows. In it, the surviving partners (Evangelista had died) make the case that they had severely underestimated the costs of gilding the monster *ancona*, spending all their fee on materials and leaving insufficient reward for Leonardo's painting, in which another buyer was interested. They valued the picture by 'the Florentine' at 100 ducats, as opposed to the 25 ducats on offer, and requested a new official *stima* (valuation) – a procedure that could only have taken place if the work was completely finished. To explain

this otherwise baffling time lag, it has been suggested that this petition was the extrajudicial last resort following a long, otherwise undocumented process.

The immediate response to this claim is undocumented. Leonardo left Milan in late 1499, after the fall of Ludovico; in 1503, with Leonardo absent, Ambrogio de Predis was still chasing extra payment, not least because his part (usually assumed to be the angel panels; he is certainly responsible for one of them) had been finished. Since he asked for the picture to be revalued or returned, we know that *a* painting by Leonardo was by then in the possession of the Confraternity, probably already installed within the altarpiece. Another document of April 1506, contains the somewhat surprising information that the central panel was at that point judged to be incomplete – and that Leonardo was to complete it within two years. He returned to the city and by August 1508 he and Ambrogio had received their final payments. The picture was to be taken out of the frame so that Ambrogio could make a copy of it under Leonardo's supervision; the two artists would then split the proceeds of its sale.

The Confraternity's chapel was demolished in 1576 and it took over an altar in the body of the church. When the altarpiece was moved, the statue of the Immacolata required a bier for its transport, providing a clue as to its scale within the complex. The sales of other parts of the altarpiece are recorded around this time, including at least some of the Marian reliefs and the canopy. It was clearly being modernised.

It seems that after this remodelling all three paintings were situated on the lower tier. But in an inventory of 1798, made after the *Virgin of the Rocks* had been removed, is a mention of what then remained of the Confraternity's altarpiece: 'at the top of the *ancona* two pieces of pictures representing two angels', flanking the gap left by the removal of the London picture. The pictorial elements had migrated yet again. That the arrangement was changed at least twice is reflected in changes made to the panels of the Musician Angels, which were cut down only after being first extended, probably in the later sixteenth century, with clumsily painted grey niches added to conceal their original backgrounds and bare wood where their original frames had been.[13]

Leonardo's painting was removed from the church when the Confraternity of the Immaculate

Conception was annexed to the Hospital of Santa Caterina alla Ruota in 1781. In 1785 the Hospital sold it to Gavin Hamilton, who passed it on almost immediately to Lord Lansdowne. It was purchased by the Earl of Suffolk in 1806 and bought by the National Gallery from his descendants in 1880. It cannot be doubted that it was the National Gallery version that came from the church of San Francesco Grande. The Musician Angels appear to have remained in place until 1798, when the church was secularised. They were confiscated by the Fondo di Religione of the Repubblica Cisalpina, the government invented for Milan by Napoleon, and acquired by Cavalier Melzi in 1809. In 1898 they were bought by the National Gallery to be reunited with the London *Virgin of the Rocks*.

In disentangling this complicated history, stylistic judgements of the Paris and London paintings of course play an essential part. No-one doubts that the Louvre *Virgin of the Rocks* was executed earlier than the National Gallery painting and, while the style of the former is perfectly consonant with a date of about 1483–5, most critics now agree that for purely stylistic reasons the London painting cannot have been started much before 1490. The Louvre version is certainly complete – so much of a piece that there is no need to assume that there was any substantial delay in finishing it; Leonardo was painting unusually fast. From the point of its style therefore there is nothing in the Paris version which would stand in the way of its being the painting that was substantially complete when the painters received their large payment in 1484, the same work that was the subject of their first petition of 1491–4. On the other hand, it cannot be the picture that still needed to be finished in 1506 (which must have been begun before 1499, when Leonardo left Milan). It is the London picture that came from the church, both later in style and actually unresolved in some parts.

The London Virgin of the Rocks

We are left with a final, fundamental question: how much Leonardo are we actually seeing in the National Gallery work? Is the London *Virgin of the Rocks* a 'replica', largely or completely delegated to the workshop, as many scholars have argued over the years? The primary differences between the two versions are very well known: the elimination of the angel's pointing hand, its now averted eyes and its introspective, melancholic expression; the addition of Saint John's banderole inscribed 'ECCE A/GNIUS' ('Behold the Lamb') and possibly his cross. Christ is sturdier and the Baptist has lost his childish appearance. The figures have all become monumental, the Virgin in particular given the ideal proportions that Leonardo had worked out by around 1490 (cat. 27). The draperies, too, have a new classicising simplicity. All these stylistic changes are present in an alternative, quickly abandoned compositional design discovered recently under the paint surface – an image of the Virgin holding her hand to her breast, with one arm extended.[14]

Leonardo appears to have revived an idea that he had first explored in relation to the Louvre picture (cat. 39; see also cat. 30). But now the figure is conceived in a High Renaissance idiom – this Virgin is quite as grand as the Saint Philip in the *Last Supper* in which the design for Mary's head was redeployed (see cat. 76). In the finished painting, the sense of the figures' stilled movement is even greater than in the first version, now accentuated by the painting's sculptural qualities. There is a new emphasis on *rilievo* – pictorial relief and volume, an effect achieved partly through the elimination of strong local colour, one of the factors that gives this work its compelling tonal unity. The green and red of the angel's costume are replaced by muted shades of the blue and gold worn by the Virgin. The palette, especially in the flesh-painting, always had a remarkable silvery cast. Moreover, Leonardo has eliminated the sense of the action taking place on a carefully defined stage; the figures now seem to project into our space. The plants are different and the sky is rendered all but invisible at the top. Because the space within the picture has been 'collapsed', the figures now appear as if in a grotto, and they have been relit accordingly.

The National Gallery picture appears to have been executed in three main phases. In the main it belongs to the early 1490s – probably around 1491–2 – when, for example, the head and gauzy sleeve of the angel were painted, both brought up to a high finish. The second phase was in the mid- to late 1490s, with the reworking of the angel's draperies and Christ's head, moved from a three-quarter view to regal profile (see cats 45, 47). Lastly, and only after his return in 1506, Leonardo applied the rather perfunctory finishing

touches which would justify the final payment: the second layer of the sky, using expensive ultramarine as specified in the 1483 contract, and the children's gingery locks. The level of finish – or lack of it – is fairly consistent throughout the picture: the angel's hand supporting Christ's back and the smudgy landscape above Saint John on the left are little more than blocked in. Leonardo's practice of shading the figures before determining their final contours is only too evident in the two children. But he has also understood that by contrasting areas of condensed detail with others that are much less resolved, he can direct the viewer's eye through a series of key diagonals in the composition, giving this picture much of its drama and energy.

But this combination of uneven finish and the move to a more monumental, less exquisitely meticulous style led some late nineteenth- and twentieth-century critics to accuse the picture of heavy-handedness and a lack of grace and delicacy. Most admit that the changes to the composition must have been dictated by Leonardo, but the majority argue that the London picture was largely or entirely delegated to pupils or assistants expected to follow his underdrawing or cartoons.[15] Herbert Cook in 1898 was the first to suggest Ambrogio de Predis, and he was followed by many others.[16] The attribution to Ambrogio has been occasionally rejected – but often only for scholars to propose other names, particularly in the last decade, such as Boltraffio and Marco d'Oggiono – mainly by comparison with the *Grifi Altarpiece* (fig. 98). According to many of these arguments, Leonardo only painted the head of the angel, perhaps that of the Madonna and a few other key parts.

The Musician Angels

For this theory of delegation to hold water, the London *Virgin of the Rocks* should be comparable in quality to the Musician Angel panels, often ascribed to the same hypothetical collaborators thought to have worked with Leonardo on the main panel. In the past these were usually given to Ambrogio and Evangelista de Predis, and in recent years almost no-one has doubted that they are by two different associates of Leonardo. The *Angel in Red with a Lute* is still consistently attributed to Ambrogio, by comparison with signed or documented works.[17] Since stylistically the *Angel in Green with a Vielle* belongs with the second version of the *Virgin of*

the Rocks, it cannot be by Evangelista (who was already deceased). In recent years this panel has been attributed to both Marco d'Oggiono and Francesco Galli, known as Francesco Napoletano. There are indeed some similarities with paintings by Marco made after 1500, but this attribution is far from satisfactory.[18] The view that the *Angel in Green* was painted by Francesco Napoletano is more convincing.[19] There are stylistic similarities with his more certain works: the small altarpiece of the *Virgin and Child with Saints John the Baptist and Sebastian* in Zurich (fig. 56) and the *Virgin and Child* in the Brera, Milan (fig. 82), both seemingly of the late 1480s. Francesco Napoletano and Ambrogio de Predis both worked for the Imperial Mint at Innsbruck in early 1494, and Ambrogio acted in the interests of Francesco's heirs after he died in Venice in 1501. Francesco therefore becomes a plausible choice of partner for Ambrogio after the death of Evangelista; if he is indeed the author of the *Angel in Green*, it must pre-date 1501. It is likely to belong to the second half of the 1490s, since the angle of the head, the fall of the hair and the facial type all depend on the figure of Saint John the Evangelist in the *Last Supper*.[20] It has recently been suggested that both pictures adapt designs perhaps by Leonardo himself, although both are technically and qualitatively light years from the London *Virgin of the Rocks*: not one of Leonardo's followers possessed the requisite skills to paint the National Gallery picture.

An act of creation

Now that the picture has been cleaned and restored, it seems wisest to return to the more 'moderate' theory that Leonardo painted two 'originals'.[21] The painting is full of changes of mind – the shoulders of the Virgin, for example, repositioned at least twice. And who other than Leonardo was capable of such remarkable transitions of light and shade? The pool of shadow in the palm of the Virgin's extended hand is particularly brilliantly observed. The plants, too, have none of the mechanical qualities of the flowers painted by Leonardo's pupils. And the protagonists have been granted a new kind of inner life, now unified in their emotions. The melancholy beauty of the angel is proverbial. But the two children are also extraordinary for their combination of innocence and wisdom.

A belief in the fully autograph status of the picture

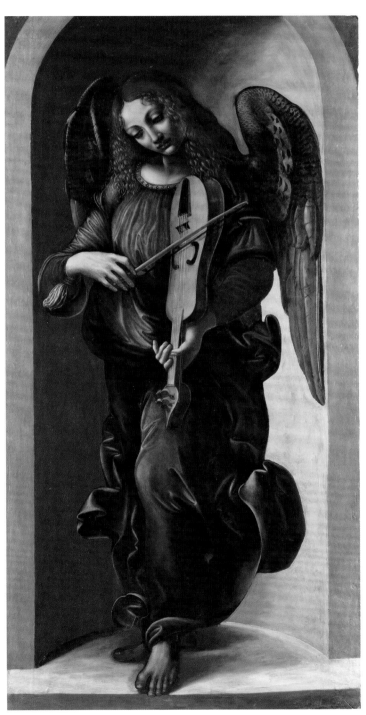

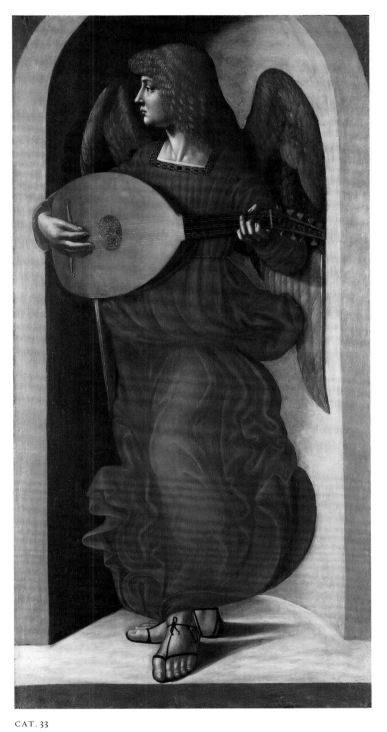

CAT. 34

CAT. 33

CAT. 34 (detail)

FIG. 82
FRANCESCO NAPOLETANO
Virgin and Child (detail), about 1490
Oil on wood, 41 × 30 cm
Pinacoteca di Brera, Milan

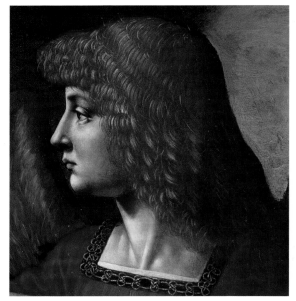

CAT. 33 (detail)

FIG. 83
Attributed to
AMBROGIO DE PREDIS
Portrait of a Woman in Profile,
probably about 1495–9
Oil on walnut, 52.5 × 37.3 cm
National Gallery, London

is supported by two other external considerations. No part of the picture is truly 'finished'. If Leonardo had used assistants, would he not have expected them to have got the job done? What otherwise is the point of delegating? And if he was allowed to employ assistants, why did the Confraternity insist on waiting for his return to Milan for the picture to be finished? Could not Ambrogio, his business partner and a competent enough painter, eager to receive his money, finish it himself?

This judgement is particularly important because the religious meaning of the work is in part bound up with its authorship. We know that Leonardo's painting technique gave priority to the figures. The Virgin is designed first, as she is in so many of his drawings, and the landscape seems to flow from her. Since Leonardo saw the painter's acts of creation as analogous to God's (see p. 40), his generation of the landscape in the *Virgin of the Rocks* and the absolute, unalterable perfection of the Madonna at the centre could be understood as

precisely connected with the doctrine of the Immaculate Conception. But the appearance of the Virgin and her companions, and of the plants and rocks, are different in the two versions: the theological meaning of his stylistic choices has shifted slightly. In the Louvre picture Leonardo relies on entirely naturalistic tactics to give the picture its spiritual flavour: the sinless beauty of the Virgin becomes the same kind of truth as the natural beauty of the iris nearby. But in the London *Virgin of the Rocks*, the Virgin and Christ are supernatural, the world around rendered notably less naturalistically: the rocks are straightened to become great columns, the flowers appear to be ideal composites of the leaves and petals of real plants. Tackling the theme for a second time, Leonardo chose to show the viewer not just a vision of the Virgin Mary, but God's perfect ideas for everything around her. What we are shown here is an ideal world made before the physical creation of our own imperfect cosmos, before the need for humankind's salvation. LS

174

NOTES

1 For which see Malaguzzi Valeri 1913–23, vol. 2, pp. 406–9, 412–25; Ferri Piccaluga 1994b; Zöllner 2003 (2007) pp. 64–75, 223–4, 229.

2 The original planking of the panel can, however, be discerned as patterns of paint loss in the X-radiograph. It emerges either that Leonardo developed his composition keeping in mind the likely movement of the four individual boards (of uneven width), or that painter and carpenter collaborated quite closely. One join comes between the head of the Virgin and her proper left hand; Leonardo has been careful to ensure that no joins run through heads. The plank on which most of the Virgin is painted is significantly wider than the other three, as in the London picture.

3 Some of these missing details are supplied by early copies. Other areas with significant overpaint include the foot of the angel except the toes, the back of Christ and the hand that supports him. The contour of the angel's cheek is determined by a restorer, though the larger size of the far eye was a decision taken by Leonardo; there is considerable retouching around the Virgin's head. The picture last received the attention of a restorer in 1952–3 but no substantial cleaning was undertaken then.

4 This hand was evidently separately studied. A copy of Leonardo's lost drawing is to be found in the Royal Library at Windsor (RL 12520).

5 The angel is often called Uriel, assuming a connection with legends of the infancy of the Baptist.

6 Steinberg (1996, pp. 234–6) argues that the marvellously powerful physique of the Christ Child in Renaissance paintings, including the 'lucid babe' in the *Virgin of the Rocks*, is an indication that he was immune from the infantile weakness in the human being that Saint Augustine had proposed was a physical symptom of original sin.

7 Sironi 1981.

8 This stipulation has been interpreted differently. It is sometimes assumed that the contract specifies prophets sharing space with a Virgin and Child with angels. Davies 1961, for example, transcribes the word as 'perfecti' to imply the perfection of these figures and to eliminate the prophets.

9 See e.g. the 1503 altarpiece by Vincenzo di Antonio Frediani (Museo Nazionale di Villa Fuinigi, Lucca).

10 This has led to the misleading theory occasionally proposed that there were two images by Leonardo in the chapel – the *Virgin of the Rocks* and a painted Immacolata.

11 See Ekserdjian 1988, pp. 107–13.

12 This document is damaged: the end of the year is illegible and has to be deduced from the combination of the date and the day of the week. It is sometime stated that Shell and Sironi miscalculated and that this payment was made in 1489, but this seems itself to be an error.

13 See Billinge et al. 2011.

14 Interestingly, the Adoration of the Child was used in other Milanese and Lombard altarpieces dedicated to the Immaculate Conception by e.g. Zenale in the central panel of the Cantù altarpiece (J. Paul Getty Museum, Los Angeles). See Natale 1982.

15 Starting with Richter 1883; Richter 1894, pp. 166–70, 300–1. He stresses the low price paid by Hamilton – just 30 ducats – impossible, he argues, for a work by Leonardo, calling the Christ Child 'an entirely wretched performance' compared with the red chalk drawing he believed was a study for the same head in the Louvre picture (cat. 45). See also Frizzoni 1894, pp. 230–5; Morelli 1890, p. 235.

16 Cook in London 1898, pp. l–lviii. In recent years Cecil Gould was the most passionate advocate of this theory. It should be said that until really quite recently scholars have had only a very imperfect understanding of the oeuvre of Ambrogio de Predis – with works by the Master of the Pala Sforzesca, Boltraffio and Marco d'Oggiono all thought to be by him (see cats 2, 8, 19).

17 See argument in Syson 2004, pp. 111–14 (albeit there the angel panels are assumed to belong to the first phase of the partners' work on the altarpiece).

18 Syson (2004, pp. 111–14) tentatively attributed the *Angel in Green* to Marco d'Oggiono on grounds that no longer seem convincing.

19 This was first proposed by Brown 1984, pp. 298–300; Brown 2003, pp. 48, 83–4 n. 89. The attribution is accepted by Shell and Fiorio (in Bora et al. 1998, pp. 126, 209). Marani attributes both pictures to Boltraffio and Marco d'Oggiono working together. See Marani 2003d, p. 14, figs 4 and 5 (see note 13 above). He had previously dated the works in the last decade of the fifteenth century, associating them stylistically with the London picture (although placing too much trust in the authenticity of the niches). See Marani 1999, pp. 149–50. His picture captions suggest that at this point Marani credits the attribution of the *Angel in Green* to Francesco Napoletano (albeit with a question mark appended to his name), while he already tentatively and most implausibly ascribes the *Angel in Red* to Boltraffio. Ballarin 1987 (2005) rejects the attribution to Francesco while Frangi 1991, p. 74, ignored it.

20 Brown 2003, pp. 83–4.

21 See Poynter 1894. He calls the Saint John in the Louvre picture 'more expressive and more momentary', and though he credits most of the picture to Leonardo, even he believes the picture was left unfinished and completed by another, heavier hand. See also Burton 1894; Reinach 1911; Beltrami 1919, pp. 104–43. This was to remain a minority view, but it was one adopted by Shearman 1962, for example, and others more recently.

35

LEONARDO DA VINCI (1452–1519)

*Sketches for an Adoration of
the Shepherds with angels*

about 1478

Pen and ink over metalpoint on prepared paper
12.1 × 13.6 cm (irregularly cut)
Gallerie dell'Accademia, Venice
(256r)

36

LEONARDO DA VINCI

*Sketches for an Adoration of
the Shepherds with angels*

about 1478

Pen and ink and wash over metalpoint on prepared paper
10.5 × 12.2 cm (irregularly cut)
Gallerie dell'Accademia, Venice
(259r)

Even before he came to paint the *Virgin of the Rocks* Leonardo contemplated painting a kneeling Madonna flanked by the animated figures of the Christ Child and the infant John the Baptist. These two irregularly cut fragments, sometimes thought to derive from the same sheet, contain some of Leonardo's most fervently energetic drawing. They are actually more likely to have come from the same notebook rather than being cut from a single sheet of paper. There are drawings on the verso of each, not by Leonardo, which would be rather hard to join up,[1] and it has recently been realised that chain lines in the paper are slightly differently spaced. Their theme – an Adoration of the Christ Child in the presence of the infant John the Baptist – has suggested to some scholars that they should be connected with the genesis of the Louvre *Virgin of the Rocks*, and therefore dated around 1483. The presence of a glory of flying angels might indeed be thought to accord with the angels stipulated for the main panel in the 1483 contract. But other ingredients in the drawings are not mentioned in the contract: in one fragment the bearded Saint Joseph with crossed legs is shown turning back to a shepherd; and in the other what is probably another shepherd has one knee firmly on the ground, the other a support for his elbow. Of course, this is also true of the kneeling Saint John, who did in the end make his way into the *Virgin of the Rocks*.

Their style and technique, however, suggest an earlier date. Martin Clayton has analysed the abbreviations that Leonardo employs in these sketches: the pinhead nose for the lost profile of the angel twisting in space; the brief 'U' of its shoulder blades; the calligraphic forelocks which define the angles of so many of the heads. These features are consistently found in drawings made at the beginning of Leonardo's career. These sketches for an Adoration of the Shepherds, and a more complete compositional design executed just a little later (Musée Bonnat, Bayonne, 658), are therefore sometimes conflated with the larger, separate sequence of drawings for Leonardo's Uffizi *Adoration of the Magi* of about 1481. The slightly scratchy penmanship in the present works and their open parallel hatching are, however, most reminiscent of one of his only two drawings from the 1470s that can be firmly dated, his grim little reminiscence of the hanged Bernardo di Bandino Baroncelli made in December 1479 (Musée Bonnat, Bayonne, 659). They therefore seem to be the first thoughts for a slightly earlier

project. When Leonardo was contracted in 1478 to paint the altarpiece for the Chapel of San Bernardo in the Palazzo della Signoria, the subject was not specified but he seems to have planned an Adoration of the Shepherds. And that this was a civic project might explain the anachronistic prominence of the little Saint John, patron saint of Florence.[2]

These fragments would therefore constitute Leonardo's first surviving drawings to tackle a subject that was to remain a constant within his oeuvre – a kneeling woman with children around her. Here we see the beginning of the long journey that would take him, via the two versions of the *Virgin of the Rocks*, all the way to his designs for a painting of the kneeling Leda and her babies. Though so much bolder in their execution, Leonardo's style and range of reference are still Verrocchiesque. We are reminded, for example, of Verrocchio's celebrated sheet showing a baby – the Christ Child – in a variety of different poses.[3] Leonardo's reclining Christ, looking back over his shoulder, recalls the putti sculpted in different materials within Verrocchio's workshop.[4] The shepherd's figure type is reminiscent of the Saint John in Verrocchio's Uffizi *Baptism of Christ* (fig. 85), which Leonardo had probably just finished completing and revising. His head would eventually inform the depiction of Saint Philip in the *Last Supper* (see figs 100, 104) and his pose was to inspire that of the Saint Jerome (cat. 20). However, the dynamism of pose and foreshortening, matched and emphasised by the gestural vigour of the line, is entirely Leonardo's own.

This was an arrangement of Virgin, Child and Saint John that informed Lorenzo di Credi's several paintings of the subject.[5] Drawings like these may even have gone on being used as a starting point for altarpieces by Leonardo's Milanese pupils – like Marco d'Oggiono – well into the sixteenth century.[6] But they remain especially important as they provide a prehistory for the *Virgin of the Rocks*. Here he begins to explore the emotional connection between the two little boys – the one praying, the other blessing – and starts imagining a *contrapposto* pose for the Virgin: her hips and knees pointing in one direction, her shoulders parallel to the picture surface, and her head looking in the opposite direction. Some of this energy of gesture and pose, even a kind of nervousness that is a feature of these sketches, found their way into the Louvre *Virgin of the Rocks*. LS

LITERATURE

Clayton in Venice 1992, pp. 196–9, cats 4, 5; Marani 1999, pp. 78–9; Bambach in New York 2003, pp. 344–8, cats 36–7; Perissa in Ancona 2005, pp. 44–9, cats 11–12 (with full bibliography).

NOTES

1 These are illustrated by Perissa in Ancona 2005, pp. 44–9. Cat. 35 has two profiles – metalpoint to the right, inked over to the left; cat. 36 has the drawing of a viol.

2 That he is not inked in, unlike the other figures, suggests, however, that in some ways he is seen as an optional ingredient. It has been suggested (Marani 1999, pp. 78–9) that a connection with the San Bernardo altarpiece is demonstrated by the flying angels at the top of Filippino's 1485 *Virgin and Child with Saints John the Baptist, Victor, Bernard and Zenobius* (Uffizi), which came from the Palazzo della Signoria and was sometimes thought to be a commission inherited by Filippino when Leonardo left town. It is now known, however, that Filippino's picture was made for another location within the palace. See Zambrano and Nelson 2004, pp. 351–2, no. 35.

3 Louvre RF 2r/v; Rubin in London 1999–2000, pp. 206–7, cat. 36. That Leonardo was inspired by his master to make these brainstorming sheets is suggested by the fact that the practice was briefly adopted by Lorenzo di Credi (National Galleries of Scotland, Edinburgh, D462v), albeit at a time when Lorenzo's connection with Leonardo was particularly strong.

4 Covi 2005, pp. 164–7.

5 See Dalli Regoli 1966, pp. 117, 124–5, 134–5, cats 33, 49 (missing Saint John), 50 and especially 68, is probably datable to the 1490s but conceivably painted earlier.

6 See e.g. Marco's Louvre altarpiece of the Adoration of the Christ Child by the Virgin Mary, Saints Joseph, Elizabeth, and Zacharias with the infant Saint John and the Annunciation to the Shepherds in the background, which combines aspects of this drawing with the figures from the *Virgin of the Rocks*. See Shell in Bora et al. 1998, p. 174, fig. 49.

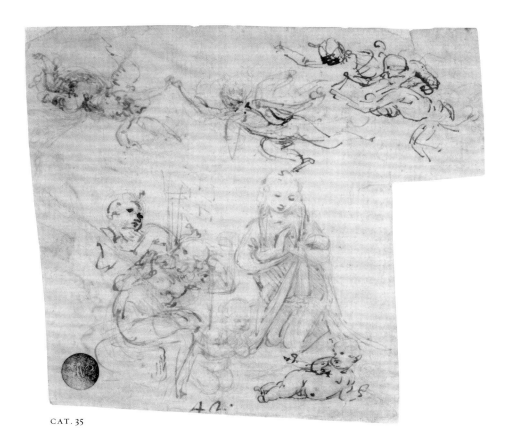

CAT. 35

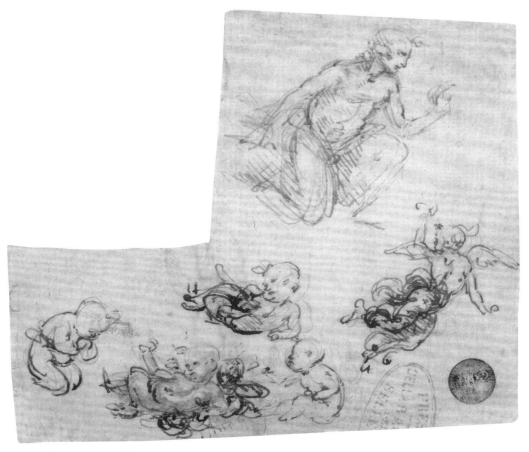

CAT. 36

LEONARDO DA VINCI (1452–1519)

Designs for a Virgin and Child with the infant Saint John the Baptist;
a male nude; heads in profile
about 1480–3

Pen and ink on paper
40.5 × 29 cm
Lent by Her Majesty The Queen
(RL 12276r)

This large sheet, which is another that constitutes an element in the prehistory of the *Virgin of the Rocks*, contains a number of quick sketches in pen and ink. The central scene shows the Virgin suckling the Christ Child with the infant Saint John the Baptist, their pose and position vigorously readjusted several times. Around this group and on the verso are a number of heads in profile. A close look at the layering of the different sketches reveals the order in which Leonardo proceeded. At first using only the lower half of the folded sheet, he started by drawing the heads of a boy and an old man. The additional heads in profile, drawn in the margins, represent variations on this theme.[1] He continued on the upper half of the sheet, drawing the Virgin with her head lowered towards the Christ Child. He then developed the Virgin's pose, showing her kneeling on her left leg and supporting the Christ Child on her right; Christ's feet are carefully arranged around the already drawn head of a boy, suggesting that his unusual pose may result from the desire to fit the figure into the available space. Leonardo eventually revised this composition by introducing the figure of the Baptist and changing the direction of the Virgin's gaze, sketching a second head, reinforced by dense hatching, over the first.

This drawing is usually dated to around 1478, mainly on the basis of the Uffizi sheet that refers to Leonardo beginning 'two Virgin Marys' (see p. 16).[2] However, its relation to an early compositional sketch for the *Adoration of the Magi* (fig. 84), now in the Louvre, suggests that the sheet in fact dates from a slightly later period, possibly the early 1480s.[3] Leonardo used the figure of the kneeling king in the Louvre drawing as the basis for the pose of the infant Baptist, copying the figure's outline in the top right corner of the present sheet: the pose is identical, and so too is the curl on the forehead of the king and the Baptist. Leonardo merely changed the position of the arms and adapted the figure's outline to suggest a protruding belly, thus changing the proportions of the body to those of an infant. Another link between the two sheets is the adjacent sketch of the figure plunging forward, which can be identified as a more finished version of the soldier on the stairs in the background of the Louvre drawing.

This sheet informed a number of Leonardo's later works and represents an intriguing link between his

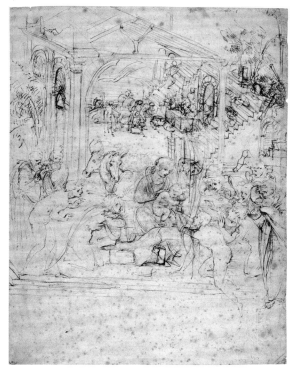

FIG. 84
LEONARDO DA VINCI
Compositional sketch for the Adoration of the Magi, about 1481
Pen and ink over metalpoint on prepared paper,
28.4 × 21.3 cm
Musée du Louvre, Paris (RF 1978)

Florentine and Milanese periods. Introducing as it does the figure of the infant Baptist into the traditional two-figure composition, it may even be regarded as an early thought for the composition of the *Virgin of the Rocks* (cat. 31). The drawing, in reverse, foreshadows the Virgin's pose in the altarpiece, while the position of her left leg anticipates that of the kneeling angel, elaborated in the later drapery study (cat. 47). The shorthand of the landscape above the Baptist, which possibly evolved from the drawing of a ravine (cat. 40), bears a strong likeness to that in the background of the *Virgin of the Rocks*. The pose of the infant Baptist, his arms crossed in front of his body, can also be seen in the *Burlington House Cartoon* (cat. 86), while the strong diagonal pull of the composition appears again in the Louvre *Virgin and Child with Saint Anne* (see fig. 48).[4] PR

LITERATURE

Bodmer 1931, pp. 113, 378–9; Suida 1929, p. 53; Berenson 1938, p. 131, no. 1170; Popham 1946, pp. 40, 117, no. 23; Clark and Pedretti 1968–9, vol. I, pp. 3–4; Roberts in London 1989, pp. 52–3, cat. 5; Kemp in Edinburgh 1992, pp. 50–1, cat. 7; Rubin in London 1999–2000, pp. 142–3, cat. 9; Clayton in Edinburgh and London 2002–3, pp. 16–19, cat. 1.

NOTES

1 For another example of a folded sheet used in a similar way, see Windsor RL 12319r. The head of the boy to the left is still akin to the work of Verrocchio and recalls the marble *Portrait of a Warrior (Alexander the Great)* in Washington, DC (see Butterfield 1997, pp. 230–32; Covi 2005, pp. 138–43). The roaring lion suggests a connection with British Museum 1895,0915.474. See Clayton in London 1996–7, pp. 20–1 and Clayton in Edinburgh and London 2002–3, pp. 16–19; see also Rosand 1988, pp. 20–3.
2 Uffizi 446ev; see e.g. Kemp in Edinburgh 1992, p. 50.
3 Louvre RF 1978r. For the commission of the altarpiece see also p. 18 in the present volume.
4 The drawing is copied, with slight adaptations, in a painting attributed to Andrea da Salerno in the Galleria Nazionale di Capodimonte, Naples (see Suida 1929, fig. 39).

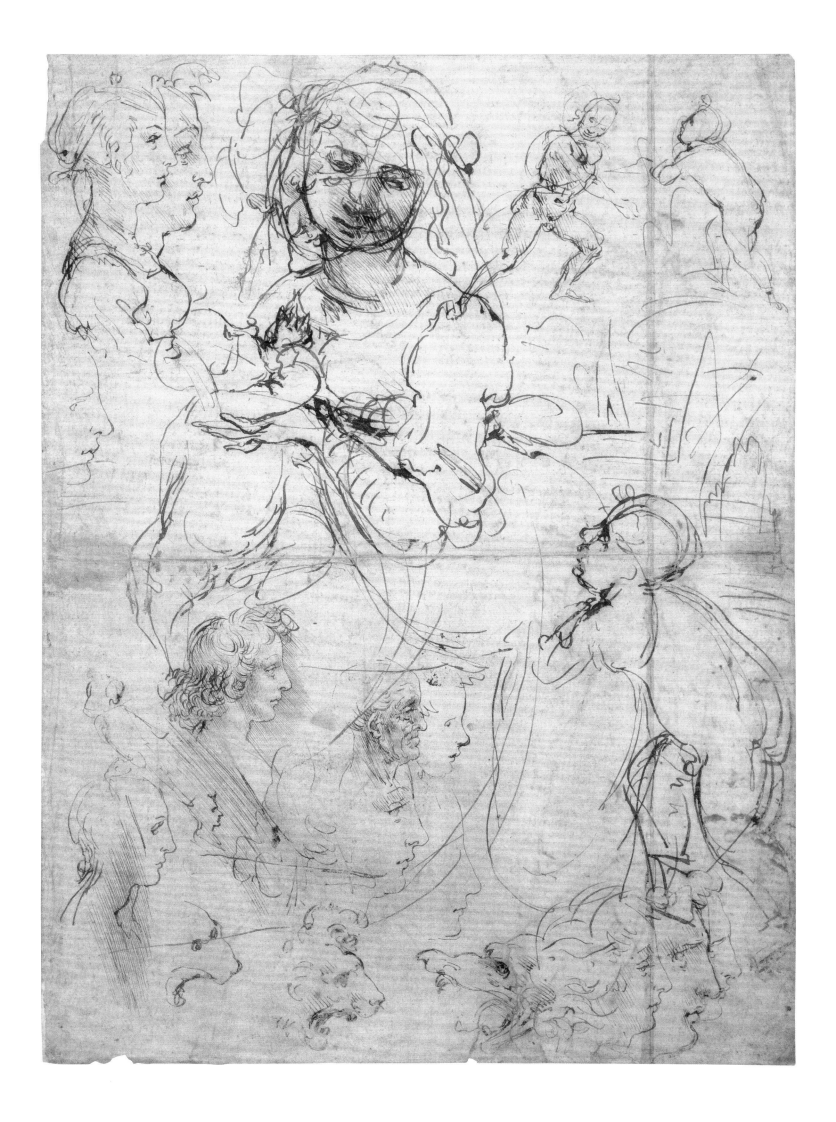

LEONARDO DA VINCI (1452–1519)

Virgin and Child with the infant Saint John the Baptist and an angel
about 1480–3

Metalpoint, much faded, over indentations with a stylus on prepared paper
14.5 × 19.1 cm
The Ashmolean Museum, Oxford
Presented by Chambers Hall, 1855
(WA 1855.84)

Leonardo went on considering how to represent the Virgin and Child as part of a larger figure group in the early 1480s. The intimate composition in the lower half of this sheet is carefully drawn in very soft, now rather faint, metalpoint. The Virgin is seated on the ground, rather like a traditional Virgin of Humility, and suckles the Christ Child. The group is accompanied by the kneeling infant Saint John the Baptist and a fourth figure next to the Virgin.[1] There are some indentations with a stylus that are barely visible: behind the figures is an indistinct sketch of a landscape, and the figures are framed by a border on three sides.[2] The verso shows calculations, sketches of optical phenomena and a perspective study of receding arches. The latter, which recalls the compositional sketch for the *Adoration of the Magi* in the Uffizi, was probably carried out first;[3] drawn in pen and ink, the sketch shows through the sheet, which may explain the off-centre positioning of the group on the recto. Although this drawing is very faint, its details, like the head of the Christ Child, have a very delicate beauty. The drawing certainly appealed to Sir Joshua Reynolds (1723–1792) and Sir Thomas Lawrence (1769–1830), who successively owned the sheet in the eighteenth and early nineteenth centuries.

The link to the *Adoration of the Magi* suggests that the drawing dates to the early 1480s. This dating is supported by a number of sketches of much the same moment that relate to the composition.[4] Popham noted that this delicate sketch shares some of the 'prophetic importance' of the large and much more vigorous drawing at Windsor (cat. 37).[5] Both drawings feature the unorthodox combination of the Virgin suckling the Christ Child and the infant Saint John the Baptist. The Baptist is depicted in a similar pose, albeit from a different angle, with his hands crossed in front of his chest, a stance that may derive from the king to the left in the Louvre sketch for the *Adoration* (fig. 84). Strangely, in the present drawing the Baptist does not actually face the Christ Child but gazes beyond him.

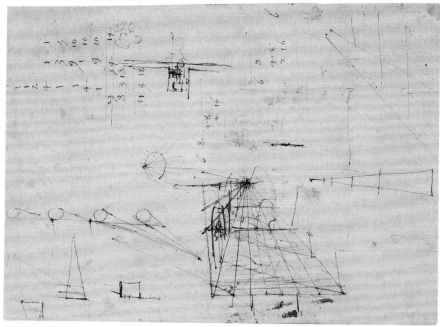

CAT. 38 (verso)
Perspective study, sketches of optical phenomena and calculations
Pen and ink

His pose becomes plausible when compared with the study for an Adoration of the Shepherds in the Accademia, Venice (cat. 35), where the Baptist is shown in an identical position but there adoring the recumbent Christ Child in front of him. A similar pose can also be found in the other Accademia drawing (cat. 36) and on the sheet with the studies for an Adoration of the Christ Child at the Metropolitan Museum (cat. 39), which establishes a particularly strong link to the *Virgin of the Rocks* (cat. 31). Although representations of the Virgin and Child with the infant Saint John the Baptist were not unusual at the time, the addition of the fourth figure already heralds the ensemble seen in the altarpiece for the Confraternity of the Immaculate Conception. PR

LITERATURE

Bodmer 1931, pp. 126, 381; Berenson 1938, vol. 2, p. 118, no. 1059; Parker 1956, p. 9, no. 14; Popham 1946, pp. 40–1, 117, no. 17; Clark and Pedretti 1968–9, vol. 1, p. 108; Veltman and Keele 1986, pp. 156–7; Bambach in Paris 2003, pp. 78–80, cat. 15; Kemp and Barone 2010, pp. 78–80, no. 29.

NOTES

1 The figure has been interpreted as an angel as well as Saint Anne and Saint Elizabeth.
2 On Leonardo and frames, see Kemp 2003.
3 Uffizi 436Er.
4 See e.g. British Museum 1860,0616.100.
5 Popham 1946, pp. 40–1.

39

LEONARDO DA VINCI (1452–1519)

Designs for an Adoration of the Christ Child
about 1482–3

Pen and ink over metalpoint on pale pink prepared paper
19.4 × 16.3 cm
The Metropolitan Museum of Art, New York
Rogers Fund, 1917 (17.142.1r)

Leonardo learnt how to think on paper from his master, Andrea del Verrocchio, and this fascinating sheet is more Verrocchiesque than others in that – with unusual discipline – Leonardo restricts himself to a single theme. Only the diagram at the bottom right shows him thinking more abstractly about the geometry of viewing. Otherwise he gives himself five possibilities, variations on the theme of the Virgin Mary kneeling in humble adoration of her Son; in the design at the centre he introduces the figure of the infant Saint John the Baptist in an animated attitude of prayer, giving the Virgin a more protective role. These are all drawn in pen and ink over looser metalpoint underdrawings. At the lower centre are three further quick sketches in metalpoint alone exploring the pose of the Christ Child and a more conventionally kneeling Baptist. This very faint and summary drawing of the little Saint John represents Leonardo's typical starting mode.

Though much studied, this drawing has proved more than usually resistant to precise dating. It has been suggested, for example, that it was executed in the late 1490s, and this argument might seem to be supported by the several versions of a Leonardesque composition, showing a kneeling Madonna with Christ and the Baptist playing around her, all of which date to the early sixteenth century.[1] The connection between drawing and paintings is likely, however, to be less direct.

And, although there is no accord as to the precise dates, the majority of scholars who have always believed that it belongs stylistically to the first part of Leonardo's career are surely correct. If this drawing is to be linked with a particular painting project, the Louvre *Virgin of the Rocks* commissioned in 1483 (cat. 31) and the devotional picture (appearance unknown) intended for King Matthias Corvinus of Hungary two years later (see pp. 25–6) are both plausible candidates, those dates according well with the style of the drawing. The latter idea is seductive since none of the designs on the Metropolitan sheet is exactly the same as the Louvre painting. Moreover, if he already knew the dimensions of the panel to be set into the altarpiece of the Immaculate Conception, then the Madonna in the two designs on the left of the sheet would have been surprisingly enormous when painted (though the uppermost is closer to the underdrawn Virgin in the National Gallery painting, fig. 42). But

this is probably too literal-minded an approach to Leonardo's drawing practice. This subject was hardly unusual and the drawings may have been made for their own sake, to provide continual points of reference. The only given here is that he envisaged an arch-topped panel. It is therefore useful to think again about how the Metropolitan sheet might have played a part in the genesis of the *Virgin of the Rocks*.

Certainly there is no need to think that the page of designs was started and revisited at different times, as has recently been suggested by Pietro Marani. Metalpoint and ink are contemporaneous and the first thing to be drawn on the sheet was the little diagram at bottom right – an early investigation of viewing angles and pictorial perspective. It is fairly clear that the other drawings were made around it. Cecil Gould established the probable order in which the Madonna designs were made, realising that Leonardo quite often drew as he wrote – from right to left. Leonardo's first idea is therefore the Virgin leaning over her Child at top right, with her hands clasped. This is perhaps the most conventional treatment of the subject. Next came the drawing at top left, in which Mary's pose is presented with more drama. The purpose of her gesture in relation to the Child is yet to be resolved, however. Leonardo has given a strong internal symmetry to the stable, but since this part is not inked in he appears quickly to have lost interest in this kind of architectural background. It is in the next drawing, at lower left, that his imagination really takes off. The stable has become more complex and interesting; the Virgin's body is now turned to the viewer, both her arms outstretched as she looks with awe into the face of her Child. Her left hand hovers over the head of Christ as it does in the *Virgin of the Rocks*. But the potential difficulty here is that Christ has turned his back to the spectator and Mary's open-armed pose still makes little sense.

Leonardo finds his solution at the centre of the sheet. The Virgin's gesture is now entirely justified since it has become inclusive of two children. Leonardo appears to be thinking back to his Venice drawing for an Adoration of the Shepherds (cat. 35). The Baptist, poised like a sprinter awaiting the starting pistol, is in much the same pose as in the large drawing at Windsor (cat. 37). With the Baptist tucked in under the Virgin's outstretched hand, Leonardo has turned the narrative of his encounter with Christ into the main theme – as

LITERATURE

Popp 1928, p. 37, no. 19; Bodmer 1931, p. 386; Pedretti 1973, pp. 59–60; Clayton in Venice 1992, pp. 202–3, cat. 7; Marani 1999, pp. 79, 82–3; Marani in Milan 2000–1, pp. 118–19, cat. 24; Bambach in New York 2003, pp. 366–70, cat. 45; Kemp 2003, pp. 145–6; Marani 2003b, p. 160.

NOTES

1 See Borenius 1930.
2 Fitzwilliam Museum PD 44-1999. See also Louvre, Collection Edmond de Rothschild 781r.

it is in the *Virgin of the Rocks*. At various points Leonardo has moved out of the main drawing to work up the poses of the Virgin (far left) and both children (below the central group). The exigencies of space have not left room for him to give the figures at the centre a setting, allowing them to be excerpted and exported in adapted form to the pure landscape setting of the *Virgin of the Rocks*. It is unlikely perhaps that Leonardo would have needed this staged progress towards his final design if he had already executed the Louvre painting. It does therefore seem that the Metropolitan sheet pre-dates that work, albeit only very slightly.

Stylistically and technically it is indeed most compatible with a drawing like the Fitzwilliam sheet of a rider on rearing horse, which can be connected with the Uffizi *Adoration of the Magi* (fig. 34).[2] Here is the same dense and controlled shadowing, the burgeoning of a new monumentality. Closest of all stylistically is the drawing of a stream running through a rocky ravine (cat. 40). And it was by bringing together these two drawings, made at about the same time, that Leonardo arrived at his revolutionary idea for the Louvre painting. LS

40

LEONARDO DA VINCI (1452–1519)
A rocky ravine
about 1480–3

Pen and ink on paper
22 × 15.8 cm
Lent by Her Majesty The Queen
(RL 12395)

The primordial landscape background of the *Virgin of the Rocks* is one of its most remarkable features. This drawing provides important clues as to how Leonardo came to realise this revolutionary idea. His intricate view of a steep precipice bordering a riverbed at the bottom of a ravine was to prove crucial for Leonardo's later work. Interestingly, there are small traces of paint on both sides of the sheet, suggesting that the drawing was indeed kept in the studio. While the upper part of the composition, where Leonardo has merely indicated the outlines of the trees to either side of the riverbank, is left unresolved, the two birds at lower right were probably added to provide a sense of scale.

The dating of the sheet remains controversial. Suggestions range from the early 1470s, based on an association with Leonardo's famous landscape drawing in the Uffizi (dated 1473),[1] to the 1490s. The close relation to Verrocchio's *Baptism of Christ* (fig. 85), however, is particularly striking. Leonardo worked on this altarpiece in the late 1470s.[2] The outcrop seen behind Saint John the Baptist and between the figures is somewhat reminiscent of the drawing; the stones and pebbles on the shore in the lower left and the flooding of the riverbed are very similar indeed.

The sheet compellingly demonstrates Leonardo's lifelong fascination with natural phenomena, which is also evident in his writings. In the Codex Leicester, for example, Leonardo contemplated the origin of rivers and mountains, devoting an entire passage to the gravel accumulating on the bottom of the River Arno. In another passage he addressed the stratification of rocks caused by the 'vagabond' courses of the rivers.[3]

Although the appearance of the precipice in this drawing is similar to geological formations that occur on the banks of the Arno near Florence, the overall composition also relates to formulae seen in contemporary paintings and prints.[4] This coexistence of the real and the imagined is particularly interesting when considering the relevance of this sheet to the *Virgin of the Rocks*. The precipice, with its distinctive cluster of vertical pinnacles leaning against the cliff, anticipates the mystical landscape in the altarpiece. Leonardo seems to have taken this study as his point of departure. But, while the drawing presents the pinnacles as a part

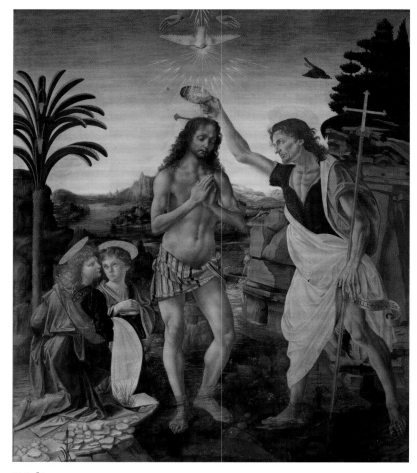

FIG. 85
ANDREA DEL VERROCCHIO (about 1435–1488) and
WORKSHOP, completed by LEONARDO DA VINCI
The Baptism of Christ, about 1468–77
Tempera and oil on poplar, 177 × 151 cm
Galleria degli Uffizi, Florence

of a complete geological formation, the landscape in the *Virgin of the Rocks* shows them isolated from their natural setting, turned into monolithic structures in their own right.[5] Another detail of the drawing akin to the *Virgin of the Rocks* is the curved strata on the bottom of the riverbed leading into the ravine, which bears a close resemblance to the stratified layers of rocks forming the ledge in the foreground of the Louvre version of the picture (cat. 31). PR

LITERATURE

Popp 1928, p. 37, no. 20; Bodmer 1931, pp. 163, 389; Berenson 1938, vol. 2, p. 138, no. 1260; Popham 1946, pp. 90–1, no. 255; Clark and Pedretti 1968–9, vol. 1, p. 58; Pedretti in Milan 1982a, p. 38, cat. 3; Kemp in London 1989, p. 107, cat. 45; Rubin in London 1999–2000, p. 233, cat. 45.

NOTES

1 Uffizi, 436E.
2 See Covi 2005, pp. 181-8; Natali 1998.
3 Leicester fols IV, 8v; R 1082. R 987.
4 See e.g. a woodcut of Mary Magdalene by the Master ES (Lehrs II.234.169); Rubin in London 1999–2000, p. 233; see Gombrich 1976, pp. 33–5
5 Similar clusters can still be seen in a number of later drawings, e.g. Windsor RL 12397, 12405 and 12408.

41

LEONARDO DA VINCI (1452–1519)

Cartoon for the head of the infant Saint John the Baptist
about 1482–3

Metalpoint with traces of pen and ink and wash heightened with white
on prepared paper, pricked for transfer
13.4 × 11.9 cm (irregularly cut), mounted on paper, 16.9 × 14 cm
Musée du Louvre, Paris
(2347r)

This is a drawing whose autograph status was doubted for many years. What is usually judged to be its rather poor condition has also been regularly deplored. Only in recent years have scholars begun to make the case for Leonardo's authorship (though often arguing that the sheet is considerably reworked by at least one other hand). And recently it has been hailed the only surviving drawing made specifically for the Paris *Virgin of the Rocks* (cat. 31).[1] This alone would be enough to give it a special place within Leonardo's graphic oeuvre, but it is also his only surviving drawing that can be securely classified as a cartoon for a painted work. It is pricked along its contours for transfer, possibly directly to a prepared panel, more likely to a blank sheet of paper which would serve as a secondary cartoon, thus ensuring that the original drawing would not be too badly damaged by having chalk or charcoal dust pounced through the pricked holes.

There is no doubt that the sheet can be directly connected with the Louvre painting. But, somewhat surprisingly, it was only a decade or so ago that a tracing made from the drawing was laid over the head of the infant John the Baptist to reveal that its outlines match precisely. Leonardo was clearly still using a technique he had learned from Verrocchio – making separate 'single-element' cartoons for heads and hands which could then be pieced together in different ways using a cut-and-paste technique.[2] Looking at painting and drawing together also does much to clarify Leonardo's own contribution to the latter. It has often been stated that much of the elaboration in ink and white heightening is by another draughtsman (perhaps more than one), sometimes thought to constitute later repairs, sometimes a working up by a pupil such as Boltraffio. Many of the scholars who believe in Leonardo's responsibility for this work have seen his hand only in the delicate metalpoint underdrawing, in the left-handed hatching in the child's temple for example. The hatched shading was indeed later reinforced in places by a right-handed draughtsman: in the nape of the child's neck, his chin and ear, perhaps the most retouched passage in the sheet. Nonetheless, a direct comparison of the drawing with the heads of both the Baptist and the Christ Child in the Louvre painting (both relatively well-preserved) suggests that the painterly application of the ink and wash, far from being a later addition, deliberately anticipates Leonardo's fluid oil technique in the painting. The

CAT. 31 (detail)

white heightening on the cheekbone thus becomes the shading's necessary corollary and is clearly original (even if lead white was also used later to efface the Lely and Richardson collectors' mark). Carlo Pedretti was one of the first modern scholars to have no doubt that these parts are autograph, emphasising that an equivalent technique is found in brush drawings by Leonardo dating to the end of his first Florentine period.[3] The brushwork is also somewhat similar to that of Leonardo's Uffizi *Adoration of the Magi* (fig. 34). There can therefore be little doubt that this head study is mostly by Leonardo's own hand, using a characteristically complex technique, and that later interventions are more minimal than many critics have thought. Understood in this way, the drawing is revealed not just as a mechanical aid but as one of the means Leonardo endowed his figures in the *Virgin of the Rocks* with the inner luminosity that is one of their most compelling characteristics. His understanding of the way in which bright light can blur contours is revealed here in the way he dissolves the bridge of the baby's nose into the far cheek, just the same effect he achieves in his portrait of Cecilia Gallerani.

The study's style and technique show that it can only have been executed a little before Leonardo

LITERATURE

Pedretti and Dalli Regoli 1985, p. 99; Ballarin 1985 (2005), pp. 12–16 (as Boltraffio); Kemp in Edinburgh 1992, pp. 74–5 (as Leonardo and Studio); Bambach 1999a, pp. 83–5; Viatte in New York 2003, pp. 158–9, 160–1, 420–3, cat. 61; Marani 2003b, pp. 138–61.

NOTES

1 By Viatte in New York 2003. But it is entirely omitted by Zöllner 2003 (2007), for example.
2 For which technique see most recently Dunkerton and Syson 2010.
3 E.g. British Museum 1895,0915.482, a study of a winged figure (Popham and Pouncey 1950, p. 62). There are also stylistic and technical links with horse studies connected with the *Adoration of the Magi*. See e.g. Louvre 781 D.R. and Fitzwilliam PD.121-1961. Pedretti 2003a, p. 96 reviews the *fortuna critica* of this sheet.
4 Ravaud 2003.
5 For which see most recently Kemp and Barone 2010, pp. 173–4, no. 139.
6 Bambach 1999, p. 85 relates this composite design, not implausibly, to the frescoed *Virgin and Child and a Donor* at the convent of Sant'Onofrio al Gianicolo, once thought Leonardo's only surviving work in Rome, now believed to be by Cesare da Sesto. But this is not necessarily to imply that the combining of the two cartoons was first done by Cesare; Boltraffio, who is almost certainly the author of the headless baby study, remains a more plausible candidate. It is worth noting, however, that, as in the Louvre *Virgin of the Rocks*, the head in the Roman fresco is lit from the opposite direction from that in the Louvre cartoon.

started work on the Paris *Virgin of the Rocks*, and may have been only one of several such cartoons he used as he laid down the underdrawing. Nonetheless, we cannot be absolutely sure that the drawing was made in the first instance for that painting. It is often noted that the light source in the picture and drawing are different – the boy's head in the drawing is illuminated from the right rather than the left. Actually, this is not unusual in Leonardo's drawings – in part a function of his left-handedness, but mainly because he always ensured that the strongest light was directed onto the face or onto whatever he wanted most clearly defined. But since he seemingly did not anticipate the lighting scheme of the Paris painting when he drew this child's head – perhaps in the first place from a sculpted source – the study may not have been made with this specific end in mind. There is some merit therefore in Pedretti's argument that it was made before Leonardo's journey to Milan, in connection with another project (though his hypothesis that it should be connected with the project to paint a Madonna and Child with a cat is too specific).

There is no question but that the cartoon went on being redeployed and not just by Leonardo. Examining the X-radiograph of the London *Virgin of the Rocks*, Elisabeth Ravaud realised that Leonardo turned it over to paint the head of the Christ Child, though he later revised it to present Christ in profile.[4] At about the same time he made the drawing available to Boltraffio, who used it as the basis for a study of the heads of the Virgin and Child in a celebrated drawing at Chatsworth (fig. 91).[5] Alessandro Ballarin argued that the Louvre cartoon is also the head cut from the drawing of a now headless baby, another pricked cartoon (cat. 51), and he attributed both to Boltraffio. Though they did not in fact derive from the same page (and are by different draughtsmen), it seems quite likely that the two cartoons were at one point combined into a single design, perhaps by yet another painter.[6] Cut out as they are, they could be joined together – the headless child perhaps provided with a hand from a third drawing – to make up a new image. Passed from painter to painter in this way, both drawings would continue to be of real practical use. LS

42

GIOVANNI ANTONIO BOLTRAFFIO
(about 1467–1516)

Head of a child in profile

about 1487–90

Metalpoint heightened with white (partially discoloured)
on blue prepared paper
13.6 × 8.8 cm
Musée du Louvre, Paris
(2350)

43

GIOVANNI ANTONIO BOLTRAFFIO

Head of a child in lost profile

about 1487–90

Metalpoint heightened with white (partially discoloured)
on blue prepared paper
13.5 × 9.3 cm
Musée du Louvre, Paris
(2351)

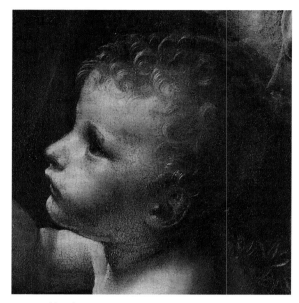

CAT. 31 (detail)

LITERATURE

Both de Tauzia 1888, no. 2025 (as by
Leonardo); Müntz 1898, vol. 1, p. 166;
vol. 2, p. 254, no. 6 (as by Leonardo);
von Seidlitz 1909, vol. 1, p. 169 (as by
Ambrogio de Predis); Berenson 1938,
vol. 1, p. 183 n. 1 (as by a follower of
Leonardo); Kwakkelstein 1999, pp. 187,
196 n. 32 (as by the 'Master of the Pala
Sforzesca'); Viatte in Paris 2003,
pp. 341–2, cats 113–14 (as by Boltraffio;
with provenance); Marani 2008,
pp. 95–6, nos 46–7 (as by Boltraffio).

NOTES

1 There are other cases in Leonardo's
 circle of two drawings being mounted
 together, probably originally from the
 same sheet. For example, Boltraffio's
 Head of a woman with the *Study of a child*
 in the Biblioteca Ambrosiana, Milan
 (Cod. F 263 inf. 99 and 100). There
 is also a Leonardesque drawing
 (hardly discussed in the literature) on
 two sheets, still mounted together,
 with two studies of children's heads
 (fig. 97). See Müntz 1898, vol. 1,
 pp. 167, 172–3. It is briefly discussed
 here under cat. 61.
2 For this hypothesis, see Kwakkelstein
 1999, p. 187.
3 On which see most recently Kemp in
 Atlanta and Los Angeles 2009–10,
 pp. 63–81.
4 The engraving by Chevignard
 (published in Magasin Pittoresque
 1858, pp. 13–14) also contributed to
 their nineteenth-century celebrity.
5 Examples of Leonardo's supreme
 achievements in this technique are
 cats 3 and 12.

The Paris *Virgin of the Rocks* lies behind these two drawings of the head of a little boy. Very close in size, these were once mounted together and probably belong to a single drawing campaign, so they cannot be discussed separately.[1] At first sight they seem almost identical, but one soon realises that there are fundamental differences. In cat. 42 the child's prominent upper lip is still visible, though partly concealed by the chubby cheek, which has become a little explosion of light. The ear, however, is completely in the shade, although reflected half-lights within it reveal its anatomical form. Cat. 43 shows the same head but now in lost profile: the left eye is more sharply foreshortened, our view of the lip is now entirely blocked by the cheek, more strongly shadowed; the ear is barely visible. The two drawings are consecutive views of a child's head that seems to be turning. However, the aim of the artist is not to illustrate any particular movement, but only the change in the incidence of light on the irregular surface of what is a near-spherical object – like the phases of the moon. This seems designed as a mental exercise, seeking to understand this form as a perfect solid, drawing from memory perhaps, yet starting from a live model. The aims and technique are thus faithfully Leonardesque.

It has been hypothesised that these studies were inspired by a sculpted model.[2] Leonardo himself is sometimes thought to have made similar drawings (cats 45, 46) – and certainly this mode of working, moving round the object he was drawing, was one which Leonardo adopted and which can indeed be seen as evidence of his sculptural approach.[3] Leonardo may well have made such drawings as he instructed one of his pupils. Another aim of this exercise was to perfect the use of the difficult medium of metalpoint, employing it particularly to achieve extraordinarily refined transitions of light and shade, the technique of *sfumato*.

In the nineteenth century the two drawings were considered – together with another head of a child in the Louvre (cat. 44) – as studies by Leonardo himself for the head of the Christ Child in the Paris *Virgin of the Rocks* (cat. 31). They were so famous, in fact, that cat. 43 appeared as the frontispiece of Eugène Müntz's great monograph of 1898, *Leonardo da Vinci*.[4] However, in 1909 Woldemar von Seidlitz rightly removed them

from Leonardo's corpus, attributing them instead to Ambrogio de Predis. This was the first important (albeit still misguided) step towards understanding the head studies as the work of one of Leonardo's pupils, which would lead eventually to their convincing attribution to Boltraffio. This proposal was first published by Françoise Viatte.

The two heads perfectly accord with works from the first phase of Boltraffio's career, in particular the Poldi Pezzoli *Madonna of the Rose* (cat. 63), in which the Christ Child might be these infants' brother. Indeed, even the lighting of the face is similar.

During this period, the late 1480s, Boltraffio was in all likelihood already the student of Leonardo, learning to think hard about systems of light and shade and exploiting the full potential of metalpoint.[5] His points of reference are therefore Leonardo's early Milanese works, in particular the Paris *Virgin of the Rocks*, from which he replicates the soft transitions of light and shade. The nineteenth-century belief that these drawing were preparatory for the *Virgin of the Rocks* altarpiece is certainly telling, but the relationship should be reversed. AM

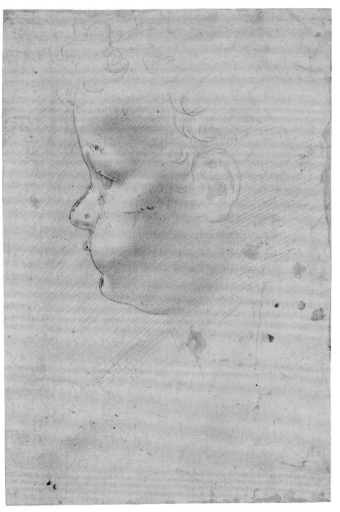

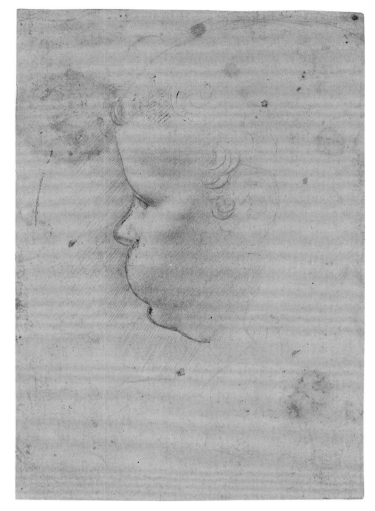

CAT. 42

CAT. 43

44

GIOVANNI ANTONIO BOLTRAFFIO (about 1467–1516)

Head of a child in profile
about 1490

Metalpoint with traces of pen and ink heightened with white
with some traces of black chalk on prepared paper
11.8 × 10 cm
Musée du Louvre, Paris
(2250)

This drawing has always been discussed in connection
with two other metalpoint studies of a similar subject
in the Louvre (cats 42, 43), which are by the same hand.[1]
In the nineteenth century all three were considered
autograph studies by Leonardo for the head of the
Christ Child in the Louvre *Virgin of the Rocks* (cat. 31). In
the twentieth century, however, scholars more sensibly
associated them with Leonardo's 'school'; the more
precise attribution to Boltraffio was recently published
by Françoise Viatte. One need only compare this study
with the head of the Child in the *Madonna of the Rose*
(cat. 63), or even that in the *Madonna Litta* (cat. 57), to
see that this hypothesis is correct. It is also technically
and stylistically very close to metalpoint drawings
today generally attributed to Boltraffio: the *Head of a
woman in profile* in the Metropolitan Museum of Art
(fig. 86) – an older sister of the present child, with
very similar lighting – and the more developed *Head
of a youth* in the Uffizi (cat. 50).[2]

The head of a child about two years old is depicted
in profile, turned towards a source of light from top
left. His expression is serious and focused; indeed, he
would be somewhat lifeless were it not for his gloriously
curly forelocks. His eye (for which there is a rough
sketch at the bottom of the sheet) is clear and trans-
parent. His nose and cheek are the most luminous
areas, thanks to their proximity to very dark zones,
a principle Leonardo explained in his notebooks.
Indeed, this is the function of the parallel hatching
beside the strongly contoured profile. The highlights
are also reinforced with white lead, the transitions of
light and shade (the famous Leonardesque *sfumato*) on
the side of the head softened – unusually – with black
chalk over the metalpoint. The purpose of this drawing
is the study of light and the importance of its angle to
the perception of volume. It seems the perfect sequel
to the other two studies (cats 42, 43).

Leonardo's metalpoint studies of the later 1480s
(such as cats 3, 12, 59, fig. 61) all show how he
exploited this technique to give visual expression to his
knowledge of light and shade, and they demonstrate

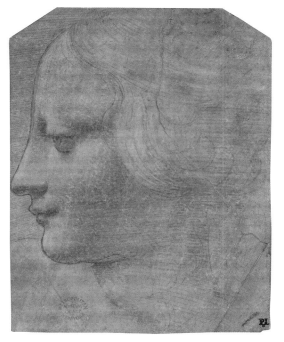

FIG. 86
GIOVANNI ANTONIO BOLTRAFFIO
Head of a woman in profile, about 1490
Metalpoint heightened with white on pale blue
prepared paper, 13.2 × 10.2 cm
The Metropolitan Museum of Art, New York,
Frederick C. Hewitt Fund, 1917 (19.76.3)

its use to give plasticity to particularised forms. In
particular, his metalpoint studies for the Sforza
monument (especially those datable to around 1489–
90, such as fig. 15), so strikingly close to the present
drawing, sum up Leonardo's technical and theoretical
knowledge at this moment. The earlier Louvre version
of the *Virgin of the Rocks* (cat. 31), in which the facial
type of the Child is still essentially Verrocchiesque, must
have served as the main source for the present study.
But it was the more plastic, sculptural and dramatically
lit later version now in London (cat. 32) that would
provide the model of lighting which Boltraffio would
go on to emulate. AM

LITERATURE

Reiset 1866, no. 383 (as by Leonardo);
Müntz 1898, vol. 1, pp. 166, 211; vol. 2,
p. 254, no. 6 (as by Leonardo); von
Seidlitz 1909, vol. 1, p. 169 (as by
Ambrogio de Predis); Berenson 1938,
vol. 1, p. 183, no. 1 (as by a follower of
Leonardo); Cogliati Arano 1965, p. 98,
no. 4, fig. 63 (as by Andrea Solario);
Kwakkelstein 1999, pp. 187, 196 n. 32
(as by the Master of the Pala Sforzesca);
Viatte in Paris 2003, pp. 339–41,
cat. 112 (as by Boltraffio; with prove-
nance); Wolk-Simon in New York
2003, pp. 651–2, cat. 125 (attributed to
Boltraffio); Marani 2008, pp. 93–4,
no. 45 (as by Boltraffio).

NOTES

1 However, these two are on blue
 prepared paper, unlike cat. 44.
2 Another drawing stylistically and
 technically very close to cat. 44 is
 the *Head of a woman* (Christ Church,
 Oxford, JBS 1062). The Lugt *Study
 for the head of the Christ Child* (cat. 61),
 although probably contemporary
 with the present drawing, belongs to
 a different category (as a preparatory
 drawing for a particular painting,
 the Hermitage *Madonna Litta*, cat. 57),
 and uses another technique but
 with the same media.

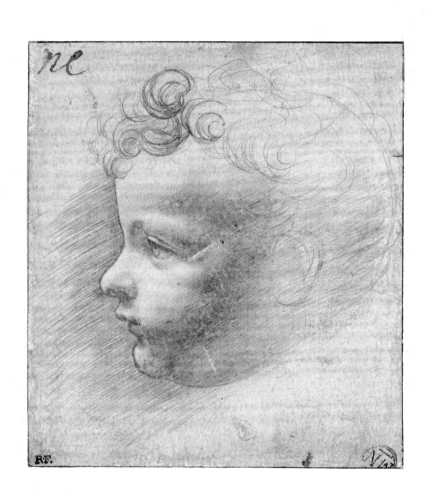

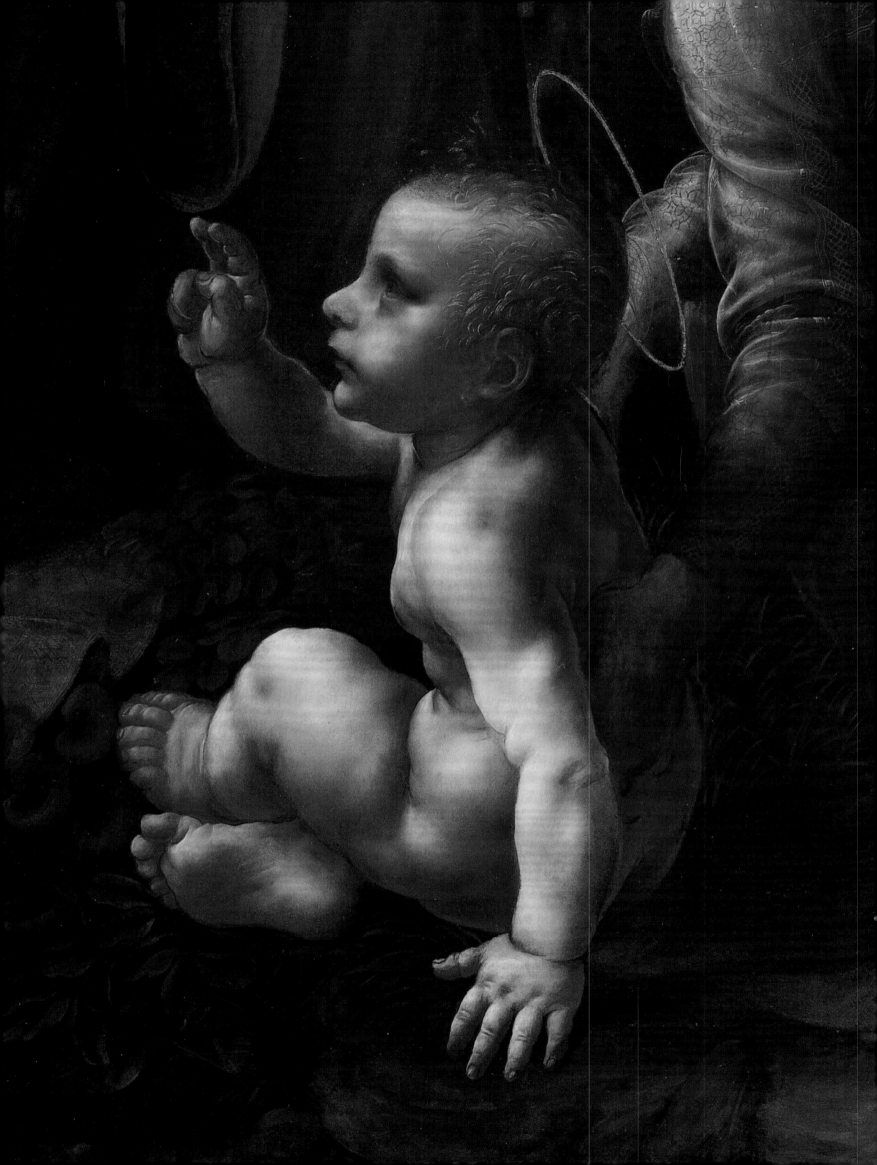

45

LEONARDO DA VINCI (1452–1519)

Head and shoulders of a child in profile

about 1494–6

Red chalk on paper
10 × 10 cm
Lent by Her Majesty The Queen
(RL 12519)

46

LEONARDO DA VINCI

Torso and shoulders of a child seen from front and back

about 1494–6

Red chalk on paper
16.5 × 13.6 cm
Lent by Her Majesty The Queen
(RL 12567)

LITERATURE

Clark 1935, pp. 78, 93; Clark and
Pedretti 1968–9, vol. 1, pp. 92, 108;
Kemp in London 1989, p. 87, cat. 30
(for cat. 45); Ames-Lewis 2001,
pp. 31–2 (for cat. 45); Clayton in
Edinburgh and London 2002–3,
pp. 40–1, 55, cats 9, 15; Clayton in
Atlanta and Los Angeles 2009–10,
pp. 30, 32–3, 35 (for cat. 45).

NOTES

1 Richter 1894.
2 See e.g. Malaguzzi Valeri 1913–23,
 vol. 2, pp. 404, 414.
3 Lomazzo (1973–4), vol. 1, p. 153;
 vol. 2, p. 113 and n. 9.
4 Vasari (1966–87), vol. 4, p. 17.
 See also K/W 88.
5 Luchs in Paris, Florence and
 Washington 2007, pp. 158–75,
 cats 9–11.
6 See Radke 2009, p. 40, pl. 17.

Though of slightly different shades of red, these two chalk studies of a boy aged no more than a year are similar in technique and were probably executed at much the same time, the remarkable control exhibited in the drawing of the child's shoulders suggests that it may have come second. Leonardo's pioneering use of red chalk is particularly suitable for drawing the naked human body; by his choice of medium alone Leonardo is able to give the flesh a roseate glow. And he is particularly successful in showing the shape of the muscles under the skin and their implied movement. His shadowing can be intense, but the red chalk is best employed for creating nuanced half-shadows and reflected lights (under the boy's chubby chin, for example). Leonardo was clearly attracted by a tonal range that is wider than in metalpoint and a medium in which he could combine strong line and subtle shading in a way that he found was actually more difficult in black chalk, which can end up looking slightly feeble (see cats 76, 81). The lightest areas of the drawing are of course simply the unmarked paper, a technique that, especially in the profile, renders the highlights somewhat shiny.

Although Leonardo went on drawing in red chalk on off-white paper well into the next decade, the present works probably pre-date the drawings in which he rubbed the sheets with red chalk dust. He began to expand the possibilities of the medium as he neared the completion of the *Last Supper* in about 1496–7. These therefore probably belong to the mid-1490s, not least because they are also more delicate and controlled, less scratchy in their handling, than his earliest efforts in this medium from the beginning of the decade (such as cats 58, 75).

The profile drawing has long been associated with the *Virgin of the Rocks*, though initially it was connected with the Louvre version and compared with the London painting only to point up the deficiencies of the latter.[1] It was quite quickly agreed, however, that it has more to do with the profile of Christ in the later version at the National Gallery, and those who believed this painting to be a workshop production similarly assigned the drawing to a follower.[2]

In part because of the cutting off of the body through the upper arm and just under the pectorals, both drawings have been associated with a lost sculpture, reputedly the work of Leonardo. His notes in which he describes making such works were transcribed by Lomazzo, who owned, he said, a bust of the infant Christ by Leonardo: 'And I find myself in possession of a little clay head, of a Christ, while he was a boy, by Leonardo da Vinci's own hand.'[3] That the shoulders are seen from front and back as they are here might be thought to reinforce this association: these are indeed features which suggest a link with a three-dimensional bust. The question therefore becomes one of whether the drawings were made from life for Leonardo's sculpted head of Christ, or whether an earlier sculpture became his source when he came to redesign the Christ in the London picture.

Even before Lomazzo's mention of such an object, Vasari had made the quite specific claim that in his youth Leonardo made 'heads of some women laughing', used as models perhaps for the joyous *Madonna Benois* (fig. 3). These, he says, a little implausibly, were 'created through the craft of plaster-casting, as well as the heads of some children, which seem to have issued forth from the hands of a master'.[4] This account of the timing of such works within Leonardo's long career may well be accurate.

There is no reason to think that such heads were made simply as workshop tools. There was a flourishing market for the heads of *bambini* in Florence, whereas none has been traced in Milan. We need only recall the busts that are more or less certainly attributed to a leading sculptor of the previous generation, Desiderio da Settignano (about 1430–1464).[5] Leonardo may actually have made plaster casts from marble carvings by others or from heads that he himself had modelled in clay (there is no evidence that he himself knew how to carve, or that he ever wanted to). These perhaps went into his baggage when he travelled north.

These observations are backed up by the style of the drawings. They were clearly executed in the mid-1490s, at a period when Leonardo's project for the Sforza equestrian monument was stalled. This is not a time when he was likely to be undertaking any such small sculptural works. On the other hand, scientific examination, especially X-radiography, establishes that the head of Christ in the London *Virgin of the Rocks* was first painted in three-quarter view, based on the cartoon he had originally made for the little Baptist in the Louvre version (cat. 41), and was only later moved into profile, evoking ancient coins and turning Christ into a little emperor.

CAT. 32 (detail)

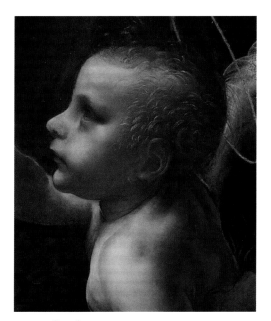

CAT. 32 (detail)

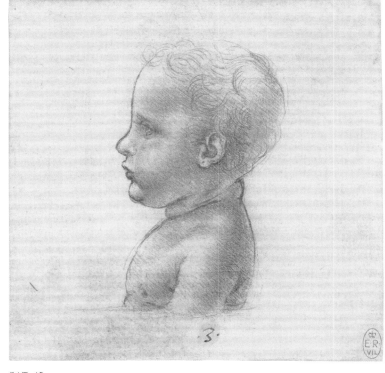

CAT. 45

Leonardo had considered sculpture very deeply while he was designing the first *Virgin of the Rocks*. The encounter of two infants is based loosely upon the relief by Mino da Fiesole (about 1429–1484) of about 1464–6 in the Salutati Chapel of the Cathedral of Fiesole, near Florence. When inventing the pose of the angel in this first version, Leonardo may even have returned to one of his own sculptures, his source the terracotta angel relief in the Louvre (Madame Adolphe Thiers bequest, TH 34) whose attribution to Leonardo is rather convincing, a work of the late 1470s.[6] It is scarcely surprising therefore that as Leonardo worked on the second version of the *Virgin of the Rocks* he could be found looking again to his own back-catalogue – or that he sought inspiration from an early sculptural work rather than a drawing.

A sculpted source would certainly explain the stiffness and formality of the pose in the profile drawing here. As Francis Ames-Lewis observes, the red chalk gives the child's curls a downy quality, but they also lie flat against the skull as they do in Desiderio's bust of a similarly rather solemn little boy (National Gallery of Art, Washington, DC, 1937.1.113). It may be objected that the child's shoulders and upper body appear to have been drawn from life, with creases of fat under the armpits and extraordinary softness of the flesh. There seems as well to be some fumbling for the contour. On the other hand, if the sculpture had been based on life studies, and especially if those included life

casts, these features would very likely be present in the head that Lomazzo later owned. Leonardo included them after all in the robust Christ Child in the *Madonna Benois*, started in the early 1480s. Indeed, in some ways the relief of the child's back sets out to rival the delicacy of effect achieved by Desiderio in marble. And drawing from immobile sculpture would also allow Leonardo to attain the great precision he has here – the whispered contour in the child's proper right shoulder in the upper drawing, for example, in which the shadow seems to fade away rather than being contained. To paint his Christ Child Leonardo needed to learn, to really know, the shape of the baby's torso – and this almost clinical drawing was his way of getting it absolutely right.

This is also a mode of drawing which is painterly – or at least it had a profound effect on Leonardo's method for achieving pictorial relief. The external contour lines are here becoming less important: in both drawing and painting the eyes of Christ are veiled by shadow, and, in the London painting, the contrast of light and shade is greater in the Child's bulbous body than in the other figures. There was a moment in the execution of the London *Virgin in the Rocks* when he stopped relying on drawings executed in metalpoint and started instead to use chalks. These drawings allow us to locate – and to date – that moment with an accuracy that is rather startling. LS

CAT. 46

47

LEONARDO DA VINCI (1452–1519)
Drapery study for an angel
about 1495–8

Brush and black ink heightened with white on pale blue prepared paper
21.3 × 15.9 cm
Lent by Her Majesty The Queen
(RL 12521)

This study for the draperies worn by a kneeling figure is seemingly the only surviving drawing by Leonardo made with the specific intention of solving a problem in the London *Virgin of the Rocks* (cat. 32).[1] The pose of the figure is very similar to the angel to the far right of the altarpiece, as is the way the mantle falls from the shoulder, turning inside out and forming a large fold across the lower torso. Careful attention is given to the manifold shapes of the cascading drapery as it meets the ground, while the upper torso is just quickly sketched in to suggest the basic shape of the figure.

The study of draperies was a common practice in 1470s Florence. Associated in particular with Verrocchio's workshop, such drawings are mentioned by Vasari in his biography of Leonardo.[2] This thorough investigation of drapery folds was made possible by the process of dipping a length of fabric in clay slip and arranging it over figures made of clay or wax. As the slip-soaked textiles set, the result could be studied from different angles and under different lighting conditions. The resulting monochrome drawings seem to have been exercises in light and shade and not necessarily studies for specific paintings. They were made with washes on prepared linen, working from dark to light, thus using a painterly technique close to that employed by Leonardo in his panel paintings until about 1500.[3] Here he uses a sheet of paper with a blue preparation added for drawing in metalpoint, presumably left over from his drawing campaign of the late 1480s (see cats 23, 24, 30).

The present study is in some ways similar to the early drapery studies. Though Leonardo is no longer working on *tela di lino* (linen) but on pale blue prepared paper, he still uses washes to achieve the soft gradation of shades that so intriguingly brings out the sculptural qualities of the drapery. This technique is very unusual for Leonardo's drapery studies from around 1490 onwards. Later examples – like the Windsor studies for the sleeve of Saint Peter in the *Last Supper* (cat. 83) or the drapery of the *Salvator Mundi* (cat. 90), which are similarly linked to particular paintings – are carried out in red and black chalk, implying that at this stage he tended to prefer a dry to a liquid medium.[4] However, the treatment of the folds here is comparable to those in the drapery study for the figure of Saint Peter (cat. 83), suggesting a date in the mid- to late 1490s, when Leonardo was working on the composition for the *Last Supper*.

The position of the angel was considerably reconsidered for the second version of the *Virgin of the Rocks* (cat. 32). While the shoulder is still in the same position, the angel is not seen from the back as in the Louvre version (cat. 31), but kneels parallel to the picture plane with only the upper torso turned towards the Virgin – very similar to the pose of the figure in this drapery study. The characteristic combination of folds in the drawing, in particular those underneath the angel's knee, also appear in the painted version, albeit slightly differing in detail. Technical examination of the London *Virgin of the Rocks* (cat. 32) has shown that the area of the angel's drapery was substantially revised during the course of painting the altarpiece, suggesting that the drawing was made when the picture was already well under way. PR

LITERATURE

Suida 1929, p. 50; Bodmer 1931, pp. 152, 387; Berenson 1938, vol. 2, p. 131, no. 1175; Popham 1946, pp. 69, 149, no. 158; Clark and Pedretti 1968–9, vol. 1, pp. 92–3; Roberts in London 1989, p. 62, cat. 11; Kemp in Edinburgh 1992, p. 66, cat. 15; Bambach in Paris 2003, pp. 139–41, cat. 38.

NOTES

1 The study has also been unconvincingly associated with Verrocchio's *Baptism of Christ* and Leonardo's *Annunciation*, both in the Uffizi. For a detailed discussion of the critical history of the sheet, see Bambach in Paris 2003, pp. 139–41, cat. 38.
2 Vasari (1966–87), vol. 4, p. 17.
3 See Paris 1989. On the early drapery studies, see Viatte 2003. See also Popham 1946, pp. 35–42; Cadogan 1983, pp. 27–63; Christiansen 1990, pp. 572–3; Bambach 2004, pp. 44–55. For the development of Leonardo's technique, see pp. 54–77 in the present volume.
4 On Leonardo and the use of chalk, see Ames-Lewis 2001.

CAT. 32 (detail)

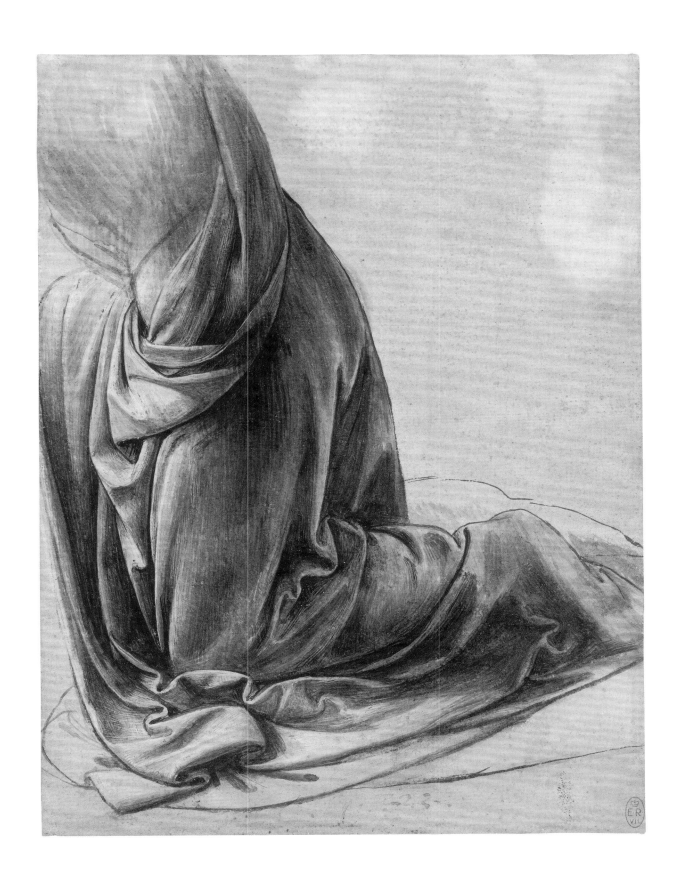

48

Attributed to FRANCESCO GALLI,
called FRANCESCO NAPOLETANO (died 1501)

Virgin and Child ('The Madonna Lia')

about 1495

Oil on wood, transferred to canvas
42.5 × 31.5 cm
Raccolte d'Arte Antica, Pinacoteca del Castello Sforzesco, Milan
(1510)

This sweetly poignant Virgin and Child, named after its most recent owner, is the best of three known versions of this composition, all seemingly painted in the 1490s.[1] That the Madonna is cited directly from the London Virgin of the Rocks (cat. 32) is seen immediately from the angle of her head, the flowing highlights of her hair and her modestly averted gaze. The painter even adapts the sweep of the orange-gold lining of the Madonna's cloak in the London painting to make it into a kind of cradle for the Christ Child. The strong, smoky shadowing and muted palette are also derived from the London picture, and the crushed mulberry red of the Virgin's dress is a clue to the original colour of the garment worn by Leonardo's Virgin in the National Gallery painting.

The impact in Milan of Leonardo's London picture was instantaneous – and seemingly greater than that of the first version. This might perhaps suggest that this version was more available for study by other artists, or simply that Leonardo was more fashionable in the 1490s than in the previous decade. Fascinatingly, however, the twisting body of the Child and the hand and forearm of his Mother are taken from a much earlier work by Leonardo, a drawing in fact, for the Virgin and Child with a cat (cat. 56).[2] If it was Leonardo himself who provided the painter of the Madonna Lia with a sketch executed many years previously, then we may well have a clue as to one aspect of his workshop practice. On the other hand, the drawing seemingly had a wider currency in Milan; it was also used by Marco d'Oggiono, some years after he had started working for himself (cat. 67).

The way in which this picture was made therefore has something in common with the method employed by an anonymous Florentine artist, until recently always known as the Pseudo-Pierfrancesco Fiorentino. This mid-fifteenth-century painter made standard devotional pictures by extracting and combining motifs from pictures by Francesco Pesellino (1422–1457) and Fra Filippo Lippi (especially his Medici Chapel altarpiece, fig. 11). Megan Holmes has argued that the evident popularity of these compendia had something to do with the Medici associations of the works they imitate.[3] It is possible that something of the same kind is going on here. The Madonna Lia is a painting which is deeply and self-consciously Leonardesque. Since Leonardo himself was identified as Ludovico il Moro's 'creature', the ownership of a

work in his style might therefore be taken as an act of political allegiance. The Madonna Lia states this link between style and politics explicitly. While the landscape seen through the window on the right is based on that in the London Virgin of the Rocks, on the left is an oblique view of the principal city façade of the Castello Sforzesco. It recurs in the two early copies, a picture that was on the Milanese art market in 1996 and the Virgin and Child in Cleveland, used as a source by Luca Beltrami when in the years around 1900 he reconstructed the central tower – the Torre di Filarete – which had been demolished in 1521. The presence of this view has suggested to David Alan Brown that the painting was commissioned by Ludovico himself, perhaps at the time after his investiture as Duke of Milan when the Castello became a main focus of his artistic patronage. Built by his father on the site of the Visconti fortress, demolished during the period of the Ambrosian Republic, the Castello di Porta Giovia (as it was then known) was a symbol of dynastic continuity and Sforza resurgence. And its inclusion in this picture and its copies suggests that these connotations were widely understood. The Castello has become a collective symbol of Ludovico's whole regime.

Despite the 'name' given him by art historians, the Pseudo-Pierfrancesco Fiorentino remains resolutely anonymous. It seems possible that the point of the present picture is that it looks like a work by Leonardo rather than that it should be recognised as the work of a particular pupil or associate. Nonetheless, the painting has most recently been attributed to Francesco Napoletano, a still rather elusive figure despite the greater knowledge of his biography that we now have thanks to the archival researches of Grazioso Sironi and Janice Shell. Francesco's signed works show that he was a follower of Leonardo, and the documents indicate that he was a probable working 'companion' of Ambrogio de Predis (see cat. 34). The Cleveland copy of this composition was well known before the present, far superior version emerged, and it had been attributed to Francesco by 1912 (in the nineteenth century it was famously 'by Leonardo').[4] The present work was first noted in a French private collection only in the early 1980s. The picture must have been in France for some time, since it was transferred from wood to its current canvas support in 1758 by Robert Picault, who recorded his achievement on the reverse (in which he also attributes the picture to Leonardo and dates it to 1515).

LITERATURE

Coe Wixom in Cleveland 1982,
p. 380; Brown 2003, pp. 9–12, 60–73
(as Francesco Napoletano).

NOTES

1 A fourth painting with the same composition is in the collection of the Pinacoteca Stuard in Parma. See Brown 2003, p. 67, fig. 47.
2 This was first noted by Pedretti 1974, especially p. 34 n. 42, in relation to what later turned out to be a workshop copy of the present painting (see below).
3 Holmes 2004.
4 See Burroughs 1912; Francis 1935.
5 First by de Ricci 1910.
6 This has sometimes been misread as both 'LTA' and, rather optimistically, 'NA'.
7 See Fiorio in Bora et al. 1998, pp. 199, 209, for an even-handed account of Francesco Napoletano's oeuvre.
8 Though he now argues the attribution of the Madonna Lia to Francesco Napoletano, Brown (1984) rightly distanced the Cleveland version from Francesco's certain oeuvre.
9 Clark 1939, p. 143, basing his attribution on Suida 1929, pp. 179, 251–2. Logan Berenson 1907 tentatively attributed the Cleveland picture to Ambrogio de Predis, comparing it with the London Virgin of the Rocks, then widely believed to have been painted by Ambrogio following Leonardo's compositional design. Brown 2003, p. 54, is surely right to believe that a drawing in the Musée Bonnat, Bayonne (153), formerly and very tentatively attributed to Boltraffio (see Fiorio 2000, p. 168, no. C6), is by the same hand. It seems not impossible that the same painter executed the 'oil sketch' of a female head known as La Scapilliata in Parma, often attributed to Leonardo himself. For which see Viatte in Paris 2003, pp. 192–4, cat. 73.

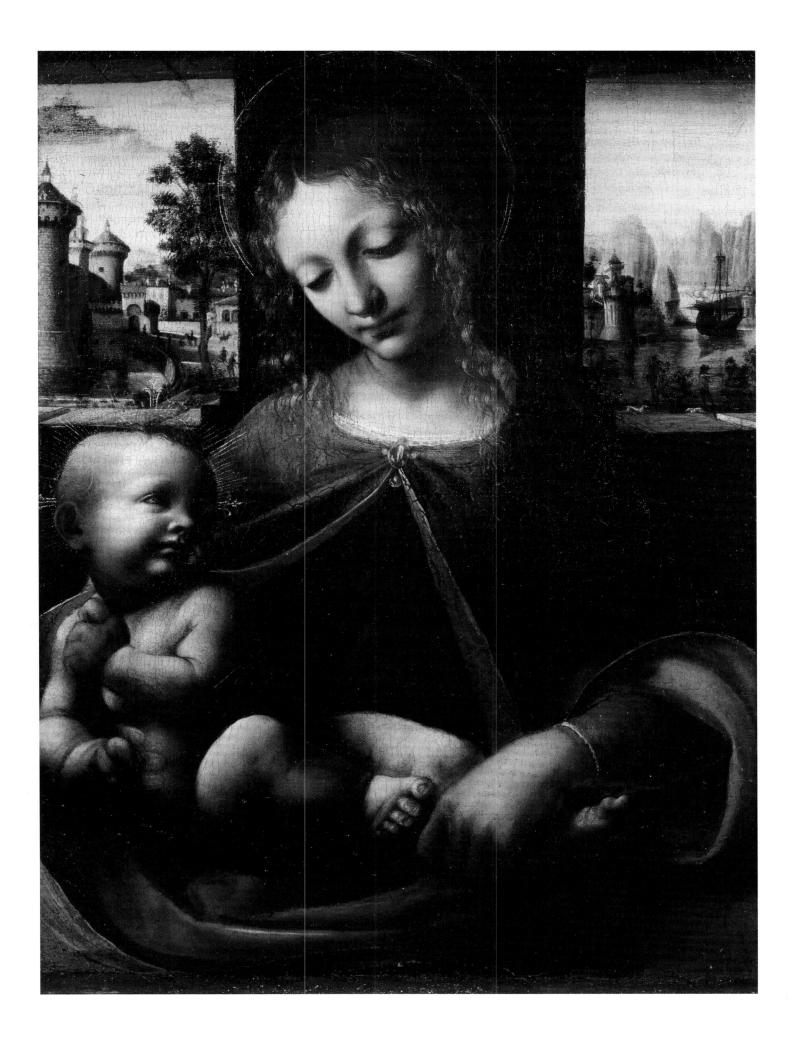

The attribution of the *Madonna Lia* to Francesco Napoletano is founded upon its closeness of style and technique to another *Virgin and Child* – similarly indebted to the *Virgin of the Rocks* – in the Kunsthaus Zurich, which is often though not universally ascribed to Francesco Napoletano (fig. 87).[5] The Zurich painting is seemingly signed; the letters FR and LIA, with abbreviation marks over both words, are written on the parapet.[6] Between the two words is a little emblem, so far impossible to decipher, though most resembling a winged and flaming heart. What it is certainly not (these ingenious suggestions have been made in the past) is a turnip, which if translated as '*napo*' would make the second word NAPOLI[T]A[NO], or a cockerel, which translated as '*gallo*' could make the surname GALLIA.

The inscription remains therefore rather obscure but cannot be simply set aside as an irrelevant mystery. Those scholars who have pondered Francesco Napoletano's oeuvre most deeply have often remarked how much more literally imitative of Leonardo are the Zurich and Cleveland pictures (and by implication the *Madonna Lia* too) than those paintings which are most certainly by Francesco: the twice signed *Virgin and Child with Saints Sebastian and John the Baptist* (fig. 56), for example, also in Zurich, or the Brera *Virgin and Child* (fig. 82).[7] The models for these pictures are works by Leonardo of the 1480s, suggesting that this was the period of their closest association. Francesco's signed Saint Sebastian panel in Brescia (from the altarpiece otherwise painted in 1495 by Vincenzo Civerchio) is more monumental, taking greater note of ancient sculpture as well as, perhaps, later works by Leonardo.

Were it not for the signature on the Zurich painting, one might quite reasonably argue that this work belongs to a later phase of his career, when the second *Virgin of the Rocks* and the *Last Supper* became the main points of reference for Leonardo's followers. This might still be possible if another explanation of the inscription on the Zurich *Virgin and Child* can be found. This and the *Madonna Lia* are pictures of high quality and it is true that Francesco's pictures fetched unusually high prices just after his death in 1501 (probably in the

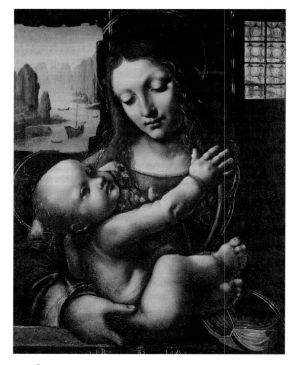

FIG. 87
Attributed to FRANCESCO NAPOLETANO
Virgin and Child, about 1495–1500
Oil on wood, 37.5 × 29 cm
Kunsthaus Zurich. On loan from
the Gottfried Keller Foundation

knowledge that there were no more to come). But it is odd to think of a painter continuing to impersonate his master as faithfully as this so long into his independent career.[8]

Perhaps therefore this is the work of another pupil, close to Leonardo in the mid-1490s. It is intriguing in that context that Kenneth Clark thought that Leonardo's chief assistant on the London *Virgin of the Rocks* (writing at a time when such a figure was always assumed in the literature) might well be the painter of the Zurich *Virgin and Child*, after Wilhelm Suida had identified him, most implausibly, as the Spanish associate of Leonardo, Ferrando de Llanos.[9] LS

FIG. 88
Castello Sforzesco, Milan,
façade with the reconstructed Filarete Tower

CAT. 48 (detail)

49

MASTER OF THE PALA SFORZESCA (active about 1490–1500)

Head of a young woman

about 1494–5

Metalpoint with traces of wash heightened with white
on grey prepared paper
24.2 × 16 cm
The British Museum, London
(1895,0915.475)

This drawing is a study after the head of Mary in the
London *Virgin of the Rocks* (cat. 32), one of several works
that demonstrate the visual impact of Leonardo's
altarpiece on the Milanese artistic scene of the 1490s
(see also cats 48, 50, 51, 53). The draughtsman faith-
fully reproduces the head of Leonardo's Virgin in
every detail, particularly in the hairline, the shadows
and the diagonal raking light which gives volume to,
for example, the heavy eyelids.[1] Yet he clearly does not
possess Leonardo's anatomical knowledge: there is no
sense of the skull beneath the skin, and some of the
features appear to be deliberately distorted, such as
the over-large eyes. This may be simply due to a lack
of ability, but is perhaps partly the result of this
artist's non-Leonardesque, artistically somewhat
eclectic, background.

 This sheet is rightly attributed to the Master of the
Pala Sforzesca, by comparison with the head of the
Virgin in the altarpiece that gives him his 'name' (fig.
89). This master was defined by Francesco Malaguzzi
Valeri in 1905 and subsequent attempts to identify him
more precisely have proved unconvincing.[2] The altar-
piece was commissioned by Ludovico il Moro around
1494 and probably completed towards the end of 1495
for the Milanese church of Sant'Ambrogio ad Nemus.
Despite his continued anonymity, this artist's style is
highly consistent, allowing art historians to compile a
corpus of paintings, works on paper and even frescoes
by his hand.[3] In this drawing the artist shows a very
personal take on the androgynous type that Leonardo
himself had pioneered. The young woman has been
endowed with some distinctly masculine features, such
as her heavy jaw.[4] And the technique reveals this artist
to be more than a mere imitator, with a distinctive
personality of his own. While Leonardo took care to
mitigate any hardness of the contours so as to integrate
the figure better with the background, the Master of
the Pala Sforzesca deliberately overworks the outlines
and his *chiaroscuro* becomes prosaic.[5] Nothing is left to
the viewer's imagination; everything is obsessively
described (quite unlike, for example, Boltraffio's
highly poetic metalpoint drawings, cats 42–4, 50).

 This *Head of a young woman* does not seem to be a
preparatory study for any surviving picture, though it
rather resembles the *Virgin and Child* in the Gemälde-
galerie, Berlin (1433), clearly by the same artist. It is

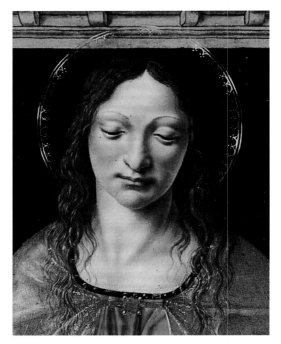

FIG. 89
MASTER OF THE PALA SFORZESCA
The '*Pala Sforzesca*' (detail of fig. 26),
about 1495

even closer to another Berlin *Virgin and Child* (284A),
this time showing the Madonna enthroned. As a study
after a head in a painting by Leonardo, it should be
considered as a workshop exercise in the use of metal-
point – chronologically of about the same moment
as, for instance, Boltraffio's *Head of a youth* (cat. 50).
Leonardo's 'text' has been reworked by an artist who,
despite his own background, decided to adopt the new
clothes of 'Leonardism', on the basis of the London
Virgin of the Rocks (cat. 32).[6]

 The capacity of this Master to reconcile local tradi-
tion – the styles and techniques of Vincenzo Foppa,
Bernardino Butinone and Ambrogio Bergognone –
with the new (demonstrated in works of the early
1490s such as the National Gallery *Virgin and Child with
Saints and Donors*, NG 4444) made him just the right
candidate for the important ducal commission of the
Pala Sforzesca, a work that sets out to be simultaneously
old-fashioned and innovative. AM

LITERATURE

Robinson 1876, p. 14, no. 39 (as by
Leonardo); Loeser 1897, p. 356 (as by
Boltraffio); Popham and Pouncey 1950,
vol. 1, p. 76, no. 128; vol. 2, pl. 117 (as
by a follower of Leonardo); Binaghi
Olivari 1978, p. 28, fig. 13 (as by the
Master of the Pala Sforzesca); Ballarin
2000, pp. 112–15 (as by the Master of
the Pala Sforzesca); Fiorio 2000, p. 199,
no. D38; Pedretti in Milan 2000–1,
p. 125, cat. III.26 (as by Marco
d'Oggiono); Brown 2003, pp. 40–2,
fig. 27, p. 82 n. 76 (as by the Master
of the Pala Sforzesca); Chapman in
London and Florence 2010–11, p. 250,
fig. 2, p. 324 n. 5, under cat. 72 (as by
the Master of the Pala Sforzesca); Kemp
and Barone 2010, p. 127, no. 96 (as by
the Master of the Pala Sforzesca).

NOTES

1 The close similarity in the shading
 suggests that the artist worked from
 a painted rather than a sculptural
 model as proposed by Kwakkelstein
 2003, who argued that the head of
 Leonardo's London *Virgin of the Rocks*
 'reflects a sculpted model which was
 repeatedly used by his pupils and
 followers who portrayed it from
 various angles'.
2 Names suggested include (among
 others) Bernardino dei Conti,
 Ambrogio de Predis, Bernardo
 Zenale and Francesco Napoletano.
 See Marani in Brera 1988, pp. 325–30,
 no. 145; Moro 1998.
3 A decisive contribution to the defini-
 tion of the artistic physiognomy of
 the 'Master' was given by Romano
 1978.
4 Similarly masculine features can be
 found in the *Study for the head of a woman*
 (Louvre, 2254: Viatte in Paris 2003,
 p. 359, no. 126), also attributed to
 the Master of the Pala Sforzesca.
5 This is also a feature of the only
 surviving preparatory metalpoint
 study for the *Pala Sforzesca* (*Study for
 the portrait of Massimiliano Sforza*,
 Ambrosiana, Milan, Cod. F 290 inf.
 13): see Bora in Vigevano 2009–10,
 pp. 192–3, cat. 49.
6 The *Head of a young woman* (Galleria
 Borghese, Rome, 512) by the Master
 of the Pala Sforzesca is also inspired
 by Leonardo's altarpiece, but looks
 more like a portrait (see Fiorio 2000,
 p. 201, no. D43).

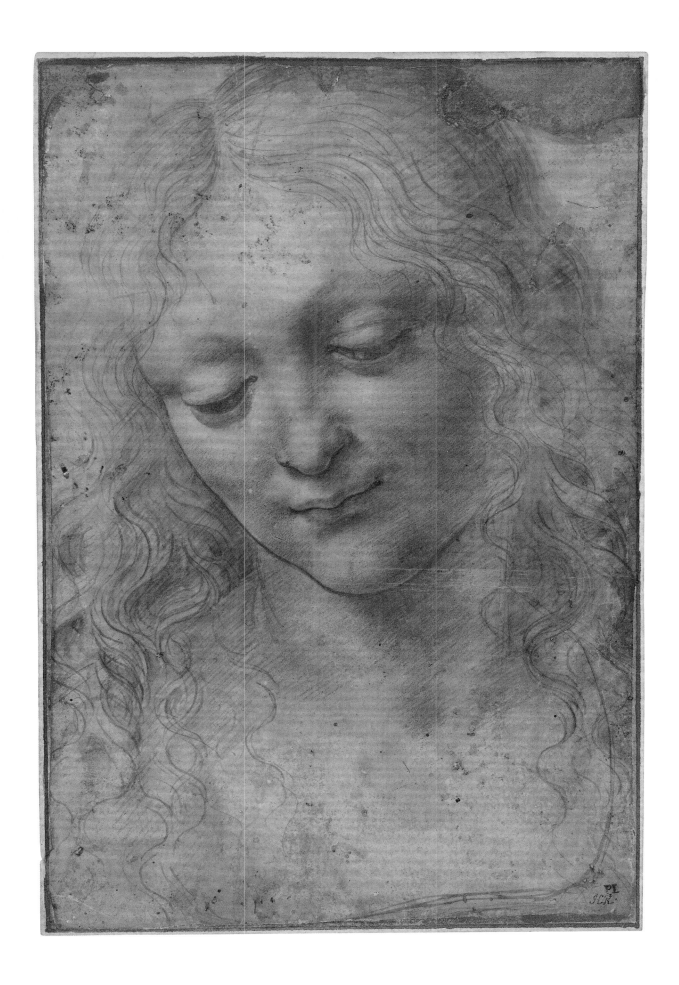

50

GIOVANNI ANTONIO BOLTRAFFIO (about 1467–1516)

Head of a youth with an ivy wreath
about 1491–4

Metalpoint on grey prepared paper
16.2 × 13.8 cm
Galleria degli Uffizi, Florence
(425E)

Boltraffio's drawing is a direct citation – in reverse – of the head of Leonardo's Madonna in the National Gallery *Virgin of the Rocks* (cat. 32). This is a comparison that exemplifies the pupil's perfect *imitatio* of the master's art: faithful, yet with strong differences in their approach to nature. The drawing is an accomplished exercise in formal perfection, typical of Boltraffio's early maturity (see cats 7, 42, 43, 44), while Leonardo's head seems to be the result of an organic layering, resulting in a still idealised but notably more naturalistic form. That Leonardo's head of the Virgin was an inspiration for other artists active in Milan in the 1490s can also be seen in works by the Master of the Pala Sforzesca (cat. 49) or attributed to Francesco Napoletano (cat. 48).

Boltraffio transforms Leonardo's head of a woman into that of an adolescent male, crowned with leaves (possibly ivy, an attribute of Bacchus, but too summarily sketched to be firmly identifiable).[1] This ideal of androgynous beauty was common in Leonardo's Milanese workshop, especially in the early 1490s:[2] for example, the *Girl with Cherries* in the Metropolitan Museum of Art, New York (fig. 90), here attributed to Marco d'Oggiono, which may well be contemporary with the present study, if not directly influenced by it.[3]

The extremely high quality of this drawing resulted – absurdly until quite recently – in its attribution to Leonardo, although the idea that it is by one of his pupils had in fact emerged long ago: Charles Loeser gave it to Boltraffio in 1897. Its attribution in recent years to other Lombard followers of Leonardo – Marco d'Oggiono or the still obscure Master of the Pala Sforzesca – are unsustainable: its remarkable quality is quite beyond these lesser painters.

The delicate raking light comes from top right; the long-haired youth looks down thoughtfully, his mature and confident expression belying his tender age. If a *moto dell'animo* (see cat. 52) is here just perceptible, it is kept under complete control by this young lad, who remains delicately distanced from the viewer. Boltraffio was the only pupil of Leonardo capable of such consummate confidence in the handling of metalpoint. This particular technique, reintroduced to Milan by Leonardo, requires the artist to construct volume through textured shading, built up by repeated parallel hatched strokes. Here the method is clearly seen in the shadowed side of the nose, shaping its classical profile,

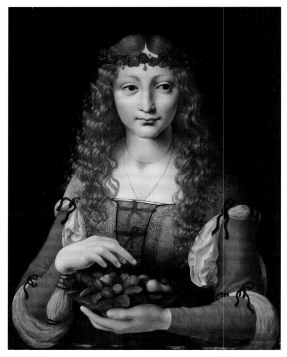

FIG. 90
MARCO D'OGGIONO
Girl with Cherries, about 1493–4
Oil on wood, 48.9 × 37.5 cm
The Metropolitan Museum of Art, New York,
Marquand Collection, Gift of Henry G. Marquand, 1890

while the other side seems to be absorbed by the light. The characteristically Leonardesque *chiaroscuro* is accompanied both by skilful technique and a thorough knowledge of the anatomy of the human skull, which Leonardo himself had researched particularly around 1489 (see cat. 25). That Boltraffio was fully aware of Leonardo's anatomical investigations is shown by his own depiction of a skull on the back of his *Portrait of a Youth* at Chatsworth (fig. 65).[4] Moreover, a comparison of this sheet with the head of the Virgin in Boltraffio's slightly earlier *Madonna of the Rose* (cat. 63) confirms that they are indeed by the same artist. The similarity of the lighting effects in Boltraffio's *Portrait of a Young Woman as Artemisia* (cat. 18), also from the first half of the 1490s, is equally striking. This was the point in Boltraffio's career at which – through the imitation of contemporary works by Leonardo – he reached pure, perfected classical forms.[5] AM

LITERATURE

Lagrange 1862, p. 547, no. 199 (as by Leonardo); Loeser 1897, p. 356 (as by Boltraffio); Wölfflin 1899, p. 25 (as by Leonardo); Suida 1929, pp. 109, 203–4, fig. 264 (as by Marco d'Oggiono); Tokyo 1982, cat. 9 (as by Leonardo); Brown 1983, p. 110, fig. 13 (as by Boltraffio); Ballarin 1985 (2005), p. 30 (as by Boltraffio); Marani 1987, p. 78, fig. 66 (as by the Master of the Pala Sforzesca); Bora 1998, pp. 95, 99, 117 n. 6, fig. 4.4 (as by Marco d'Oggiono); Fiorio 2000, pp. 45, 143, 145–6, no. B7 (as by Boltraffio); Agosti 2001, pp. 39–40, 188–94, no. 33 (as by Boltraffio).

NOTES

1 The ivy is employed in a famous and mysterious print (cat. 55). A few years later, around 1495–7, Boltraffio revisited this type in the perturbing and much less idealised *Head of a young man with a crown of thorns and ivy* (fig. 92), a sort of 'Christ–Bacchus'. Raffaellino del Garbo's *Risen Christ* in the British Museum, (Pp,1.32: see Rook in London and Florence 2010–11, pp. 244–5, cat. 69), datable to about 1495–7, is also crowned with ivy leaves.

2 See Brown 1983.

3 For a more complete discussion on the Metropolitan painting and its stylistic group, see cat. 19.

4 Both Marco d'Oggiono and the Master of the Pala Sforzesca lacked this capacity and knowledge; in their studies of hands and heads there is always some deformation, a lack of structure in the bones, as in the *Bust of a girl crowned with leaves*, best attributed to Marco d'Oggiono, at the Pushkin Museum, Moscow (see Maiskaya in Moscow 1995–6, p. 177, cat. 108) or the British Museum *Head of a young woman* by the Master of the Pala Sforzesca (cat. 49).

5 It is not by chance that Heinrich Wölfflin in his *Die Klassische Kunst* (1899, p. 25) discussed the Uffizi drawing as one of the most characteristic of Leonardo's works.

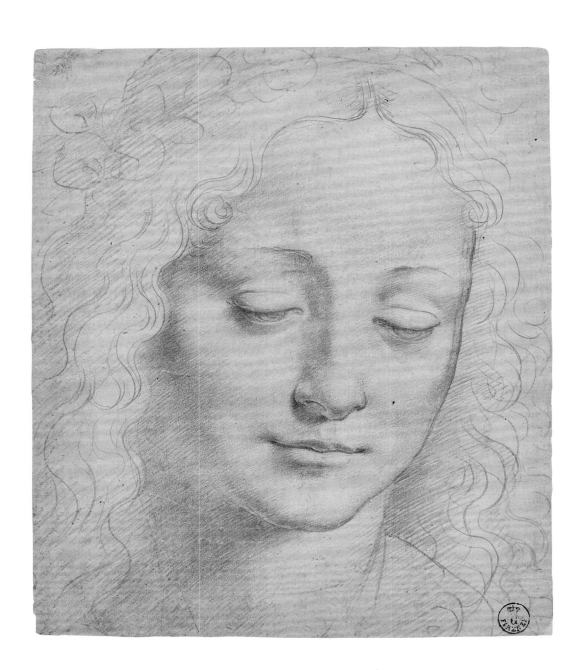

51

GIOVANNI ANTONIO BOLTRAFFIO (about 1467–1516)
Body of a child, turning right
about 1492–4

Metalpoint with traces of pen and ink and wash heightened with white on
blue prepared paper, pricked for transfer
42.6 × 25.5 cm (irregularly cut)
Musée du Louvre, Paris
(RF 5635)

This is the work of a Milanese pupil of Leonardo, close to his master and aiming to emulate his interest in figural *contrapposto*. But in its sophisticated light effects its author would seem to have been responding to Leonardo's London *Virgin of the Rocks* (cat. 32). The fleshy and rather muscular body in this drawing seems to depend directly upon those of the young John the Baptist and Christ Child in that picture; there are also striking anatomical resemblances, such as the thick toes (so like Christ's) and the chubby elbow of the outstretched arm (like the Baptist's).

This large drawing was probably part of a larger (squarish) sheet. The missing head may suggest that the artist decided to cut it off and re-draw it on a new sheet, to be reinserted afterwards (though we cannot actually be sure he ever had a head).[1] When it was mounted, the drawing was rotated about 30 degrees anticlockwise, as can be seen by the now sloped crease running through the middle, originally horizontal. This repositioning was probably in order to give the figure a greater equilibrium, with the body and right leg set vertically, but in the end it has the opposite effect: if rotated so that the crease is properly horizontal, the delicate balance between the weight of the four limbs becomes more plausible, the left leg functioning as a pivot. The body is strongly oriented towards the right, the baby's right arm stretched out to something or somebody beyond. Were it not for his left arm, and particularly his hand, leaning on an invisible surface and bearing the body's whole weight, the whole precarious pose would collapse.[2]

That this is a preparatory drawing for a specific painting is indicated by its unusually large scale and the outlines pricked for transfer to another surface (a panel or wall, or possibly another sheet of paper). Thus it may be defined as a single-element *cartone* (cartoon) of a kind also used by Leonardo in this period.[3] However, no painting survives that is both datable to the same period as the cartoon and follows it precisely. The picture that is compositionally – and, more importantly, stylistically – closest to it is Boltraffio's Budapest *Virgin and Child* (cat. 53), also of a similar scale.[4] The Child in the Budapest painting is reversed, but evinces the same horizontal tension (arms outstretched, the balance kept only by the Virgin's protective gesture holding him with both hands). The main difference is that in the Budapest painting the Child's leg is positioned in a more

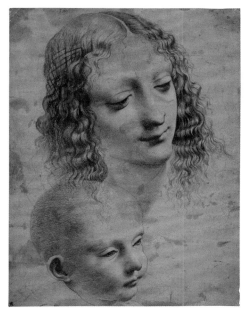

FIG. 91
GIOVANNI ANTONIO BOLTRAFFIO
Heads of the Virgin and Child, about 1492–4
Metalpoint on grey-blue prepared paper, 29.7 × 22 cm
Devonshire Collection, Chatsworth (893)

perspectively ambitious foreshortening, probably a consequence of Boltraffio's growing interest in Bramantino's art from the mid-1490s (see cat. 53).

Of all Leonardo's pupils Boltraffio is the most likely to have been responsible for this cartoon. In technique it resembles his Berlin *Drapery study* (cat. 62), preparatory for the *Madonna Litta* (cat. 57): the lunar light effects are very similar, created by the calibrated use of lead white on blue prepared paper. This is also true of another preparatory drawing for the *Madonna Litta*, the *Study for the head of the Christ Child* (cat. 61). The body of the Child in the *Madonna Litta* also echoes the present drawing, with similar *contrapposto*, the soft flesh of the belly creased as a result of his twisting pose.

Alessandro Ballarin proposed that this drawing could be one of a series of studies for a lost (or never executed) *Virgin and Child* by Boltraffio.[5] The *Heads of the Virgin and Child* at Chatsworth (fig. 91), commonly ascribed to Boltraffio, would, he thought, also have served as a preparatory study for this work. This lost composition by Boltraffio would appear to be reflected in Francesco Melzi's *Holy Family* in the Národní Galerie, Prague, of around 1520.[6] AM

LITERATURE

Müntz 1898, vol. 2, p. 202, pl. 25, p. 257 no. 111 (as by Leonardo); Ballarin 1985 (2005), pp. 11–16 (as by Boltraffio); Bambach 1999, p. 85, fig. 73, p. 404 nn. 33, 34 (as by Boltraffio or, more probably, by Cesare da Sesto); Fiorio 2000, pp. 84–6, under no. A4 (as by a Milanese artist); Viatte in Paris 2003, pp. 351–3, cat. 121 (as by school of Leonardo); Marani 2008, pp. 100–1, no. 52 (as by circle of Boltraffio).

NOTES

1 It has been argued that cat. 41 could be this missing head. Ballarin 1985 (2005), pp. 11–16.
2 A similar balance can be seen in Boltraffio's *Madonna of the Rose* (cat. 63).
3 The design might be transferred either by brushing powder through the holes to create dotted outlines, or by pricking through the page onto a sheet of paper below.
4 Of Boltraffio's three early *Virgin and Child* groups, all exhibited here, two are similarly small (cats 57, 63), while cat. 53 is nearly as twice as big, the body of the Child similar in scale to the present drawing.
5 Ballarin 1985 (2005), pp. 11–16. This group includes also the Louvre cartoon (cat. 41), usually attributed to Leonardo, and the *Head of a woman* in the Ambrosiana, Milan (Cod. F 263 inf. 99). See Bora in Milan 1987–8, pp. 46–7, cat. 2.
6 Reproduced as 'after Francesco Melzi' in Marani 1998b, p. 381, fig. 265. The Louvre drawing, or at least its composition, seems to have been known in Milan, inspiring other artists: see, for example Andrea Solario's Brera *Virgin of the Pinks* (Brown in Brera 1988, pp. 376–9, no. 169), datable to about 1493–4 and the Boltraffiesque *Virgin and Child* at the National Gallery (NG 2496). There is also a compositional similarity to a fresco of the *Virgin and Child with a donor* at Sant'Onofrio al Gianicolo, Rome, sometimes attributed to Cesare da Sesto and even to Boltraffio (Carminati 1994, pp. 154–8, no. 6). This resemblance caused this sheet to be wrongly attributed to Cesare in the past.

52

GIOVANNI ANTONIO BOLTRAFFIO (about 1467–1516)

Head of a young woman
about 1495–7

Metalpoint heightened with white on grey prepared paper
15 × 12.4 cm
Sterling and Francine Clark Art Institute, Williamstown, MA
(1955.1470)

This astonishing *Head of a young woman* is closely related to Boltraffio's Budapest *Virgin and Child* (cat. 53). In both painting and drawing, a raking light catches the left side of the face, making a strong division between its two sides, the left fully lit, with very little shading, and the other mostly in shadow (yet still remarkably luminous), with direct light falling only on the eyelid and cheekbone. The inclination of the heads in both is very similar, as is the hair, from the braids tied together on top of the head to the wisps on the shoulder, which in the drawing are executed with strong, continuous metalpoint strokes and in the painting with liquid brushstrokes. Thus the drawing might appear preparatory for the painting. But there are some important differences that force us to conclude differently. The drawing is a study for a woman's head, posed more frontally than in the painting, her gaze directed towards the viewer. Indeed, she is so focused upon this observer, notionally standing close, that she is almost cross-eyed. Her demeanour is movingly human – a slight smile plays almost imperceptibly around her mouth. This charming concentration on the spectator would be odd in the Virgin Mary, suggesting therefore that the drawing was independent of the painting, conceived not as part of a larger composition but as an autonomous study of light and human psychology. When adapted for the painting, the light effects remained substantially the same but the Virgin's gaze was directed downwards, concentrating on an invisible object on the left of (or outside) the painted space.[1]

The fact that the drawing was reused by Boltraffio for his painting is not in itself enough to prove his authorship. In 1914–15 Colvin asserted: 'this is one of a group of attractive Leonardesque drawings scattered in various collections and commonly ascribed to his Milanese pupil Boltraffio', but concluded that it 'seems somewhat too hard and mechanical for Boltraffio himself'.[2] Suida, on the other hand, related it to a drawing at Christ Church, Oxford (*Head of a young woman*, JBS 1062), already attributed to Boltraffio.[3] Once this stylistically consonant group of drawings mentioned by Colvin began to be widely accepted as by Boltraffio, his authorship of the present drawing became certain. Indeed, it is now treated as a touchstone for Boltraffio's metalpoint draughtsmanship.

The drawing has often been dated to the early 1490s. However, in others probably made at that time, like the Uffizi *Head of a youth* (cat. 50), Boltraffio seems to have been more aware of Leonardo's artistic ideals

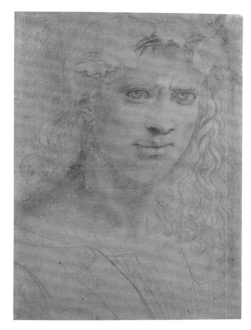

FIG. 92
GIOVANNI ANTONIO BOLTRAFFIO
Head of a young man with a crown of thorns and ivy,
about 1495–7
Metalpoint on prepared paper, 30.8 × 21.9 cm
Biblioteca Reale, Turin (15587)

as displayed in the heads of the figures in his London *Virgin of the Rocks* (cat. 32). In this earlier phase of Boltraffio's career his figures seem frozen, controlled, confined within their interior worlds. But here the woman, with her gaze directed to us in a kind of appeal, appears to be experiencing a powerful *moto dell'animo* (stirring of the spirit). This desire to express fleeting emotion is characteristic of a later phase of Leonardo's pictorial researches, above all expressed in the heads of the apostles in the *Last Supper* (see p. 250). Thus the present drawing may be plausibly dated a little later in the decade, when Boltraffio may have been responding to Leonardo's most famous Milanese masterpiece. This work therefore belongs to Boltraffio's last phase of drawing in metalpoint (as also cat. 65); soon afterwards – following Leonardo's technical trajectory – he took up black and coloured chalks.[4] Among this last group of metalpoint drawings is an extraordinary study of a *Head of a young man with a crown of thorns and ivy* (fig. 92), in which the sitter is also characterised by his penetrating – and actually rather aggressive – gaze towards the viewer.[5] AM

LITERATURE

Colvin 1914–15, vol. 10, p. 15, no. 6 (as probably not by Boltraffio); Suida 1929, p. 189 n. 1 (implicitly as by Boltraffio); Lawder in Haverkamp-Begemann et al. 1964, vol. 1, pp. 10–11, no. 7, vol. 2, pl. 9 (as by a follower of Leonardo; with full provenance); Ballarin 1985 (2005), pp. 35–7 (as by Boltraffio); Fiorio 2000, pp. 142–3, no. B5 (as by Boltraffio); Bora in Paris 2003, pp. 346–7, cat. 118 (as by Boltraffio); Wolk-Simon in New York 2003, pp. 649–50, cat. 124 (as by Boltraffio).

NOTES

1 Boltraffio seems to have kept this drawing in mind when, later, he painted the head of the Virgin in his monumental *Virgin and Child* now in the National Gallery, London (NG 728), in which the Virgin also looks down. The Williamstown drawing has sometimes been compared to the Poldi Pezzoli *Virgin and Child* (cat. 63), which, however, belongs to another phase of his career: the lighting is less dramatic and emotions remain hidden.
2 Colvin reproduced the drawing in 1914–15, when still in the collection of Abel John Ram (1842–1920). On Ram, see *Who was Who 1947*, pp. 866–7.
3 Suida related the Oxford drawing to both the Budapest *Virgin and Child* (cat. 53) and the Poldi Pezzoli *Virgin and Child* (cat. 63). For the Oxford drawing, see Byam Shaw 1976, vol. 1, p. 273, no. 1062.
4 On Boltraffio's technical development as a draftsman, see Agosti 2001, pp. 39–40, 197.
5 The same eruption of sentiment and warmth can be seen in the Windsor *Head of a woman* (RL 12510). This desire to communicate directly with the viewer reaches its peak in the Christ Child in Boltraffio's Casio altarpiece (Louvre), painted in 1500 for the Casio chapel in the Church of the Misericordia in Bologna, in which Christ stares out us, almost unnervingly.

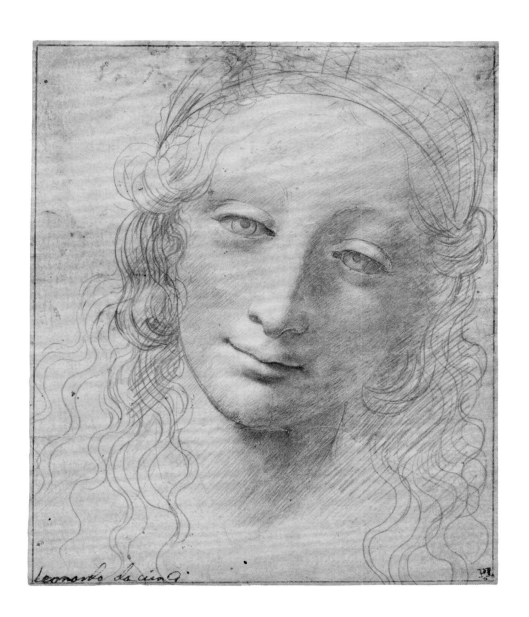

Leonardo da Vinci

53

GIOVANNI ANTONIO BOLTRAFFIO (about 1467–1516)

Virgin and Child ('The Esterházy Madonna')

about 1495–7

Oil on poplar
82.4 × 63.4 cm
Szépművészeti Múzeum, Budapest
(52)

This imposing *Virgin and Child*, sometimes known by the name of its earliest known owner, is one of several works of the 1490s by artists in Milan that display a thorough knowledge of Leonardo's London *Virgin of the Rocks* (cat. 32). This is evident in many details: the head of the Child is a version, subtly and appropriately transformed, of that of the angel on the right in the *Virgin of the Rocks*:[1] the two have identical eyes with heavy eyelids and transparent irises, shiny as gemstones; in the Budapest painting the Virgin embraces the Child with her left hand, much as Leonardo's Virgin caresses the Baptist (with her right) in the London painting. These striking resemblances show that the painter must have been close to Leonardo when the *Virgin of the Rocks* was being painted, with privileged access to the master's work. But the author of the Budapest *Virgin and Child* created an intelligent amalgam of Leonardo's ideas with his own, revealing his particular personality and experience.

Boltraffio was first identified by Giovanni Morelli as the creator of the picture and his authorship is now universally accepted (although its high quality led Suida to believe that the picture was by Leonardo, assisted by Boltraffio).[2] The attribution is mainly based on a comparison with that keystone of Boltraffio's early career, the Poldi Pezzoli *Virgin and Child* (cat. 63). In both pictures a wide parapet occupies the foreground, the Christ Child sitting on it and the Virgin's mantle falling across it into the viewer's space. She stands behind, set against a black background, ensuring that her space remains undefined and emphasising the dramatic spotlit effect on both figures. However, the Budapest *Virgin and Child* has a maiolica bowl on the left, and the Child stretches his arm towards an object, which might be imagined as outside the painted space.[3] This gesture creates a sense of ambiguity and uncertainty typical of a painter of Leonardo's circle.

Several metalpoint drawings by Boltraffio are related to this painting, but none can be considered as strictly preparatory. The way in which the Virgin's drapery falls over the parapet was first conceived by Boltraffio in his *Drapery study* (cat. 64) of nearly a decade earlier, and first used for the Poldi Pezzoli *Virgin and Child*. Several details of the drapery in the drawing

are still found in the present picture. The *Head of a young woman* (cat. 52) is also connected to the head of the Budapest Virgin, especially in its lighting. The *contrapposto* of the Child's body, particularly the torsion, the plump belly and flexed leg, was conceived by Boltraffio in a metalpoint drawing now in the Louvre (cat. 51), reversed and slightly modified some years later for the present picture.

Another metalpoint drawing, less directly related to the motifs in the Budapest *Virgin and Child*, is, however, stylistically the closest to it: the *Drapery study for the Risen Christ* (cat. 65) made for the *Grifi Altarpiece* (fig. 98)[4] has the same soft folds as the sleeve of the Budapest Virgin. These appear to have been inspired by Leonardo's black chalk studies, such as the *Drapery study for the right sleeve of Saint Peter* (cat. 83), preparatory for the famous figure in the *Last Supper*. Thus in the Budapest *Virgin and Child* Boltraffio combines his experiences of the *Virgin of the Rocks* and the *Last Supper*, just as he did in the *Grifi Altarpiece*. These two works should be regarded as belonging to the same phase of his career. Moreover, in the Budapest painting the rather forced horizontal movement of the Child's outstretched arms recalls those of the Apostles on the right in the *Last Supper*. This emotional dynamism differs markedly from the controlled gestures of the Poldi Pezzoli *Virgin and Child* (cat. 63) or the marmoreal stillness of the *Madonna Litta* (cat. 57).

Only in one detail does Boltraffio begin to reject his Leonardesque inheritance. The Child's left leg, sharply, almost artificially lit and dramatically foreshortened, has no real equivalent in Leonardo's oeuvre. Instead it resembles the conceptual and perspectival experiments of the great Lombard painter Bramantino, such as in his *Lamentation* of the late 1480s (Pinacoteca Ambrosiana, Milan), once the lunette of the portal of the church of San Sepolcro, now mutilated in the lower part but originally with an innovative and audacious perspectival foreshortening for Christ's legs.[5] Bramantino took careful note of Leonardo's art after the *Last Supper* but had emerged from a different tradition. The *Virgin and Child* marks the beginning of a new direction for Boltraffio in the late 1490s, to result in such highly Bramantinesque works as the *Saint Barbara*, of 1502 (Gemäldegalerie, Berlin). AM

LITERATURE

Fischer and Rothmüller 1820 (1915), p. 200, no. 42 (as by Leonardo); Mündler 1869 (1909), p. 65 (as by Bernardo Zenale); Morelli 1880, p. 469 (as by Boltraffio); Suida 1929, pp. 57–8, 87, 188–9, 272, 287, fig. 63 (as by Leonardo but finished by Boltraffio); Pigler 1967, pp. 78–80 (as by Boltraffio); Ballarin 1985 (2005), pp. 5–16, 19–20, 25, 35–7, 40–3, 51–5 (as by Boltraffio); Brown in Frankfurt 1999–2000, pp. 132–3, cat. 4 (as by Boltraffio); Fiorio 2000, pp. 84–6, no. A4 (as by Boltraffio); Agosti 2001, p. 194 (as by Boltraffio); Villata in Budapest 2009–10, pp. 244–5, cat. 55 (as by Boltraffio).

NOTES

1 The head of the child is usually compared to that of the Baptist in the *Virgin of the Rocks*, which is very similar – but not identical – in shape, reversed and with different light effects. A possible source of inspiration is the small cartoon in the Louvre (cat. 41).
2 The painting was restored at the J. Paul Getty Museum in 2008–9. A partial adaptation of this *Virgin and Child*, similar in the structure of the composition (especially in the right arm of the Virgin) but with a landscape in the background, is in the Staatliche Kunsthalle, Karlsruhe. This seems to belong to the stylistic group of the 'Pseudo Francesco Napoletano' (Fiorio 1992; Fiorio 1998a).
3 The inclusion of such objects merits further research. Federica Nurchis (personal communication) suggests that the maiolica bowl seems to be of a Hispano-Moresque type common in Florence in the fifteenth century (see Spallanzani 2006, especially pp. 273, 289, pls 43, 71).
4 The *Grifi Altarpiece* was commissioned by the family from Boltraffio and Marco d'Oggiono in 1491, and the contract renewed in 1494 (see Shell and Sironi 1989).
5 Rossi in Ambrosiana 2005, pp. 79–83 no. 14. Its original appearance can be imagined from the many copies (some listed in Agosti 2005, p. 431 n. 163). On Bramantino and Boltraffio, see Ballarin 1985 (2005), pp. 51–5; Agosti 2001, p. 194.

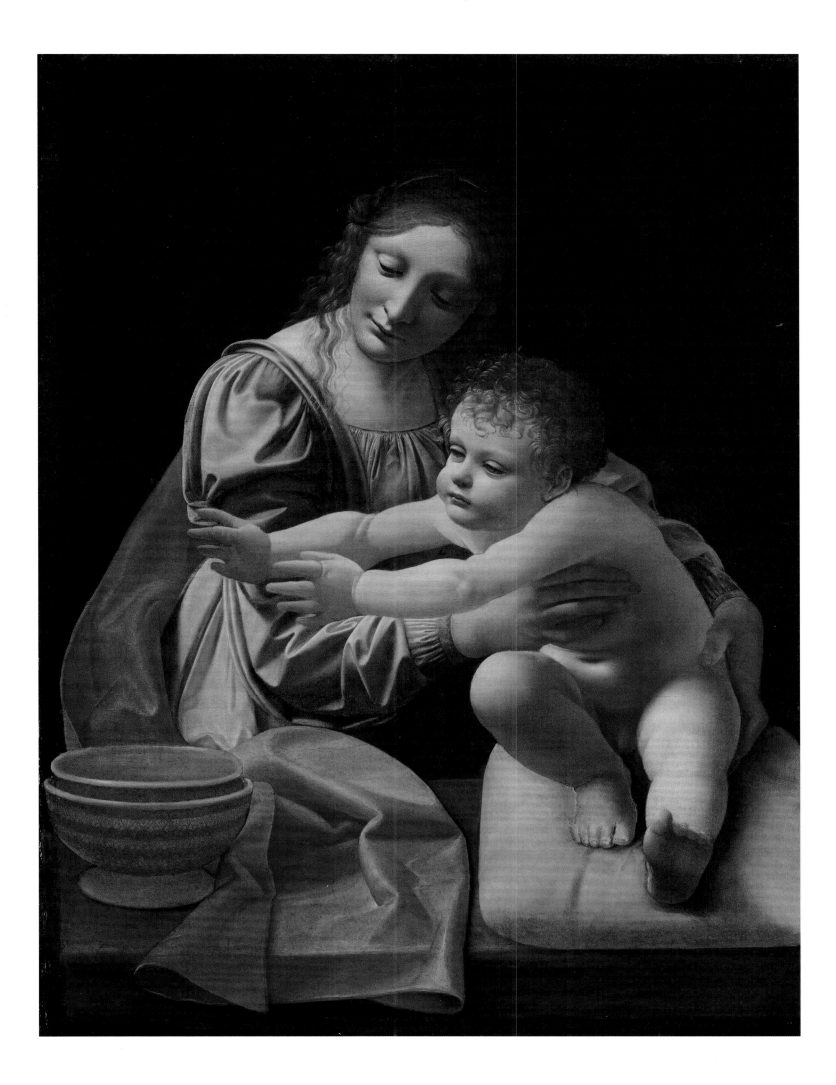

THE MADONNA LITTA
LEONARDO AND HIS COMPANIONS

THE ENAMELLED BEAUTY OF THE *Madonna Litta* (cat. 57) is not open to doubt. Nor can we question its immediate impact on the artistic landscape of Milan in the years around 1500; its fame, seemingly as a work by Leonardo, was instant and surprisingly widespread. There has been less agreement, however, that the picture was actually painted by Leonardo himself. Some consider it to be an entirely autograph work; others as one in which he did not participate at all. The case for its attribution to Leonardo alone is made in this volume by Tatiana Kustodieva. For many of the art historians who view the picture as a workshop product, it is best attributed to Giovanni Antonio Boltraffio, Leonardo's most talented (but ironically also his most inventive) pupil. There are shades of opinion in between, many scholars arguing that it was partly or completely designed by Leonardo, or that he applied some of the delicate finishing touches. Similar arguments have been made about the London *Virgin of the Rocks* (cat. 32), and also about the *Portrait of a Musician* (cat. 5) and the *Belle Ferronnière* (cat. 17), the last two quite regularly assigned to Boltraffio. What makes the situation with the *Madonna Litta* particularly complicated is the fact that it does not look like a characteristic painting by Boltraffio, yet in some ways – not least technical ones – it also remains anomalous within Leonardo's oeuvre. And once again

there has been little accord as to which, if any, of the three drawings most closely connected with it is strictly preparatory: one is perhaps Leonardo's most poignantly lovely head study (cat. 59); the others are among the most accomplished works attributed to the ever-skilful Boltraffio (cats 61, 62).

Leonardo arrived in a Milan that was used to a system of painters and other craftsmen working together; more or less temporary teams were formed to deliver large projects at minimal cost. Sometimes they might follow a ready-made overall design; often individual painters were simply made responsible for separate parts with only limited concern for stylistic coherence. Leonardo's work with the de Predis brothers in the 1480s and 1490s on the Altarpiece of the Immaculate Conception was little different from the collaboration between Francesco Napoletano (see cat. 48) and Vincenzo Civerchio, separately responsible for different panels of an altarpiece in Brescia.[1] But Leonardo had been trained in another way, emerging from a Florentine painting workshop – Andrea del Verrocchio's – where the master might delegate distinct areas of quite small pictures to pupils and assistants, giving them responsibility for a particular head, apparently from its detailed graphic elaboration onwards (though presumably working within the limits set by the master's first compositional sketch).[2] The making of highly finished scale drawings that could be copied or even exploited as partial cartoons was fundamental to this practice. On his return to Florence, Leonardo is described on the other hand as getting members of his workshop to make 'copies' (ritratti) of his own works, which he would finish off.[3] This, it should be stressed, is a rather different category of work, a much less creative activity.

How then did Leonardo use his several assistants and pupils in Milan, the young painters documented in his workshop from the early 1490s but probably present earlier? He took apprentices, and like other leading artists in Milan, was paid to do so (the master becoming responsible for food and clothing).[4] It is in this category that Gian Giacomo Caprotti da Oreno, the wicked Salaì, belonged, destined to be one of Leonardo's lifelong companions; he surely was one of Leonardo's team of copyists in 1501.

Giovanni Antonio Boltraffio and Marco d'Oggiono are known to have been present in Leonardo's studio in 1490–1, both the victims of Salaì's thieving. Boltraffio was later described hyperbolically as Leonardo's only pupil, and it is true that uniquely among Leonardo's followers he seems to have understood something of Leonardo's painting technique.[5] Marco d'Oggiono, on the other hand, seems to have arrived fully trained (he had taken on his own apprentice in 1487), just as Perugino did in Verrocchio's bottega. And as Verrocchio had, Leonardo always stressed the importance of drawing – disegno – making his pupils reproduce his drawings and perhaps one another's; this explains why he saw no contradiction between his idea of drawing as both solitary and group activity.[6]

His pupils were considerably more adept at imitating his drawing techniques, especially in metalpoint, than they were his use of paint; some even copied his left-handed hatching (cat. 60). Finished drawings (like cat. 41) would circulate, to be used and reused by Leonardo and those around him. Pupils' copy drawings and their own designs might be similarly disseminated. Since these were generally drawings of heads and hands, and of the body of the Christ Child (such as cat. 51), they could go on being combined in different ways to make works that were in some senses original compositions, but which remained self-evidently and self-consciously indebted to Leonardo.

Some questions remain. It becomes clear that some of these painters were more respected as draughtsmen than others, Leonardo above all of course, but also Boltraffio. When Boltraffio and Marco d'Oggiono entered a partnership to paint the Grifi Altarpiece (fig. 66) they painted separate parts, but some stylistic unity was now guaranteed by Marco's use of Boltraffio's detailed drapery studies (cat. 65). And Boltraffio provided Marco with the drawn portrait from life of the young Duchetto – Francesco Maria, son of Gian Galeazzo Sforza – for him to make his painted portrait in about 1492–3 (figs 93, 94).[7] The portrait is unsigned; thus we might very well ask who was considered its author, Marco d'Oggiono or Boltraffio – or, given that both were still together in Leonardo's workshop, was it viewed as 'by' the master himself? The distinction is far

FIG. 93
GIOVANNI ANTONIO BOLTRAFFIO
Study for the portrait of a child (Francesco Maria Sforza, 'Il Duchetto'?), about 1491–3
Metalpoint on blue prepared paper, 19.7 × 16.4 cm
Biblioteca Ambrosiana, Milan
(F 263 inf. n. 100)

FIG. 94
MARCO D'OGGIONO
Portrait of Francesco Maria Sforza ('Il Duchetto'), about 1492–3
Oil on wood, transferred to canvas, 36.8 × 26.6 cm
Bristol Museum and Art Gallery

from clear-cut and it even seems that Leonardo might redeploy drawings by his assistants. The painter of the *Pala Sforzesca* (fig. 26) may well be one of the several named pupils and assistants encountered in documents in the mid-1490s. He is almost certainly the person who drew the cartoon profile of the young Massimiliano Sforza, eldest legitimate son of il Moro, though this is by some stretch the best of this artist's surviving drawings.[8] But the same cartoon was used after Leonardo was asked to introduce Sforza votive portraits into the Crucifixion fresco opposite the *Last Supper*.[9] These are too damaged to be precisely attributed, but whoever painted them (perhaps the same anonymous master), they were surely thought of as Leonardo's.

We should keep all these various possibilities in mind as we reconsider the *Madonna Litta* (and other pictures attributed to Leonardo's workshop). If the Hermitage picture was not executed by Leonardo, it represents the summit of his workshop practice, which at this stage elegantly combined local practice with what he had learnt from Verrocchio. It is seen here both with pictures more readily recognised as by Boltraffio and Marco (cats 53, 63, 67) and with others that might come into the same

category (cat. 7). Leonardism had become fashionable, a house style for Ludovico and his supporters.[10] And it is only if we realise that Leonardo was considered responsible (albeit differently) both for his own painstakingly autograph efforts and for the impersonations of his pupils that we can understand a passing reference in Matteo Bandello's *Novelle* to a lavishly adorned chamber in a Renaissance palace with – most improbably – several pictures by Leonardo hanging in it.[11] LS

NOTES

1 Fiorio in Bora et al. 1998, pp. 202–4.
2 Dunkerton and Syson 2010.
3 Kemp 1994.
4 Shell 1995, pp. 64–8.
5 Spring et al. 2011, pp. 94–100.
6 BN 2038 fols 26v, 27v.a; Urb. fols 31v, 37r–v; R 494–5; McM 73–4; K/W 531, 533.
7 For this portrait see Ballarin 1985 (2005), pp. 17–19.
8 Bambach in New York 2003, pp. 643–6, cat. 122 (with earlier bibliography).

9 Fiorio 2003, pp. 194–8.
10 Syson 2004, pp. 109–10, 123. The argument, I believe, still stands, although many of the details of the attributions are mistaken.
11 Bandello (1952), vol. I, p. 53 (*Novella* III). In the midst of a description of lavish textiles and carved chests furnishing a particularly rich chamber are 'several pictures' by Leonardo. Even in this fictional context the plural is odd. The passage is cited, rather vaguely, by Pedretti 1973, p. 65.

ACADEMIA LEONARDI VICI

54

After LEONARDO DA VINCI

Knot pattern

about 1495

Engraving
29 × 21 cm
Inscribed: 'ACADEMIA LEONARDI VI͞CI'
The British Museum, London
(1877,0113.364)

55

After LEONARDO DA VINCI

Idealised head of a woman

about 1495

Engraving
13.6 × 13 cm
Inscribed: '·AC͞HA · L͞E · V͞I'
The British Museum, London
(1850,1109.92)

The purpose and meaning of a group of prints inscribed with variations on 'Academia Leonardi Vinci' have been much, though inconclusively, discussed. The idealised female head in the British Museum is the only surviving impression from this plate. More sheets survive from the set of six engravings with knot or interlace patterns, but they remain nonetheless extremely rare, the only complete set now to be found at the Biblioteca Ambrosiana in Milan. We cannot know how or where Albrecht Dürer (1471–1528) obtained the examples he used to make his woodcut copies (omitting the inscriptions).

The engraved knot patterns were first mentioned unsympathetically by Giorgio Vasari:

> He even wasted his time in making a regular design of knots so that the cord can be traced from one end to the other, the whole filling a round space. There is a fine engraving of this most difficult design, and in the middle are the words, 'Leonardus Vinci Accademia'.[1]

Their inscriptions indicate the existence of some kind of academy with Leonardo as its prime mover or figurehead. Vasari failed, however, to explain this ingredient, and that such an academy – self-consciously referring to Plato's Academy in Athens – ever existed in Milan has been doubted. And if it did, there has been little agreement as to what form it might have taken. Was it a kind of art school, or a grouping of intellectuals that included the makers of works of art (unlike Marsilio Ficino's Platonic Academy in Florence which excluded them)? Early commentators maintained that it was an institution where Leonardo taught drawing, painting and sculpture. Though he unquestionably took pupils and, like other leading painters in Milan, was paid for so doing, there is no evidence to suggest that his workshop was unusual. Nonetheless, this idea has been revived by Pietro Marani, pointing to evidence from the decades around 1500 of the institutional or civic encouragement of artistic training.[2] We should remember that, while still in Florence, Leonardo is said to have studied in the Medici sculpture garden, later used for more formalised teaching.[3]

For most of the last century, however, scholars agreed that a Milanese academy was more likely to have been an informal symposium of humanists, poets, artists and musicians, probably supported by Ludovico il Moro. The recent discovery in Henrico Boscano's *Isola beata*, a manuscript of about 1513, containing what is effectively the membership list of just such a group, lends weight to this theory. Leonardo is mentioned only as one member among many; others included Donato Bramante, the goldsmith and gem engraver Caradosso, and the poets Gaspare Visconti and Bernardo Bellincioni.[4] Since Bellincioni died in 1492, the Academy must have been in existence before then. It has been reasonably suggested that Leonardo, the most famous of its putative members, was adopted as its figurehead.[5] This then would seem to be the point of the prints inscribed 'Academia Leonardi Vinci', his images and style taken as representative of a collective endeavour. If this Academy was indeed sponsored by Ludovico, these implications become even more significant.

The designs for both the ideal head and the knot pattern are best attributed to Leonardo himself.[6] It is sometimes argued that he also engraved the plates himself but, though there is some evidence of him inventing an etching process, there is none that he had skills – or the time – to be an engraver. Milan abounded with talented goldsmiths who could have tackled the job,[7] but the unusual refinement of these prints, especially in their delicate hatching, suggests that Leonardo kept tight control. The print of the wreathed female head, with a single breast exposed, is often linked with a drawing by a Leonardo pupil of a male profile crowned with an oak wreath, now in the Louvre (inv. 2251).[8] Recently it has even been argued that this drawing was made to be copied by the engraver. But the differences are too many and it should be realised that this ideal of beauty, which can be male or female, recurs so often in works by Leonardo's closest followers as to suggest a lost prototype by the master.

One of the most sophisticated responses to Leonardo's model was Boltraffio's, in his drawing of a wreathed head seen in full face (cat. 50; tellingly, scholars have argued about the sex of this figure) and in a lost painting of Narcissus in profile, known from copies.[9] This is Leonardo's model of supreme beauty and, associated with an Academy, could be perceived as a Platonic ideal. She is clearly linked to the ancient

LITERATURE

Hind 1910, pp. 405, no. 4, 404–6, no. 6 (as 'School of Leonardo da Vinci', with earlier bibliography); Suida 1929, pp. 108–9, fig. 123 (for ideal head, 'after Leonardo'); Hind 1948, vol. 5, pp. 90, no. 13, 95, no. 6; Levenson et al. 1973, p. 281 (for Washington example of knot pattern); Alberici in Milan 1984, p. 21, cat. 9 (for Milan example of knot pattern); Lambert 1999, p. 270, no. 522 (for Paris example of knot pattern); Wolk-Simon in New York 2003, pp. 652–5, under cat. 126 (for ideal head).

CAT. 55

world: her draperies are arranged like a toga (their forms strongly reminiscent of the drapery study for the London *Virgin of the Rocks*, cat. 47) leaving her shoulder and her (nurturing?) right breast exposed. Leonardo wrote of ivy, here in her wreath, as symbolic of long life; the permanence of beauty created by art is a constant theme not only in his writings, but also of those near him, like Bellincioni (see cat. 59).[10] The circle around her was of course seen as a perfect shape, but also evokes ancient coins and fifteenth-century portrait medals, also regarded as durable and unchanging.

Leonardo's knot patterns are often discussed as design sources for work in other media – inlaid pavements, the tooling of leather bindings, embroidery and so on.[11] It is true that such patterns emerge from the world of decorative and applied arts – and Leonardo and his contemporaries were undoubtedly impressed by the interlace ornament found on Islamic metal- and leatherwork, imported into Italy in considerable quantity. But these are much too complicated to be easily reproduced and, even if a didactic function in respect of lesser artisans is proposed, the choice of inscription would have been distinctly odd. Moreover, like the ideal head, these are the very finest of fine manner prints; the plates would have become quickly unusable and only very few impressions could ever have been made. We must therefore assume a strictly limited circulation, perhaps among the 'members' of the Academy.[12] Leonardo drew many designs for interlace patterns, though none survive that are as complex as this. Ornament is now elevated into an end in itself

and these prints may even be regarded as the first examples of abstract art.

It is sometimes thought that the elaboration of knots – *vinci* – is a play on Leonardo's 'surname' as well as on the Latin verb *vincere* ('to conquer'). In documents of 1493 and 1494 referring to the embroidery of Beatrice d'Este's gowns, knot pattern designs are termed *fantasie dei vinci*, widely perceived as archetypal products of the imagination. They could also stand for discipline and learning. Bramante was credited by Leonardo as having devised knot patterns – *gruppi* – which others interpreted as serious mathematical 'games' – *ludi*. Vasari was wrong when he thought that Leonardo had arranged a single unbroken line; in fact he cunningly employed a repeat pattern.[13] Yet although they cannot strictly be linked to the concept of the labyrinth, they are labyrinthine in that the eye is unable easily to follow all the twists and turns of their design, while the overall design is quickly understood as ordered and coherent, simultaneously static and dynamic, above all rational.[14] Robert Zwijnenberg suggested that this paradox should be read as a metaphor for Leonardo's detailed investigation of the minutiae of the natural world, while he was simultaneously seeking to discover overarching rules for creation – a blend of the Aristotelian and the Platonic. And if such efforts were broadly those of the whole Academy, then this congregation of separate parts into a visually satisfying whole could also stand for all the many complex and individual ways of thinking within a unified group of philosophers. LS

NOTES

1 Vasari (1966–87), vol. 4, p. 18.
2 Marani 1998d, pp. 15, 32–3 n. 39.
3 Elam 1992.
4 Pederson 2008, pp. 454–60.
5 Pederson 2008, drawing on Chambers 1998.
6 Leonardo was probably responsible for the ambitious composition of an engraved portrait print of Bernardo Bellincioni known from a unique surviving example in Paris. See Villata 2000. Its technique is very close to these.
7 Caradosso was just one. Ambrogio de Predis and Francesco Napoletano both seem to have been able to engrave dies for coins, and the latter was probably responsible for a less skilled print of Sant'Alessio. See Agosti 1998, pp. 51–2.
8 This is sometimes dubiously attributed to Boltraffio. See Bora 1998a, p. 98; Wolk-Simon in New York 2003, pp. 652–5, cat. 126. It might be better attributed to Marco d'Oggiono at the beginning of his career, as defined in this volume by Antonio Mazzotta.
9 Fiorio 2000, pp. 164, 166–7, nos C2, C4.
10 Windsor RL 12282v; R 683 – the annotation to a later design for fancy dress of about 1508.
11 See Bambach 1991, pp. 72–3 nn. 1–2 for bibliography.
12 I am grateful to Michael Bury for this observation.
13 Egger 1952.
14 Zwijnenberg 1999, pp. 183–5.

56

LEONARDO DA VINCI (1452–1519)

Virgin and Child with a cat

about 1480

Pen and wash on grey prepared paper
12.8 × 10.9 cm
Galleria degli Uffizi, Florence
(421Er)

LITERATURE

Müller-Walde 1889, pp. 102–3; Morelli 1890, p. 225 (as by Sodoma); Berenson 1903, vol. 1, p. 151; vol. 2, p. 57, no. 1015; Bodmer 1931, p. 380; Popham 1946, pp. 45–6, no. 10; Petrioli Tofani in Florence 1980, p. 132, cat. 262; Kemp 1981, pp. 54–7; Pedretti and Dalli Regoli 1985, pp. 59–60, no. 10; Petrioli Tofani in Florence 1992, pp. 147–8, cat. 73; Bambach in Paris 2003, pp. 76–7, cat. 13 (with bibliography).

Leonardo preserved all kinds of drawings, from quick preliminary sketches to more resolved studies, creating an archive to spark new ideas. He frequently revisited motifs observed or formulated many years earlier. Well aware of the dangers of copying the work of others, he justified using his own drawings as teaching tools. He encouraged his pupils to work in the same way, first copying, but then – crucially – adapting his designs.

This sheet appears to have been a constant point of reference for both master and pupils. In definitively attributing the drawing to Leonardo, Bernard Berenson rightly considered it an early work. The force and fluidity of line and the use of wash have much in common with his sketches of about 1481–2 of horses

for the background of the *Adoration of the Magi* (fig. 34).[1] He himself learned from the Florentine 'master of design' Antonio del Pollaiuolo that by varying the thickness and weight of the principal contours he could give his drawing a flickering energy.[2]

This is one of a number of sheets exploring the combined poses of the Virgin supporting the Child while he plays with a cat or kitten, a sequence often associated with Leonardo's declaration that in autumn 1478 he had begun '2 Virgin Marys'.[3] The inclusion of a cat with the infant Christ would have been highly unusual, seemingly without iconographic precedent in Florence.[4] The idea is so unorthodox that some scholars have suggested the cat was included only as

FIG. 95
LEONARDO DA VINCI
Sketches for a Virgin and Child with a cat (detail),
about 1478–82
Pen and ink on paper, 20.6 × 14.3 cm
The British Museum, London (1857,0110.1r)

CAT. 56 (detail)

an excuse for the Child's dynamic pose, to be omitted
or substituted in a finished work. For example, an early
sixteenth-century version of the composition now in
the Brera, Milan, by a follower of Leonardo, replaces
the cat with a rather awkward lamb[5] – revealed by
X-radiography to have begun life as a cat. Perhaps
Leonardo had a similar failure of nerve. Yet if he
had gone on to paint this subject he would have
been creating something new: a Madonna and Child
whose movements are not determined by familiar
iconographic formulae, but express the real emotions
of a mother and her child.[6]

Even if at one time Leonardo did plan to paint a
Virgin and Child with a cat, this study nonetheless
became valuable primarily for the dynamic pose of the
Child, regardless of what he is holding. And it differs
from other quickly drawn sketches of an infant with a
cat in its carefully calculated *contrapposto*. Christ's pose is
based on Leonardo's observation of a similar interaction
between boy and beast in two earlier drawings, in
which the Child convincingly supports his own weight,
keeping his balance – and the cat under control – by
clutching it tight to his chest (fig. 95).[7] The present
study is a considered synthesis, the summation rather
than, as some have thought, the beginning of the
sequence. The infant's hold on the cat is now impos-
sibly loose, the twist of his body more extreme. This
figure, drawn first, is certainly the more important: the
Virgin was added around and across him. As has long
been recognised, she represents a return to Leonardo's

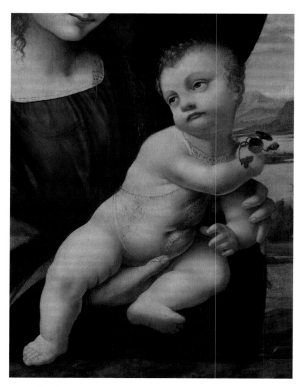

CAT. 67 (detail)

artistic roots, closely based on a type invented by Fra Filippo Lippi and reiterated several times by Verrocchio.[8] Leonardo's major contribution is to add a placid smile, giving her, in Berenson's words, 'the added mystery, subtlety and majesty of Leonardo's most haunting types of women'.

He continued to work on the Child's pose, re-drawing him almost immediately, tracing from front to back of the sheet (his head in a different position on the verso). His lower body and the Virgin's hand holding his ankle also appear in the *Adoration of the Magi* (fig. 34), perhaps suggesting that the drawing was made before he left Florence; if so, he certainly took the sheet with him to Milan. Alternatively, the drawing may belong to his first years in Milan, representing a return to a motif tried out in the abandoned *Adoration*.[9] One of the few known precedents for a Virgin and Child with a cat, a mid-fifteenth-century fresco, is in Vigevano, birthplace of Ludovico il Moro.

The drawing continued to be a source of inspiration for Leonardo himself – the Child on the verso is echoed in the *Burlington House Cartoon* (cat. 86). But the Child was also copied and adapted by pupils and followers, identified as the source for both Marco d'Oggiono (in cat. 67) and the painter of the *Madonna Lia* (cat. 48), combined with other recognisably Leonardesque motifs. LS

CAT. 56 (verso)

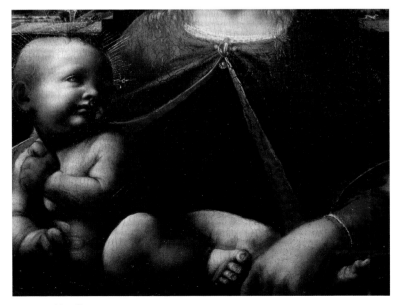

CAT. 48 (detail)

NOTES

1 Ashmolean, 88:139; British Museum, 1952,1011.2; Louvre, 781r.
2 See e.g. Pollaiuolo's study for the Eldest Magus (Uffizi, 369E).
3 Uffizi, 446E.
4 It is often said that the cat refers to a medieval legend where a cat in the manger had kittens at the same time as the Virgin bore Christ. It has not been possible to trace this story.
5 Pinacoteca di Brera, Milan, by the Circle of Leonardo da Vinci, perhaps Cesare da Sesto, formerly attributed to Sodoma (hence Morelli's attribution of cat. 56, considered its source, to the same artist).
6 British Museum, 1856,0621.1. Leonardo 'frames' the group, giving it a remarkably finished appearance, but placing the Virgin and Child in an interior so similar to that of the *Madonna Benois* (fig. 3) as to make the assumption that the one work evolved from the other entirely reasonable.
7 British Museum, 1856,0621.1, 1857,0110.1, 1860,0616.98; Musée Bonnat, Bayonne, 152 and a private collection (Bambach in New York 2003, pp. 290–6, cats 18–19).
8 E.g. Gemäldegalerie, Berlin, 104A, in which the Madonna holds Christ's ankle. See also Filippino Lippi's *Virgin and Child with Angels* (*Madonna of the Pomegranate*) (Louvre) of the mid-1470s (Zambrano and Nelson 2004, p. 127, fig. 10).
9 See Pedretti in Pedretti and Dalli Regoli 1985, pp. 99–100.

LEONARDO DA VINCI (1452–1519)

Virgin and Child ('The Madonna Litta')
about 1491–5

Tempera on wood, transferred to canvas
42 × 33 cm
The State Hermitage, St Petersburg
(GE 249)

This painting depicts the Madonna leaning tenderly over her curly-headed baby, who nestles against her breast but gazes out at the viewer. Mary has smooth, brown hair, combed with a straight parting and partly wrapped in a light transparent scarf or veil with fine gold ornament. The profile of the Mother of God is precisely delineated against the background of a smooth, dark wall, symmetrically pierced on either side by arched windows, through which can be seen a mountainous landscape fading into a bluish haze.

Leonardo's starting point was one of the oldest iconographic images of the Virgin, the *Madonna lactans* (nursing Madonna), which was particularly widespread in fourteenth-century Italian art. Master painters were attracted by the purely human theme of a mother feeding her son at her breast. The absence of haloes above the heads of the Madonna and Child is noteworthy. But at the same time the artist paid tribute to standard religious symbolism, preserving the traditional colours of Mary's clothes: a red dress and a blue cloak. In his left hand the Child grasps a goldfinch, whose feathers, according to legend, were stained with blood when the bird was scratched by Christ's crown of thorns, a hint of his redemptive sacrifice to come.

But it would be a mistake to see the picture as depicting the everyday: its generalised qualities, its majesty lift it above the purely quotidian. In this respect it is instructive to compare the study stage with the final painted version: the Louvre collection includes Leonardo's famous study of a woman's head in silverpoint and white heightening (cat. 59) which served as a model for the Madonna. Comparing this sketch, undoubtedly drawn from life, with the painting shows how the master worked up the image. Although the same face is recognisable in the painted version, one can clearly see the changes which remove too particular elements and exalt the image.

In addition to the Louvre study, the fragment published by Pedretti (cat. 60), which he considers to be the artist's study for the *Madonna Litta*, should also be mentioned.[1] Pedretti notes the technical similarity to the Paris sheet and suggests that Leonardo had begun to use this technique in about 1495. This drawing shows the lower part of a woman's face, very close to the depiction in the painting.

Paul Müller-Walde proposed a link between a drawing in the Royal Library at Windsor (fig. 96) and the Hermitage painting.[2] But apart from the motif of

a child suckling at a mother's breast, this sketch has nothing in common with the *Madonna Litta*. Other studies by Leonardo have been compared with the St Petersburg painting, but as Brown justly remarked, these are all 'sketches from life, of the type which Leonardo was using throughout all his activities'.[3]

The acquisition of the *Madonna Litta* by the St Petersburg museum caused a noticeable stir elsewhere in Europe. An eminent art expert of the time, Gustav Waagen, wrote: 'this picture . . . is the rarest of all those ascribed to the great master which it is currently possible to buy in Europe. Without doubt, this is one of the Hermitage's most valuable treasures.'[4]

Before it came to the Hermitage, the *Madonna Litta* was usually considered to be the work of Leonardo.[5] From the second half of the nineteenth century doubts began to be expressed about the correctness of this attribution. A wide variety of names from Leonardo's circle was proposed for the author of this painting, though this did not prevent scholars from classing it a masterpiece.[6] However, as was justly remarked by Gukovskij: 'Those critics who doubt that the *Madonna Litta* was painted by Leonardo himself have not succeeded in putting forward the name of another artist to whom there are any kind of convincing grounds for ascribing a picture of such great artistic quality.'[7]

Those scholars who continue to write about the participation of one of Leonardo's pupils in the creation of the *Madonna Litta* should take into account the indisputable evidence of the scientific examinations carried out in the Hermitage, concluding that the work was painted by one artist working alone, not by two. Furthermore, despite all that has been said about it being in a ruinous state, the painting is in fact well preserved. X-radiography has shown that the original *imprimitura* was partly preserved when the painting was transferred from wood to canvas. One can see, for example, the vertical cracks caused by the former wood support, with resultant small paint losses. In some areas of the picture, such as the window on the right, a fine crazing of the paint layer is discernible. Mary's face and neck and the figure of the baby show very delicate transitions from light to shade. The contours are also notably soft. These features are markedly similar to those revealed in X-radiographs of the *Mona Lisa* (Musée du Louvre, Paris).

The painting is however distinguished by the fact that it was painted in tempera rather than oil. It should

LITERATURE

Paris 1935, p. 106 n. 230; Moscow 1962, pp. 5–6; Milan 1990; Kustodieva 1994 (with preceding bibliography); Moro 1994, p. 19; Fiorio 1998c, pp. 137, 153; Sarti 2002, p. 208; Brown 2003, pp. 23–7; Kustodieva 2003; Kustodieva in Rome and Venice 2003–4; Pedretti 2003b, pp. 55–61; Zöllner 2003 (2007), p. 277, no. 14; Bertelli 2004; Danieli 2006. p. 124, n 8; Kustodieva 2011, no. 116.

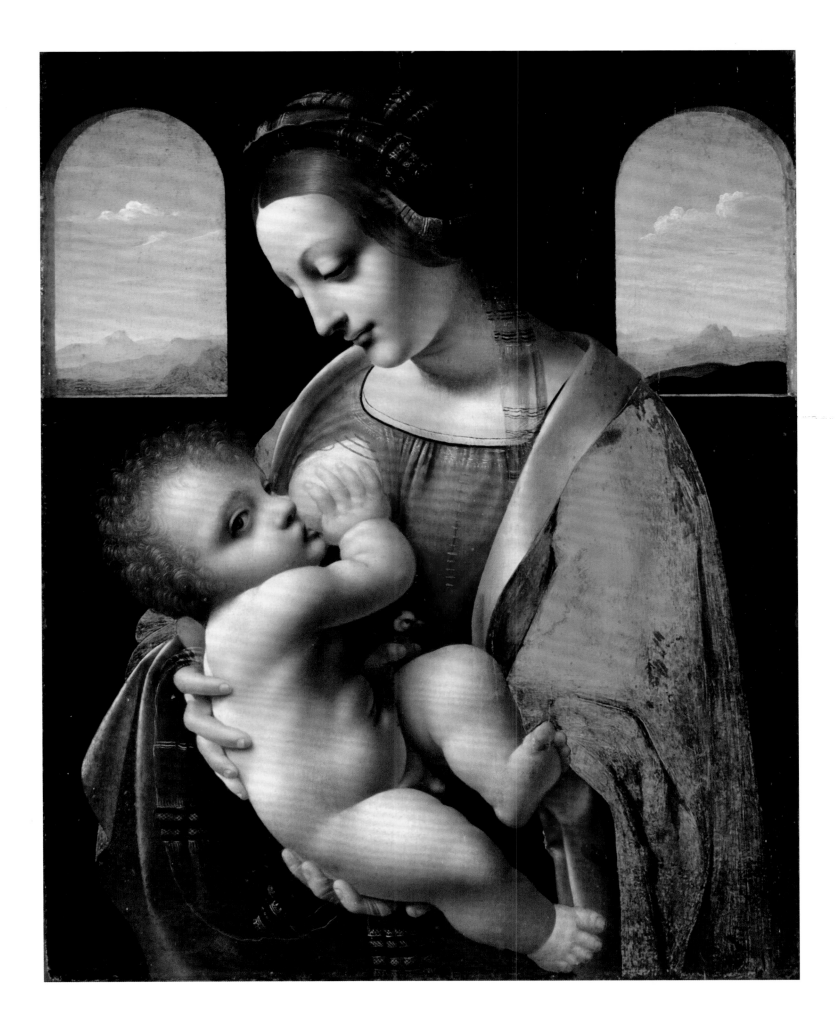

be remembered that in the 1490s, the decade in which the *Madonna Litta* was created, Leonardo was working on the *Last Supper* in the Dominican convent of Santa Maria delle Grazie in Milan, in which, as is well known, he experimented with the composition of paints and used tempera among other media. It is highly probable that he harboured a desire to create an easel painting using this traditional technique, requiring a new approach and giving different results from oil painting. And it may be no coincidence that the colours of the draperies of the *Madonna Litta* on the one hand and of Christ in the *Last Supper* on the other (red and dark blue) and the pale bluish hilly landscapes of both are so similar.

To judge from its style, the *Madonna Litta* is undoubtedly a product of Leonardo's first Milanese period, created, in my opinion, in the mid-1490s. In attempting to determine when this picture was painted, scholars have relied on Leonardo's list of works in the Codex Atlanticus (fig. 4; see pp. 21–2), in which there is mention of 'Una nostra donna finita un'altra qu[a]si che'n profilo'. One may read this text in two ways – this Madonna either almost finished or almost in profile; assuming the inventory to document the works Leonardo brought with him to Milan, scholars have thus supposed that he brought this work from Florence with him almost finished. But the Hermitage painting bears no trace of the hallmarks of the Florentine stage of Leonardo's creativity.

In the words of Pietro Marani, 'Leonardo was in Venice in March 1500, and it is not at all improbable that he brought with him the *Madonna Litta* finished by one of his pupils'.[8] Leonardo brought the *Madonna Litta*, his own work, to Venice. It is well known that when he moved to other places Leonardo took his work with him. But this picture remained (for unknown reasons) in Venice, and it was there, in the Contarini house, that Marcantonio Michel saw it in 1543: 'There is a little picture, of a foot or a little more, of an Our Lady, half length, who gives milk to the little boy, coloured by the hand of Leonardo da Vinci, a work of great power and highly finished.'[9] The discrepancy in dimensions, which is occasionally pointed out, is of no real significance: the size given is approximate (one Venetian foot = 34.7 cm). Furthermore, it is not clear whether this refers to the height or width of the panel – if the width, then it virtually coincides with what we have. It was in Venice that one of the first engravings of the picture was created, by a print-maker in the circle of

Zoan Andrea (1464–1526). Moreover, at least one reworking of the *Madonna Litta* in the *Madonna and Child* (Museo di Castelvecchio, Verona) is in the stylistic tradition of the Venetian school.

But before its appearance in Venice, the *Madonna Litta* was already well known in Milan, as evidenced by the large number of copies and variants produced by Lombard artists. This work was instantly famous, the object of constant attention. Leonardo's contemporaries were sensible people. It would hardly have occurred to the numerous copyists to repeat and adapt the work unless they were convinced that they were dealing with an original by the great master. For the people of the Renaissance there was no lack of clarity about attribution of works of art – as has come to be felt by subsequent generations, centuries removed from that time. It is simply not possible that a picture by one of Leonardo's pupils would have become as well known as a work by the master himself.

The copies include some which directly repeat the figures of the St Petersburg painting, although for most artists it served as a basis for their own variations on Leonardo's theme. For example, a *Madonna and Child* (Castello Sforzesco, Milan) by an unknown Lombard painter of the end of the fifteenth century reproduces the central group but changes the shape of the windows to rectangular, and alters the landscape. This picture was at one time connected with the name of Boltraffio. A *Madonna and Child* in the Cheramy sale in Paris in 1908 (lot 4) was also attributed to Boltraffio. The artist copied Leonardo's *Madonna Litta* but again changed the background, putting a curtain above Mary's head and adding on the left, seen through the only window, a city view. A copy of the St Petersburg painting now in the Poldi Pezzoli Museum in Milan is also one of Boltraffio's circle: repeating the position of the figures, the artist depicted them separated from the landscape by a curtain. Mary's head is now covered by a complex headdress like a turban. In the foreground there is a parapet with a cushion lying on it; here the baby sleeps, his mother holding him lightly by the left foot.

Echoes of the *Madonna Litta*, which Leonardo's contemporaries undoubtedly believed to be one of his masterpieces, can be found in the work of many of his followers: Marco d'Oggiono, Giovanni Antonio Boltraffio, Bernardino dei Conti, Giampietrino, Bernardino Luini and Andrea Solari.

NOTES

1 Pedretti 1989. The sketches were first published in Pedretti 1988c.
2 Müller-Walde 1889, pp. 93–7.
3 Brown 1990b, p. 9.
4 For previous attributions, see Kustodieva 1994.
5 Purchased in 1865 from Antonio Litta in Milan.
6 Gukowskij 1959, p. 9.
7 Gukowskij, op.cit., p. 27.
8 Marani 1991, p. 203.
9 Michel 1884, pp. 225–6.
10 Brown 1990b; Brown 1991, pp. 25–34; Brown 2003.
11 Clark 1939, p. 107.
12 Scholars have had the opportunity to study the picture when it was exhibited at Paris 1935, p. 106 n. 230; Moscow 1962, pp. 5–6; Milan 1990; Madrid 1990 (without catalogue); Venice 1992, pp. 362–3, no. 74; Rome and Venice 2003–4.
13 Lipgart 1928, p. 4.

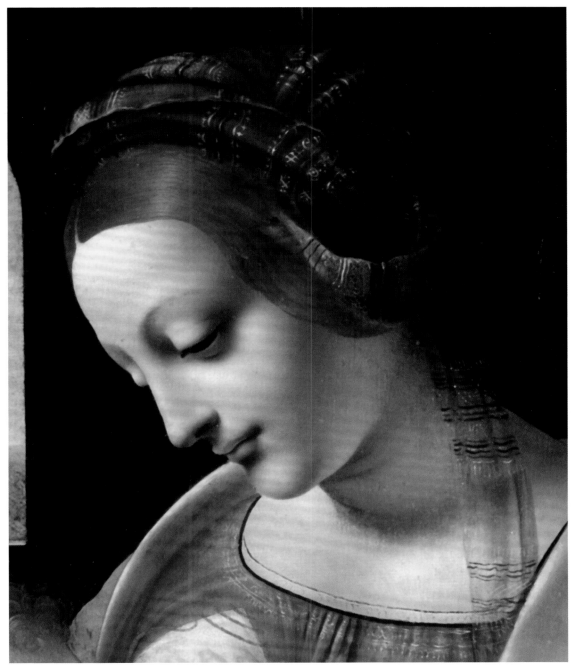

CAT. 57 (detail)

David Alan Brown has been among the most active opponents of the attribution to Leonardo in recent decades. Although he justly described the *Madonna Litta* as a masterpiece, in 1990 he still called it 'the result of cooperation of teacher and pupil'. Then, in 1991, he tried to demonstrate that the creator of the picture was Marco d'Oggiono. Brown does not provide a logical argument in favour of Marco as the author, but he also changes the attribution of several of the drawings connected with the composition which in his 1990 article he describes as being the work of Leonardo's pupils and in 1991 he ascribes to Marco (see cats 61, 62).[10]

Marco d'Oggiono, whom Kenneth Clark described, not without foundation, as 'particularly distasteful',[11] is in fact the very last candidate one might choose for the authorship of the Hermitage's masterpiece. One need only compare the *Madonna Litta* with Marco's *Madonna and Child* in the Louvre, painted under its influence. Marco's composition has neither the spiritual unity, nor the marvellous counterpose, nor the expressiveness that turns the figure of the Child into a living baby, nor the tenderness of the image of Mary – all of which are features of Leonardo's work.[12]

Ernst Lipgart, who had the distinction of establishing that Leonardo was responsible for the *Madonna Benois*, was surely right when he wrote that 'the *Madonna Litta* is, in my opinion, the Hermitage's most valuable treasure'.[13] TK

225

58

LEONARDO DA VINCI (1452–1519)
Studies of a baby
about 1490

Red chalk on paper
13.8 × 19.5 cm
Lent by Her Majesty The Queen
(RL 12568)

Leonardo drew babies throughout his career, always seeking novel ways to invigorate depictions of the Virgin and Child. In particular he explored new, animated poses for the Child, intended as both aesthetically satisfying and emotionally convincing. This is one of two companion sheets with baby studies, of which (probably) the earlier was drawn in metalpoint (fig. 96).[1] Both show a baby feeding. In 1933 Kenneth Clark stated that the baby's kicking leg on the right of the present sheet 'is almost identical with that finally used and reproduced in the *Madonna Litta*'. So great was Clark's conviction that the *Madonna Litta* (cat. 57) was started in Florence before 1483 that he was forced to conclude that these studies were also executed early in his career, though he pointed out more than once that Leonardo did not otherwise use red chalk before about 1490. This he therefore characterised as a precocious and uncomfortable experiment, not repeated, in which the red chalk is harder and more orange than elsewhere, used like metalpoint with the emphasis on line rather than texture.

Clark may have felt doubly justified in dating these two pages early because several of the child poses adapt models invented or employed by Verrocchio. Since babies are notoriously hard to draw, Verrocchio made plaster casts of their body parts – 'hands, feet, knees, legs, arms and torso', according to Vasari;[2] these were circulated so they could be copied. The straight standing leg in this drawing, with its folds of flesh and its dimpled knee, may be based on one of the several standing Christ Child figures in Madonna reliefs by Verrocchio and his workshop.[3] The motif that most interested Clark – the bent leg, the thigh pressed against the belly, the genitals fully exposed – is also Verrocchiesque.[4] Leonardo's indebtedness to Verrocchio here should not, however, be taken as evidence for an early date; he continued to rely upon his master's prototypes well into the 1490s.[5]

In recent years these two sheets have been re-dated to around 1490. David Alan Brown, still associating this chalk sheet with the *Madonna Litta* (which he dates, as most scholars now do, to about then), suggests that

LITERATURE

Bodmer 1931, p. 387; Clark 1933, p. 139; Clark 1935, vol. 1, p. 93; Clark and Pedretti 1968–9, vol. 1, p. 109; Clayton in Edinburgh and London 2002–3, p. 108, cat. 3; Brown 2003, p. 80 n. 40.

FIG. 96
LEONARDO DA VINCI
Studies of a naked infant, about 1490
Metalpoint and pen and ink on prepared paper,
17.1 × 21.8 cm
The Royal Collection (RL 12569r)

CAT. 57 (detail)

NOTES

1 Windsor RL 12569. The baby lying on his back, holding his fingers to his mouth, comes (in reverse) from Verrocchio's Ruskin *Madonna* (National Galleries of Scotland, Edinburgh). See Covi 2005.

2 Vasari (1966–87), vol. 3, pp. 543–4.

3 E.g. Verrocchio's polychromed terracotta relief at the Bargello, Florence, and the marble Virgin and Child relief in the same collection. Covi 2005.

4 Found in the tiny putto at the lower right of Verrocchio's model for a tomb monument (Victoria and Albert Museum, London, inv. 2314). See Rubin in London 1999–2000. pp. 146–7, cat. 11.

5 Joannides 1989.

'the drawing, particularly given the medium, might well be a later life study made in connection with the picture'. Martin Clayton relates the metalpoint sheet to Leonardo's drawings of horses for the Sforza equestrian monument, which are so close in style and medium, in their paper and its preparation, as to suggest that they belong to the same moment. Clayton concluded that this work in red chalk, begun at much the same time, should likewise be re-dated, thus solving the problem of Leonardo's 'anomalous' use of the medium. It is rather similar in style and technique to his measured study of a foot (cat. 73).

We can only guess why Leonardo chose to switch medium between these two sheets. Red chalk of course suits the depiction of the human body rather well. But his choice may have been as much about speed. When using metalpoint his first exploratory lines are tentative, but as his forms emerged, he vigorously reinforced the final contours; using red chalk, these strong sharp lines could be achieved quickly by pressure rather than by reiteration. So is this in fact, like the horse studies, a drawing from life? Babies are easiest to draw when asleep or feeding – and Leonardo may well have had a baby in front of him when he made the sketches on the left. But these studies could not be copied directly into a Virgin and Child painting in which, as the *Madonna Litta* demonstrates, Christ's face had to be more visible. He therefore revisited his inherited repertoire of useful poses and, with the infant's chubby anatomy fully understood, he could draw partly from life and partly from memory and imagination.

The use of sculptural models in Verrocchio's workshop encouraged the creation of composite figures, and Leonardo's suggestion that the artist should combine what was best and most beautiful in nature (see pp. 33, 36–9) was a brilliant rationalisation of this practice. The legs and hand in this drawing were studied to be employed in just this way and, unlike the many drawings of horses' heads, hocks and hoofs, might be especially useful for his pupils and assistants. It is very improbable therefore that Leonardo made this drawing with the *Madonna Litta* in mind (not least because it is lit from the other direction), but its painter – whether Leonardo himself or, more likely, Boltraffio – may well have taken this study of a baby's leg as one of the ingredients of an amalgam of existing motifs. LS

59

LEONARDO DA VINCI (1452–1519)

Head of a woman
about 1488–90

Metalpoint heightened with white on grey prepared paper
17.9 × 16.8 cm
Musée du Louvre, Paris
(2376)

One of the most exquisitely lovely of Leonardo's drawings, its brilliantly nuanced metalpoint technique complements the sitter's own extraordinary beauty. Just as in his *Portrait of Cecilia Gallerani* (cat. 10), Leonardo has here found a way of recording a living, palpably real ideal of womanhood. And there can be no doubt that this is a drawing from life. The *sfumato* shadowing is complex and sophisticated, Leonardo focusing especially on reflected lights (on the side of her neck, for example). He brilliantly conveys a sense of this woman's interior life as she sits, slightly slumped, withdrawn, pensively self-absorbed. He has observed the resigned droop of her head, her hair falling distractedly out of its chignon, the shadow in her eyes and the vulnerable softness of the flesh under the chin. The drawing has a twilight melancholy that is very moving.

This great work has often – justly – been compared with the even more celebrated study of a young woman's head in Turin (fig. 61). Though the latter is more quickly and loosely drawn, the two are otherwise remarkably similar in style and technique – and probably also in function. The Turin drawing was (and is) – and wrongly – often published as preparatory for the angel's head in the Louvre *Virgin of the Rocks* (cat. 31) and dated to about 1483. As early as 1919, however, Ochenkowski proposed that Cecilia Gallerani modelled for the Turin study, though at a time when her portrait was thought similarly to belong to the early 1480s.[1] In 1973 Pedretti declared that the Turin study 'is unquestionably the portrait of a young lady';[2] and in recent decades several leading scholars have convincingly argued that this study was executed in 1490 or just a little before.[3] The Turin drawing's starting point was the Louvre angel, but the relative proportions of the features are different. In fact, this drawing lies behind the revised head of the angel in the second version of the *Virgin of the Rocks*, not a portrait as such but a record of one person's almost excessive beauty, so remarkable that it could be taken as divine.

The present head study is also usually regarded as preparatory to the *Madonna Litta* (cat. 57). On this basis, and because Leonardo was thought to have begun the *Madonna Litta* during his first Florentine period, it was widely believed that this drawing too was executed around 1482–3. Because nowadays the *Madonna Litta* is considered a work of about 1490, the drawing has also been re-dated to around that time.[4] This new sense

CAT. 59 (verso)
Pen and ink

of its chronology seems broadly correct, even if the reasoning is faulty. It was probably made in 1488–90,[5] the same moment as Leonardo's portrait of Cecilia.

It is with these works that we reach the peak of Leonardo's naturalism. This drawing is usefully compared to his skull studies of 1489 (figs 9, 10, 69). His depiction of this young woman reveals his understanding of the anatomical structure of the head and the delicate build-up of parallel hatching is rather similar (though Leonardo drew his skull with a pen – with the finest possible nib). Nonetheless, he has struggled a little with the challenging recession, searching for the right contours of the chin, nose and especially the forehead before finding exactly the right solution. This view of a woman's head – looking down and moved just out of profile to render the far eye visible – had been thought particularly beautiful by Verrocchio and was much copied by his pupils; it was also used several times by Lorenzo di Credi (about 1459–1537). Since a woman's downward gaze was thought to convey her modesty, it was most appropriately adapted for the Virgin Mary.[6]

This therefore is another record drawing of an exceptionally beautiful woman in an expressive pose,

LITERATURE

Vallardi 1855, pp. 35–6, fol. 170; Suida 1920, pp. 43, 285–6; Bodmer 1931, p. 399; Clark 1933, p. 139; Popham 1946, pp. 39,47, no. 19; Gould 1975, pp. 63–5; Viatte in Paris 2003, pp. 90–3, cat. 21 (trans. in New York 2003, pp. 362–6, cat. 44); Marani 2008, pp. 53–5, no. 26.

made as a point of reference rather than in preparation for a particular painting. She could stand for the Virgin Mary, and the drawing could also serve as a model for Leonardo's pupils and assistants. And this is how it should be connected with the *Madonna Litta*: the direction of the woman's gaze is altered, but the composition is built around this head. The drawing on the verso, mechanically traced through from the front, shows how it might be copied, using a practice Leonardo employed throughout his career (see cats 56, 78, 85). In the past the connection with the *Madonna Litta* was rejected only by Wilhelm Suida,[7] who argued that it is better linked with a rather clumsy painting of the *Virgin and Child with Saint Catherine of Alexandria* (Accademia Carrara, Bergamo).[8] That it was in fact used for both these pictures demonstrates the way in which this beautiful drawing, or copies after it, might circulate within the workshop. LS

NOTES

1 Ochenkowski 1919, p. 79.
2 Pedretti 1973, p. 66.
3 See e.g. Marani in Milan 2001, pp. 120–1, cat. 25.
4 A dating in early 1490s revives an idea proposed in the early twentieth century by Demonts (1921, p. 14, pl. 14), who dates the drawing to around 1491–4. He noted that Seidlitz had ascribed the *Madonna Litta* to Ambrogio de Predis but maintained the attribution of the drawing to Leonardo, one of the first to make a distinction between the study and the painting. Bodmer 1931, p. 399, dated the drawing to around 1490–3.
5 Brown and Fiorio also dated this drawing to the late 1480s, but mainly on account of their dating of the Hermitage picture. As has long been realised, it also very close to cats 11 and 12, both rightly re-dated to the late 1480s.
6 She usually gazes down on her Child in altarpieces and small devotional panels; the pose was therefore entirely suitable for a *Madonna lactans*. See the badly abraded *Madonna and Child* by Lorenzo di Credi in Cleveland, Ohio, made early in Lorenzo's career, perhaps while still working as Verrocchio's number two. Dalli Regoli 1966, p. 103, no. 8; Coe Wixom in Cleveland 1974, pp. 66–7, cat. 25.
7 Suida 1920, pp. 285–6; Suida 1929, pp. 57, 60.
8 Giacomo Carrara Bequest, no. 127; painted on canvas and said to have been executed in tempera. The *Saint Catherine* echoes types used by Bergognone – and may have been executed some time around 1500. See Rossi 1988, p. 214.

60

Follower of LEONARDO DA VINCI

Study for the head of a woman

about 1490

Metalpoint on prepared paper
6.5 × 9 cm
Städel Museum, Frankfurt am Main
(6954v)

This small, apparently left-handed drawing is in a mutilated state: the sheet is cut at the bottom, through the watermark, and at the top, which must once have contained the rest of the head. In the early sixteenth century an anonymous German draughtsman used the back of the paper (the drawing now treated as scrap) for a study of a man in middle age, perhaps trimming the sheet to do so; this new head, on what is now the recto, is perfectly framed. Alternatively, the page was trimmed later around the head of the man, considered by its then owner the more important drawing.[1] In 1987 Carlo Pedretti 'discovered' what had become the verso. In fact, this drawing had long been catalogued by the Städel Museum as by Leonardo, published decades before by Muntz but disregarded. In 1987 Pedretti relaunched the work as an autograph study by Leonardo for the Hermitage *Madonna Litta* (cat. 57) as proof of Leonardo's authorship of the painting. His attribution is accepted wholeheartedly by only one scholar – Frank Zöllner – and was almost instantly rejected by David Alan Brown. Otherwise it has been met by a wall of deafening silence.

Compared with Leonardo's exquisitely moving drawing of a woman's head (cat. 59), certainly a source for the *Madonna Litta*, this drawing is decidedly weak: the contours are scratchy, as if the author lacked experience of drawing in metalpoint, with, rather peculiarly, some outlines seemingly drawn only after the internal modelling was complete. This, in fact, appears to be a copy of cat. 59, of exactly the same size though in some respects closer to the finished painting with its slightly revised illumination.

This sheet is not by Leonardo, although its author is clearly impersonating him. Could it then be the work of the painter of the *Madonna Litta*, widely believed to be an assistant seeking to replicate his master's style and technique? This too seems unlikely. This drawing is of a different character to those regarded as strictly preparatory for the Hermitage painting (cat. 61 and 62), in which Boltraffio does nothing to disguise his right-handedness. This is an ostensibly left-handed drawing, but on closer examination, the cross-hatching (not a technique found in Leonardo's metalpoint drawings of the late 1480s) under the cheekbone appears right-handed. And the slightly curving parallel

hatching on the neck – certainly drawn from left to right but in what for Leonardo would be an uncharacteristically shallow diagonal – looks like the efforts of a right-hander straining to imitate his left-handed master.

This is not therefore a drawing which furthers our understanding of the genesis or authorship of the *Madonna Litta*. But it does constitute valuable evidence of Leonardo's teaching practice in the early 1490s. This is precisely the kind of copy drawing that he required his young pupils – Boltraffio included – to make as they began their apprenticeships. In his eyewitness account Paolo Giovio wrote: 'until twenty years of age he would forbid them to use a paintbrush or paints, making them work with metalpoint to choose and reproduce diligently the excellent models of earlier works …'.[2] Later his pupils were allowed to make their own life studies. Giovio's statement has the ring of truth. Leonardo himself declared: 'The painter first ought to discipline the hand by copying drawings by a good master … subject to the judgement of his tutor.'[3] Was the pupil in this instance supposed to be concentrating on the light and shade? Reproducing the exact size of the original seems to have been important. Here Leonardo is instructing the young artist in how to commit a motif – one he himself has drawn – to

LITERATURE

Müntz 1898, vol. 2, p. 260 (as by Leonardo); Pedretti 1989 (as by Leonardo); Brown 1990b, p. 13 (as probably after Leonardo); Kustodieva 1994. pp. 220–2 (tentatively attributed to Leonardo); Pedretti 2003b, pp. 59–61, fig. p. 59 (as by Leonardo); Zöllner 2003 (2007), p. 82 (as by Leonardo); Pedretti 2008, pp. 86–7 (as by Leonardo).

CAT. 60 (recto)
GERMAN ARTIST
Portrait of a middle-aged man, about 1510

CAT. 57 (detail)

CAT. 60 (verso)

memory so that its reproduction becomes automatic, again a method he may have used in his teaching, helping to explain some of the infelicities here:

> When you have drawn the same thing so many times that you think you know it by heart, test it by drawing it without the model; but have the model traced on flat thin glass and lay this on the drawing you have made without the model, and note carefully where the tracing does not coincide with your drawing[4]

In the years 1490–4 Leonardo had at least seven assistants.[5] Not all worked simultaneously and not all were painters; but some are known to have been German,[6] perhaps explaining how this copy drawing made its way north of the Alps so soon after it was made. LS/AM

NOTES

1 The drawing was in the collection of William Mitchell, London, sold in Frankfurt am Main on 7 May 1890 (F.A.C. Prestel). The sale catalogue mentions only the *Study of an old man* on the recto, then considered the principal side, with an attribution to Ambrosius Holbein (Mitchell 1890, p. 29, no. 52). It was bought by the Städel Museum, and the record of the acquisition (no. 6954, 7 May 1890) now mentions the verso drawing of a woman's mouth and chin, changing the attribution of both recto and verso from Holbein to Leonardo da Vinci.

2 Giovio (1999), pp. 216–17; Farago 1999a, vol. 1, p. 72; often cited e.g. by Fiorio 1998b, p. 42.

3 BN 2038 fol. 10r; R 485. He also wrote: 'First copy drawings by a good master, made with skill and from nature, and not according to [standard] practice . . .' (BN 2038 fol. 33r; R 484).

4 BN 2038 fol. 24r; Urb. fol. 37v; R 531; McM 66; K/W 534.

5 Marani 1998c, p. 12.

6 'On the 28th day of March 1493 Giulio, a German, came to be with me' (Forster III 88b, R 1459). Giulio, seemingly a metalworker, was apparently paying for his training – owing four months at the beginning of that November (R 1460, R 1462). It is possible that the Galeazzo who arrived in March 1494 was also German since he and his father paid the fees in Rhenish florins (R 1461).

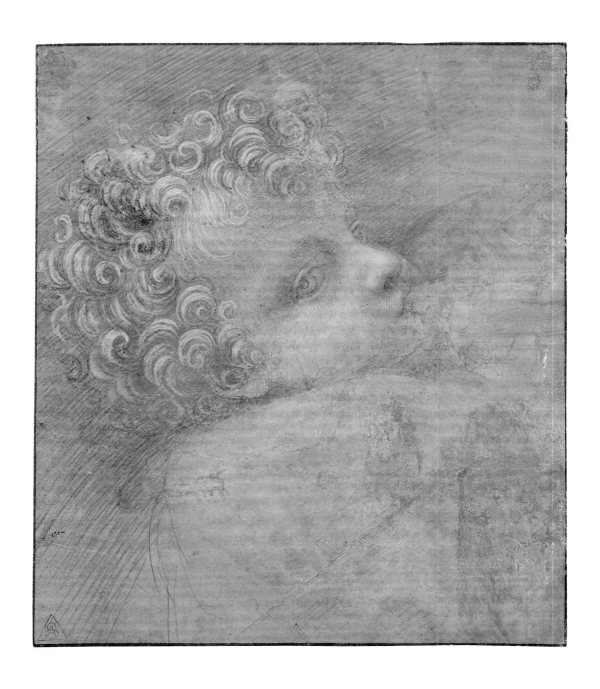

61

GIOVANNI ANTONIO BOLTRAFFIO (about 1467–1516)
Study for the head of the Christ Child
about 1490–1

Metalpoint heightened with white on blue prepared paper
16.6 × 14 cm
Frits Lugt Collection, Institut Néerlandais, Paris
(2886)

This study on a small – and unfortunately damaged – sheet should be related to the figure of the Infant Christ in the *Madonna Litta* (cat. 57). As in the painting, Christ looks out towards the viewer while apparently suckling at his mother's breast. The only fully defined and finished part is, however, his head; the rest is either damaged or left to our imagination. Hence we need to look at the equivalent part in the painting – of a Madonna breastfeeding her Child – to understand more precisely what the drawing represents. It has been suggested that it was copied from the painting. But that it was actually preparatory soon becomes apparent, since the quality of the drawing is extremely high and the correspondence is close but not exact.[1] An eighteenth-century inscription on the verso celebrates its qualities, and shows that early on it was believed to be a sheet by Leonardo.[2] However, that Boltraffio was its author had been realised at least by the time it entered the Lugt Collection.[3] Kenneth Clark's authoritative and convincing statement, with its straightforward but illuminating comparison ('It is by the same hand as the Child in the Poldi Pezzoli *Madonna* [see cat. 63], usually ascribed to Boltraffio'), rendered this attribution indisputable.[4]

The existence of a preparatory drawing for the *Madonna Litta*, and one firmly attributable to Boltraffio, constitutes a key piece of evidence for the attribution of the painting itself to Leonardo's pupil rather than the master himself. A drapery study (cat. 62), also preparatory for the painting, had been attributed to Boltraffio even earlier. The two are undoubtedly by the same hand, and as preparatory studies for the same painting they compositionally complement each other.[5]

Both, moreover, are executed using a very similar technique: drawn on blue prepared paper with metalpoint strokes that define the concave surfaces and the shadows, while the white heightening is employed to 'mould' the convex surfaces, touched by the fall of what seems a kind of moonlight.[6] Because of this very subtle interplay with the metalpoint (its use even more developed in the British Museum *Drapery study*, cat. 65), the strokes of white heightening cannot be considered a later addition or by another hand. In fact, the lead white results in wonderful effects, such as the curly hair of the Child in the present drawing, executed with free and quick brushstrokes. The Child in the *Madonna Litta* has softer, more refined hair, an effect of the oil medium.

This particular drawing technique may well have been borrowed from Leonardo, especially from his studies for the Sforza equestrian monument, such as his *Four studies of horses' forelegs* in Turin (Biblioteca Reale, 15580 D.C.) of around 1490–1, or even some of his anatomical studies (such as cat. 20).[7] This was the period of closest contact between master and pupil: Boltraffio is recorded in Leonardo's studio on 2 April 1491, when Salaì stole a silverpoint from him.[8]

A Leonardesque drawing with *Two studies of children's heads* in the Musée des Beaux-Arts, Caen (fig. 97) displays a similar extravagance and virtuosity in the representation of their hair, and a style that is indeed not too far from Boltraffio's, and somehow analogous to Francesco Napoletano's.[9] It seems to be a drawing of high quality, although unfortunately heavily retouched by a later hand with ink in the outlines and gold in the background. AM

LITERATURE

Berenson 1938, vol. 2, p. 138, no. 1261C (as perhaps by Francesco Melzi or Salai); Clark 1939, p. 43 n. 2 (as by Boltraffio); Byam Shaw 1983, vol. 1, pp. 383–5, no. 387 (as by Boltraffio?; with provenance); Ballarin 1985 (2005), pp. 44–6 (as by Boltraffio); Brown 1991b, pp. 25, 27, fig. 3 (attributed to Marco d'Oggiono); Fiorio 2000, pp. 82, 140, no. B3 (as by Boltraffio); Viatte in Paris 2003, p. 339, cat. III (as by Boltraffio); Marani 2008, pp. 99–100, no. 51 (attributed to Boltraffio).

NOTES

1 The scale of the drawing is slightly larger than the corresponding part of the painting, so it was not used or conceived as a cartoon.
2 The inscription is given by Viatte in Paris 2003, p. 339.
3 When sold as by Boltraffio at Sotheby's, London, 26 April 1927, lot 24 (bought by Frits Lugt).
4 See also the head of the Child in Boltraffio's National Gallery *Virgin and Child*, esp. the depiction of the hair.
5 Their composition shows them to be studies for a particular picture, in contrast to other head studies (e.g. cats 42, 43, 44, 49, 50), which are more exercises in the pursuit of perfection.
6 Similar light effects achieved using lead white on blue paper can be seen in Boltraffio's earlier *Drapery study* (cat. 64).
7 For the Turin drawing, see Bambach in New York 2003, pp. 426–9, cat. 63, where other studies in the same technique by Leonardo for the Sforza monument are listed.
8 Villata 1999, pp. 63–4, no. 53.
9 The Caen drawing was considered a study for the Christ Child and the Baptist in the Louvre *Virgin of the Rocks* (cat. 31) by Müntz (1898, vol. 1, pp. 167, 172–3) and as a free imitation by 'Boltraffio (?)' of the *Virgin of the Rocks* by Malaguzzi Valeri (1913–23, vol. 2, p. 405, fig. 458). Francesco Napoletano was the only other strictly Leonardesque painter of the 1490s with genuine talent (Ballarin 1987 [2005], pp. 59–69; Frangi 1991); see cats 34, 48.

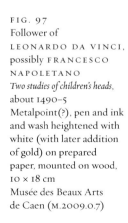

FIG. 97
Follower of
LEONARDO DA VINCI,
possibly FRANCESCO
NAPOLETANO
Two studies of children's heads,
about 1490–5
Metalpoint(?), pen and ink and wash heightened with white (with later addition of gold) on prepared paper, mounted on wood,
10 × 18 cm
Musée des Beaux Arts de Caen (M.2009.0.7)

62

GIOVANNI ANTONIO BOLTRAFFIO (about 1467–1516)

Drapery study for a Madonna lactans
about 1490–1

Metalpoint heightened with white on blue prepared paper
28.5 × 21.3 cm
Kupferstichkabinett, Staatliche Museen, Berlin
(KdZ 4090)

This large sheet is in particularly wonderful condition, enabling us to appreciate its superb quality. Like the *Study for the head of the Christ Child* (cat. 61), by the same hand and executed using the same technique, it should be related to the *Madonna Litta* (cat. 57).[1] Neither was intended or used as a cartoon – they are not pricked for transfer and their scale is slightly larger than the equivalent parts of the painting.[2] However, they are almost certainly preparatory drawings for the painting rather than copies after it, since they do not overlap each other compositionally and – more importantly – they differ significantly from the picture in several respects. For example, some of the beautifully designed deep folds of drapery falling over the arm in this drawing are covered by the Child's left leg in the painting, which can therefore be understood as the result of a series of independent studies, cleverly assembled.[3]

Here the upper body of a female figure emerges from the neutral blue background. Her bodice appears to be unlaced over her right breast, while a heavy swathe of drapery covers her left shoulder. It is only by comparison with the *Madonna Litta*, a Madonna lactans, that the meaning of these motifs becomes clear. The drawing is also extremely important for the formal analysis of the painting in which the blue lapis lazuli of the drapery is blanched, resulting in the almost complete loss of its volume, which the drawing allows us mentally to reconstruct. The existence of this and other preparatory drawings for the *Madonna Litta* is therefore essential to any discussion of this much-studied work.

In the nineteenth century the drawing was doubt-fully ascribed to Leonardo, and then to an anonymous Florentine master.[4] But by 1902 Charles Loeser had attributed it to Boltraffio, to whom it is usually given today. It is in fact by the same hand – and in the same technique – as the drapery studies in Oxford (cat. 64) and London (cat. 65), both now widely accepted as by

Boltraffio. In all three, metalpoint and lead white heightening are employed with great mastery, in such a way as to indicate the clear connection between them, but with slight differences in technique. The Oxford sheet is probably Boltraffio's earliest surviving drapery study (and one of his first-known drawings), in which the definition of light and volume is achieved entirely by the interplay of lead white and blue ground. This technique is analogous to Leonardo's Florentine drapery studies on linen of the 1470s, while metalpoint is used only for the loose and spontaneous outlining. On the other hand, the British Museum study (cat. 65) demonstrates Boltraffio's total control of metalpoint, with which volume and *chiaroscuro* are chiefly defined, while lead white is used sparingly – only on the crests of the drapery waves just touched by light. The present sheet is a half-way point in the development of this technique, and indeed chronologically it must sit between the other two. This work demonstrates a perfect balance between metalpoint and lead-white heightening (often cross-hatched), much like that achieved by Leonardo in his studies for the Sforza equestrian monument (see fig. 15), some of which have the same blue ground, or in some of his anatomical studies (such as cat. 28).[5]

The drapery here has the tactility of a sheet of hammered metal and gleams as if in moonlight. The nocturne effect of the drawing results from its marvellous combination of just three colours – blue, dark grey and white. The remarkably precise technique invites the viewer's eye to penetrate the deep hollows of the folds, where form is defined by reflected light. This *Drapery study* embodies Boltraffio's deep under-standing of Leonardo's ongoing investigations of light and shade, a recurrent theme in his several notebooks later combined to make up his *Treatise on Painting*, and pictorially synthesised in the London *Virgin of the Rocks* (cat. 32). AM

LITERATURE

Loeser 1902, p. 352 (as by Boltraffio); Suida 1929, p. 57 (as by a Lombard artist); Ballarin 1985 (2005), pp. 46, 48 (as by Boltraffio); Bora 1987–8, pp. 15, 19 n. 17 (as by Boltraffio?); Brown 1991, pp. 25, 27–8, fig. 4 (attributed to Marco d'Oggiono); Schulze Altcappenberg 1995, pp. 110–12, no. 14, p. 191 (attributed to Boltraffio, with provenance); Fiorio 2000, pp. 82, 139, no. B2 (as by Boltraffio); Bambach in Paris 2003, pp. 335–8, cat. 110 (as by Boltraffio); Wolk-Simon in New York 2004, pp. 82–3, cat. 9B (as by Boltraffio).

NOTES

1 The connection was first made by Ballarin, as can be seen by his dated (1984) inscription on the mount of the drawing.
2 For a cartoon apparently by the same hand, see cat. 51.
3 The present drapery study seems to have inspired Marco d'Oggiono in his *Young Christ* (cat. 66) and (in reverse) in the *Madonna of the Violets* (cat. 67).
4 When still in Emile Galichon's collection: Schulze Altcappenberg 1995, pp. 110–11, 191, no. 14.
5 The same blue ground and metal-point with white heightening technique are used by Leonardo in, for example, his studies of horses' forelegs (Biblioteca Reale, Turin, 15580 D.C.), around 1490–1. See Bambach in New York 2003, pp. 426–9, cat. 63.

63

GIOVANNI ANTONIO BOLTRAFFIO (about 1467–1516)

Virgin and Child ('The Madonna of the Rose')
about 1487–90

Oil on walnut
45.5 × 35.6 cm
Museo Poldi Pezzoli, Milan
(1609)

A richly dressed, red-blonde Virgin Mary stands behind a wide parapet, on top of which sits the Child, resting on his right foot. Both focus their attention on a red rose placed carefully on a fold of her blue mantle draped across the parapet. The rose sparks a series of actions and reactions, as a symbol of Christ's Passion but also of the Virgin and her compassion for his suffering.[1] The Child reaches towards it while his mother keeps him safely balanced, holding the band around his torso with her left hand. With her other hand she grasps a bunch of long-stemmed flowers in a maiolica vase also placed on the parapet.[2]

This rather complex description reflects what might seem as an ambitious, perhaps even somewhat over-sophisticated experiment by a supremely talented young artist – Boltraffio – 'the only pupil of Leonardo', as Gerolamo Casio described him.[3] In fact the artificiality of the composition was the result of a careful design process: a drawing by Boltraffio (cat. 64) served as the source for the Virgin's drapery at bottom left, while that for her head was probably very similar to the metalpoint *Head of a woman* (also at Christ Church, JBS 1062). Infrared reflectography has revealed an important pentiment in the head of the Child, showing that it was moved – eyes, nose, and cheek – to the lower left; recent analysis has also confirmed that the panel was slightly cut down along the left and the bottom edges.[4]

According to Paolo Giovio, writing in the 1520s, Leonardo did not allow his students to paint before they reached the age of 20; until then they were only allowed to draw in metalpoint.[5] In what must therefore be considered his first surviving work as a painter, Boltraffio here shows an acute understanding of Leonardo's profoundly new approach to the traditional subject of the Virgin and Child, fully expressed when he was still in Florence in such works as the *Madonna Benois* (fig. 3) and in graphic studies of the period such as his sketch of the *Virgin and Child with a cat* (cat. 56). Another frequently cited comparison with a work by Leonardo is in the dynamic pose of the *Portrait of Cecilia Gallerani* (cat. 10), whose spiral structure is clearly a source for Boltraffio's composition here. Moreover, Boltraffio's delicate and soft *chiaroscuro* demonstrates his knowledge of Leonardo's 'Florentine' first version of the *Virgin of the Rocks* (cat. 31), as opposed to the later version (cat. 32), where the lighting is more dramatic.

Bernard Berenson wrote that the *Madonna of the Rose* may 'hark back to an early idea of Leonardo's', a perceptive idea that fits with Carlo Amoretti's 1804 description of the picture: 'The same Virgin is represented in a panel of Leonardo's first manner that is in the Litta, Visconti, Arese collection.'[6] Amoretti's description follows another, probably referring to the *Madonna Litta* (cat. 57), then still in Prince Belgiojoso's collection.[7] His reference to 'the same Virgin' suggests that Amoretti believed the two Virgins to have been drawn (and painted) from the same model – an interesting statement, since they seem at the very least to be by the same hand. Soon afterwards they could be seen together in the same gallery, both listed as by the 'School of Leonardo' and similarly priced in a 1836 evaluation of the Litta collection by the painter Francesco Hayez.[8] Otto Mündler saw this 'charming Leonardesque Virgin and Child' in 1856, still in the Litta collection, and correctly attributed it to Boltraffio.[9]

These two paintings of the Virgin and Child are thus fundamental to our understanding of Boltraffio's formal appropriation of Leonardo's art. Yet while imitating Leonardo's organic dynamism, in the *Madonna of the Rose* Boltraffio's poses and composition are artificial, justified by observation of mothers and children, particularly the way in which mothers may do several things at the same time while holding their babies in this deliciously casual way – but on closer observation here appearing perhaps a little cold. By contrast, in the *Madonna Litta*, painted a little later, Boltraffio simplified the composition and reduced its energy, transforming Leonardo's lively organic forms into a classicised, perfect – but no longer alive – academic ideal. AM

LITERATURE

Amoretti 1804, p. 157 (as by Leonardo); Mündler (1985), p. 102 (as by Boltraffio?); Milan 1872, p. 29, cat. 199 (as by Boltraffio); Bertolini 1881, p. 33, no. 109 (as by Boltraffio); Suida 1929, pp. 58–9, 87, 188–9, 272, 287, fig. 64 (as by Leonardo and Boltraffio); Berenson 1938, vol. 2, pp. 112–13 (as by Boltraffio); Natale in Poldi Pezzoli 1982, pp. 83–4, no. 27 (as by Boltraffio); Ballarin 1985 (2005), pp. 7–10, 35–7 (as by Boltraffio); Fiorio 2000, pp. 23–6, 76–7, no. A1 (as by Boltraffio).

NOTES

1 Levi d'Ancona 1977, pp. 339–40.
2 Levi d'Ancona (1977, p. 195) identified these flowers as jasmine, but Prof. Enrico Banfi as *Philadelphus coronarius* (mock orange; opinion given around 1983, reported in a document in the archive of the Museo Poldi Pezzoli). Ballarin 1985 (2005), p. 8, called it a crucifer.
3 Casio 1525, c. 46r: see Villata 1999, pp. 289–90, no. 335.
4 Conducted prior to restoration by Carlotta Beccaria, whom I thank.
5 Giovio (1999), pp. 216–17.
6 Amoretti's description closely follows that given in the 1800 inventory of the Litta collection (drawn up by Girolamo Stambucchi), kindly shown to me by the Litta heirs.
7 Even though, as reported by Morandotti (1991, pp. 173, 181 n. 69), Giuseppe Vallardi (1855, pp. 35–6, no. 170) asserted that the *Madonna Litta* (cat. 57) came from the Visconti collection, probably confusing its provenance with that of the present panel. The provenance of this picture and of the *Madonna Litta* will be the subject of an article to be published in *Prospettiva* by the present author and Alfonso Litta.
8 Litta archive, Milan.
9 Mündler (1985), p. 102. For more on the nineteenth-century attributional history of the picture, see Di Lorenzo 1996, pp. 127–8; Di Lorenzo 2000, pp. 72–5, n. 29.

64

GIOVANNI ANTONIO BOLTRAFFIO (about 1467–1516)

Study for drapery lying across a parapet

about 1487–90

Metalpoint and wash heightened with white on blue prepared paper
25.1 × 18.6 cm
Christ Church, Oxford
(JBS 23)

This study of drapery – of a glacial beauty – was connected to Boltraffio's *Madonna of the Rose* (cat. 63) only quite recently,[1] and this association and the attribution of the drawing have not been seriously challenged since. The connection with the painting is clear, and the drawing may be considered an early step as the artist worked out how to place a standing female figure behind a wide parapet. The overall scheme is very similar, though many small differences can be noted. For example, the drapery in the drawing is larger in relation to the body and arm (which are just sketched in) and the position of the arm is lower, probably due to the addition of the Child in the painting. Moreover, in the drawing the fold falling from the shoulder is more developed, while in the painting it is thinner. However, the detail that unequivocally connects drawing and painting is the ribbon-like drapery fold in the centre; though this area is damaged in the painting it is still clearly visible (particularly after its recent careful conservation treatment). And it can be seen even better in a photograph of the painting before Mauro Pellicioli's 1951 intervention that removed all the reconstruction of the drapery made by the nineteenth-century restorer Giuseppe Molteni (the picture had suffered from the ultramarine blanching so common in the work of Leonardo and his followers). Curiously, Molteni's reconstruction resembled the present drawing, though he was almost certainly unaware of it.[2]

A further link can be traced between this drawing and another painting by Boltraffio: the Budapest *Virgin and Child* (cat. 53). When the right fold of drapery lying on the parapet in the drawing is compared to the equivalent passage in the Budapest painting it is evident that Boltraffio reused the study for this later work, and this is confirmed by the general arrangement of the folds. However, the cold, dry beauty of the Oxford drawing, still linked to Leonardo's early style, is softened and monumentalised in the Budapest *Virgin and Child*, which may indeed date to a decade or so later in Boltraffio's career. This, then, is an example of a practice that was common in Leonardo's workshop: to create versatile prototypes of draperies and parts of the body which could then be reused for various purposes in different contexts, and even by different artists within the same workshop.[3]

This drawing is arguably Boltraffio's earliest, if we assume that it slightly precedes his *Madonna of the Rose*,

widely agreed to be his first surviving painting. There is also stylistic and technical evidence to support this argument. The drapery in the drawing still possesses an accentuated angularity giving it the appearance of a crumpled sheet of metal. This characteristic can still be seen, for example, in the Berlin *Drapery study for a Madonna lactans* (cat. 62), but less so in later drawings such as the British Museum *Drapery study for the Risen Christ* (cat. 65), which has a new softness. In both these studies the use of metalpoint is more developed than in the present drawing, where it is reserved for the outlining of the drapery, and – washed over – for the dark shading behind the bust of the figure. But the highlights and shadows in the drapery are constructed purely by the use of white heightening on the blue prepared paper, with no sign of the metalpoint parallel-hatched shadows so typical of Boltraffio's studies of the early 1490s.

This method of achieving lighting effects once again links this work to Leonardo's Florentine drapery studies on linen of the late 1470s, suggesting that at the time he drew this work Boltraffio may still have been a novice in Leonardo's workshop, with access to the master's works of about ten years earlier.[4] AM

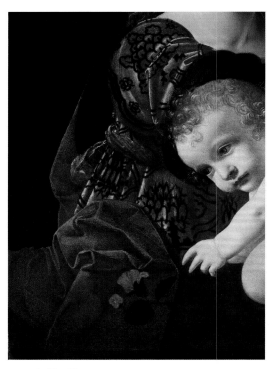

CAT. 63 (detail)

LITERATURE

Byam Shaw 1976, vol. 1, p. 39, no. 23; vol. 2, pl. 15 (as by a 'close follower of Leonardo', with provenance); Ballarin 1985 (2005), pp. 46–8 (as by Boltraffio); Fiorio 2000, p. 138, no. B1 (as by Boltraffio); Wolk-Simon in Cremona and New York 2004, pp. 82–3, cat. 9A (as by Boltraffio); Kemp and Barone 2010, p. 156, no. 120 (as by Boltraffio).

NOTES

1 Ballarin 1985 (2005), pp. 46–8; James Byam Shaw considered it a study for a kneeling saint, possibly Saint Jerome (Byam Shaw 1976, vol. 1, p. 39, no. 23) There is another fascinating metalpoint *Head of a woman* at Christ Church (JBS 1062; Byam Shaw 1976, vol. 1, p. 273, no. 1062; vol. 2, pl. 639), surely also by Boltraffio and stylistically very close to his *Madonna of the Rose*.

2 Ballarin 1985 (2005), p. 47. See also Di Lorenzo 2000, pp. 72, 74, 75 n. 29. For a good image of the painting before Pellicioli's restoration, see Ballarin 1994–5, fig. 71.

3 See also Boltraffio's *Body of a child turning right* (cat. 51), reused by the artist at various times, but also, much later, by other painters. Another example is the British Museum *Drapery for the Risen Christ* (cat. 65), arguably by Boltraffio, but trans-formed in paint by Marco d'Oggiono.

4 See also Boltraffio's *Madonna of the Rose* (cat. 63), strongly inspired by Leonardo's *Madonna Benois* (fig. 3).

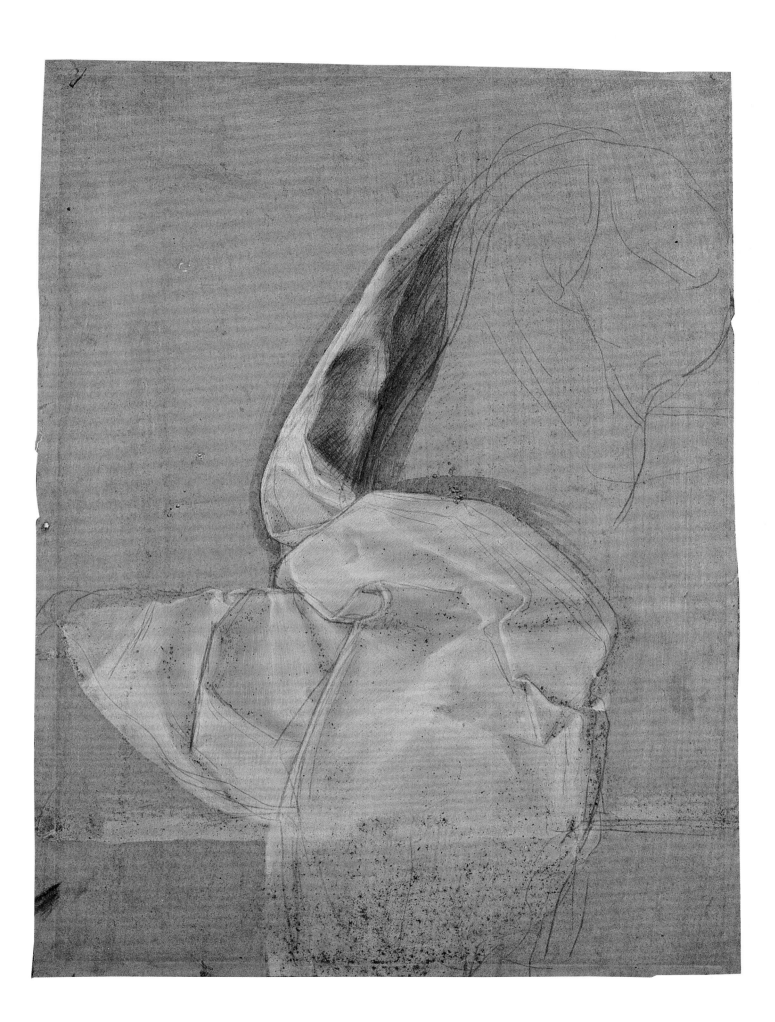

GIOVANNI ANTONIO BOLTRAFFIO (about 1467–1516)
Drapery study for the Risen Christ
about 1495–7

Black chalk and metalpoint heightened with white on blue prepared paper
18 × 15.5 cm
The British Museum, London
(1895,0915.485)

In 1885, when this drawing was still in the Malcolm collection, Giovanni Morelli attributed it to Leonardo and established its connection with the *Grifi Altarpiece* (fig. 98).[1] This altarpiece was painted for the Oratory of San Leonardo, abutting the church of San Giovanni sul Muro in Milan, now demolished.[2] Local tradition attributed it to Bramantino, but as early as 1838 Johann David Passavant detected in it the style of Marco d'Oggiono, almost 150 years before it was finally established that he, together with Boltraffio, was indeed one of its authors.[3] The 1989 discovery of the contracts for the altarpiece confirmed that in 1491 the Grifi brothers had commissioned it from the *compagni depinctori* (companion painters) Marco d'Oggiono and Boltraffio, recorded in Leonardo's studio in 1490 and 1491 respectively.[4] A second contract was drawn up in 1494, after they had failed to deliver the work.

The present work is a preparatory drawing for the drapery of the Risen Christ in the *Grifi Altarpiece*. This figure is today attributed to Marco d'Oggiono, while the two saints below are widely considered to be by Boltraffio. The fact that the drawing is related to the part of the painting for which Marco was responsible has caused many to assume that the drawing is also his. However, this study is of a much higher artistic quality than the equivalent passage in the painting. Here in the drawing a bearded figure with raised arms seems to be truly flying: his body is just outlined, while the drapery is highly defined and finished.[5] A pale light falls from above, catching the peaks of some folds of the cloak (an effect rather close to the lighting of the orange-gold lining of the Madonna's cloak in the London *Virgin of the Rocks*, cat. 32). This is achieved by subtle yet confident use of lead white over the metalpoint, which on its own does almost enough to define the volumes of the drapery. In the painting these lighting effects are rendered vulgar and the volume flattened, the exquisitely crumpled silver-leaf folds of the drawing clumsily transformed into rough, heavy material. The drawing is better ascribed to Boltraffio (by comparison with other drapery studies known to be by him, such as cats 62, 64), but was used as the source by the less talented Marco d'Oggiono.

This mode of collaboration between Leonardo's two closest pupils occurred in at least one other case. A metalpoint *Study for the portrait of a child* (fig. 93) in the Ambrosiana is rightly considered preparatory for the

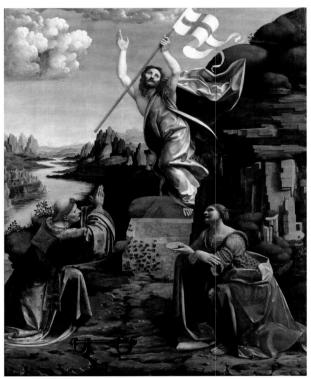

FIG. 98
GIOVANNI ANTONIO BOLTRAFFIO
and MARCO D'OGGIONO
The *Grifi Altarpiece*, about 1497
Oil on wood, 234.5 × 185.5 cm
Gemäldegalerie, Staatliche Museen, Berlin

Portrait of Francesco Maria Sforza (the sitter born 1491) in Bristol City Museum and Art Gallery (fig. 94).[6] Here, too, there is a clear discrepancy in quality between drawing and painting. The former is of an intense beauty, surely attributable to Boltraffio by comparison with his other metalpoint studies (such as cats 44, 50). The painting is clearly derived from it but the subtle light effects are minimised: there is no reason to suppose that they are by the same hand. The Bristol portrait can be dated – on stylistic and historical grounds – to about 1492–3, and is surely by the same hand as the *Archinto Portrait* (cat. 19), here argued to be by none other than Marco d'Oggiono.

The present *Drapery study* is stylistically close to Boltraffio's Budapest *Virgin and Child* (cat. 53), especially in the morphology of the folds. This is datable to about 1495–7 owing to its strong stylistic connection with the *Last Supper* and the *Grifi Altarpiece*, which although

LITERATURE

Robinson 1876, p. 16, no. 47 (as by Leonardo); Suida 1929, pp. 87–8 (as after Leonardo and assistants); Berenson 1938, vol. 2, p. 138 no. 1261D (as after Leonardo); Möller 1939, pp. 86–9, fig. 9 (as by Ambrogio de Predis, after Leonardo); Popham and Pouncey 1950, vol. 1, p. 76, no. 127; (as by a follower of Leonardo; with provenance); Ballarin 1985 (2005), pp. 55–7 (as by Boltraffio); Bora in Milan 1987–8, pp. 15, 88 (as by Marco d'Oggiono); Brown 1991, pp. 28, 33, fig. 13 n. 25 (as by Marco d'Oggiono); Fiorio 2000, pp. 22, 79, 138, 171–2, no. C10 (as by Marco d'Oggiono or Boltraffio); Bambach in Paris 2003, pp. 349–51, cat. 120 (as attributed to Boltraffio); Chapman in London and Florence 2010–11, pp. 248–9, 324, cat. 71 (as by Boltraffio); Kemp and Barone 2010, p. 123, no. 91 (as by Boltraffio).

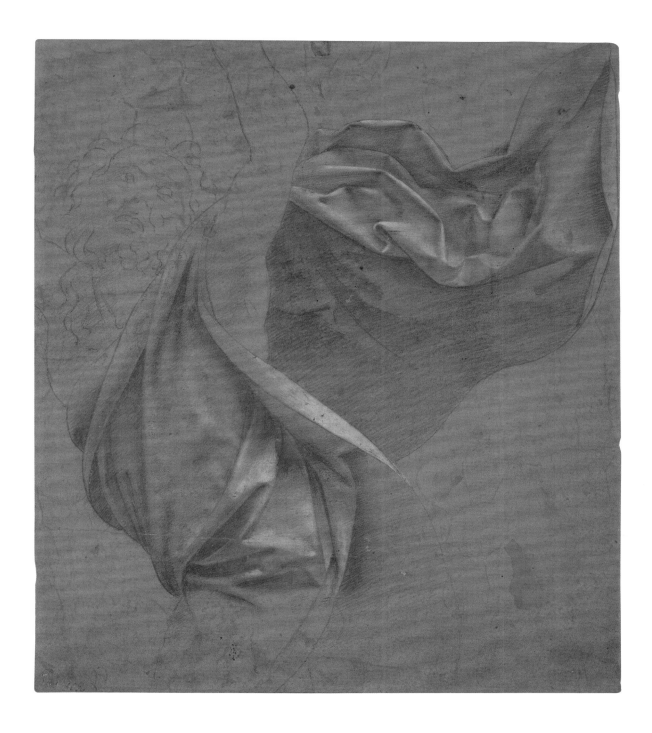

commissioned in 1491 (and again in 1494), was almost certainly executed a few years later, just as the *Last Supper* was being finished.[7] This connection is demonstrated by direct quotations from Leonardo's masterpiece: in particular, Boltraffio's head of Saint Lucy is based on Leonardo's Saint Philip. A date in the later 1490s for the *Drapery study* is also suggested by comparing it to Boltraffio's other studies of drapery from an earlier period (such as cats 62, 64). These have crisper folds and are technically less evolved, with white lead and metalpoint used more profusely and dryly. The present drawing is highly accomplished, pushing the metalpoint technique to its limits. Shortly afterwards Boltraffio abandoned the medium and moved on to black and coloured chalks, again following Leonardo's technical innovation.[8] AM

NOTES

1 I am grateful to Giovanni Agosti for drawing my attention to this reference: Richter and Richter 1960, p. 407.

2 The Oratory of San Leonardo was renamed Santa Liberata in the sixteenth century.

3 The attribution to Bramantino was reported by local guidebooks, e.g. Torre 1674, p. 213; Latuada 1737–8, vol. 4, p. 428. For Passavant's attribution to Marco d'Oggiono, see Passavant 1838, p. 290. For a discussion of the altarpiece, see Möller 1939. Ballarin anticipated the discovery of the contracts by attributing the *Grifi Altarpiece* to both Boltraffio and Marco d'Oggiono: Ballarin 1985 (2005), pp. 49–57.

4 See Shell and Sironi 1989a.

5 This is a characteristic of many other Leonardesque drawings, e.g. Boltraffio's *Drapery study* (cat. 64). Recent technical analysis has revealed interesting new information on the mixed technique between figure and drapery in the present drawing: see Chapman in London and Florence 2010–11, pp. 248–9, 324, no. 71.

6 For the Ambrosiana drawing, see Bora in Vigevano 2009–10, pp. 194–5, cat. 50. For the identification of the sitter in the Bristol painting, see Ballarin 1985 (2005), pp. 17–19.

7 See Ballarin 1985 (2005), pp. 49–55.

8 On Boltraffio's technical development see Agosti 2001, pp. 39–40, 197.

MARCO D'OGGIONO (documented from 1487; died 1524)

The Young Christ
about 1490–1

Oil on beech
25.4 × 18.6 cm
Fundación Lázaro Galdiano, Madrid
(2680)

This tiny but attractive head of Christ, still lacking his adult beard, has sometimes been linked to the 'Youthful Christ of about twelve, at that age when he debated [with the Elders] in the Temple' that in 1504 Isabella d'Este hoped Leonardo would paint for her.[1] It is unlikely he ever executed the painting she asked for, but she may originally have had the idea because she knew that Leonardo had already experimented with this subject.[2] It is possible that the *Young Christ* was based directly on a drawing by Leonardo himself (see p. 25), but the source cannot be a work of the early sixteenth century, since its design is linked to the Leonardo of the *Portrait of Cecília Gallerani* (cat. 10) and the Paris *Virgin of the Rocks* (cat. 31), whose Florentine style was so prized when he first arrived in Milan.[3] If it is indeed based on a study by Leonardo, it would belong to the same category as the *Madonna Litta* (cat. 57, inspired by cat. 59), with which it is almost exactly contemporary.

A black chalk drawing in the Musée des Beaux-Arts, Rennes, has been considered as preparatory for the present painting.[4] The two share some formal aspects, such as the direction of the light, the curls of the hair, the slightly open mouth (as if Christ is speaking) and the muscle of the neck emphasising the pose of the turned head: both depict the young Christ as if turning to speak, debating with invisible Doctors standing alongside the viewer. However, as well as being slightly different in scale, stylistically the two belong to completely separate eras of Italian art: this fundamental difference is encapsulated by the nineteenth-century attribution of the Rennes drawing to the school of Raphael (wrong but not entirely misguided).[5] Today the drawing is convincingly ascribed to Correggio: it may well be that nearly twenty years after the *Young Christ* was painted Correggio used the same lost study by Leonardo (or a visual record of it) as a source for his own drawing.[6] Correggio's drawing, which is pricked for transfer, was then used for his own painting of the *Young Christ* in the National Gallery of Art, Washington, DC.

Any attribution of the Lázaro Galdiano *Young Christ* – which in a 1902 postcard was (astonishingly) considered to be Leonardo's portrait of Verrocchio's daughter – needs to take account of the fact that this is a pupil's skilful combination of workshop models and techniques, with such a commitment to 'academic' rules and his master's ideas, that the pupil seems here to be acting, in the words of Wilhelm Suida, 'as Leonardo's right hand'.[7] For this reason the suggestion that it was painted by Ambrogio de Predis, never really a fully Leonardesque painter, should be decisively rejected. The picture is probably better associated with the stylistically consonant group formerly defined as by the Master of the Archinto Portrait. This hitherto anonymous painter is here identified as the young Marco d'Oggiono (see cat. 19), recorded in Leonardo's studio in 1490.[8] The Christ has also been given to Boltraffio, a hypothesis explicable in the light of its high quality and of Marco's close working relationship with him in the 1490s.[9] Indeed, there are many features here that evoke Boltraffio's work: the lighting and structure of the head, hair and neck are similar to his *Madonna of the Rose* (cat. 63); the swathe of drapery over the shoulder and concertina folds of the shirt recall his early drapery studies (such as cats 62 and 64); the greyish skin tones and palette are similar to those of the *Madonna Litta* (cat. 57). But Boltraffio's figures are more elegant and controlled. The rather too prominent eyes are typical of Marco d'Oggiono: the *sfumato* modelling is applied like make-up, though the eyelids remain both flat and oddly puffy. As a result, Marco loses control of Christ's expression, which is at the same time melancholic and slightly gormless, an expression that strongly resembles that of the sitter for the *Archinto Portrait* (cat. 19) and the *Girl with the Cherries* (fig. 90).

The knot pattern along the neck of the robe is a *leitmotiv* of Leonardo's workshop (see cat. 55),[10] reappearing in almost identical form in his *Portrait of Cecília Gallerani* (cat. 10) and the London *Virgin of the Rocks* (cat. 32). Marco d'Oggiono himself reused it on the belt of *Il Duchetto* (fig. 94), and – in a slightly different form – on the transparent veil worn by the Christ Child in the *Madonna of the Violets* (cat. 67). AM

LITERATURE

Meier-Graefe 1910 (1926), p. 76 (as by the circle of Leonardo); Berenson 1932, p. 472 (as by Ambrogio de Predis); Romano 1981, pp. 45–6, fig. 58 (as attributed to the 'Pseudo-Boltraffio'); Ballarin 1985 (2005), pp. 20–3 (as by Boltraffio); Marani in Brera 1988, p. 189 (as by the 'Pseudo-Boltraffio'); Baudequin in Modena and Rennes 1990, pp. 30–1, under cat. 9 (as by Marco d'Oggiono); Brown 1991, p. 33 n. 28 (as attributed to Ambrogio de Predis); Ruiz Manero 1996, pp. 108–9, fig. 52 (as by Ambrogio de Predis?); Fiorio 2000, pp. 185–6, no. D12 (as by Ambrogio de Predis); Marani in Florence 2005–6, cat. IV.50 (as by a Milanese artist close to Leonardo); Saguar Quer 2004 (as by Boltraffio, with detailed provenance); Danieli in Mantua 2006–7, pp. 172–3, cat. 54 (as by a Lombard painter close to Boltraffio).

NOTES

1 Romano 1981, p. 46.
2 Romano 1981, p. 46. A similar subject by Leonardo, which however cannot be Isabella's, survives: the *Salvator Mundi* of about 1500 (cat. 91).
3 The hypothesis that this is a sixteenth-century work (Marani 1987, p. 211, under no. 39) should be rejected (see Marani in Florence 2005–6, p. 168).
4 Inv. 794.1.3094. See Baudequin in Modena and Rennes 1990, pp. 30–1, cat. 9.
5 Müntz 1898, vol. 2, p. 259, no. 11.
6 See Roman in Paris 2008–9, pp. 436–7, cat. 195.
7 See Saguar Quer 2004. The postcard is reproduced in Fúster 1999, p. 180, fig. 2.
8 When he was victim of the theft by Salaì of a silverpoint (Villata 1999, pp. 63–4, no. 53).
9 In June 1491 he was commissioned – together with Boltraffio – to paint an altarpiece for the Grifi family chapel (see cat. 65), suggesting that at that date the pair were regarded as a good substitute for Leonardo himself.
10 See Venturelli 1997; Borsi 1999.

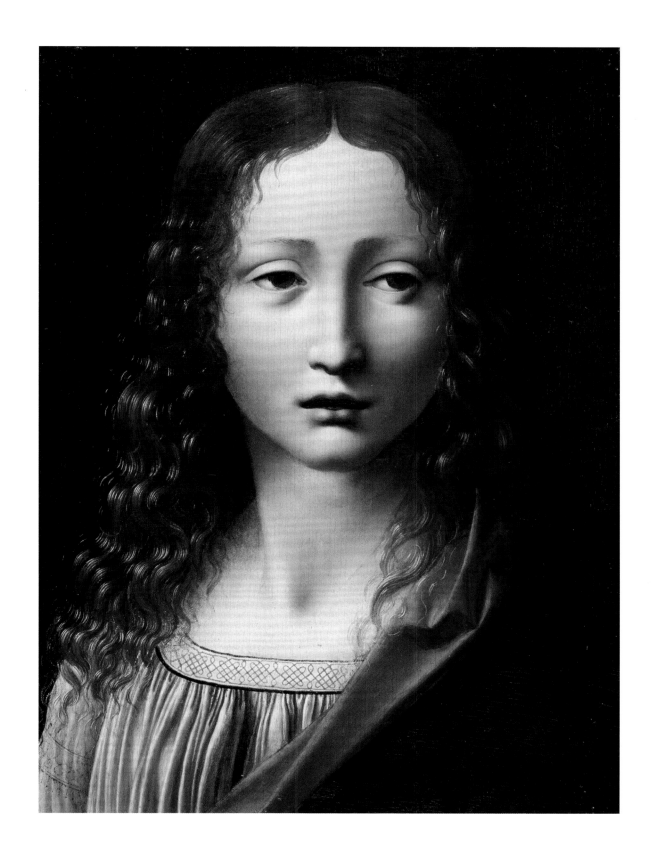

67

MARCO D'OGGIONO (documented from 1487; died 1524)

Virgin and Child ('The Madonna of the Violets')
about 1498–1500

Oil on wood, transferred to canvas
56.2 × 42.9 cm
Collection De Navarro

The *Madonna of the Violets*, sometimes known as the 'Davenport Bromley *Madonna*', is shown here for the first time since it was exhibited in Milan in 1964. Despite its long absence from public view, the painting is nevertheless considered one of the most representative of Leonardo's workshop. Indeed, comparison with his own pen-and-ink drawing of the *Virgin and Child with a cat* (cat. 56) reveals that its composition is highly indebted to the master himself. In both works the Virgin stands in three-quarter view, holding the restless Child. Christ looks back at his mother with an anguished twist of his head and she returns his gaze with motherly indulgence. Whereas in the drawing Christ embraces a cat, here he holds a bunch of violets.[1]

The painting was famous by the nineteenth century when, in the collection of Cardinal Fesch in Rome, it was believed to be by Bernardino Luini. Gustav Waagen later viewed it in the Davenport Bromley collection at Wootton Hall, describing it as a 'very beautiful picture' belonging to 'the early part of Leonardo's residence in Milan'.[2] He later compared it with the *Madonna Litta* (cat. 57): in composition (reversed) and style it is indeed indebted to that higher-quality and still controversial painting most plausibly attributed to Boltraffio.[3] Interestingly, the *Madonna of the Violets* has similarities to other works by Boltraffio, especially his drawings. For example, the metalpoint study of the head of a woman in the Ambrosiana, Milan (Cod. F 263 inf. 99), which served as a model for the head of the Virgin here, while the Christ Child's fleshy body is strikingly similar to his drawing of the body of a child (cat. 51).

Such dependence on Boltraffio's oeuvre of the 1490s fits the attribution of this painting to Marco d'Oggiono very well. Wilhelm Suida first suggested it was painted by Marco in 1949, adding that 'the soft shadow and utmost refinement in the modelling of the Virgin's head indicate Leonardo's participation in this exquisite work'. This last hypothesis is highly dubious: the picture's quality is completely consistent throughout, showing no signs of Leonardo's hand.[4] But this exhibition provides an opportunity for scholars to review the question anew.

When compared with Marco d'Oggiono's only documented work of the 1490s, the *Risen Christ* from the *Grifi Altarpiece* (figs 66, 98), executed jointly with Boltraffio (see cat. 65), the *Madonna of the Violets* emerges as fundamental to our understanding of Marco's early

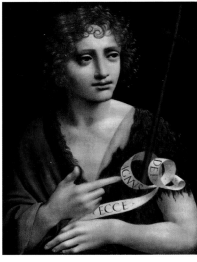

FIG. 99
MARCO D'OGGIONO
Saint John the Baptist, about 1498–1500
Oil on wood, 28 × 21 cm
National Trust, Knightshayes Court, Devon

career. The head of the Risen Christ in the altarpiece (fig. 66) is closely related to that of the Child here, especially in the emphatic pose and the structure of the shadows. Comparison with paintings stylistically attributed to the Master of the Archinto Portrait, here identified with Marco d'Oggiono (see cat. 19, which has a similar streaked marble parapet, and cat. 66), confirm that they were painted by the same artist. Yet the bright palette of works now attributed to Marco from the early 1490s becomes somewhat simpler and more homogeneous in the *Madonna of the Violets*, more in keeping with his later career. His *Saint John the Baptist* (fig. 99), for example, is of an identical mood and similar colour scheme.[5]

The setting here, with a curtain dividing the 'terrace' where the figures stand from a distant landscape, is very un-Leonardesque. The arrangement is more typical of a Venetian Virgin and Child group of the late fifteenth century, such as those by Giovanni Bellini, taken up elsewhere in north-east Italy around 1500.[6] Marco d'Oggiono is documented as working for the Scuola di Sant'Ambrogio at the Frari church in Venice in 1498.[7] The atmospheric lakeside landscape, with the Lombard Pre-Alps in the background, movingly evokes Marco's own birthplace of Oggiono, on the shores of Lake Annone near Lake Como.[8] AM

LITERATURE

Waagen 1854, vol. 3, p. 377 (as by Leonardo); Waagen 1875, p. 156 (as by Leonardo); Suida in Los Angeles 1949, pp. 80–1, cat. 18 (as by Marco d'Oggiono and Leonardo); De Grada in Milan 1964, pp. 10–11, cat. 5 (as by Leonardo and assistant); Berenson 1968, vol. I, p. 242 (as by Marco d'Oggiono); Marcora 1976, pp. 262–3, pl. 89 (as by Marco d'Oggiono); Sedini 1989, pp. 40–1, no. 9 (attributed to Marco d'Oggiono); Brown 1991, pp. 25, 31 fig. 8, 33 nn. 17 and 18 (as by Marco d'Oggiono); Shell 1998c, p. 169 (as by Marco d'Oggiono); Ballarin 2000, pp. 132, 135 (as by Marco d'Oggiono).

NOTES

1 A symbol of humility, the violets are emblems of the Crucifixion, and the Virgin Mary (Levi d'Ancona 1977, pp. 398–9).

2 The painting was sold as by Leonardo da Vinci at the Davenport Bromley sale (Christie's, London, 12 June 1863, lot 81, bought by 'Goldsmith'). In the late 1940s it was in Jacob Heiman's collection, Los Angeles, and subsequently bought by the present owner in 1960 (for a more complete provenance see Rush 1961, pp. 315–16, illus. p. 317).

3 An engraving of the *Madonna Litta* in reverse, usually attributed to the circle of Giovanni Antonio da Brescia, was probably available by the end of the fifteenth century (Hind 1948, vol. 5, p. 86, no. 1; vol. 6, pl. 610).

4 As pointed out in the review of the Milan 1964 show: Brizio 1964.

5 Considered an early work by Marco d'Oggiono since Suida 1934–9, pp. 140–1, fig. 37. I am grateful to Sara Adams of the National Trust for permission to examine the picture.

6 The Getty *Christ carrying the Cross*, recently attributed to Marco d'Oggiono (Brown 1991, pp. 28, 33 n. 25, p. 34, fig. 14), is also more typical of north-east Italy around 1500 (e.g. Marco Palmezzano and Giovan Francesco Maineri, who painted several versions).

7 Shell 1992 (to be read with the corrections of Momesso 1997, pp. 28–9, 41 n. 74).

8 It is interesting to note that Marco d'Oggiono is documented as a cartographer: see Marani and Shell 1992.

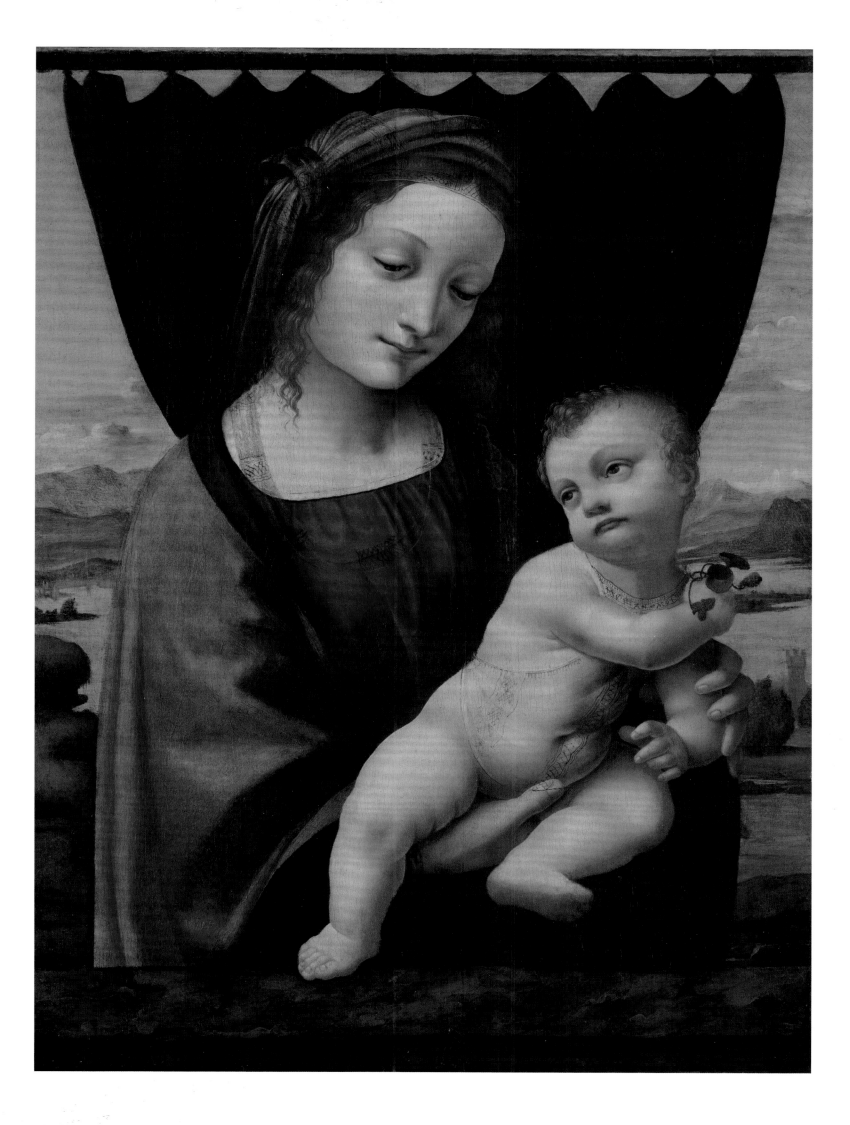

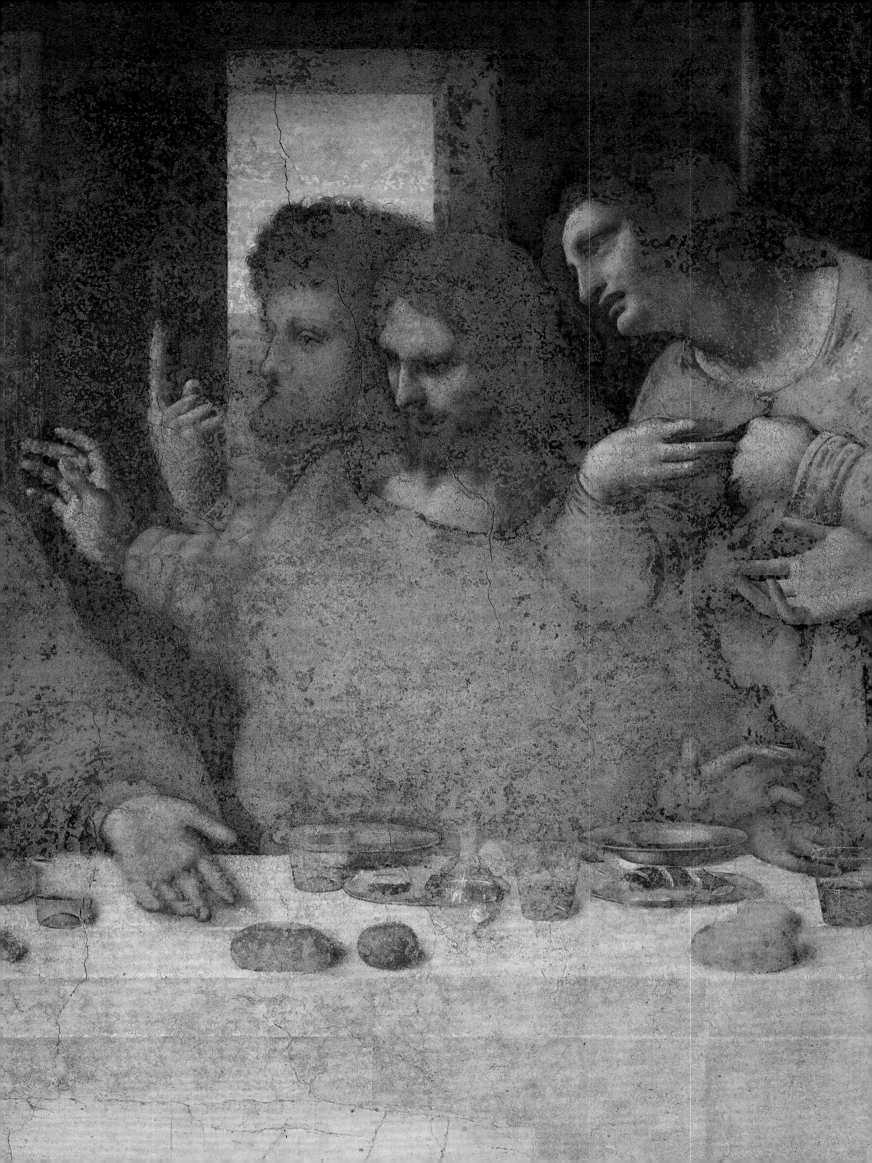

CHARACTER AND EMOTION
THE LAST SUPPER

L EONARDO DA VINCI'S RENOWNED MURAL OF THE *Last Supper* (fig. 100) was the most ambitious work he undertook while painter at the court of Milan.[1] It was also, thanks in part to pressure from his patron Ludovico il Moro, one of the few large-scale projects he ever brought to completion. Probably begun in 1492 while he was working on the full-scale model for the Sforza equestrian monument (see pp. 30–4) and finished by early 1498, the *Last Supper* became famous even before it was completed. However, Leonardo's use of an experimental technique to paint the mural meant that within 20 years of completion the work was a ruin of its former self. Today the *Last Supper*, which remains in its original location on the wall of the refectory of the Dominican convent of Santa Maria delle Grazie in Milan, continues to draw awestruck admiration and excite debate – even wild speculation – as to its meaning. The surviving drawings connected with the project, all of which are gathered here, and the evidence provided by one of the earliest copies, made when the *Last Supper* retained much of its original form (cat. 84), provide us with invaluable insights into Leonardo's thought processes and working methods. Through them we can also glimpse how he strove to achieve an ideally harmonious solution to an intensely ambitious composition in which he might both portray

the individual reactions of the Twelve Apostles to the devastating announcement from Christ that one among their number would betray him, while simultaneously communicating the ineffable beauty and divine mystery of the Saviour's imminent sacrifice.

Ludovico il Moro asked Leonardo to paint the *Last Supper* as part of a grand programme of works at Santa Maria delle Grazie in Milan.[2] This included commissioning the celebrated architect Bramante to rebuild the apse of the convent church to house a planned Sforza mausoleum, in which Ludovico intended to be buried alongside his wife, Beatrice d'Este. For the Dominican friars who would be charged to pray for his immortal soul Ludovico also provided a newly refurbished refectory, in which, it is said, he himself took to dining twice a week, on Tuesdays and Saturdays. Leonardo was given the north wall of the room for a depiction of the *Last Supper* – and possibly after 1494, when Ludovico finally achieved the exalted title of Duke of Milan, Leonardo was also charged to paint the Ducal, Sforza and Este coats of arms in the lunettes above the composition.[3] Framed by the Sforza arms and the living presence of the Duke himself, the harmonious perfection of the *Last Supper* has to be seen within the context of the rhetoric surrounding Ludovico's court (see pp. 13–53). But study of the work itself alongside Leonardo's drawings and Giampietrino's early copy also reveals the *Last Supper* to be another instance of Ludovico providing Leonardo with an opportunity to demonstrate the full range of his powers on a grand scale, and to put into practice ideas he may have been working on for some time.

In Leonardo's day, the Last Supper was a well-established subject for the refectories of religious institutions as it appropriately combined the depiction of a sacred meal with an object for personal reflection. According to the Gospel of Saint John (13:21), at the last meal Christ shared with his disciples before his arrest and crucifixion, he appeared troubled and said: 'Verily, verily, I say unto you, that one of you shall betray me.' Other artists had used the inherent drama of the event as an opportunity to test their skills in portraying emotion and individual character, and Leonardo's own study (cat. 69) may well be a sketch

he made after another painter's version. However, Leonardo was the first to conceive of the Last Supper as such an astonishing piece of theatre, setting the action in a carefully devised perspective space that would appear to physically extend the refectory itself while making the head of Christ both the perfect centre and the vanishing point for the whole.[4] The convincing presence of the figures and the highly illusionistic depiction of the meal upon the table are similarly arranged by Leonardo according to an harmonious and abstract geometry that makes the credible world he creates simultaneously appear a higher reality. Particularly noticeable is Leonardo's repeated use of the divinely significant number three to group the Apostles, for example, as well as the windows in the back wall and the doors between the tapestries.

This striving for some sense of a universal or divine harmony may also have affected Leonardo's decision to rethink the usual depiction of the Last Supper's narrative. In conventional treatments Judas appears alone on the viewers' side of the table and is shown being handed a sop (a piece of bread dipped in wine) by which Christ has said he will identify his traitor (see cat. 70). But by placing Judas on the same side of the table as the other Apostles (his shadowed quarter-profile can be seen on the left, third in from Christ), Leonardo abandons this more obviously story-telling aspect of the narrative and removes Christ from direct interaction with any of his followers. Leonardo instead shows Christ isolated, reaching towards a glass of wine and a loaf of bread, which may suggest he is about to prepare the sop. But with Leonardo's typical brilliance for introducing multiple layers of meaning without disrupting the integrity of his chosen subject or the overall harmony of his composition, Christ's gesture also references his later institution of the Eucharist by which he invites the Apostles to eat his bread saying 'this is my body' and to drink his wine saying 'this is my blood'.[5] The pose also makes Christ's body take on the form of a triangle, in Christian iconography a symbol of the Holy Trinity of Father, Son and Holy Ghost, while his open arms remind the faithful of his fate upon the Cross.

The drawings gathered here give some insight into the processes by which Leonardo was able to arrive at this

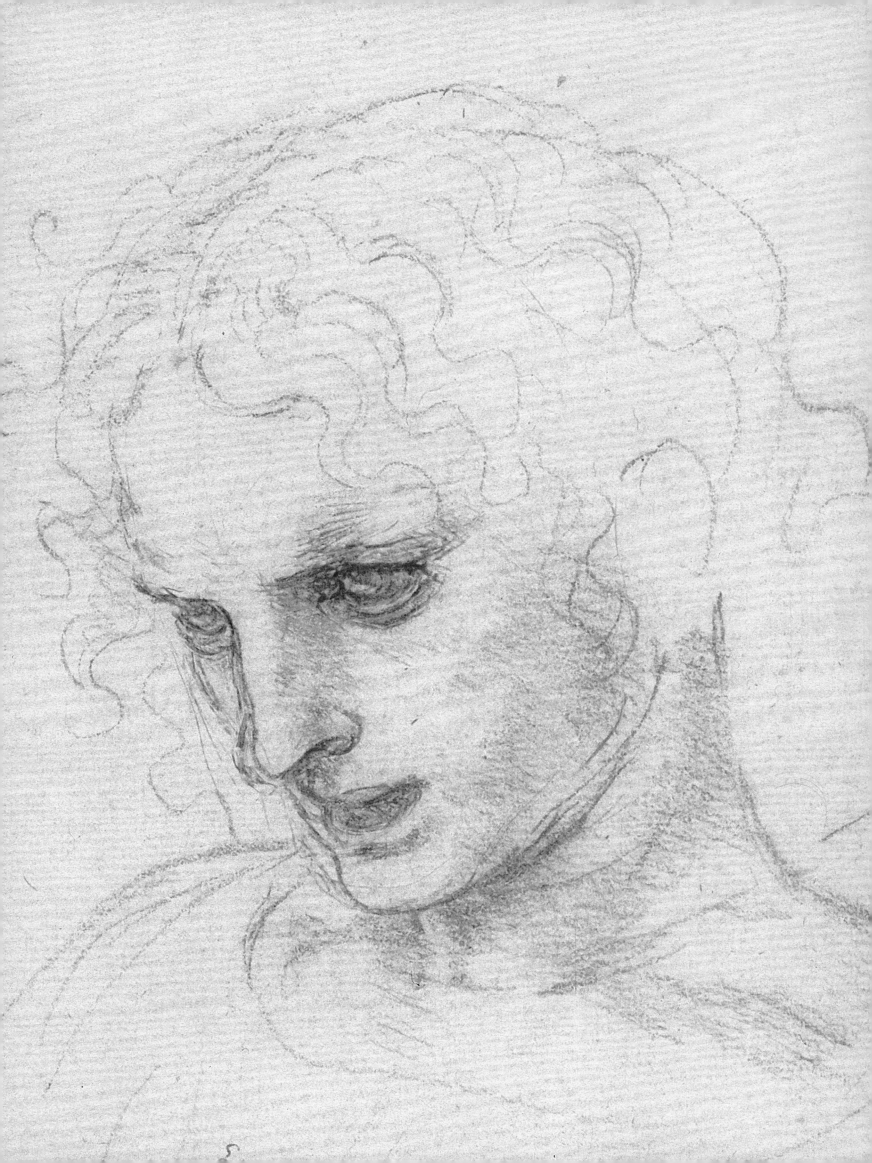

extraordinary depth of complexity. They range from rapidly penned brainstorming sketches for the overall composition (cat. 70), the earliest of which pre-dates Leonardo's arrival in Milan, right through to the extraordinary individual studies for the heads of the Apostles. In the case of his study used for Saint James the Greater (cat. 75), the drawing appears to have been quickly sketched from life and was treated by Leonardo with typical lack of preciousness when he scribbled a drawing of castle architecture in one corner of it. The study possibly for the head of Bartholomew (cat. 80), on the other hand, seems a carefully synthesised amalgam of a virile, military type that, along with all other manner of other character types, Leonardo is reported as having made a point of observing and sketching. In 1554 the Ferrarese writer Giambattista Giraldi, called 'il Cinzio' (1504–1573), described Leonardo's working practice:

> Whenever he would paint some figure, he considered first its quality and its nature, whether it was noble or plebeian, happy or severe, troubled or serene, old or young, irritated or tranquil, good or wicked; and then knowing its being, he went where he knew persons of that kind congregated and observed diligently their faces, manner, clothes and bodily movements. Having found that which seemed to him fitting, he drew it with his stylus in the little book that he always kept at his belt. And having done this again and again, and feeling satisfied that he had collected sufficient material for the figure which he wished to paint, he would proceed to give it shape and did it marvellously.[6]

Having once gathered and synthesised his material to create a convincing type, Leonardo then worked on animating his character. 'That figure is most praiseworthy which, by its action, best expresses the passion of his soul',[7] he wrote, and he went on:

> The movement which is depicted must be appropriate to the mental state of the figure. It must be made with great immediacy, exhibiting . . . great emotion and fervour, otherwise this figure will be deemed twice dead, in as much as it is dead because it is a depiction, and dead yet again in not exhibiting motion either of the mind or of the body.[8]

The surviving *Last Supper* studies of individual faces, hands and, in one case, the sleeve of Saint Peter (cat. 83), can be seen as part of Leonardo's attempt to fix how, according to their character and age, each individual Apostle's *moti mentali* (mental movements) might outwardly manifest themselves. However, unlike some of his studies of grotesque heads (cat. 74) where the facial expressions are coarse and extreme, in the *Last Supper* Leonardo needed to portray the emotions of divine individuals whose gestures might also be orchestrated into a harmonious and meaningful whole. As a great many of the drawings made in Milan attest, Leonardo spent much time pursuing his studies into natural, physical and mathematical science. Among the many phenomena he studied were the effects of stones dropped in water, and the way ripples first move outward from the central point and then rebound off other surfaces (he observed similar effects in sound waves and in light). So in the *Last Supper,* while the Apostles express their individual responses according to their character, those closest to Christ (Saint John and Judas on the left and Saint James the Greater on the right) push backwards to suggest the initial impact of Christ's announcement, while the forward movements of Bartholomew at the far left and Philip on the right represent the rebound back towards the centre. In the midst of these reverberations, Christ's stillness raises him above his disciples and, in spite of this area of the painting having suffered extreme damage, the palimpsest of subtle emotions we can still read from his face and open-armed gesture suggests that in him Leonardo was striving to create a figure that might represent the ideal embodiment of all emotion, both human and divine.

In trying to bring so much together Leonardo decided against using the conventional mural technique of fresco, which demanded that the artist rapidly paint directly onto wet plaster and commit to the first thing put down. Instead, he invented an experimental technique in which he applied paint on to the dry plaster wall using a thick layer of egg tempera on top of a chalk ground bound with glue, with an additional thin layer of oil paint in places.[9] This allowed him to make frequent revisions, create the subtle light effects and modelling he was after, and let him

CAT. 68 (recto, detail)

work when it suited him. The writer of *novelle* Matteo Bandello (about 1480–1562), who had familial connections with the Grazie and was a boy when the *Last Supper* was being painted, published this vivid account of Leonardo's erratic work-patterns:

> Many a time I have seen Leonardo go early in the morning to work on the platform before the *Last Supper*; and there he would stay from sunrise to darkness, never laying down the brush, but continuing to paint without eating and drinking. Then three or four days would pass without his touching the work, yet each day he would spend several hours examining it and criticising the figures to himself. I have also seen him, when the fancy took him, leave the Corte Vecchia when he was at work on the stupendous horse of clay, and go straight to the Grazie. There climbing on the platform, he would take a brush and give a few touches to one of the figures: and then suddenly he would leave and go elsewhere.[10]

The instability of Leonardo's technique meant that the paint surface soon began to flake away, and the darker, more intensely coloured areas of paint that you can see in the present reproductions represent all that is left of the original. In 1978, following several disastrous attempts at restoration dating back to the eighteenth century, a 20-year programme of conservation and scientific analysis began. In this the surviving drawings and early copies played a crucial part. The most faithful of the surviving painted copies is by Giampietrino (cat. 84) and proved particularly valuable. Painted on the same scale as Leonardo's *Last Supper*, it gives some idea of the challenges Leonardo faced in translating his drawings to such a heroic scale, as well as shedding light on a number of details which are today lost in the original. However, when set against the present ghost of Leonardo's painting, there is no comparison. Even as it stands, it is hard not to consider Leonardo's *Last Supper* the greatest work he ever made. LAK

NOTES

1 On the *Last Supper* see Clark 1939, pp. 99–101; Brambilla Barcilon and Marani 2001; Milan 2001; Romano 2005; Wassermann 2007.
2 Marani 1999, pp. 15–22.
3 Marani 1999, pp. 21–2.
4 Kemp 1981, pp. 188–89.
5 See Steinberg 2001, pp. 31–53.
6 Quoted in Kwakkelstein 1994, p. 139.
7 BN 2038 fol. 29v; Urb. fol. 123v; R 584; MCM 400; K/W 390.
8 Urb. fol. 110r; MCM 401; K/W 391 (cited on p. 73 in this volume). See also K/W 392–5.
9 On the history of the technical problems of the *Last Supper*, see Marani 1999, pp. 36–51.
10 For the original text, see Villata 1999, p. 301.

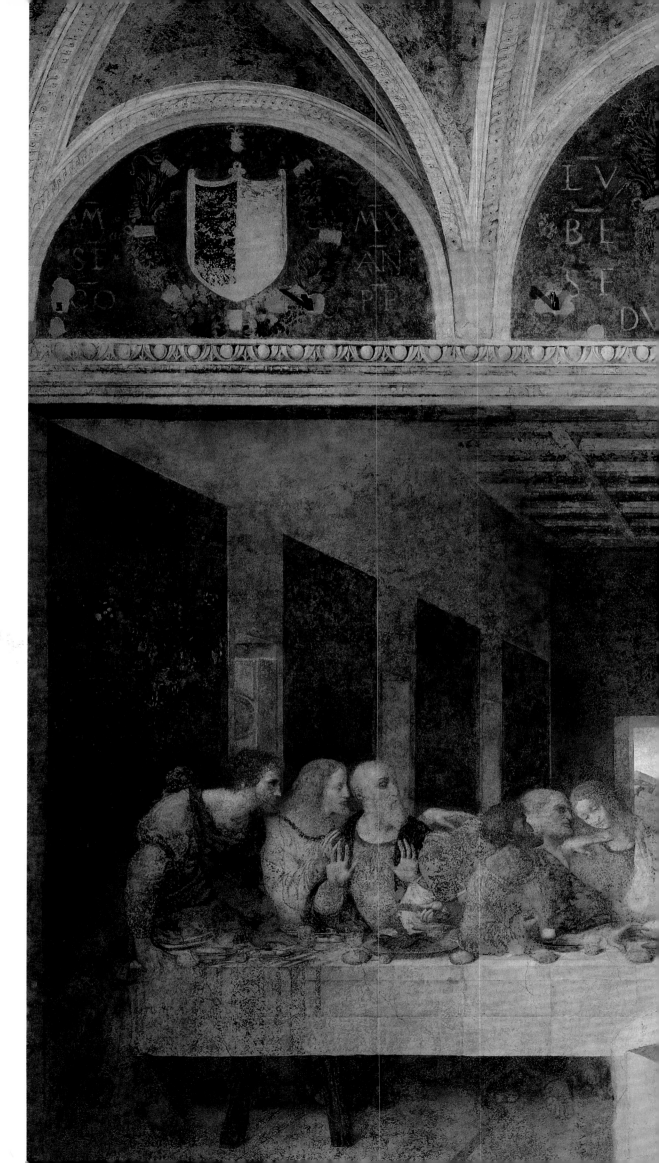

FIG. 100
LEONARDO DA VINCI
The Last Supper, 1492–7/8
Tempera and oil on plaster,
460 × 880 cm
Santa Maria delle Grazie, Milan

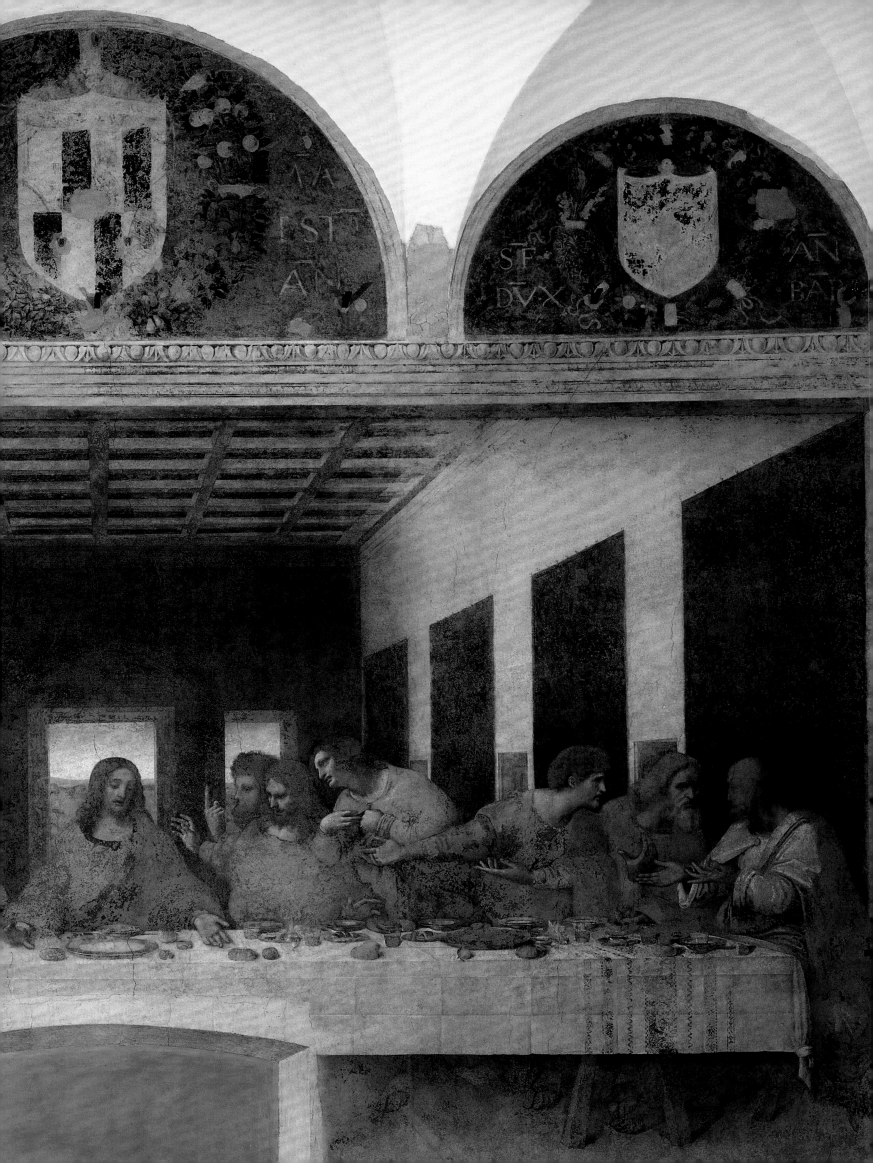

68

LEONARDO DA VINCI (1452–1519)

Studies of male figures; a hygrometer; a mother and child (recto); *Studies of male figures* (verso)
about 1480–1

Pen and ink over metalpoint on prepared paper
27.7 × 20.9 cm
Inscribed in Italian
Musée du Louvre, Paris
(2258)

The brilliantly orchestrated arrangement of Apostles in the *Last Supper* mural implies that it was the result of years of thinking about figure groups, human gesture and, above all, how best to depict figures interacting with one another. This drawing shows that thinking on the page.

It was Leonardo's practice to try out ideas for different subjects simultaneously on the same sheet of paper. By doing so, motifs and figure groups associated with one subject would often, intentionally or serendipitously, migrate into another. On the recto and verso of this double-sided sheet are figure studies connected with Leonardo's unfinished painting of the *Adoration of the Magi* (fig. 34).[1] On the recto they are joined by a study of a hygrometer (used to measure moisture in the atmosphere), a leadpoint study for a mother tending her child and what have been identified as early ideas for figure groupings for a Last Supper. The sheet dates to 1480–1, when Leonardo was still in Florence, and of course long before he actually received the commission to paint a Last Supper for the refectory of Santa Maria delle Grazie in Milan.

Leonardo's incessant creative drive meant that during his lifetime he covered literally thousands of sheets with drawings and notes; committing things to paper was for him a way of thinking them through. Thus the present sheet is a lively reminder of Leonardo's thought-process as he arranged and rearranged the human form to varying effect. Working from top to bottom, the single figure at the upper left of the sheet, leaning forward and gesticulating, can be connected quite easily with the supplicating magus in the *Adoration* altarpiece, where this figure is rotated and kneeling before the Christ Child. He is then repeated underneath, this time placed with another figure so that the two now appear engaged in discussion. This pair then expands to become the group of five interacting figures beneath that, now seated around a table. It is this group, together with the bearded figure at bottom left, seemingly a Christ, also seated behind what appears to be a table and pointing to a plate, that have been identified as early ideas for a Last Supper.

However, pre-dating the *Last Supper* commission by over a decade, this sheet cannot strictly speaking be considered preparatory for the wall painting – and there is no evidence that such a commission was ever

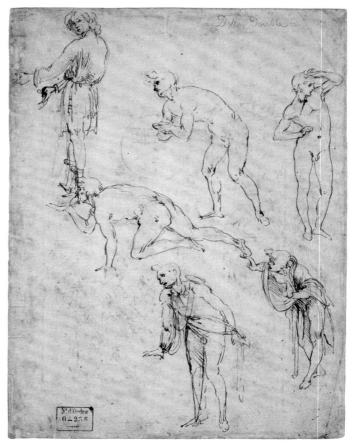

CAT. 68 (verso)

mooted in Florence. Instead, we can understand this as a fascinating example of the way in which Leonardo's mind worked. It is clear that while experimenting with how to depict figures in lively conversation, he was struck by the realisation that such a group would work well for a painting of the Last Supper. Leonardo's figures are at this stage nude – already, and in line with Florentine practice of the period, he wanted to give viewers as true and accurate a representation of the human body in particular and sometimes difficult poses, even if his protagonists would eventually be fully clothed. Here lie the roots of what would become his very much more innovative and evolved investigations of the body. MME

LITERATURE

Kemp 1981, p. 70; Clayton in Venice 1992, pp. 192–3, cat. 2; Bambach in New York 2003, cat. 29, pp. 324–8; Viatte in Paris 2003, pp. 107–12, cat. 26; Marani 2008, pp. 33–5, no. 15.

NOTES

1 Other drawings of bystanders for the *Adoration of the Magi* commission survive; one in the Wallraf-Richartz Museum (z 2003) is particularly close in character to the present drawing, but see also the drawing in the Ecole Nationale Supérieure des Beaux-Arts (424) and the recto of a sheet in the British Museum (1886,0609.42). See Bambach in New York 2003, pp. 320–3, cat. 28, pp. 329–33, cats 30–1.

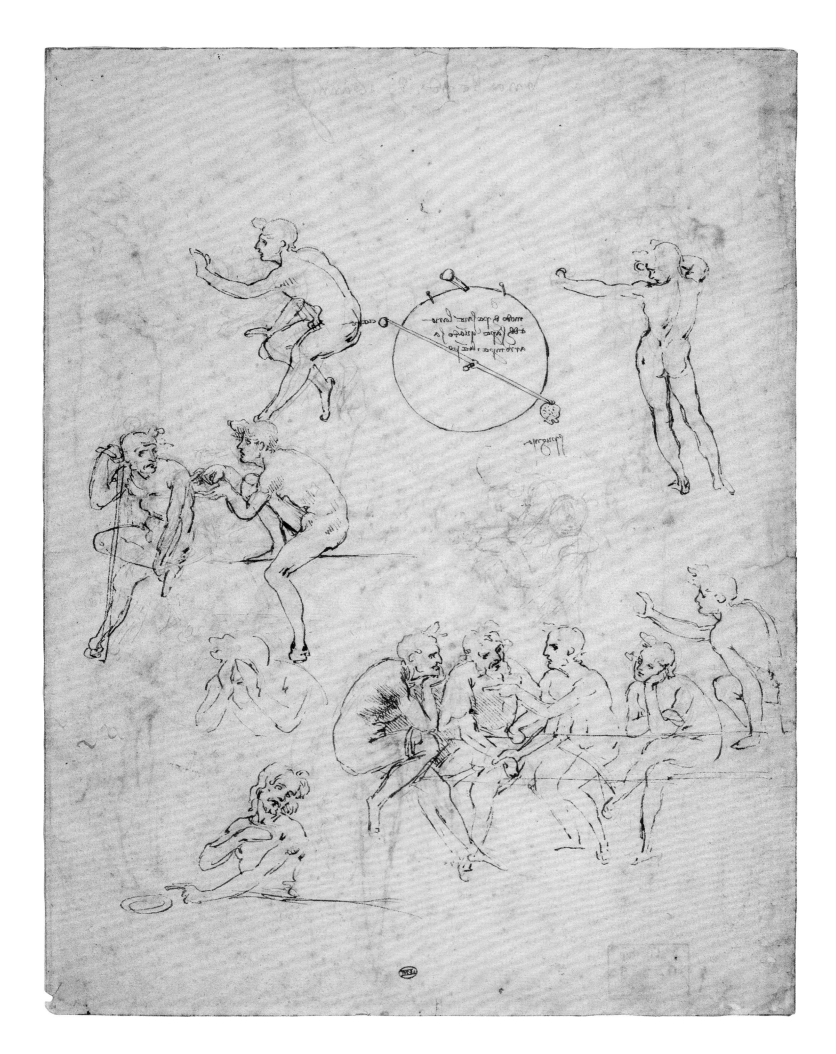

69

LEONARDO DA VINCI (1452–1519)
Study after a Last Supper
about 1492

Red chalk and traces of pen and ink on paper
25.3 × 39.4 cm
Inscribed in Italian with the names of the Apostles
Gallerie dell'Accademia, Venice
(254)

The somewhat awkward character of this drawing, which is nonetheless grand in its scale, has led to passionate controversy surrounding its authorship.[1] The style of the figures and the quality of the drawing do not appear to accord with Leonardo's own, although some details, such as the spidery chalk line, can be matched with other sheets that are certainly his.[2] The most persuasive argument in favour of its autograph status has been the analysis of the handwriting naming the disciples. The distinctive left-handed backwards script is absolutely typical of Leonardo's handwriting in the early 1490s, and the red chalk with which he writes is the same as in the drawn parts of the sheet.

The drawing focuses on the individual disciples and their arrangement. Working as he did from right to left, it is not surprising that the most highly worked-up part of the sheet is on the right side; Leonardo presumably started with the study in the top half of the sheet, which depicts the right end of the table, before running out of space and continuing the left end of the table underneath. This explains why the disciple on the top left, his hand turned uncomfortably back on itself, is then repeated below, t far right. This is an iconographically traditional representation of the Last Supper story, with Judas placed on the opposite side of the table to the other figures, being handed the sop – the dipped bread – which will identify him as the traitor, while the youthful Saint John swoons across the table. These are all devices that Leonardo would eventually abandon in favour of a less formal, more naturalistic rendition.

The awkwardness of the drawing comes in part from the fact that it has none of the searching, spontaneous quality normally seen in Leonardo's sketches. The disciples are not woven together convincingly as an interacting group, but instead appear as an assembly of isolated individuals. This is best explained by the likelihood that Leonardo was not here developing his own composition but copying another, of an earlier era. Judging from the style of the drawing, with its sweeping draperies and flowing locks of hair, it seems plausible that the work he copied dated from the late fourteenth or early fifteenth centuries.[3]

Leonardo's decision to name some of the Apostles (presumably unnamed in the original) suggests that he was still trying to assign names to character types – thus Philip is named twice (on the furthest right in the top sketch and second from right in the bottom), since Leonardo perhaps considered that a youthful type would be best suited to Saint Philip (who is certainly young and beardless in the finished painting).

The other factor to be taken into consideration when relating this drawing to the rest of Leonardo's oeuvre is that it was only around this date that he began to use the medium of red chalk. With its intrinsically limited tonal range, red chalk is ideal for depicting surface texture and in particular the subtle transitions of light and shadow, as Leonardo would go on to demonstrate so marvellously (see cat. 75, for example). But, as this sheet testifies, it is perhaps less suited to working out or describing a composition.[4] The extremely straight left-handed parallel hatching lines evident here were however a defining feature of Leonardo's hand – in other drawing media – in this period of his career. The memory of the figures at the upper right would linger in Leonardo's finished painting. MME

LITERATURE

Clark 1952, p. 95; Pedretti in Washington 1983–4, p. 33; Clayton in Venice 1992, pp. 232–3, cat. 19; Marani in Milan 2001, pp. 152–3, cat. 41, (as a copy).

NOTES

1 Marani categorises it as a later copy after Leonardo (Marani in Milan 2001, pp. 152–3, cat. 41). See Bambach in New York 2003, p. 54, cat. 37 for a full list of the varying opinions on this drawing.
2 Clayton remarks that this spidery line is found in Manuscript H and Forster III, and the same 'coarse' use of red chalk can be observed in a sheet of coition studies (Windsor RL 19096r/v). Clayton in Venice 1992, p. 232.
3 Curiously, there are not as many surviving examples of the Last Supper in Milan and its environs as there are in other cities (e.g. Florence). Pedretti in Washington 1983–4, p. 33 proposed the nearby and locally celebrated fresco of the Last Supper in the Franciscan convent of Sant'Angelo alle Fosse, destroyed in 1551. Fragments from a late fourteenth-century Last Supper survive in the parish church of Brione Verzasca, Ticino; see Dell'Aqua and Matalon 1963, pl. 297; see pls 56–9 for examples of other Trecento frescos in the region (not necessarily of the Last Supper) that are close to Leonardo's drawing, supporting the suggestion that the work he was copying dated from this moment.
4 Clayton in Venice 1992, p. 232.

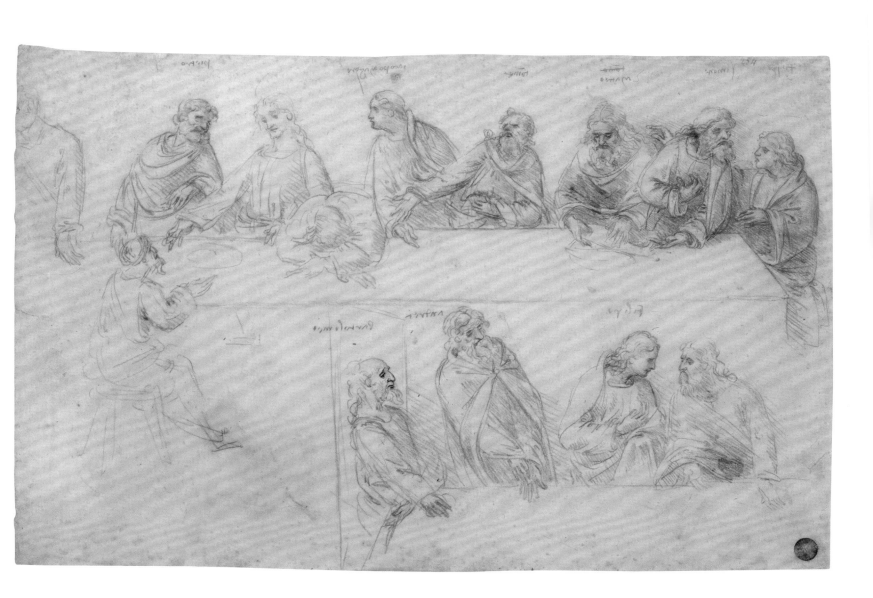

70

LEONARDO DA VINCI (1452–1519)

Compositional sketches for the Last Supper;
architectural and geometric sketches
about 1490–2

Pen and ink on paper
26.6 × 21.4 cm
Inscribed in Italian
Lent by Her Majesty The Queen
(RL 12542r)

The two separate studies of figure groups in the top portion of this sheet constitute Leonardo's earliest surviving compositional ideas for the *Last Supper* and show how the artist was trying to break away from the traditional way of representing the subject. Although both groups are quickly sketched, Leonardo probes the internal dynamics of the scene with great vigour. Unlike the early Louvre drawing (cat. 68), Leonardo clearly knows exactly what his subject is here and what he wants to achieve with it. The result is coherent thinking about how to orchestrate an animated group around a table. For the first (and only) time among his drawings we see Leonardo working out how to set a narrative within an architectural space; the group on the left are seated in front of a faint indication of an arcade, which diminishes in strength from right to left, as we have come to expect from this left-hander. In fact it bears no relation to the real architectural space in the refectory, where the north wall is surmounted by three lunettes with foliage and the arms of Sforza family.

The larger figure group, at the top left, represents the Apostles on either side of Christ, although precisely which figure is meant to be Christ has been debated.[1] They are arranged along the far side of a long table, with plates and dishes of food in front of them, and what must be the figure of Judas, on the near side, physically separated from the others, according to iconographic tradition. To the right of this is a slightly enlarged study of the main protagonists in the story; this time Christ is unequivocally identifiable as the bearded figure with his head inclined to the left, his right arm resting on the back of John, who has collapsed, prostrate, in response to Christ's prophetic words. Two alternative positions are tried out for Christ's left arm: reaching across the table towards the bread, and raised in a pointing – possibly blessing – gesture. Judas is still on the opposite side of the table; he has risen from his seat and reaches forward to the same plate as Christ, a visual realisation of the

Saviour's words as recounted in the Gospel of Saint Matthew (26:23), 'he that dippeth his hand with me into the dish, he shall betray me'. Ultimately the *Last Supper* composition would look quite different, with all the Apostles on the same side of the table so that the viewer can see their faces and feel part of the holy gathering. However, this drawing tells us a great deal about the beginning of Leonardo's artistic journey.

The sheet also contains a diagram which investigates the construction of an octagon, complete with explanatory notes underneath, four, tiny architectural sketches down the left hand side[2] and, to the left of these, a column of numbers which have been understood as either relating to the mathematical division of an architectural space or alternatively merely as sums pertaining to Leonardo's accounting. The question of whether there was a mathematical component in the planning of the *Last Supper* continues to divide opinion; on the verso of the present sheet, however, there are more calculations, some of which clearly annotate geometric and architectural studies.[3] MME

LITERATURE

Clark 1935, vol. 1, pp. 84–5; Clark and Pedretti 1968–9, vol. 1, pp. 99–100; Roberts in London 1989, pp. 60–1, cat. 10; Clayton in Venice 1992, pp. 230–1, cat. 18; Marani in Milan 2001, pp. 124–6, cat. 27; Steinberg 2001, pp. 273–87; Bambach in New York 2003, pp. 435–9, cat. 65.

NOTES

1 Bambach in New York 2003, p. 439, cat. 65.
2 Marani (Milan 2001, p. 107) says that these sketches show a rapport with the *tiburio* of the Duomo in Milan, about which Leonardo was thinking around 1487–90.
3 Kemp 1981, pp. 196–9 cites this drawing as proof of the connection between the *Last Supper* and Leonardo's mathematical interests. He also makes the point that the period of its execution was when Leonardo collaborated with the mathematician Luca Pacioli on illustrations for the *De Divina Proportione*. See Kemp 1981, pp. 196–9.

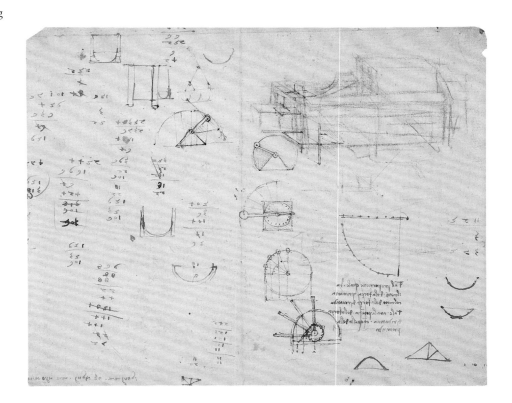

CAT. 70 (verso)
Architectural and geometric drawings; calculations
Pen and ink and black chalk

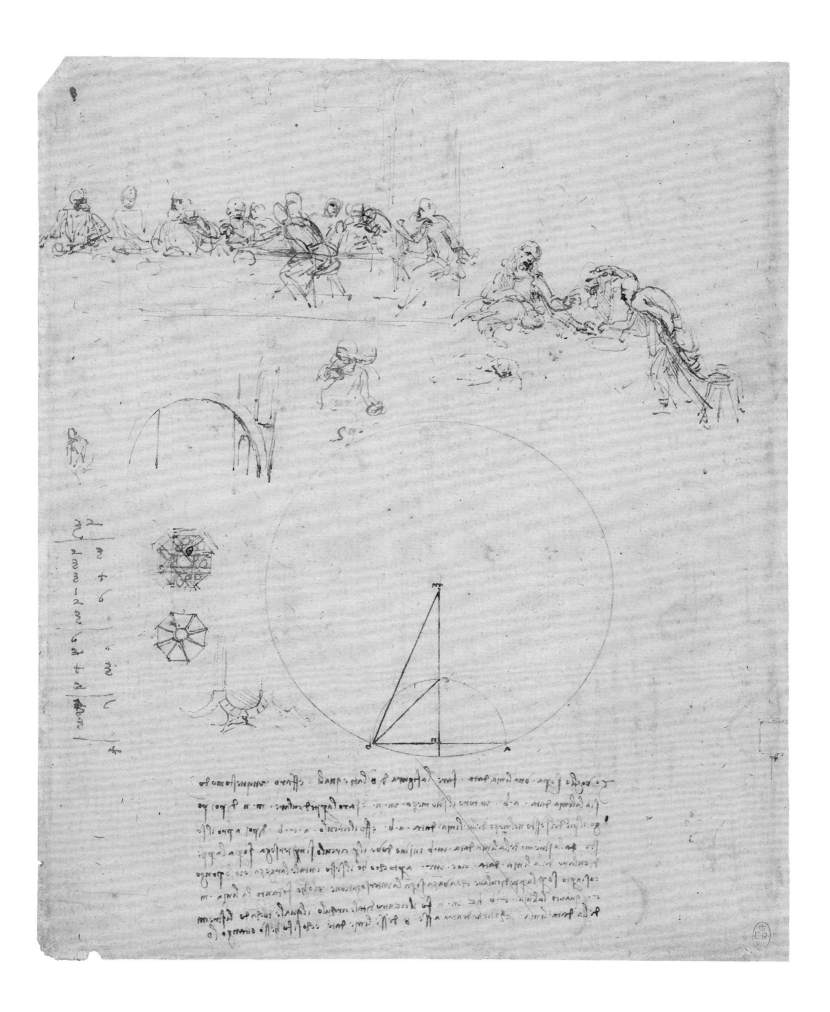

FIGS 101, 102
LEONARDO DA VINCI
The Last Supper (details of fig. 100),
1492–7/8

LEONARDO DA VINCI (1452–1519)

Description of men dining; emblem designs
about 1493–4

Pen and ink and red chalk on paper
9.5 × 7 cm
Fol. 62v (inscribed in Italian): 'One who was drinking and has
left the glass in its place and turned his head towards the speaker.
Another, twisting the fingers of his hands together, turns with
stern brow to his companion. Another with his hands spread open
shows the palms, and shrugs his shoulders up to his ears, making
a mouth of astonishment. Another speaks into his neighbour's
ear and he, as he listens to him, turns towards him to lend an ear,
while he holds a knife in one hand, and in the other the loaf half
cut through by the knife. Another who has turned, holding a
knife in his hand, upsets with his hand a glass onto the table'[1]
Fol. 63r (inscribed in Italian): 'Another lays his hands on the
table and is looking. Another blows his mouthful. Another
leans forward to see the speaker, shading his eyes with his hand.
Another draws back behind the one who leans forward, and
sees the speaker between the wall and the man who is leaning'[2];
in red chalk: 'the cut down tree grows again'/'I still hope'/
'falcon'/'time'
Codex Forster II, fols 62v–63r
Victoria and Albert Museum, London

Codex Forster II is one of three parchment-bound
volumes containing five of Leonardo's notebooks now
surviving at the Victoria and Albert Museum. Pocket-
sized, they contain the artist's day-to-day ruminations
on a wide variety of subjects: in the present book
there are notes that pertain to subjects ranging from
mathematics and proportion to bells and a striking
mechanism. It is not known when the notebooks were
bound into three volumes, but it is possible that it was
while they were in Spain, owned by the Italian sculptor
Pompeo Leoni (1533–1608). Now known as the Forster
Codices, they were bequeathed to the Victoria and
Albert Museum by the English bibliophile John
Forster (1812–1876).

The passage in black ink, written in a careful
specimen of Leonardo's backwards writing, comes from
a notebook compiled around 1493–4 and describes
the actions and reactions of a group of men at dinner
listening to a speaker, always assumed to be the disciples
responding to the words of Christ at the Last Supper.
Throughout his life the combination of word and
image was crucial to Leonardo – indeed, it is salutary to
be reminded that he wrote more than he drew.
Articulating ideas through the written word was always
another avenue for him in his quest to record and
interpret the world around him. This, however, is an
extremely rare example of how his observations would

be translated not into another developed text but
into a picture, functioning as a wonderfully vivid aide-
memoire as he sought a repertoire of suitable poses for
the disciples. His words are all the more precious since
the *Last Supper* seems to be the only one of his works
to which Leonardo directly refers in his writings.

Among the list of dramatic gestures for the disci-
ples here, some are identifiable with the final poses
that Leonardo painted in the *Last Supper* mural, but the
final sentence suggests that the artist was still envisag-
ing a more traditional Last Supper composition at this
stage, with a long table placed in front of a wall.[3] In
the same way that the Accademia study (cat. 69) was
probably copied by Leonardo from a Last Supper by
another artist who impressed him, it is possible that
he was making a list of possible attitudes having seen
a Last Supper in which he was taken by the disciples'
characterisation. Equally, he may have been watching
and remembering a real group of men. It is revealing
that Christ is called merely 'the speaker' and that none
of the actions is yet assigned to a named Apostle. Like
the two drawings of the whole composition (cats 69,
70), this written description can be dated to a very
early stage in the gestation of the project, before
Leonardo had settled on what was to be his own,
highly innovative solution. MME

LITERATURE

Clayton 1992; Pedretti in Washington
1983–4, p. 27.

NOTES

1 R 665; K/W 579.
2 R 666; K/W 580.
3 Clayton 1992, p. 229.

72

LEONARDO DA VINCI (1452–1519)

A bearded old man (Saint Peter?)

about 1487–90

Pen and ink over metalpoint on grey-blue prepared paper
14.5 × 11.3 cm
Albertina, Vienna
(17614)

In Leonardo's *Last Supper*, Saint Peter appears on the left between the young Saint John and Judas. Half-rising from his seat, Peter leans forward between them, his neck craned as if to hear and see better, his left hand gesticulating towards Christ in astonishment and disbelief. His right arm is bent back on his hip and in his right hand he holds his fisherman's knife, a reminder of his hasty temper.[1]

The present drawing was first connected to the *Last Supper* by Berenson in 1903.[2] Although the association is generally accepted, since the facial type of the bearded man with his prominent nose and chin is so similar, if it was indeed drawn with the *Last Supper* in mind, it must have been made before Leonardo had settled upon his final composition. Not only is the pose very different (rather like Cecilia Gallerani's, cat. 10), but the figure is lit from the upper right, whereas in the mural the group is lit from the upper left (coinciding with the actual light source of the windows in the refectory). Such a transformation was, however, Leonardo's speciality. Seemingly rapidly executed but highly worked, this is a tremendously exciting drawing, with the facial area given particular focus. Tufts of hair protrude from his mainly bald head, his thick, curly beard joining with the curls around his ears. A series of

semicircular lines indicates the sags and bulges of his ageing face, while beneath his deeply furrowed brow his eyes look out especially piercingly.

The medium of metalpoint, which allowed so little flexibility, is combined here with pen and ink to extraordinary tonal effect.[3] Not only does Leonardo capture the power and monumental stature of the saint, but he also manages to convey a sense of the drama of the inner man, the workings of his soul – his fierceness, steadfastness and strength. For Leonardo, outward appearances reflected the inner human state:

> It is true that the face shows indications of the nature of men, their vices and temperaments ... Men whose faces are deeply carved with marks are fierce and irascible and unreasonable. Men who have strongly marked lines between their eyebrows are also irascible. Men who have strongly marked horizontal lines on their foreheads are full of sorrow, whether secret or admitted.[4]

This drawing would have provided a good basis for Saint Peter's character-type for the mural; having successfully defined this, it is not difficult to see how the figure was inserted into the choreographed whole of the final wall-painting. MME

LITERATURE

Pedretti in Washington 1983–4, p. 38; Marani in Milan 2001, pp. 122–3, cat. 26; Bambach in New York 2003, pp. 440–3, cat. 66.

NOTES

1 Cadogan 2000, p. 214 suggests that the presence of Saint Peter's knife in pictures of the Last Supper is as a reminder of his action in cutting off the ear of a soldier at the moment of Christ's arrest.
2 Berenson 1903, vol. 1, p. 156; vol. 2, p. 62, no. 1113.
3 For more on Leonardo's use of the metalpoint technique see Bambach in New York 2003, p. 442.
4 Baxandall 1972, p. 59; Urb. fol. 109v MCM 425; K/W 398. For a detailed discussion of this subject, see Laurenza 2001, pp. 161–72.

LEONARDO DA VINCI (1452–1519)

Measured study of a foot

about 1490–2

Red chalk on paper
9 × 7 cm
Inscribed in Italian: 'a b c are equal'
Lent by Her Majesty The Queen
(RL 12635r)

The small size of this sheet suggests that it was originally a page from one of Leonardo's pocket-sized notebooks, like the Codex Forster (cat. 71). Kenneth Clark was the first to make the connection between this study of a right foot from above and the foot of Christ (or Judas) in the *Last Supper*,[1] but his suggestion has not been unanimously accepted: it may be that this drawing was used for the *Last Supper* or made initially for its own sake, as part of Leonardo's researches into the human body which he began around 1490.[2] The lines traversing the foot and the inscription imply that he is trying to understand the proportions of the foot when viewed from this awkward angle.[3] It corresponds very well with Christ's right foot in the mural, which

was originally visible beneath the table before a door was cut into the refectory wall in 1652, obliterating this section. This missing part of the mural can today only be understood from early copies of the painting, such as that by Giampietrino (cat. 84). In the mural Christ wears sandals but the relative proportions of the toes, with the second toe fractionally longer than the big toe, is identical to the drawing.

It was always crucial for Leonardo to understand exactly how the underlying structure of the human body worked before he inserted it into its painted context, regardless of whether or not he intended eventually to clothe the body. MME

LITERATURE

Clark 1935, vol. 1, pp. 112–13; Pedretti in Washington 1983–4, pp. 78–81, cat. 5; Marani in Milan 2001, pp. 136–7, cat. 33; Wolk-Simon 2004, p. 57.

NOTES

1 Clark 1935, vol. 1, pp. 112–13.
2 In technique it may be compared to cat. 58.
3 The verso of the sheet is also concerned with proportions, this time relating to the fall of light and shade. See Pedretti in Washington 1983–4, pp. 78–81, cat. 5.

CAT. 104 (detail)

74

LEONARDO DA VINCI (1452–1519)
Five character studies ('A man tricked by gypsies')
about 1490–3

Pen and ink on paper
26 × 20.5 cm
Lent by Her Majesty The Queen
(RL 12495r)

Leonardo's so-called caricature studies – or grotesques – are evidence of his fascination with the expressive potential of the human figure.[1] Intrigued by old age, deformity and ugliness as much as by beauty, Leonardo was, in the words of Giorgio Vasari, 'so delighted' when he saw 'certain bizarre heads of men, with the beard or hair growing wildly, that he was capable of following them for an entire day in order to impress their features on his mind to then draw them from memory'.[2] These '*visi mostruosi*',[3] as Leonardo himself called them, were never inserted into his paintings but were very likely shown to people, perhaps at court, as a source of serious and amusing entertainment, often satirising or mocking well-known types. Of the group (about 200 in total), the present sheet is by far the most sophisticated and, unlike the others, appears to have a narrative.

Martin Clayton has convincingly argued that it tells the story of the 'Man tricked by Gypsies'. Gypsies had arrived in Western Europe from the Balkans by the early fifteenth century and, despite the fascination with which they were regarded, they soon acquired a reputation for deceit.[4] In 1493 Ludovico Sforza issued an edict expelling the gypsies from the Duchy of Milan; Leonardo's drawing seems therefore to be a response to a real contemporary issue.[5]

The malevolent nature of the characters surrounding the central protagonist here is suggested by their grotesque facial types: the wizened, toothless old woman on the left who wears the characteristic fringed headscarf of a gypsy; the figure at the back left with wild hair, laughing raucously; the bald, menacing man next to him on the right; and the strange, androgynous creature on the far right with protruding lower lip. In the centre, by comparison, is a distinguished elderly man in profile, his bald head crowned with a wreath of oak leaves. His right forearm is held by the woman on the right, who is seemingly in the act of reading his palm (but this edge of the sheet has been cut), while the old woman on the left reaches her hand under his coat, apparently attempting to pick his pocket.[6]

Two copies of this drawing survive today, but its composition became widely known in Italy and north of the Alps, suggesting that it was much more copied; it was also engraved.[7] The trimming of the sheet must have taken place at an early date for the copies tend not to show the palm-reading and focus instead on the contrast between the perfidy of the surrounding characters versus the perhaps somewhat dim-witted innocence of the central one. Indeed, this compositional tactic was to prove key to Leonardo himself in the *Last Supper*, where the characterful, expressive Apostles are contrasted with the impassive features of the centrally placed Christ. This drawing is datable to about 1490–3, when Leonardo was thinking about how best to orchestrate his *Last Supper* to elicit maximum emotional impact; one can imagine the present sheet as the great mural's burlesque counterpart. MME

LITERATURE

Gombrich 1976, pp. 57–75, especially pp. 71–2; Kemp 1981, pp. 156–9; Cogliati Arano in Venice 1992, pp. 320–1, cat. 59; Clayton 2002, pp. 27–33; Clayton in Edinburgh and London 2002–3, pp. 96–9, cat. 41; Bambach 2003a, p. 16; Wolk-Simon 2004, pp. 51–2.

NOTES

1 Leonardo made grotesque studies between about 1490 and 1505. They were hugely popular from the Renaissance onwards and copied well into the eighteenth century. For a recent, focused study of this subject, see Kwakkelstein 1994.
2 Vasari (1966–87), vol. 4, p. 24. Vasari himself owned some of Leonardo's 'bizarre heads'.
3 Bambach in New York 2003, p. 443.
4 Clayton in Edinburgh and London 2002–3, p. 96.
5 Clayton in Houston, Philadelphia and Boston 1992–3, p. 29.
6 The last two sentences of Leonardo's inscription on the verso of this sheet are interesting in this context: 'And if anyone who possesses some virtue finds himself among them, he will be treated by the others just as I am treated: in fact I have reached this conclusion: it is a bad thing if they are enemies and worse if they are friends.'
7 On the drawn copies, see Kwakkelstein 1993, pp. 56–66.

75

LEONARDO DA VINCI (1452–1519)

Sketch of a youth; fortifications

about 1493

Red chalk and pen and ink on paper
25.2 × 17.2 cm
Lent by Her Majesty The Queen
(RL 12552)

In 1787 Johann Wolfgang von Goethe visited Santa Maria delle Grazie in Milan on his return journey from Italy. Thirty years later, in his review of Giuseppe Bossi's seminal publication on Leonardo's *Last Supper*,[1] he described the drama of the composition in prose that became so famous that his reading entirely dominated the literature on Leonardo's great mural for the next century.[2] Of Saint James, for whom this drawing is a study, he wrote: 'James the elder draws back, from terror, spreads his arms, gazes, his head bent down, like one who imagines that he already sees with his eyes those dreadful things, which he hears with his ears.'

Among the most beautiful of the surviving studies used for Apostles' heads, this drawing has the added excitement of being apparently drawn from the life.[3] As such it is a rare survival among the group of extant drawings for the *Last Supper* and gives a strong sense of the ways in which the artist searched for expressions to give to his protagonists. The hair is hastily sketched in and there is little description of the body below the neck. Leonardo's attention is instead focused on the face, looking down and therefore in shadow, and specifically on the area of the eyes and mouth through which the facial expression is conveyed. These parts are heavily worked and it is clear from the furrowed brows and parted lips that Leonardo's intention here is to find an expression of horror as the subject recoils from what he hears and sees. This is exactly the response of the Apostle James the Greater, seated second from the right of Christ in the *Last Supper*. As is characteristic of Leonardo's working method, the Apostle's reaction is only enlarged in the final painting, where his arms are thrown out to the sides as his whole body reacts, aghast, to Christ's words.

In the bottom right corner of the sheet is the faint indication of what must be his left hand, which appears to be holding something; this is quite altered in the mural. At bottom left are four architectural sketches for domed corner pavilions, usually described as schemes for the modification of the Castello Sforzesco; these help to date the sheet to the early 1490s.[4] The combined use of red chalk and pen and ink seems to suggest a slightly earlier date for this drawing than is often given, comparable to the way in which both pen and ink and red chalk appear on the same page in the Codex Forster II (cat. 71).[5] MME

FIG. 103
LEONARDO DA VINCI
The Last Supper (detail of fig. 100 showing Saint James the Greater), 1492–7/8

LITERATURE

Clark 1935, vol. 1, pp. 86–7; Clark and Pedretti 1968–9, vol. 1, p. 102; Pedretti in Washington 1983–4, pp. 98–101, cat. 10; Marani in Milan 2001, pp. 130–1, cat. 30; Clayton in Edinburgh and London 2002–3, pp. 132–3, cat. 51; Wolk-Simon 2004, p. 52.

NOTES

1 Goethe 1818.
2 On this issue see Steinberg 2001, pp. 35–8; app. B, B
3 Marani suggests that Leonardo used the same model for his painting of the *Musician* (cat. 5).
4 See Pedretti in Washington 1983–4, p. 100, cat. 10.
5 As also seen in cat. 1.

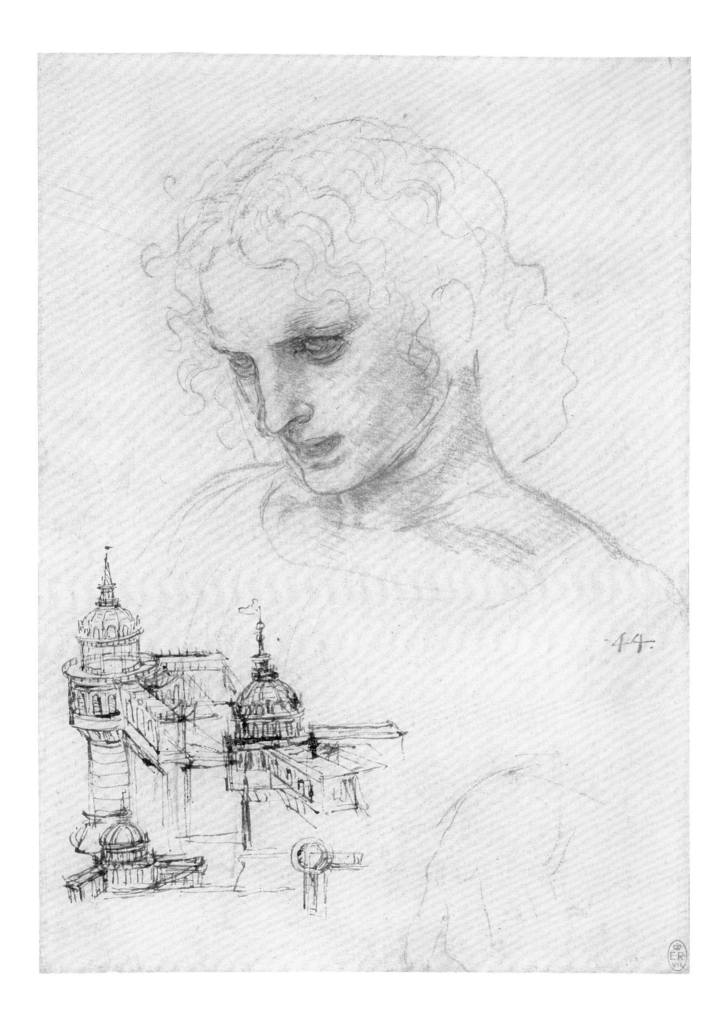

LEONARDO DA VINCI (1452–1519)
Head of a youth
about 1491–3

Black chalk on paper
19 × 15 cm
Lent by Her Majesty The Queen
(RL 12551)

FIG.104
LEONARDO DA VINCI
The Last Supper (detail of
fig. 100 showing Saint Philip),
1492–7/8

This study is related to the depiction of the youthful Philip in the *Last Supper*, who stands furthest to the right of the group of three immediately to the right of Christ. His is an active pose, his head straining forward, his left arm gathering up his robe, his right hand touching his chest as if profoundly moved by what he hears. Perhaps the most appealing aspect of Philip's attitude is the way in which his head is inclined, in precisely the way of people absorbed by trying to comprehend what they are experiencing. The head is more subtly inclined in the drawing. As with all the surviving preparatory drawings of Apostles' heads for the *Last Supper*, it is only when Leonardo transfers them to the mural that he raises the emotional tenor of the narrative. What becomes something near anguish in the mural is in this study a calmer, although still intense, spiritual absorption.

The beauty of this face has led some to suggest that Leonardo used a female model.[1] However, it is just as likely that he drew a young man, since his ideal of beauty is never obviously masculine nor feminine.[2] Indeed, the refined features suggest that the drawing was not in fact made from life, but was an already worked-up design for a pose that Leonardo intended to use in the mural.[3] The youth of the subject is apparent, with

smooth, unlined skin and no trace of facial hair. Here Leonardo manipulates the black chalk brilliantly, blending it in certain areas, specifically around the eye sockets, to create his famous *sfumato*. His lips parted, the young man takes on an otherworldly appearance.

The recent discovery of two underdrawings beneath the paint of Leonardo's London *Virgin of the Rocks* (cat. 32) has added a further dimension to the evolution of the figure of Saint Philip. The first of these shows a kneeling Virgin Mary adoring, we assume, the Christ Child, her left hand held to her breast (see pp. 66–7, fig. 45).[4] Her features precisely match those of Saint Philip in the painted *Last Supper*, albeit in reverse, and are in fact closer to the final, painted version of Saint Philip than to the head in the present drawing.[5] It may therefore be that Leonardo first used this drawing for the underdrawn head of the Madonna in the *Virgin of the Rocks* (interesting given the debate over the sex of the model); pleased with the result but eventually discarding the composition, he may then have reused the drawing when he came to paint Saint Philip in the mural, this time without reversing it but giving him the same gesture as the Virgin and again exaggerating the incline of the head.
MME

LITERATURE

Clark and Pedretti 1968–9, vol. 1, p. 102; Pedretti in Washington 1983–4, pp. 102–5, cat. 11; Clayton in Venice 1992, pp. 336–7, cat. 65; Clayton in London 1996–7, pp. 56–9, cat. 30; Marani in Milan 2001, pp. 132–3, cat. 31; Clayton in Edinburgh and London 2002–3, pp. 134–5, cat. 52.

NOTES

1 Pedretti in Washington 1983–4, p. 104.
2 Philip's idealised features recall Verrocchio's *Doubting Thomas* from his sculptural group at Orsanmichele in Florence, unveiled in June 1483; see Butterfield 1997, pp. 56–80. It was Verrocchio who established two types that recur frequently in Leonardo's oeuvre, the idealised youth and the mature male with prominent chin and nose. See Clayton in Edinburgh and London 2002–3, pp. 51–4.
3 A similar drawing by Leonardo had a great impact on Venetian painting at a slightly later date. See Brown 1992a, pp. 87–8.
4 See Syson and Billinge 2005, p 452. The scale of the figures in the *Last Supper* is of course much larger than in a panel painting like the *Virgin of the Rocks*. For evidence of Leonardo's system for scaling his figures up and down, see ibid., p. 456.
5 These are mapped over one another in Syson and Billinge 2005, p. 456.

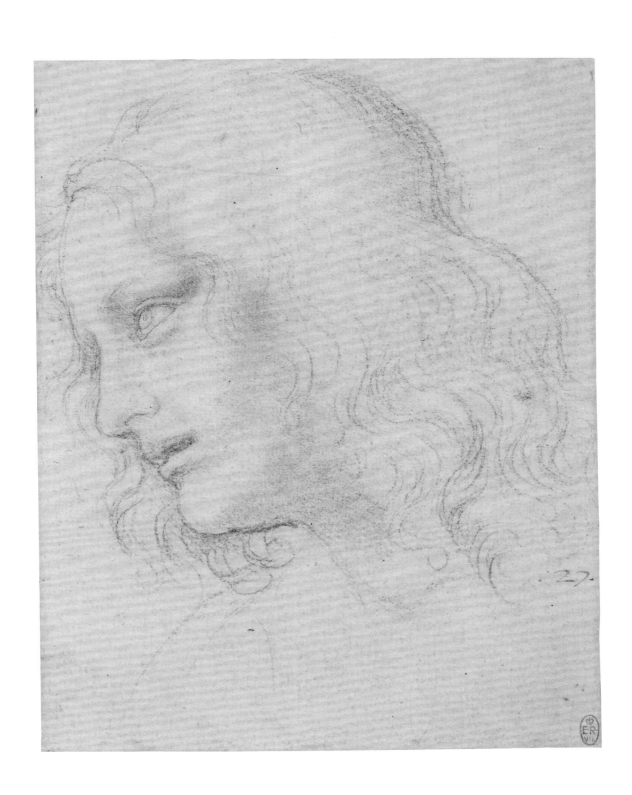

77

LEONARDO DA VINCI (1452–1519)

Head of an old man in profile

about 1490–5

Red chalk on paper
10.1 × 7.3 cm
The British Museum, London
(1900,0824.106)

78

LEONARDO DA VINCI

Study of a man in profile; calculations (recto)
Study of a man in profile facing a grotesque figure (verso)

about 1491–5

Red chalk (only recto) and pen and ink on paper
17.2 × 12.4 cm
Inscribed on recto in Italian: 'If a figure has to lift a man of its own weight,
how should this figure stand on its legs. / When you make a figure, think
well about what it is and what you want it to do, and see that the work is
in keeping with the figure's aim and character.'
Lent by Her Majesty The Queen
(RL 12555)

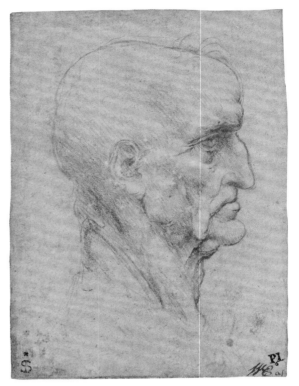

CAT. 77

The bald head, hooked nose and jutting chin of the old man depicted on both these sheets are variations on a physiognomy Leonardo drew many times. The earlier of the two, now in the British Museum (cat. 77), appears to have been drawn from life as it includes naturalistic details such as wisps of hair on the top of the man's head and a fold of sagging skin beneath his chin. The firm penmanship and unwavering outline of the head on the verso of the sheet from the Royal Collection (cat. 78), and the red chalk tracing that appears on its recto, on the other hand, suggest Leonardo had now moved from direct observation to the depiction of a type.

In this sheet the features are more exaggerated and it has been suggested that this is an early study for the head of Judas in the *Last Supper*, who shares the same pronounced hooked nose and jutting chin (cat. 79).[1] Others have argued it does not have the appearance of a preparatory work.[2] But it does seem to tie in with Leonardo's search for appropriate characters on which to base his Apostles, and could therefore be seen as the type that would eventually metamorphose into Judas. The inscription on the recto advising that artists consider a 'figure's aim and character' before embarking on a subject, also chimes with what must have been a preoccupation for Leonardo in the early 1490s.

The verso of cat. 78 includes a rapidly sketched profile of a simian figure, with bulging eyes and an exaggerated gap between nose and mouth, which pops out from the left edge of the drawing. This caricature seems to be a last-minute addition, Leonardo suddenly aware of how its presence would both offset and enhance the gravitas of the main figure. It was a practice he recommended in his projected treatise on painting, where he wrote: 'Beauty appears more powerful with ugliness [seen] one with the other.'[3] The bald man is hardly a figure of beauty; nonetheless, his scornful and contemptuous expression is effectively unbalanced by his buffoon-like companion. The confrontation of the two heads may also be a witty parody of the marriage double-portrait type.[4] MME

LITERATURE

Popham and Pouncey 1950, vol. 1, p. 70, no. 3; Clark and Pedretti 1968–9, vol. 1, p. 103; Kemp and Barone 2010, p. 65, no. 20; Chapman in London and Florence 2010–11, pp. 214–15, cat. 55.

NOTES

1 Richter was apparently the first to make this connection; see Pedretti in Washington 1983–4, p. 75, cat. 4.
2 Clayton in Edinburgh and London 2002–3, p. 76, cat. 26. The head is actually closest to Saint Simon's on the far right of the wall painting.
3 Urb. fol. 51; McM 277.
4 See Clayton in Edinburgh and London 2002–3, p. 76, cat. 26.

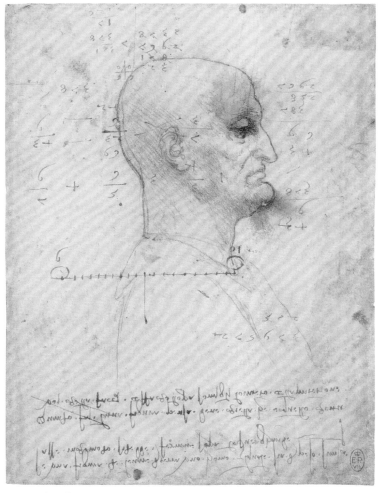

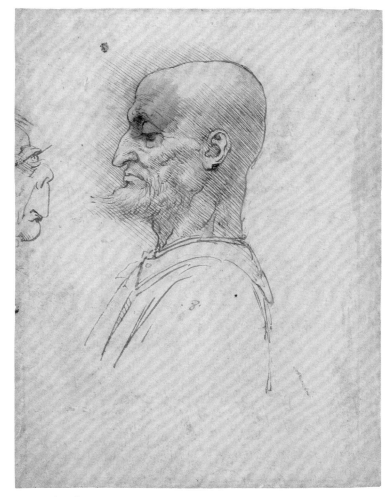

CAT. 78 (recto)

CAT. 78 (verso)

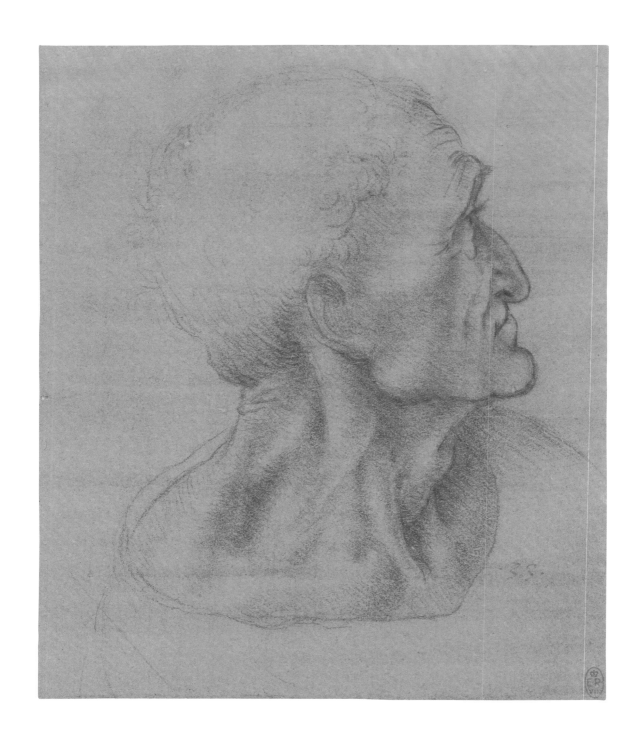

79

LEONARDO DA VINCI (1452–1519)
(with additions?)

Study of a man with his head turned
about 1495

Red chalk on red-ochre prepared paper
18 × 15 cm
Lent by Her Majesty The Queen
(RL 12547)

This study is almost certainly preparatory for the figure of Judas in the *Last Supper*. Swivelling round so that his chin is above his left shoulder, his pose is close to that in the mural, although in the painting Leonardo chose to increase the angle of recoil, thereby enhancing the expression of mock horror and creating a 'V' shape in the composition between Judas and Christ's body. In the final work Judas is given a mop of dark hair and a beard, curling upwards and exaggerating his jutting chin and malevolent demeanour. In the drawing, his expression is rather one of surprise and mild disdain.

As in his drawing of the *Man tricked by gypsies* (cat. 74), Leonardo enhances the grotesqueness of the facial features here to suggest a thieving and untrustworthy nature: it is said that he sought out criminal types to model for the figure of Judas.[1] In his biography of the artist, Vasari recounts how Leonardo left the heads of Christ and Judas until last, conscious of the difficulty of finding anyone who might serve as a model for the divine Christ and, conversely, a type evil enough to represent one who could 'betray his own master and the creator of the world'.[2] In the end Leonardo joked that if he was really stuck he would copy the features of the prior of Santa Maria delle Grazie, who had been tactlessly pestering him to finish his mural.

Here the artist concentrates on the physiognomy of the sitter, and particularly on the tension created in his neck when he turns his head with some force. Leonardo uses the red chalk medium to model the deep crevices and undulations of his taut muscles and sinews like the roots of a beech tree. The anatomy is certainly not entirely naturalistic, although it has been plausibly suggested that the outlines of the profile may have been strengthened, and thereby further exaggerated, by another hand.[3] However, the whole reflects Leonardo's relentless search to find an exterior physical form that could translate the inner human passions of the wicked Judas. It is therefore not a drawing from life, but comes rather several stages further down the line. Leonardo, having established the pose he wanted for Judas, prepared a final study that could be used in the execution of the mural perhaps after he had already begun. MME

FIG. 105
LEONARDO DA VINCI
The Last Supper (detail of fig. 100 showing Judas), 1492–7/8

LITERATURE

Clark 1935, vol. I, pp. 85–6; Clark and Pedretti 1968–9, vol. I, p. 101; Pedretti in Washington 1983–4, pp. 108–11, cat. 13; Kwakkelstein 1994, p. 139; Marani in Milan 2001, pp. 103–4; Clayton in Edinburgh and London 2002–3, pp. 138–9, cat. 54.

NOTES

1 Gianbattista Giraldi, called Cinzio was the first to comment on Leonardo's interest in grotesque physiognomy; in 1554 he published an anecdote which described Leonardo taking himself 'to the Borghetto, where all the vile and ignoble people live, wicked and villainous for the most part ...' in order to find a model for Judas, who 'deserves to be painted with a face fitting to such villainy'. See Kwakkelstein 1994, p. 139; Clayton in Edinburgh and London 2002–3, p. 128. The anecdote was subsequently adopted by Vasari in his second edition.
2 Vasari (1966–87), vol. 4, p. 26.
3 See Clayton in Edinburgh and London 2002–3, p. 138.

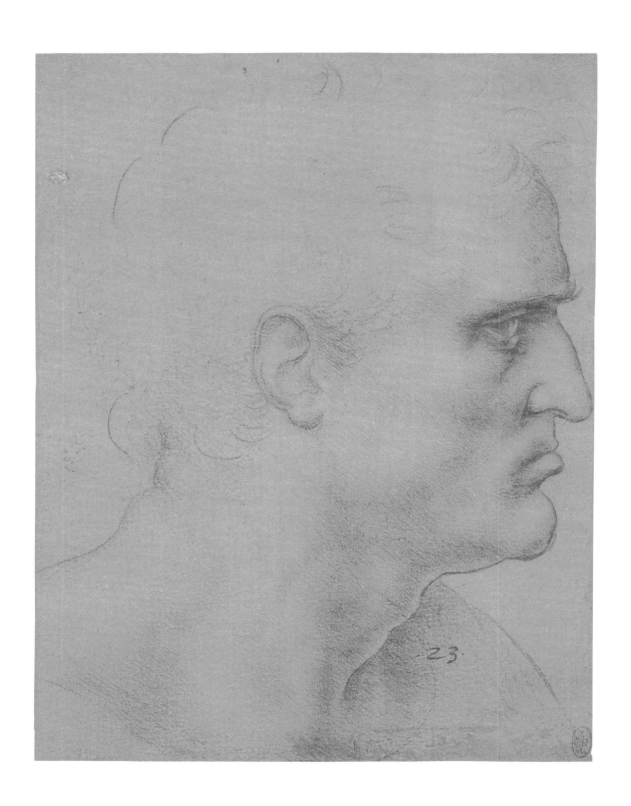

LEONARDO DA VINCI (1452–1519)

Study of a man in profile

about 1495

Red chalk on red-ochre prepared paper
19.3 × 14.8 cm
Lent by Her Majesty The Queen
(RL 12548)

This drawing is generally agreed to be a study for Saint Bartholomew, who is positioned furthest left in the *Last Supper*; the drawing gives a better idea of Bartholomew's characterisation than the mural itself, where the painted figure's face has almost completely disappeared. Leonardo's finished Bartholomew has a beard, and his pose has been adjusted so that he looks down the length of the table towards Christ, intent on the pronouncement being made.

The bullish character of the model in the drawing, with his powerfully set jaw and projecting lower lip, is reminiscent of Leonardo's warrior type, whose origins can be found in the Florentine workshop of his master, Verrocchio.[1] There is in particular a striking similarity to the head of Bartolommeo Colleoni in Verrocchio's equestrian monument (fig. 107).[2] The fixed gaze, deep-set eyes and furrowed brows are very like those in the present drawing. Leonardo has softened the *condottiere*'s aquiline nose a little to give the Apostle a slightly gentler demeanour.

FIG. 107
ANDREA DEL VERROCCHIO (about 1435–1488)
Equestrian Monument of Bartolommeo Colleoni (detail),
about 1481–96
Bronze (formerly gilded), height 395 cm
Campo Santi Giovanni e Paolo, Venice

Leonardo must also have had classical prototypes in mind. The strict profile format employed for the head in this drawing evokes the portraits of Roman emperors on antique medals, cameos and coins, specifically the distinctive features of Emperor Galba (3BC–AD69), the most bellicose of the emperors, whose chin (according to visual records) jutted forward almost as far as the tip of his nose. As has been observed, classical profile heads based on the coinage of emperors such as Galba were a standard decorative motif in Lombardy at this date, one of the best examples being the *tondi* by Giovanni Antonio Amadeo at the Certosa di Pavia (1474–80), about 20 miles south of Milan, which Leonardo must surely have seen.[3]

The drawing is extremely subtly modelled in red chalk, particularly across the fleshy cheek area. But the figure's attitude is less dynamic and graceful overall than, say, that of the shifty Judas (cat. 79). This stolid-ness would certainly be partly explained by Leonardo's memory or direct citation of a sculptural model, and the modelling of the head evokes the surfaces of marble or bronze. What the drawing does transmit very effectively is a strong sense of an individual precisely characterised and, in spite of its poor condition, this can still be read in the finished painting: the fierce disbelief of Bartholomew and his almost combative stance in the face of Christ's revelation.

The use of red chalk on red-ochre prepared paper was particularly employed by Leonardo in the years around 1500. And, like the study of Judas (cat. 79), which is similarly executed in red chalk on red-ochre prepared paper, the finished nature of the technique may indicate that this drawing was made by Leonardo late in the preparatory process, at the point when the artist was ready to begin translating his drawings on to the wall of the refectory itself or had already begun.
MME

FIG. 106
LEONARDO DA VINCI
The Last Supper (detail of fig. 100 showing Saint Bartholomew),
1492–7/8

LITERATURE

Clark 1935, vol. I, p. 86; Clark and Pedretti 1968–9, vol. I, p. 101; Pedretti in Washington 1983–4, pp. 106–7, cat. 12; Marani in Milan 2001, pp. 142–3, cat. 36; Clayton in Edinburgh and London 2002–3, pp. 136–7, cat. 53.

NOTES

1 Leonardo's most impressive early use of the Verrocchio warrior type may be seen in his drawing, at the British Museum, (1895,0915.474). See Chapman in London and Florence 2010–11, pp. 204–5, cat. 50.
2 Verrocchio had been awarded the commission in 1481–3, but had only completed his model by the time of his death in 1488. The casting of the monument was given to Alessandro Leopardi, who had completed the work by 1496. Leonardo may have watched the design taking shape in Florence, or he may even have visited his former master in Venice.
3 We know that Leonardo was in Pavia with the artist Francesco di Giorgio in June 1490 (Clayton in Edinburgh and London 2002–3, pp. 22, 53).

81

LEONARDO DA VINCI
(1452–1519)

Study for the hands of Saint John

about 1491–3

Black chalk on paper
11.7 × 15.2 cm
Lent by Her Majesty The Queen
(RL 12543)

82

Follower of
LEONARDO DA VINCI

The hand of Judas

about 1500–15

Red chalk heightened with white
on red-ochre prepared paper
20.8 × 16.1 cm
Gallerie dell'Accademia, Venice
(140)

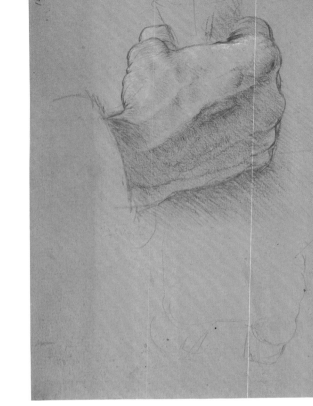

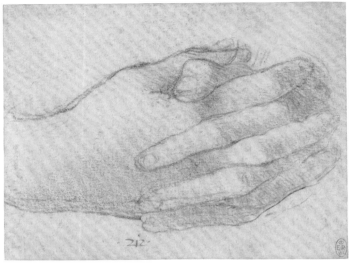

CAT. 81

CAT. 82

Leonardo had been taught by his master Verrocchio to make studies of hands beautifully and tellingly posed, and this was one of the several techniques he pursued in attempting to fix the individual characters of the Apostles for the *Last Supper* – as seen in this black chalk study for the hands of Saint John (cat. 81). In the mural the youthful saint, referred to in the Bible as the 'beloved disciple', sits on Christ's immediate right. His response to Christ's words is mild-mannered: he leans away from his master, his eyes downcast, his hands clasped together. The drawing is immensely sensitive. The revised lines suggest that it was made at least partly from life, and also that Leonardo was still searching for the form he wanted. Although neither highly finished nor strongly modelled, the soft use of black chalk beautifully conveys the quality of youthful skin, something observed by Leonardo himself in his *Treatise on Painting*: 'In youthful figures you should not make the shadows end like stone, for the flesh retains a slight transparency, as one sees when looking at a hand held between the eye and the sun, when it is seen to flush red and be of a luminous transparency.'[1]

The numerous studies of hands Leonardo must have made for the *Last Supper* but which are now lost appear to have proved useful objects of instruction for pupils who joined his workshop around 1500 in Milan and then in Florence. From their surviving copies,

made under the master's instruction and emulating his left-handed hatching, we get tantalising glimpses of the originals.

The red chalk study drawn on red prepared paper now in Venice,[2] depicting a clenched hand holding a money bag (cat. 82), may have been made after one of Leonardo's preparatory studies for the hand of Judas. This sheet has been attributed recently to Leonardo himself;[3] it is included here to test this hypothesis. Certainly the work has the appearance of a preparatory drawing rather than a copy of the painting, as more of Judas's wrist is visible here than in the mural. It also seems to have been made from life. The outlines of the clenched hand are first rather tentatively laid down at what is now the bottom of the sheet. The foreshortening of the thumb is badly executed, partly perhaps because the object being held was missing, explaining the need to start again; the paper was then turned through 180 degrees. But this kind of new beginning is not a feature of Leonardo's own draughtsmanship and while the battle to find the correct contour is more characteristic, the heavy-handedness of the result is not: there is a certain lack of balance between the outlines and the internal modelling. The work could therefore be seen as a life drawing made by a pupil re-exploring a motif already used successfully by Leonardo.[4] MME/LS

LITERATURE

Cat. 81: Clark 1935, vol. 1, p. 85; Clark and Pedretti 1968–9, vol. 1, p. 100; Pedretti in Washington 1983–4, pp. 116–17, cat. 15; Eichholz 1998, pp. 349–50; Steinberg 2001, pp. 55–61.

Cat. 82: Selvatico 1854, vol. 7, no. 6 (as Cesare de Sesto); Cogliati Arano in Venice 1966, p. 44, cat. 54 (as close to Tanzio da Varallo); Cogliati Arano 1980, p. 86, no. 47 (as Lombard artist); Bologna in Milan 1983, pp. 47, 51 (as perhaps Cesare da Sesto).

NOTES

1 A fol. 3v; BN 2038 fol. 31v; R 561.
2 A number of these workshop drawings, all using this red-on-red technique, have made their way to Venice, all often judged erroneously to be autograph works by Leonardo. See Accademia 141, 217, 257. Though executed in red chalk on unprepared paper, it should be asked if the famous sheet for the *Battle of Anghiari* (Szépmüvészeti Múzeum, Budapest, 1174r/v) falls into the same category. Sometimes, it would appear, Leonardo and a pupil drew on the same sheet. See also cat. 90.
3 Personal communication (Alessandro Ballarin to Annalisa Perissa Torrini.)
4 The identity of this hypothetical pupil remains an open question.

83

LEONARDO DA VINCI (1452–1519)

Drapery study for the right sleeve of Saint Peter
about 1493–6

Black chalk and pen and ink heightened with white on paper
16.6 × 15.5 cm
Lent by Her Majesty The Queen
(RL 12546)

This beautiful drapery study is the only one for the *Last Supper* to survive, and it gives some idea of the others that he very likely drew. It was made for the right arm of Saint Peter, who in the mural pushes forward in some agitation, his right arm bent back so that his wrist rests on his hip. In his hand he clutches his fisherman's knife, the blade of which is clearly visible in the mural, but is only cursorily indicated here.[1]

Leonardo uses the black chalk medium to its fullest effect in this drawing; with the pointed edge of the chalk he gives form and outline to the sleeve and its voluminous folds, blending it to create a softness and sense of volume. The crevices of the folds are rendered by a dense build-up of black chalk, while the areas that catch the light are indicated by touches of white chalk. In spite of the fact that there is virtually no suggestion of the anatomy of the arm in this sleeve, the drapery appears to have a life of its own, Leonardo taking obvious delight in the series of curved shapes of the folds around the arm. Such a sophisticated use of black chalk is rare for this date and anticipates the drapery studies he made rather later, for the *Virgin and Child with Saint Anne*.[2] The pose of the arm of Saint Peter is in fact adapted in reverse in the Louvre drawing of the *Virgin and Child with Saint Anne*.[3]

It has also been noted that the position of the right arm here is identical to a frontispiece woodcut which shows the poet Bernardo Bellincioni in his study, from his posthumously published *Rime* (Milan 1493).[4] Pre-dating the completion of the *Last Supper* mural by several years, the implication is that the printmaker responsible for the frontispiece and a related engraving had access to Leonardo's drawings. Even if the present drawing was not executed by this date, the pose of Saint Peter may already have been decided. Leonardo and Bellincioni were close friends, and it is possible that Leonardo provided a drawing from which the frontispiece was made. MME

LITERATURE

Clark 1935, vol. 1, p. 85; Clark and Pedretti 1968–9, vol. 1, p. 101; Pedretti in Washington 1983–4, pp. 112–15, cat. 14; Clayton in London 1996–7, pp. 56–9, cat. 31; Marani in Milan 2001, pp. 134–5, cat. 32.

NOTES

1 See p. 262, cat. 72 n. 1 on the significance of Saint Peter holding a knife. See also Pedretti in Washington 1983–4, p. 114.
2 See Clayton in London 1996–7, pp. 56–9.
3 This was pointed out by Marani 1992a, p. 7.
4 Villata 2000.

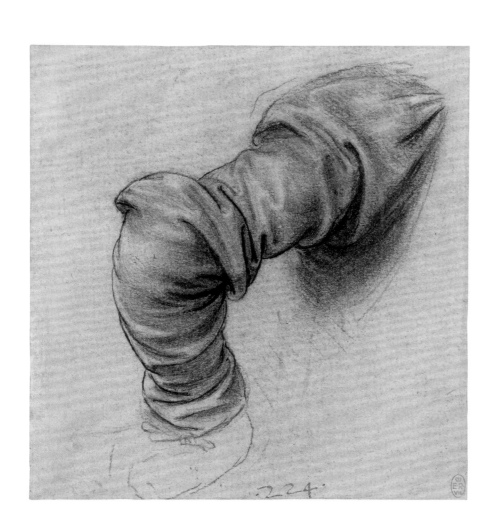

84

GIOVANNI PIETRO RIZZOLI
called GIAMPIETRINO
(active 1508–1549)

The Last Supper
about 1520

Oil on canvas
302 × 785 cm
The Royal Academy of Arts, London
On loan to Magdalen College, Oxford

Given the deteriorated state of Leonardo's *Last Supper* mural today, the question of which of the early painted copies can be said to be most faithful to the original is of particular and tantalising importance.[1] Always viewed as among the most accurate is this scale copy by Giampietrino, the Milanese artist whose full name was established only a few years ago as Giovanni Pietro Rizzoli. Believed to have been a live-in apprentice of Leonardo's during his first Milanese period (probably joining the workshop in the mid-1490s),[2] Giampietrino would have been present during the period when Leonardo was preparing and painting the *Last Supper*, perhaps even assisting his master.[3]

During the lengthy recent restoration work on Leonardo's wall-painting (1979–99), Giampietrino's painting was sent to Milan in 1987 so that it, too, might be conserved[4] but also, crucially, in the hope that it might shed light on the appearance of Leonardo's original. The juxtaposition proved useful and Giampietrino's canvas is today considered the most reliable of the surviving painted copies.[5] In addition, however, it should be understood as a picture of high quality by a painter about whose career we still have very little definitive information. Indeed, we know neither the patron, the original intended location for the work,[6] nor how Giampietrino made his copy after his master's original. The close similarity in scale between the figures in the two works has led some to question whether he might have used a lost cartoon, or cartoons, by Leonardo.[7] Alternatively, the Strasbourg series of coloured chalk heads for Christ and the Apostles by a follower of Leonardo[8] may indicate that Giampietrino too was making his own reproductions of the Apostles' heads in preparation for this Certosa copy. Lastly, there remains the possibility that Giampietrino was able to make tracings from the finished mural.[9] Certainly by the time he made his copy, around 1520, he was working as an independent painter (probably from 1509) and following Leonardo's death in 1519 he may also have had access to drawings from the workshop.[10]

A fundamental difference between Leonardo's original mural and Giampietrino's copy is, of course, the medium: while Leonardo's *Last Supper* was painted directly on to the refectory wall, Giampietrino's is an oil painting on canvas. There is an immediate disparity therefore in their appearance. Giampietrino's saturated oil-paint finish gives his work a clarity that Leonardo's intrinsically more muted and matt paint would never

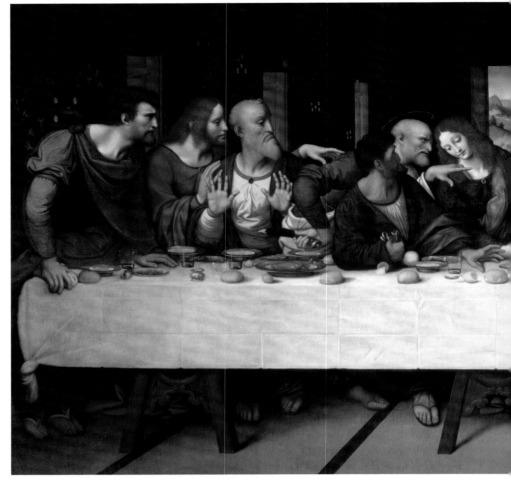

Figures depicted, from left to right: Saint Bartholomew, Saint James the Lesser, Saint Andrew, Saint Peter (leaning towards John, holding a fisherman's knife), Judas (in green and blue, clutching a small bag of silver), Saint John, Christ, Saint James the Greater (in green, his arms outstretched), Saint Thomas (raising his index finger), Saint Philip, Saint Matthew, Saint Thaddeus, Saint Simon.

have had.[11] When it was first painted, Leonardo was particularly praised for his use of colour in the *Last Supper*, the pattern of blues, yellows and reds that leads one's eye along the table, a carefully choreographed sequence of hues glowing in the dark refectory interior. Giampietrino's stronger, more richly saturated palette was never co-ordinated across the composition in the same way. However, his choice of colours often helps, quite straightforwardly, in confirming the colours of Leonardo's original. Saint Simon, for example, seated on the far right, can be clearly seen in Giampietrino's painting dressed in a rather striking combination of a red robe over a white undershirt, a colour scheme no longer visible in Leonardo's mural. Similarly, Simon's face is one of the worst damaged in the original, but in the copy we can understand the *profil perdu* view that Leonardo intended.

A number of other details are satisfyingly clear in Giampietrino's copy but can no longer be made out in the damaged original: the money bag that Judas clutches in his right fist, the salt cellar he has just over-

LITERATURE

Marani in Milan 2001, pp. 190–1, cat. 53; Steinberg 2001, app. E, no. 6; Shell et al. 1988 (with complete bibliography on this painting, pp. 61–2).

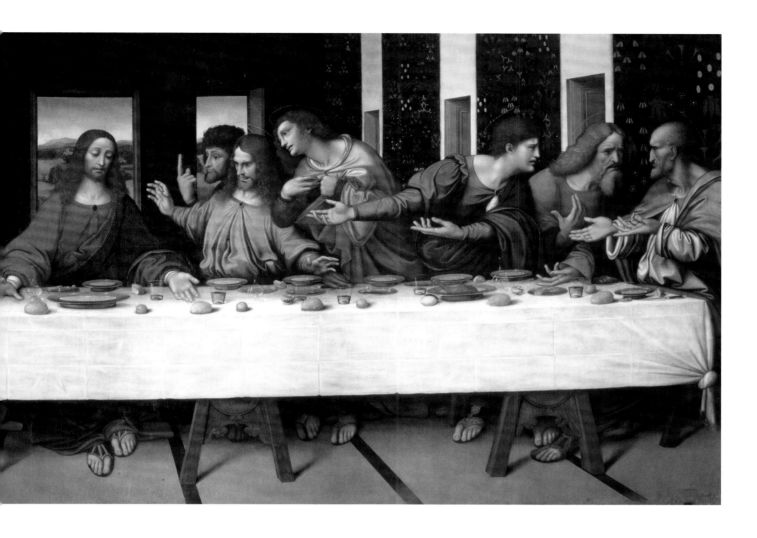

turned[12] – and the wonderfully varied and dynamic actions and expressions of the Apostles rendered with great clarity and three-dimensionality by Giampietrino. Today it is tempting to read Christ's mouth as being open in Leonardo's mural, almost as if he were talking, whereas in fact the copy shows that this gap is actually caused by paint loss – in Giampietrino's painting Christ's mouth is not tightly closed but his lips are only very slightly parted, his expression serene. The copy is especially valuable for its inclusion of the lowest tier of the composition showing the feet of Christ and the Apostles, since the central part of this area of Leonardo's original was obliterated when a door was inserted into the refectory wall in 1652.

There are, however, some disparities between the copy and the original: Leonardo shows clearly the uncovered blade of Saint Peter's knife, whereas Giampietrino chooses to paint it in its scabbard. And, although he reproduces the architecture faithfully, Giampietrino's figures loom larger in their architectural space than do Leonardo's.[13] M M E

NOTES

1 For a discussion of the early copies made after Leonardo's *Last Supper*, and for the provenance of the present work, see Steinberg 2001, pp. 227–57.
2 The name 'Gian Pietro' is found among Leonardo's list of pupils in C A fol. 264r (ex 96r.a); R 1467 (datable to about 1497–9). That this may be the artist known as Giampietrino, is suggested by Lomazzo in his *Trattato dell'arte della pittura, scolura et architettura* of 1584; see Shell et al. 1988, p. 14 for suggestions that it was one of Ludovico il Moro's sons, Massimiliano or Francesco, who commissioned this copy.
3 Bora et al. 1998, pp. 275–300.
4 See Shell et al. 1988, pp. 40–59.
5 One of the copies believed to have rivalled Giampietrino's for fidelity to the original, the Castellazzo fresco attributed to Andrea Solario, was destroyed during the Second World War and is recorded only in a photograph. For a comparison between this and Giampietrino's copy see Steinberg 2001, app. D, pp. 219–25. On other copies of the *Last Supper* made in Leonardo's lifetime, see Shell and Sironi 1989c, pp 103–117.

6 In 1626 the work is recorded as in the refectory of the Certosa di Pavia by Bartolomeo Sanese in *De Vita et moribus Beati Stephani Maconis*, Siena 1626, p. 137 (see Shell et al. 1988, pp. 9–10.). However, a painting on this scale is unlikely to have gone unnoticed by visitors to the Certosa before this date, so we can assume it had only recently been moved, perhaps from a less important Carthusian foundation. This point was first made in Möller 1952, p. 139. See also Shell et al. 1988, p. 10.
7 For a discussion of this wider subject see Keith and Roy 1996, pp. 4–19.
8 Wolk-Simon 2011, pp. 148–55.
9 In 1508 Ambrogio de Predis and Leonardo were given permission to remove the newly installed altarpiece of the *Virgin of the Rocks* from San Francesco Grande in Milan so that Ambrogio could copy it under Leonardo's supervision. See Bambach in New York 2003, p. 237; Shell and Sironi 1989c, pp. 107–8.
10 We know that Leonardo's drawings did serve as starting points for independent works by his pupils; e.g., Giampietrino's *Leda* (Gemälde-

galerie Alte Meister, Kassel) was based on a design by Leonardo. Beneath this painting there is also an underdrawing showing a design for the *Virgin and Child with Saint Anne*, suggesting that it was originally intended to be a *Saint Anne* before being changed to a *Leda*. See Zöllner 2003 (2007), p. 188.
11 It must be stressed that this is a result of the different media; Leonardo's acclaimed technique based on the application of delicate glazes was something Giampietrino particularly emulated. Marani in Bora et al. 1998, p. 275.
12 Brown in Shell et al. 1988, p. 18, figs 2 and 3.
13 Marani in Milan 2001, p. 190. This point may be explained if we knew the painting's intended original location and dimensions. When Giampietrino's *Last Supper* was conserved in the mid-1980s it was discovered that the upper edge of his original canvas only reached the top of the windows, a later strip added to take it to its present height. Its original height is not known. See Shell et al. 1988, pp. 40–59. See also Steinberg 2001, p. 235.

THE MIRACLE OF TALENT
LEONARDO AND THE FRENCH

WHEN IN SEPTEMBER 1499 LEONARDO LOST HIS patron, his world changed entirely. The invasion of Milan by the French king, Louis XII, forced him to think about how he would make his living, after years of relying upon a Sforza salary (however irregularly paid). Moreover, he could no longer expect that any substitute patron, Louis or a member of his entourage, would understand the philosophical frame of reference for his painting as Ludovico Maria seems to have done. This, then, was a moment when he needed to present himself in a new way – indeed, to find an entirely new way of working.

His celebrity was now extraordinary; his great fame could therefore become part of his persona as an artist. And though the French were infinitely more visually sophisticated than the Sforza had been at the time of Leonardo's arrival in Milan in 1482/3, they were clearly astonished by Leonardo's art. Louis is said to have wanted to transport the *Last Supper*, presumably wall and all, to France. And the impact of Leonardo's painting was clearly enduring, as his last journey to France demonstrates. But thinking by this date about image-making was still perhaps more traditional in France than it was in Italy. It may be that what was deemed Leonardo's achievement of pictorial perfection could be most

easily appreciated as a remarkable chapter within the long history of religious painting. Certainly his paintings and drawings of this period seem to re-position him slightly, and his depictions of perfection are subtly reformulated. They continued to demonstrate the ways in which his all-encompassing study of the natural world allowed him to understand – even depict – the fundamental principles by which the universe operated. But this hard work was now subsumed by the sense that Leonardo's access to the perfect had been specially granted him by God – that his talent was not just enormous: it was truly miraculous. The belief that he was a really exceptional human being would continue to sustain French desire to obtain his works, tested not just by his departure from Milan at the end of the year, but also by his famously dilatory working habits.

This, certainly, is the point of Giorgio Vasari's story of Leonardo's 'cartoon' of the Virgin and Child with Saint Anne and the infant John the Baptist displayed like a sacred relic at the Florentine Church of Santissima Annunziata, the home of the city's most celebrated cult image. After a period of inactivity, Vasari tells us,

> Finally he made a cartoon, in which there was an Our Lady and a Saint Anne with a Christ, which not only made all the craftsmen marvel, but when it was finished for two days men and women, young and old went to see it in the room, as one goes to solemn festivals, to see the marvels of Leonardo, that stupefied all the people . . .[1]

There is no good reason to doubt that this, the first exhibition of Leonardo's work, took place and it cannot be stressed often enough just how unprecedented such an event was.[2] This is evidence of a completely new way of looking at Leonardo – and it is possible, not only that he was showing off work undertaken in connection with a commission from the French king, but that this was actually the drawing now to be seen by visitors to the National Gallery in London. The *Burlington House Cartoon* (cat. 86) is a work in which Leonardo set out to make his divine inspiration obvious to all.

He did much the same in his picture of *Christ as Salvator Mundi* (cat. 91). By painting the holy face of Christ

Leonardo stakes another claim to the possession of God-given talent: he becomes the witness of the face of Christ. This, too, is very likely to have been a picture commissioned by Louis. Leonardo's autograph version is newly discovered, displayed for the first time here and distinguished from the countless copies made early in the sixteenth century, many seemingly within Leonardo's workshop. He was not, it seems, receiving a salary from Louis at this time, and he therefore had another imperative here: the need to make his painting practice more commercially viable.

In a well-known letter to Isabella d'Este, Marchioness of Mantua, her agent in Florence, Fra Pietro da Novellara, describes a system by which Leonardo's assistants made copies – *ritratti* – of pictures by the master himself. Though it has been argued that he may in some cases only have made drawings for these *garzoni* to follow, this in fact is not the implication of the word *ritratti*, which suggests the reproduction of an original. This was not in itself a remarkable departure; the reproduction by pupils of major works by their master was standard Florentine practice. Hans Belting, however, has explained a process whereby miraculous images – pictures supposedly painted by Saint Luke, or finished by an angel, or indeed images of Christ like the Mandylion of Edessa on which Leonardo seems to have based his *Salvator Mundi* – were copied over and over again, the imitations still maintaining the authority and something of the mystery of the originals. Belting argues that such practices belong to the 'age before art', that is, before about 1500.[3] But the *Salvator Mundi* appears to have been copied on just this basis and the power of the workshop copies would have been much reduced if Leonardo had not painted a first, authoritative image.

It now seems that his much-repeated composition of the *Madonna of the Yarnwinder* falls into the same category. Though copies and variations abound, it is argued here that they all depend upon a single primary version (cat. 88), a picture that was started by Leonardo, even if it was finished off in a distinctly amateurish way by someone unconnected even with his workshop. Its composition seems to refer to the *Burlington House Cartoon*. Leonardo

CAT. 91 (detail)

had arrived at a way of collaborating that was financially expedient – but was also justified by an established theology of devotional images. By reiteration, his talent became all the more marvellous.

By the mid-sixteenth century, Leonardo and his works (like those of Michelangelo and Raphael) were celebrated in these terms. The two mentions of the *Last Supper* in the brief biography of Leonardo written by Antonio Billi in about 1518 are early evidence of this kind of acclaim.

He first called the picture a *cosa eccellente* (excellent thing), but then, much less anaemically, *uno Cenacolo miracoloso*.[4]

Vasari, at the beginning of his *Life* of the artist, called Leonardo's 'every action' divine; so much so that his talent 'makes itself clearly known as a thing bestowed by God'.[5] The pictures that Leonardo began in about 1499–1500 show that this image of the artist was carefully nurtured, even stage-managed, by the artist himself. This was perhaps the last legacy of his 18 or so years in Milan. LS

NOTES

1 Vasari (1966–87), vol. 4, pp. 29–30.
2 It has recently been discussed by Nethersole 2011.
3 Belting 1994, *passim.*
4 Billi (1991), pp. 102–3. Billi also singles out an 'Our Lady Saint Anne' among Leonardo's *infiniti disegni maravigliosi.*
5 Vasari (1966–87), vol. 4, p. 15.

85

LEONARDO DA VINCI (1452–1519)

Sketches for the Virgin and Child with Saint Anne and the infant Saint John the Baptist; machinery designs
about 1499–1500

Pen and ink and wash over black chalk heightened with white on paper, indented for transfer
26.5 × 19.9 cm
The British Museum, London
(1875,0612.17)

For Leonardo, the act of drawing could sometimes seem inspired. Sketches like this one, full of changes of mind, become the records of bursts of creative fervour which might even contain images he had not intended, happy accidents that would inspire further imaginative journeys. Order, he thought, would eventually emerge from confusion and, though he never glossed it in precisely this way, there is a mystical aspect to these acts of creation, not least when he was, as here, treating a Christian theme. In this kind of drawing Leonardo was showing why a painter's creativity could be seen as analogous to God's, and by this stage of his career the parallel was self-conscious.

This famous sheet with designs for a composition of the Virgin and Child with Saint Anne and the infant Baptist provides perhaps the most extreme example of this practice. The principal design is drawn and redrawn so often as to make it a dark, almost unintelligible miasma. Once deciphered, it becomes clear that it is closely related to the large-scale *Burlington House Cartoon* (cat. 86), and is rightly catalogued as a preparatory study for that work. But, quite characteristically, it would turn out to be important too for another work: the Louvre painting of almost the same subject (fig. 48), substantially complete by October 1503.

It can usually be assumed that artists made compositional drawings to find solutions to the particular problems associated with an individual project. However, in drawings like this one, perhaps his most extreme example of his 'pentiment drawing', Leonardo adopted a brainstorming method which was about maintaining a whole range of possibilities. He might find a temporary solution – an image which could help him to the next stage – but this was a deliberately open-ended procedure.[1]

In the present drawing he may have started by drawing the figures in the main group very loosely in black chalk – his first marks were often extraordinarily free. But very soon, perhaps before anything else, he drew a frame to enclose the group, disciplining himself and at the same time contemplating the picture that would result. Before he moved the left edge inwards, using a ruler and the points of a divider he constructed a scale along the chalk lines at the right and bottom,

breaking them up into, respectively, 25 and 17 units. This would seem to indicate that he was employing a system for the mechanical enlargement of the design, and it has been suggested that each of these units might correspond to a hand's length, a *palmo* (7.25 cm). We can therefore deduce that the picture Leonardo had in mind would be about 181.25 by 123.25 cm, taller and wider than the present dimensions of the *Burlington House Cartoon*.

Art historians have often tried to work out the order in which the different parts of this marvellously incoherent main design were drawn and to describe the exact – albeit changing – arrangement of the women's limbs, especially their legs.[2] They have been helped to some extent by looking at the verso. More than once Leonardo drew over the black chalk with pen and ink. His use of two media superimposed was usually a means of clarifying an image, but here it just adds to the confusion. And, as he very occasionally did (see cat. 11), Leonardo employed a stylus to incise further contour lines into the composition. While doing so he laid the page over another sheet thickly rubbed with black chalk so that the image, or rather a crudely schematic version of it, would be transferred by the pressure of the incisions on to the verso of the original sheet. Though far from beautiful, this diagram (a by-product, not an end in itself) might have proved useful as he began again on another sheet.

The figure of the infant Saint John the Baptist at the right of the main composition is perhaps the most clearly visible. He is posed as in the *Cartoon*, his left foot on the ground, his right leg resting on a hummock. Leonardo drew the Christ Child twice, both times leaning out from his mother's body in what seems to be the twisting pose of the *Cartoon*. At first he would have loomed over the Baptist, but when drawn a second time, to the left, he is more tightly tucked into mother's body (as in the *Cartoon*), his blessing gesture now making better sense. It is possible that Leonardo first sketched him wrestling with a cat – or a lamb: the shape that projects beyond the strong diagonal enclosing the right side of the group might well be an animal's tail. In what would be a characteristic piece of lateral thinking, this would become the hand of Saint Anne, as seen in the verso image.

LITERATURE

Popp 1928, pp. 9, 44, no. 44; Bodmer 1931, pp. 407–8; Popham 1946, pp. 121–2, 132, no. 175; Popham and Pouncey 1950, pp. 65–9; Kemp in London 1989, pp. 150–1, cat. 77; Clayton in Venice 1992, pp. 246–7, cat. 23; Bambach in New York 2003, pp. 525–8, cat. 96; Kemp 2003, pp. 151–4; Chapman in London and Florence 2010–11, pp. 216–17, 322–3, cat. 56; Kemp and Barone 2010, pp. 66–9, no. 21 r/v.

NOTES

1 Gombrich 1966; Zwijnenberg 1999, pp. 65–9, 200 n. 10.
2 See e.g. Budny 1983.
3 As it was also in the Louvre drawing treating this subject (RF 460), which must have been made at much the same time – and in which Christ is more clearly struggling with an animal.
4 For this phrase see Urb fols 61v–62r; MCM 216; K/W 571. For the famous passage regarding the inspirational qualities of the stains on a wall, see Urb. fols 33v–34r; MCM 93; K/W 523. Discussed by Zwijnenberg 1999, pp. 68–9.
5 Pedretti 1982a, p. 104.
6 Chapman in London and Florence 2010–11, p. 322, n. 10.

Perhaps then it was a cat's tail that prompted Leonardo to redeploy one of his favourite motifs when he drew Saint Anne's upward-pointing forefinger in the *Cartoon* itself. He depicts Anne's head (on the right) turned to look at her daughter. The Virgin's torso and head face the same way, but her body is twisted at the waist, legs and feet pointing in the other direction. She sits rather precariously on her mother's thigh; only when Leonardo reached the incision stage did he lift her proper left foot slightly (as in the *Burlington House Cartoon*).

In the smaller sketches below, Leonardo investigates this dynamic figure group from new starting points, with the Virgin in much the same *contrapposto* pose. It has often been suggested that quite early in the drawing of the main image the two women swapped legs and that Leonardo first envisaged the Virgin sitting 'side-saddle' across Anne's lap. Looking hard, and giving the Virgin what are now Anne's legs, the image can indeed be read in this way, finding a composition which becomes closer to the Louvre *Virgin and Child with Saint Anne*.

In the second-most complex of his sketches, at lower right, there is a rapidly drawn sequence of heads getting closer to the ground and an amorphous shape on the right; these are both elements that might have sparked further ideas which he would also incorporate in the Louvre picture. This shape could represent a lamb on the ground instead of or as well as the Baptist. Similarly, the Virgin was initially conceived with her elbow bent and her wrist turned against her hip, a pose that Leonardo had used before (see cat. 83) and later assigned to Saint Anne.

This, then, is a sequence of drawings that seems both to express and to feed Leonardo's imagination. In advocating the effectiveness of the *componimento inculto* (untidy composition), he makes a comparison with the stains on walls that give rise to beautiful *invenzioni*.[4] He has created his own stain, a drawing intended to provoke unexpected conclusions. It is perhaps unsurprising, therefore, that though he rejected Mary's complicatedly turning pose for the Louvre *Virgin and Child with Saint Anne*, he nonetheless adapted it for the *Madonna of the Yarnwinder* (cat. 88). This little painting is known to have been well under way by April 1501 – and the British Museum drawing and the *Cartoon* seem likely to precede it.

If this argument is accepted, it might assist with what has proved to be a thorny problem: the dating of both this sheet and the resulting *Cartoon*. In recent decades the date often judged most likely for the present drawing (about 1505–8) has often been used to determine the date of the *Cartoon* itself, both therefore associated with Leonardo's return to Milan. This is based mainly on what is deemed a plausible context for the hydraulic studies at the right and bottom of the paper, those on the right probably the first things to be drawn on this sheet. But this argument depends in part on the view that a fragment with other hydraulic studies now at Windsor (RL 12666), more precisely datable to 1508, had once been part of the same large sheet.[5] This theory has recently been disproved on technical grounds,[6] and it should be stressed that the study of hydraulics had been a constant in Leonardo's working life from the early 1480s. Indeed, this was an area of his expertise that was much prized by Ludovico il Moro. Neither the rather sketchy designs nor the handwriting on this sheet are susceptible to quite such precise dating, and a date in the very late 1490s cannot therefore be ruled out.

On the verso is a drawing of an old man in profile, based on ancient Roman coin portraits, executed in a beautifully calibrated black chalk. This must precede the traced reiteration of the recto composition since it is highly unlikely that Leonardo would have drawn the head across the latter. Black chalk, becoming ever softer in its use, is a medium associated particularly with the end of Leonardo's career. Its use begins in the mid-1490s and its style here would not contradict a date of about 1499–1500. LS

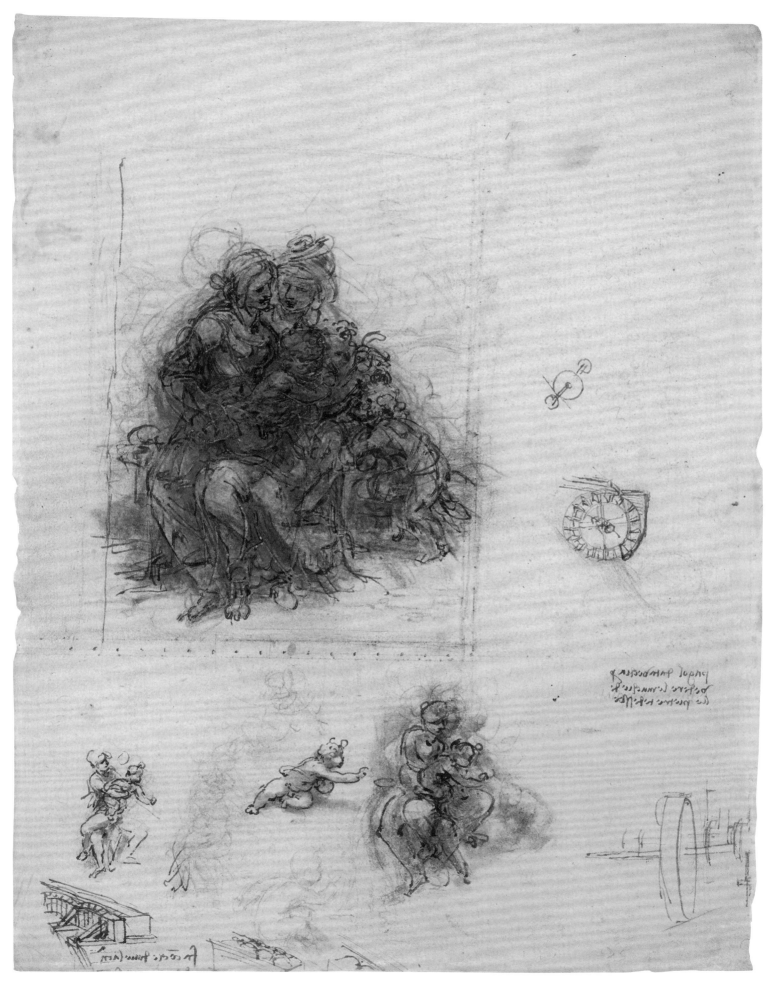

CAT. 85 (recto)

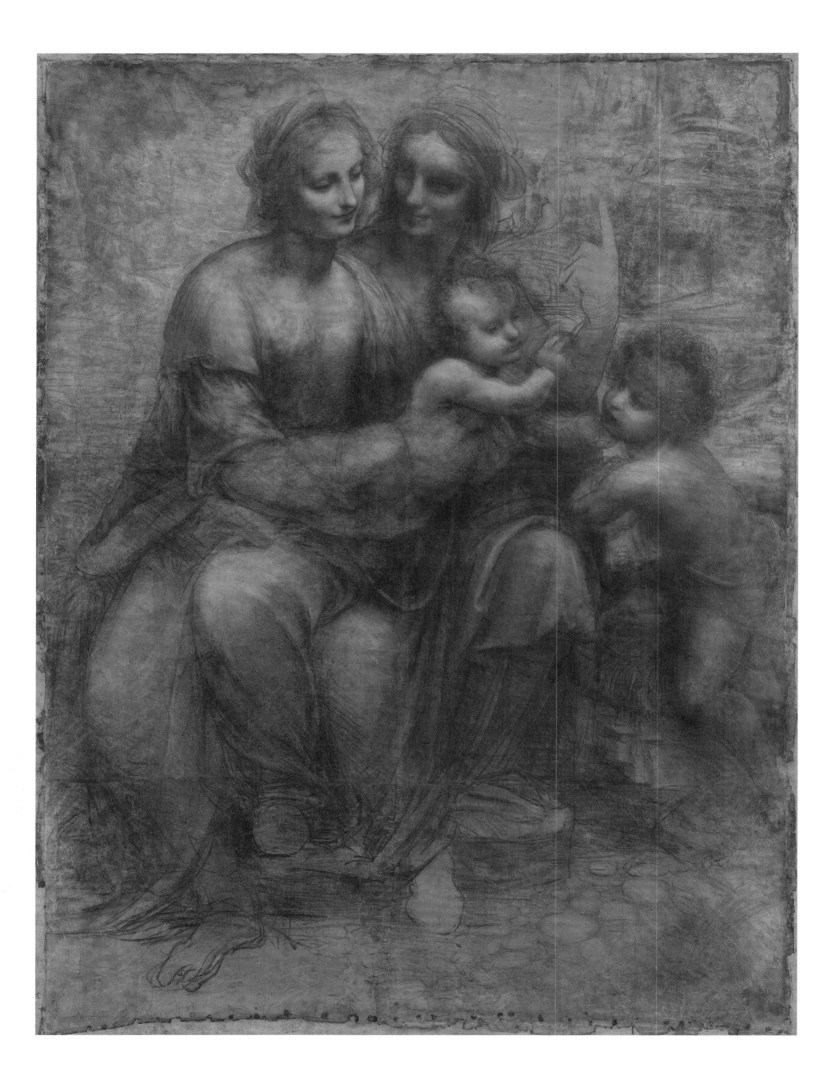

86

LEONARDO DA VINCI (1452–1519)

The Virgin and Child with Saint Anne and the infant Saint John the Baptist ('The Burlington House Cartoon')
about 1499–1500

Charcoal (and wash?) heightened with white chalk on paper, mounted on canvas
141.5 × 104.6 cm
The National Gallery, London
(NG 6337)
Purchased with a special grant and contributions from The Art Fund, The Pilgrim Trust,
and through a public appeal organised by The Art Fund

LITERATURE

Popham 1946, pp. 120–1, 132,
nos 176–80; Popham and Pouncey
1950, pp. 65–9; Clark and Gould 1962;
Davies 1963, pp. 49–58; Clark and
Pedretti 1968–9, vol. 1; Wasserman
1971; Pedretti 1973, pp. 104–8; Gould
1975, pp. 162–4; Kemp 1981, pp. 223–6;
Harding et al. 1989; Arasse 1997,
pp. 446–50; Marani 1999, pp. 256–64;
Zöllner 2003 (2007), pp. 143–5, 234–5,
no. 20; Plazotta in London 2004–5,
pp. 170–1, cat. 49; Kemp and Barone
2010, pp. 75–8, no. 28.

It would appear that this, the only large-scale drawing by Leonardo to have come down to us, was always considered remarkable. Its subject, the Virgin and Child depicted with her mother, Saint Anne, and the infant Saint John the Baptist, was unprecedented. The daring monumentality of the *Burlington House Cartoon* stems not merely from its size; this is also Leonardo's most complete and sustained graphic exercise in achieving a relief that is less pictorial than sculptural, modelled in charcoal and white chalk. At the same time it remains intensely aware of itself as an extemporised drawing. Its solid forms can suddenly dissolve, as Leonardo moves outwards from the bodies of figures towards draperies that are as yet not fully defined.

The *Cartoon*'s survival in such good condition is explained in part by the fact that it was never actually translated into a finished painting. Unlike other large drawings by Leonardo that are known to have existed, which were used for mechanically transferring a design from paper to panel, its contours were never pricked or scored – treatment that inevitably (and often fatally) weakens the paper on which it is drawn. This is not therefore a 'cartoon' as the term is usually defined today.

Its oddities would indeed have become more marked had the *Burlington House Cartoon* become a painting. In particular what makes it astonishing – its brilliant, frieze-like sculptural relief – is the aspect that causes one to ignore the anatomical errors forced upon Leonardo by his systematically complex entangling of the bodies. Where are Anne's proper right shoulder and arm, for example? Could the Virgin and Christ really twist at the waist in this way? These aspects of the work, its impressiveness as a drawing, its unsuitability for a painting, the combination of resolve and uncertainty that even by Leonardo's standards is extreme, and the way all these factors play within its function as a religious image, are often ignored in favour of discussions focused on its dating.

Though tirelessly debated, there is no agreement as to whether it was executed in about 1499–1500, started just before Leonardo left Milan, or later, around 1506–8, when he returned there. It is not known precisely why it was made or for whom (if anyone). And still to be determined is its relationship with the Louvre picture of the same subject, in which the infant Baptist is substituted by a lamb (fig. 48), and with the cartoon seen by Fra Pietro da Novellara in April 1501, which seems to have closely resembled the painting (see pp. 44, 46). And what are we to make of Vasari's story that a cartoon that included both a lamb and the infant Saint John the Baptist was shown at the convent of Santissima Annunziata quite soon after Leonardo's return to Florence? Though both London drawing and Paris painting are much too small, Vasari connected this work with an otherwise unrecorded project to paint the altarpiece for the high altar; in his second, 1568 edition he claims that this cartoon went to France. Had Vasari, in a muddle, conflated two works? And, if so, which of them was displayed at Santissima Annunziata – or was this another version altogether?

Though the evidence is slightly contradictory and mostly derived from later sixteenth- and seventeenth-century sources, perhaps we should place greater trust in the historical record. The first certain reference to the *Burlington House Cartoon* – its inclusion in a drawing by E.F. Burney – was in 1779, when it already belonged to the Royal Academy in London (based in Burlington House). Its earlier history contains a few gaps, but its provenance from the late sixteenth century can be pieced together with some confidence. This must be the cartoon mentioned in 1584 by Lomazzo, who states that it was once in France but by then was in the possession of the painter Aurelio Luini in Milan – a source of many copies. These include the picture (now in the Pinacoteca Ambrosiana, Milan) painted by his father, Bernardino Luini, in the 1520s. It has recently been confirmed by overlaying images of the *Burlington House Cartoon* and the Ambrosiana painting that Bernardino employed some form of mechanical means – probably a tracing – to transfer the design.[1] By this time the *Cartoon* seems to have belonged to the aristocratic Milanese collector Galeazzo Arconati, bought from the estate of the sculptor Pompeo Leoni in 1614. It is almost certainly the drawing described, still in Arconati ownership, by Padre Resta in a letter to Giampietro Bellori written before 1696: 'Louis XII, king of France, before 1500 ordered a cartoon of Saint Anne from Leonardo, while he was living in Milan in the service of Ludovico il Moro. Leonardo made a first sketch [*schizzo*] of it, now in the house of their lordships the counts Arconati.' Probably in 1721 it moved from the Arconati collection into the possession of the Casnedi family, also in Milan, and then to the Sagredo family in Venice. It had arrived in England by Christmas 1762, purchased a year earlier by John Udny, British

FIG. 108
BERNARDINO LUINI (1480–1532)
*The Holy Family with Saint Anne and
the infant Saint John the Baptist*, about 1520
Tempera and oil on wood, 118 × 92 cm
Pinacoteca Ambrosiana, Milan

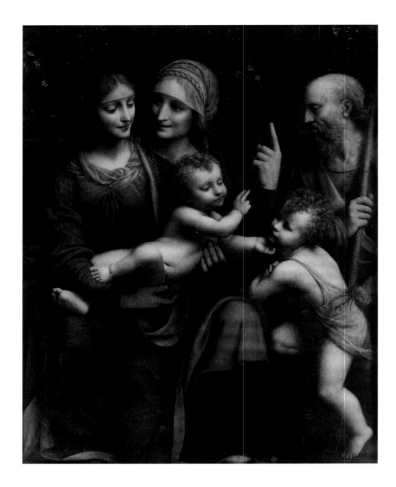

Consul in Venice. It is not quite certain how it was acquired by the Royal Academy, who sold it to the National Gallery in 1962.

Until the mid-twentieth century there existed a wide consensus that a painting of the Virgin and Child with Saint Anne had been ordered by Louis XII, around the time of his invasion of Milan in September 1499. Certainly by April 1501 Leonardo was said to be trying to wriggle out of obligations to the French king, presumably commissions he had accepted while still in Milan. This was a period of particular devotion to Saint Anne, the model of Christian womanhood. And Louis's consort, Anne of Brittany, had an especial devotion to her name saint, making Louis a particularly plausible patron for a picture with this subject.

In recent decades, however, many scholars have dated the *Cartoon* to around 1506–8. Almost all agree that the Louvre painting is more resolved – compositionally and iconographically – which would mean dating the picture later still. But this we now know is impossible since the Louvre painting was substantially completed by October 1503 (see pp. 44–5). This makes it likely that the cartoon described in 1501 by Fra Pietro da Novellara was used for the underdrawing of the Paris picture, and that the design of the *Burlington House Cartoon* had been abandoned in favour of that work. It must therefore have been made earlier still – bolstering the view that it was commissioned by Louis XII, and with the judgement of several scholars that stylistically it is most closely related to the *Last Supper*.

The four three-figure groups in the *Last Supper* are less ambitiously entwined than in the *Cartoon* but have similar rhythms and intervals between the lined-up heads; these are also the only two pictures in which Leonardo relinquishes his favourite pyramidal structure for his figure groups. The figures' heavy draperies are similar, and even the peculiarly hulking shoulder of the Virgin (suppressed in Luini's copy) is found in the Apostle on the far right of the *Last Supper* (fig. 102). Moreover, the features of Saint Anne resemble those of Saint James the Greater in the wall painting, most strikingly in the shadow around the eyes (see cat. 75, fig. 103).

The only remaining objection to a dating in the very early 1490s is the *Cartoon*'s obvious debt to ancient sculpture, something usually associated with Leonardo's visit to Rome in March 1501. The figures are imbued with a new classicism, evident in the rounded facial type of the Virgin, the treatment of

her parted hair and the heavy, deeply folded draperies. But this trend begins at least as early as the Apostle group on the far left of the *Last Supper*. It may well be explained in part by the arrival in Milan of one of the few pieces of ancient sculpture that could be seen in the city: in 1495 Ludovico il Moro received a marble statue of the nymph Leda.[2] This was the gift of Cardinal Gian Giacomo Sclafenata, Bishop of Parma, sent from Rome. It is likely that this was one of the numerous surviving marble statues that copy a lost Hellenistic bronze attributed to the Greek sculptor Timotheos (fig. 109). Leonardo, starved in Milan of the stimulus he had received in the Medici sculpture garden, seems to have taken immediate note: Leda lifts herself off a rock in a pose that seems to have informed that of the Virgin as she half rises from Anne's thigh in the *Cartoon*.[3]

Assuming a start date of about 1499, the *Burlington House Cartoon* would then have travelled with Leonardo to Florence, where he went on working on the royal commission. The *Cartoon* was seemingly known in Florence from the very beginning of the sixteenth century. There can be little doubt that Michelangelo had studied it before he made his own frieze-like drawing now in Oxford, usually dated around 1502 (fig. 110).[4] The cartoon used for the Louvre picture was seemingly known to Raphael, but there are indications that he, too, knew the London *Cartoon*.[5] We can therefore be fairly certain that both could be seen in Florence. But it is worth remembering that a finished painting of the Virgin and Child with Saint Anne did eventually enter the French royal collection, set up in a chapel by Louis's successor, François I. It may very well

NOTES

1 I am grateful to Larry Keith and Joseph Padfield for sharing with me the fruits of their research on this relationship.

2 For this Leda type, see Rieche 1978; Schröder 2004, no. 112; Monaco 2007a, especially p. 35.

3 She was to become one of Leonardo's subjects, though differently posed in both his variations on this theme, begun after his departure from Milan. This connection was made in Allison 1974.

4 Ashmolean Museum 1846.37 (P. II 291). See Joannides 2007, pp. 59–64, no. 1, who states that 'the recto drawing could have been made at any time between 1502 and 1506'. He points out that Michelangelo also appears to have had sight of another of Leonardo's designs for this group – Louvre RF 460 – which it more closely resembles. The brainstorming aspect of the verso – which seems to contain Leonardo's name in abbreviated form – may also have been learnt from the older master.

5 In, for example, the metalpoint studies at the Musée des Beaux-Arts, Lille, PL 437, identified as preparatory for the *Aldobrandini* (or *Garvagh*) *Madonna*.

FIG. 109
Roman copy of *Leda* by Timotheos, 370 BC
Marble, height 143 cm
Museo Nacional del Prado, Madrid

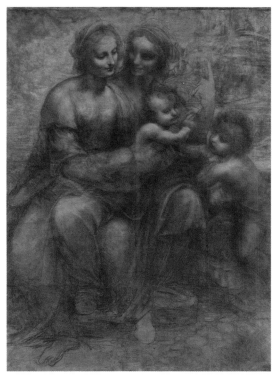

CAT. 86

FIG. 110
MICHELANGELO BUONARROTI (1475–1564)
Virgin and Child with Saint Anne, about 1502
Pen and ink on paper, 25.4 × 16.8 cm
Ashmolean Museum, Oxford (WA 1846.37)

6 The current width of the *Burlington House Cartoon* is 104.6 cm. Assuming, as would seem reasonable, that the pieces of paper glued together to make up sheet were all originally the same size, it has been deduced that it was probably trimmed on the left by about 5 cm. See Harding et al 1989. The original width of the Louvre painting before the strips of wood were added on either side was 112 cm – therefore almost exactly the same size as the *Cartoon* before it was cut. Though this has been discounted in the past, the same might very well be true for the height, the uppermost sheets of paper cut by around 30 cm. The *Cartoon*'s original height may therefore have been about 170 cm, again very close indeed to the 168 cm height of the Louvre painting. The dimensions of the Louvre painting are taken from Foucart-Walter 2007, p. 80.

be that there was only ever one commission for a painting of the Virgin and Child with Saint Anne and, despite the many ingenious theories to the contrary, that Leonardo's patron may always have been the French monarch, just as Padre Resta thought. The Paris *Virgin and Child with Saint Anne* would therefore constitute one of his very few pictures to be delivered (more or less) to the person who had ordered it. It is surely more than an odd coincidence that the *Cartoon* and the Louvre picture once had almost exactly the same dimensions.[6] The *Cartoon* seems to have travelled with Leonardo to France but remained in his possession; it was probably inherited by Francesco Melzi, who brought it back to Milan after Leonardo's death.

That the cult of Saint Anne was favoured by the Florentine republic because the tyrannical Duke of Athens had been expelled from Florence on her Feast Day (26 July) in 1343 may account in part for the great popularity of the display of Leonardo's *Cartoon*. Vasari is surprisingly imprecise about the timing of this display – and it may have taken place rather earlier than Easter 1501, perhaps at the time of Saint Anne's Feast Day the previous year (Leonardo was back in Florence by 24 April 1500 and remained there for the rest of the year). Though we cannot be sure, it is therefore entirely possible that it was the drawing that now survives in London that was shown so memorably to the hordes of admiring Florentines.

There are several features of the *Burlington House Cartoon* that would have made it a particularly suitable candidate for this kind of celebration. In the first place, it was important that this miracle of inspired talent should be a drawing. From at least the mid-fifteenth century it was agreed that *disegno* – the word which encapsulates not just the action of drawing but also of conceptual design or plan – was the activity that best linked hand to mind, raising the status of the painter above that of a craftsman. Leonardo takes this a step further: his drawing – of a religious subject – had become truly creative since it appears to connect the hand to the soul. That this drawing is so clearly unfinished in parts, and that it should contain visible changes of mind, could in themselves be taken as proof of creative fervour. The least finished but nonetheless the most resolved parts of the drawing are Saint Anne's right foot anchoring the composition and her hand pointing upwards towards God in Heaven. Both are left as crisp outlines. In Anne's hand we see laid down on paper that moment of inspiration – flowing, it would appear, directly from God, through her figure into the rest of the drawing. More than that, a hierarchy is set up. Saint Anne is imagined as the throne for her daughter, not just a model of maternal love but also the vessel for God's creation of the Immaculate Virgin: Mary seems to emerge from her mother. John is divided from the rest of the group by a little stream, a reminder of the Baptism of Christ. The presence of John – patron saint of the city – is also a feature that might have appealed to a Florentine audience. If not yet containing the narrative poignancy of the Louvre painting, the *Burlington House Cartoon* sets out to reveal the link between the creative mind and the energetic hand in a way that might well be regarded as miraculous. LS

87

LEONARDO DA VINCI (1452–1519)

Bust of a woman
about 1499–1501

Red chalk over metalpoint on red-ochre prepared paper
22.1 × 15.9 cm
Lent by Her Majesty The Queen
(RL 12514)

This drawing is a seeming rarity within Leonardo's graphic oeuvre in that red chalk, a technique he pioneered in the 1490s, is combined with metalpoint (seen best in the woman's head), much used by him until the end of the 1480s.[1] He had previously used metalpoint for underdrawing (as here), but for studies worked up in pen and ink. His use of metalpoint here is notably less precise than in his drawings made in Florence or during his early Milanese period, where he used metalpoint alone to reproduce the delicate play of light on the half-length figure (see for example cat. 12). In the present drawing, however, shadows are created by fully exploiting the potential of the red chalk, just as he had in some studies connected with the *Last Supper* a few years earlier. Interestingly, the red chalk technique is still in certain respects reminiscent of the way in which he used metalpoint, the shading achieved by brilliantly controlled parallel hatching. The treatment of the figure's proper left shoulder is particularly characteristic, its bold contour energised by the splash of shade behind it, and the soft, almost tender passages of *sfumato* below the collarbone.

That we are looking at a study from life is intimated by the repeated attempts to find the contour of this shoulder, with hatched lines above emphasising the turning movement of the woman's body. Leonardo's long-standing interest in the movements of the human frame here reaches its apogee. And it is mainly because of the kind of movement being investigated here that this page has long been considered the only autograph drawing connected with the *Madonna of the Yarnwinder* (cat. 88), despite the obvious differences in the figure's pose and costume. These marked variations mean that the drawing cannot be considered a straightforward preparatory study for the *Madonna of the Yarnwinder*, but as in some sense preliminary: as so often, Leonardo used the study as a starting point rather than copying it into the finished painting.

Chronologically the drawing and painting belong to much the same moment. As we know from the Carmelite friar Pietro da Novellara, the painting was well under way by 1501 – and the drawing's style and technique, closest perhaps to Leonardo's study used for the head of Saint Bartholomew (see cat. 80), make a date of about 1500 entirely plausible. But, although the connection between the *Madonna of the Yarnwinder* and this page appears well-founded, we are still some way from a complete understanding of their exact relation-

ship. Before the publication in 1926 of Emil Möller's important article on the subject, the present drawing was generally linked to Leonardo's *Lady with an Ermine* (cat. 10), thought to be one of the many studies (others assumed to be lost) he must have made in his search for the perfect position for his sitter, Cecilia Gallerani. Even if chronologically this direct link is clearly impossible, it seems likely that the pose of the *Lady with an Ermine*, painted about a decade earlier, served as the starting point for this drawing. In particular, Leonardo re-examines the movement achieved by juxtaposing a dropped right shoulder and a partly naked, dramatically sloping left, brilliantly convincing and at the same time the least naturalistic part of the design. The meeting of the lines of shoulder, neck and jaw is almost a trademark. And Leonardo now takes this pose further. Though this drawing is of a completely different flavour from such extraordinarily complex contemporary creations as the *Burlington House Cartoon* (cat. 86), the positioning of the half-figure, the angle of her body more acute than Cecilia's, has a certain family relationship with the figure of Saint Anne there. Once again we see Leonardo moving fluidly between sacred and secular, this drawing used to rethink his portrait of Cecilia into a Madonna.

The connection between this page and the *Madonna of the Yarnwinder* is affirmed by another red-chalk drawing in the (Gallerie dell'Accademia, Venice, 141) in which the study is 'completed' by a fully elaborated head and face. To the side are three small, loosely sketched figures in related poses, one of which echoes the position of the *Madonna of the Yarnwinder*. The draughtsman responsible for the Venice drawing began by copying the present study very literally, to the extent that the hatching is also left-handed; for this reason the page in the Accademia has sometimes mistakenly been identified as another preparatory study, made slightly later, for the painting seen by Fra Pietro; in fact, a certain lack of control and heaviness of line exclude it from Leonardo's own graphic corpus.[2] The attribution to Cesare da Sesto is only slightly more convincing. It was probably made in the 1510s by another close associate of Leonardo, at a time when drawings based on Leonardo's originals were being almost serially reproduced or reconstructed (see cat. 82),[3] and when there was an explosion of pictures based on his *Madonna of the Yarnwinder* in both Florence and Milan.
AG

LITERATURE

Möller 1926, p. 68; Clark 1935, vol. 1, pp. 76–7; Berenson 1938, vol. 2, p. 130, no. 1168; Popham 1946, p. 152, no. 173; Clark and Pedretti 1968–9, vol. 1, pp. 90–1; Pedretti 1982b, pp. 22–3; Vezzosi in Naples and Rome 1983–4, p. 58, cat. 31; Kemp in Edinburgh 1992, p. 49, cat. 6; Clayton in London 1996–7, p. 64, cat. 32.

NOTES

1 It may be that the scientific study of Leonardo's red chalk drawings on red prepared paper will reveal other underdrawings of this kind, completely covered over.

2 Formerly attributed to Leonardo by Gerli 1784, pl. 7. More recently, only Pedretti has remained convinced by the attribution to Leonardo (Pedretti 1982b, pp. 22–3; Pedretti 1983, pp. 58–9).

3 See Carminati 1994, p. 299, no. D80. Also in favour of the attribution to Cesare but dating the work to the beginning of the century is Perissa Torrini in Venice 1992, p. 406, cat. 91.

LEONARDO DA VINCI (1452–1519) and
ANONYMOUS SIXTEENTH-CENTURY PAINTER
Virgin and Child ('The Madonna of the Yarnwinder')
about 1499 onwards

Oil on walnut
48.9 × 36.8 cm
The 10th Duke of Buccleuch
and The Trustees of the Buccleuch Living Heritage Trust

The *Madonna of the Yarnwinder* is the first painting on which Leonardo is known to have worked after his return to Florence in 1500. Thanks to a letter written by the Carmelite friar Pietro da Novellara to Isabella d'Este, Marchioness of Mantua, we can be fairly sure that this picture was on his easel in April 1501.[1] Fra Pietro, whose task it was to encourage Leonardo to push on with the commissions he had received from the Marchioness the previous year, explains Leonardo's lack of progress: he was distracted by mathematics and was already busy painting a picture for Florimond Robertet (died 1527), influential secretary to King Louis XII of France and an ardent admirer of Italian art.[2] He probably received the commission for the present painting just before he left Milan at the end of 1499, and since it is painted on a walnut panel it may have been started there (all Leonardo's certainly Florentine pictures are on poplar). Fra Pietro describes the artist wrestling with a *quadretino* (little painting):

> . . . a Madonna sitting as if she wished to wind yarns onto a winder. The Child has put his foot in the small basket of yarns and has grasped the winder and looks attentively at the four spokes which are in the form of the Cross. And, as if he longed for this Cross, he laughs and holds it fast, not willing to yield it to his Mother, who seems to want to take it away from him.

Though these words do not entirely square with the appearance of this painting (there is no basket), this description of the *Madonna of the Yarnwinder* puts the picture into the very select category of works by Leonardo interpreted by one of his contemporaries. Fra Pietro's serene image of a game between a mother and her son, in which the cross-shaped yarnwinder foreshadows the Passion of the unsuspecting infant, shows that he has fully understood an important innovation to the iconography of the Madonna and Child. Here a symbol of the Passion becomes an object of childish play, much like the cruciform flower in the *Madonna Benois* (fig. 3) or the sacrificial lamb in the *Virgin and Child with Saint Anne* (fig. 48).

Fra Pietro's words also provide us with an idea of the narrative and emotional intensity of the image, and of its extraordinary structural complexity. The rotation of the Virgin's head and shoulders means that she can follow and simultaneously restrain the movement of the Christ Child. The sense of instability, the precarious

balance of their poses, should be seen as an expression of their *moto dell'animo* (stirring of the spirit) of the kind Leonardo had explored in the *Last Supper* (see p. 250).

As so often in his work, we are confronted here by a re-thinking of earlier ideas. The Child's sudden movement as he twists round, levering himself up onto his bent leg and playfully trying to escape his mother's grasp, recalls a subject studied in depth years earlier in the studies for the *Virgin and Child with a cat* (see cat. 56, fig. 35). Similarly, the position of the Madonna's foreshortened right hand reuses an idea thoroughly explored in the two versions of the *Virgin of the Rocks*. More novel, however, is her imposing upper body, borrowed from creations like the Apostles in the *Last Supper*, and encountered again in Leonardo's monumental portrait of Isabella d'Este in the Louvre (fig. 28).

His startlingly original invention, which inspired both Raphael in his Bridgewater *Madonna* (Duke of Sutherland collection, on loan to the National Galleries of Scotland, Edinburgh) and Michelangelo in the *Taddei Tondo* (Royal Academy of Arts, London), enjoyed extraordinary success; myriad variants and copies can be found in museums and collections all over the world.[3] Two versions in particular have been judged to stand above the rest: the painting exhibited here, known as the Buccleuch *Madonna* – probably the original seen by Fra Pietro – and one now in a private collection, often called the Lansdowne *Madonna*. Ever since these two pictures were first directly compared at the Burlington Fine Arts Club exhibition of 1898, the relationship of one to the other has been debated.

Unfortunately their respective provenances are no help in resolving this problem.[4] That of the Lansdowne painting is known for certain only from the early nineteenth century. The present work was first inventoried in Montagu House in London in 1770. It arrived there after the sale in 1756 of the collection of the duc de Tallard in Paris, in whose possession Dézallier d'Argenville records it in 1752.[5] No earlier mention has thus far been traced. Certainly this eighteenth-century French provenance is too far-removed to allow it to be securely identified as the *quadretino* painted for Florimond Robertet, and in fact we do not even know whether the commissioner ever received his picture. In the posthumous inventory of Robertet's collection, drawn up in 1532, there is no trace of any painting that might have resembled the *Madonna of the*

LITERATURE

Cook in London 1898, p. 16, cat. 60; Möller 1926, pp. 61–9; Milan 1939, p. 170; London 1952, p. 68, cat. 251; Popham in London 1960, cat. 315, p. 118; Kemp 1992, pp. 9–24; Kemp in Edinburgh 1992, cat. 1, p. 40; Gould 1992, pp. 12–16; Penny 1992, pp. 542–4; Bury 1992, pp. 187–9; Zöllner 2003 (2007), p. 239, no. 24.

NOTES

1 Villata 1999, pp. 136–7, no. 151. Its correct date is 14 April 1501 (not 4 April, as sometimes given).
2 See Crowe 1992, pp. 25–33.
3 See Vezzosi in Naples and Rome 1983–4, pp. 62–5, cats 40–62; Kemp in Edinburgh 1992, pp. 42–7, cats 3–5.
4 Fredericksen 1991, pp. 116–18; Kemp in Edinburgh 1992, pp. 40–1; Pedretti 2000, pp. 30–1. It has been suggested, however, that it is the picture attributed to Leonardo in an inventory of the collection of Robertet's grandson Charles d'Escoubleau, Marquis de Sourdis (1588–1666): 'une Vierge tenant un petit Jesus entre ses bras'. This mention is intriguing but the description is too generic for us to be certain that it is a picture with the *Madonna of the Yarnwinder* composition that is being described. It should also be remembered that there was an explosion in the seventeenth century in the number of pictures optimistically ascribed to Leonardo. For the provenance of the Lansdowne *Madonna* see Straussman-Pflanzer in Chicago 2011, pp. 196–8, cat. 114.
5 Dézallier d'Argenville 1752, p. 212.
6 Fredericksen 1991, p. 118. The Robertet inventory is in Gresy 1868, pp. 21–66. It should be pointed out, however, that the authenticity of the Robertet inventory has been questioned. See Mayer and Bentley-Cranch 1994, p. 142. The *Madonna of the Yarnwinder* is not the only painting missing from the inventory, in which there is also no trace of Lorenzo Costa's *Veronica* (Louvre). No information relating to transfers of property prior to the inventory exists either. The hypothesis that the painting could have been given to an ancestor of the duc de Tallard by Robertet himself (Snow-Smith 1979, pp. 195–6; Kemp 1992, p. 13) seems to have no documentary confirmation (Fagnart 2009, p. 27).
7 Beltrami 1919, p. 124 , no. 183.

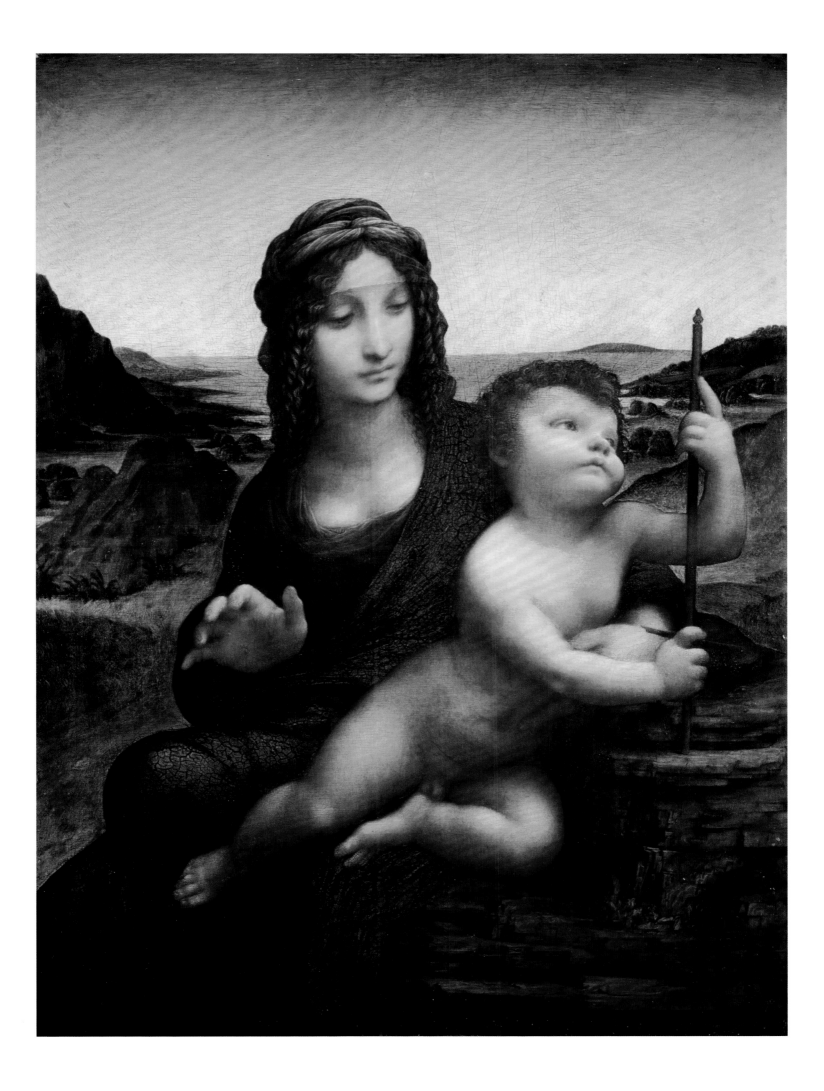

Yarnwinder.[6] It has been suggested that its absence can be explained because it had passed into the French royal collection before the death of Robertet, and that the *piccol quadro* (small painting) by Leonardo that arrived in Blois in 1507, which according to the Florentine ambassador Pandolfino Malatesta so pleased Louis XII,[7] was none other than Robertet's *Madonna*.[8] This is a beguiling hypothesis but it has alas no documentary evidence to support it. Nor has there been any satisfactory explanation of how and when the painting left the royal collection – from which all the Leonardos now in the Louvre came.[9] It has been observed that there is no direct echo of this picture in sixteenth-century French painting – unlike others by Leonardo that travelled early to France.[10] Leonardo often disregarded the wishes of his clients and, though the fact that he returned to Milan in 1506 to work at the French court there might encourage one to imagine that the painting had thus arrived at its destination, its early history remains profoundly mysterious.[11]

Until the 1926 publication of the crucial article by Emil Möller promoting the Buccleuch version (linking the painting to cat. 87), the *Madonna* now in New York was always regarded as the better of the two, even though neither was considered to be by the artist's hand alone.[12] Although opinions differ on the precise role of Leonardo in the two paintings, especially since they were shown side by side in Edinburgh in 1992, it seems most likely that the Buccleuch *Madonna* was the painting for Robertet, and the New York painting is a studio version, begun under Leonardo's supervision and perhaps based on his underdrawing.[13]

Thanks to its warm, softly blurred colours and the strongly accented, beautifully controlled passages of light and shade in the skin tones, the figures in the Buccleuch painting seem closer to Leonardo's mature style and technique than those of the other version, which has something of the sentimental about it. The Buccleuch *Madonna* is less than perfectly preserved in some areas: the lapis lazuli in the Virgin's blue mantle appears degraded, and the flesh painting was somewhat compromised even before the current varnish, now badly yellowed, was applied. Nonetheless, certain entirely characteristic and exquisite details are quickly discerned: the Virgin's transparent veil, the delicately curled locks of her hair and the finely attuned modelling of her left hand, emerging from the shadow cast by

the Child's arm. The depiction of the large rock upon which the figures are arranged supports the attribution of the picture to Leonardo himself; he has rendered its jagged, irregular forms with a painstakingly scholarly accuracy worthy of a geologist.

This standard is not, however, maintained throughout and, given that our expectations of a painting entirely by Leonardo's hand are justifiably high, even the more enthusiastic critics have been reluctant to recognise the Buccleuch *Madonna* as a fully autograph original.[14] In Fra Pietro's slightly earlier letter, to Isabella, of 3 April, he describes a version of the Saint Anne cartoon (see p. 44) and claims that Leonardo had achieved nothing else, 'se non che dui suoi garzoni fano retrati, et lui a le volte in alcuno mette mano' ('if not for the two assistants who make copies, and he sometimes puts his hand to one of them'). Taking into account the discrepancy in his description of Robertet's picture, it has been suggested that this is just such a copy of a lost original, with finishing touches by Leonardo. Some of its mildly disappointing aspects might be ascribed to collaboration; but it is also worth remembering that in Fra Pietro's letter there emerges a Leonardo grown somewhat idle, submerged in mathematical experiment and indifferent to painting.[15] These too might be traits that found their way into the picture.

However, it is worth recalling that earlier critics' preference for the other principal version of the *Madonna of the Yarnwinder* was (apart from its beguilingly clear colour scheme) principally based on its landscape, thought to be typical of Leonardo with its well-watered valleys and bluish hills dissolving into the distance.[16] The Lansdowne *Madonna* is stylistically much more of a piece than the Buccleuch picture, and even if it follows a design of Leonardo's, it seems to be by a single hand. In 1926 Möller stressed that the defects and deficiencies of the Buccleuch version are at their most evident in the landscape, and it is in the qualitative difference between figures and landscape that we find evidence of two hands – and this is not a simple matter of delegation. The background to the Buccleuch *Madonna* was added round the figures by another painter at a rather later date. This can be observed in the areas around the Virgin's head and the Child's raised left hand, executed in thick paint which is rather coarsely applied, giving the figures a misleadingly crude contour.[17] The valley opening out onto

8 Möller 1926, p. 68; Brown 1981, p. 25; See also Fredericksen 1991, p. 118.
9 However the Louvre *Saint John the Baptist* did leave the French royal collection to travel to England before returning to France.
10 Fagnart 2009, p. 27. The copy in the Louvre appears to be an Italian work and to have originated in Rome in the early eighteenth century (Vincent Delieuvin, personal communication 2011; Foucart-Walter 2007, p. 82), while the copy in the Musée des Beaux-Arts in Dijon is from the late seventeenth century (Guillaume 1980, p. 40, no. 63).
11 Robertet's direct contact with Leonardo was certainly renewed then. See Beltrami 1919, pp. 115–16, no. 184; Villata 1999, pp. 209–10, no. 241.
12 Gustavo Frizzoni attributed the version now in New York to Sodoma, and described the Buccleuch version as a copy of it, see Cook in London 1898, p. 16, nos 59–60; also favouring the attribution to Sodoma were Venturi 1898, p. 318 and Berenson 1910, p. 288.
13 Some scholars, however, continue to consider the Lansdowne *Madonna* to be by Leonardo (Pedretti 2000, pp. 23–40; Kemp 2006, pp. 209–13; Straussman-Pflanzer in Chicago 2011, pp. 196–8).
14 Gould 1975, p. 107.
15 As mentioned by Pietro da Novellara on 3 April 1501; see Beltrami 1919, p. 72.
16 Pedretti 1982b, pp. 20–22; Pedretti 1983, p. 57; Suida 1929, pp. 135–6; Suida 1931, pp. 333–9; Starnazzi 2000, pp. 11–19.

17 Penny 1992, p. 543.

18 See Kemp 1992, pp. 16–20; Kemp 1994, pp. 259–74; Kemp 2006, p. 212. Martin Kemp's approach to the problem of attribution is notably even-handed. He regards both as 'generated alongside each other in the master's studio and with his direct participation'. He stresses the presence of *pentimenti* and the similarly creative underdrawings in both pictures, especially in the suppressed figure group in the middle distance. 'What these and other shared changes show is that Leonardo took advantage of his work on Robertet's commission to generate simultaneously a second, readily saleable devotional painting to offer to a patron when the opportunity arose.'

19 Not only does this area contain considerable quantities of carbon black, blocking our view of any drawing underneath, if Leonardo executed this part of the drawing using iron gall ink (used in the *Saint Jerome*, for example) it would not be visible under infrared.

20 Gould 1992, p. 13. The improvised style of underdrawing in the landscape would not suggest the use of a cartoon for the whole composition.

the sea, with its feebly reduced hills and mountains, shows no sign of the scientific knowledge which so profoundly underpins Leonardo's own depiction of nature and was understood as a key feature of his work even by the less astute members of his studio. The zig-zagging promontories jut into the heads, the horizon line is unfortunately placed, and clumsiest of all is the slope of a hill in the middle ground trailing into the crucial junction between the Christ Child's cheek and his shoulder, confusing the connection between his eyes and the Cross. This is not a landscape executed under Leonardo's supervision. The preparatory drawing revealed by infrared indicates that the artist originally planned a very different landscape.[18] A little scene loosely sketched in the middle ground at the upper left apparently shows a Holy Family, the Child in a baby-walker, playing with a small ball or hoop.

Fascinatingly, this feature recurs in the underdrawing of the New York version but was here suppressed in favour of the mountainous landscape that more closely resembles that of the *Mona Lisa* (fig. 32), bringing the picture up to date. A number of other copies, like that attributed to Pedro Yanez de Almedina (National Galleries of Scotland, Edinburgh), contain a finished version of this group. It therefore appears that Leonardo's *garzoni* were expected – or permitted – to copy their master's every move. Since the many versions of the *Madonna of the Yarnwinder* have such diverse landscapes, we may surmise that the background of the original was left incomplete and unresolved for quite a long time, the picture copied at various moments in its evolution but leaving the copyists room for manoeuvre when it came to 'completing' the landscape. In the case of the Buccleuch primary version, a later owner had the work finished by an unsympathetic hand.

The painter of the Lansdowne *Madonna*, on the other hand, chose to imitate other models.

The underdrawn domestic scene is not the only idea in the *Madonna of the Yarnwinder* that has been lost. The Buccleuch and Lansdowne versions are both characterised by the absence (seemingly also in the underdrawings) of the basket of yarns mentioned by Pietro da Novellara in his letter to Isabella d'Este. This feature can, however, be found in some of the copies, although it appears in a different place from that described by Fra Pietro. This again leads us to think that the copyists may have been aware of Leonardo's ideas abandoned as the work proceeded. Although no basket has been securely identified in the underdrawing of the Buccleuch *Madonna*, the fragment of rock painted relatively crudely at lower left, below Christ's feet, might well cover a first sketch for this element.[19] Fra Pietro therefore saw a version of the *Madonna of the Yarnwinder* that was different from this only because it was still in the process of being painted; it would be illogical to assume that on 14 April 1501 he saw a lost cartoon.[20] In his letters to Isabella, written just a few days apart, he makes a clear distinction between the *cartone* (cartoon) with Saint Anne and the *quadretino* of the *Madonna of the Yarnwinder*. When writing to someone as quick on the uptake as Isabella d'Este, eager for detailed information about Leonardo, he would certainly not have made the elementary mistake of confusing the two. Technical analyses of his pictures – and indeed the unfinished state of the *Saint Jerome* – show that Leonardo typically worked up his figures to quite a high level before resolving their landscape setting. The Buccleuch picture may have been abandoned as he got to that point; nevertheless, it remains a work devised and to a great extent executed by Leonardo. AG/LS

89

LEONARDO DA VINCI (1452–1519)
Drapery study for the Salvator Mundi
about 1500

Red chalk and traces of pen and ink heightened with
white chalk on red-ochre prepared paper
22 × 13.9 cm
Lent by Her Majesty The Queen
(RL 12524)

90

LEONARDO DA VINCI and WORKSHOP
Drapery studies for the Salvator Mundi
about 1500

Red chalk and traces of pen and ink heightened with
white chalk on red-ochre prepared paper
16.4 × 15.8 cm
Lent by Her Majesty The Queen
(RL 12525)

These two sheets are almost always discussed together
– and were long ago connected with a painting of
Christ as Saviour of the World that Leonardo was
thought to have painted. But until now discussion
of the drawings has been somewhat hampered by the
disappearance of his painting, and they could only
be related to a whole series of pictures which are best
described as variations on a basic theme, in which
some ingredients are stable while others are subject to
change. With the recent re-emergence of the primary
version, it can now be confirmed that these studies do
indeed seem to be preparatory for Leonardo's picture.
The draperies were studied from life, though the
summary description of the wrist in both sheets
suggests that they were arranged on a lay figure. These
drawings therefore fall into the long tradition within
Leonardo's oeuvre of separately studied draperies,
drawings which might be made before he started
painting or once it was under way (see cat. 91).

Leonardo is here seen grappling with a somewhat
intractable, sticky dark red chalk, perhaps chosen
because it would render his shadows particularly strong
and dense – especially in the drawing of the arm, at the
point where one sleeve emerges from the other.[1] The
result, however, is uncharacteristically heavy-handed.
He may therefore have taken up another red chalk
for the lighter areas in the study of the drapery pleats
falling over Christ's chest – the upper study in cat. 90
– at this stage bisected by just one band of what would
be a crossed stole (though the other would be roughly
indicated after the drawing was complete).

Christ's tunic was seemingly drawn after the much
less assured and significantly coarser study of the sleeve
below, in which the apparently left-handed hatching
strokes are rather more horizontal than Leonardo's
own. It is conceivable that we are witnessing a right-
handed draughtsman using his left hand to emulate
Leonardo. Moreover, the white chalk highlighting is
clearly right-handed and can only be the work of a
pupil. It was evidently executed in the period around
1500, when Leonardo's red chalk technique was closely
imitated by a number of pupils,[2] and at a time when
very occasionally we encounter drawings in which
Leonardo and a pupil can be seen working side by
side.[3] Though less delicate, cat. 89 and the autograph
parts of cat. 90 are best compared with Leonardo's
study of a woman's neck and torso (cat. 87) related to,
though not strictly preparatory for the *Madonna of the*

Yarnwinder. Although these drapery studies are most
frequently dated to around 1504, that they were in
fact drawn around 1500 is therefore more plausible.

There are elements in each sheet that are particu-
larly close to details in Leonardo's finished painting.
The oversleeve in cat. 89 has the same sharply high-
lighted S-shaped fold and pattern of folds below. The
omega-shaped tuck in the drawing of Christ's vestment
is not as evident in the newly rediscovered picture as
it is in some of the other workshop versions, but it is
present nonetheless. It has been argued by Joanne
Snow-Smith that this shape evokes the lance wound in
Christ's side when he was on the cross, but this would
be the only reference in the picture to his Passion
(and an expendable ingredient regularly dispensed
with in the copies).

Importantly, there are also several details which
differ from Leonardo's painting, some of which appear
in one or other of the variant copies. This, too, may
provide a clue as to his workshop practice at this time.
The inner sleeve in cat. 89 has a buttoned cuff like that
in the ex-Yarborough picture, where the whole double
sleeve appears in simplified form. For this reason this
picture has sometimes been seen as closer than others
to Leonardo's lost original, or used as evidence that
he himself made two different designs for the *Salvator
Mundi*. The version formerly in the Yarborough
Collection has the crossed stole, but this is also
dropped in other versions. Copyists evidently were
given – or took – some license: the orb is usually but
not always crystal; the recently recognised autograph
version is unusual in depicting Christ entirely in blue
– more often his tunic is the canonical red.

Under infrared light, the copy in the Ganay collec-
tion, once promoted as the lost original, shows signs
of the use of a pricked cartoon in the folds of Christ's
vestment.[4] But there is still much to be resolved on the
matter of how reproductions were made. We might
therefore conclude that, though probably developed
with a particular patron in mind, Leonardo may always
have envisaged this composition, like that of the
Madonna of the Yarnwinder, as one to be serially replicated,
with pupils and assistants allowed – even encouraged –
to insert individual touches, sometimes reverting
to his earlier preparatory studies to do so. Thus the
resulting pictures could go on being acts of devout
creation while still containing the authority of
Leonardo's prototype. LS

LITERATURE
Bodmer 1931, p. 409; Clark 1935, vol. 1,
p. 80; Heydenreich 1964, pp. 96, 98,
100–1; Clark and Pedretti 1968–9,
vol. 1, p. 94; Snow-Smith 1982,
pp. 16–17, 59, 61, 81 n. 13; Clayton in
London 1996–7, pp. 81–3, cats 43–4;
Bell 2002, p. 253 (for cat. 90).

NOTES
1 I am grateful to Martin Clayton for
 this observation.
2 See e.g. the Venice sheet, sometimes
 thought to contain Leonardo's own
 ideas for the Christ in the Louvre
 Virgin and Child with Saint Anne, but
 in fact the work of another pupil
 impersonating his master
 (Accademia 257). See also cat. 82.
3 Like Windsor RL 12328.
4 Snow-Smith 1983, p. 37.

CAT. 90

CAT. 89

LEONARDO DA VINCI (1452–1519)

Christ as Salvator Mundi

about 1499 onwards

Oil on walnut
65.5 × 45.1 cm
Private collection

FIG. III
WENCESLAUS HOLLAR (1607–1677)
After Leonardo da Vinci, *Salvator Mundi*, 1650
Etching, first state, 26.4 × 19.0 cm
The Royal Collection (RL 801855)

It has always seemed likely that Leonardo painted a picture of Christ as the Saviour of the World.[1] In 1650 the celebrated printmaker Wenceslaus Hollar signed an etching of Christ raising his right hand in blessing, holding a transparent orb in his left, with a nimbus of light behind his head; the image was taken, he states, from a painting by Leonardo (fig. III).[2] Though Hollar was generally well-informed, this would not be enough on its own to prove that an autograph picture by Leonardo had once existed. By the seventeenth century any number of paintings by his pupils and associates were firmly attributed to Leonardo himself and there was no shortage of pupils' pictures depicting the *Salvator Mundi*, all clearly related to one another, all unmistakably Leonardesque. In 1978 and 1982 one of these many versions was promoted as Leonardo's lost 'original', partly because of its similarities to the etching, a suggestion that has rightly been rejected.[3] Hollar might very well have been copying a copy.

There is other evidence, however, that Leonardo explored this or a related subject. As early as the mid-1480s he drew a 'head of Christ', in pen and ink, which appears in the list of his works preserved in the Codex Atlanticus (see p. 25). And in the early sixteenth century he discussed painting an adolescent Christ for Isabella d'Este, Marchioness of Mantua.[4] Most importantly, there survive two red chalk drawings of draperies, obviously related to the composition etched by Hollar and the many workshop copies (cats 89, 90). But even these do not constitute proof that Leonardo painted a *Salvator Mundi*, and it has sometimes been argued that these drawings might have formed the basis for one or more finished designs – perhaps cartoons – that he made expressly to be copied by pupils but with no primary version by the master himself. Other scholars have imagined, more straightforwardly, that Leonardo's own painting disappeared long ago.

The re-emergence of this picture, cleaned and restored to reveal an autograph work by Leonardo, therefore comes as an extraordinary surprise. Though Hollar's Christ is very slightly stouter and broader, the two images coincide almost exactly. The draperies are just a little simplified and there is no glow of light around Christ's head. Otherwise the newly discovered painting has the same snaking locks of hair, expressionless face and uncannily direct gaze, and the same swathe of monumental drapery across his shoulder. And the knot-pattern ornament on Christ's crossed stole and on the border of his vestment are very similar indeed, a particularly important consideration given that this ornament is the aspect most subject to change in the different surviving versions. There can be no doubt that this is the picture copied by Hollar.

In fact this version of the *Salvator Mundi* is not a new discovery. It has been known since the beginning of the twentieth century but never seriously studied and certainly not recognised as Leonardo's own work. The picture was acquired in 1900 by Sir Francis Cook for his collection at Doughty House in Richmond, Surrey, through or from his long-standing adviser, Sir J.C. Robinson. It has not yet been discovered where Robinson obtained it. In 1913 Tancred Borenius catalogued it as a 'free copy after Boltraffio', twice removed therefore from Leonardo. In 1958 it was sold from the Cook collection, still as a copy after Boltraffio. The low esteem in which it was held is easy to explain: by the time it came into Francis Cook's possession it had been very considerably overpainted. Christ's blessing hand was the least altered area but his head had been almost entirely reinvented. And that after 1958 it was known only from the poor black-and-white photograph reproduced in Borenius's catalogue only compounded the problem.

The reasons for such abundant overpaint are also clear. Though both Christ's hands are well preserved, elsewhere the picture has suffered. Sometime in the past the panel split in two, causing paint losses along the length of the crack. It has also been aggressively over-cleaned, with some abrasion of the whole picture surface and especially in the face and hair of Christ, where Leonardo's sequence of delicate paint layers

LITERATURE

Borenius 1913, p. 123; Suida 1929, p. 140; Clark 1935, vol. I, p. 80; Suida in Los Angeles 1949, pp. 85–6; Heydenreich 1964, p. 109; Snow-Smith 1982, pp. 11, 12, fig. 7.

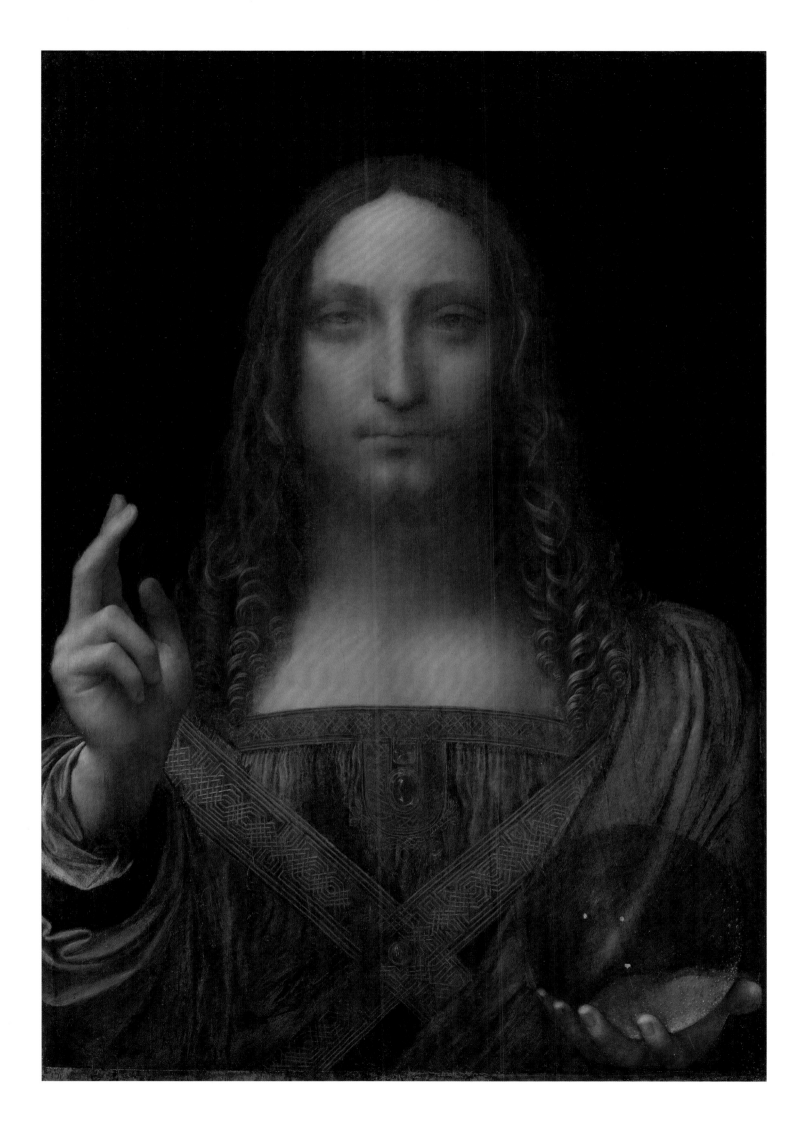

were especially vulnerable. It may well be that this ill-judged restoration took place quite early in the picture's history, possibly soon after it arrived in England in the early seventeenth century.

The location of the picture in Hollar's 1650 etching has long been a matter of speculation. It is known that his long-standing patron, the exiled Queen Henrietta Maria, received proof copies,[5] and it seems that this gift had special meaning. Both the Queen and the Royalist printmaker had fled England in 1644, and when Hollar presented Henrietta Maria with the etched *Salvator Mundi* her king, Charles I, had been dead just a year, beheaded in 1649. In the inventory of the royal collection drawn up after his execution, there appears: 'A peece of Christ done by Leonardo at 30:00:00 / Sold to Stone a/o 23 Oct. 1651'.[6] It appears to have hung in Henrietta Maria's private 'closets' at her house in Greenwich. Hollar must have made a drawing of Leonardo's painting while he was still in England, when it still belonged to the King and Queen. This drawing then formed the basis of the print, an image that had now come to have additional associations for the Catholic Henrietta Maria. The several connections with the Queen suggest that the *Salvator Mundi* is likely to have come to England when she married Charles in 1625, and was originally the property of the French royal family: several of the best copies have a French provenance.[7]

None of this, of course, is evidence for the picture's autograph status. After all, the pictures by pupils copying Leonardo's design may sometimes have been rather good, and one such might easily have been owned by Henrietta Maria. The quality of Christ's blessing hand suggests that the picture had previously been significantly underestimated; but it took its recent cleaning to reveal the picture's overall quality, as well as characteristics consistent with Leonardo's own technique. There is, for example, a major pentiment in the thumb of Christ's proper right hand, and other, lesser adjustments of the contours elsewhere (such as in the palm of the left hand seen through the transparent orb). Such changes of mind are typical of Leonardo and would be surprising in a copy of an existing design. The head was perhaps executed with the aid of a cartoon; when the picture is examined in infrared, *spolverí* can be seen running along the line of the upper lip. The rest of the body has a much looser, brushy underdrawing, with further small changes of mind.

This combination of careful preparation for the head and much greater improvisation for the body is again characteristic of Leonardo. The painting technique is close to that of the *Mona Lisa* (fig. 32) and the *Saint John the Baptist* (fig. 41), the face in particular built up with multiple, extremely thin paint layers, another technical aspect that makes Leonardo's authorship certain. Like both these pictures, the *Salvator Mundi* may well have been painted over an extended period of time.

There are several remarkable features, all painted with startling delicacy and precision: the curling highlights in the hair, the brilliantly irregular pleats in the tunic, the grand sweep of the cloak. Only the repeat pattern of the ornament is a little disappointing. Leonardo appears to have painted the first section on the left and perhaps delegated the rest. Christ, unusually for this date, is dressed entirely in clothes of celestial blue, painted with precious lapis lazuli.

And it is with Christ's costume that we begin to understand the ways in which Leonardo chooses to present him as king of the whole universe. This is Christ as characterised in John 4:14: 'And we have seen and testify that the Father has sent his Son as the Saviour of the World.' There is nothing obvious about this. Christ does not have a crown, nor even a halo. But he does carry an orb, the emblem of kingship as well as a symbol of the world. Its tiny specks show that Leonardo conceived this globe as made of rock crystal, the purest form of quartz, widely thought to have particular properties of which Leonardo was certainly aware.[8] It was believed to be formed from ice petrified on the very highest mountain peaks, possessed of formidable magic powers. During the Middle Ages, pieces of rock crystal, all cut in Antiquity, were frequently set into reliquaries, giving the stone a sacred context. And it was precious in part because, during this period, the secrets of how it could be worked were lost. It was not until the early sixteenth century, after the execution of this painting, that Renaissance craftsmen rediscovered the technique. There were therefore several features of Christ's orb that made it into something miraculous even before its perfect spherical shape is taken into account.

As Leonardo knew very well, the sphere was a divine form, regarded as perhaps the most important of the Platonic solids, an unattainably regular and continuous form in which, Plato proposed, the whole universe is contained. By depicting this sphere as if

NOTES

1 This discussion anticipates the more detailed publication of this picture by Robert Simon and others. I am grateful to Robert Simon for making available his research and that of Dianne Dwyer Modestini, Nica Gutman Rieppi and (for the picture's provenance) Margaret Dalivalle, all to be presented in a forthcoming book.

2 'Leonardus da Vinci pinxit. Wenceslaus Hollar fecit Aqua forti, secundum Originale, A.°1650.'

3 Snow-Smith 1978, pp. 69–81; Snow-Smith 1982.

4 A figure of Christ the Redeemer by Leonardo is recorded by Padre V.M. Monti in his *Catalogus Superiorum Cenobi Ord. Praed. S. Mariae Gratiarum* (Archivio di Stato, Milan), painted in a lunette over the main door leading from the church of Santa Maria delle Grazie to the convent. It was destroyed in 1594 or 1603 when the door was enlarged. See Marani 1989, p. 130, no. 6A

5 Snow-Smith 1982, p. 27.

6 Millar 1972, p. 63. Research soon to be published by Margaret Dalivalle will show that John Stone was forced to return it to the Royal Collection after the Restoration. Subsequently it seems to have passed from James II into the possession of John Sheffield, 1st Duke of Buckingham (1648–1721). In 1763 it was sold for a rather low sum by Buckingham's illegitimate son, not to reappear until 1900.

7 See Fiorio 2000, pp. 162–3. A version of the picture is recorded in an inventory drawn up in Milan on 21 April 1525 thought to list copies made by Salaì, Leonardo's much beloved assistant, of pictures by his master that had been left in France. Coming just after Salaì's death, the description of the picture is interesting: 'Uno Cristo in modo de uno Dio Padre' ('A Christ in the guise of a God the Father'). See Shell and Sironi 1991a, p. 49.

8 Pliny, *Natural History*, XXXVII, 23–9. See Castelli 1977, pp. 310–11, 351–3, cat. 234–6; Gasparotto 2000, pp. 67–8. Leonardo certainly owned at least two books in which he might have found such information, a 'Lapidario', most likely the text by Marbodeus, *Il lapidario o la forza e la virtù delle pietre preziose delle erbe e degli animali*, and the *Secreti d'Alberto Magno*, which could be the *Liber secretum de virtutibus herbarum lapidum et animalium* by Albertus Magnus published in Bologna 1478. See Reti 1974, vol. 3, pp. 98–9, 102–3.

9 BN 2038, fol 22a; R 118.
10 See Koerner 1993, pp. 80–5, 104, 106, 127, 468 n. 76.
11 See Montesano 2004; Petti Balbi 2007.
12 The painting must also be the source for the painting of the same subject by the Master of the Pala Sforzesca (Fitzwilliam Museum, Cambridge), most recently dated 1490–4 though it might be a little later. See Marani 2007, p. 55. Christ's blessing hand is almost directly cited, and the picture therefore seems to belong to around 1500. The same is true of Marco d'Oggiono's *Young Christ* in the Galleria Borghese, Rome.

made from rock crystal, Leonardo ensured that it would be perceived as if formed from light itself. He explained that the light which passes through 'diaphanous bodies' like glass or crystal [*vetri* or *cristalli*] produce 'the same effect as though nothing intervened between the shaded object and the light that falls upon it'.[9] This perfect sphere is seen to both contain and transmit the light of the world. Moreover, Christ's hand remains miraculously undistorted. Leonardo has therefore created an object which would be understood as a piece of divine craftsmanship, but still be his own invention. Never did he make the connection between his own creativity and God's more explicit.

He made the same point by the way he painted the face of Christ itself. If the painting of the orb is marvellously modern, dependent on Leonardo's understanding of the passage of light, the face of Christ – rigid, symmetrical, absolutely frontal – is deliberately archaic. He seems to have been aware of the central panel of a polyptych ascribed to Giotto and his workshop (North Carolina Museum of Art, Raleigh) showing Christ blessing. From this he takes the blessing hand, with the index and third finger crossing, and particularly the sweep of the drapery across the body. And, as Joanne Snow-Smith observed, he also based his first design for Christ's sleeve (cat. 89) on this painting. His picture also contains a reminiscence of the terracotta busts of Christ produced in Verrocchio's workshop. But, above all, Leonardo is demonstrating his awareness of those images of the Holy Face believed to have been made miraculously: the *sudarium* or veil of Saint Veronica, treasured at St Peter's until the Sack of Rome in 1527, and especially the Mandylion of Edessa, the portrait of Christ that he made by pressing his face to a piece of cloth that he sent to the king of Edessa, curing him of a fatal illness. Both these miraculous images were regarded as examples of the so-called *acheiropoietos*, an image not made by human hands; they therefore become the ultimate truthful, unmediated likenesses.[10]

They had already been imitated by painters. In the Netherlands, it was Jan van Eyck who was chiefly responsible for formulating the canonical Holy Face, though no autograph version survives. Joseph Leo Koerner has pointed out that van Eyck (to judge from copies) makes a case for this picture as similarly unmediated by the elimination of all visible signs of its making. It is by his extraordinary artistry, he seems to

say, that he can become a privileged witness of the face of Christ. He too can make the invisible visible, the word flesh, and his work becomes a new kind of miracle, founded on God-given talent. Leonardo makes the same extraordinary claim; the extreme delicacy of his technique in the *Salvator Mundi* conceals any sign of his brushwork. Just as God created Christ as his perfect image and likeness, so Leonardo has sought to recreate the perfect icon. Leonardo's art is therefore seen to be just as wonderful as that of the crystal orb, itself unmakable except by God and Leonardo.

To become the witness of Christ, Leonardo needed, as van Eyck had done, to base his image upon one of the existing images already recognised as miraculous. His own picture of 'the most beautiful among the children of men' needed to be recognisable, and he was forced to abandon his own canon of ideal proportion. He may also have taken his patron's wishes into account. The history of the Mandylion of Edessa is obscure. It is thought to have been transferred to Constantinople in AD 944, but what happened thereafter is much disputed. Suffice it to say that by 1500 at least three images were all claimed as authentic. One belonged to the French kings, kept at the Sainte-Chapelle in Paris until the French Revolution. Another, still revered today, was (and is) just outside Genoa, at San Bartolomeo degli Armeni.[11] Genoa was a Sforza possession, and when Milan fell to the French in 1499 they also took over the great port city as well as responsibility for its treasured Holy Face.

Snow-Smith has shown that King Louis XII and his consort, Anne of Brittany, were particularly devoted to Christ as *Salvator Mundi*, and that they could connect this cult with the Mandylion of Edessa, twice over we now see. Given the date – around 1500 – of Leonardo's preparatory drawings, the style of the picture and its subsequent association with a French princess, Louis and Anne become the most likely patrons for Leonardo's *Salvator Mundi*, probably commissioning the work soon after the conquest of Milan and Genoa. This would therefore be one of the French commissions mentioned by Fra Pietro da Novellara.[12] And it was perhaps to accommodate their wishes that Leonardo based Christ's features, the set of his eyes and the heavy lower lids, and especially his smoothly arched eyebrows running down into a long nose, on the Christ of the Mandylion of Edessa. LS

List of Lenders

BERLIN
Staatliche Museen zu Berlin,
 Kupferstichkabinett

BUDAPEST
Szépmüvészeti Múzeum

CAMBRIDGE
The Fitzwilliam Museum

CRACOW
The Princes Czartoryski
 Foundation

EDINBURGH
The National Galleries of
 Scotland

FLORENCE
Galleria degli Uffizi, Gabinetto
 Disegni e Stampe

FRANKFURT AM MAIN
Städel Museum, Graphische
 Sammlung

LONDON
The British Museum
The Samuel Courtauld Trust,
 The Courtauld Gallery
The Royal Academy of Arts
Victoria and Albert Museum

LONG ISLAND
De Navarro Collection

MADRID
Fundación Lázaro Galdiano

MILAN
Veneranda Biblioteca
 Ambrosiana, Pinacoteca
Pinacoteca di Brera
Raccolte d'Arte Antica e
 Pinacoteca, Sala delle Asse,
 Castello Sforzesco
Mattioli Collection
Museo Poldi Pezzoli
Archivio Storico Civico e
 Biblioteca Trivulziana

NEW YORK
The Metropolitan Museum of Art

OXFORD
The Ashmolean Museum
Christ Church Picture Gallery

PARIS
Institut Néerlandais, Frits Lugt
 Collection
Musée du Louvre

SELKIRK
The 10th Duke of Buccleuch and
 The Trustees of the Buccleuch
 Living Heritage Trust

ST PETERSBURG
The State Hermitage Museum

VATICAN CITY
Vatican Museums

VENICE
Gallerie dell'Accademia,
 Gabinetto Disegni e Stampe

VIENNA
Graphische Sammlung Albertina

WASHINGTON, DC
National Gallery of Art

WILLIAMSTOWN
Sterling and Francine Clark Art
 Institute

WINDSOR
Her Majesty The Queen

And all lenders and private
collectors who wish to remain
anonymous.

This exhibition has been made
possible by the provision of
insurance through the
Government Indemnity Scheme.
The National Gallery would like
to thank the Department for
Culture, Media and Sport and
the Museums, Libraries and
Archives Council for providing
and arranging this indemnity.

Bibliography

Leonardo's writings and their abbreviations

A TO M
Institut de France, Paris
Les manuscrits de Léonard de Vinci, ed. C. Ravaisson-Mollien, 6 vols, Paris 1881–91; ed. A. Corbeau and N. de Toni, Grenoble 1960 (B); 1964 (C, D); 1972 (A); *I manoscritti e i disegni di Leonardo da Vinci: Il Codice A*, 2 vols, Rome 1938; *I manoscritti dell'Institut de France: Il manoscritto A*, ed. A. Marinoni, Florence 1990; *The Manuscripts of Leonardo da Vinci in the Institut de France*, ed. J. Venerella, Milan 1999

BL
British Library, London
Codex Arundel 263
I Manoscritti e i disegni di Leonardo da Vinci: Il Codice Arundel 263, 4 vols, Rome 1923–30; *Il Codice Arundel 263 nella British Library*, eds C. Pedretti and C. Vecce, 2 vols, Florence 1998

BN 2038
Institut de France, Paris
MS Ashburnham II
Les manuscrits de Léonard de Vinci, ed. Ravaisson-Mollien, vol. 6, Paris 1891 (see A to M above)

CA
Biblioteca Ambrosiana, Milan
Codex Atlanticus
Il Codice Atlantico della Biblioteca Ambrosiana di Milano, ed. A. Marinoni, 12 vols, Florence 1975–80; *The Codex Atlanticus of Leonardo da Vinci: A Catalogue of its Newly Restored Sheets*, ed. C. Pedretti, New York 1978–9 (Note: references to Codex Atlanticus list new, post-restoration folio nos followed by the old nos)

FORSTER I, II AND III
Victoria and Albert Museum, London
Codex Forster
I manoscritti e i disegni di Leonardo da Vinci: Codice Forster, 5 vols, Rome 1930–6; *I Codici Forster del Victoria and Albert Museum di Londra*, ed. A. Marinoni, 3 vols, Florence 1992

LEICESTER
William M. Gates Collection, Bellevue, WA
Codex Leicester
Codex Leicester: A Masterpiece of Science, eds C. Farago, C. Pedretti, M. Kemp and O. Gingerich, New York 1996

MADRID I AND II
Biblioteca Nacional, Madrid
MSS 8937 and 8936
The Madrid Codices, ed. L. Reti, 5 vols, New York 1974

TRIV.
Biblioteca Trivulziana, Milan
Codex 2162
Il codice di Leonardo da Vinci nella Biblioteca Trivulziana di Milano, ed. A.M. Brizio, 2 vols, Florence 1980; *Codice Trivulziano*, ed. A. Marinoni, Milan 1980

URB.
Vatican Library
Codex Urbinus Latinus 1270
Das Buch von der Malerei, ed. H. Ludwig, 2 vols, Vienna 1882; C. Farago, *Leonardo da Vinci's Paragone: A Critical Interpretation with a New Edition of the Text, in the Codex Urbinus*, Leyden and New York 1992; *Libro di Pittura*, eds C. Pedretti and C. Vecce, Florence 1995; see also McM below

English translations

K/W
Leonardo on Painting: An Anthology of Writings by Leonardo da Vinci, ed. and trans. M. Kemp and M. Walker, New Haven and London 1989

McM
Treatise on Painting (Codex Urbinas Latinus 1270) by Leonardo da Vinci, ed. and trans. A.P. McMahon, 2 vols, Princeton 1956

R
The Literary Works of Leonardo da Vinci, ed. and trans. J.P. Richter, 2 vols, London 1883 (Oxford 1939, London and New York 1970); Pedretti 1977

Literature

ACKERMAN 1969
J.S. Ackerman, 'Science and Art in the Work of Leonardo', in O'Malley 1969, pp. 205–25

ACKERMAN 1978
J.S. Ackerman, 'Leonardo's Eye', *Journal of the Warburg and Courtauld Institutes*, XLI (1978), pp. 108–46

ACKERMAN 1980
J.S. Ackerman, 'On Early Renaissance Color Theory and Practice', in *Studies in Italian Art and Architecture*, ed. H.A. Milon, Rome 1980, pp. 11–44

ACKERMAN 1998
J.S. Ackerman, 'Leonardo da Vinci: Art in Science', *Daedalus*, CXXVII, no. 1 (1998), pp. 207–24

ADHÉMAR 1975
J. Adhémar, 'Une galerie de portraits italiens à Amboise en 1500', *Gazette des Beaux-Arts*, LXXXVI (1975), pp. 99–104

ADY 1907
C.M. Ady, *A History of Milan under the Sforza*, London 1907

AGOSTI 1987
G. Agosti, 'Sul gusto per l'antico a Milano tra regime sforzesco e dominazione francese', *Prospettiva*, XLIX (1987), pp. 33–46

AGOSTI 1990
G. Agosti, *Bambaia e il classicismo lombardo*, Turin 1990

AGOSTI 1993
G. Agosti, 'Su Mantegna, 2', *Prospettiva*, LXXII (1993), pp. 71–81

AGOSTI 1998
G. Agosti, 'Scrittori che parlano di artisti, tra Quattro e Cinquecento in Lombardia', in *Quattro pezzi lombardi (per Maria Teresa Binaghi)*, Brescia 1998, pp. 39–93

AGOSTI 2001
G. Agosti, *Disegni del Rinascimento in Valpadana*, Galleria degli Uffizi, Florence 2001

AGOSTI 2005
G. Agosti, *Su Mantegna I: La storia dell'arte libera la testa*, Milan 2005

AGOSTI AND ISELLA 2004
G. Agosti and D. Isella (eds), *Antiquarie prospettiche romane*, Parma 2004

ALBA 2001
Macrino d'Alba: Protagonista del Rinascimento piemontese, ed. G. Romano, exh. cat., Fondazione Ferrero, Alba, Savigliano 2001

ALBERTI (1950)
Leon Battista Alberti, *Della Pittura*, ed. L. Mallè, Florence 1950

ALBERTI (1972)
Leon Battista Alberti, *On Painting and On Sculpture: The Latin Texts of De Pictura and De Statua*, ed. and trans. C. Grayson, London 1972

ALLISON 1974
A.H. Allison, 'Antique Sources of Leonardo's Leda', *Art Bulletin*, LVI (1974), pp. 375–84

AMBROSIANA 2005
Pinacoteca Ambrosiana, vol. 1: *Dipinti dal Medioevo alla metà del Cinquecento*, Milan 2005

AMES-LEWIS 1990
F. Ames-Lewis, 'Leonardo's Techniques', in *Nine Lectures on Leonardo da Vinci*, London 1990, pp. 32–44

AMES-LEWIS 2001
F. Ames-Lewis, 'Leonardo da Vinci e il disegno a matita', *Raccolta Vinciana*, XXIX (2001), pp. 3–40

AMORETTI 1804
C. Amoretti, *Memorie storiche su la vita e gli studj e le opere di Lionardo da Vinci*, Milan 1804

ANCONA 2005–6
Leonardo: Genio e visione in terra marchigiana, ed. C. Pedretti, exh. cat., Mole Vanvitelliana, Ancona, Florence 2005

ANGELELLI AND DE MARCHI 1991
W. Angelelli and A.G. De Marchi, *Pittura dal Duecento al primo Cinquecento nelle fotografie di Girolamo Bombelli*, Milan 1991

ANONIMO (1903)
The Anonimo: Notes on Pictures and Works of Art in Italy made by an Anonymous Writer in the Sixteenth Century, ed. G.C. Williamson, trans. P. Mussi, London 1903

AQUINAS (1935)
Saint Thomas Aquinas, *On the Governance of Rulers*, trans. G. Phelan, Toronto 1935

ARASSE 1997
D. Arasse, *Léonard de Vinci: Le rythme du monde*, Paris 1997

ARASSE 2006
D. Arasse, 'La science divine de la peinture selon Léonard de Vinci', in *L'art de la Renaissance entre science et magie*, ed. P. Morel, Paris 2006, pp. 343–56

ARCANGELI 2000
L. Arcangeli, 'Ludovico tiranno?', in Milan 2000b, pp. 29–38

AREZZO 2000
La Madonna dei fusi di Leonardo da Vinci e il paesaggio del Valdarno Superiore, ed. C. Starnazzi, exh. cat., Palazzo dei Priori, Arezzo 2000

ARONBERG LAVIN 1955
M. Aronberg Lavin, 'Giovannino Battista: A Study in Renaissance Religious Symbolism', *Art Bulletin*, XXXVII (1955), pp. 85–101

ATLANTA AND LOS ANGELES 2009–10
Leonardo da Vinci and the Art of Sculpture, ed. G.M. Radke, exh. cat., High Museum of Art, Atlanta; J. Paul Getty Museum, Los Angeles, New Haven and London 2009

AULUS GELLIUS (1927)
The Attic Nights of Aulus Gellius, trans. J.C. Rolfe, 3 vols, London and New York 1927

AVERY-QUASH 2011
S. Avery-Quash (ed.), 'The Travel Notebooks of Sir Charles Eastlake', Walpole Society LXIII (2011), 2 vols

BALLARIN 1985 (2005)
A. Ballarin, 'Problemi di leonardismo milanese tra Quattro e Cinquecento: Giovanni Antonio Boltraffio prima della pala Casio', in Ballarin 2005, pp. 3–57

BALLARIN 1987 (2005)
A. Ballarin, 'Riflessioni sull'esperienza milanese dello Pseudo-Bramantino', in Ballarin 2005, pp. 59–84

BALLARIN 1994–5
A. Ballarin, *Dosso Dossi: La pittura a Ferrara negli anni del ducato di Alfonso I*, 2 vols, Padua 1994–5

BALLARIN 2000
A. Ballarin, 'Marco d'Oggiono', in *Pittura del Rinascimento nell'Italia settentrionale (1480–1530) – Milano nell'età di Ludovico il Moro: Parte seconda: Altri problemi di leonardismo milanese di fine Quattrocento*, Padua 2000, pp. 129–41

BALLARIN 2005
A. Ballarin, *Problemi di leonardismo milanese tra Quattro e Cinquecento: Giovanni Antonio Boltraffio prima della pala Casio (Le due conferenze degli anni Ottanta)*, Cittadella 2005

BAMBACH 1990
C.C. Bambach, 'Pounced Drawings in the Codex Atlanticus', in *Achademia Leonardi Vinci*, III (1990), pp. 129–31

BAMBACH 1991
C.C. Bambach, 'Leonardo, Tagliente, and Dürer: "La scienza del far di groppi"', *Achademia Leonardi Vinci*, IV (1991), pp. 72–98

BAMBACH 1999a
C.C. Bambach, *Drawing and Painting in the Italian Renaissance Workshop: Theory and Practice, 1300–1600*, Cambridge 1999

BAMBACH 1999b
C.C. Bambach, 'The Purchases of Cartoon Paper for Leonardo's *Battle of Anghiari* and Michelangelo's *Battle of Cascina*', *I Tatti Studies*, VIII (1999), pp. 105–33

BAMBACH 2003a
C.C. Bambach, 'Introduction to Leonardo and his Drawings', in New York 2003, pp. 3–30

BAMBACH 2003b
C.C. Bambach, 'Leonardo, Left-Handed Draftsman and Writer', in New York 2003, pp. 31–57

BAMBACH 2004
C.C. Bambach, 'Leonardo and Drapery Studies on "tela sottilissima di lino"', *Apollo*, CLIX, no. 503 (2004), pp. 44–55

BANDELLO (1952)
M. Bandello, *Tutte le opere*, 2 vols, Milan 1952

BARBIERI 1938
G. Barbieri, *Economia e politica del Ducato di Milano 1386–1535*, Milan 1938

BARKAN 1975
L. Barkan, *Nature's Work of Art: The Human Body as Image of the World*, New Haven and London 1975

BAROLSKY 1992
P. Barolsky, 'La Gallerani's "galée"', *Source*, XII, no. 1 (1992), pp. 13–14

BARONI 1938
C. Baroni, 'Elementi stilistici fiorentini negli studi vinciani di architetture a cupola', in *Atti del I Congresso Nazionale di Storia dell'Architettura, 1936*, Florence 1938, pp. 57–81

BARTOLETTI 2008
Il coro ligneo della Cattedrale di Savona, ed. M. Bartoletti, Cinisello Balsamo 2008

BATTAGLIA 2007
R. Battaglia, *Leonardo e i Leonardeschi*, Milan 2007

BATTAGLIA 2008
R. Battaglia, *Léonard de Vinci et son heritage*, Paris 2008

BATTEZZATI 2009
C. Battezzati, 'Carl Friedrich von Rumohr e l'arte nell'Italia settentrionale', *Concorso*, III (2009), pp. 6–24

BAXANDALL 1972
M. Baxandall, *Painting and Experience in Fifteenth Century Italy*, Oxford 1972

BEENKEN 1951
H.T. Beenken, 'Zur Entstehungsgeschichte der *Felsengrotten-Madonna* in der Londoner National Gallery', *Festschrift für Hans Jantzen*, Berlin 1951, pp. 132–40

BÉGUIN 1983
S. Béguin, *Léonard de Vinci au Louvre*, Paris 1983

BELL 2002
J. Bell, 'Sfumato, Linien und Natur', in *Leonardo da Vinci: Natur im Übergang*, ed. F. Fehrenbach, Munich 2002, pp. 229–56

BELLINCIONI (1876)
Bernardo Bellincioni, *Rime*, ed. P. Fanfani, 2 vols, Bologna 1876

BELLUCCI ET AL. 2000
R. Bellucci, M. Cetica, E. Pampaloni, L. Pezzati and P. Poggi, '"La prospettiva e timjore della pittura...": Analisi agli infrarossi e riconstruzione geometrica', in Natali 2000, pp. 113–20

BELTING 1994
H. Belting, *Likeness and Presence: A History of the Image before the Era of Art*, trans. E. Jephcott, Chicago and London 1994 (*Bild und Kult: Eine Geschichte des Bildes vor dem Zeitalter der Kunst*, Munich 1990)

BELTRAMI 1896
L. Beltrami, 'Le corti italiane del secolo XV', *Emporium*, III (1896), pp. 83–95

BELTRAMI 1906
L. Beltrami, 'Il *Musicista* di Leonardo da Vinci', *Raccolta Vinciana*, II (1906), pp. 75–80

BELTRAMI 1910
L. Beltrami, *La chiesa di S. Maria delle Grazie in Milano ed il Cenacolo di Leonardo da Vinci*, Milan 1910

BELTRAMI 1919
L. Beltrami, *Documenti e memorie riguardanti la vita e le opera di Leonardo da Vinci*, Milan 1919

BERENSON 1903
B. Berenson, *The Drawings of the Florentine Painters*, 2 vols, London 1903

BERENSON 1910
B. Berenson, *North Italian Painters of the Renaissance*, New York and London 1910

BERENSON 1927
B. Berenson, *Three Essays in Method*, Oxford 1927

BERENSON 1932
B. Berenson, *Italian Pictures of the Renaissance*, Oxford 1932

BERENSON 1938
B. Berenson, *The Drawings of the Florentine Painters*, 3 vols, Chicago 1938

BERENSON 1968
B. Berenson, *Italian Pictures of the Renaissance: Central Italian and North Italian Schools*, 3 vols, London 1968

BERNARDONI 2010
A. Bernardoni, 'Leonardo and the Equestrian Monument for Francesco Sforza: The Story of an Unrealized Monumental Sculpture', in Atlanta and Los Angeles 2010–11, pp. 95–135

BERRA 1993
G. Berra, 'La storia dei canoni proporzionali del corpo umano e gli sviluppi in area lombarda alla fine del Cinquecento', *Raccolta Vinciana*, XXV (1993), pp. 159–310

BERSELLI 1997
E. Berselli, 'Un committente e un pittore alle soglie del Cinquecento: Girolamo Casio e Giovanni Antonio Boltraffio', *Schede Umanistiche*, XI, no. 2 (1997), pp. 123–43

BERTANI ET AL. 1986
D. Bertani, M. Cetica, E. Buzzegoli, L. Giorgi, D. Kunzelman and P. Poggi, 'Andrea del Sarto in riflettografia', in *Andrea del Sarto: Dipinti e disegni a Firenze*, exh. cat., Palazzo Pitti, Florence 1986

BERTELLI 2004
C. Bertelli, 'Per il ritorno a Venezia della Madonna Litta', *Arte Documentato*, XX (2004), pp. 102–11

BERTOGLIO PISANI 1907
N. Bertoglio Pisani, *Il Cenacolo di Leonardo da Vinci e le sue copie*, Pistoia 1907

BERTOLINI 1881
F. Bertolini, *Fondazione artistica Poldi-Pezzoli*, Milan 1881

BIANCHI 2003
S. Bianchi, 'Appunti relativi ad alcune fonti a stampa delle principali realizzazioni nell'arte della scultura lignea in Lombardia tra Quattro e Cinquecento', *Rassegna di Studi e Notizie*, XXVII (2003), pp. 123–74

BIANCONI 1787
C. Bianconi, *Nuova guida di Milano: Per gli amanti delle belle arti*, Milan 1787

BILLI (1991)
Il libro di Antonio Billi, ed. F. Benedettucci, Rome 1991

BILLINGE ET AL. 2011
R. Billinge, L. Syson, and M. Spring, 'Altered Angels: Two Panels from the Immaculate Conception Altarpiece once in San Francesco Grande, Milan', *National Gallery Technical Bulletin*, XXXII (2011), pp. 57–77

BINAGHI OLIVARI 1978
M.T. Binaghi Olivari, 'Il ciclo di Annone Brianza', in Romano et al. 1978, pp. 25–30

BINAGHI OLIVARI 1983
M.T. Binaghi Olivari, 'La moda a Milano al tempo di Ludovico il Moro', in *Milano nell'età di Ludovico il Moro*, vol. 2, Milan 1983, pp. 633–50

BISCARO 1909
G. Biscaro, 'Lucrezia Crivelli procuratrice nella curia arcivescovile', *Archivio Storico Lombardo*, XXXVI (1909), pp. 559–60

BLACK 2009
J. Black, *Absolutism in Renaissance Milan: Plenitude of Power under the Visconti and the Sforza, 1329–1535*, Oxford 2009

BLUM 1932
A. Blum, 'Léonard de Vinci, graveur', *Gazette des Beaux-Arts*, VI, no. 8 (1932), pp. 89–104

BLUM 1953
A. Blum, 'L'oeuvre gravé de Léonard de Vinci', in *Atti del Convegno di Studi Vinciani*, Florence 1953, pp. 66–74

BLUNT 1940
A. Blunt, *Artistic Theory in Italy: 1450–1600*, Oxford 1940

BOBER AND RUBINSTEIN 1986
P.P. Bober and R. Rubinstein, *Renaissance Artists and Antique Sculpture: A Handbook of Sources*, London and Oxford 1986

BODE 1889
W. von Bode, 'Ein Bildnis der zweiten Gemahlin Kaiser Maximilans, Bianca Maria Sforza, von Ambrogio de Predis', *Jahrbuch der Königlich Preußischen Kunstsammlungen*, X (1889), pp. 71–9

BODE 1921
W. von Bode, *Studien über Leonardo da Vinci*, Berlin 1921

BODMER 1931
H. Bodmer, *Leonardo: Des Meisters Gemälde und Zeichnungen*, Stuttgart and Berlin 1931

BOLOGNA 1980
G. Bologna, *Libri per una educazione rinascimentale*, Milan 1980

BOŁOZ ANTONIEWICZ 1900a
J. Bołoz Antoniewicz, 'Portret Cecylii Gallerani przez Lionarda da Vinci w Muzeum książąt Czartoryskich w Krakowie', *Pamietnik III Zjazdu Historyków Polskich w Krakowie*, IV (1900)

BOŁOZ ANTONIEWICZ 1900b
J. Bołoz Antoniewicz, *Świątynia zagadkowa Lionarda da Vinci*, Lviv 1900

BONGRANI 1986a
P. Bongrani, 'Gli storici sforzeschi e il volgarizzamento landiniano dei *Commentarii* del Simonetta', *Lingua Nostra*, XLVII (1986), pp. 40–50

BONGRANI 1986b
P. Bongrani, *Lingua e letteratura a Milano nell'età sforzesca*, Parma 1986

BORA 1987a
G. Bora, *Due tavole leonardeschi: Nuove indagini sul Musico e sul San Giovanni dell'Ambrosiana*, Vicenza 1987

BORA 1987b
G. Bora, 'I Leonardeschi e il ruolo del disegno', in Milan 1987–8, pp. 11–19

BORA 1998
G. Bora, 'The Leonardesque Circle and Drawing', in Bora et al. 1998, pp. 93–120

BORA 2003
G. Bora, 'Girolamo Figino, "stimato valente pittore e accurate miniature", e il dibattito a Milano sulle "Regole dell'arte" fra il sesto e il settimo decennio del Cinquecento', *Raccolta Vinciana*, XXX (2003), pp. 267–325

BORA 2007
G. Bora, 'Dalla regola alla natura: Leonardo e la costruzione dei corpi', in Milan 2007, pp. 29–39

BORA ET AL. 1998
G. Bora, D.A. Brown, M. Carminati, M.T. Fiorio, P.C. Marani, J. Shell, *The Legacy of Leonardo: Painters in Lombardy 1490–1530*, Milan 1998 (*I Leonardeschi: L'eredita di Leonardo in Lombardia*, Milan 1998)

BORENIUS 1913
T. Borenius, *A Catalogue of the Paintings at Doughty House, Richmond*, vol. 1: *Italian Schools*, London 1913

BORENIUS 1930
T. Borenius, 'Leonardo's Madonna with the Children at Play', *Burlington Magazine*, LVI, no. 324 (1930), pp. 142–3, 146–7

BORN 1928
L.K. Born, 'The Perfect Prince: A Study in Thirteenth- and Fourteenth-Century Ideals', *Speculum*, III (1928), pp. 470–504

BORSI 1999
S. Borsi, 'I "nodi" di Leonardo: Un groviglio da sciogliere', *Art e Dossier*, XIV, no. 146 (1999), pp. 12–16

BOSCA 1672
P.P. Bosca, *De origine et statu Bibliothecae Ambrosianae*, Milan 1672

BOSKOVITS AND BROWN 2003
M. Boskovits and D.A. Brown (eds), *Italian Paintings of the Fifteenth Century*, National Gallery of Art, Washington, DC, New York and Oxford 2003

BOSSI 1810
Giuseppe Bossi, *Del Cenacolo di Leonardo da Vinci*, Milan 1810

BOTH DE TAUZIA 1888
P.P. Both de Tauzia, *Dessins, cartons, pastels et miniatures des diverses écoles*, Musée du Louvre, Paris 1888

BOVI 1982
A. Bovi, 'Su una recente interpretazione del Cenacolo', *Arte Lombarda*, LXI (1982), pp. 55–7

BRACHERT 1969
T. Brachert, 'A Distinctive Aspect in the Painting Technique of the *Ginevra de' Benci* and of Leonardo's Early Works', *Report and Studies in the History of Art*, XX (1969), pp. 84–104

BRAMBILLA BARCILON 1984
P. Brambilla Barcilon, *Il Cenacolo di Leonardo in Santa Maria delle Grazie: Storia, condizioni, problemi*, Milan 1984

BRAMBILLA BARCILON AND MARANI 2001
P. Brambilla Barcilon and P.C. Marani, *Leonardo: The Last Supper*, trans. H. Tighe, Chicago 2001 (*Leonardo: L'Ultima Cena*, Milan 1999)

BREDIN AND SANTORO-BRIENZA 2000
H. Bredin and L. Santoro-Brienza, *Philosophies of Art and Beauty: Introducing Aesthetics*, Edinburgh 2000

BRERA 1988
Pinacoteca di Brera: Scuole lombarda e piemontese, 1300–1535, Milan 1988

BRERA 2010
Pinacoteca di Brera: Dipinti, eds L. Arrigoni and V. Maderna, Milan 2010

BRESCIA 2002
Vincenzo Foppa, eds G. Agosti, M. Natale and G. Romano, exh. cat., Museo Civico di Santa Giulia, Brescia, Milan 2002

BRION 1952
M. Brion, *Léonard de Vinci*, Paris 1952

BRION 1953
M. Brion, *Léonard de Vinci: Génie et destinée*, Paris 1953

BRIZIO 1964
A.M. Brizio, 'Lettere al *Corriere*: La Mostra di Milano', *Corriere della Sera*, 28 April 1964, p. 5

BROWN 1981
C.M. Brown, 'Un tableau perdu de Lorenzo Costa et la collection de Florimond Robertet', *Revue de l'Art*, LII (1981), pp. 24–8

BROWN 1983
D.A. Brown, 'Leonardo and the Idealized Portrait in Milan', *Arte Lombarda*, LXVII (1983), pp. 102–16

BROWN 1984
D.A. Brown, 'A Leonardesque Madonna in Cleveland', in *Scritti di storia dell'arte in onore di Federico Zeri*, ed. M. Natale, vol. 1, Milan 1984, pp. 291–302

BROWN 1987
D.A. Brown, *Andrea Solario*, Milan 1987

BROWN 1990a
D.A. Brown, 'Leonardo and the Ladies with the Ermine and the Book', *Artibus et Historiae*, XI, no. 22 (1990), pp. 47–61

BROWN 1990b
D.A. Brown, *Madonna Litta*, Florence 1990

BROWN 1991
D.A. Brown, 'The Master of the Madonna Litta', in Fiorio and Marani 1991, pp. 25–34

BROWN 1992a
D. A. Brown, 'Il Cenacolo di Leonardo:
La prima eco a Venezia', in Venice 1992,
pp. 85–96

BROWN 1992b
D.A. Brown, 'Verrocchio and Leonardo:
Studies for the "giostra"', in Florentine Drawing at
the Time of Lorenzo the Magnificent, ed. E. Cropper,
Bologna 1992, pp. 99–109

BROWN 1998a
D.A. Brown, Leonardo da Vinci: Origins of a Genius,
New Haven and London 1998

BROWN 1998b
D.A. Brown, 'Leonardo nella bottega del
Verrocchio', in Natali 1998, pp. 39–59

BROWN 2001
D.A. Brown, Introduction, in Washington 2001,
pp. 11–23

BROWN 2003
D.A. Brown, Leonardo da Vinci: Art and Devotion
in the Madonnas of his Pupils, Milan 2003

BROWN 2010
D.A. Brown, 'Leonardo's Lady with an Ermine
as a "ritratto al naturale"', in Muster der Welt:
Untersuchungen zur italienischen Malerei von
Venedig bis Rom, ed. N. Schleif, Munich 2010,
pp. 93–107

BRUSCHI 1969
A. Bruschi, Bramante architetto, Bari 1969

BRUSCHI 1977
A. Bruschi, Bramante, London 1977

BRUSCHI 2002
A. Bruschi, 'La formazione e gli esordi di
Bramante', in Bramante milanese e l'architettura
del Rinascimento lombardo, eds C. Frommel,
L. Giordano and R. Schofield, Venice 2002,
pp. 33–66

BUBENIK 2009
I. and E. Bubenik, Leonardo da Vinci's Madonna
Immaculata Rediscovered, Wolnzach 2009

BUCCI 1998
C.A. Bucci, 'Gallerani, Cecilia', in Dizionario
Biografico degli Italiani, vol. 51, Rome 1998,
pp. 551–3

BUDAPEST 2009–10
Botticelli to Titian: Two Centuries of Italian
Masterpieces, exh. cat., Szépmüvészeti Múzeum,
Budapest 2009

BUDNY 1983
V. Budny, 'The Sequence of Leonardo's
Sketches for the Virgin and Child with Saint Anne
and Saint John the Baptist, Art Bulletin, LXV (1983),
pp. 34–50

BUENO DE MESQUITA 1960
D.M. Bueno de Mesquita, 'Ludovico Sforza
and his Vassals', in Italian Renaissance Studies:
A Tribute to the Late Cecilia M. Ady, ed. E.F. Jacob,
London 1960, pp. 184–215

BUENO DE MESQUITA 1976
D.M. Bueno de Mesquita, 'The Deputati del
denaro in the Government of Ludovico Sforza',
in Cultural Aspects of the Italian Renaissance: Essays in
Honour of Paul Oskar Kristeller, ed. C.H. Clough,
Manchester 1976, pp. 276–98

BULL 1992
D. Bull, 'Two Portraits by Leonardo: Ginevra
de' Benci and the Lady with an Ermine', Artibus et
Historiae, XIII, no. 25 (1992), pp. 67–83

BULL 1998
D. Bull, 'Analisi scientifiche', in Rome,
Milan and Florence 1998–9, pp. 83–90

BURNETT AND SCHOFIELD 1998
A. Burnett and R.V. Schofield, 'An
Introduction to the Portrait Medallions on
the Certosa di Pavia', in The Image of the
Individual: Portraits in the Renaissance, eds
N. Mann and L. Syson, London 1998

BURROUGHS 1912
B. Burroughs, 'Early Italian Paintings lent
by Mrs Liberty E. Holden', Bulletin of the
Metropolitan Museum of Art, VII, no. 10 (1912),
pp. 180–1

BURTON 1894
F.W. Burton, 'The Virgin of the Rocks', The
Nineteenth Century (July 1894), pp. 79–86

BURY 1992
M. Bury, 'Leonardo/non Leonardo: The
Madonna of the Yarnwinder', Apollo, CXXVI, no. 367
(1992), pp. 187–9

BUTAZZI 1983
G. Butazzi, 'Elementi "italiani" nella moda
sullo scorcio tra il XV e il XVI secolo', in Tessuti
serici italiani, 1450–1530, exh. cat., Castello
Sforzesco, Milan 1983, pp. 56–63

BUTAZZI 1998
G. Butazzi, 'Note per un ritratto: Vesti e
acconciatura della Dama con l'ermellino', in Rome,
Milan and Florence 1998–9, pp. 67–71

BUTTERFIELD 1997
A. Butterfield, The Sculptures of Andrea del
Verrocchio, New Haven and London 1997

BYAM SHAW 1976
J. Byam Shaw, Drawings by Old Masters at Christ
Church, Oxford, 2 vols, Oxford 1976

BYAM SHAW 1983
J. Byam Shaw, The Italian Drawings of the Frits Lugt
Collection, 3 vols, Paris 1983

CADOGAN 1983
J.K. Cadogan, 'Linen Drapery Studies by
Verrocchio, Leonardo and Ghirlandaio',
Zeitschrift für Kunstgeschichte, XLVI, no. 1 (1983),
pp. 27–62

CADOGAN 2000
J.K. Cadogan, Domenico Ghirlandaio: Artist and
Artisan, New Haven and London 2000

CALDERINI 1924–5
A. Calderini, 'Le antichità classiche nella
tradizione e nello studio milanese', Annuario
dell'Università Cattolica del Sacro Cuore, IV
(1924–5), pp. 203–22

CALVI 1869
G.L. Calvi, Notizie sulla vita e sulle opere dei princi-
pali architetti, scultori e pittori che fiorirono in Milano
durante il governo dei Visconti e degli Sforza, vol. 3,
Milan 1869

CALVI 1925
G. Calvi, I manoscritti di Leonardo da Vinci: Dal
punto di vista cronologico, storico e biografico,
Bologna 1925

CAMEROTA 2006
F. Camerota, 'Lo studio prospettico', in
Camerota et al. 2006, pp. 108–79

CAMEROTA ET AL. 2006
F. Camerota, A. Natali and M. Seracini (eds),
Leonardo da Vinci: Studio per l'Adorazione dei Magi,
Rome 2006

CAMPBELL 1983
L. Campbell, 'Memlinc and the Followers of
Verrocchio', Burlington Magazine, CXXV, no. 968
(1983), pp. 674–6

CAMPBELL 1990
L. Campbell, Renaissance Portraits: European
Portrait-Painting in the 14th, 15th and 16th Centuries,
New Haven and London 1990

CAMPBELL 1998
S.J. Campbell, Cosmè Tura of Ferrara: Style, Politics,
and the Renaissance City, 1450–1495, New Haven
and London 1998

CARMINATI 1994
M. Carminati, Cesare da Sesto: 1477–1523,
Milan and Rome 1994

CAROTTI 1901
G. Carotti, Capi d'arte appartenenti alla S.E.
la Duchessa Joséphine Melzi d'Eril Barbò,
Bergamo 1901

CARTWRIGHT 1903
J. Cartwright, Beatrice d'Este, Duchess of
Milan (1475–1497): A Study of the Renaissance,
London 1903

CASANOVA 1899
E. Casanova, 'L'uccisione di Galeazzo Maria
Sforza e alcuni documenti fiorentini', Archivio
Storico Lombardo, XXVI (1899), pp. 299–332

CASAZZA ET AL. 2000
O. Casazza, F. Ciattini, M. Fioravanti and
R. Rimaboschi, 'Indagini sul supporto ligneo
e osservazioni tecniche sul colore', in
Natali 2000, pp. 121–7

CASIO 1525
Girolamo Casio, Libro intitulato Cronica,
Bologna 1525

CASSIRER 1946
E. Cassirer, The Myth of the State, New Haven
and London 1946

CASTELFRANCI VEGAS 1983
L. Castelfranchi Vegas, '"Retracto del
naturale": Considerazioni sulla ritrattistica
lombarda degli anni fra Quattrocento e
Cinquecento', Paragone, XXXIV, nos 401–3
(1983), pp. 64–71

CASTELLI 1977
P. Castelli, 'Le virtù delle gemme: Il loro
significato simbolico e astrologico nella
cultura umanistica e nelle credenze popolari
del Quattrocento', in L'oreficeria nella Firenze del
Quattrocento, exh. cat., Santa Maria Novella,
Florence 1977, pp. 307–64

CASTIGLIONE (1964)
Baldassare Castiglione, Il libro del Cortegiano,
ed. B. Maier, Turin 1964

CATALANO 1956
F. Catalano, 'Il Ducato di Milano nella politica
dell'equilibrio', in Storia di Milano, vol. 7: L'età
sforzesca dal 1450 al 1500, Milan 1956, pp. 227–414

CAVALIERI 1989
F. Cavalieri, 'Osservazioni ed ipotesi per le
ricerche sull'arte di Zanetto da Milano, pittore
degli Sforza', Arte Lombarda, XC/XCI (1989),
pp. 67–80

CECCHI 1984
A. Cecchi, 'Una predella e altri contributi per
l'Adorazione dei Magi di Filippino', in I pittori della
Brancacci negli Uffizi, Florence, Florence 1984,
pp. 59–72

CENNINI (1971)
Cennino Cennini, Il libro dell'arte, ed.
F. Brunello, Vicenza 1971

CERUTI 1875
A. Ceruti, 'Il corredo nuziale di Bianca
Maria Sforza-Visconti, sposa dell'Imperatore
Massimiliano I', Archivio Storico Lombardo, II
(1875), pp. 51–76

CHAMBERS 1995
D.S. Chambers, 'The Earlier "Academies"
in Italy', in Italian Academies of the Sixteenth
Century, eds D.S. Chambers and F. Quiviger,
London 1995, pp. 1–14

CHASTEL 1982
A. Chastel, 'The Arts during the Renaissance',
in The Renaissance: Essays in Interpretation, London
and New York 1982, pp. 227–71

CHASTEL 1995
A. Chastel, Leonardo da Vinci: Studi e ricerche
1952–1990, trans. G. Coccioli, Turin 1995

CHRISTIANSEN 1990
K. Christiansen, 'Leonardo's Drapery Studies',
Burlington Magazine, CXXXII, no. 1049 (1990),
pp. 572–3

CIATTI ET AL. 2008
M. Ciatti, C. Frosinini and A. Natali (eds),
Raffaello: La rivelazione del colore (Il restauro della
Madonna del Cardellino della Galleria degli Uffizi),
Florence 2008

CINZIO 1554
Giovambattista Giraldi Cinzio, Discorsi intorno
al comporre dei Romanzi, delle Commedie e delle
Tragedie e di altre maniere di poesie, Venice 1554

CLARK 1933
K. Clark, 'The Madonna in Profile', Burlington
Magazine, LXII, no. 360 (1933), pp. 136–40

CLARK 1935
K. Clark, A Catalogue of the Drawings of Leonardo
da Vinci in the Collection of His Majesty the King at
Windsor Castle, 2 vols, Cambridge 1935

CLARK 1939
K. Clark, Leonardo da Vinci: An Account of his
Development as an Artist, Cambridge 1939

CLARK 1969
K. Clark, 'Leonardo and the Antique', in
O'Malley 1969, pp. 1–34

CLARK AND GOULD 1962
K. Clark and C. Gould, The Leonardo Cartoon,
London 1962

CLARK AND PEDRETTI 1968–9
K. Clark and C. Pedretti, The Drawings of
Leonardo da Vinci in the Collection of Her Majesty
the Queen at Windsor Castle, 3 vols, London
1968–9

CLARKE 2003
G. Clarke, Roman House – Renaissance Palaces:
Inventing Antiquity in Fifteenth-Century Italy,
Cambridge 2003

CLAYTON 1992
M. Clayton, 'L'Ultima Cena', in Venice 1992,
pp. 228–9

CLAYTON 2001
M. Clayton, 'Leonardo da Vinci', in Amazing
Rare Things: The Art of Natural History in the Age of
Discovery, London 2001, pp. 38–71

CLAYTON 2002
M. Clayton, 'Leonardo's Gypsies and the
Wolf and the Eagle', Apollo, CLVI, no. 486
(2002), pp. 27–33

CLERCX-LEJEUNE 1972
S. Clercx-Lejeune, 'Fortuna Josquini:
A proposito di un ritratto di Josquin des
Prez', Nuova Rivista Musicale Italiana, VI (1972),
pp. 315–37

CLEVELAND 1974
Cleveland Museum of Art: European Paintings before
1500, Cleveland 1974

CLEVELAND 1982
Cleveland Museum of Art: Catalogue of Paintings,
vol. 3: European Paintings of the 16th, 17th, and 18th
Centuries, Cleveland 1982

COGLIATI ARANO 1965
L. Cogliati Arano, Andrea Solario, Milan 1965

COGLIATI ARANO 1980
L. Cogliati Arano (ed.), Disegni di Leonardo e della
sua cerchia alle Gallerie dell'Accademia, Milan 1980

COLALUCCI 1993
G. Colalucci, 'Leonardo's St Jerome: Notes on
Technique, State of Conservation and its
Restoration', in High Renaissance in the Vatican,
exh. cat., National Museum of Western Art,
Tokyo 1993, pp. 106–10, 262–3

COLBACCHINI 1887
G. Colbacchini, Quattro dipinti di sommi maestri,
Bassano 1887

COLE AHL 1995
D. Cole Ahl (ed.), Leonardo da Vinci's Sforza
Monument Horse: The Art and the Engineering,
Bethlehem, PA and London 1995

COLENBRANDER 1992
H. Colenbrander, 'Hands in Leonardo
Portraiture', Achademia Leonardi Vinci, V (1992),
pp. 37–43

COLOMBO 1956
A. Colombo, 'Milano "secunda Roma" e la
lapide encomiastica dall'antica Porta Romana',
Archivio Storico Lombardo, LXXXIII (1956),
pp. 148–69

COLVIN 1904–15
S. Colvin, *The Vasari Society for the Reproduction of Drawings by Old Masters*, 10 vols, London 1904–15

COMANDUCCI 1992
R.M. Comanducci, 'Nota sulla versione landiniana della *Sforziade* di Giovanni Simonetta', *Interpres*, XII (1992), pp. 309–16

COOMARASWAMY 1944
A. Coomaraswamy, 'The Iconography of Dürer's "Knots" and Leonardo's "Concatenation"', *Art Quarterly*, VII (1944), pp. 109–28

COVI 2005
Dario A. Covi, *Andrea del Verrocchio: Life and Work*, Florence 2005

CREMONA AND NEW YORK 2004
Painters of Reality: The Legacy of Leonardo and Caravaggio in Lombardy, ed. A. Bayer, exh. cat., Museo Civico, Cremona; Metropolitan Museum of Art, New York, New Haven and London 2004

CROCE 1921
B. Croce, *Curiosità storiche*, Naples 1921

CROPPER 1976
E. Cropper, 'On Beautiful Women: Parmigianino, Petrarchismo, and the Vernacular Style', *Art Bulletin*, LVIII (1976), pp. 374–94

CROPPER 1987
E. Cropper, 'The Beauty of Woman: Problems in the Rhetoric of Renaissance Portraiture', in *Rewriting the Renaissance: The Discourses of Sexual Difference in Early Modern Europe*, eds M.W. Ferguson and M. Quilligan, Chicago 1987, pp. 175–90

CROWE 1992
A.T. Crowe, 'Florimond Robertet: International Politics and Patronage of the Arts', in Edinburgh 1992, pp. 25–33

CROWE AND CAVALCASELLE 1871
J.A. Crowe and G.B. Cavalcaselle, *A History of Painting in North Italy: Venice, Padua, Vicenza, Verona, Ferrara, Milan, Friuli, Brescia, from the Fourteenth to the Sixteenth Century*, 2 vols, London 1871

CUCCHI 1942
F. Cucchi, *La mediazione universale della Santissima Vergine negli scritti di Bernardino de' Bustis*, Milan 1942

CUMMINGS 2004
A. Cummings, *The Maecenas and the Madrigalist: Patrons, Patronage, and the Origins of the Italian Madrigal*, Philadelphia 2004

D'ADDA 1873
G. D'Adda, *Leonardo da Vinci e la sua libreria*, Milan 1873

DALLI REGOLI 1966
G. Dalli Regoli, *Lorenzo di Credi*, Cremona 1966

DALTON 1915
O.M. Dalton, *Catalogue of the Engraved Gems of the Post-Classical Periods in the Department of British Medieval Antiquities and Ethnography in the British Museum*, London 1915

DANIELI 2006
M.F. Danieli, *La Madonna della Grazia in Galatone: Storia, arte e pietà popolare*, Galatina 2006

DAVIES 1961
M. Davies, *The Earlier Italian Schools*, National Gallery, London 1961

DELL'AQUA AND MATALON 1963
G.A. dell'Aqua and S. Matalon, *Affreschi lombardi del Trecento*, Milan 1963

DEMONTS 1921
L. Demonts, *Les dessins de Léonard de Vinci*, Paris 1921

DEMPSEY 1987
C. Dempsey, 'The Carracci and the Devout Style in Emilia', in *Emilian Painting of the 16th and 17th Centuries*, Bologna 1987, pp. 75–87

DE RINALDIS 1926
A. De Rinaldis, *Storia dell'opera pittorica di Leonardo da Vinci*, Bologna 1926

DE ZAHN 1867
A. de Zahn, 'Notizie artistiche tratte dall'Archivio Segreto Vaticano', *Archivio Storico Italiano*, VI (1867), pp. 166–94

DÉZALLIER D'ARGENVILLE 1752
A.-N. Dézallier d'Argenville, *Voyage pittoresque*, Paris 1752

DI LORENZO 1996
A. Di Lorenzo, 'Piero della Francesca nel Museo Poldi Pezzoli', in *Il polittico agostiniano di Piero della Francesca*, ed. A. Di Lorenzo, Turin 1996, pp. 121–31

DI LORENZO 2000
A. Di Lorenzo, 'Molteni restauratore per Gian Giacomo Poldi Pezzoli', in Milan 2000a, pp. 69–75

DINA 1884
A. Dina, 'Ludovico Sforza detto il Moro e Giovan Galeazzo Sforza nel *Canzoniere* di Bernardo Bellincione', *Archivio Storico Lombardo*, 11 (1884), pp. 717–40

DINA 1886
A. Dina, 'Lodovico il Moro prima della sua venuta al governo', *Archivio Storico Lombardo*, XIII (1886), pp. 737–76

DINA 1921
A. Dina, 'Isabella d'Aragona, duchessa di Milano e di Bari', *Archivio Storico Lombardo*, XLVIII (1921), pp. 269–457

DIONISOTTI 1962
C. Dionisotti, 'Leonardo, uomo di lettere', *Italia Medioevale e Umanistica*, V (1962), pp. 183–216

DODGSON 1913
C. Dodgson, 'Two Unpublished Drawings by Leonardo', *Burlington Magazine*, XXIII, no. 125 (1913), pp. 264–7

DUNKERTON 2011
J. Dunkerton, 'Leonardo in Verrocchio's Workshop: Re-Examining the Technical Evidence', *National Gallery Technical Bulletin*, XXXII (2011), pp. 4–31

DUNKERTON AND ROY 1996
J. Dunkerton and A. Roy, 'The Materials of a Group of Late Fifteenth-Century Florentine Panel Paintings', *National Gallery Technical Bulletin*, XVII (1996), pp. 20–31

DUNKERTON AND SYSON 2010
J. Dunkerton and L. Syson, 'In Search of Verrocchio the Painter: The Cleaning and Examination of *The Virgin and Child with Two Angels*', *National Gallery Technical Bulletin*, XXXI (2010), pp. 4–41

EDINBURGH 1992
Leonardo da Vinci: The Mystery of the Madonna of the Yarnwinder, ed. M. Kemp, exh. cat., National Galleries of Scotland, Edinburgh 1992

EDINBURGH AND LONDON 2002–3
Leonardo da Vinci: The Divine and the Grotesque, ed. M. Clayton, exh. cat., The Queen's Gallery, Edinburgh and London 2002–3

EDINBURGH, NEW YORK AND HOUSTON 1999–2000
The Draughtsman's Art: Master Drawings from the National Gallery of Scotland, exh. cat., National Galleries of Scotland, Edinburgh; Frick Collection, New York; Museum of Fine Arts, Houston, Edinburgh 1999

EGGER 1952
G. Egger, 'Zur Analyse der sechs Knoten von Albrecht Dürer', *Das Antiquariat*, VIII (1952), pp. 28–30

EICHHOLZ 1998
G. Eichholz, *Das Abendmahl Leonardo da Vincis: Eine systematische Bildmonographie*, Munich 1998

EKSERDJIAN 1988
D. Ekserdjian, 'The Altarpieces of Correggio', Ph.D. thesis, Courtauld Institute of Art, University of London, 1988

ELAM 1988
C. Elam, 'Art and Diplomacy in Renaissance Florence', *RSA Journal*, CXXXVI (1988), pp. 813–26

ELAM 1992
C. Elam, 'Lorenzo de' Medici's Sculpture Garden', *Mitteilungen des Kunsthistorischen Institutes in Florenz*, XXXVI (1992), pp. 41–84

ELKINS 1988
J. Elkins, 'Did Leonardo develop a Theory of Curvilinear Perspective?', *Journal of the Warburg and Courtauld Institutes*, LI (1988), pp. 190–6

EMBOLDEN 1987
W.A. Embolden, *Leonardo da Vinci on Plants and Gardens*, Portland 1987

ÉMILE-MÂLE 2008
G. Émile-Mâle, 'La transportation de la *Vierge aux rochers* de Léonard de Vinci', in *Pour une histoire de la restauration des peinture en France*, Paris 2008, pp. 275–9

ESCOBAR 1983
S. Escobar, 'Il tecnico idraulico tra sapere e saper fare', in *Leonardo e le vie d'acqua*, exh. cat., Rotonda di Via Besana, Milan, Florence 1983, pp. 11–25

FABJAN 1998
B. Fabjan 1998, 'In margine all'ermellino', in Rome, Milan and Florence 1998–9, pp. 73–5

FAGNART 2009
L. Fagnart, *Léonard de Vinci en France: Collections et collectionneurs (XVème–XVIIème siècles)*, Rome 2009

FARAGO 1991
C.J. Farago, 'Leonardo's Color and Chiaroscuro Reconsidered: The Visual Force of Painted Images', *Art Bulletin*, LXXIII (1991), pp. 63–88

FARAGO 1992
C.J. Farago, *Leonardo da Vinci's Paragone: A Critical Interpretation with a New Edition of the Text in the Codex Urbinas*, Leyden and New York 1992

FARAGO 1994
C.J. Farago, 'Leonardo's *Battle of Anghiari*: A Study in the Exchange between Theory and Practice', *Art Bulletin*, LXXVI (1994), pp. 301–30

FARAGO 1999a
C.J. Farago (ed.), *Leonardo da Vinci: Selected Scholarship*, 5 vols, New York and London 1999

FARAGO 1999b
C.J. Farago (ed.), *Leonardo's Writings and Theory of Art*, New York 1999

FARAGO 2008
C.J. Farago (ed.), *Leonardo da Vinci and the Ethics of Style*, Manchester and New York 2008

FARROW 2001
S. Farrow, 'An Examination of the *Archinto Portrait* in the National Gallery of London', *Raccolta Vinciana*, XXIX (2001), pp. 65–102

FASOLI 1992
S. Fasoli, 'Tra riforme e nuove fondazioni: L'osservanza domenicana nel Ducato di Milano', *Nuova Rivista Storica*, LXXVI (1992), pp. 417–94

FAVARO 1919
G. Favaro, 'Plinio e Leonardo', in *Per il IV centenario dalla morte di L. da V.*, ed. M. Cermeneti, Bergamo 1919, pp. 133–8

FEHL 1995
P. Fehl, 'In Praise of Imitation: Leonardo and his Followers', *Gazette des Beaux-Arts*, CXXVI (1995), pp. 1–12

FEHRENBACH 1997
F. Fehrenbach, *Licht und Wasser: Zur Dynamik naturphilosophischer Leitbilder im Werk Leonardo da Vincis*, Tübingen 1997

FERRI PICCALUGA 1994a
G. Ferri Piccaluga, 'Sofia'. *Achademia Leonardi Vinci*, VII (1994), pp. 13–42

FERRI PICCALUGA 1994b
G. Ferri Piccaluga, 'La prima versione della *Vergine delle Rocce* riconsiderata nelle repliche', *Achademia Leonardi Vinci*, VII (1994), pp. 43–50

FERRI PICCALUGA 2005
G. Ferri Piccaluga, 'Leonardo, Pico e l'ambiente ebraico', in Frosini 2005, pp. 37–52

FFOULKES 1894
C.J. Ffoulkes, 'Le esposizioni d'arte italiana a Londra', *Archivio Storico dell'Arte*, VII (1894), pp. 249–68

FFOULKES AND MAIOCCHI 1909
C.J Ffoulkes and R. Maiocchi, *Vincenzo Foppa of Brescia, Founder of the Lombard School*, London and New York 1909

FICINO (1985)
Marsilio Ficino, *Commentary on Plato's Symposium on Love*, ed. and trans. S.R. Jayne, Dallas 1985

FIORIO 1984
M.T. Fiorio, 'Per il ritratto lombardo: Bernardino de' Conti', *Arte Lombarda*, LXVIII–LXIX (1984), pp. 38–52

FIORIO 1992
M.T. Fiorio, 'Lo pseudo-Francesco Napoletano', *Raccolta Vinciana*, XXIV (1992), pp. 88–107

FIORIO 1998a
M.T. Fiorio, 'Francesco Napoletano (and the Pseudo Francesco Napoletano)', in Bora et al. 1998, pp. 199–210

FIORIO 1998b
M.T. Fiorio, 'The Many Faces of Leonardismo', in Bora et al. 1998, pp. 39–63

FIORIO 1998c
M.T. Fiorio, 'Giovanni Antonio Boltraffio', in Bora et al. 1998, pp. 131–62

FIORIO 1999
M.T. Fiorio, 'In margine al de' Predis', in *Studi di storia dell'arte in onore di Maria Luisa Gatti Perer*, eds M. Rossi and A. Rovetta, Milan 1999, pp. 149–55

FIORIO 2000
M.T. Fiorio, *Giovanni Antonio Boltraffio: Un pittore milanese nel lume di Leonardo*, Milan and Rome 2000

FIORIO 2001
M.T. Fiorio (ed.), *Museo d'Arte Antica del Castello Sforzesco: Pinacoteca*, vol. 5, Milan 2001

FIORIO 2003
M.T. Fiorio, 'Qualche aggiunta al Maestro della Pala Sforzesca', *Raccolta Vinciana*, XXX (2003), pp. 179–206

FIORIO 2010
M.T. Fiorio, '"Scrivi che cosa è anima...": Leonardo e Antonello a confronto', in Rome 2010–11, pp. 47–59

FIORIO AND LUCCHINI 2007
M.T. Fiorio and A. Lucchini, 'Nella Sala delle Asse, sulle tracce di Leonardo', *Raccolta Vinciana*, XXXII (2007), pp. 101–40

FIORIO AND MARANI 1991
M.T. Fiorio and P.C. Marani (eds), *I Leonardeschi a Milano: Fortuna e collezionismo*, Milan 1991

FIRPO 1956
L. Firpo, 'La città ideale del Filarete', in *Studi in memoria di Gioele Solari*, ed. F. Balbo, Turin 1956, pp. 11–59

FIRPO 1963
L. Firpo (ed.), *Leonardo architetto e urbanista*, Turin 1963

FIRPO 1967
L. Firpo (ed.), *Francesco Filelfo educatore e il Codice Sforza della Biblioteca Reale di Torino*, Turin 1967

FISCHER AND ROTHMÜLLER 1820 (1915)
J. Fischer and A. Rothmüller, 'Inventarium No. 10 der fürstlich Esterhazyschen Gemählde, 1820', in S. Meller, *Az Esterházy Képtár története*, Budapest 1915, pp. 199–237

FLORENCE 1948
La casa italiana nei secoli, exh. cat., Palazzo Strozzi, Florence 1948

FLORENCE 1980
Il primato del disegno, ed. A.M. Petrioli Tofani, exh. cat., Galleria degli Uffizi, Florence 1980

FLORENCE 1992
Il disegno fiorentino del tempo di Lorenzo il Magnifico, ed. A. Petrioli Tofani, exh. cat., Galleria degli Uffizi, Florence, Milan 1992

FLORENCE 2005-6
Leonardo da Vinci: La vera immagine, eds V. Arrighi, A. Bellinazzi and E. Villata, exh. cat., Archivio di Stato, Florence 2005

FLORENCE 2006-7
La mente di Leonardo: Nel laboratorio del genio universale, ed. P. Galuzzi, exh. cat., Galleria degli Uffizi, Florence 2006

FLORENCE 2008-9
Caterina e Maria de' Medici: Donne al potere, ed. C. Innocenti, exh. cat., Palazzo Strozzi, Florence 2008

FLORENCE 2010
I grandi bronzi del Battistero: Giovanfrancesco Rustici e Leonardo, eds T. Mozzati, B. Paolucci Strozzi and P. Sénéchal, exh. cat., Museo Nazionale del Bargello, Florence, Milan 2010

FLORENCE 2010-11
Bronzino: Pittore e poeta alla corte dei Medici, eds C. Falciani and A. Natali, exh. cat., Palazzo Strozzi, Florence 2010

FOUCART-WALTER 2007
É. Foucart-Walter (ed.), *Catalogue des peintures italiennes du Musée du Louvre*, Paris 2007

FRANCESCO DI GIORGIO (1967)
Francesco di Giorgio Martini, *Trattati di architettura ingegneria e arte militare*, ed. C. Maltese, Milan 1967

FRANCIS 1935
H.S. Francis, 'The Holden Francesco Napoletano', *Bulletin of the Cleveland Museum of Art*, XXII, no. 10 (1935), pp. 156-9

FRANCK 2006
J. Franck, 'L'invenzione dello sfumato', in Florence 2006-7, pp. 342-57

FRANCK 2011
J. Franck, 'Léonard de Vinci: La technique picturale', Ph.D. thesis, École Pratique des Hautes Études, Paris 2011

FRANGI 1991
F. Frangi, 'Qualche considerazione su un leonardesco eccentrico: Francesco Napoletano', in Fiorio and Marani 1991, pp. 71-86

FRANKFURT 1999-2000
Von Raffael bis Tiepolo: Italienische Kunst aus der Sammlung des Fürstenhauses Esterházy, exh. cat., Schirn Kunsthalle, Frankfurt am Main, Munich 1999

FRANKLIN 2001
D. Franklin, *Painting in Renaissance Florence, 1500-1550*, New Haven and London 2001

FREDERICKSEN 1991
B.B. Fredericksen, 'Leonardo and Mantegna in the Buccleuch Collection', *Burlington Magazine*, CXXXIII (1991), no. 1055, pp. 116-18

FRIEDMANN 1946
H. Friedmann, *The Symbolic Goldfinch: Its History and Significance in European Devotional Art*, New York 1946

FRIZZONI 1894
G. Frizzoni, 'I disegni delle teste degli apostoli nel *Cenacolo* di Leonardo da Vinci', *Archivio Storico dell'Arte*, VII (1894), pp. 41-9

FRIZZONI 1898
G. Frizzoni, 'Exposition de maitres de l'école lombarda a Londres', *Gazette des Beaux-Arts*, XX (1898), pp. 293-304, 389-403

FROSINI 1997
F. Frosini, 'Pittura come filosofia: Note su "spirito" e "spirituale" in Leonardo', *Achademia Leonardi Vinci*, X (1997), pp. 35-59

FROSINI 2002
F. Frosini, 'Leonardo e il senso infinito del ricercare', *Civiltà del Rinascimento*, 11 (2002), pp. 68-73

FROSINI 2005
F. Frosini (ed.), *Leonardo e Pico: Analogie, contatti, confronti*, Florence 2005

FUSCO AND CORTI 2006
L. Fusco and G. Corti, *Lorenzo de' Medici: Collector and Antiquarian*, Cambridge 2006

FÚSTER 1999
M.D. Fúster, 'Estudio y tratamiento de restauración de una pintura de escuela lombarda del Museo Lázaro Galdiano', *Goya*, CCLXX (1999), pp. 179-88

GALLI MICHERO 2000
L.M. Galli Michero, 'Elenco e rispettivo prezzo dei restauri eseguiti da Giuseppe Molteni ai quadri di proprietà del nobile Sig. Cav. Don Giacomo Poldi dall'anno 1853 in avanti', in Milan 2000, pp. 241-4

GARIN 1952
E. Garin, 'La cultura fiorentina nell'età di Leonardo', *Belfagor*, VII (1952), pp. 1-19

GARIN 1961
E. Garin, *La cultura filosofica del Rinascimento italiano*, Florence 1961

GARIN 1972
E. Garin, *La città in Leonardo*, Florence 1972

GARIN 1978
E. Garin, *Science and Civic Life in the Italian Renaissance*, trans. P. Munz, Gloucester, MA 1978 (*Scienza e vita civile nel rinascimento*, Bari 1965)

GARIN 1983
E. Garin, 'La cultura a Milano alla fine del Quattrocento', in *Milano nell'età di Ludovico il Moro*, vol. 1, Milan 1983, pp. 21-8

GARRARD 1992
M.D. Garrard, 'Leonardo da Vinci: Female Portraits, Female Nature', in *The Expanding Discourse: Feminism and Art History*, eds N. Broude and M.D. Garrard, Oxford 1992, pp. 59-85

GASPAROTTO 2000
D. Gasparotto, '"Ho fatto con l'occhio e con la mano miracoli stupendissimi": Il percorso di Valerio Belli', in *Valerio Belli Vicentino*, eds H. Burns, M. Collareta and D. Gasparotto, Vicenza 2000, pp. 53-109

GAULT DE SAINT-GERMAIN 1803
Leonardo da Vinci, *Traité de la peinture*, ed. and trans. P.M. Gault de Saint-Germain, Paris 1803

GAYE 1839-40
G. Gaye, *Carteggio inedito d'artisti dei secoli XIV, XV, XVI*, 3 vols, Florence 1839-40

GAZZINI 2006
M. Gazzini, *Confraternite e società cittadina nel Medioevo italiano*, Bologna 2006

GERLI 1784
C.G. Gerli, *Disegni di Leonardo da Vinci*, Milan 1784

GHINZONI 1889
P. Ghinzoni, 'Lettera inedita di Bernardo Bellincioni', *Archivio Storico Lombardo*, VI (1889), pp. 417-18

GIBSON 1991
E. Gibson, 'Leonardo's *Ginevra di Benci*: The Restoration of a Renaissance Masterpiece', *Apollo*, CXXXIII, no. 349 (1991), pp. 161-5

GILBERT 1939
F. Gilbert, 'The Humanist Concept of the Prince and *The Prince* of Machiavelli', *Journal of Modern History*, XI, no. 4 (1939), pp. 449-83

GIORDANO 1993
L. Giordano, 'L'autolegittimazione di una dinastia: Gli Sforza e la politica dell'immagine', *Artes*, 1 (1993), pp. 12-19

GIORDANO 1995a
L. Giordano, 'Nihil supra: La magnificenza di Ludovico Sforza', in *Arte, committenza ed economia a Roma e nelle corti del Rinascimento (1420-1530)*, eds A. Esch and C.L. Frommel, Turin 1995, pp. 273-96

GIORDANO 1995b
L. Giordano (ed.), *Ludovicus dux*, Vigevano 1995

GIORDANO 2008
L. Giordano (ed.), *Beatrice d'Este, 1475-1497*, Pisa 2008

GIOVIO (1999)
Paolo Giovio, *Scritti d'arte: Lessico ed ecfrasi*, ed. S. Maffei, Pisa 1999

GLASSER 1977
H. Glasser, *Artists' Contracts of the Early Renaissance*, New York and London 1977

GOETHE 1818
J.W. von Goethe, 'Joseph Bossi über Leonardo da Vincis Abendmahl zu Mailand', in *Über Kunst und Alterthum*, vol. 1, Stuttgart 1818, pp. 115-88

GOLDSCHEIDER 1959
L. Goldscheider, *Leonardo da Vinci: Life and Work, Paintings and Drawings*, London 1959

GOMBRICH 1948
E.H. Gombrich, '"Icones symbolicae": The Visual Image in Neoplatonic Thought', *Journal of the Warburg and Courtauld Institutes*, XI (1948), pp. 163-92

GOMBRICH 1962
E.H. Gombrich, 'Dark Varnishes: Variations on a Theme from Pliny', *Burlington Magazine*, CIV, no. 707 (1962), pp. 51-5

GOMBRICH 1963
E.H. Gombrich, 'Controversial Methods and Methods of Controversy', *Burlington Magazine*, CV, no. 720 (1963), pp. 90-4

GOMBRICH 1966
E.H. Gombrich, 'Leonardo's Method for Working out Compositions', *Norm and Form: Studies in the Art of the Renaissance*, London 1966, pp. 58-63

GOMBRICH 1968
E.H. Gombrich, *Art and Illusion: A Study in the Psychology of Pictorial Representation*, London 1968

GOMBRICH 1976
E.H. Gombrich, *The Heritage of Apelles: Studies in the Art of the Renaissance*, Oxford 1976

GÖTZ POCHAT 1973-4
A. Götz Pochat, 'The Ermine: A Metaphor on Renaissance Poetry and a Portrait by Leonardo da Vinci', *Tidskrift för Litteraturvetenskap*, III (1973-4), pp. 140-57

GOULD 1975
C. Gould, *Leonardo: The Artist and the Non-Artist*, Boston 1975

GOULD 1984
C. Gould, 'The Early History of Leonardo's *Vierge aux Rochers* in the Louvre', *Gazette des Beaux-Arts*, XLVII (1984), pp. 99-108

GOULD 1992
C. Gould, 'Leonardo's *Madonna of the Yarnwinder*', *Apollo*, CXXXVI, no. 365 (1992), pp. 12-16

GRABSKI AND WAŁEK 1991
J. Grabski and J. Wałek (eds), *Leonardo da Vinci: Lady with an Ermine*, Vienna and Cracow 1991

GRESY 1868
E. Gresy, 'Inventaire des objets d'art composant la succession de Florimond Robertet', *Memoire de la Société Impériale des Antiquaires de France*, XXX (1868), pp. 21-66

GRUYER 1879
G. Gruyer, *Les illustrations des écrits de Savonarole publiés en Italie au XV et au XVI siècles et les paroles de Savonarole sur l'art*, Paris 1879

GUILLAUME 1980
M. Guillaume, *Catalogue raisonné du Musée des Beaux-Arts de Dijon*, Dijon 1980

GUKOVSKIJ 1959
M.A. Gukovskij, *Madonna Litta: Kartina Leonardo da Vinci v Ermitaže*, Leningrad (St Petersburg) 1959

HANKINS 1990
J. Hankins, *Plato in the Italian Renaissance*, 2 vols, Leiden 1990

HANKINS 1996
J. Hankins, 'Humanism and the Origins of Modern Political Thought', in *The Cambridge Companion to Renaissance Humanism*, ed. J. Kraye, Cambridge 1996, pp. 118-41

HANKINS 2004
J. Hankins, *Humanism and Platonism in the Italian Renaissance*, vol. 2: *Platonism*, Rome 2004

HARDING ET AL. 1989
E. Harding, A. Braham, M. Wyld and A. Burnstock, 'The Restoration of the Leonardo Cartoon', *National Gallery Technical Bulletin*, XIII (1989), pp. 4-27

HAVERKAMP-BEGEMANN ET AL. 1964
E. Haverkamp-Begemann, S.D. Lawder and C.W. Talbot Jr, *Drawings from the Clark Art Institute: A Catalogue Raisonné of the Robert Sterling Clark Collection of European and American Drawings, Sixteenth through Nineteenth Centuries*, 2 vols, New Haven and London 1964

HEGENER 2010
N. Hegener, 'Riverberi vinciani: Leonardo e Rustici nell'opera di Baccio Bandinelli', in Florence 2010, pp. 213-37

HENRY AND PLAZZOTTA 2004
T. Henry and C. Plazzotta, 'Raphael: From Urbino to Rome', in London 2004-5, pp. 15-65

HEWETT 1907
A.E. Hewett, 'A Newly Discovered Portrait by Ambrogio de Predis', *Burlington Magazine*, X, no. 47 (1907), pp. 309-12

HEYDENREICH 1943
L.H. Heydenreich, *Leonardo*, Berlin 1943

HEYDENREICH 1949
L.H. Heydenreich, *I disegni di Leonardo da Vinci e della sua scuola conservati nella Galleria dell'Accademia*, 2 vols, Florence 1949

HEYDENREICH 1954
L.H. Heydenreich, *Leonardo da Vinci*, 2 vols, London, New York and Basel 1954

HEYDENREICH 1964
L.H. Heydenreich, 'Leonardo's Salvator Mundi', *Raccolta Vinciana*, XX (1964), pp. 83-109

HEYDENREICH 1977
L.H. Heydenreich, 'Giuliano da Sangallo in Vigevano, ein neues Dokument', in *Scritti di storia dell'arte in onore di Ugo Procacci*, vol. 2, Milan 1977, pp. 321-3

HILLS 1980
P. Hills, 'Leonardo and Flemish Painting', *Burlington Magazine*, CXXII, no. 930 (1980), pp. 608-15

HIND 1910
A.M. Hind, *Catalogue of Early Italian Engravings Preserved in the Department of Prints and Drawings in the British Museum*, London 1910

HIND 1938-48
A.M. Hind, *Early Italian Engravings: A Critical Catalogue with Complete Reproduction of all the Prints Described*, 7 vols, London 1938-48

HOCHSTETLER MEYER 1990
B. Hochstetler Meyer, 'Leonardo's Hypothetical Painting of *Leda and the Swan*', *Mitteilungen des Kunsthistorischen Institutes in Florenz*, XXXIV, no. 3 (1990), pp. 279-94

HOLLAND 1952
R. Holland, 'A Note on *La Vierge aux Rochers*', *Burlington Magazine*, XCIV, no. 595 (1952), pp. 284–6

HOLLY 1996
M.A. Holly, 'Writing Leonardo Backwards', in *Past Looking: Historical Imagination and the Rhetoric of the Image*, Ithaca, NY 1996, pp. 112–48

HOLMES 1997
M. Holmes, 'Disrobing the Virgin: The Madonna lactans in Fifteenth-Century Florentine Art', in *Picturing Women in Renaissance and Baroque Italy*, eds G.A. Johnson and S.F. Matthews Grieco, Cambridge 1997, pp. 167–95, 283–90

HOLMES 1999
M. Holmes, *Fra Filippo Lippi: The Carmelite Painter*, New Haven and London 1999

HOLMES 2004
M. Holmes, 'Copying Practices and Marketing Strategies in a Fifteenth-Century Florentine Painter's Workshop', in *Artistic Exchange and Cultural Translation in the Italian Renaissance City*, eds S.J. Campbell and S.J. Milner, Cambridge 2004, pp. 38–74

HÖRNQUIST 2004
M. Hörnquist, *Machiavelli and Empire*, Cambridge 2004

HOUSTON, PHILADELPHIA AND BOSTON 1992–3
Leonardo da Vinci: The Anatomy of Man, ed. M. Clayton, exh cat., Museum of Fine Arts, Houston; Philadelphia Museum of Art; Museum of Fine Arts, Boston, Toronto and London 1992

IANZITI 1988
G. Ianziti, *Humanistic Historiography under the Sforzas: Politics and Propaganda in Fifteenth-Century Milan*, Oxford 1988

INNSBRUCK 1992
Das Bildnis Kaiser Maximilians I. auf Münzen und Medaillen, exh. cat., Tiroler Landeskundliches Museum, Innsbruck 1992

JANAWAY 1995
C. Janaway, *Images of Excellence: Plato's Critique of the Arts*, Oxford 1995

JESTAZ 1999
B. Jestaz, 'François I, Salaì et les tableaux de Léonard', *Revue de l'Art*, XCCVI (1999), pp. 68–72

JOANNIDES 1989
P. Joannides, 'Leonardo and Tradition', in *Nine Lectures on Leonardo*, ed. F. Ames-Lewis, London 1989, pp. 22–31

JOANNIDES 2007
P. Joannides, *The Drawings of Michelangelo and his Followers in the Ashmolean Museum*, Cambridge 2007

JONES 1990
P.M. Jones, 'Bernardo Luini's Magdalene from the Collection of Federico Borromeo: Religious Contemplation and Iconographic Sources', *Studies in the History of Art*, XXIV (1990), pp. 67–72

JUCKER 2009–10
R. Jucker, 'Trascrizione dello Zibaldone di Gaetano Giordani (1800–1873) e relativi indici', BA thesis, Università degli Studi, Milan 2009–10

KEELE AND PEDRETTI 1979
K.D. Keele and C. Pedretti, *Corpus of the Anatomical Studies in the Collection of Her Majesty the Queen at Windsor Castle*, 3 vols, London 1979

KEITH AND ROY 1996
L. Keith and A. Roy, 'Giampietrino, Boltraffio, and the Influence of Leonardo', *National Gallery Technical Bulletin*, XVII (1996), pp. 4–19

KEITH ET AL. 2004
L. Keith, M. Moore Ede and C. Plazzotta, 'Polidoro da Caravaggio's Way to Calvary: Technique, Style and Function', *National Gallery Technical Bulletin*, XXV (2004), pp. 36–47

KEITH ET AL. 2010
L. Keith, A. Roy, and R. Morrison, 'Technique and the Context of Restoration', in *Studying Old Master Paintings: Technology and Practice*, ed. M. Spring, London 2010, pp. 72–9

KEITH ET AL. 2011
L. Keith, A. Roy, R. Morrison and P. Schade, 'Leonardo da Vinci's *Virgin of the Rocks*: Treatment, Technique and Display', *National Gallery Technical Bulletin*, XXXII (2011), pp. 32–56

KEMP 1971
M. Kemp, M., '"Il concetto dell'anima" in Leonardo's Early Skull Studies', *Journal of the Warburg and Courtauld Institutes*, XXXIV (1971), pp. 115–34

KEMP 1976
M. Kemp, '"Ogni pittore dipinge se": A Neoplatonic Echo in Leonardo's Art Theory?', in *Cultural Aspects of the Italian Renaissance: Essays in Honour of Paul Oskar Kristeller*, ed. C.H. Clough, Manchester 1976, pp. 311–23

KEMP 1977
M. Kemp, 'Leonardo and the Visual Pyramid', *Journal of the Warburg and Courtauld Institutes*, XL (1977), pp. 128–49

KEMP 1981
M. Kemp, *Leonardo da Vinci: The Marvellous Works of Nature and Man*, London 1981

KEMP 1985
M. Kemp, 'Leonardo da Vinci: Science and the Poetic Impulse', *RSA Journal*, CXXXIII (1985), pp 196–214

KEMP 1988
M. Kemp, *Leonardo e lo spazio dello scultore*, Florence 1988

KEMP 1990
M. Kemp, *The Science of Art: Optical Themes in Western Art from Brunelleschi to Seurat*, New Haven and London 1990

KEMP 1992
M. Kemp, 'Leonardo's *Madonna of the Yarnwinder*: The Making of a Devotional Image', in Edinburgh 1992, pp. 9–24

KEMP 1994
M. Kemp 'From Scientific Examination to the Renaissance Market: The Case of Leonardo da Vinci's *Madonna of the Yarnwinder*', *Journal of Medieval and Renaissance Studies*, XXIV (1994), pp. 259–74

KEMP 1995
M. Kemp, 'Leonardo's Drawings for "Il Cavallo del Duca Francesco di Bronzo"', in Cole Ahl 1995, pp. 64–78

KEMP 2003
M. Kemp, 'Drawing the Boundaries', in New York 2003, pp. 141–54

KEMP 2004a
M. Kemp, *Leonardo*, Oxford 2004

KEMP 2004b
M. Kemp, 'Leonardo and the Idea of Naturalism: Leonardo's Hypernaturalism', in Cremona and New York 2004, pp. 65–73

KEMP 2006
M. Kemp, *Leonardo da Vinci: The Marvellous Works of Nature and Man*, Oxford 2006

KEMP AND BARONE 2010
M. Kemp and J. Barone, *I disegni di Leonardo da Vinci e della sua cerchia: Collezioni della Gran Bretagna*, trans. D. Laurenza, Florence 2010

KEMP AND COTTE 2010
M. Kemp and P. Cotte, *Leonardo da Vinci, La Bella Principessa: The Profile Portrait of a Milanese Woman*, London 2010

KEULS 1989
E.C. Keuls, *Plato and Greek Painting*, Leiden 1989

KIANG 1988
D. Kiang, 'Bramante's *Heraclitus and Democritus*: The Frieze', *Zeitschrift für Kunstgeschichte*, LI (1988), pp. 262–8

KIANG 1989
D. Kiang, 'Gasparo Visconti's *Pasitea* and the Sala delle Asse', *Achademia Leonardi Vinci*, II (1989), pp. 101–9

KLEINBAUER 1967
W.E. Kleinbauer, 'Some Renaissance Views of Early Christian and Romanesque San Lorenzo in Milan', *Arte Lombarda*, XII (1967), pp. 1–10

KOERNER 1993
J.L. Koerner, *The Moment of Self-Portraiture in German Renaissance Art*, Chicago and London 1993

KOHL AND WITT 1978
B.G. Kohl and R.G. Witt (eds), *The Earthly Republic: Italian Humanists on Government and Society*, Philadelphia 1978

KOLLER AND BAUMER 2006
J. Koller and U. Baumer, '"Er. [...] erprobte die seltsamsten Methoden, um Öle zum Malen [...] zu finden"', in Munich 2006, pp. 155–74

KRAYE 1979
J. Kraye, 'Francesco Filelfo's Lost Letter *De ideis*', *Journal of the Warburg and Courtauld Institutes*, XLII (1979), pp. 236–49

KÜHN 1985
H. Kühn, Naturwissenschaftliche Untersuchung von Leonardos *Abendmahl* in Santa Maria delle Grazie in Mailand', *Maltechnik – Restauro*, XCI, no. 4 (1985), pp. 24–51

KUSTODIEVA 1994
T.K. Kustodieva, *Italian Painting: Thirteenth to Sixteenth Centuries*, State Hermitage Museum, St Petersburg, Florence 1994

KUSTODIEVA 2003
T.K. Kustodieva, *La Madonna Litta: Storia di un capolavoro di Leonardo*, in Rome 2003, pp. 27–49

KUSTODIEVA 2011
T.K. Kustodieva, *Gosudarstvienny Ermitage: Italyanskaya zhivopis XIII–XVI vekov* (Кустодиева Т.К., Государственный Эрмитаж: Итальянская живопись XIII–XVI веков), St Petersburg 2011

KWAKKELSTEIN 1993
M.W. Kwakkelstein, 'The Lost Book on "moti mentali"', *Achademia Leonardi Vinci*, VI (1993), pp. 56–66

KWAKKELSTEIN 1994
M.W. Kwakkelstein, *Leonardo da Vinci as a Physiognomist: Theory and Drawing Practice*, Leiden 1994

KWAKKELSTEIN 1999
M.W. Kwakkelstein, 'The Use of Sculptural Models by Italian Renaissance Painters: Leonardo da Vinci's *Madonna of the Rocks* Reconsidered in Light of his Working Procedures', *Gazette des Beaux-Arts*, CXXXIII (1999), pp. 181–98

KWAKKELSTEIN 2003
M.W. Kwakkelstein, 'The Use of Sculptural Models by the Master of the Pala Sforzesca', *Raccolta Vinciana*, XXX (2003), pp. 147–78

KWIATKOWSKI 1991
K. Kwiatkowski, 'Scientific Analysis of the *Lady with an Ermine*', in Grabski and Wałek 1991, p. 39

LAGRANGE 1862
L. Lagrange, 'Catalogue des dessins de maîtres exposés dans la Galerie des Uffizi, à Florence', *Gazette des Beaux-Arts*, XII (1862), pp. 535–54 and XIII (1862), pp. 276–84, 446–62

LAMBERT 1999
G. Lambert, *Les premières gravures italiennes: Quattrocento – début du Cinquecento (Bibliothèque Nationale de France, Paris)*, Paris 1999

LAMY 2000
M. Lamy, *L'Immaculée Conception: Étapes et enjeux d'une controverse au Moyen Âge (XIIe–XVe siècles)*, Paris 2000

LANG 1972
S. Lang, 'Sforzinda, Filarete and Filelfo', *Journal of the Warburg and Courtauld Institutes*, XXXV (1972), pp. 391–7

LATUADA 1737–8
S. Latuada, *Descrizione di Milano ornata con molti disegni in rame: Delle fabbriche più cospicue che si trovano in questa metropoli*, 4 vols, Milan 1737–8

LAURENZA 2001
D. Laurenza, *De figura umana: Fisiognomica, anatomia e arte in Leonardo*, Florence 2001

LEHRS 1908–30
M. Lehrs, *Geschichte und kritischer Katalog des deutschen, niederländischen und französischen Kupferstichs im XV. Jahrhundert*, 14 vols, Vienna 1908–30

LEVENSON ET AL. 1973
J.A. Levenson, K. Oberhuber and J.L. Sheehan, *Early Italian Engravings from the National Gallery of Art*, Washington, DC 1973

LEVEROTTI 1983
F. Leverotti, 'La crisi finanziaria del Ducato di Milano alla fine del Quattrocento', in *Milano nell'età di Ludovico il Moro*, vol. 2, Milan 1983, pp. 585–632

LEVI D'ANCONA 1957
M. Levi d'Ancona, *The Iconography of the Immaculate Conception in the Middle Ages and Early Renaissance*, New York 1957

LEVI D'ANCONA 1977
M. Levi d'Ancona, *The Garden of the Renaissance: Botanical Symbolism in Italian Painting*, Florence 1977

LEVI DELLA TORRE 1998
S. Levi della Torre, 'Similitudini: Considerazioni intorno alla *Vergine delle Rocce*', in *Tutte le opera non son per istancarmi': Raccolta di scritti per i settant'anni di Carlo Pedretti*, ed. F. Frosini, Rome 1998, pp. 203–15

LEVI PISETZKY 1964
R. Levi Pisetzky, *Storia del costume in Italia*, 2 vols, Milan 1964

LIPGART 1928
E.K. Lipgart, *Leonardo and his School*, Leningrad (St Petersburg) 1928

LITTA 1842–3
P. Litta, *Famiglie celebri di Italia*, vol. 3, Milan 1842–3

LIVI 1990
A. Livi, *Filosofia del senso commune. Logica e la scienza e della fede*, Milan 1990

LOESER 1897
C. Loeser, 'I disegni italiani della raccolta Malcolm', *Archivio Storico dell'Arte*, III (1897), pp. 341–59

LOESER 1901
C. Loeser, 'Un opera di Ambrogio de' Predis', *Rassegna d'Arte*, I (1901), pp. 65–7

LOESER 1902
C. Loeser, 'Über einige italienische Handzeichnungen des Berliner Kupferstichkabinetts', *Repertorium für Kunstwissenschaft*, XXVI (1902), pp. 348–59

LOGAN BERENSON 1907
M. Logan Berenson, 'Dipinti italiani in Cleveland, U.S.A.', *Rassegna d'Arte*, VII (1907), pp. 1–5

LOMAZZO (1973–4)
Giovanni Paolo Lomazzo, *Scritti sulle arti*, ed. R.P. Ciardi, 2 vols, Florence 1973–4

LONDON 1898
Catalogue of Pictures by Masters of the Milanese and Allied Schools of Lombardy, exh. cat., Burlington Fine Arts Club, London 1898

LONDON 1952
Leonardo da Vinci: Quincentenary Exhibition, exh. cat., Royal Academy of Arts, London 1952

LONDON 1960
Italian Art and Britain, exh. cat., Royal Academy of Arts, London 1960

LONDON 1983
Mantegna to Cezanne: Master Drawings from the Courtauld, eds W. Bradford and H. Braham, exh. cat., Courtauld Gallery, London 1983

LONDON 1989
Leonardo da Vinci, eds M. Kemp and J. Roberts, exh. cat., Hayward Gallery, London 1989

LONDON 1996–7
Leonardo da Vinci: A Curious Vision, ed. M. Clayton, exh. cat., The Queen's Gallery, London 1996

LONDON 1999–2000
Renaissance Florence: The Art of the 1470s, eds P.L. Rubin and A. Wright, exh. cat., National Gallery, London 1999

LONDON 2004–5
Raphael: From Urbino to Rome, eds H. Chapman, T. Henry and C. Plazzotta, exh. cat., National Gallery, London 2004

LONDON AND FLORENCE 2010–11
Fra Angelico to Leonardo: Italian Renaissance Drawings, eds H. Chapman and M. Faietti, exh. cat., British Museum, London; Galleria degli Uffizi, Florence, London 2010

LOS ANGELES 1949
Leonardo da Vinci: Loan Exhibition, eds W.R. Valentiner and W.E. Suida, exh. cat., Los Angeles County Museum, Los Angeles 1949

LOTZ 1974
W. Lotz, 'La piazza ducale di Vigevano: Un foro principesco del tardo Quattrocento', in *Studi Bramanteschi*, Rome 1974, pp. 205–21

LUZIO 1887
A. Luzio, *I precettori d'Isabella d'Este*, Ancona, 1887

LUZIO 1888
A. Luzio, 'Ancora Leonardo da Vinci e Isabella d'Este', *Archivio Storico dell'Arte*, I (1888), pp. 181–4

LUZIO 1901
A. Luzio, 'Isabella d'Este e la corte sforzesca', *Archivio Storico Lombardo*, III, no. 15 (1901), pp. 145–76

LUZIO AND RENIER 1890a
A. Luzio and R. Renier, 'Delle relazioni di Isabella d'Este Gonzaga con Ludovico e Beatrice Sforza', *Archivio Storico Lombardo*, XVII (1890), pp. 74–119, 346–99, 619–74

LUZIO AND RENIER 1890b
A. Luzio and R. Renier, 'Francesco Gonzaga alla battaglia di Fornovo', *Archivio Storico Italiano*, VI (1890), pp. 205–46

MCCURDY 1928
E. McCurdy, *The Mind of Leonardo da Vinci*, New York 1928

MCCURDY 1938
The Notebooks of Leonardo da Vinci, ed. and trans. E. McCurdy, London 1938

MCKENDRICK 1991
S. McKendrick, 'The Great History of Troy: A Reassessment of the Development of a Secular Theme in Late Medieval Art', *Journal of the Warburg and Courtauld Institutes*, LIV (1991), pp. 43–82

MACOLA 2007
N. Macola, *Sguardi e scritture: Figure con libro nella ritrattistica italiana della prima metà del Cinquecento*, Venice 2007

MADRID AND LONDON 2008–9
Renaissance Faces: Van Eyck to Titian, exh. cat., Museo Nacional del Prado, Madrid; National Gallery, London 2008

MAGLIABECHIANO (1968)
L'Anonimo Magliabechiano, ed. A. Ficarra, Naples 1968

MAGASIN PITTORESQUE 1858
'Recueil de dessins de Léonard de Vinci au musée du Louvre', *Magasin Pittoresque*, XXVI (1858), pp. 11–14

MAIORINO 1992
G. Maiorino, *Leonardo da Vinci: The Daedalian Mythmaker*, University Park, PA 1992

MALAGUZZI VALERI 1902a
F. Malaguzzi Valeri, 'Artisti lombardi a Roma nel Rinascimento: Nuovi documenti su Cristoforo Solari, Bramante e Caradosso', *Repertorium für Kunstwissenschaft*, XXV (1902), pp. 57–64

MALAGUZZI VALERI 1902b
F. Malaguzzi Valeri, *Pittori lombardi del Quattrocento*, Milan 1902

MALAGUZZI VALERI 1912
F. Malaguzzi Valeri, 'Il ritratto femminile del Boltraffio lasciato dal Senatore d'Adda al Comune di Milano', *Rassegna d'Arte*, XII (1912), pp. 9–11

MALAGUZZI VALERI 1913–23
F. Malaguzzi Valeri, *La corte di Ludovico il Moro*, 4 vols, Milan 1913–23

MALAGUZZI VALERI 1914
F. Malaguzzi Valeri, 'Un ritratto di Ambrogio de Predis a Brera', *Bollettino d'Arte*, VIII, no. 9 (1914), pp. 298–304

MALTESE 1954
C. Maltese, 'Il pensiero architettonico e urbanistico di Leonardo', in *Leonardo: Saggi e richerche*, ed. A. Marazza, Rome 1954, pp. 333–58

MANCA 1996
J. Manca, 'The Gothic Leonardo: Towards a Reassessment of the Renaissance', *Artibus et Historiae*, XVII (1996), pp. 121–58

MANCA 2000
J. Manca, *Cosmè Tura: The Life and Art of a Painter in Estense Ferrara*, Oxford 2000

MANCA 2001
J. Manca, *Moral Essays on the High Renaissance: Art in Italy in the Age of Michelangelo*, Lanham, MD 2001

MANTUA 2006–7
Mantegna a Mantova: 1460–1506, ed. M. Lucco, exh. cat., Galleria Civica di Palazzo Te, Mantua 2006

MARANESI 2005
P. Maranesi, 'L'inizio delle dispute e gli interventi pontifici', in *La Scuola francescana e l'Immacolata Concezione*, ed. S.M. Cecchin, Vatican City 2005, pp. 303–40

MARANI 1982a
P.C. Marani, 'Leonardo e le colonne ad tronchonos: Tracce di un programma iconologico per Ludovico il Moro', *Raccolta Vinciana*, XXI (1982), pp. 103–20

MARANI 1982b
P.C. Marani, 'Leonardo, Francesco di Giorgio e il tiburio del Duomo di Milano', *Arte Lombarda*, LXII (1982), pp. 81–92

MARANI 1986
P.C. Marani, 'Le fonti del bestiario di Leonardo', in *I manoscritti dell'Institut de France: Il manoscritto H*, ed. A. Marinoni, Florence 1986, pp. 141–53

MARANI 1987a
P.C. Marani, 'Fortuna dei Leonardeschi lombardi nelle esposizioni milanesi', in Milan 1987–8, pp. 34–42

MARANI 1987b
P.C. Marani, *Leonardo e i Leonardeschi a Brera*, Florence 1987

MARANI 1989
P.C. Marani, *Leonardo: Catalogo completo dei dipinti*, Florence 1989

MARANI 1991a
P.C. Marani, 'Francesco di Giorgio a Milano e a Pavia: Conseguenze e ipotesi', in *Prima di Leonardo: Cultura delle macchine a Siena nel Rinascimento*, ed. P. Galluzzi, Milan 1991, pp. 93–104

MARANI 1991b
P.C. Marani, 'Una *Madonna Litta* tedesca?', *Achademia Leonardi Vinci*, IV (1991), pp. 200–3

MARANI 1992a
P.C. Marani, 'I dipinti di Leonardo, 1500–1507: Per una cronologia', in *Leonardo, Michelangelo and Raphael in Renaissance Florence from 1500–1508*, ed. S. Hagar, Washington, DC 1992, pp. 1–28

MARANI 1992b
P.C. Marani, 'Leonardo a Venezia e nel Veneto', in Venice 1992, pp. 23–36

MARANI 1998a
P.C. Marani, 'Francesco Melzi', in Bora et al. 1998, pp. 371–84

MARANI 1998b
P.C. Marani, 'The Question of Leonardo's Bottega: Practices and the Transmission of Leonardo's Ideas on Art and Painting', in Bora et al. 1998, pp. 8–37

MARANI 1998c
P.C. Marani, 'Resistenze locali e affermazione della maniera moderna: Pittura a Milano dal 1480 al 1500 circa', in *Pittura a Milano: Rinascimento e Manierismo*, ed. M. Gregori, Milan 1998, pp. 12–23

MARANI 1998d
P.C. Marani, 'Scheda storico-artistica', in Rome, Milan and Florence 1998–9, pp. 76–82

MARANI 1999
P.C. Marani, *Leonardo: Una carriera di pittore*, Milan 1999

MARANI 2001
P.C. Marani, 'Leonardo, i moti e le passioni: Introduzione alla fortuna e alla sfortuna del Cenacolo', in Milan 2001, pp. 29–38

MARANI 2003a
P.C. Marani, *Leonardo da Vinci: The Complete Paintings*, New York 2003

MARANI 2003b
P.C. Marani, 'Leonardo's Drawings in Milan and their Influence on the Graphic Work of Milanese Artists', in New York 2003, pp. 155–90

MARANI 2003c
P.C. Marani, 'I committenti di Leonardo al tempo di Ludovico il Moro, 1483–1499', in *Lombardia rinascimentale: Arte e architettura*, eds M.T. Fiorio and V. Terraroli, Milan 2003, pp. 164–87

MARANI 2003d
P.C. Marani, *La Vergine delle Rocce della National Gallery di Londra: Maestro e bottega di fronte al modello* Florence 2003

MARANI 2003e
P.C. Marani, '"Imita quanto puoi li Greci e Latini": Leonardo da Vinci and the Antique', in *In the Light of Apollo: Italian Renaissance and Greece*, ed. M. Gregori, exh. cat., National Gallery, Alexandros; Soutzos Museum, Athens, 2003, pp. 475–8

MARANI 2004
P.C. Marani, 'Francesco di Giorgio e Leonardo: Divergenze e convergenze a proposito del tiburio del duomo di Milano', in *Francesco di Giorgio alla corte di Federico da Montefeltro*, ed. F.P. Fiore, Florence 2004, pp. 557–76

MARANI 2007
P.C. Marani, 'Dürer, Leonardo e i pittori lombardi del Quattrocento', in *Dürer e l'Italia*, ed. K. Herrmann Fiore, exh. cat., Scuderie del Quirinale, Rome 2007, pp. 51–61

MARANI 2008
P.C. Marani, *I disegni di Leonardo da Vinci e della sua cerchia nelle collezioni pubbliche in Francia*, Florence 2008

MARANI 2009a
P.C. Marani, 'Leonardo, the Vitruvian Man, and the *De statua* Treatise', in Atlanta and Los Angeles 2009–10, pp. 82–91

MARANI 2009b
P.C. Marani, 'Le *Saint Jean* de Léonard de Vinci: Quelques nouvelles hypotheses sur les remaniements anciens de l'oeuvre, sa genèse et sa fortune', in Milan 2009, pp. 45–60

MARANI 2009c
P.C. Marani, *Il Cenacolo di Leonardo*, Milan 2009

MARANI 2010a
P.C. Marani, 'Dati tecnici e analisi scientifiche', in Rome 2010–11, pp. 73–87

MARANI 2010b
P.C. Marani 'Lo sguardo e la musica: Il *Musico* nell'opera di Leonardo a Milano', in Rome 2010–11, pp. 15–45

MARANI 2011
P.C. Marani, *Il Cenacolo svelato*, Milan 2011

MARANI AND SHELL 1992
P.C. Marani and J. Shell, 'Un dipinto di Marco d'Oggiono ora a Brera e alcune ipotesi sulla sua attività come cartografo', *Raccolta Vinciana*, XXIV (1992), pp. 61–78

MARANI ET AL. 1986
P.C. Marani, R. Cecchi and G. Mulazzani, *Il Cenacolo e Santa Maria delle Grazie*, Milan 1986

MARCONI 1968
P. Marconi, 'Una chiave per l'interpretazione dell'urbanistica rinascimentale: La cittadella come microcosmo', *Quaderni dell'Istituto di Storia dell'Architettura*, XV (1968), pp. 53–94

MARCONI 1973
P. Marconi, *La città come forma simbolica*, Rome 1973

MARCORA 1976
C. Marcora, *Marco d'Oggiono*, Oggiono 1976

MARKOVA 1991
V.E. Markova, 'Il *San Sebastiano* di Giovanni Antonio Boltraffio e alcuni disegni dell'area leonardesca', in Fiorio and Marani 1991, pp. 100–7

MARTIN ET AL. 2005
E. Martin, C. Scaillierez, P. Le Chanu, J-P. Rioux and N. Volle, *'La Vierge, l'Enfant Jésus et Sainte Anne de Léonard de Vinci: Création et transmission d'un chef d'œuvre', Techné*, XXI (2005), pp. 26–34

MATTEINI AND MOLES 1979
M. Matteini and A. Moles, 'A Preliminary Investigation of the Unusual Technique of Leonardo's Mural *The Last Supper*', *Studies in Conservation*, XXIV, no. 3 (1979), pp. 125–33

MATTEINI AND MOLES 1986
M. Matteini and A. Mols, 'Il *Cenacolo* di Leonardo: Considerazioni sulla tecnica pittorica e ulteriori studi analitici sulla preparazione', *OPD Restauro*, I (1986), pp. 34–41

MAYER AND BENTLEY-CRANCH 1994
C.A. Mayer and D. Bentley-Cranch, *Florimond Robertet (?–1527): Homme d'état français*, Paris 1994

MAYER AND BENTLEY-CRANCH 1997
C.A. Mayer and D. Bentley Cranch, 'François Robertet: French Sixteenth-Century Civil Servant, Poet, and Artist', *Renaissance Studies*, XI, no. 3 (1997), pp. 208–22

MAZZOCCHI DOGLIO 1983
M. Mazzocchi Doglio, 'Spettacoli a Milano nel periodo sforzesco', in *Leonardo e gli spettacoli del suo tempo*, Milan 1983, pp. 20–40

MEIER-GRAEFE 1926
J. Meier-Graefe, *The Spanish Journey*, trans. J. Holroyd-Reece, London 1926 (*Spanische Reise*, Berlin 1910)

MELZI D'ERIL 1973
G. Melzi d'Eril, *La Galleria Melzi e il collezionismo milanese nel tardo Settecento*, Milan 1973

MERLINI AND STORTI 2009
V. Merlini and D. Storti, *Léonard à Milan: Saint Jean Baptiste*, Paris 2009

MICHEL (1884)
Marcantonio Michel, *Notizia d'opere di disegno*, Bologna 1884

MILAN 1872
Catalogo delle opere d'arte antica esposte nel Palazzo di Brera, exh. cat., Regia Accademia di Belle Arti, Milan 1872

MILAN 1939
Mostra di Leonardo da Vinci, exh. cat., Palazzo dell'Arte, Milan 1939

MILAN 1958
Arte lombarda dai Visconti agli Sforza, exh. cat., Palazzo Reale, Milan 1958

MILAN 1964
Arte europea da una collezione americana, exh. cat., Palazzo Reale, Milan 1964

MILAN 1972
Capolavori d'arte lombarda: I Leonardeschi ai raggi 'X', ed. M. Garberi Precerutti and L. Mucchi, exh. cat., Castello Sforzesco, Milan 1972

MILAN 1982a
Leonardo all'Ambrosiana: Il Codice Atlantico; I disegni di Leonardo e della sua cerchia, eds A. Marinoni and L. Cogliati Arano, exh. cat., Pinacoteca Ambrosiana, Milan 1982

MILAN 1982b
Leonardo da Vinci: Studi di natura della Biblioteca Reale nel Castello di Windsor, ed. C. Pedretti, exh. cat., Castello Sforzesco, Milan 1982

MILAN 1982c
Zenale e Leonardo: Tradizione e rinnovamento della pittura lombarda, ed. M. Natale, exh. cat., Museo Poldi Pezzoli, Milan 1982

MILAN 1983
Milano e gli Sforza: Gian Galeazzo Maria e Ludovico il Moro (1476–1499), ed. G. Bologna, exh. cat., Castello Sforzesco, Milan 1983

MILAN 1984
Leonardo e l'incisione: Stampe derivate da Leonardo e Bramante dal XV al XIX secolo, ed. C. Alberici, exh. cat., Castello Sforzesco, Milan 1984

MILAN 1987–8
Disegni e dipinti leonardeschi dalle collezioni milanesi, exh. cat., Palazzo Reale, Milan 1987

MILAN 1990
Da Leonardo a Tiepolo: Collezioni italiane dell'Ermitage di Leningrado, exh. cat., Palazzo Reale, Milan 1990

MILAN 1998
L'Ambrosiana e Leonardo, eds P.C. Marani, M. Rossi and A. Roveta, exh. cat., Pinacoteca Ambrosiana, Milan 1998

MILAN 1999–2000
La Milano del Giovin Signore: Le arti nel Settecento di Parini, eds F. Mazzocca and A. Morandotti, exh. cat., Palazzo Morando Attendolo Bolognini, Milan 1999

MILAN 2000a
Giuseppe Molteni (1800–1867) e il ritratto nella Milano romantica, exh. cat., Museo Poldi Pezzoli, Milan 2000

MILAN 2000b
'Io son la volpe dolorosa': Il ducato e la caduta di Ludovico il Moro, ed. E. Saita, exh. cat., Castello Sforzesco, Milan 2000

MILAN 2000–I
Il Cinquecento lombardo: Da Leonardo a Caravaggio, ed. F. Caroli, exh. cat., Palazzo Reale, Milan 2000

MILAN 2001
Il genio e le passioni: Leonardo e il Cenacolo, ed. P.C. Marani, exh. cat., Palazzo Reale, Milan 2001

MILAN 2006
Il Codice di Leonardo da Vinci nel Castello Sforzesco, eds P.C. Marani and G.M. Piazza, exh. cat., Castello Sforzesco, Milan 2006

MILAN 2007
Leonardo: Dagli studi di proporzioni al trattato della pittura, eds P.C. Marani and M.T. Fiorio, exh. cat., Castello Sforzesco, Milan 2007

MILAN 2009
Leonardo a Milano: San Giovanni Battista, eds V. Merlini and D. Storti, exh. cat., Palazzo Marino, Milan 2009

MILAN 2010
Leonardo, la politica e le allegorie, ed. M. Versiero, exh. cat., Pinacoteca Ambrosiana, Milan 2010

MILAN 2010–11
Il rinascimento nelle terre ticinesi: Da Bramantino a Luini, eds G. Agosti, J. Stoppa and M. Tanzi, exh. cat., Pinacoteca Cantonale Giovanni Züst, Milan 2010

MILLAR 1972
O. Millar, *The Inventories and Valuations of the King's Goods*, London 1972

MITCHELL 1890
Catalog der Sammlung von Handzeichnungen alter Meister aus dem Besitze des Herrn William Mitchell in London, sale catalogue, F.A.C. Prestel, Frankfurt am Main, 7 May 1890

MOCZULSKA 1995
K. Moczulska, 'The Most Graceful and the Most Exquisite 'galée' in the Portrait of Leonardo da Vinci', *Folia Historiae Artium*, I (1995), pp. 77–86

MODENA AND RENNES 1990
Disegno: Les dessins italiens du Musée de Rennes, ed. P. Ramade, exh. cat., Galleria Estense, Modena; Musée des Beaux-Arts, Rennes 1990

MOFFITT 1990
J.F. Moffitt, 'Leonardo's Sala delle Asse and the Primordial Origin of Architecture', *Arte Lombarda*, XCII–XCIII (1990), pp. 76–90

MOHEN ET AL. 2006
J.-P. Mohen, M. Menu and B. Mottin, *Mona Lisa: Inside the Painting*, New York 2006

MÖLLER 1916
E. Möller, 'Leonardos *Bildnis der Cecilia Gallerani* in der Galerie des Fürsten Czartoryski in Krakau', *Monatshefte für Kunstwissenschaft*, IX (1916), pp. 313–26

MÖLLER 1926
E. Möller, 'Leonardo's Madonna with the Yarnwinder', *Burlington Magazine*, XLIX, no. 281 (1926), pp. 61–9

MÖLLER 1929
E. Möller, 'Die Madonna mit den spielenden Kindern aus der Werkstatt Leonardos', *Zeitschrift für bildende Kunst*, LXII (1929), pp. 217–27

MÖLLER 1939
E. Möller, 'Lionardos Altartafel mit der Auferstehung Christi', *Jahrbuch der Königlich Preußischen Kunstsammlungen*, LX (1939), pp. 76–102

MÖLLER 1952
E. Möller, *Das Abendmahl des Lionardo da Vinci*, Baden-Baden 1952

MOMESSO 1997
S. Momesso, 'Sezioni sottili per l'inizio di Marco Basaiti', *Prospettiva*, LXXXVII–LXXXVIII (1997), pp. 14–41

MOMPELLIO MONDINI 1943
G. Mompellio Mondini, *La tradizione intorno agli edifici romani di Milano dal secolo V al secolo XVIII*, Milan 1943

MONACO 2007a
M.C. Monaco, 'L'eredità dell'antico', in Nanni and Monaco 2007, pp. 21–51

MONACO 2007b
M.C. Monaco, '"... una Leda di marmo, bona, anchora li mancha qualche membro; non restaro di torla": Sulle tracce dei modelli di età classica', in Nanni and Monaco 2007, pp. 125–55

MONSTADT 1995
B. Monstadt, 'Judas beim Abendmahl: Figurenkonstellation und Bedeutung in Darstellungen von Giotto bis Andrea del Sarto', *Beiträge zur Kunstwissenschaft*, LVII (1995)

MONTESANO 2004
M. Montesano, 'Da Genova a Parigi, da Parigi a Genova: Il furto e il ritorno del Mandylion nel primo Cinquecento', in *Mandylion: Intorno al Sacro Volto*, eds G. Wolf, C. Dufour Bozzo and A.R. Calderoni Masetti, exh. cat., Museo Diocesano, Genoa 2004, pp. 285–91

MORANDOTTI 1991
A. Morandotti, 'Il revival leonardesco nell'età di Federico Borromeo', in Fiorio and Marani 1991, pp. 166–82

MORELLI 1800
J. Morelli, *Notizia d'opere di disegno, nella prima metà del secolo XVI, esistenti in Padova, Cremona, Milano, Pavia, Bergamo, Crema e Venezia*, Bassano 1800

MORELLI 1880
I. Lermolieff [G. Morelli], *Die Werke italienischer Meister in den Galerien von München, Dresden und Berlin: Ein kritischer Versuch*, Leipzig 1880

MORELLI 1886
I. Lermolieff [G. Morelli], *Le opere dei maestri italiani nelle Gallerie di Monaco, Dresda e Berlino*, Bologna 1886

MORELLI 1890
I. Lermolieff [G. Morelli], *Kunstkritische Studien über italianische Malerei: Die Galerien Borghese und Doria Panfili in Rom*, Leipzig 1890

MORELLI 1892–3
I. Lermolieff [G. Morelli], *Italian Painters: Critical Studies of their Works*, trans. C.J. Ffoulkes, 2 vols, London 1892–3

MORO 1994
F. Moro, 'Ancora su Marco d'Oggiono', *Museoviva*, V (1994), pp. 17–27

MORO 1998
F. Moro, 'Francesco Napoletano ossia il Maestro della *Pala Sforzesca*', in *'Tutte le opere non son per istancarmi': Raccolta di scritti per i settant'anni di Carlo Pedretti*, ed. F. Frosini, Rome 1998, pp. 279–98

MOSCOW 1962
Exhibition of Masterpieces of World Art from the Collection of the Hermitage, exh. cat., Pushkin State Museum of Fine Arts, Moscow 1962

MOSCOW 1995–6
Five Centuries of European Drawings: The Former Collection of Franz Koenigs, ed. I. Danilova, exh. cat., Pushkin State Museum of Fine Arts, Moscow 1995

MOTTA 1884
E. Motta, 'Curiosità di storia italiana del secolo XV tratte dagli archivi milanesi: Morte del pittore Zanetto', *Bollettino Storico della Svizzera Italiana*, VI (1884), p. 79

MOTTA 1893
E. Motta, 'Ambrogio Preda e Leonardo da Vinci (nuovi documenti)', *Archivio Storico Lombardo*, XI (1893), pp. 972–87, 990–6

MOTTA 1903
E. Motta, 'Arazzi in Milano', *Archivio Storico Lombardo*, XXX, no. 29 (1903), pp. 484–6

MOTTIN 2010
B. Mottin, 'Leonardo da Vinci's *The Virgin and Child with Saint Anne* (Musée du Louvre, Paris): New Infrared Reflectography', in *Studying Old Master Paintings: Technology and Practice*, ed. M. Spring, London 2010, pp. 65–71

MULAS 1995
Pier Luigi Mulas, 'I libri per l'educazione di Massimiliano', in Giordano 1995b, pp. 58–91

MÜLLER-WALDE 1889
P. Müller-Walde, *Leonardo da Vinci: Lebensskizze und Forschungen über sein Verhältniss zur Florentiner Kunst und zu Rafael*, Munich 1889

MÜNDLER (1909)
O. Mündler, 'Catalog der Galerie Esterházy von Galantha zu Pest, mit kritischen Bemerkungen um der Schätzung der einzelnen Bilder von Otto Mündler, 1869', in J. Peregriny, *Az Országos Szépmvészeti Múzeum Állagai*, vol. I, Budapest 1909, pp. 3–40

MÜNDLER (1985)
'The Travel Diaries of Otto Mündler', *Walpole Society*, LI (1985), pp. 69–254

MUNICH 2006
Leonardo da Vinci: Die Madonna mit der Nelke, ed. C. Syre, J. Schmidt and H. Stege, exh. cat., Alte Pinakothek, Munich, 2006

MÜNTZ 1898
E. Müntz, *Leonardo da Vinci: Artist, Thinker, and Man of Science*, 2 vols, London and New York 1898

NAGEL 1993
A. Nagel, 'Leonardo and sfumato', *Res*, XXIV (1993), pp. 7–20

NAGEL 2010
A. Nagel, 'Structural Indeterminacy in Early Sixteenth-Century Italian Painting', in *Subject as Aporia in Early Modern Art*, ed. A. Nagel and L. Pericolo, Farnham 2010, pp. 17–42

NAJEMY 1995
J.M. Najemy, 'The Republic's Two Bodies: Body Metaphors in Italian Renaissance Political Thought', in *Language and Images of Renaissance Italy*, ed. A. Brown, Oxford 1995, pp. 237–62

NALDUS (1943)
Naldus Naldius Florentinus, *Epigrammaton liber*, ed. A. Perosa, Budapest 1943

NANNI AND MONACO 2007
R. Nanni and M.C. Monaco, *Leda: Storia di un mito dalle origini a Leonardo*, Florence 2007

NAPLES AND ROME 1983–4
Leonardo e il leonardismo a Napoli e a Roma, ed. A. Vezzosi, exh. cat., Museo Nazionale di Capodimonte, Naples; Roma, Palazzo Venezia, Rome, Florence 1983

NATALE 1982
M. Natale, 'L'ancona dell'Immacolata Concezione a Cantù', in Milan 1982c, pp. 24–33

NATALI 1998
A. Natali (ed.), *Lo sguardo degli angeli: Verrocchio, Leonardo e il Battesimo di Cristo*, Cinisello Balsamo 1998

NATALI 2000
A. Natali (ed.), *L'Annunciazione di Leonardo: La montagna sul mare*, Florence 2000

NATALI 2006
A. Natali, 'Il tempio ricostruito', in Camerota et al. 2006, pp. 8–29

NATHAN 1992
J. Nathan, 'Some Drawing Practices of Leonardo da Vinci: New Light on the *St Anne*', *Mitteilungen des Kunsthistorischen Institutes in Florenz*, XXXVI (1992), pp. 85–102

NATIONAL GALLERY 1963
Acquisitions 1953–62, National Gallery, London 1963

NETHERSOLE 2011
S. Nethersole, '"Parve cosa miracolosa": Giusto Giusti d'Anghiari and Leonardo da Vinci', in *'Una insalata di più erbe': A Festschrift for Patricia Lee Rubin*, eds J. Harris, S. Nethersole and P. Rumberg, London 2011, pp. 73–82

NEW YORK 2003
Leonardo da Vinci: Master Draftsman, ed. C.C. Bambach, exh. cat., Metropolitan Museum of Art, New York, New Haven and London 2003

NICHOLL 2004
C. Nicholl, *Leonardo da Vinci: The Flights of the Mind*, London 2004